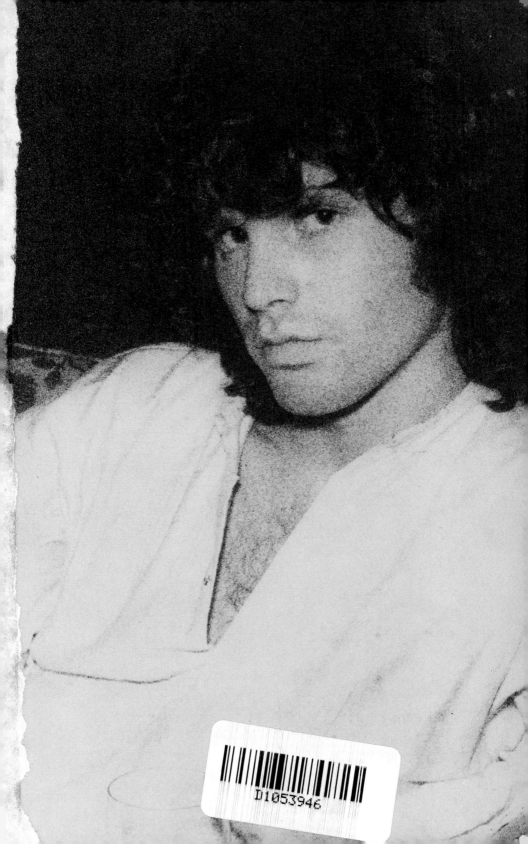

BREAK
ON
THROUGH

OTHER BOOKS BY JAMES RIORDAN

The Platinum Rainbow (with Bob Monaco)

Making It In The New Music Business

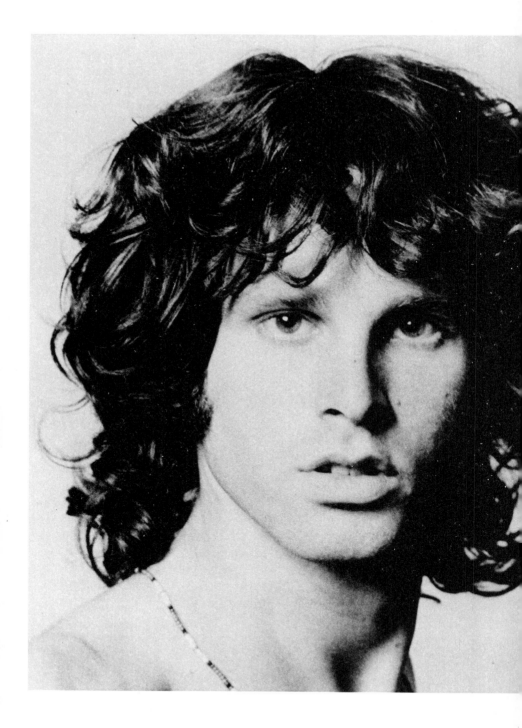

BREAK ON THROUGH

The Life and Death of Jim Morrison

James Riordan
and
Jerry Prochnicky

William Morrow and Company, Inc.
New York

Library of Congress Cataloging-in-Publication Data

Riordan, James.
 Break on through : the life and death of Jim Morrison / James
Riordan and Jerry Prochnicky.
 p. cm.
 ISBN 0-688-08829-5
 1. Morrison, Jim, 1943–1971. 2. Rock musicians—United States—
Biography. I. Prochnicky, Jerry. II. Title.
ML420.M62R6 1991
782.42166'092—dc20
 [B] 90-26580
 CIP

Printed in the United States of America

First Edition

1 2 3 4 5 6 7 8 9 10

BOOK DESIGN BY NICOLA MAZZELLA

James Riordan would like to dedicate this book, "To Bill Myers, a writer/director of great talent and integrity, whose continual support and encouragement has enabled me to complete the manuscript and still retain a portion of my sanity."

Jerry Prochnicky would like to dedicate this book, "To Stephanie Ann."

ACKNOWLEDGMENTS

Having written about music for most of my adult life I had always resisted the temptation to do a rock star biography. It always seemed to me that the lives of most rock performers could be better summed up by one good record than an entire book devoted to sex, drugs, and rock 'n' roll. And while I admired those few in-depth approaches that somehow managed to get done, I also understood those critics who claimed such tales of debauchery and music could never be treated as serious books. Then I met Jerry Prochnicky with his library of information on Jim Morrison. It wasn't long before I realized that Morrison's story was as serious and as relevant as any subject could be and yet, to tell it right, it could not be separated from the sex, drugs, and rock 'n' roll that spin madly at its center.

Five years later I've learned the hard way that it's not easy to separate truth from myth and the bigger the legend the more difficult it becomes. All good myths soon become self-perpetuating and each person who recounts them tends to add a little something of his or her own. Add this to the fact that there are a host of people out there *consciously* perpetrating the Morrison myth for their own financial gain, and the maze becomes a considerable one. The funny thing is that Morrison never needed exaggeration. His truth is indeed far stranger than the fiction that has grown up around him.

Nonetheless, the passage of twenty years has clouded the

issues and led to many obstacles—lost documents, an absence of witnesses, selective memory, and even worse, creative memory—people remembering what they wish would've happened instead of what actually did.

In the end, after battling through a maze of broken promises, paranoid reticents, and outright opportunists we got by with the help of a few gutsy individuals whose desire to set the record straight eclipsed not only their own financial gain, but their need for privacy and, most important, the temptation to let painful memories stay buried. We are especially grateful to the nearly forty people who consented to interviews and also to those magazine and newspaper editors who allowed us to excerpt information to counterbalance and cross-check our sources as well as others who participated in the collecting of photographs and other areas that were invaluable to the completion of this book— especially Alan Ronay, Diane Gardiner, Vince Treanor, Patricia Kennealy, Mirandi Babitz, Ray Manzarek, Robby Krieger, John Densmore, Danny Sugerman, Columbus Courson, Frank Lisciandro, Bill Siddons, Michael Ford, Rich Linnell, Paul Rothchild, Bruce Botnick, Jac Holzman, John Haeny, Pamela DesBarres, Dr. Arnold Derwin, Danny Fields, Richard Blackburn, Terrance McWilliams, Alison Martino, David Keiser, Carolyn Cruise, Max Fink, Emma Sweeney, Jeff Simon, Marianne Faithful, John Carter, Jeannie Cromie, David Walley, and Oliver Stone.

As well as Mr. and Mrs. Tom Baker, Sr., Lee and Jan Batchler, Wendy Bellerman, Toni Brown, Jay and Gail Caress, Bob and Lorri Cashatt, David Causer, Bob Chorush, Jim and Karen Covell, Gregg Cox, Harry Dagget, Leslie Denson, Pam Denson, Roman Diaczenko, Digby Diehl, Greg Dix, Duncan Dunn, Joyce Faris, Gus Feiner, Robyn Flans, Chris Fuller, Vic Garbarini, Mike Gershman, Richard Goldstein, Robert Gover, William and Delores Griffin, John Hoover, Jerry Hopkins, Michael Horowitz, Blair Jackson, Mike Jahn, Marylee Johnson, Fin and Adrian Johnston, Mike and Jo Lawryk, Mike and Mary Leppert, Coleman and Carel Luck, Doug McIntosh, Erica Meek, Jessica Meek, Clara and Sherry Moyer, David Petrizzi, Fred Powledge, Ivan and Anna Prochnickyj, Chris Riordan, Debbie Riordan, Elicia Riordan, Jeremiah Riordan, Joe and Joni Riordan, Nancy Joe Riordan, Mrs. Nancy Riordan, Ann Rittenberg, Fred Roberts, Ed Romero, Mike Rosen, Raeanne Rubenstein, Chris and Melissa Rudy, Harry and Paula

Ruscigno, Joe Russo, Stan Sempler, Bob Shamah, Jeff Sharp, Loren
and Vicki Silver, Kevin Smith, Dorothy Stadnyk, Kevin Stein, Mark
Stepp, Salli Stevenson, Dick Sugerman, Jeff Tamarkin, Derrick
Warfel, Paul Williams, Jim and Karen Youell, Mick Zillo.

Thanks also to our agent Julian Bach for his vision, counsel,
and encouragement, to Liza Dawson, our editor, for her immea-
surable help and editing skills, and to Jim Landis for recognizing
the book's potential and giving it a home at Morrow.

 James Riordan and Jerry Prochnicky

CONTENTS

THE MORRISON MYSTIQUE

The shard of glass was jagged. It jutted toward the sky as if trying to pierce it, to cut away the boundary between heaven and earth. Or maybe slice off a piece of hell. So thought the lanky figure who stared into the broken mirror. He was handsome; the distorted reflection of the shattered glass could not hide his good looks. His hair was long and curled over the collar of his white T-shirt. His skin was pale and his face looked even younger than his twenty-two years. There was a softness to him, a gentleness, an almost seductive quality. His face was more than handsome, it was pretty; and the way he cocked his head slightly, exposing his alabaster white neck, displayed a vulnerability that most men would be afraid to reveal. But he was not feminine. In his eyes something definitely masculine burned. More than masculine even. Something dangerous.

Jim Morrison peered closely at his image in the mirror. He looked so different than he had a year and a half ago when he'd

15

arrived in Los Angeles. The chubbiness was completely gone—
the past few weeks of near starvation had taken away the last of
it. His eyes were more penetrating, his cheeks hollow and slightly
sunken, like a fashion model's. The easygoing strut that had
looked clumsy when he was a pudgy kid at FSU had taken on a
sleekness at UCLA. He looked graceful now.

Morrison ran his fingers over the sharp edge of the glass. He
hadn't eaten a decent meal in over a week. For a while it had
bothered him, but this past day had been the easiest of all. Since
the can of beans he had eaten at noon yesterday, nothing but
water had entered his system. Well, of course, there was the acid.
For an instant he wondered if there was any nutritional value to
acid. Since nutrients gave one energy and helped the body func-
tion correctly and acid enabled him to feel he could do the same
things by using mind over matter, perhaps it qualified. His mind
easily made the jump in logic and he knew that if he wanted to
he could explore this concept and all its ramifications for hours.
He looked at the finger he had been rubbing over the sharp glass.
It was bleeding. Good. The acid was kicking in.

But tonight was not for exploring the mundane until it be-
came the magnificent. Nor was this the night to dissect details—
like the time he had observed how the melting drops of wax
from his candle solidified themselves to the coffee can next to his
sleeping bag. Eventually they had become not a minute detail of
the burning candle, but the dominant theme, the very purpose of
the candle's existence. Before that night had ended he had even
been able to *hear* the drops bond with the aluminum of the cof-
fee can. *Feel* the alloys of the metal break down to the point
where they could be fused slightly with the wax. But not tonight.
Tonight was for something special. He had saved the lion's share
of the acid for this night and already he knew that it was not
going to be wasted.

The sun was dropping. Soon it would be time. From his posi-
tion on the rooftop he could watch the sun descend into the
ocean until the Santa Monica pier blocked the view in the dis-
tance. Fire melting into the sea. That was how he thought of it.
Jim liked the sea, but it was the sun that fascinated him. Actually,
more than that, it was the disappearance of the sun. Watching
something so bright and so powerful vanish without a trace ex-
cited him. It was the onset of the night, the rising of the moon

and appearance of the stars that spoke to his inner being: *Let's swim to the moon/Let's climb thru the tide/Penetrate the evenin' that the city sleeps to hide.* Of all the lines of poetry he'd written in the weeks since coming to the rooftop this was his favorite.

Outwardly it appeared that he was failing miserably at life. Here he was living on the roof of an abandoned office building in Venice, California. Having graduated from UCLA a month ago, he had thought so little of his degree that he hadn't even bothered to pick it up. Film school seemed a thousand miles away; here was where the real issues of his life would be determined. He knew that now. The roof was barren except for his little corner near the chimney—a sleeping bag, an orange crate housing a few books covered with a towel to keep out the moisture, the coffee can, and the candle. But those things weren't what mattered. Next to them, lying open on the cement floor, was something more valuable than than anything in the finest house in Beverly Hills—a tattered black Scholastic notebook filled with his poetry. And although he'd been writing poetry all his life, he felt that these words were different, that there was something more powerful about these poems. Not only more powerful, but more rhythmic—they had a natural beat to them.

He stared out at the descending sun and his gaze dropped to the collage of T.V. antennas on the houses below: *Gazing on a city undertelevision skies.* The words poured into his mind. It had been like this the past few days; that's how he knew he was getting closer. It had something to do with the isolation, he knew that for sure. He was in a different world up on the roof. Just him and his mind. Sometimes, late at night, when he heard sounds in the abandoned building below, he liked to imagine they were spirits. Restless souls who had crossed over to the other side too early, without saying what they had to say. And lately he'd been hearing sounds on the roof itself, late at night when it was pitchblack. Darker than dark. He was above the streetlights and the reflections of the city below. It was really midnight here. *The bright midnight.*

For a brief instant a slight stab of hunger hit his stomach, but he concentrated and drove it out. He knew that the lack of food was having an effect on him. He'd read about Indian braves using food and sleep deprivation to put themselves in a trance state

and he knew it was an important key for many shamans. And although he'd intentionally kept himself awake all through the night before, Jim Morrison was not the least bit tired this night. He was too excited to be tired. This was the night he'd been waiting for. He might not learn the answers to why he was so different from everyone else, but he would surely learn to stop asking the questions.

A chill rose up as soon as the darkness came. But it soon passed and with it went the last semblances of what most people would call reality. The normal physical sensations of life—heat, cold, hunger, thirst, pain, pleasure—vanished into the night, replaced by sensations purely mental. In his mind he could hear a rhythmic drumming now. A steady throbbing, hypnotic in its rhythm, compelling in its relentlessness. Jim honed in on it like following a beacon guiding him to the netherworld of the shaman. He tried to open himself to it, he wanted to absorb it, to inhale it if possible. He would not draw back this time. This time he was ready.

Soon there came a soft haze near the edge of the roof, an eerie sort of glow. It seemed to pulsate ever so slightly with the rhythm of the drum. It seemed to draw him. Further and further in. Jim Morrison stared hard at the glow, not to determine if it were real, but to see inside it because he was convinced that was where the truth he had been seeking lived. He felt a slight quiver, a small hesitation, which reminded him for the last time that once he crossed into this world he might never be able to return. But there was no real doubt for Jim. He had long ago determined that this was where he was meant to be. He did not want the inner peace that so many of his generation were seeking. He wanted something more, and this was the only way he knew how to get it. He focused on the glow, throwing himself into it, not caring what the consequences were, only caring that he did it completely. And then he began to hear the music . . .

It was during that week in the summer of 1965, high on acid and claiming to hear an entire concert in his head, that Jim Morrison wrote most of the songs for the first two Doors albums—

songs that even today, twenty years after his death in Paris, are still a thriving part of our culture. The Doors' six studio albums sold over three million copies last year—more than two decades after they were recorded. The truth is that the music's never over.

"HE'S HOT, HE'S SEXY AND HE'S DEAD" read the front cover headline of *Rolling Stone* a decade after Jim Morrison's death. With his sultry looks, black leather pants, and quasi–James Dean vibe, Morrison was a hypnotic figure in the sixties and to this day millions of kids still see him as the ultimate rebel. His very name triggers controversy, or as some have put it, the man's been dead for twenty years and he's still causing trouble.

History is often a wanton slut who chooses to remember only what catches her fancy at a particular moment in time and that often depends more on talk show hosts, pop trends, and supermarket rags than on actual events. Morrison's life and persona both established The Doors and doomed them to a brief reign in rock's ivory tower, but it was his death that made them legendary.

What is it about Morrison that causes his myth to grow instead of fade away? Is it the music, the mystique, or the man himself? Morrison's look, his attitude, and his philosophy, all stand up and remain relevant today. His poetry still conveys a jagged urgency and his lyrics address the question of what life and death are all about—that sort of thing never goes out of style.

The status quo of the late sixties viewed Morrison as a political revolutionary. However, he never had any such desire—the last thing he wanted to do was organize anything. Morrison argued that we should all set ourselves free from our mental prisons and cease playing warden to our souls. His was the voice that bid us to dance on fire, to listen to the butterfly scream, and to break on through to the other side—away from social and parental conditioning to "true" feelings and sensitivities.

Nonetheless, the means Morrison took to make people aware, to shock them through to his idea of reality, absolutely horrified most adults, especially parents. In their minds, Jim Morrison was a threat, someone who started riots, continually challenged every authority, and sang about psychopathic sexuality in an effort to seduce the young of America. Parents didn't see him

as a poet or a philosopher. They saw him as an outlaw, and in a sense, they made him one. To be a free spirit and follow your own feelings in those days meant you were going to get busted (Morrison was arrested no fewer than ten times and he was the first rock performer to be arrested onstage during a concert performance).

Enigmatic in death as in life, Morrison was the perfect tragic superstar. He was born to be a rock star, and the power of his image not only helped create him, it also helped destroy him. Jim Morrison committed the ultimate sin for a rock idol. The Greeks called it hubris—becoming so arrogant as to challenge the very gods that were the source of your power. So it was with Morrison and the media that made him a modern-day god. He once said: "Whoever controls the media controls the mind. The media is the message and the message is me." In the end, though, he let it get out of control not because the image overwhelmed him, but because he overwhelmed himself.

Dr. Jekyll and Mr. Hyde

The image Jim Morrison created for the media was considerably different from the real person. The press saw the side of Morrison that best suited their needs. Predictably, their accounts were steeped in paradox: Writers praised the emotional insight in Morrison's lyrics and then criticized him for trying to be a poet. The press called him the "King of Orgasmic Rock" and then attacked him for being pretentious. They praised him for the fusion of rock and drama that The Doors created and then put him down for carrying it too far. They hailed him as the chief shaman of a new religion and then questioned his sanity for taking himself too seriously.

The volume of outrageous acts attributed to Morrison made him a living study in contemporary mythology. Long before his death, he became a cult figure to the young of the world and especially America. Morrison took it all the way. That was the thing his fans loved about him. He insisted on living his life on the verge of chaos. His actions were an enactment of his beliefs and the sixties generation knew he was sincere because he lived the life he sang about. So the kids saw him as a rock messiah

while their parents were sure he was the embodiment of hell. Both groups were right. He *was* both angelic and demonic. In fact everything about him was split; he was two personalities within one body—the devil and the angel, the rock star and the poet, the rebel and the sage. The private Jim Morrison was the antithesis of his extroverted stage personality. He spoke slowly and quietly with little emotion, often pausing to reflect or collect his thoughts before continuing. Though he was confident, he was not usually egotistical or pretentious. On the contrary he often was gentle, sensitive, and considerate of others' feelings. Many who knew Morrison will tell you he was a well-mannered "Southern gentleman," someone you would have no problem taking home to meet your mother. It was only onstage, or after having too much to drink, that his voice became deep and loud, his manner vibrant and gruff, and his actions quick and mindless.

Doors producer Paul Rothchild elaborates: "Jim really was two very distinct and different people. A Jekyll and Hyde. When he was sober, he was Jekyll, the most erudite, balanced, friendly kind of guy . . . He was Mr. America. When he would start to drink, he'd be okay at first, then, suddenly, he would turn into a maniac. Turn into Hyde."

The mask that you wore
My fingers would explore

Even Morrison's on-again, off-again, relationship with Pamela Courson, his longtime girlfriend, was reflective of his dual personality. Their romance was a tumultuous blend of tenderness and uncontrolled passion right from the beginning and this fire-and-ice quality lasted right to the end.

Doors keyboardist Ray Manzarek also saw two sides of the same man: "Like all geniuses, he was difficult to work with, but he was also a pleasure to work with. Sometimes the guy would be just the nicest guy in the world and at other times, the demons would take over. He had those angels and devils inside of him fighting for control, and you could never be sure whether the devil or the angel was going to come out."

Morrison's bouts with alcohol are legendary. The next whiskey bar was always just around the corner and Jim always found it. He supposedly still holds the record for downing mai tais in a

Honolulu bar—thirty-two in a single evening! He was a master at holding liquor. After half a dozen boilermakers he would still appear to be unaffected—he remained articulate, even smooth, and not desensitized at all. If someone so much as looked closely or jarred his consciousness, there would be that Morrison psyche like an exposed nerve—a raw awareness, that vast amounts of alcohol could not muffle. But the change would be sudden—moments later, without warning, Morrison would turn into a wild, falling down, uncontrollable drunk.

Why the near psychotic shift in behavior from stone sober, kind, coherent gentleman to raging drunk with nothing in between? Recent medical studies may provide a physiological answer. Many people lack the proper enzymes to correctly metabolize alcohol. When they drink, the alcohol is not assimilated at a normal rate and the usual warning signals are not sent to the brain. The brain can be cold stone sober one moment and then assaulted by a massive dose of almost pure alcohol the next. This amounts to a chemically induced psychosis, which could easily trip the schizoid switch in an otherwise totally normal brain.

One statement Morrison made about drinking in a 1969 interview for *Rolling Stone* with Jerry Hopkins seems to support this theory: "Getting drunk . . . you're in complete control up to a point. It's your choice every time you take a sip. You have a lot of small choices. It's like . . . I guess it's the difference between suicide and slow capitulation."

What prompted Jim Morrison to drink? If he did have a physiological condition, why didn't he just quit drinking in the early days when he knew what could happen? Morrison was like a forty-watt bulb that was being fed a hundred-watts of current. He was driven. He was a genius and a creative giant, but he was always being pushed somehow. Robby Krieger remembers that in the beginning Morrison was impatient for notoriety: "We always knew we had the potential to be big. But Jim was always disappointed it took so long. Even though we had a smash the first time out."

Doors drummer John Densmore agrees: "He was always saying at first that it wasn't happening fast enough. He said he wanted to be thought of as a shooting star; a big flash and then it's all gone. But look what happened to him; it happened too

fast . . . That's what makes me sad about Jim, because in the early days, here's this incredible, beautiful, smart guy who was curious about everything in the world. When you turn to alcohol, you're trying to stop something. He thought it was romantic, but I never saw anyone drink as much as him; he was sick . . . there was this big black cloud that hovered over him. Anyone who came into close contact with him found himself under the fringes of that darkness."

Alcohol is a depressant. For Morrison, it was depressing a lot of things he didn't want to deal with. He was being pushed from the inside out. Pushed to new and greater tests against authority. Driven harder against the boundaries of sanity. Hurled relentlessly into the walls of conformity and slammed head-on into the barriers of the reality that he was trying to break through. What was pushing Jim Morrison? For one thing it was his fascination with the occult practice of shamanism. Morrison, although too independent to become a regular practioner or participant in any group activities, patterned much of his life after the precepts of this ancient religion. The shaman is the medicine man, the visionary healer who is the central figure in many tribal cultures. The spiritual world of gods, demons, and ancestral spirits is believed to be responsible only to the shaman who gets his powers through supernatural visions and trances. In American Indian culture the shaman used songs, rhythms, and dances in a tribal ritual to bring about a metaphysical experience. This is exactly what Jim Morrison tried to do in concert. And some people believe he actually accomplished it.

Frank Lisciandro, Doors photographer and friend, is one of them: "Jim drank *not* for inspiration, but to quiet the ceaseless clamor of the demons, ghosts, and spirits begging for release. Alcohol put his visions temporarily to rest and allowed him to relax and play. He drank because there were demons and voices and spirits shouting inside of his head and he found that one of the ways to quell them was with alcohol. These were the voices of creation. I believe he used alcohol as a kind of relief from the incessant demands of his creative spirit."

Morrison attempted to live out the concepts of shamanism. With the audience playing the role of the tribe and The Doors providing the rhythm, he became an electric shaman onstage. He disoriented his senses, allowing his subconscious to dominate,

and subjected his body to a trance brought on by frenzied movements and chanting. With his long hair, leather pants, and silver Indian concha belt, Morrison not only conjured up a contemporary version of the Indian medicine man, but actually attempted to turn his concerts into séances, providing a catharsis for his audience.

Following the Dionysian principles of shamanism, Morrison continually sought to submerge his conscious mind in order to allow the subconscious to have complete control. First with acid and later with alcohol and at times just with the music itself, he totally disoriented and disorganized his senses to let his subconscious come out. Consequently, the fearless explorer of truth on the one hand and the wild satyr on the other, he walked a tightrope between self-fulfillment and hedonism. He portrayed perfectly the tense, nonviolent yet near-violent generation who demanded to be heard in the sixties. It was a decade that emphasized freedom, and that included spiritual freedom. All across the country youths experimented with new forms of spiritual awareness. But Morrison was far more than just another seeker of the spirit world. As with everything else he did, Morrison took shamanism to its furthest extreme. And unlike so many others, Jim Morrison didn't experience his spiritual awakening in the 1960s. For him, it began much earlier. And it was much more dramatic.

> *A natural leader, a poet,*
> *a Shaman, w/the*
> *soul of a clown*

WILD CHILD

It was on December 8, 1943, that a child later christened James Douglas Morrison arrived into the world to parents Steve and Clara. The United States was in the middle of World War II and George Stephen Morrison was a career man in the U.S. Navy. He had just been transferred to flight training in Florida from the Pacific, where he'd been part of the fleet's mine-laying operations, and it was in the small town of Melbourne that Jim was born. Shortly after Morrison's birth, his father returned to the war, recapturing islands from the Japanese as part of the great onslaught that would take the navy to Japan's front door and set the stage for the birth of the nuclear age. Life would never be the same again.

Jim was given the middle name Douglas after Douglas MacArthur, the flamboyant and controversial World War II general, and it was assumed he would continue in the family's military tradition one day. The Morrisons were career navy men.

Eventually, Steve would attain the coveted rank of rear admiral commanding squadrons of aircraft carriers in the Pacific, but when Jim was born he was only a captain rising up the navy ladder. Towing the line.

Men who go out on ships
To escape sin & the mire of cities

Captain Morrison was in his mid-twenties then. He was a small man physically, but tight and trim as a young Napoleon. Born in Rome, Georgia, Steve Morrison graduated from the Naval Academy at Annapolis in 1941 and met Clara Clarke later that year on a blind date when he was stationed in Hawaii. Not long after, they exchanged marriage vows, including a special one never to talk at home about his frequently secret work. Clara Morrison was warm, gracious, thoughtful, considerate—a perfect captain's wife. Pretty, but slightly plump, she was usually to be found smiling pleasantly in the shadow of her husband's presence.

With kind, affable, and upwardly mobile parents such as these, Morrison would seem to have had a good thing, but there were difficulties. Florida was as much of a home state as Morrison could claim. He lived in Pensacola briefly as an infant and his family's military home of record was always listed as Clearwater, where Jim and his mother lived with Steve's parents, Paul and Caroline, until he was three. At that age he was already a bright and sensitive child, but his insecurity was compounded by the fact that he rarely saw his father. With the birth of his sister, Anne, when he was three, the little time he did have with his father then had to be shared. In addition, due to his father's vocation, the family moved four times before Jim was four years old which increased the instability of the children. When Steve finally came home from the war in mid-1946 the family moved first to Washington, D.C., for six months and then on to Albuquerque, New Mexico, in 1947, where he was stationed at the Los Alamos testing ground. Thus it was that four-year-old Jim Morrison was in a state of emotional turmoil and perfectly set up for the traumatic shock that occurred while he was living in Albuquerque. It was an event so powerful that he would later describe it as "the most important moment of my life."

The Morrison family was driving in the desert. It was an omi-

nous day with a huge thunderstorm building and t
with threatening clouds. Jim was sleeping in the ba
his father woke him up to see the storm clouds, a r
the desert. But that was not all Jim saw that day.where
between Albuquerque and Santa Fe, they came upon a horrible
traffic accident. In Jim's own words: "It was the first time I dis-
covered death . . . Me and my mother and father and my grand-
mother and grandfather were driving through the desert at dawn.
A truckload of Indian workers had hit another car or some-
thing—there were Indians scattered all over the highway, bleed-
ing to death. So we pulled the car up . . . I must have been about
four or five. A child is like a flower, his head is just floating in the
breeze, man. I don't remember if I'd ever even been to a movie,
and suddenly, there were all these redskins, and they're lying all
over the road, bleeding to death. I was just a kid, so I had to stay
in the car while my father and grandfather went back to check it
out . . . I didn't see nothing—all I saw was funny red paint and
people lying around, but I knew something was happening, be-
cause I could dig the vibrations of the people around me, 'cause
they're my parents and all. And all of a sudden I realized that they
didn't know what was happening any more than I did. That was
the first time I tasted fear . . . and I do think, at that moment, the
souls or the ghosts of those dead Indians—maybe one or two of
'em—were just running around, freaking out, and just leaped into
my soul, and I was like a sponge, ready to just sit there and ab-
sorb it . . . And they're still in there. It's not a ghost story, it's
something that really means something to me."

There are several ways of looking at this incident. On a
purely pragmatic level, it was enough to birth in Morrison a fas-
cination for death and the dark side of life. On a more psycholog-
ical level, the shock of viewing such carnage at four years old is
enough to cause an inner withdrawal, setting the stage for artistic
escapes into poetry, film, and music, and the lower-level ventures
into drugs and alcoholism. And finally on a spiritual level, Jim
Morrison believed that he was possessed by the spirit of a shaman,
an Indian medicine man. It was the shaman who sometimes went
out of control onstage. It was the shaman who turned him from
angel to devil in his relationships and it was the shaman who
relentlessly drove him to the very edge throughout his life.

Indians scattered on dawn's highway bleeding
Ghosts crowd the young child's fragile eggshell mind

Parapsychologists believe a traumatic experience occurring at so young an age can result in a demonic attachment or fixation which some call possession. Morrison himself said repeatedly that he drank to silence the constant voices of the demons, ghosts, and spirits within his mind. As strange as it may sound, there is no denying that a chance accident somewhere in that sixty-mile stretch from Albuquerque to Santa Fe left an indelible mark on a four-year-old boy named Jim Morrison—a boy who would grow into a man, who would leave an equally indelible mark on the youth of America.

In early 1948, Steve Morrison's career took the family to Los Altos in northern California, where they stayed for almost four years. The first year they were there Jim's brother, Andy, was born, when Jim was six. It was in Los Altos that Jim started public school. He was a chubby boy in grade school, shy and afraid to open up with people.

Jim Morrison was Steve and Clara's firstborn and that in itself carried a burden of expectation. Add to that the rigid and intense mentality of the navy way and the almost continuous relocation of the family. Compound this by the male authority figure's absence for long periods of time and it's no wonder Morrison, a bright child, probably lonely and certainly bored, felt there was little chance of achieving genuine approval from his parents, friends, or teachers. There seemed to be no other logical choice but to rebel, and rebel Jim did, both with enthusiasm and imagination.

While the captain could be a charmer in public, friends of the family say he fluctuated between treating his children as if they were green recruits or, worse, just leaving it all up to Clara. He was absent so often that he was almost a visitor to the household during his son's early life and he exercised little parental authority when he was there. As a result, Morrison's life would always lack personal discipline.

Desperately in need of some stranger's hand

It was Clara, who had to contend with Jim on a daily basis as she took the reins of the household when Steve left for his tours

of duty. Neighbors remember her as an attractive, witty, and active person who had a few oddities of her own. According to Emma Sweeney who later lived next to the Morrisons, Clara had a passion for onion sandwiches and would sometimes pluck the hairs from her legs with tweezers as she sat gabbing in a lawn chair near the pool. Many afternoons she could be found walking the beach with a metal detector looking for coins or other minor treasures. Clara had a deep respect for nature and would share its wonders with those who were close to her through fascinating stories and demonstrations. Frequently, she would scour the sands for sand dollars and interesting sea shells and sometimes she would craft skillful arrangements of them around a mirror to hang in the Morrison home or give to friends. While Steve and Clara almost never spanked their children, they meted out whatever verbal abuse they felt was necessary to produce sufficient remorse and repentance. Being made to feel guilty repeatedly resulted in what psychologists call "shame-based behavior" in Morrison, yet another element that pointed him toward rebellion.

As Jim and Andy grew older the captain was able to spend more time at home. Unfortunately, though, Mr. Morrison chose this period to attempt to establish a steady diet of strict discipline, only to discover that both boys deeply resented it. Steve Morrison was accustomed to giving orders and having those orders obeyed without question. If Clara had any reservations, she kept them to herself and went along with her husband, seeking to preserve what little peace the family was able to have amid its ramblings across the country from base to base.

Morrison grew to be looked upon as a minor terror within the family, his hell-raising, attention-seeking behavior often caused embarrassment to Steve and Clara. He was a far cry from a navy kid. As a child, Jim also resented his brother and sister, probably because he didn't feel there was enough love and attention in the family to go around. According to psychologists, in most families the oldest child takes on the role of responsibility, leaving rebellion as an option to the other siblings striving for their own identity. With Morrison assuming to the role of the rebellious child, his younger siblings became the "responsible" ones. Morrison felt his parents preferred Andy over him because Andy was less complicated, more of a "normal boy" who loved sports and the things that normal boys loved. Later, Jim would

grow close to Andy and Anne, but when he was ten, like so much else in his life, they represented a threat to him. Often he taunted his younger brother and sister, as Andy recalled in *No One Here Gets Out Alive* (Jerry Hopkins and Danny Sugerman, Warner Books, 1980): "I don't know how many times I'd be watching TV and he'd come sit on my face and fart. Or after drinking chocolate milk or orange juice, which makes your saliva real gooey, he'd put his knees on my shoulders so I couldn't move and hang a goober over my face." Frequently, Jim was punished for this type of behavior. Then feeling guilty, he rebelled against the guilt with anger and took out this anger on Andy and Anne again to complete the cycle. Later, he once remarked about his outrageous behavior, "I didn't get enough love as a kid."

In the early 1950s the Morrisons moved to Washington, D.C., again for a year and then back to California, settling for some two years in Claremont while Jim's father was serving in Korea. When Steve returned, the family relocated back to Albuquerque, staying for two more years before again moving to California. It was at this time that Morrison began his fascination with reptiles. Even as a child he was a serious reader and one of his favorite books was about these creatures. Later, he would choose to call his alter ego the Lizard King, often quoting Nietzsche's Aphorism 276 (*Beyond Good and Evil*): "In all kinds of injury and loss the lower and coarser soul is better off than the nobler one . . . In a lizard a lost finger is replaced again; not so in man." This attraction foretold Morrison's interest in the darker side of life.

"I just always loved reptiles," he told the *L.A. Free Press's* Bob Chorush in 1971. "I grew up in the Southwest and I used to catch horned toads and lizards. It is interesting to me that reptiles are a complete anachronism. If every reptile in the world were to disappear tomorrow, it wouldn't change the balance of nature one bit. They are a completely arbitrary species. I think that they might, if any creature could, survive another world war or some kind of total poisoning of the planet. I think that somehow reptiles could find a way to avoid it."

Throughout Jim's childhood mobility and separation characterized the Morrison family. They lived in Pensacola, Melbourne, and Clearwater, Florida, twice in both Washington, D.C., and Albuquerque, New Mexico, and once each in Los Altos, Claremont, and Alameda, California, by the time Jim attended high school in Alex-

andria, Virginia. These moves often came with little warning, and such a nomadlike existence provided no consistency, but inconsistency in Morrison's life. Those who knew him best said the family moved so often that Jim's most immediate childhood memories were of landscapes. On the positive side, he was forced to learn to make friends quickly, but on the negative side he also learned not to get too close. He was afraid to open himself up to people, preferring to draw further into his mind and the security of his books because they were the things that couldn't be taken away from him. In later life, Jim Morrison would earn a great deal of money, but the money never mattered. He would still choose to sleep in cheap motel rooms or crash on the couch in The Doors' office. He seemed to constantly choose a life of shiftlessness, preferring a lack of roots. It was safer that way.

∎

Perhaps the real cause of this attitude was that as a child he had given up on the idea of ever having a real home, and the very thought of such a thing always brought back memories too painful to deal with. When he first achieved stardom in 1967, Morrison stated repeatedly in interviews that his family was dead. Two years later this was disproved. "I just didn't want to involve them," Morrison said at the time. "It's easy enough to find out personal details if you really want them. When we're born we're all footprinted and so on. I guess I said my parents were dead as some kind of joke."

Maybe Morrison considered his parents dead in his mind or maybe he was just being protective of them. Perhaps he thought that the publicity associated with having a rock star for a son would compromise his father's career and wreak havoc on the family's privacy. In any event, he always avoided discussing his childhood, maintaining that he "had such a *normal* one that there was no sense in talking about it." He admitted his family moved around a lot, but that's all he would say, though he agreed that what people become is largely a product of the way are brought up and their environment. Consequently, his background is somewhat hazy and unclear. It is evident, however, that there was a great deal of pressure on him. It is easy to imagine

Morrison as a tender, lonely kid—a sensitive, frustrated boy who never stayed in one place for more than a couple of years.

Growing up in the fifties was stifling in many ways. The kids of the baby boom were doomed to drab conformity, a somewhat plastic existence. The trim front lawn, church on Sundays, flag on holidays, keep up with the Joneses lifestyle all translated into a complacent hum for young Jim Morrison. There had to be more than the crew-cut mentality which dominated all realms of life from religion to music to sex. America was at peace with the confident bliss that arose out of World War II. America had the bomb. The economy was booming and most people's goal was a split-level house with a Cadillac in the driveway. Most kids wanted to be Mouseketeers, and Howdy Doody and Mickey Mantle were their heroes. Morrison hungered for something deeper and saw that just beneath the surface of the fifties façade festered physical abuse, psychological tyranny, racism, and other horrors. But the apple-pie wholesome world Jim Morrison grew up in was emotionally void, repressive, and predictable—everything he decided he did not want to be.

In school, Morrison was tested as having a genius IQ of 149. His grades were good, but he was often in trouble. Unmerciful with teachers, he constantly questioned their authority and intelligence. He would invent words to confuse them or ask them questions in a language they didn't understand. He felt challenged and uneasy by what they taught him. He hated authority. From his childhood to his death, Jim Morrison abhorred being told to do anything by anyone.

Morrison's early relationships with the opposite sex were equally turbulent. He called all the shots and could be extremely jealous, frequently bullying his young girlfriends but he could also be very sweet to them. Invariably, he would try to win female approval by spinning outrageous stories that were convincing because he told them with such an air of superiority. But it was a false confidence and Jim could go from relative calm to rage to crumbling sorrow in a matter of minutes when his emotions were pressed.

High School

In December 1958, Morrison's father was again transferred to Washington, D.C., and the Morrisons moved to Alexandria, Vir-

ginia. Alexandria in the fifties was a former bastion of the Old Dominion and Virginian elegance which had deteriorated into just another Middle Atlantic port town. But there were places in Alexandria that spoke of next-door Arlington's style and glitz, and Braddock Heights, where the Morrisons lived, was one. It had modern, colonial houses with paneling and flagstone, surrounded by large well-kept lawns and wonderfully thick trees. One of the most impressive houses on its block, 310 Woodlawn Terrace was the closest thing to a real home Jim Morrison ever knew. He was there three years.

Captain Morrison was a charming man during the family's time in Alexandria. Witty and literary, he was inclined to take a turn at the piano now and then at parties. Always a pilot at heart even though he was over forty now, Steve still rose early to get in fifty miles of flying time before tackling his desk job in Washington. His relationship with his eldest son, however, was not improving. They saw little of each other and when they did, there was little communication and occasional fireworks.

It was becoming harder and harder for the Morrisons to understand their son. Nearly everything he did was an act of rebellion. Clara would give Jim five dollars to buy a shirt and he would get one for a quarter at the Salvation Army and spend the rest on something else. There were times, though, when Jim did try to dress and wear his hair in a way to gain approval from his father, but he found the sacrifices rarely worked. Invariably, he was still told to get a haircut and reminded that he needed to dress better. More than ever, Jim Morrison grew to hate conformity and authority. He was breaking loose and Captain Morrison would never be able to regain touch with his son. During this period Jim became closer to his brother, Andy, as the competition for affection they felt as kids faded and they began to side together against their parents.

Jim spent his rocky but academically successful high school years at George Washington High School, alma mater to such other music notables as Cass Elliot, Zal Yanovsky of the Lovin' Spoonful, and Scott McKenzie ("San Francisco/Wear Some Flowers in Your Hair"). In contrast to the suburban glitz of nearby Arlington's stylish split-level high school, sleepy Alexandria's George Washington High was a dreary relic of the failures of the educational system: monotonous, with up-and-down staircases,

detention-yellow paint, grim architecture, and in the late fifties, an attitude that viewed progressive education as a passing fad.

It was in this muddled environment that Jim Morrison attended high school: "I was a good student," he recounted to Richard Goldstein in an interview for *New York* magazine. "Read a lot. But I was always . . . uh . . . talking when I wasn't supposed to. They made me sit at a special table." He is remembered as being sullen and not taking part in most school activities. That proverbial yardstick of teen success, the yearbook caption, reads only "Honor Roll (2)" under Jim Morrison's name. No Sports. No Band. No Clubs. No Nothing. Jim Morrison was in the netherworld, incubating between a childhood that left him wanting and a future in which he was about to explode. But not yet. Not until it all crystallized inside him.

Morrison had an amazing, if raw and uncooperative, intelligence. But he didn't work and play well with others, and he didn't fit the mold. Somewhat small and slight, his sensitive, intense face was not quite enough to name the game at George Washington High School. Morrison's "easy ride" at old GW High became his impetuous nature. He was admired and later remembered by fellow students for doing things like yelling out the answers to questions that even the teachers didn't have, or shouting, "Hey motherfucker," in the middle of class as friends would pass by in the hall. Often he gave his teachers outrageous excuses for being late, claiming to have been robbed or kidnapped by gypsies, and once he left class early saying he had to be operated on that afternoon for a brain tumor. The next day Clara was shocked when the school principal called and asked how the operation went. He was eccentric and weird, hip before there was hip.

It was at George Washington that Morrison met Tandy Martin, a sweet and sensitive girl who lived in the same neighborhood. Jim teased Tandy incessantly, pretending to be retarded or doing things in public to embarrass her like lying on the floor and trying to kiss her feet on the bus. Though she grew tired of his joking, Tandy was attracted to Morrison because he wasn't afraid to be different. In fact he relished it. During his three years at George Washington, Morrison performed various stunts to ensure that he would become the focus of attention of students and teachers alike. Depending on his mood, these antics would be calculated either to amaze or annoy. He would walk on ledges, take dares and

never seemed to know when to back off. Even so, he pulled his grades. He did the least amount of homework possible, yet always made sure to come out looking good. Getting good grades seemed to be his way of saying that he could screw around, be different, refuse to conform and still beat them at their own game.

I was a fool
&
The smartest kid in class

No doubt there were many teachers who sympathized with this troubled but brilliant youth, as the amount of trouble he caused had to be frequently overlooked for him to receive his high marks. He is remembered for doing things like studying reference books in the library and then amazing a class and his instructor with some piece of unusual knowledge about shamanism or some other obscure subject. His insatiable curiosity resulted in voracious reading. Morrison read very slowly, carefully, weighing and measuring the meaning of each word. He loved knowledge and particularly ravished any book to do with literature, philosophy, mysticism, poetry, and the arts.

Did you know freedom exists
in a school book

Morrison is quoted as saying: "The key to education is reading, basically. You can do the same thing on your own. Anything and everything is at the library." It was an odd statement for a prince of rebellion. Jim Morrison's idols were not those his peers shared—baseball stars, actors, or even rock 'n' rollers. He idolized poets and writers, having been helped on to the literary road by an English class where he was introduced to the classics. He proceeded to learn all about poets and poetry and this melded with his long-standing ambition to be a writer. His heroes were Blake, Baudelaire, Rimbaud, and Kerouac and he devoured their works.

On the Road, Jack Kerouac's beat novel, especially impressed Morrison. It is a saga of youth adrift in America, traveling the highways, exploring drugs, liquor, sex, and the philosophy of experience. Kerouac preached the poetry of being—freedom from rules that he felt didn't make sense, from emotional repres-

sion, elitism, hypocrisy, and the worship of comfort and material goods. He entices his readers to discover the world, experience life, and find out who they are on their own terms with lines like "I could hear a new call and see a new horizon, and believe it at my young age." Jim often copied entire passages from *On the Road* into his notebooks and imitated Dean Moriarty's maniacal laugh. Moriarty is based on real-life rebel Neal Cassady who later became the driver of Ken Kesey & The Merry Pranksters' electric kool-aid bus. Moriarty is one of the people Kerouac calls "mad ones, the ones who are mad to live, mad to talk, mad to be saved, desirous of everything at the same time, the ones who never yawn or say a commonplace thing, but burn, burn, burn like fabulous yellow roman candles exploding like spiders across the stars and in the middle you see the blue centerlight pop and everybody goes 'Awww!'"

Another character on the road is based on beat poet Allen Ginsberg. Kerouac describes the character he called Carlo Marx as "the sorrowful poetic con-man with the dark mind." Morrison related to these and other such characters and they influenced and helped to develop his young mind. He was also intrigued by the life-styles of their creators and soaked up anything and everything he could find about their lives. He learned that Arthur Rimbaud had done all his writing by the age of nineteen and then disappeared to Africa to be a gunrunner. The freewheeling Jack Kerouac was known for being crazy and adventurous and reportedly wrote the entire manuscript of *On the Road* on a paper towel roll that he stole from a hotel bathroom and simply inserted into his typewriter. He finished the book in three weeks and mailed the whole roll to his publisher. When Morrison grew up, he would live out some of the exploits of these writers in his own life, the vagabond life-style—wild liquor, wild women, and wild nights and a legendary career that streaked across the universe like a shooting star to end in tragic death, just like so many of his heroes.

> *People need Connectors*
> *Writers, heroes, stars, leaders*
> *To give life form*

Baudelaire also influenced Morrison, versing him in the concept of duality with passages like "every man is made up of two

beings, linked together, the highest and the lowest, side by side, the good gaining some intense quality from the bad." His depiction of the struggle between man's aspirations toward virtue and his inclination toward vice further stimulated Jim's imagination. Baudelaire was tried for obscenity over a book of poetry that the French court found "obscene and clearly indecent" and was forced to delete six poems from future editions. He also personally practiced all manner of corruption, smoked opium and hashish, and even dabbled in satanism and Black Masses. The occult fascinated Morrison. Like shamanism, it seemed to explain things that were not explainable.

Meanwhile, life at home was an ever-increasing struggle. He continued to clash frequently with his parents over the length of his hair and the kind of clothes he wore. He had less and less respect for them, especially for his father whom he felt had the power of a navy captain yet could not master his own household. Clara, who so many times had to be both parents when Steve was away, often still ran things as she saw fit. The incident that cemented this for Jim occurred in high school when Steve took him out for a ride on an aircraft carrier. Reportedly, Steve asked his son if he'd like to "go fishing." Jim said sure and they went down to the pier at Norfolk together. There, a launch was waiting which took them out to a huge aircraft carrier, an incredible giant of a ship nearly nine hundred feet long and weighing over two hundred thousand tons. From the moment they boarded the launch, six marines followed them everywhere they went, seeing to their needs. Everyone addressed Captain Morrison as "Sir" and Jim could see in their eyes that they respected his father. After a little while the ship began to move out of the harbor. Obviously someone gave the order to sail and the only person who could do that was his father, yet Jim had never heard him say a word. Jim realized he had probably just lifted a finger or waved his hand casually to one side and that was all it took for this vast behemoth to churn forth its power.

As the ship moved out to sea, Steve asked his son if he'd like to "have a little target practice." Moments later the six marines escorted them to the rear of the carrier, where perhaps two hundred more soldiers were shooting at wooden targets bobbing up and down in the sea. The targets were painted to look like United States Navy sailors and this gave Jim some second thoughts. The

blasting away at the targets with huge riot guns, to pieces as his father explained that one of the marines were on the ship was for "security" in the mutiny. Jim was propped up and handed a gun, but he *ring until his father *ordered* him to. Finally, he reluctantly began shooting away at the "men," resenting it all the time.

After a while the ship began to move back toward the harbor, again under his father's orders and again without Jim noticing the command. When it docked they rode back to shore on the launch and then drove home. All the way back Jim was both enthralled with and intimidated by the power his father possessed. Two hundred thousand tons of killing machine at his command and hundreds of armed marines doing his every bidding. Power. The two Morrisons arrived home and Steve sat down in his easy chair, picked up the newspaper, and began to read. In his civvies now and wearing his reading glasses he looked like anyone else, but Jim knew differently. Suddenly Clara came into the room and began to angrily bawl out her husband for not taking out the garbage. Happening so close to the time on the ship, this was startling to Jim. He stood there watching his father apologize, repenting even, trying to make amends, and Jim was overwhelmed by the disturbing inconsistency of it all. What had happened to his father's power? How could he command such power over life and death and not be the commander of his own home? To Jim this said that something was terribly wrong. There had to be something more—a higher truth to attain. The incident left a lasting mark on him and triggered the rumblings of an inner philosophical awakening.

> *Something wrong*
> *Something not quite right*

Friedrich Nietzsche

When he was about sixteen, Morrison began reading a philosopher who was to shape much of his thinking. In the works of Friedrich Nietzsche (1844–1900) the young Jim found insight into the essence of power and the nature of man. He learned that all men, even men of great power like his father, still had to obey

someone. While choosing to allow Clara to run the household may have been an act of tolerance or even disinterest for Steve Morrison, he still had to toe the line for his superiors in the navy. After all, they were the men who gave him his power and they could take it away at any time. But Nietzsche described a different kind of man—one who because of his creativity and independence answered to no man. Nietzsche believed that some men were so far "above" other men that they transcended morals and the very concepts of right and wrong. They were "supermen" who by the greatness of their minds had the right to determine their own standards and define their own set of rules for what was right and what was wrong.

Morrison read two of Nietzsche's books, *Beyond Good and Evil* and *The Genealogy of Morals,* and their views on aesthetics, morality, and the Apollonian-Dionysian duality were to appear again and again in his conversations, poetry, and life. *Beyond Good and Evil* was first published in 1886 and still stands as one of the most influential books of the nineteenth century. In it, Nietzsche attempts to sum up his philosophy. In his Aphorism 194 from this book, Nietzsche says, "Involuntarily, parents turn children into something similar to themselves—they call that 'education' . . . and like the father, teachers, classes, priests and princes still see, even today, in every new human being an unproblematic opportunity for another possession."

Jim ate this kind of stuff up and it fueled the fires of rebellion already burning within him, for Nietzsche too was controversial to the bone. He preached a message that was in direct conflict with the Bible and the Judeo-Christian ethic of Jim's parents. Nietzsche claims that "fear was the mother of morals" (Aphorism 134) and that "all credibility, all good conscience, all evidence of truth come only from the senses."

He says: ". . . we are born, sworn, jealous friends of solitude: that is the type of man we are, free spirits! . . ." and "one has to do everything oneself in order to know a few things oneself."

Morrison embraced these concepts as truths without ever seriously questioning them. He saw them as not only explaining the inconsistencies of his parents' world, but also as blatant justification for the self-obsession that was rising within him. This prophetic independence of the spirit opened hundreds of doors in young Jim Morrison's mind. One of these doors may have been

a deeper interest in music when Nietzsche described a musician as "an oracle, a priest . . . a ventriloquist of God." But what shaped him most from the writings of Nietzsche was probably the dissertations on the new breed of philosopher that Nietzsche saw coming into being, the perfect example of the "superman" concept. Nietzsche defined a philosopher as "a human being who constantly experiences, sees, hears, suspects, hopes, and dreams extraordinary things; who is struck by his own thoughts as from outside, as from above and below . . . as by 'his' type of experiences and lightning bolts; who is perhaps himself a storm pregnant with new lightnings; a fatal human being around whom there are constant rumblings and growlings, crevices, and uncanny doings."

If not at age sixteen, then certainly by age twenty-two, Morrison saw himself almost exactly as this paragraph describes. In passage after passage Nietzsche described the new species of philosopher as a "free spirit," "a lover of knowledge and truth," "a philosopher of the dangerous," "an agitator and an actor," "destined for martyrdom." And just as Nietzsche built a foundation for the young Jim Morrison to expand his wings upon, he also sowed the seeds for his destruction: ". . . What serves the higher type of men as nourishment or delectation must almost be poison for a very different and inferior type. The virtues of the common man might perhaps signify vices and weaknesses in a philosopher . . . He shall be greatest who can be loneliest, the most concealed, the most defiant, the human being beyond good and evil . . . Like a rider on a steed that flies forward, we drop the reins before the infinite, we modern men, like semi-barbarians— and reach our bliss only where we are most in danger."

And so Jim Morrison would submit himself to vices and poisons, thinking he was beyond them. He would believe that the hammerlike will to power was enough to legislate the future and that the most defiant would be greatest. And, like the rider on a steed, he most certainly did drop the reins before the infinite when he was the most in danger. Nietzsche prophesied that some day would come a great redeemer whose isolation would be misunderstood as if it were an escape *from* reality while it would actually be an immersion *into* reality. It was this man, Nietzsche said, who would "liberate the will and restore its goal to the earth." It was this man whom Nietzsche called "the Antichrist . . .

the victor over God and nothingness." And, whether he fully realized it or not, for most of the remainder of his life, Jim Morrison would try in vain to be that person.

Early Poetry and High School Journals

Morrison was not altogether a wild child and his sensitive side also blossomed at this time. His girlfriends put up with his mean teasing because there was a gentle, caring part of him that captivated them. This was most evident in his early poetry. There were no artists in the Morrison family, yet when asked who turned him on to poetry Jim replied, "I guess it was whoever taught me to speak, to talk. Really. I guess it was the first time I learned to talk. Up until the advent of language, it was touch— nonverbal communication."

Morrison had a great gift for words and began to use it at an early age: "Around the fifth or sixth grade I wrote a poem called 'The Pony Express.' That was the first I can remember. It was one of those ballad-type poems. I never could get it together, though. I always wanted to write, but I always figured it'd be no good unless somehow the hand just took the pen and started moving without me really having anything to do with it. Like automatic writing. But it just never happened. I wrote a few poems, of course. Like 'Horse Latitudes' I wrote when I was in high school . . . It's called 'Horse Latitudes' because it's about the Doldrums, where sailing ships from Spain would get stuck. In order to lighten the vessel, they had to throw things overboard. Their major cargo was working horses for the New World. And this song is about that moment when the horse is in air. I imagine it must have been hard to get them over the side. When they got to the edge they probably started chucking and kicking. And it must have been hell for the men to watch, too. Because, horses can swim for a little while, but then they lose their strength and just go down . . . slowly sink away."

HORSE LATITUDES
by James Morrison

When the still sea conspires an armor
And her sullen and aborted
Currents breed tiny monsters,
True sailing is dead.

Awkward instant
And the first animal is jettisoned,
Legs furiously pumping
Their stiff green gallop,
And heads bob up
Poise
Delicate
Pause
Consent
In mute nostril agony
Carefully refined
And sealed over

It is interesting to note that the young Morrison doubted that he could write well unless he "didn't have anything to do with it." It was as though he already believed that in order for him to accomplish anything significant, he would have to break away from his past and completely release himself to some other force, something that would move his hand for him and lead him past his inhibitions. He spent much of his youth looking for just such a release—an escape that would allow him to be someone else.

Not only was he writing poetry, but in high school Morrison began keeping a daily journal. This was not simply a daily diary describing his life at the time, as one might expect; rather it was notebooks filled with random observations, notes to himself, ideas, and poetic fragments. He got the idea from reading Franz Kafka's diaries. Kafka was a man who lived fully though his work, attacking with stunning craft and powerful vision the bureaucratic world he hated, and Morrison admired him for this. Kafka's most famous work is a novelette, *The Metamorphosis,* but he also wrote short stories, parables, letters, and personal diaries, which were what most attracted Morrison. In fact, Jim permanently "borrowed" the *Diaries of Franz Kafka 1910–1913 and 1914–1923* from the Alexandria library. As was the case with Nietzsche, he was strongly influenced by these writings, taking a word here and there and combining them into his own thoughts. Sometimes he even tore out a whole page of Kafka's diary and put it into his notebook. Anyone who knows Morrison's poetry can recognize Kafka's influence by reading a few of the passages from these diaries, such as the following:

October 18th, 1921, on "life's splendor" lying in wait about each one of us . . . "If you summon it by the right word, by its right name, it will come. This is the essence of magic, which does not create but summons."

September 23rd, 1912 . . . "only in this way can writing be done, only with such coherence, with such a complete opening out of the body and the soul."

September 15th, 1917: "If you insist on digging deep into yourself, you won't be able to afford the muck that will well up, but don't wallow in it."

Morrison was also attracted to the romance of Kafka's life—the artist dying virtually undiscovered and then achieving posthumous success beyond his wildest dreams. In his short career of about ten years, Kafka published only a handful of the many stories he had written, and before he died he asked that his remaining manuscripts be destroyed. Fortunately, his work was saved, and today he is acknowledged as having one of the greatest influences on modern literature. It was Kafka who said that standing up to one's father was facing "the ultimate authority" and that an "innocent child was yet a devilish human being."

Kafka too spoke of releasing oneself to a greater power, but his words carry a warning: "Once we have granted accommodation to the Evil One, he no longer demands that we should believe him . . . the afterthoughts with which you justify your accommodations of the Evil One are not yours, but those of the Evil One." For Jim Morrison those words were but a few sentences in an avalanche of philosophical thought. A slight hesitance in the onrushing desire to embrace the wisdom of the supernatural which Morrison believed was not so much good or evil as it was pure inspiration—the source of all art and power. After all, Nietzsche said the superman was beyond good and evil and Jim agreed with him.

How interesting it would be today to leaf through the notebooks of the high-school-aged Jim Morrison. No doubt they would tell us much about his character. But this opportunity has long passed. Shortly after he left college, Morrison threw all his old notebooks away. (Coincidentally, Kafka's early writings were also lost and never recovered.) Perhaps Morrison wanted to discard any keys that could unlock his past. Or maybe it was just a whim. He described those days in *Rolling Stone:* "I kept a lot of notebooks through high school and college and then when I left school, for some dumb reason—maybe it was wise—I threw them all away. There's nothing I can think of I'd rather have in my possession right now than those two or three lost notebooks. I was thinking of being hypnotized or taking sodium pentothal to try to remember, because I wrote in those books night after night. But maybe if I'd never thrown them away, I'd never have written anything original—because they were mainly accumulations of things that I'd read or heard, like quotes from books. I think if I'd never gotten rid of them I'd never be free."

The high school journals that Morrison kept with their frag-
mented notes and thoughts would mature into more original
writings in college. These UCLA notes, in fact, would blossom
into his first book, *The Lords: Notes on Vision*, a collection of
random thoughts much like Kafka's writings or Nietzsche's aph-
orisms. And later on in his life, Jim would still carry such note-
books as a rock superstar, but by then he would be knitting the
fragments together into powerful song lyrics.

Rock 'n' Roll

Even though Morrison managed to become well known to
the student body at George Washington High School, he had few,
if any, close friends there. He seemed to prefer keeping those
who knew him off-balance as to the "real" Jim Morrison, often
telling wild stories about himself and later laughing them off as
jokes. He loved to tease and taunt and did so incessantly. His
sense of humor was the biting satirical kind so prevalent in *Mad*
magazine which he loved to read. *Mad* was a leading voice of
satire in the 1950s and its symbol, Alfred E. Neuman and his
"What—Me Worry?" motto summed up the era.

Morrison has been described by fellow students as intro-
verted, a loner. Others say he ran with a pack of boys, all of
whom were a bit rowdy and troublesome. Both versions are
probably true. Morrison did run with a group, but he wasn't that
close to any of them. He was kind of slippery, alienated at times,
but most of all he was just different and that difference was no-
ticeable. This was most evident in his desire to stray outside his
social environment, and often these activities centered around
music. In high school Jim developed a considerable interest in
the blues and sought out nightclubs in the rougher parts of town,
sometimes even going to the black sections of nearby Washing-
ton, D.C. Something about the seediness of those places attracted
him and if he had any qualms about going to such tough areas,
his relentless curiosity overcame them. This affection for the
blues would later be combined with his poetic talents to form
the foundation for The Doors.

Walks in D.C. in
Negro streets. The library
& book stores. Orange
brick in warm sun.
The books & poets magic.

Once you cross Jefferson Davis Highway away from Alexandria, you're in a new world and this was where the adolescent Morrison really began to thrive. Alexandria was ancient, old and tired, but when Jim was in high school, Jefferson Davis Highway was jumping. Lights. Music. Action. Heading south from Hunting Creek, this was a road of glitzy bars, truck stops, bowling alleys, steak houses, adult motels, and loose discothèques. Morrison had long heard about the Sins of Route One and he wanted to experience it all firsthand. The main attraction at that time was just south of Penn Daw, a roadhouse bar called the 1320 Club. It had everything high school boys with fake IDs could want. A strobe light, an elevated dance floor, waitresses in black tights, and live bands. Black music intrigued Jim and he was fascinated by blues acts like Little Willie Downing and the Handjives. Wil Downing and the other bluesmen that frequented the club had something Morrison liked, something wilder than the white acts, something he couldn't quite describe. And he was drawn back often to see what it was.

When Morrison was younger he had tried piano for a while, but he didn't have the discipline to keep up with it and gave up after a few months. So it was his interest in the blues at this time that rekindled his fascination for music. He felt that the fire and passion of rock 'n' roll begun by Elvis Presley, Jerry Lee Lewis, Chuck Berry, Little Richard, and others died out around the time Buddy Holly was killed in 1959 and it wasn't brought back until The Beatles. In between, for Jim Morrison, were the blues. "The blues were one of the few truly original American art forms," he said later. "Rock 'n' roll was a mixed breed, born of the blues, which had its origins in Africa and in the country and mountain music that originally came from Scotland, Ireland, and England. My earliest influences were all the old blues singers and the early

rock 'n' roll singers—Elvis Presley was among them. I heard them at an age when I was ready for this influence. It seemed to open up a whole other world which I wasn't aware of, a strange landscape which I'd only had glimpses of in my daily life. I listened to Jerry Lee Lewis, Little Richard, Fats Domino, Gene Vincent—all of them."

Morrison didn't see himself as a singer then; his real loves, his passions, were poetry and film. But something was building. He would later describe rock 'n' roll as "a perfect mix of white music and black music, and that's why I love it." When discussing its effect on him he said, "The birth of rock 'n' roll coincided with my adolescence, my coming into awareness. It was a real turn-on, although at the time I could never allow myself to rationally fantasize about ever doing it myself. I guess all that time I was unconsciously accumulating inclination and listening. So when it finally happened, my subconscious had prepared the whole thing."

At home, Jim Morrison still had to face his father. They both knew by now that Jim would never be the career navy man his father had hoped for that December 1943. He had neither the temperament nor the desire for the military life. Throughout most of high school there were two sets of realities in the Morrison home. The first was the usual: Steve off on duty and Clara left in charge of the family ship. The second was when Steve returned and everyone pretended that his absence didn't make a difference.

The Man is at the door

Morrison admitted his inhibitions kept him from making friends easily, and in later life, he would blame these inhibitions on the rigid Catholicism of his parents. Whether through the Church itself, his parent's interpretation of their religion, or his own experiences, Jim he felt that Catholicism was condemning, portraying a God who was more hellfire and less love, a religion that looked for faults to criticize and gave the impression that one slip was all it took to fall over the edge to eternal damnation. Christ had preached love and forgiveness, but Morrison saw the Church as preaching only judgment and condemnation. He turned from what he felt was the hypocrisy of his parents'

Church, but in later life, he still occasionally wore a cross around his neck. When asked about it he answered, "It's just a cross. Almost an accident, really. I was raised in a Christian culture and the cross is one of its symbols, that's all." Yet he loved to discuss God and religion for endless hours with just about anyone who would listen to his countless theories on man's relationship to the Creator.

It all made sense. Confused and repressed at home, Jim Morrison was a brilliant recluse in school, exploding into knowledge rather than learning gradually. Once outside the walls of 310 Woodland Terrace and George Washington High, he was wild, seeking the thrills of the dark side of life. From the well-mannered son of a navy officer to the rock 'n' roll rebel, it was out of this eclectic morass that James Douglas Morrison developed into the spokesman for a generation. A generation that didn't have all the answers, but knew that it wanted something more.

I am a guide to the Labyrinth

In June 1961, Jim Morrison graduated from George Washington High School. He had no intention of showing up at the graduation ceremonies and his diploma was mailed to him after his name was called repeatedly and no one stepped forward to pick it up. It was one of the first of many such public statements.

St. Petersburg and Florida State

Morrison's careless attitude toward formal education continued and he delayed making a decision about college so long that Steve and Clara wound up making it for him. Without even consulting their son, they enrolled him in St. Petersburg Junior College in Florida and announced that he was to live with his grandparents in Clearwater. Jim agreed, knowing that such an arrangement would result in the one thing he wanted most at that time—more personal freedom. So in September 1961, he moved to Clearwater while the rest of the Morrisons moved on as well, following the navy to San Diego. The night before he left, Morrison called Tandy Martin, his girlfriend of over two years, and asked if he could come over. When Tandy said she was busy, Jim

suddenly blurted out that he was moving to Florida the next day and would never see her again. It was the first she'd heard of it. The next day he was gone.

He had at last broken free from his military home. Not particularly enthusiastic about junior college, he considered it the lesser of two evils. "I couldn't think of anything else to do. I didn't learn too much. School was easy. I didn't want to go to the army and I didn't want to go to work."

The time in Clearwater was an opportunity to develop his offbeat life-style. At St. Petersburg, Morrison signed up for psychology courses, while at home with his grandparents he became obsessed with Elvis Presley. In his last year of high school he had felt that rock 'n' roll had become clouded with mushy romanticism, but now he returned to its roots with a passion. Morrison's wild imagination also grew during this time. Once, when he had been assigned a term paper for art class, he selected the mysterious Renaissance Dutch artist, Hieronymus Bosch. Very little is known of Bosch's life, but that didn't bother Morrison. He simply made it up, creating a whole history that included the artist's birth, education, lovers, and even a family tree. His professor was amazed at the detail and gave him an "A" on the term paper. Another time, Jim took a train to Washington, D.C., and went to the Library of Congress, where he composed an essay about the life-style of a primitive African tribe. The work was well researched, but his professor still checked out the information with the head of the science department at another school, just to make sure the research was not another product of Morrison's sensational imagination.

After a year at St. Petersburg, Morrison, in typical freshman trauma fashion, switched to Florida State University in Tallahassee in the fall of 1962. Before leaving Clearwater, however, he met an engaging high school senior named Mary Francis Werbelow. Quiet and self-assured, Mary wanted to be a dancer in the movies and was attracted to Jim's artistic side. Morrison found her beautiful and after he moved to Tallahassee he continued to see her every weekend. Later he described those years in Florida. "I lived in Florida at a very formative period in my life. I always loved the landscape most of all. I used to hitchhike from Tallahassee to Clearwater (280 miles!) almost every weekend. I had some friends who lived near there. I got to know the

landscape pretty well. To me, it was a strange, exotic, exciting place . . ."

At FSU Morrison shared a house with five fellow students, but after the end of the first term, he was asked to leave. His roommates could no longer tolerate his loud music and wild antics. Jim gave little resistance and relocated to a small trailer with no one but himself to annoy.

While at FSU Morrison was very impressed with one particular book, Norman O. Brown's *Life Against Death: The Psychoanalytical Meaning of History* (Wesleyan University Press, 1959). In it Brown wrote that "Freud was right: our real desires are unconscious. It also begins to be apparent that mankind, unconscious of its real desires and therefore unable to obtain satisfaction, is hostile to life and ready to destroy itself. Freud was right in positing a death instinct, and the development of weapons of destruction makes our present dilemma plain: we either come to terms with our unconscious instincts and drives—with life and with death—or else we surely die." These ideas furthered the formulation of Morrison's budding philosophy of life. In his work, Brown concluded that repression was the cause of virtually all social pathology and that the essence of society was the repression of the individual. Like Freud, he believed that the root of all neurosis was the Oedipus complex and concluded that the universal neurosis of mankind was a psychoanalytical equivalent of the concept of original sin. Man was born with a sense of guilt. Was this a false guilt resulting from parental conditioning or was it a valid sense of alienation from the creator? By now, Jim Morrison had already made his choice.

Morrison theorized that Brown's psychological concepts could be applied to crowds as well as individuals. He believed that an audience could be manipulated to do almost anything and tried to persuade some of his friends at FSU to help him create a riot during a campus seminar as an experiment. Fortunately, they refused.

It wasn't long after transferring to FSU that Morrison decided he wanted to study film at UCLA. That summer he visited his parents in California and announced his intentions. The Morrisons were not enthralled with the idea of their son's attending liberal UCLA. Any relief they felt at Jim's finally taking an interest in a career was more than offset by the fear that his irrational

tendencies might run full bloom in mega-hip Los Angeles. They vetoed his plans, and once again disillusioned, Morrison returned to FSU.

Back at college in the fall of 1963, Morrison decided he wasn't going to accept the family's decision and would make the move without their consent. He applied to UCLA for the next semester and spent his fall term at FSU taking courses to build a foundation for classes in Los Angeles. Once he completed the move without their knowledge, Jim figured his family would change their minds. What else could they do when faced with such determination? So, in early 1964, he hitchhiked to California and enrolled in the theater arts department of UCLA, paying the tuition out of a fund that his father had set up for him when he was a boy.

It wasn't long after this that Steve Morrison completely disowned his son and severed all contact with him. In a sense, however, it was Jim who cut off relations first, breaking with his parents and rejecting all the values they embraced. Shortly after he had become a rear admiral, Steve Morrison was interviewed by journalist Michael Horowitz under the pretense of an article, "The New Navy," for a local university. When the subject of his sons becoming navy men came up, the admiral said: "I have never pressured my family and as it turns out neither one of them has shown any interest in a military career. I'll say this, though. If my boys wanted to go into the service, they'd choose navy."

That may have been true, but apparently the pressure of the navy life still ate away at Jim Morrison. Part of him was striking back at his parents by breaking away totally from their environment. And another part of him knew that what he sought could be found only in the land of the sunset. He saw his breakthrough to the West as a giant step toward ultimate freedom.

Heaven or Hell the circus
of your actions

THE WEST IS
THE BEST

There were more reasons than just UCLA for Jim Morrison to make his break to the West. As he hitchhiked the twenty-five hundred miles across the country, he must have relished the thought of California—it must have felt like deliverance. The Golden State, a place where both the seekers and the oddballs always seemed to wind up. If you couldn't make it where you were, you went to California. The West in general, and California in particular, seemed to have become the hope of continental America. And in 1964 there was a strong drift to the Coast, a vast gathering of young people who thought along the same lines as Morrison. A movement of some sort was developing in the West and a new generation would soon be unfolding. The country was about to go through a liberalization of thought that would center on and grow out of the very vortex that Jim Morrison was now entering. And he would be one of the leaders in that movement.

Ride the King's highway . . .
Ride the highway west

In February 1964, Morrison was admitted to the theater arts department with advance standing and embarked on a course of training in film production. This was a radical departure from the fields of biology, psychology, and sociology that he had studied at Florida State. Morrison's attraction to the film school grew partly out of his dislike of authority, since he regarded film students as the new revolutionaries, but he also loved the power of the medium for its Dionysian tendencies. "I'm interested in film," he said later, "because to me it's the closest approximation in art that we have to the actual flow of consciousness, in both dream life and in the every day perception of the world."

Film was about to become the Holy Grail of all art forms. It was being studied and pursued by painters, novelists, musicians, and photographers—and poets. They all wanted to get a camera and start expressing themselves on a larger canvas—preferably one that was forty feet high. For many of them, the camera had become the modern equivalent of the revolutionary manifesto and they believed that if they could capture it on film, they could do something about it. According to screenwriter Richard Blackburn (*Eating Raoul*), who was a student at the film school during that time, there were three types of film students at UCLA: "The Hustlers who were always going to make a film for Roger Corman at the end of the semester. The Technicians who talked a lot about filter factors and stock sensitivities. And the Film Poets."

Morrison was in the latter group as Frank Lisciandro, who met Jim when both were at UCLA, describes. "Jim had an undying interest in films. And on a lot of different levels—very much aesthetic—that is, in the theory, the history, the politics of film. He never engaged in the craft of film—editing, being a cameraman."

But in many ways, Morrison's real forte at college was communication. At one point he wrote a thesis on the "sexual neuroses of crowds" which discussed music's ability to help transform the sexual energies of a group, which if done properly could create a true communal consciousness. More than anything else, Morrison was interested in reaching the masses and film was the best medium he had found for it up to this time.

Film was an all-consuming passion for those students who became Morrison's contemporaries for the next year and a half. They were not only into film, they were into it twenty-four hours a day. They talked, ate, and made love to the art of film. The graffiti in the editing room john read: "Screwing is a twenty-lap-frame dissolve through a diffusion filter." This was typical of the prevailing attitude. It was not uncommon for screaming fights to break out during a screening of a student's film. UCLA was a somewhat radical school in itself and the film department was the most radical of all. And Morrison was part of this craziness. He belonged there and he knew it.

Cinema is most totalitarian of the arts

When Jim Morrison arrived at UCLA, he was a pudgy kid with dark hair curling just over his ears. Those few who spent time with him on a one-to-one basis found him shy and retiring. To most of the "heavies" he was sort of "a mascot with a pissed-off expression." While he hung around with the high jivers he was surely different from most of them. Alan Ronay, who remained very close friends with Morrison through most of his adult life, remembers: "I was one of the first people Jim met in Los Angeles. He was very shy and withdrawn. But he was very into film. I remember us sitting through *Sleep*, Andy Warhol's eight-hour film. And we actually made it through a great deal of those eight hours. It was like a point of honor, to get through it. We were fanatics."

In an article he wrote for *Crawdaddy*, Richard Blackburn remembers that Morrison never seemed to have the desperate need to "Make It Big" the way the others did: "In that way he was oddly pure. He communicated in sexy little inarticulate mumblings. He'd stand off from the action in tight wheat jeans and tight white T-shirt, round head lolling to one side, exposing the soft white neck that was his seductive come-on to members of both sexes."

Was Morrison bisexual at UCLA? Most likely not, although one former student who wishes to remain nameless mused that "he would've liked to have been." Morrison told anyone who would listen that he wanted to "have every experience," but those that knew him doubt if he was ready to cross that par-

ticular border at age twenty. Besides, he wasn't there long before
Mary Werbelow moved to Los Angeles and got a job at the UCLA
medical center. Morrison had been urging her to come, hoping
they could live together, but Mary insisted on having her own
place and began looking for an agent to get her dancing jobs.

Having Mary around made Jim reasonably content for a
while, but there was no denying that he had his problems. One
classmate reflected that Jim was a lot like the image he later be-
came, but in those days nobody paid much attention. Within a
few short years there would be a great deal of talk about the
"Morrison look" and how unique it was. Most people figure that
this appearance came about by accident, but the truth is, like
most things about him, the Morrison look was carefully designed
and planned by Jim Morrison himself. A student of Roman and
Greek drama, he loved to read Plutarch, the Greek historian, and
he especially loved the sections that described Alexander the
Great. In one passage Plutarch mentions that Alexander had a
habit of tilting his head on his left shoulder as if he were asleep
and letting his eyes open and stare off as if they were melting
into space. Morrison practiced this stance until he had it down
perfect, until he could strike a pose with the best of them. And
two years later when he became a star and had his first official
media haircut, he asked Hollywood stylist Jay Sebring to make
him look like Alexander the Great.

Why Alexander? It wasn't just Alexander's looks that at-
tracted Morrison—it was also the parallels in their lives. Alex-
ander was born into an aristocratic family and his father, King
Philip of Macedonia, was a military man. Philip was very orga-
nized, disciplined, and intimidating without an introspective or
artistic bone in his body. Alexander met this intimidation by be-
coming everything his father wasn't: artistic, a thinker, a pupil of
Aristotle. And yet, Alexander wound up being an even greater
military man than his father, amassing more power in his lifetime
than any man before or since. Morrison used to say that "the big
mistake Alexander made was that he *hesitated* at the Danube. If
he had gone ahead and conquered Europe and England he would
not have become mired in the East and India. He should have
gone west. If he had, the whole history of the world would have
been changed."

Jim Morrison was also a student of people and UCLA in the

mid-60s had some of the most interesting. A wild collection of individuals who ranged from future Wall Street lions to dedicated radicals to everything in between. And if that wasn't enough, just a few miles up the road was Venice beach and down the road was Hollywood, both with some of the most bizarre people on earth strolling down the sidewalk at any given moment on any given day.

Shit hoarders & individualists
drag-strip officials
Tight-lipped losers
& lustful fuck salesmen

Morrison was a great voyeur. He often sat in the school library making comments about various people, little allusions that always implied he had a vast amount of secret knowledge. The same implications filled any discussion of his own life. He told fellow students he wanted to base his life on the poet Rimbaud. Even then Morrison loved to attract people to himself, drawing them in and manipulating them with an almost scientific detachment.

At UCLA he continued to be an omnivorous reader. In addition to the film courses, he studied Greek and Roman classics on his own. Some of the ideas he developed at this time set the stage for The Doors' pioneering efforts in rock theater. The Greeks believed that the more terrible the events and the greater the suffering depicted in a tragedy, the more intense was the pleasure the audience experienced. "In its origin," Morrison once said, "the Greek theater was a band of worshippers, dancing and singing on a threshing floor at the crucial agricultural seasons. Then, one day, a possessed person leaped out of the crowd and started imitating a god. At first it was pure song and movement. As cities developed, more people became dedicated to making money, but they had to keep contact with nature somehow, so they had actors do it for them. I think rock serves the same function and may become a kind of theater."

A true eclectic, Morrison loved surrealism, Australian novels, and a great variety of other works including dime store novels his classmates remember as "really filthy and violent ones." Some say he had no taste of his own but adopted and discarded things for effect, allowing his views to be determined by what best fit in with

the persona he was creating. This might explain his preference for off-the-wall films. During this time, the noted director Josef von Sternberg was teaching film direction at UCLA and Morrison was much influenced by this man and his works. In fact, Jim always claimed his favorite movie was *The Saga of Anatahan,* von Sternberg's last film. Shot in 1953 in Japan, *Anatahan* is a semidocumentary about Japanese soldiers trapped on an atoll in the South Pacific with one woman for seven years. The film is a chronicle of the psychological changes that occurred during the isolation. Morrison said: "I like that film because it is very real. For me films have to be either very artificial and surreal or very real and documentary. The more extreme in either tendency, the better." But his choice of *Anatahan* also reflects Morrison's elitism, considering that the film was never in general release in the United States and is rarely seen.

Morrison loved to learn and he loved to prove he had a great deal of knowledge. He used to play a game at UCLA where he would go into another room and challenge a visitor to randomly pick out any book from his large library, open to any page, and read a passage. From the hint, Jim would recite the chapter, the name of the book, and the author. This was truly a remarkable feat, since his collection of texts numbered well over a thousand! But Morrison wanted something more than what he could get out of books and he probed into every new idea with gusto. Once a concept or new trend of thought synched with one of his many obsessions, he'd stay with it until he could discuss it at length and even portray it through his actions. He didn't just learn things—he merged with them.

During his days in film school, Morrison continued to write, filling notebook after notebook with thoughts ranging from pure philosophy to cheap fiction. At one point he announced that maybe what he really ought to do with his life was write trashy, sexy Westerns. But his major written work while at UCLA turned out to be a series of observations and insights called *The Lords: Notes on Vision.* Later he described the work as "a thesis on film esthetics."

> *Film confers a kind of spurious eternity*
> *Film spectators are quiet vampires*

"I wasn't able to make films then, so all I was able to do was think and write about them and it probably reflects a lot of

that . . . I think in art, but especially in films, people are trying to confirm their own existences. Somehow things seem more real if they can be photographed and you can create a semblance of life on the screen. But those little aphorisms that make up most of The Lords—if I could have said it any other way, I would have."

Films are collections of dead pictures which are given artificial insemination

But "The Lords" talks about more than film. Morrison saw most people as being like sheep, a herd, following the leaders. The Lords were the people who controlled them, the ruler class. In between these two groups Jim saw the individuals, kids mostly, who had the power to not go along with the herd. "What that book is a lot about is the feeling of powerlessness and helplessness that people have in the face of reality," Morrison said. "They have no real control over events or their own lives. Something is controlling them. The closest they ever get is the television set."

Fear the Lords who are secret among us
The Lords are w/in us
Born of sloth & cowardice

Michael Ford, a recognized poet with several published volumes, first met Jim Morrison at UCLA. He remembers Morrison's interests being primarily in film and poetry. "We were sort of scribbling in notebooks about the same time. I would characterize Jim as searching for his personal concept of truth and cultivating integrity as a filmmaker. That's what he always wanted to be, but he also thought being a poet was a noble and dangerous profession and that's what put him out on the edge so much."

Some of Morrison's tendency to watch rather than participate in his early UCLA days was probably related to his being overweight. The simple truth was that he loved to eat as he later good-humoredly described: "I had a food ticket to the cafeteria. Cafeteria food is mainly all based on starch. You know, it's cheap food. I don't know what it was, but I felt if I missed my meal . . . I was getting screwed. I felt if I missed a meal that I blew it. So, I'd

get up at six-thirty each morning just to make breakfast! Eggs, grits, sausages, toast, and milk. Then I'd go do a few classes. Make it in there for lunch. Mash potatoes. Every now and then, they'd put a little piece of meat or something in. Then I'd do a few more classes. Then go to dinner. More mash potatoes. So about three months later I was 185 pounds! You know what? I felt so great. Felt like a tank. I felt like a large mammal. A big beast. When I moved through the corridors or across the lawn, I just felt I could knock anybody out of my way. I was solid, man. It's terrible to be thin and wispy because you could be knocked over by a strong wind or something."

Even his increased pudginess did not keep Morrison from running with an ever faster crowd than he had in high school or at Florida State. The film students at UCLA stuck together and that was quite an achievement considering the department had accepted just about every crazy who had managed to apply in the name of truly liberal arts. They were an odd mixture of talent, bravado, rebellion, and intellectualism. They listened attentively as the art of film was dissected in class and they ravaged each other's work in the screening room. They bullshitted each other over an occasional joint at a campus lunchstand named the Gypsy Wagon and shot pool over beers at a local Mexican restaurant called the Lucky-U. The students saw themselves as the vanguard of something big, something important, something that would have far-reaching effects. But in those days, none of them quite knew what that something was to be.

There were those in Morrison's crowd who stood out. Besides Ronay and Ford there was Big John DaBella, a self-described hustler and former longshoreman who often boasted about madcap sexual adventures in a way that delighted his fellow students. Phillip O'leno was another friend—dark, brooding, intensely serious, and passionate. During his time at the school he was reputed to have read the entire works of Carl Jung. Then there was Dennis Jakob, who was described by a fellow student as "the best mind to have remained in the nineteenth century." He graphed *Ivan the Terrible, Parts I & II* on the blackboard in thirty different colors of chalk.

Of course, the person Jim Morrison met at UCLA who had the longest-lasting relationship with him was Ray Manzarek. Manzarek was older and had a powerful influence on some of

the younger students in the film department, including Morrison. A grad student, he had originally enrolled in UCLA's law school after earning a Bachelor's degree in economics from De Paul University. Two weeks with the law books proved two weeks too long, however, and Manzarek changed over to film. Alan Ronay introduced the two men that would later form the nucleus of The Doors when he brought Jim over to John DaBella's for dinner. Ray Manzarek recalls that first meeting. "Morrison impressed me. When I first met Jim, he was great, terrific, really smart. I thought he was intelligent and funny, a real cut-up, he had a devilish sense of humor. He could be a real wise guy."

While Manzarek and Morrison didn't become close until later, Jim admired Ray for taking a stand against the faculty by refusing to edit out a nude scene (of lovely Oriental girlfriend Dorothy Fujikawa) in his class film. "At school I was primarily interested in film," Manzarek remembers. "It seemed to combine my interest in drama, visual arts, music, and the profit motive."

There were others from this group of ambitious film auteurs who later became part of The Doors team. Paul Ferrara was one; Frank Lisciandro was another. Together they later became The Doors' photographers and filmmakers.

But of all the people Jim Morrison knew at UCLA, the man who most influenced him was a maverick, rowdy, self-titled philosopher named Felix Venable. It was Felix who taught him to do drugs and booze, and it was Felix who continually encouraged him to break on through no matter what was on the other side. "Felix and Ray were sort of the two elder statesmen," Ronay recalls. "Ray was very brilliant even though he was arrogant. Felix was a great talker and a great drinker, but he probably had the most talent of any of us. His film, *Les AngeS Dorment,* was very creative. The title means 'the angels sleep' and he used those angels you always see at Christmastime, the brass ones that hold candles or move around and tinkle. The film was very poetic, a beauty. It was done with so much flair."

Felix was like Dean Moriarty gone to film school. Or worse, he was like a Neal Cassady who had finally decided that he had to do something with his life. And that decision carried just enough real commitment to get him to the cinematography department. Once he was there, however, his ambition had waned again, leav-

ing Felix in a sort of permanent cruising state. Felix's past was appropriately veiled in mystery. A few said he was merely a redneck bus driver from Oklahoma. But others claimed he was a true genius—he had poetry published in *The New Yorker* and *Les AngeS Dorment* (*LSD*) won some short-film awards. Still others seriously theorized that he was an ex-CIA agent who'd blown his mind and was hiding out. All that was for certain was that one day Felix mysteriously appeared at the film school and a few years later he was dead of alcoholism and drug abuse. In between, however, he left a very important mark on one particular man. Felix may have been a lecher, a moocher, and a bullshitter extraordinaire, but Morrison clearly saw him as one of the most engaging and interesting individuals he'd ever known.

> *We scaled the wall*
> *We tripped through the graveyard*

The truth was probably that Felix was too intensely involved in everything to be truly involved with anything. He came from the Beat Scene, with his poetry and a passion for bongos. Perhaps he was more of a dated outlaw than anything else, but to Morrison Felix was Virgil to his Dante. Not that they were that close—no one could really get that close to Felix because he was spinning too fast. Those who remember him say it isn't so much that they miss him, it's that they miss the feeling he generated in them. In his *Crawdaddy* article Richard Blackburn described it as the sense that, no matter how misguided Felix was, he "represented the desire to Find It! To, once and for all, set the night on fire." And Jim Morrison discovered he loved that sensation very much.

Morrison was busy, if not contented, trying to open a continual line of new doors in his quest for the missing element in it all. More often than not what he found on the other side of those doors was a mirror, and he wound up focusing on his own reflection. But each time he saw it a little differently. One door that Jim Morrison opened again and again during this time was drugs and behind this door he found a fun house mirror.

Not only did Felix get Morrison into drugs, he eventually became his supplier. Ray Manzarek remembers that before meeting Felix Jim had too much pride in himself to do drugs or even

drink very heavily. Then suddenly he was into it all. "Jim was polite, a perfect gentleman who never touched drink or smoked . . . then he took up with this guy—really just a plain, evil mind-fuck. And the next time we were with him socially he was drinking and smoking like a man possessed. And he was also starting to act a little weird. It's like those black demons were always there just waiting—I suppose we all have them—and this guy happened to come along and swing the gate open, and they all came howling out."

Ronay also recalls Jim's sudden change: "Jim changed radically in school. In the beginning he was not aggressive at all, but after becoming close with Felix, he changed. He became more and more outrageous until eventually he was just horrible to everyone. That was why I broke with him for a while there. I couldn't take him anymore. He was completely out of hand."

Some of Jim's exploits with Felix are to this day classic lore among the UCLA film department. In those early days of LSD and other mind-altering drugs, there was a series of tests on experimental drugs being conducted by the UCLA Neuropsychiatric Center. Anyone could sign up to serve as a willing guinea pig to help the scientists measure the effects of the new drugs. Of course the tests were strictly monitored, and students were allowed to sign up for only one of them because of the potential danger of combining the experimental drugs. Felix and Jim were among the first to sign up, but this wasn't good enough for them. They reasoned, what the hell, and using a series of aliases they signed up for *every test!*

Each time they showed up for a test a white-smocked assistant would give them one pill each to take and a paper cup of water. After they took the pill, the assistant would leave, saying he'd be back in twenty minutes to check their reactions to the drug. As soon as he was gone, Felix and Jim would race down to another test area and give different names (Fred Nietzsche and Art Schopenhauer were favorites) to sign up again. Then they would do another drug, wait for the attendant to leave, and tear off to another room. When the twenty minutes was nearly up for the first pill, they would return to the first room and deny that they'd had any effect whatsoever so that they could receive yet another pill. This went on all day!

One friend reported that he came upon them at the end of

the day as they nodded in snakelike fashion at the Gypsy Wagon. When he asked them what they were on, they replied something like ". . . two blues, a yellow, two whites, and a little speckled motherfucker . . ."

Carol Winters, a close friend of Morrison's in those days, remembers another of Felix and Jim's drug exploits when they came to her apartment after ripping off an entire case of doctor's samples from somewhere in Culver City. "They just sat down on the floor and went through everything in the bag taking one of each." It wasn't long before Morrison was out on the balcony screaming and having dry heaves. But, according to friends, this was not all that unusual and soon he was ready for more action.

It was an easy time to get drugs. LSD was not yet illegal and the general public and most authorities were not that hip to grass yet. It was a time of testing limits anyway and no one really thought you could get hurt by it. The feeling was that if you ingested a lot of various exotic drugs the worst that might happen is they would make you sick and throw up. To many that little bit of inconvenience was well worth the risk. That is, until a few years later, when people started dying left and right from drug overdoses or from doing insane things during bad LSD trips.

Drugs are a bet w/your mind

Even though Morrison was playing the same games as many of his friends, he was a lot more vulnerable, and a lot younger. He hung out with some bizarre, but intellectually heavy people and he really didn't yet have the intellect to compete with them. And those were the days when intellect was everything and if you didn't have it, you had better learn to fake it or compensate for it. Jim did both exceedingly well and consequently he was driven to prove himself through more physical acts like fast driving, drugs, and booze. Michael Ford remembers Jim's reading Rimbaud while balancing himself on the ledges of tall buildings at UCLA for a student film. Another time in the cinematography lab he just went wild, suddenly throwing cans of film and stuff all over the place. No one was quite sure why he did it, but it made a powerful impression.

Phillip O'leno, one of Morrison's best friends at UCLA, describes him in those days: "Jim was a very talented and very brilliant

person who was a little too young to be wise." Part of Morrison's
lack of wisdom at this time translated into proving himself with
drugs. He may have been slow to join the drug revolution, but
once he did, it became another obsession. And alcohol, the poet's
classic weakness, was embraced with even more passion. Thus,
over the years at UCLA, booze, the traditional sentimentalizer of
the past, coupled with psychedelics, the reputed mind expander
of the present, became Morrison's rather askew formula for
growth. And why not? All of his peers were off-the-wall revolution-
aries who might come to class stoned or drunk one day with little
interest in what was going on, then work around the clock without
sleep the next to complete a project they believed in. They had
their own brand of academics. They all wanted to crack the bar-
riers that held them back, each in his own way. And Morrison took
it all in with his special gift for absorption. All the foolish brave
talk. All the stoned, drunken days. All the wild, electric nights.

Michael Ford elaborates: "Jim didn't really start knocking back
the booze until Felix was around, but it's not that Felix was some
sort of demonic influence. We used to sit around the Gypsy Wagon
and talk about reality and I think Felix thought he had to succumb to
the nineteenth-century Romantic myth that you had to be a drunk
and a womanizer in order to be a poet. I mean he might even have
been joking but Jim had a tendency to take jokes very seriously."

As college continued Morrison became moodier and the show-
off side of his nature more and more dominant. If he were visiting
your apartment, you might be having a wonderful discussion about
French poetry one moment and the next discover him throwing
lighted matches onto your bed. If he crashed the night you might
leave in the morning sure that he was your friend for life only to
return later to discover he had smeared tuna fish all over your walls
as some sort of vague gesture of protest toward you. Carol Winters
remembers: "He was manipulative, but he was also very protective.
We weren't lovers except for one weekend, but I really loved him
and he looked out for me. He wouldn't let me do really dangerous
stuff like drive a car when I was on acid. But he hurt me too. After he
got famous he didn't want me in his new life. I guess he didn't want
to remember that I'd been supporting him."

Many serious students accused Morrison of being a dilettante
because he got drunk and goofed around so much. He seemed to
be less interested in the "important issues of life" and more in the

outrageous. He talked often of forming a band even though he was the first to admit he couldn't sing a note or play an instrument. But he wrote poetry regularly and it was obvious he wanted to join the burgeoning music scene that was at the center of the hippie culture. Morrison was intrigued with the idea of performing. Once, when he was visiting college friend Martin Bondell, he met a girl who had just returned from a Bob Dylan concert. "Jim sat down with the girl," Bondell recalled, "and quizzed her intently as to what Dylan sang, what clothes he wore, how he moved, and what the effect of his act was. He was totally fascinated by it."

But before these things took hold, Morrison did manage to complete one film of his own. It was his first and last, and predictably, it was very controversial. A few students called it a masterpiece of nonlinear filmmaking, but the faculty and most of the other students felt it was a waste of good celluloid. The film was essentially a work print with a sound track, and its one print appears to have been lost in the UCLA archives. The untitled original was first screened at a grading session, where it kept breaking in the projector because of poor splicing. When it was finally shown in projectionable form it came off as sort of a Freudian dream, a chain of startling surrealistic images. The film began with a black screen and strange sounds—erotic ones mixed with the chanting of a priest and children from a Catholic catechism hour radio show. It sounded primitive. The first image was of a group of men waiting for a stag movie to begin. When the movie breaks in the projector the men make shadow puppets of animals with their hands on the screen, but then become angry because the film hasn't come back on. Then the scene shifts to a blonde girl doing a striptease on top of a television set that is tuned into a Nazi storm trooper rally. After she takes off most of her clothes she straddles the TV, causing the marching German soldiers to look almost as if they are coming out of her. The film continues with images of a walking woman's rear and ends with a giant close-up of Morrison taking a hit off a huge joint and giving the audience the Big Wink!

Cinema, heir of alchemy, last of an erotic science

Morrison later called it "less a film than an essay on film," but it indicated that his fascination with blending violent and

erotic images was present even then. Ray Manzarek gives his opinion of the film: "Jim just put a lot of things he liked into a film. It didn't have anything to do with anything. Everybody hated it at UCLA. It was really quite good."

It is certain that the lighting and camera techniques were not that good, but what about the effect of the images? The faculty unanimously agreed that it stunk and Morrison was given a "D" for his girlie/TV/Nazi/pot movie. His friends said it was great. According to Richard Blackburn, "After the screening, Jim's film was attacked at length by a rather uptight faculty member who called it a product of a degenerate mind . . . A few minutes later, Jim was seen talking to someone in a phone booth, crying bitterly, tears streaming down his cheeks."

Morrison stated: "The good thing about film is that there aren't any experts. There's no authority on film. Any one person can assimilate and contain the whole history of film in himself, which you can't do in other arts. There are no experts, so, theoretically, any student knows almost as much as any professor."

And that was the way Morrison had always wanted it. Even the most liberal department in one of the most liberal colleges in the country gave him a sense of being restricted or censored. Even those that supposedly championed individuality and eccentricity had left him with a sense of limitation. "I've always had this underlying sense that something's not quite right," he told *Eye* magazine's Digby Diehl. "I felt blinders were being put on me as I grew older. I and all my friends were being funneled down a long narrowing tunnel. When you're in school, you're taking a risk. You can get a lot out of it, but you can get a lot of harm, too."

Life continued to be an ongoing exciting experiment for Jim Morrison. Partly he was just out for a good time, and to hell with anyone that got in his way, but at the same time he was serious. His primary concern could best be said to be *vision*. He was always testing the bounds of reality and trying to find some meaning to it all. If that meant bending the reality or shaping it a bit, then he was all for it. And yet, still coexisting with it all at this time, just a hair's breadth beneath the surface, was the shy, repressed kid who used drugs not just for experimentation, but because they gave him confidence.

For Morrison at UCLA there was no fraternity rat-pack party

scene happening. That classic college tradition had already faded into the deeper and more lasting freedom that would soon become the love generation. The music of this time in Los Angeles was that of Love, Buffalo Springfield, and The Byrds. And the partying was more along the lines of an occasional lunatic adventure or simply just bringing wine to a screening and passing it around. Often the film school students would go to see Ray Manzarek's band on the weekends. Rick & the Ravens was a somewhat uninspired little combo which featured "Screamin' Ray Daniels, the bearded blues-shouter." "Screamin' Ray" was Manzarek's alter ego and the band could usually be found playing (for five dollars each a night) at a bar on Second Street and Broadway in Santa Monica, improbably called The Turkey Joint West. It was the spring of 1965 and Rick & the Ravens had a nucleus of the three Manzarek brothers: Ray on vocals, Rick on guitar, and Jim on harmonica.

Since Manzarek had switched from studying for a law degree to being a film student and musician, his classmates used to say he changed from studying for the bar to playing in a bar. Manzarek remembers: "I was at UCLA and the money kept me paying the tuition. I would switch from film school grubby to a blue jacket with a velvet collar and a frilly shirt to be the bearded blues-shouter. Immediately afterward, I would put my sweatshirt and corduroy jacket back on and return to being a film student."

The brothers had played together in Chicago, and when the family moved to Redondo Beach, the blues band was formed for weekend gigs. The Turkey Joint West was frequented by a college crowd who came to hear Manzarek belt out "Money," "Louie, Louie," "Hoochie Coochie Man," and "I'm Your Doctor, I Know What You Need" in a somewhat forced Chicago blues style. Often the film school students joined in, participating in a sort of spontaneous live jam onstage. And one of these students was Jim Morrison. At Ray's beckoning Morrison would climb up on the stage, but once he was up there he was unable to do much more than clap along, shake an occasional tambourine, and shout, "Right on," every once in a while behind Manzarek's lead vocals. Ray remembers: "That was the first time Jim sang onstage. A whole lot of guys from the UCLA film department came down, and you know, there wouldn't be anyone in the club, so I'd say, 'Come up, Jim, come up, Paul [Ferrara],' and there'd be about

twenty of us screaming and jumping around." During one such gig Morrison sang an extremely rough version of "Louie, Louie" to a delighted film school audience.

Although he had been seeing her sporadically for some time, Jim and Mary Werbelow were coming to a parting of the ways. Her dreams of stardom now seemed like schoolgirl fantasies to him, and when she refused to appear in his student film because her agent advised her not to, Jim was furious. Mary also believed he was taking too many drugs, but the last straw came when she showed up unexpectedly at his apartment and caught him with another girl. Jim defended his position, claiming she had no business coming over uninvited.

As he drew nearer to graduation, Morrison became locked into the idea of never doing anything halfway. Thus, he drank not for enjoyment, but to get drunk, and he smoked grass not to get merely high, but to get stoned out of his mind. Both the creative and the destructive voices inside him were picking up steam and beginning to shape him into some sort of human bullet, one who would approach life as if he had been shot out of a gun. Very noticeable—very fast—and about to smash into something.

Venice

After Morrison received his Bachelor's degree in cinematography from UCLA, he told his friends that he was going to New York to get into films and make a living at what he'd learned. But he never left because he discovered he'd been classified 1-A after graduation and figured he'd be drafted any time. Instead, he wandered to Venice and moved in for a time with Dennis Jakob, a friend from college. He and Jakob used to joke about forming a rock duo called The Doors: Open and Closed. Their repertoire was to consist of two songs, "I'm Hungry" and "Want." Morrison's inspiration for the name The Doors came from a quote from William Blake, "If the doors of perception were cleansed every thing would appear as it is, infinite." Jim used to say, "there are things known and things unknown and in between are The Doors." He had also read a book by Aldous Huxley entitled *The Doors of Perception* after the Blake line. Huxley's book is basically an account of his experiences with

mescaline. His descriptions of the mind-altering drug appealed to Morrison, especially passages such as: "It has always seemed to me possible that . . . by taking the appropriate drug, I might so change my ordinary mode of consciousness as to be able to know, from the inside, what the visionary, the medium, even the mystic were talking about."

The last paragraph of the book reads: "But the man who comes back through the Door in the Wall will never be quite the same as the man who went out. He will be wiser but less cocksure, happier but less self-satisfied, humbler in acknowledging his ignorance yet better equipped to understand the relationship of words to things, of systematic reasoning to the unfathomable Mystery which it tries, forever vainly, to comprehend."

It is no wonder Morrison not only wanted to experience these things, but became attracted to the idea of being the door through which others could experience them.

Before I sink into the big sleep
I want to hear the scream of the butterfly

While he was sharing a place with Jakob, Morrison took his physical for the army. Most of America was still pretty naïve about the slowly escalating war in Vietnam, but Jim Morrison already knew all he wanted to know about military life. Hoping to flunk his physical, he ingested a healthy quantity of various drugs and, when this failed, told the army doctors he was a homosexual. Much to his relief, he was refused for service. It is uncertain why, at that point, Morrison did not leave for New York as previously planned. Most likely it was because he knew how difficult life there would be. "Film is a hard medium to break into," he later said. "It's so much more complex than music; you need so many more people and so much equipment."

Instead, Morrison began staying on a rooftop of a decaying, deserted office building in Venice, seeking solitude and a place to let his mind roam free. College was over and it was time to take the step into manhood. It was also time to answer the questions of childhood. For Jim, Venice was the perfect place to do both. The small artistic community was changing from a dying beatnik hangout to the oncoming age of the hippie, attracting more and more longhairs, runaways, and artists everyday. The counter-

culture was just beginning and Morrison was one of many anonymous barefoot drifters in long hair, T-shirt, and jeans. San Francisco had the Haight and Los Angeles had Venice. It was a place where transience was a given and acid the drug of preference. LSD, being both plentiful and legal, was sold over the counter at the local head shop and Morrison ingested an ever-increasing daily ration of it. One friend later maintained that Jim ate acid during this period of his life, "like candy."

█

So, in the sleazy beach area of Venice, Jim Morrison began the final stages of his catharsis from a shy, overweight kid to a poet and rock legend. Among the muddy canals and peeling colonnades, he lived alone, above abandoned rooms where the only sound was the occasional echo of a passing car and the only light an eerie reflection from the vacant passageways below. It was a strange place which befitted a strange time in his life. Like the building, Morrison began to close out the world around him. The light struggled to get in and the darkness pushed to get out, but all Jim Morrison knew was that a change was taking place inside him. After a while he rarely left the roof, dropping acid almost continually and spending his time meditating and writing, but most of all waiting. Something was about to happen.

Morrison now realized that he had come to this rooftop searching for answers. And for something more. For himself. He was doing what each of us has to at one time or another: Leave our past behind and search for our niche, our special role in the future. But for Jim Morrison it was something more because he was at last going to face the "other side"—travel to the edge of a border that he had before feared to cross. He knew now that he had chosen such a desolate place intentionally, planning to cocoon himself. This was his wilderness—living in abject poverty on the roof of an abandoned building. It was symbolic because it was an emptiness in soul and a poverty in spirit that he had come to fill.

Confused about his future and disillusioned by the hypocrisy and pretense all around him, Morrison settled into a period of deep reflection. Deluding his conscious mind with drugs, he sought to open his subconscious to what he believed to be the source of wisdom and inspiration—the spirit world. It was time for all the

words he had read to come to life—Nietzsche, Kafka, Blake, Rimbaud, Baudelaire, and countless others—time to cross over to the "other side." Though he may not have known it, his fasting, meditating, and ingestion of mind-altering drugs put him into an ideal state for contact with the supernatural. It wasn't long before the voices within him began to rise. And this time he began to understand their whispers. There was far more to life than he had thus far experienced. Greater meaning, wondrous sensations, higher heights to climb to, and deeper depths to tumble to. And he could have it all.

Before long, the university was far behind him, a distant memory. Now Morrison turned to the medium that had sustained him through much of his life—poetry. He began to write. Without much more than a blanket and a few cans of food, he settled down for the long haul in his new abode. No doubt he spent hour upon hour, riding the crests of acid waves, he wrote with a frenzy until his fingers ached. The only time he left this refuge was not to get a pillow, a light, or any of the other creature comforts; it was to get a pencil and a tablet so he could continue to write the words flowing through his head. As soon as he got these sacred instruments, he would hurry back to the roof and there—by sunlight through the day and candlelight through the night—he poured out all the thoughts that entered his rich imagination.

And he imagined much. On and on he wrote—almost without ceasing. Often he tore up pages or burned them, but others he rewrote because the spark was in them. He laughed when he knew it was good and cried when he saw it was bad. After a few days of this the things that had seemed so important in that "other world" molted like useless scales as new ideas and new thoughts were burned into his mind. His childhood experiences suddenly seemed to make more sense. It became clear why things had been so difficult for him—he was different. He was meant to be different. He had been chosen long ago on a distant New Mexico highway and, once chosen, could not refuse the "call."

The next step toward shamanism, the empowering by the supernatural, was taking place. Morrison's rooftop experience

compares closely to passages from texts on shamanism that describe the songs of a shaman. Such songs are believed to be sacred sounds that came from the spirit world when a man is about to become a shaman, occurring of their own accord and more or less forcing themselves out in a complete form with little or no conscious attempt to compose them.

Jim Morrison later recounted what happened to him during this time: "I was living in this abandoned office building, sleeping on the roof. And all of a sudden I threw away most of my notebooks that I'd been keeping since high school and these songs just kept coming to me. It was a beautiful hot summer and I just started hearing songs. This kind of mythic concert that I heard . . . I thought I was going to be a writer or a sociologist, maybe write plays. I never went to concerts—one or two at most. I saw a few things on TV, but I'd never been a part of it all. But I heard in my head a whole concert situation, with a band and singing and an audience—a large audience. Those first five or six songs I wrote, I was just taking notes at a fantastic rock concert that was going on inside my head. And once I had written the songs, I had to sing them."

I met the Spirit of Music

The first song Morrison "heard" and wrote down was "Moonlight Drive." Another was "End of the Night" for which he took his inspiration from a novel by Louis-Ferdinand Céline called *Journey to the End of the Night.* Others were "Summer's Almost Gone," "Not to Touch the Earth," and "My Eyes Have Seen You." But more than these, the songs written on that roof touched on things rarely described in song. Pieces and stray lines of poetry now fused together in monstrous metaphysical visions such as "The End" and "When the Music's Over." Morrison had caught the fire of the young and captured it in his words. He had spelled out all their aching and longing, their fears and desires, their unquenchable thirst for love and for someone to be loved by. By putting it down on paper he had made it his own. The words like the thoughts were fragile but forceful, delicate but strong. They were poems of loneliness, fear, longing, love, and the fire. Morrison would never again equal the majesty or sheer poetic power of these words, but they would provide him with

an artistic base from which he would influence and change the lives of legions of fans.

Like the young Indian shaman, Morrison went through his test of fire. As the ancients had used peyote and exhaustion from dancing to prepare the way for communication with the Great Spirit, he used acid and the stimulus of isolation in his own ritual hunt for a face-to-face encounter with the spirit he knew had always been near him, the voice that had whispered to him since childhood. Some part of him had decided that the wait was over. He would no longer hold back, but turn himself over completely to this spirit and see what it had to offer.

And there is little question that he did just that. Or at least he found something that spoke to him, inspired in him endless reams of poetry that was to become the basis for The Doors' first two albums. And with that eruption of artistic growth came a personal metamorphosis as well. Jim Morrison had changed. His mind, his goals, his belief in himself, had crystallized. He had walked along the sacred precipice, he had survived his trial by fire. And his body reflected these changes as well. Partly from lack of regular meals, partly from drug use, and partly as a reflection of the changes within, Morrison changed from a 185-pound pudgy kid to a trim Adonis. When he came down off the rooftop that last time, there was no doubt that the boy had changed into a man. The Jim Morrison that had been raised in Alexandria, Virginia, was gone. And whatever he could have become was gone with it, replaced by the shaman, the mystic visionary. Win or lose the struggle for an identity was over and Jim Morrison was content for a time. There was a new confidence in him as if he knew what lay ahead. As if, when the time was right, the next door would automatically open. And indeed it did.

An appearance of the devil on a Venice canal
Running, I saw a Satan or Satyr,
moving beside me, a fleshy shadow of my secret mind.
Running, Knowing.

Meeting on the Beach

The Doors were conceived in the pristine warmth of a sandy beach on a sunny day. During the summer of 1965, Ray Manzarek

was living in Venice, on the oceanfront south of Santa Monica, when he ran into an old film school colleague down on the beach. Manzarek had to wipe his glasses on his beach towel and look again to make sure that the tan and lean figure with the striking long hair was the same chubby, shorthaired kid he'd known at UCLA.

As Manzarek said: "It was a beautiful California day in July around one in the afternoon, when who comes walking down the beach but James Douglas Morrison . . . And I said, 'Hey, man, what have you been doing? How come you're still here in L.A.?'

"He said, 'Nah, Ray, I never even left. I decided just to stay for the summer.' I said, 'Well, what's going on?' He said, 'I've been living on some rooftop writing songs.'

"'Songs?' I asked. Well, obviously, I knew he was a poet, but writing songs? Now, that was interesting.

"'Yeah,' Jim said. 'Just bits and pieces. Ya know, in my notebook.'

"I said, 'Well, far out. C'mon over, man, sit down here and sing me a song.' So Jim sits down on the beach and digs his hands into the sand. He pulls up two big handfuls of sand, lifting 'em up and the sand drips out between his fingers, just kind of streaming down. He clears his throat, closes his eyes, and sings in a haunting voice: *'Let's swim to the moon/Let's climb thru the tide/ Penetrate the evenin' that the city sleeps to hide.'*

"I said, 'Hey, that's great, man, those are the best lyrics I've ever heard for a rock 'n' roll song!' As he was singing, I could hear the chord changes and the beat; my fingers immediately started moving. I could hear weird, strange, spooky notes that I could do on the keyboards around his vocals. Then he sang a few more tunes that he'd put together. And when he was done, I said, 'Why don't we get a rock 'n' roll band together and make a million dollars?' He said, 'That's exactly what I had in mind all along.'"

When Manzarek heard that Morrison wanted to call the band The Doors, he thought it was ridiculous until he remembered the Blake line. "At the time, we had been ingesting a lot of psychedelic chemicals," Manzarek remembers, "so the doors of perception were cleansed in our own minds, so we saw music as a vehicle to, in a sense, become proselytizers of a new religion, a religion of self, of each man as god. That was the original idea behind The Doors. Using music and Jim's brilliant lyrics."

The astute and sensitive Manzarek saw immediately that lyrics such as these could have a tremendous impact on rock music and the world. He had always thought of music in cinematic terms because it evoked images and existed in vibrations. "Music has rhythm, harmony, melody, and lyrics," Ray once said, "the vibrations get into your mind and create images." Now he was hearing cinematic poetry. Poetry that created images in the mind—pictures. The combination of the cinematic aspects of poetry and the cinematic aspects of music was a concept of unlimited potential. The fifties had the beatniks with jazz and poetry. Why not the sixties with rock and poetry? Poetry set to rock music. Two post-beatniks with a similar vision. It was only natural to get a band together. Faced with the Pacific Ocean, at the end of Western Civilization, listening to poetry that was itself infused with the power of the elements, the ocean as the traditional image of death, the sun as life, Ray Manzarek knew what he wanted to do with his life: "When I saw Jim walking on the beach that day, I was surprised at first because he had told me he was going to New York City. I thought he was gone. And now I wonder why he chose to go to the beach on that particular day and why I happened to be there. Somebody must have planned it."

When they met on that Venice beach, Morrison had still never sung in a band, but he'd begun writing song lyrics. And now he had an outlet for them. Perhaps he did it partly out of rebellion against his parents because he knew they would probably view his becoming a rock singer as the ultimate bad thing. Perhaps it was because that is where the voices on the rooftop led him to go, and perhaps it was simply because there were no other doors open at the moment.

Forming the Doors

Things got serious after that day on Venice beach. Morrison moved in with Manzarek and his girlfriend, Dorothy Fujikawa. When they agreed to form a band, Morrison figured Ray would sing the songs, but Manzarek insisted that since they were Jim's songs, he must feel them more and should sing them. When Morrison was reluctant, Manzarek reassured him, reasoning that since Jim had a rich deep speaking voice, with a little practice he would do fine. More than this, however, Manzarek felt that since

Morrison had the power and passion to compose such songs, singing them onstage would create the opportunity for those elements in Jim's personality to rise up and be projected out toward the audience. He knew that if Morrison could cut loose with this inner power onstage it would more than compensate for any lack of musical experience.

For a while they shared a tiny flat in Ocean Park, and Morrison spent the next few weeks sharing his poems and exploring his voice. Sensing now that this was his true vocation, he continued to write—on the beach and in the streetside cafés of Venice. Wherever he went, Jim Morrison wrote songs. "The music came first, and then I'd make up some words to hang on the melody, because that was the only way I could remember it, and most of the time I'd end up with just the words and forget the tune." Some of these songs were inspired by his surroundings. Olivia's Place was a run-down diner located on Main Street. If you wanted to be polite, you could describe it as funky: faded pink on the outside and faded green on the inside, a tapestry of JFK hanging over the cash register and a faded landscape on the wall, a shiny jukebox, and plastic booths. The menu was written in pencil but offered good food at low prices. Fittingly, "Soul Kitchen" was dedicated to Olivia's Place.

"Hello, I Love You" was also written around this time. Jim and Ray were sitting on the beach in Venice one day when a sexy black girl came walking down the sand. Morrison called out to her, "Hello, I love you," and a few days later wrote the song.

Others were triggered by images from his past: "I wrote 'Break on Through' one morning down in the canals. I was walking over a bridge. I guess it's one girl, a girl I knew at that time."

Wisely, Manzarek decided to devote some time to rehearsing with Morrison before introducing the rest of Rick & the Ravens to their new lead singer. Even then everyone was immediately skeptical. Worst of all were Morrison's former classmates, most of whom were astounded. "You're in a band with *Morrison*? For God's sakes, Ray, why would you want to go and do something like that?" They thought Manzarek had gone off the deep end. Considered the film student with the best chance of making it, Manzarek had even been mentioned in *Newsweek* as a bright hope alongside former student Francis Ford Coppola and many couldn't believe Ray would give up on such a promising film ca-

reer to start a band with Jim Morrison. Manzarek's brothers, Rick and Jim, had a similar skepticism, but they began putting some very moody music to Morrison's lyrics and tried to help him become a singer.

Were it not for Ray Manzarek's vision it is highly unlikely that Jim Morrison would have become a rock singer. Without Manzarek's encouragement and influence, Morrison was far too undisciplined to have taken the time to work with his voice. Manzarek saw something in Morrison that no one else had seen before, and even more important, he had the discipline and the patience to wait for Morrison to develop. With the same bear-down tenacity he had applied to the keyboards when he was young, Manzarek now worked with Jim Morrison. He taught him the basics of singing, motivated him, and at times tolerated him, all the while keeping his eyes focused on the greatness he believed was within.

Ray Manzarek

Raymond Daniel Manzarek, the man who orchestrated The Doors' dark and mysterious sound was born on February 12, 1939, in Chicago. He studied piano as a child, showing considerable promise in the classical forms, having to master the likes of Kabalevsky, Stravinsky, and Tchaikovsky. "When I was seven years old my parents bought an upright piano, put it in the recreation room, and said to me, 'Well, Raymond, it's time for you to learn the piano.'"

Practicing did not come easy to Manzarek, most likely because he lived across the street from a playground where the sounds of a heated ball game could easily distract a young boy. But it was on this same playground a few years later that he heard something that was to have a major impact on his music. "When I heard the blues I knew I wanted to become a keyboard player," he later told Steve Rosen in *Keyboard Magazine.* "Up to then the only pop songs I knew about were 'How Much Is That Doggie in the Window?' and 'The Shrimp Boats Are A-Comin'.' But one day somebody had a portable radio tuned to the right-hand side of the dial, the ethnic side, and the blues blew my

mind. I'd never heard music with such a sense of rhythm and such a minorish, strange overtone to it; the harmonies, the way the singer would sing, and the whole approach to the music was just totally different from white popular music. From then on I was hooked on Muddy Waters, Jimmy Reed, John Lee Hooker, and the Chicago blues school."

Then Manzarek approached learning the piano with a new intensity. He loved playing boogie-woogie and began listening to people like Pinetop Smith and Albert Ammons. "I heard their left hands repeating those figures over and over and learned to keep a repeating line going with my left hand while being free to improvise with my right. Lenny Tristano was also a big influence. He was the king of the left hand during the forties and never used a bass player because his left hand was just going like gangbusters."

While still studying classical music at the Chicago Conservatory, Manzarek in his teens began hanging out steadily at the great, smoky blues rooms of the South Side. In addition to deepening his appreciation of the blues, he also soon turned on to jazz artists such as Miles Davis, John Coltrane, Ahmad Jamal, Ramsey Lewis, and Bill Evans. He loved it and probably would have been content with jazz and the blues forever until radio again intervened. "One day one of those stations played a song called 'Mystery Train' by a new guy named Elvis Presley. They didn't know he was a white guy because he didn't sound like it and I didn't know he was white either. But it was different from the black music because it had acoustic rhythm guitar patterns with a country kind of feel. That was rockabilly, or rock 'n' roll and hillbilly music. Then rock 'n' roll hit. Chuck Berry, Little Richard, Fats Domino, and Jerry Lee Lewis were big influences on me."

This sound also quickly translated into Manzarek's personal style. Soon he was getting together with other musicians and playing rock 'n' roll gigs around town. "I played with a lot of different bands in Chicago just on weekends to make some money. They were mostly jukebox bands, doing a little jazz, a little of our own stuff, and for the most part, just playing Top Forty for fifteen dollars a night. Thirty dollars for doing that was kind of a nice part-time job."

After graduating from St. Rita High School in Chicago,

Manzarek earned a Bachelor's degree in economics from De Paul University, believing that it would be ridiculous to try to make a career out of music. He then left Chicago at age twenty-one and enrolled in the UCLA law school, but dropped out after two weeks and went to work at the Westwood Bank of America. Three months later he followed his creative instincts and enrolled as a graduate student in the UCLA film department. In December 1961 a broken romance led Manzarek to abandon his student deferment and join the army. A couple of years of duty as a piano player in an interservice band proved that the army was not where Manzarek longed to be and he told the base psychiatrist that he thought he might be developing "certain unspeakable tendencies." He was released from duty and returned to the UCLA film school around the time Jim Morrison arrived in 1964.

After Morrison joined, Rick & the Ravens/proto Doors consisted of the three Manzarek brothers, Rick (guitar), Jim (harmonica), and Ray (keyboards and vocals) and Jim Morrison (vocals). There was no bass player or drummer and the band was always forced to pick up whoever was available whenever they landed a gig. Then Manzarek met John Densmore.

This was the summer of 1965 when Maharishi Mahesh Yogi, the swami to the stars (before his Beatle fame in 1968), opened his Third Street Meditation center in Los Angeles. For thirty-five dollars you got a series of six lectures and a mantra. Ray Manzarek was an early disciple and so was John Densmore. "I'd been talking to one fellow about getting a rock 'n' roll band together," Manzarek recalled, "and he said 'That guy over there is a drummer.' So I went up to John and said, 'Listen man, I'm a keyboard player and I've got this great singer-songwriter and we're trying to get a band together. We need a drummer—would you be interested?' He said, 'Sure, why not?'"

Densmore remembers the first time he saw Manzarek: "There was this blond guy with glasses and a Japanese girlfriend. At the end of the session he said he'd heard I was a drummer and asked if I'd like to join a rock 'n' roll band. And then he said a curious thing. He said he'd call me in a few months because the time wasn't right yet. And I thought, 'Gee, that's pretty cosmic. Far out.'"

Apparently the cosmic clock shifted a bit, however, because a few weeks later Densmore joined the band.

John Densmore

John Paul Densmore was born almost exactly a year after Jim Morrison, on December 1, 1944, in Santa Monica, California. The heartbeat of The Doors, Densmore was a unique drummer for rock in that he played with a subdued kind of eloquence accentuating the music instead of overpowering it.

John Densmore's first serious musical endeavors came when he was in the seventh grade. "It started when I was in junior high and enrolled in the band. I loved music and I knew I wanted to play an instrument. I thought I wanted to play clarinet, but my teeth weren't too great and the dentist said it would screw them up more. But the teacher said, 'Hey, nobody is playing drums this season.'"

Soon Densmore was taking private lessons, playing drums in the dance band, snare in the marching band, and tympani in the orchestra. It wasn't long before he started giging: "I played weddings and bar mitzvahs for fifteen dollars a night doing fox-trots, waltzes, cha-chas, and that stuff. I feel you have to be at a certain level of proficiency to be able to fulfill that. At a wedding, you can't play Chuck Berry the whole time; you have to be well-rounded."

In high school John became interested in jazz. "I started going to Shelley's Manne-Hole (on Cahuenga Boulevard in North Hollywood)—I got in with a fake ID when I was sixteen or seventeen. I used to see Art Blakey and sit right next to him and watch everything he did. And I really had Elvin Jones down. He was my main guy. I copied everything Elvin did. I had this piano player friend and he would play like McCoy Tyner and we'd just jam forever after seeing Coltrane live and all. There was Philly Joe Jones and bebop too. No one could really teach me that, so I listened to records. I started to do a little studio work; that's what switched me to rock 'n' roll—I started making some money. But, I didn't want to do it all my life because it's a hard life, man. Like I went to Tijuana and got a fake ID so I could play in bars and stuff to support my college career. I was playing in dives when I

was eighteen. For me it was fun, but it could've been depressing if I had to do it all my life. I don't mean jazz clubs, I mean dumpy bars, man."

John's college days reflect his doubts about a career in music. He was a music major at Santa Monica City College and got "A"s in music and "C"s in everything else, but still thought of it as a hobby. "It was something on the weekends to give me money to buy my books or something. Music is such a crapshoot, all or nothing. I loved music and I loved playing, but I never considered it as a way to make a living. So after a year of being a music major, I thought, 'Well, this isn't realistic. I have to make more money to live, so I will be a business major. Business equals money, right? Very naïve, since I got a 'D' in accounting and then took it again and got a 'C' in the same course. That was not too good. It wasn't because I was dumb, I just could not apply myself. I hated it."

Later Densmore switched to sociology and then anthropology, attending Valley State which later became Cal State Northridge. It was here he started taking LSD. "Fred Katz, who used to be the cello player with Chico Hamilton, was teaching ethnological music there and Edmund Carpenter, who was a Marshall McLuhan devotee, was also in the anthropology department. So I got 'A's in that stuff and I got an 'A' on my term paper for anthro, which I wrote about an LSD experience. At that time, no one had ever heard of LSD aside from Leary and those people, but it wasn't in the press. When I started reading about Art Linkletter's daughter is when I stopped taking it. Then I got paranoid. Before that, I was innocent. I had no idea what it was. I wasn't programmed to be negative, but when I knew what it was all about, I stopped."

Finally, John too went to UCLA where he was only a year away from a B.A. in anthropology when he dropped out. As he had done since junior high Densmore was still playing music on weekends: "It was always my avocation in college. But I played a lot, so I kept my chops up. Jazz was it for me, but when I played for fraternity parties, I had to play danceable stuff. The guys I played with and I made some avant-garde electronic music tapes like John Cage's, where we'd just break some glass and make a bunch of noise, and then we'd go to these fraternity parties and play 'Louie, Louie.' We'd turn the electronic music on in the mid-

dle of it, but we still kept the beat, so they just thought we were weird."

Initially, Densmore had reservations about joining forces with Manzarek and Morrison: "So Ray finally did call me and I went down to his parents' garage in Manhattan Beach, although he lived in Venice. There wasn't any music. It was just Jim's words. Ray said, 'This is Jim, the singer.' He had never sung. But they showed me some of the lyrics and I was attracted to them. Songs like 'Moonlight Drive' and 'Soul Kitchen' were real out there, yet I could see the fluidity and rhythm to them and right away thought, 'God, put this to rock music? Yeah!' I didn't understand very much, but then I figured I'm the drummer, not the lyricist. Jim was real shy and sung facing the corner of the garage, but he was different and great-looking. He didn't know anything about chords or any of that, but he was a genius for melody; he heard them in his head. Ray's background was Chicago blues, but he listened to Miles and Coltrane, so it wasn't like I was selling out by being in a rock band. I was playing in a bunch of bands, but I figured, 'Okay, I'll rehearse here for a while and see what happens.'"

The Demo

Like every band who dreams of scoring a record deal and climbing the charts, The Doors made a demo. After Densmore joined they rehearsed for a couple of weeks to get some of the new songs down and then headed for downtown L.A. to cut a demo at World Pacific Studios on Third Street. Before Manzarek had hooked up with Morrison, Rick & the Ravens had landed a contract with Aura Records. They had released a single, but it went nowhere, and rather than go to the expense of pressing another record that would most likely do the same thing, Aura offered the band free studio time to forget the rest of the contract. Not the best of ways to enter a studio, but still a free ride.

The tape was completed in about three hours. This was in September 1965, about two months after Morrison and Manzarek's meeting on the beach. For the studio the band added a female bass player and to this day the surviving Doors swear they can't remember her name. The songs on the initial demo were

somewhat crude renditions of "Moonlight Drive," "Hello, I Love You," "Summer's Almost Gone," "My Eyes Have Seen You," "End of the Night," and "Go Insane." The last song would later be incorporated as part of "The Celebration of the Lizard." Although all were Morrison originals and all were later recorded on Doors albums, the demo does not sound like The Doors. The absence of Krieger, Manzarek's playing piano instead of organ, the inclusion of harmonica, and Ray's background harmonies create much more of a conventional feel than what The Doors sound would become. Morrison's voice is still undeveloped, often sounding precise and uninspired but sometimes coming off more like random screaming and shouting (especially on "Go Insane"). The demo is raw and empty, containing far less of that strange combination of sensuality and mystery that later made The Doors so special.

After the tape was finished, the band began the tedious experience of shopping it around. Armed with an acetate each, Morrison, Manzarek, and Densmore began doing the rounds of record companies in the hope of getting a deal. Manzarek remembered those days in an interview with Pete Fornatale of *Musician.*: "We would go from record company to record company to record company, saying we're a band called The Doors, and they'd go, 'The What? The Doors? How do you spell that?' And then we'd play the demo for them—we got rejected by everybody in town. Even got thrown out of a few offices. Everyone, but everyone, said, 'No! You can't—that's terrible—I hate it—no, no.' I especially remember one guy at Liberty. I played him 'A Little Game' and said, 'You might like this one.' He listened, then said, 'You can't, you can't do that kind of stuff!' Because it said things like 'go insane.'"

As a West Coast band that emerged in the wake of groups such as The Beach Boys and The Mama and the Papas the somewhat dark and mysterious Doors seemed decidedly out of place to the record moguls of the time. They were, quite simply, the antithesis of the fun-loving "beach party" philosophy that was the main ingredient of the California sound. At a time when "peace and love, flower power, and good vibes" were just starting to spread, Morrison's lyrics suggested paying attention to the other side. Their sound was so different in that fall of 1965 and the

music industry so conservative, it's a miracle that anyone listened past the first cut.

But someone did. Billy James had worked for Columbia Records for years and in late 1965 was given a position in a new department called Talent Acquisition & Development, which gave him the power to sign and produce bands. He describes the day he met The Doors: "One day late in '65, I came back from lunch and there were these guys waiting for me. It was them, The Doors. They had a quality that attracted me to them immediately. I guess they appealed to the snob in me because they were UCLA graduates and I thought, 'Great, here are some intellectual types getting involved with rock 'n' roll.' They played me an acetate of several songs they'd recorded. The music was so raw, so basic, so simplistic, so unlike anything I was familiar with. It intrigued me that they could combine this sort of music with such interesting lyrics. As they sat there with me, they seemed very friendly. They exuded this air of confidence. They seemed to know exactly what they were doing. So, we signed a deal. Since my background up to that point had been more in publicity than producing, I felt that I wouldn't be able to bring out this very elusive power they had in the studio. So I approached the other Columbia staff producers (among them Bruce Johnston later in The Beach Boys) and Alan Stanton who was head of A&R. Well, because of their schedules and prior commitments, none of them felt they could get involved with the band."

The result was that The Doors were signed, but nothing happened. Since Columbia owned Vox at the time, Manzarek was able to get a Vox organ and an amp for free. "I said, 'All right! I can get a Vox organ, you know like The Dave Clark Five. For free!' It was red and black, the keys were inverted—black and white were opposite the way they are on a normal piano—and the chrome legs on the sides formed the letter Z. It was cool."

The Doors waited and hoped, but the free equipment seemed to be the extent of Columbia's commitment. It was at this time that Ray's brothers decided to call it quits and return to school. Jim Manzarek's harmonica was not essential to The Doors sound, but losing Rick Manzarek's guitar was another matter. Fortunately, Ray remembered that John had once pointed out a guitar player at the Meditation center. Densmore said the guitarist was an old friend of his and that he might be just right for the band. His name was Robby Krieger.

Robby Krieger

Robert Alan Krieger was born January 8, 1946, in Los Angeles. The revolutionary classical-based style he brought to the electric guitar has proven to be an important influence on the instrument and produced a uniquely personalized sound. Born into prosperity, Krieger was the son of an aeronautical engineer who did contract research work for the government. As a youth he was exposed to classical music: "The first music I liked was "Peter and the Wolf" when I was about seven. Later, I listened to rock 'n' roll on the radio a lot: Fats Domino, Elvis Presley, The Platters."

One of Krieger's friends had a guitar and whenever Robby visited, he found himself picking it up and trying to play, but his career in music really began when his parents decided he was getting into too much trouble at University High in L.A. and sent him to private school near San Francisco: "The guitar just kind of drew me to it, but I didn't play much until I was sent to private school. I wasn't really a delinquent, but on the verge. I was flunking out of school and spending too much time surfing. My parents thought if they sent me away, I might not get in so much trouble, but I did anyway. At Menlo School I started playing the guitar, because there was a rule that you were locked in your room for three hours every night—so you were forced to study. But if you had a guitar or something, you could do that."

Soon Robby's interest in the instrument became focused on the flamenco style, with its heroes like Sabicas and Juan Serrano, and local luminaries like Peter Evans and Arnold Lesser. "I never dreamed of becoming a guitarist. It was just for fun. I started playing at sixteen and one of the first records I copied was 'Dos Flamencos.' That was the first type of guitar I played, a classical guitar. I learned to play with my thumb under the neck."

After graduating from high school, Krieger enrolled at the University of California at Santa Barbara for a year, where he describes his major as "keeping out of the army." At UCSB his musical interests began to expand. "I got involved in the folk music scene up there and played a few gigs with the official Bob Dylan neck-mounted harmonica, singing folk songs. I was also in a jug band called The Back Bay Chamberpot Terriers."

Besides Dylan, Krieger began listening to John Hammond, the finger-picking blues of Dave Van Ronk, and the seven-string

style of Spider John Koerner, but the big moment came at a Chuck Berry concert. "I saw Chuck Berry at the Santa Monica Civic Auditorium. That was the greatest Chuck Berry show I've ever seen because he was still young and not jaded or mad or something. He was really great that night and that did it for me. He had this red rockin' guitar, you know. The next day I went out and traded my classical in on a Gibson SG. My first electric was the SG, the same one I had in The Doors. I played that one until it got ripped off, and then got another. If I hadn't gone electric, I probably wouldn't have got into rock 'n' roll. I wanted to learn jazz, really. I got to know some people who did rock 'n' roll with jazz, and I thought I would make money playing music."

Krieger began listening to jazz guitarists like Django Reinhardt, Wes Montgomery, and Kenny Burrell as well as bluesman Albert King and The Paul Butterfield Blues Band. He also developed a keen interest in Indian music and switched to UCLA to major in physics and study sarod and sitar in an Indian music class. Ironically, Robby had met John Densmore at University High before really getting into the guitar. Now, reunited at UCLA, they formed a blues group called The Psychedelic Rangers. "We were just a garage band," Krieger remembers. "We might have had a gig or two here and there, but it was basically just some friends playing."

John Densmore agrees. "Yeah, well, we took acid together, Robby, this piano player, Grant, Bill Wolf, and I and then we decided, 'Well, let's form a band!' It was back when the word 'psychedelic' wasn't really known. We were just screwing around, jamming on blues and a couple of originals."

So on the one side, Krieger was playing the blues with Densmore, and on the other, he was into Indian music. "I had a sitar and a sarod and took a lot of lessons on them. I even went to the Ravi Shankar School out here, which was called the Kinnara School. This was during his heyday. He had about ten teachers and millions of guys coming in with sitars." It was at the Meditation Center that Robby met Ray, but it wasn't until Rick Manzarek quit the band that he was asked to join. "I was in another group and John was telling me about this group he was in called The Doors. They had this wild and crazy guy, Jim Morrison, who was going to be the lead singer even though he couldn't sing at the time. But I knew he had potential because he had just started

singing about a month before and he was already pretty good. A couple weeks after John joined they needed another guitar player. John brought Jim over to my house and we hit it off good. So we rehearsed and that was it."

Ray Manzarek remembers that first rehearsal: "When Robby came to audition for the band we played 'Moonlight Drive.' He slipped his bottleneck on his finger and tuned his guitar to an open tuning and hit a few wriggly snaky notes and Jim and I just got shivers up and down our spine. At the end of the song I said, 'Whooaa, what a sound! Incredible—that's it, that is The Doors' sound!' The band was whole, complete. I said, 'I've been playing music since I was seven years old. I've played in a lot of bands. I've played in little pickup bands, in bar bands, rock bands, jazz bands, but this is the most *intense* musical experience I've ever had.' I had never really understood music until that point, and what it meant to get into it. Of course we were a little high at the time, but it was just . . . right. Then I said to Jim, 'You know that section of Kerouac where he said the guy had *"it"*? I know what *it* is now—it's what we've just done.' It was a natural—it couldn't miss. I said, 'This is it, we're gonna make it. We're gonna make great music and the people are going to love it.'"

The music had been bolted w/ new sound

It took Krieger a little longer to discover the potential they had stumbled upon in this new band. "The first time we played together I couldn't tell that much. All I knew was that it was better than this other group I was in, The Clouds. So I quit The Clouds and joined The Doors. The Doors said they had a contract with Columbia Records. I believed 'em . . . After a couple of rehearsals and a couple of gigs, I thought we were incredible! I thought we were as good as anybody out there and I had no doubt that we would make it."

Once Krieger became committed to the new group he asked Densmore to give up his other gigs as well. "I was still playing with several different bands and when Robby got in the band, he said to me, 'Would you just quit the other bands you're in, damnit. Are you in this or not?' And I did finally. I could see the potential. I could see that Jim was real special."

Krieger and Densmore added hinges to The Doors' sound
and a group dynamic began to happen. They soon ceased being
Morrison, Manzarek, Krieger, and Densmore and became The
Doors. Four minds acting as one. With each rehearsal the syn-
thesis grew stronger and they began to put their innermost selves
into the music. Jim committed his visions to music and Ray,
Robby, and John evolved the songs in endless woodshedding
sessions. Ray described these rehearsals to Jeff Tamarkin in
Goldmine: "The songs came together. Jim would chant-sing the
words again and again and the sound to go with them would
slowly emerge. We were all kindred souls—acidheads who were
looking for some other way to get high and stay there as long as
possible. We knew that if we continued the drugs we'd burn out
so we went for it in the music. And we found it there."

From the very beginning The Doors were dominated by the
vision of Jim Morrison. It was his lyrical flights they were expand-
ing upon. "He would sing the melodies a cappella," Densmore
recalled. "He would just sort of peck it out that way and we'd go,
'Well, let's see. A flat.' I'd say, 'Sounds like it's in three-four. Let's
try it in three-four.' We paid our dues growing up, individually,
and when we met, it was the right synthesis. So here's this guy
who has these words, but he also has melody ideas, just out of
nowhere, a cappella, off the top of his head, so that was special.
And then the fact that we hacked it all out together was special,
which made it a real democracy in honing down those songs.
Everybody had equal input and if anybody was dissatisfied about
anything, he said so. There was no paranoia about that, so the
songs got absolutely the best treatment they could get."

Once the band got together they practiced almost every day
in a garage behind the Santa Monica bus depot. Not too long after
the new band was formed though, Ray got a place on the beach
that was ideal for rehearsals. It was basically one long room and
the people in the neighboring apartments worked which enabled
the band to practice during the day. Ray's idea was to live there
with Dorothy, but he wanted the band to split the rent equally
since its primary purpose was for rehearsals. This triggered some
resentment among the other Doors, especially Jim, who by now
was starting to see the older Ray as a father figure. Nonetheless,
the place was ideal for creating music. Morrison later had this to
say about those days: "In the beginning we were creating our

music, ourselves, every night . . . starting with a few outlines, maybe a few words for a song. Sometimes we worked out in Venice, looking at the surf. We were together a lot and it was good times for all of us. Acid, sun, friends, the ocean, and poetry and music."

The music came together quickly. The new group was tight and sinewy from the start. Manzarek's haunting keyboards gave the band its identity and his passion for musical structure provided a firm foundation upon which they could improvise. Krieger's flamenco background provided a clarity and his fondness for unique tones made the guitar something to hone in on. Densmore's ability to accentuate with the drums underscored the intensity and added an authority. All of this set the stage for Morrison's poetic lyrics. His vocal credibility gave The Doors their guts, substance, and the very reason to be. A sound began to form. The hypnotic rushes of the organ, the pirouetting of the guitar, the dynamic charges and retreats of the drums. The strange and captivating lyrics.

Rehearsing for The Doors was different from that of most groups. Instead of practicing a song over and over until they learned it, they preferred to create a loose structure and then wait for the song to happen. "We'd have the basic structure of the song," Densmore remembers. "Then we go to a free part— we'd improvise musically—Jim improvised lyrically, then we'd get back to the basic form again."

While this free-form approach stimulated creativity, it also limited the type of material the early Doors could learn. They would work up only the kinds of songs that stimulated their talents and they were not about to compromise on material. Their attitude was that if the songs they liked led to club dates or other gigs, that would be great, but if they didn't, they weren't going to change them.

In the early days the band would rehearse with Morrison doing the vocals, but when a somewhat rare gig would come along Ray would handle most of the singing while Jim stood with his back to the audience, having yet to overcome his unease at performing for someone other than friends. It didn't matter much, though, because most of the people who saw them hated them anyway. They were too weird. But the hostile reaction by

the public never bothered the band. They just believed they weren't reaching the right people for their music.

Meanwhile the Columbia contract just gathered dust, but that didn't stop the band. In December The Doors began auditioning for various small clubs, but were always turned down for the same reason—no bass player. "We thought we needed one and we auditioned several," Densmore remembers. "Every time they played, though, we sounded like The Rolling Stones or some regular old blues/rock band. Then Ray discovered the Fender-Rhodes keyboard bass, which was mushy, but we thought, 'Yeah, this is different. We're different.'"

Manzarek described the day he first saw the piano bass to Alan D. Perna in *Modern Keyboard*: "I always felt we had to have somebody on the bottom, because I couldn't get it out of the Vox Continental that I was playing . . . We never found a bass guitarist we wanted to work with. The bass players invariably played too much. No bass player would want to play the way we wanted, which was very sparse and hypnotic. Then one day we were auditioning at some place—we didn't get the gig of course because we were too weird—but the house band there had an instrument called a Fender Rhodes piano bass sitting on top of a Vox Continental organ just like I had. I switched on the amplifier, played the thing, and realized it was a keyboard bass. When I saw that I said, 'This is it. We have found our bass player!'"

Traditionally, drummers like to have a strong bass line, but Densmore enjoyed the freedom the keyboard bass gave him: "There was more of a responsibility to hold the tempo down because it was just me and Ray's left hand, which could play only simple repetitive patterns. But there wasn't a big bass filling the sound, so I was free to mess around and answer Jim's words with accents. It was real freedom for me."

Keyboard bass or no, it was still extremely tough for The Doors to get a job. They auditioned for many clubs such as Bido Lito's on the far side of Sunset, but no one was interested. They were too strange. Even in 1965 there was such a thing as being too different and The Doors were it. Although all of band members were pretty hard up financially, they continued to work away at the beach house. They believed that something special was happening as the sound began to evolve into something more and more unique. They were functioning as a group more

each day, learning how to implement the controlled insanity that Jim Morrison was soon to set loose on the world of rock music.

Of course, dealing with the wild side of Morrison's nature was not always easy for the others. In fact many times things did not seem in control at all. He was capable of just about anything at any time and the more relaxed and free he became with the band, the more outrageous his behavior became as well. A good deal of Morrison's madness in those days was directly dependent upon whom he was with at the time. With someone like Ray, who knew how to keep control, Jim was more subdued than he would be with someone like Felix Venable, for example, who pushed him further out of bounds. It was during this early rehearsal period Morrison went off to Mexico with Felix and another college friend, Phillip O'leno. To this day no one is really sure what happened.

Carol Winters gives this account: "Felix and Jim called me up at 4 A.M. They were freaked out at the Fox Hills Golf Course and I snuck out of my parents house in my orange Mustang to get them. So they got back to Phil's house and got Phil's brother's car and the three of them took off for Mexico to meet the Indians and take peyote and mescaline.

"On the way down, Jim jumped out of the car at a stoplight, ran over to this girl walking down the sidewalk and kissed her, then got back in the car. No one will ever know exactly what happened when they all got down there, but I think they were beat up by a gang of Mexicans—not once but several times—because they came back all bruised. Felix and Jim came back alone and immediately told everyone they'd killed Phil and left him in a riverbed. But I knew it was a lie because Jim enjoyed telling it so much. Still it got back to Phil's father, who was an attorney, and he got the girl Jim kissed to press assault charges so Jim could be arrested and then he could get him to tell about Phil. And Jim was arrested and I had to go down there and bail him out. It all blew over, of course."

Supposedly, Jim and Felix had beaten up Phil because he wound up with a girl Morrison thought was his, but another version is that the three of them actually went to New Mexico where they were beaten up by the police. Whether they'd actually met the Indians, done peyote, and had the mystical adventure they were looking for is doubtful, but not impossible.

Whatever happened, Carol Winters maintains it was the end of Morrison's relationship with Phil. "He had some really bad argument with Jim. I don't know what it was, but Phil was always more serious about spiritual experiences and he finally called Jim an asshole and didn't want to have anything more to do with him. Jim didn't want to be a monk or a scholar, he wanted excitement. Well, he did for a while anyway because it was after he came back from that trip that The Doors began to happen."

> *Ensenada*
> *the dead seal*
> *the dog crucifix*
> *ghosts of the dead car sun.*
> *Stop the car.*
> *Rain. Night.*
> *Feel.*

No matter what craziness he got into with other friends, Morrison always came back to The Doors, showing up at rehearsal and trying his best to master becoming a singer. When the band wasn't rehearsing they were fantasizing about making it big. Often Jim and Ray would speculate on the future and what it might hold for The Doors. One day the two were walking on Venice Beach and had a conversation that went something like this:

JIM: How long do you want to live?
RAY: Oh, I'd like to go to about eighty-seven—get to see my grandchildren and great-grandchildren.
JIM: Not me. You know how I see myself? As a great shooting star, a huge fiery comet. Everyone stops and gasps and points up and says, "Oh, look! Oh, look at that!" Then whooosshh! I'm gone. But they'll never see anything like it again—and they'll never be able to forget me.

> *The West is the best*
> *Get here and we'll do the rest*

THE DOORS

In January 1966, The Doors auditioned for yet another Sunset Strip club. The now defunct London Fog was a beer bar located between the Hamburger Hamlet and the Galaxy on Sunset Boulevard just a few doors down from the Whisky. For audition night The Doors convinced their friends from the UCLA film school to pack the place out and applaud frantically after every number. The owner of the club, whose name was Jesse James, was amazed and hired them to be the regular house band on the spot. The next night, of course, the club was empty, but The Doors now had a steady gig.

The Fog was nonunion and the band was paid breadline wages, earning ten dollars each night from Thursday through Sunday. For this they played five sets per night from 9 P.M. to 2 A.M. Since they didn't have enough original material, over half of their repertoire at the London Fog consisted of reworked blues and rock 'n' roll standards, like "Gloria," "Louie, Louie," "Little

Red Rooster," "Money," "Who Do You Love," "Crawling King
Snake," and a couple of Chuck Berry tunes. John Densmore
recalls other ways the band would fill the time: "We had
this song where we just hit kind of a Latin groove and played
for fifteen minutes. That was 'Latin Bullshit #2' and then
we had 'Latin Bullshit #1,' which was a different lick of some
Latin feel, a samba or something, and we'd drag that one out
too."

The club was a virtual closet, a sleazy bar that attracted dere-
licts and strange people. "Nobody ever came in the place," Ray
Manzarek remembers. "Maybe an occasional businessman, a
sailor or two on leave, a prostitute, a few drunks. They had a go-
go dancer, lovely Rhonda Lane, dancing in a cage to our songs
which was ridiculous . . . it was a very depressing experience,
but it gave us time to really get the music together."

The group was using Sears Silvertone amps and Morrison
was still shy, even fearful onstage. As he did in rehearsals, Jim
almost always sang with his back to the crowd, choosing to inter-
act with the band rather than the audience. Of course there
wasn't much of an audience to interact with anyway. Mostly it
was just the occasional UCLA fans. But as time progressed a cross
section of others began to appear at the club, wanderers coming
in from the night on the Strip. The club's manager decided the
band was helping and asked them play two more nights a week—
at five dollars each per night. A long time veteran of bar wars,
Densmore was offended: "I refused because, hey, I was a musi-
cian, a working professional; but Jim wanted to do it and so we
did. In the back of my mind, I knew it was invaluable honing of
the material."

Under the steady grind of this six-nights-a-week job Mor-
rison began to change. He directed some of his energy outward
toward the audience and then began getting the hang of it. Soon
he started to love it. With each new night he became more self-
expressive. Ray remembers: "Most of the time, there was no one
in the club anyway. We could do anything. And we had the
chance to develop songs like 'Light My Fire,' 'When the Music's
Over,' and 'The End.' 'The End' was originally a very short love
song, but because of all the time we had to fill onstage, we
started extending songs, taking them into areas that we didn't
know they would go into . . . and playing stoned every night. It

was a great time for acid, and we really got into a lot of improvisation, and I think the fact that no one was at that club really helped us to develop what The Doors became."

It was while playing at the London Fog, during one of his first real performances, that Morrison met and captivated Pamela Susan Courson. How fitting that the predominant relationship of Morrison's life would begin simultaneously with his entry into the public spotlight. There may have been little public and even less spotlight at the dingy club on Sunset Strip, but meeting Pam must have made it special. Her long reddish-golden hair, blue-green eyes, and Snow White complexion attracted Jim and he was strongly drawn to her. She was very sweet, very pretty, very California. And she was on a par with Morrison intellectually, and even sexually. They were both physically attractive and very bright. Neither was the athletic type, preferring the sanctity of the indoors and the cover of the night.

Pam had been born near Weed, California, at the foot of Mount Shasta, an area Morrison knew the Indians considered holy ground. When they met, she was nineteen and studying art at Los Angeles City College. Morrison's relationships with females had always been bizarre and he was a bit gun-shy at first. His feelings for women were a mixture of love and hate—he would be an utmost gentleman one day and a cruel persecutor the next. But, unlike the girls who had come before, Pam could hold her own with Jim. He had finally found someone who would not only take his best dares, but challenge him to go one better. She was shy sometimes, but fearless others, and there was a fire in her eyes and in her personality which often flared up. Pam was demanding, but in many ways she was a person who appeared much weaker than she really was. A princess in distress on the outside, an independent queen on the inside.

Mirandi Babitz was a close friend of Pam's and had met her at L.A. City College, where neither of them stayed very long. "We were both long-haired little girls out to have fun," Babitz remembers. "She was going with Jimmy and I was going with a guy in another band. For a while John Densmore played with both bands and they all shared one set of equipment. We trucked it back and forth up and down the Strip. I was kind of a big sister to Pam because I'd been raised in Hollywood and she was raised in

Orange County. Her folks were really square, very Orange Countyish, and mine were more Bohemian."

Jim and Pam soon found they had a lot in common—they began spending a great deal of time together. She turned up often at the club and just as often he would accompany her home. He was starving and she wasn't much better off, but she believed in his talent. She was convinced he was a great poet and continually encouraged him and pushed him to write. When Morrison got his first check from the club, which was for something like seventeen dollars, Pam was so excited that they went out to dinner to celebrate. Anyone watching them that night would have thought they had hit the big time.

The Whisky a Go Go

At this point The Doors could still have sunk into small-time oblivion. They had been unable to crack the barrier into any of the more important clubs on the Strip. After four auditions at Bido Lito's they were turned down and managed only an occasional off-night gig at the Brave New World or Sneeky Pete's. In between their sets at the Fog they would go over to the Whisky a Go Go to peek in the doorway. The Whisky was the premier club on the Strip, drawing such name acts as The Young Rascals, The Turtles, and The Seeds. John Densmore remembers: "We'd see Love playing or The Byrds, and I'd be drooling, thinking, 'Why am I in this band? I can play better than that drummer. I can be in that band.'"

Whenever he'd stop by the Whisky, Morrison would seek out Ronnie Haran who booked the club and try to get her to come see them play at the Fog. She was always too busy, but Jim was slowly winning her over. In the meantime, nothing was happening with the Columbia deal. After months of waiting, the group finally lost hope and asked to be released from the contract. Billy James describes it: "The deal we signed was for five and a half years with the half year being the initial term during which Columbia was obligated to produce and release a single from the band. We wrote that in the contract because I didn't want them to just languish on the label and have nothing happen for a long time. At the end of five months John Densmore finally

called and asked if they could be released from their contract. I said, 'Okay. There's obviously nothing happening here.' An A&R administrator prepared a release for them and Columbia officially lost The Doors."

Although The Doors had requested their release, the truth was their days at Columbia were numbered. While at the label offices one day, Densmore had accidentally seen a Columbia drop sheet that listed a dozen new groups the label was picking up and a dozen they were dropping. The Doors were number seven.

Naturally, the group was depressed. Being able to say they had a recording contract with Columbia had always been a source of encouragement for the band. Once they finally admitted it was a dead-end street, part of the dream seemed to fade. Onstage, night after night at the London Fog, however, something even more important to the band's future was happening. Jim Morrison was finding himself as a performer and beginning to experiment with his power over audiences.

"The Doors weren't very good then," Mirandi Babitz recalls. "The other bands didn't think a whole lot of them. Jimmy's antics were considered extreme even then. Nobody quite understood what he was up to or why he had to be so brazen at times. I know that he hated to sing. He didn't think he was any good and didn't like performing. There was always a part of him that was self-critical and questioning. As though he felt he was being a sham. It wasn't so much that he would rather do something else. It was as if he was very unhappy inside. It made him so nervous he had to get totally looped. He would smoke dope all day, drink at night, and then drop speed when he needed it. And he really loved acid and could get very far-out on it. I used to wonder what was holding him up."

As usual with Morrison, he sought his answers in rebellion and recklessness and the onstage persona that began to form set him apart from the hundreds of other lead singers in Los Angeles in 1966. His increasingly flamboyant presence started to scare people and the band began to both attract and repel. Their music was ardently defended by a growing segment of the Strip population and utterly condemned by others. Richard Blackburn describes seeing The Doors at the London Fog: "The club was a narrow, smoky, dirty bar frequented by a cliental that ranged from bikers to gays. Jim used to get up and pop amyl nitrates

right onstage and then collapse over the piano, cutting off his own improvised lyrics. I often saw him outside, crazed on acid, bumping into telephone poles."

Morrison's rebellious side was showing itself offstage as well. The resentment he felt toward Ray over the beach house finally boiled over when he and Robby brought a couple of hookers from the club over around dawn one night after a gig and let themselves in. High on acid, Jim began taking Ray's favorite records out of their jackets and sailing them like Frisbees across the large rehearsal room until Manzarek came out of his bedroom and asked him to cool it. Begrudgingly, Morrison left. Ever since living with Ray and Dorothy the year before, Jim had seen Manzarek as some sort of a father figure and it was time to show him that he could rebel.

Morrison's interest in shamanism and other related subcultures was increasing and Michael Ford remembers what must have been a pivotal experience for Jim in this area: "He wanted to meet with Carlos Castaneda. I think it was a matter of further investigation on Jim's part. I arranged a meeting for him with a woman in the Latin American studies department at UCLA because I knew she could get him to Castaneda. I don't know exactly what happened when he met Castaneda, but I know it was certainly full of revelation for Jim. It fulfilled part of his search somehow."

After four months, the London Fog showed The Doors the door. There was a fight in the bar and they were blamed for it. But the defeat turned into a victory because moments after they had been given their notice Ronnie Haran finally showed up to see the band play and offered them a job at the Whisky. Much to the surprise of the other band members, Morrison suddenly decided to play it cool and told Haran to come back the next night because they "would have to think about her offer." When Haran left, Jim told the others that he "didn't want to appear too easy." The next night, their last at the Fog, Haran returned and The Doors accepted her offer.

Haran had talked the Whisky into hiring The Doors as their new house band without an audition. She may have steered the group only fifty yards down the street, but it was light-years away in prestige. "I knew Jim had star quality the minute I saw him," she recalls. "I had a hard time getting hold of him, though, be-

cause in those days he was living on the beach and no one knew quite where (he was sleeping under the boardwalk in Venice). He didn't have a pot to piss in. I had to dress him, get him some T-shirts and turtle necks at the Army-Navy store—the leathers didn't come until several months later. They'd been playing at the Fog for a hundred dollars a week—twenty-five dollars a man—only because they could eat there for free."

Haran not only got Morrison some new clothes (suggesting he stop wearing underwear in keeping with the freedom of the sixties), she also helped get the band into the musicians' union and even let Jim stay at her apartment up the road from the Whisky for a while. Since the Whisky was a union club The Doors went from $5 or $10 a night each to $135 per man. They must have felt as though they'd arrived.

It was at the Whisky that Morrison began to perfect the image he was creating. As his confidence increased, his dramatic flair blossomed and he began to experiment with words and styles, frequently taking off on long and increasingly strange improvisational flights. Bolstered by ever-increasing quantities of alcohol and hallucinogens, he took his best poems, the ones he felt had been virtually dictated to him on the Venice rooftop, and began to work them up with the band. The result was the perfection of The Doors' epic masterpieces, "The End" and "When the Music's Over." There are several stories about how "The End" originated. One is that, high on acid, Morrison sat for four hours in front of a soundless television set watching violent images and then wrote the original lyrics. Another is that it started out as a simple love song and then evolved into something more bizarre each time it was performed in public. Most likely, the original words to the song were written on the roof in Venice along with the lyrics from most of the first two Doors albums and it grew as an improvisational piece.

As the group's reputation began to grow, they performed at all the big clubs and the people of the Strip realized this band wasn't going away. They dressed more like a road gang than a rock band and their performances often degenerated into pandemonium, but their singer was more than just a weird dude who went crazy onstage. There was something deadly and threatening about him, yes, but also something very real. Morrison's psychological approach to lyrics and X-rated floor show was be-

coming the talk of the Strip. He learned early that while vulgarity seemed to horrify the audience, they always came back to hear more. He improvised crude passages to several non-Doors songs as well, including "Gloria" ("Little girl, how old are you? Little girl what school do you go to? Little girl suck my . . .").

The crowd on the Strip was often abuzz with weekly tales of The Doors' freaked-out adventures: "Morrison was so stoned last night he fell off the stage *again* . . . Ray sniffed an amyl nitrate cap and played so long he had to be *dragged* away from the organ . . . They all arrived stoned and started improvising . . . I don't know what it was, but it was great." Those who were there say that Morrison was so consistently high on LSD that he could eat acid-coated sugar cubes all night without visible effect. And somehow, despite this madness, the band grew tighter, they began to think alike onstage and the music kept getting better.

Elmer Valentine, the owner of the Whisky at the time, admitted that he didn't like The Doors at first. "He was kinda ahead of his time on certain things—like swearing," he said. "But those calls kept coming in. 'When's that horny motherfucker comin' in?' The phones were incredible. We never got that many calls before for just a second group."

The men don't know
But the little girls understand

The big-time world of rock passed through the Whisky and it began to take notice of one James Douglas Morrison. Ray remembers those days: "We played with Them, and Van Morrison and Jim Morrison jammed and sang together onstage. Then we played with Love, and Frank Zappa's Mothers of Invention and The Buffalo Springfield and The Byrds. They were incredible times . . . absolutely magical."

The Strip was an exciting place to be and every weekend more and more people began flocking to it—swarms of kids and young adults who came to see and be seen. Many were too young to get into the clubs but that didn't matter—there were more people on the streets than in the clubs anyway. A tremendous energy was happening and The Doors were evolving in the midst of it. Of course the person getting the most attention was Morrison. The audience wanted to know who this person was,

dressed in jeans and a T-shirt, who tu'
twenty minutes at a time and pounded a v
was this swimming to the moon and soul kit
came to see Love or The Buffalo Springfield, bu
singing "Light My Fire" or getting stoned reliving

A *Los Angeles Times* review at the time read: "1
a hungry-looking quartet with an interesting original s
with what is possibly the worst stage appearance of any
roll group in captivity. Their lead singer emotes with his
closed, the electric pianist hunches over his instrument as if re.
ing mysteries from the keyboard, the guitarist drifts about the
stage randomly and the drummer seems lost in a separate world."
With a review like that, you just had to go see them.

When Morrison was onstage the crowd hung on his every
word. He was moving back and forth now, dragging the mike
with its cord trailing out behind him, a reminder of the tradi-
tional blues black snake and a foreshadowing of the reptilian as-
sociation soon to come. He whimpered, groaned, shouted, and
crooned, often caressing the microphone with suggestive move-
ments. It was body poetry and it was drama.

"I just remember that some of the best musical trips we took
were in clubs," Morrison said later. "There's nothing more fun
than to play music to an audience. You can improvise at re-
hearsals, but it's kind of a dead atmosphere. There's no audience
feedback. There's no tension, really, because in a club with a
small audience you're free to do anything. You still feel an obliga-
tion to be good, so you can't get completely loose; there are
people watching. So there is this beautiful tension. There's free-
dom and at the same time an obligation to play well. I can put in
a full day's work, go home and take a shower, change clothes,
then play two or three sets at the Whisky, man, and I love it. The
way an athlete loves to run, to keep in shape."

More than even Morrison's increasing mastery of the stage it
was the development of the band's material at this time that pre-
destined their stardom. Usually the songs began with Morrison
bringing some lyrics to rehearsal. Sometimes he would have the
whole song worked out in his head, but often he just had a rough
idea of the melody. The band would develop a chordal structure
and build on Morrison's basic idea. But it was in live performance
that the songs were honed and polished. Morrison described it

ay: "Our most interesting songs develop over a period of
, playing night after night in clubs. We'll start out with a
sic song and then the music settles into a hypnotic river of
und. That leaves me free to make up anything that comes into
my head at the time. It's the part of the performance I enjoy the
most. I pick up vibrations from the music and what's coming
from the audience and then I follow it wherever it goes. Music
puts me into that state of mind with its hypnotic qualities. Then
I'm free to let my subconscious play it out wherever it goes. The
music gives me a kind of security and makes it a lot easier to
express myself."

John Densmore remembers: "We'd start playing, some words
would come out, and I'd remember the best ones and tell him
later. The next night, he'd use those words and the melody in a
different way. Eventually, it would evolve into a song."

Although he had developed as a writer, Morrison still clung
to his belief that "the best songs come unasked for. You don't
have to think about them." Perhaps another reference to the Ven-
ice period was that he also felt he wrote his best in the summer:
"Summer is a good time for songs. When it's real warm, if you
have a sense of freedom, not a lot on your mind, and a feeling
that there's plenty of time, it just seems to be a good climate for
music."

There is little doubt that the summer of 1966 proved to be a
productive one for The Doors. Once Morrison was able to com-
bine his lyrics with the music, the concert that he had heard in
his head on that Venice rooftop began to become a reality. Al-
though they were fired and rehired by Elmer Valentine prac-
tically every week, either because they were playing too loud
(according to Densmore the general idea was "to blow the head-
liners off the stage") or because Jim turned up drunk and stoned,
or simply didn't show up at all, the band had now developed a
large and loyal following.

"There were a lot of crazy stories about Jimmy even then,"
Mirandi Babitz remembers. "One time The Doors were late for
the Whisky and as they came through the door Elmer was really
ragging on Jimmy and Jimmy just grabbed him on both sides of
his head and planted this big kiss right on his mouth and walked
right by."

They made a powerful impression on the "so cool" crowds

that frequented the Sunset Strip clubs. Morrison had the innocent face and cascading locks of "a Renaissance angel fresh from a Raphael painting" but the hymns he sang focused on destruction, decay, and death—apocalypse, Los Angeles style. The L.A. bar scene thought it had seen it all, but here was something truly different. Morrison conveyed an element of danger and violence bubbling just under a surface of beauty and innocence. When would it erupt? This was the beginnings of rock theater and the ultrahip patrons of clubs like the Whisky began to cheer on these hometown boys. They knew that one of their own was on the verge of making it.

As a result of such commotion, the record labels began to check out The Doors but most felt the band was far too strange for them to seriously consider signing. Ronnie Haran, however, would not give up and managed to get Jac Holzman, the president of Elektra Records, to see them. She recalls that Holzman initially thought they were "terrible," but saw the crowd reaction and kept coming back. Holzman agrees. "I didn't like them at first. But I was drawn back. I went four straight nights, then spoke to them and said I wanted to record them."

Reportedly what convinced Holzman was "Alabama Song" because he knew it was from a German opera of the late 1920s and showed the group had depth and intelligence. But, before Elektra would make an offer, they wanted to hear what Paul Rothchild thought of the band. Rothchild, the senior staff producer for Elektra, had produced albums by The Butterfield Blues Band, Love, and Koerner, Ray and Glover. He describes that first night he saw The Doors at the Whisky: "I was living on the East Coast and I got a call from Jac Holzman telling me I should check out this band called The Doors. Jac's wife, Nina, also loved them . . . So I flew out and met Jac and Nina and we saw the group's first set. I thought to myself, 'My God, Jac and Nina have lost their minds. These guys suck!' I caught a horrible show. At the same time they were awful, I could tell they were very different from anything I'd heard before. I had nothing to relate them to. This intrigued me, so I decided to stay for the second set. The second set was brilliant. I had religion. In that second set I heard 'The End,' 'Light My Fire,' 'Twentieth Century Fox,' 'Break on Through,' and a few others, and I was *convinced.*"

Soon others became interested in the group. Lee LaSeff's

White Whale who had The Turtles and a new label producer
Terry Melcher (The Byrds) was starting to make inquiries and
Frank Zappa was also interested in producing the band. One
might have thought that this would've had the effect of calming
Morrison down, making him take life a little less recklessly, but it
seems to have had the reverse effect, according to Ronnie Haran
describing how she and Jim parted ways: "He was getting crazy,
taking acid every day. He was obsessed with death, never did
anything in moderation—a consumptive personality. When we
parted, he said, 'I'm gonna be dead in two years.'"

Richard Blackburn describes how Morrison handled the
pressure of a potential recording deal with Elektra: "It was at a
party during that threshold of success time that I asked Jim about
the record contract. What was the news? Was it going through?
And he, in a drug haze, had looked over at me and for an instant
the haze was gone and with a real tiredness as if even then he
saw where it was all going to lead, said, 'It'll happen, man.' I
waited for some elaboration, but he had already unplugged from
the immediate."

Most of Morrison's acquaintances at the time agree that Jim
knew he was going to make it, knew he had something in him
that was going to make him famous. Carol Winters says the main
ingredient was pure sex appeal: "Sure he was talented. Maybe a
genius. But if it wasn't for the sex appeal he would have never
have got where he did. I think he knew it and everybody else did
too."

Shortly thereafter, Elektra Records offered The Doors a re-
cording contract. After their bad experience with Columbia the
band was somewhat hesitant to sign and sought out advice from
one of the few people in the music business that they trusted—
Billy James, the Columbia A&R man who had first believed in
them. James remembers: "I had brought The Mothers of Inven-
tion to Columbia and they didn't sign them. I'd brought them
The Jefferson Airplane—same thing. Lenny Bruce—same thing. I
was getting frustrated there when one day Jac Holzman called to
ask if I'd head up the label's new West Coast offices. About three
weeks before I left Columbia, and before I told anyone there
about my decision to leave, I got a call from Ray Manzarek saying
he wanted to meet with me at my house. That night he showed
me the contract that Elektra had offered The Doors. I told him I

didn't want to comment on the contract because, as I explained in confidence, I was about to go to Elektra myself. We'd had a good relationship and Ray liked that I would be at Elektra too if the group signed with them."

Jac Holzman had offered The Doors a basic deal, guaranteeing them three albums, but The Doors didn't jump at it. "To be honest, we were pretty shrewd, businesswise," John Densmore remembers: "We didn't know a lot about business, but we were cautious. We wouldn't just sign stuff. Robby came from sort of a semiwealthy family and his dad kind of oversaw us and that was helpful. Record companies started coming in and everybody knew 'Light My Fire' was a hit, but nobody knew how to do it. Sonny and Cher's manager wanted seventy-five percent of the publishing, which is immoral, so we thought, 'No, no.' Jac Holzman was really the only one who made a good offer, five thousand dollars and five percent so we could get equipment. So we did it."

Meanwhile, Jim Morrison was becoming more outrageous with each new performance. The band was finally starting to make it and Morrison's behavior—the same outlandish behavior that had gotten them attention in the first place—was threatening to blow it all away. As usual, he was failing to draw the line between life and art, business and pleasure, self-instruction and self-destruction. Ray recalls the night it all came to a head: "We signed with Elektra on Wednesday and Friday night Jim didn't show up at the Whisky. By nine-thirty, still no Jim Morrison, so we went ahead and took the stage without him and played some blues. We leave the stage and one of the owners, Phil Tanzini, grabs me and said, 'I've got a contract for four performers and you better get that Morrison.' So John and I left to find him."

John and Ray raced over to the Alta-Cienega Motel where Morrison was staying. On the way Densmore complained to Ray about Jim's drug taking and his resultant erratic behavior. With true sixties tolerance, Ray reminded Densmore that he had once been a drug taker. John replied that he never took acid more than once a week and Jim was dropping it at least every other day. When they arrived at the motel they knocked on the door, but there was no answer. Hearing some movement in the room, they knocked again and pleaded with Jim to open the door. Finally the door opened and a bedraggled Morrison wearing only

his shorts and boots stared out. He muttered three words of explanation. "Ten thousand mikes." They knew what he meant, but they could hardly believe it—a normal dose of acid was closer to four hundred micrograms. Morrison insisted that he couldn't go onstage that night. True to form, Ray convinced Jim by reminding him that it could be one of his greatest shows. "He was blitzed on acid, but I told him, 'Let's give Tanzini something to remember.' John and I had to help Jim get dressed. He was struggling, trying to put his pants on over his boots, so we had to take his boots off first and then pull his pants on. Finally we got him into the car and all the way back to the club he was like a generator, a dynamo in the backseat—buzzing and humming."

Back at the club, Morrison was totally out of it for a while, but then something happened. He told the others he felt like doing "The End." Whether he was down enough off the acid to regain control or whether he was so high that he completely lost control is debatable, but that night Jim Morrison made a breakthrough into the realms he had pursued ever since he had been a child. He took the faded love song he had written and improvised on it, adding the apocalyptic/Oedipal part that sealed his special fame and perhaps his ultimate fate. Maybe Morrison's Dionysian genius was stronger than even the strongest dose of acid. Or perhaps "riding the snake" as he liked to call weathering an LSD overdose had finally taken him into that spiritual netherworld of the shaman he had longed to become. The only problem was no one ever told him how to get back.

Later Morrison said: "Something clicked. I realized what the whole song was about, what it had been leading up to." Manzarek recalls the performance: "It sent a chill, a shiver, through the entire place and it froze the Whisky a Go Go. He was taking us on this psychic journey. The club stopped little by little. The dancers stopped, the waitresses stopped serving drinks. Jim was so hypnotic that night. When he came to the section 'Mother, I want to . . .' he screamed out the forbidden F-word. It shocked the entire audience. And John and Robby and I just poured it on. The whole place went crazy. At the end of the song we left the stage to a thunderous ovation. Then Phil Tanzini comes running up and says, 'You filthy foul-mouthed Morrison! You guys are fired. Don't you ever come back to this club. Nobody has a right to say that about their mother. You don't ever say that about your fa-

ther. You're fired!' Well, that concluded our engagement at the Whisky."

Whether or not Morrison had already written the Oedipal section of "The End" is not known, but this was the first time The Doors performed it. Densmore remembers: "As far as the Oedipal section . . . we had never even heard of it before that night. We're just playing along and all of a sudden, he's killing his father and screwing his mother. Elmer's old partner, Phil Tanzini, thought he was crazy."

Now without a steady gig the band tried to get booked at Gazzarri's. Bill Gazzarri recalls when Morrison approached him about playing at his club: "He kept asking if they could come in and play. I said, 'Jim, you gotta wear shoes to come in here. I mean, it's a must.' Anyway, he hit me up a couple of days later. Same routine. 'We wanna audition,' Jim said. I looked at him. 'You remember what I told you?' He nodded, so I leaned over the counter. He had his foot in there and had one shoe on. I walked around the counter and saw that he didn't have a shoe on the other foot. I said, 'What did you do, lose a shoe?' Jim answered, 'No, I found one, so I could get in.' "

Shortly after, the band began playing the club on a regular basis. On one of their first nights the place was virtually empty except for Pamela and a friend. Most of the band was let down by this, but not Morrison. He launched into "When the Music's Over" and cut loose even more than usual, gyrating, screaming, and throwing his mike stand down on the stage. When the song was over and The Doors took a break, Pamela asked him why he did it. Morrison replied, "You never know when you're giving your last performance."

The Doors had gotten fired from the London Fog and wound up at the Whisky. Morrison had dropped too much acid and improvised "The End." They had been canned from the top club on the Strip, but not before signing a record deal. Though he was already planting the seeds that would cause him to slowly lose control of his life, Jim Morrison must have felt he was doing something right.

The Making of the First Album

Jac Holzman had started Elektra Records when he was still in college. In eighteen years the New York–based company had

gone from little more than a tape recorder and a microphone strapped onto the back of Holzman's motor scooter to a well-known folk label expanding into the burgeoning rock scene. Holzman had signed both Paul Butterfield and Love and now wanted The Doors to enlarge his interest in the electric politics he saw building on the Coast. He had great foresight, for many other record executives were blind to this movement in 1966—the same executives who would descend upon the California rock scene like ravenous buzzards the following year hoping to scrape up whatever was left. When Rothchild's opinion confirmed his own, Holzman decided this exhibitionistic debauch called The Doors was just what he needed. If it didn't sell records it would at least establish Elektra as among the forefront of the new rock on the basis of daring alone.

Sunset Sound Recording Studios was located at 6650 West Sunset Boulevard in Los Angeles. Like most recording studios, it was an inconspicuous concrete building on the outside. How strange that what happens in these plain, drab little buildings sparks such lavish life-styles and technicolor performances. Sunset was known at the time for its ability to duplicate a "live" feel, and Rothchild, having seen The Doors at the Whisky, decided this was the sound he wanted. In early September 1966, just after the Labor Day weekend, The Doors and Rothchild began the sessions. The Doors were ready to record. They'd anticipated this moment for nearly an entire year and now it was happening.

Ray Manzarek recalled the moment to John Tobler in an interview. "It was four incredibly hungry young men, striving and dying to make it, desperately wanting to get a record, a good record, out to the American public and wanting the public to like the record . . . it was a dream come true for us. Getting the songs down, having a record contract. Being at Sunset Studios."

Robby recalls how The Doors felt during those first sessions: "The first night we were afraid to play too loud. With all that expensive equipment in there we were afraid that we'd blow it out."

Rothchild was just the kind of producer the band needed. He was intelligent, well-read, and understood poetry, jazz, and rock 'n' roll. While a very strong presence in the studio, Rothchild knew how to give the band room when they needed it. He was smart enough not to try and dictate to them. Instead, he

would make "suggestions" and ask the band what they thought of them. Since The Doors were by nature open-minded artistic types, they were willing to listen for the good of the project. And most of the time they agreed Rothchild was right.

As a producer, Rothchild wisely concentrated on capturing The Doors' sound without a lot of effects. "Things were wonderful in the sixties because it was an era of intense experimentation," he says. "Everyone was trying to outhip each other. With The Doors we tried to strike a very fine line between being very fresh and original and being documentary—making the record sound like it really happened live, which it did, for the most part. I personally always try to focus on longevity and honesty. We stayed away from trendy clichés, including the use of popular devices of the time like wa-wa pedals. I asked them if they wanted to be remembered in twenty years and they said yes. 'Well,' I said, 'we can't use any tricks. We have to stay honest and it's got to be pure. We would do advanced and avant-garde things, but they couldn't be trendy.'"

Without a great engineer all the producer's efforts would be wasted. It is the engineer's job to get the most out of the equipment. He turns the band's talents and the producer's concepts into reality. He gets it on tape. When he met The Doors, Bruce Botnick had been an engineer for five years, having worked with Love and Buffalo Springfield. "They walked into the studio. I'd never seen them before in my life. They were just a local bar band. I was impressed with them but it wasn't like 'Oh my God, this is going to be the heaviest band in the world,' because you just didn't think about that. It was my music also, my genre, they were all my age, we were all growing together. It felt real natural."

Botnick remembers that Rothchild put in considerable time before the sessions: "Paul sat in on the rehearsals like any good producer does, and clarified things for recording. He, of course, had problems with dramatic license, having to deal with profanity, which in those days had to be kept out of a record. Paul had a lot of work to deal with Jim at that time, it was tough, real tough work for him, but he hung in there and did it."

"The essential function of the producer is to draw from the creative musician the maximum of his capabilities," Rothchild

says, "to bring out whatever expression he is trying to show in the music. Whatever his theater is, I try to help him stage that."

For The Doors the studio was a new medium. Not only did they have to contend with recording techniques that were unfamiliar to them, but they had to get used to performing in a different environment as well. If the record was to be all they hoped it would be, they would have to give their best without depending on that rush of energy they were used to getting from the crowd. Much of this gap was bridged by Paul Rothchild: "A rock group needs to have an audience to react against," he told Paul Williams in *Crawdaddy.* "In the recording studio the producer has got to fulfill those functions. What we did to break the recording cherry of The Doors, so to speak, was to go into the studio with the band feeling that they were going in for a session. I realized we'd probably blow a day or so but we went in to cut masters, not screw around. We cut two tunes (including 'Moonlight Drive'), neither of which showed up on our first album; we didn't stop at a perfect take, we stopped at one we felt had the muse in it. That was the most important thing, for the take to have the feel, even if there were musical errors. When the muse came into the studio to visit us, that was the take."

According to Rothchild the entire album was done on a four-track recorder, and for the most part, they only used three of those. He recorded bass and drums on one track, guitar and organ on another, and Morrison's vocals on the third, leaving the fourth track open for a few extras. Rothchild brought in an uncredited bass player named Larry Knechtel because he felt Ray's piano-bass sound lacked definition. Rothchild wasn't afraid to give Morrison any ideas, but he felt little was needed. Jim was completely in control, on top of everything he did. Rothchild remembers: "I'd met musicians who were fine people, but Jim was the first I'd met since Michael Bloomfield, who was a stunning intellect. He was well-read and sensitive to things around him and within himself. He was unafraid to reveal himself, to put the vulnerable side of him onstage. He was exposing his soul and that was bravery to the extreme in those days when everybody was posturing."

Rothchild overdubbed Morrison singing harmony to himself on a couple of songs. At that time double voicing was very avantgarde and it accounts for part of the eeriness of the vocal sound

on the first album. The producer tried some other unusual techniques as well, like having the whole band march on a wooden platform on "Twentieth Century Fox" to add to the rhythm sound on the chorus.

In 1966, Sunset Sound had one of the greatest echo chambers in the world. It was essentially a small floating room (a room inside a room) constructed of superhard surfaces. To add echo to an instrument, the sound would be piped through a speaker in the echo chamber and rerecorded so that it would pick up the reverberation of the chamber. Just listen to the snap of the snare in "Light My Fire." Bruce Botnick describes another aspect of the studio that The Doors used in the recording of their first album: "Sunset Sound had the first isolation booth in a recording studio. So we put Jim in the isolation booth, which was ten feet from the rest of the band, with windows so they could interact. But we'd have a hundred percent isolation between the vocal and the music which was great. That's one of the reasons those records sound as good as they do, because there was no leakage on the vocals, but good leakage between instruments, which gives a good live feel."

Botnick remembers Morrison as a natural, spontaneous singer. "He never considered himself a singer," he said to David Gotz in *Record Review.* "Although near the end he started to think of himself in light of Frank Sinatra, because he liked the way Sinatra used to phrase. He was a big student of singers, he used to listen to Elvis's phrasing, but I think his biggest influence was Sinatra. But he sang from his heart, it wasn't premeditated. He was among the first group of singer-songwriters where his singing was a way to present his words. He never studied singing, he just sang. He had good pipes."

Many bands struggle with disagreement in the studio. The Doors on their first album seemed to have a real unity of purpose. According to Rothchild, he and the band set one goal: Every song had to be perfect in that it took you on an aural, visual, and psychological journey. From a strictly musical standpoint, the material was exceptionally good. The group chose the songs carefully. All of them were originals except for "Back Door Man" and Brecht/Weill's "Alabama Song." Robby had heard John Hammond, Jr., do "Back Door Man" and Ray had a record of Brecht/Weill songs that he played for the group. Paul Rothchild

believes the inclusion of "Alabama Song" was intellectually significant for The Doors: "Both Ray and Jim were admirers of Brecht and Weill," he told Vic Garbarini in an interview: "I suppose they were saying in the thirties what Jim was trying to get across in the sixties . . . in different ways they were both trying to declare a reality to their generation. The inclusion of "Alabama Song" was a sort of a Doors tribute to other brave men in another brave time, even though the lyric is remarkably contemporary. There is another verse that The Doors didn't sing because it was out of context for them. The missing verse is 'Show us the way to the next little dollar/Oh don't ask why,' and that wasn't quite what they had in mind."

Most of The Doors' originals were recorded the way they'd performed them night after night on the Strip. What they had evolved over the course of a year was now being captured on tape. While recording "End of the Night," however, Morrison decided at the last minute to change one of the lines. He had always performed it as "take a trip to the end of the night," but in the studio he decided the word "trip" had been overused so he changed it to "highway."

Everyone involved with the recording felt there were many special moments where things just came together in an almost magical way. This feeling was particularly prevalent during the recording of two songs, "Light My Fire" and "The End." "Light My Fire" was primarily written by Robby Krieger, but like most Doors songs, everyone participated in its development. Manzarek remembers the day Krieger brought the song in: "We had a rehearsal room/beach house where Dorothy and I lived with a thirty-foot glass living room window. Robby came in and started to play the song. John gave it that Latinesque rhythm behind the verse and we went into a straight rock feel for the chorus. For the solo we decided to do a repeating pattern and play solos on top of it. Then I said, 'How do we start it? Let me see if I can come up with some kind of introduction. Everybody leave the room for fifteen minutes and let me think about this.' So everybody walked out the door that led right on to the beach. And I kind of noodled around and my fingers just fell right into place. It came out like magic. And then Jim said, 'Well, we need a second verse here and we don't have anything and I've got something . . . Our love becomes a funeral pyre.' That verse. And so it went, little by little, the song began to develop."

It was the first song Robby ever wrote. He had decided to write a song about one of the four basic elements—earth, air, fire, and water. He chose fire partly because he had always liked The Stones' song "Play with Fire." He describes the writing of The Doors' signature tune: "I never even thought about writing till one day Ray said, 'Hey, you guys, we need some songs! Everybody go home and write some songs.' So I went home and wrote 'Light My Fire' and 'Love Me Two Times.' Those are the first two songs I ever wrote. They took about an hour or so."

Manzarek compared the spiritual atmosphere of the sessions to a "séance in which we tried to communicate with the basic forces of existence and the basic power of the act of creating music. That was what we attempted to capture and communicate to the listener."

This spiritual quality was especially evident in the recording of "The End." Although the song would eventually come off as unique and exciting in the studio as it was live, the first time The Doors tried to record it, Morrison was high on acid and booze, and after numerous tries they had to give it up for the night. Rothchild describes that night for *Crawdaddy:* "We tried and we couldn't get it. Jim couldn't do it. He wanted desperately to do it. His entire being was screaming, 'Kill the father, Fuck the mother!' He was very emotionally moved. At one point he had tears in his eyes during the session and he shouted in the studio, 'Does anybody understand me?' And I said, 'Yes, I do,' and right then and there we got into a long discussion about this section of the song. But it wasn't working. I have tried several times to record artists on acid and it doesn't work."

Music inflames temperament

The next day was different, however. Due to the complexity of the song a good part of the day was spent setting up, but once the tape began rolling the performance was what Paul Rothchild later called "the most awe-inspiring thing I'd ever witnessed in a studio." For the recording, the studio had been completely darkened except for a single candle burning next to Morrison and the lights on the v.u. meters in the control room. Rothchild describes the recording: "I was totally overwhelmed. Normally, the producer sits there just listening for all the things that are right and anything about to go wrong, but for this take I was completely

sucked up into it, absolutely an audience. We were about six
minutes into it when I turned to Bruce Botnick and said, 'Do you
understand what's happening here? This is one of the most im-
portant moments in recorded rock 'n' roll.' It was a magic mo-
ment. Jim was doing 'The End,' doing it for all time, and I was
pulled off, right on down his road. He said come with me and I
did. And it was almost a shock when the song was over—you
know when Robby plays those last little tinkling notes on the
guitar. It felt like, yes, it's the end, that's the end, that's the state-
ment, it cannot go any further. When they were done, I felt emo-
tionally washed. I had goose bumps from head to foot. For one of
the very first times in rock 'n' roll history, sheer drama had taken
place on tape . . . Bruce was also completely sucked into it. His
head was on the console and he was just absolutely immersed in
the take—he became part of the audience too. So the muse did
visit the studio that time, and all of us were audience. The ma-
chines knew what to do, I guess. It was magic."

Ray Manzarek remembered it this way: "When it came time
to do 'The End' a very different mood took Jim over. He became
shamanistic and led the small group on a shamanistic voyage. He
put himself into a trance and, through that, put us all into a
trance."

Despite the power of the moment Rothchild stuck to his gut
instinct as a producer. "I went into the studio and told them how
great I thought it was and then I asked them to do it again. 'Let's
make sure we've got it.' So they did it again and it was equally
brilliant. Afterward, Ray said, 'Whew, I don't think we can do that
any better.' I said, 'You don't have to. Between these two takes
we have one of the best masters ever cut.' It turns out we used
the front half of take one and the back half of take two."

According to Morrison, the recording of "The End" was a
turning point in The Doors' attitude toward their music. "We
didn't start out with such big ideas. We thought we were going
to be just another pop group, but then something happened
when we recorded 'The End.' We saw that what we were doing
was more important than just a hit song. We were writing serious
music and performing it in a very dramatic way. 'The End' is like
going to see a movie when you already know the plot. It's a time-
less piece of material . . . It was then that we realized we were
different from other groups. We were playing music that would
last for years, not weeks."

A record noise shot out
& stunned the earth

The night they recorded "The End" would always remain a significant moment for Jim Morrison. After everyone finally went home for the night he couldn't stop thinking about it and wound up returning to the studio alone. Ray Manzarek tells what happened next: "Later that night Jim came back and went into the studio and took the fire extinguisher and hosed the whole place down . . . not in the control room, thank God, just in the area where the band was, their side of the window. Just fire-extinguished, just blasted the whole place, man, just to cool it down. That's what he was doing. I know he was doing that. Just calming the whole thing down. 'Wait a minute. Too much heat in here, man.' Stoned out of his mind. And the studio people came in the next morning; they didn't even know anything about it. Somehow he just snuck in there, past the guard and everything. Thank God—he would've been in jail!"

Manzarek recalls coming to the studio the next morning. "The studio people just absolutely freaked. Paul Rothchild said, 'Uh, don't worry, don't worry, Elektra will pay for it, no, there's no reason to call the police, no, just some minor vandalism, don't worry about it, Elektra will take care of all this.' He knew right away who did it, you know. He went 'Oh no!' He knew. We all knew right away what had happened."

Just as he drank to quiet the screeching voices in his head, Jim Morrison knew he would get no rest that night until he quenched the fire he had lit in that studio. He was drunk but he knew enough about himself to know it was the only way he would get any peace. What he may not have known is that the real fire he started that night was on the inside, where it could never be put out.

Doors Music

Amid the wild and sensational escapades of Jim Morrison, it is important to remember that it was the music of The Doors on that first album that made them fascinating.

The basic foundation of The Doors' sound grew out of Ray Manzarek's staccato yet melodic approach to the organ. His chord-

ing, developed from a stride piano style, provided the machine that drove each song. Though he never sounds forced or frantic, Manzarek has a tendency to attack his instrument as he plays it. Densmore is an expressionistic drummer who emphasizes dramatic texture rather than pure rhythm, stressing accents rather than a heavy beat. He punctuates and pushes, trading rhythmic patterns with the organ. Densmore was the perfect drummer for Morrison because he worked more closely with the words than the musical riffs, carrying on a sort of dialogue with the lyrics. Couple these things with Morrison's ability to use his voice almost as an instrument, accenting like a horn section and taking many roles from rhythmic to lead, not only singing, but whispering, talking, and screaming as well, and it begins to become apparent why The Doors were so unique rhythmically.

It was Robby Krieger who tied these various elements together—playing fluidly, with a slowness, a thoughtfulness, unifying the sound. Krieger's flamenco approach made his playing totally individualistic in rock. His guitar moves in and between the instruments and applies the right feeling or the right noise to complete a sound the whole group is reaching for. On their fast songs the result is a sort of pulse, but on the slower songs it creates a strong, even, forward movement. The organ chords act as circular passages wrapping around the other sounds, keeping the group tight. Morrison was out front, clashing against it or flowing with it. Unlike most groups, each member of The Doors knew the words to every song the group performed. Consequently, no matter where they went musically, the band always accentuated the lyrics.

The Doors were disciplined, inventive, strong in their sense of beat and form. They employed a wide variety of musical dynamics in their arrangements, never playing on the same level for very long. Another key to their musical uniqueness was the fact that they improvised so much, something that is especially evident in "Light My Fire" and "The End." Although improvisation is usually associated with jazz, The Doors applied the same techniques to rock. Much of their approach to music came from their basic instrumentation—keyboards, guitar, and drums. Making music without a bass player is almost unheard of in rock. This alone required a different approach to playing. As a threesome, Manzarek, Krieger, and Densmore showed amazing power. When

there are only three musicians every note has to have meaning. And the organ was not just a fill-in instrument like in so many other groups. Ray Manzarek elaborates: "We felt by using organ and one guitar you could hear every instrument because they are all different . . . and you can pick up the words better. We listened to each other and left a lot of area for improvisation. Within improvisation lies the danger of music and within that danger lies your freedom."

Much of The Doors' group sound has to do with the individual styles of its members. Robby Krieger learned to play the guitar with his thumb under the neck and played without a pick. Stylistically he used an arpeggio, alternating fingering with the first two fingers, but for faster picking he used his index finger as a flat pick. A pick can play only one string at a time or a group of strings, but using fingers allows the guitarist to pluck any one or several strings at a time. Krieger sometimes used his third finger for picking as well, but never his fourth, and for rhythm he employed his whole hand. He would often play bass lines with his thumb while doing lead work with the other fingers. His ability to sustain one note for an extended period of time and then make a smooth transition to yet another sustain is also a benefit of his flamenco training. Robby Krieger played a wide variety of tones from twangs that were reminiscent of a sitar to solid blues to funk and his mastery of bottleneck guitar was well known. He preferred "a pure sound" and seldom employed effects with The Doors.

Ray Manzarek also had a variety of musical influences: "My style is a combination of the blues things and Russian classical music of the late nineteenth and early twentieth centuries. Stravinsky's sense of harmony really blew me away and appealed, of course, to my Polish soul too. So what I try to do is to add that Eastern European ethic minor sense of drama and heaviness to our good old American rock 'n' roll beat; it's Africa and Eastern Europe."

Although trained in the piano Manzarek switched to playing mostly organ when The Doors formed. "Switching from piano to organ calls for a slower technique," Manzarek said. "The organ note sustains, so you have to take advantage of the sustaining quality. I'm forced to hold notes in a different way than I would on a piano. On the piano you can just run across the keys, but on

the organ you have to flow across smoothly to keep that sustained sound going."

The Doors used several unconventional rhythm patterns. "Break on Through" has a very fast bossa nova beat with a 4/4 feeling (a true bossa nova is much slower with a two-beat feeling). "Light My Fire" is even more complex with the bass line playing in 4/4 time and the snare drum and guitar playing in 3/4. John Densmore was noted for his dynamics. He specialized in enhancing the group sound rather than attracting attention to himself. "I never got into solo drumming," he says. "I'm not that good a solo drummer. My trip was ensemble. And I love to not only keep the beat, but to put little accents any syncopations to spur the soloist or singer on to new heights. I don't play just one-two-three-four. I try to play melodies. When we're improvising in the middle of a tune, I may try to answer something the organ or guitar has played."

Since Densmore is not a big man, many people have wondered how he can play with a power and authority equal to much larger drummers like Buddy Miles. "The power is in the wrist," Densmore says. "It's in the snap, not the arm."

While Jim Morrison didn't know much about music, he did know about language. He was a musician of words: "In a song you have to obey certain rules of meter and rhyming, whereas in poetry you don't have to follow those rules of rhyming and rhythm. Since I do not play a musical instrument, I must make up words as fast as I can to hold on to the melody that enters my mind. I use pen and paper, the physical act of writing. On a tape recording you eventually have to transcribe, and the sound of my own voice makes me self-conscious in composing."

Equipment

The Doors used a wide variety of brands of musical equipment for a wide variety of reasons. Ray describes some of his early choices: "The very first electric keyboard I used was a Wurlitzer. Then I went to a Vox Continental organ. The Vox was flat on top so I could put the Fender Rhodes Piano Bass right on top of it. The bass would be up on the left, so I'd play the organ with my right hand. That's how I did the first album before we

brought in a studio bass player. I played bass on the Rhodes
Piano Bass, but it didn't have the punch, the attack of something
hitting a string. It was fine in concert because it would move a lot
of air and carried a deep bottom. The Vox had the best organ
sound. You couldn't get it to sound like anything other than an
organ. There were a lot of organs back then that could sound like
all kinds of instruments, but they didn't sound like organs. I used
the Vox for about two and a half albums. Then Vox was sold to
somebody and the organs started falling apart. I'd go out on a gig
and in half a set I'd break about six or seven keys. I eventually got
a Gibson Kalamazoo. It had a little more versatility than the Vox.
It could make the sort of pianoish sound I used on 'Back Door
Man.' "

Like choosing the right tool for the job, Manzarek believes
musical instruments should be varied and selected carefully.
"Every instrument has an entirely different approach and that's
what is great about the keyboards," he told *Keyboard*'s Steve
Rosen. "What you play on the piano is not what you play on the
Clavinet is not what you play on the organ is not what you play
on the synthesizer. Each one makes me play a different way be-
cause of the nature of the instrument. On the piano you can get
into a very lyrical thing or you can get into a very hard choppy
rock 'n' roll thing. The Clavinet automatically puts you into a
funky thing, but it can also be used like a harpsichord which is
nice. Of course you use a legato technique on the organ where
you sustain notes and the synthesizer is cuckoo: All the craziness
you can think of you do on the synthesizer."

Robby Krieger discusses the musical equipment he used in
the early days of The Doors. "I originally was using a 1964 Gib-
son Melody Maker that got stolen so I went to an SG Special. We
used Jordan and Acoustic amps and then built our own stuff. But
I always preferred the old Fender Showmans. I wound up using a
Fender Twin Reverb quite a bit in the studio, too." The guitar
Krieger most often played was a Gibson SG Special with hum-
bucking pickups and Ernie Ball Super Slinky strings. "I always
hold the toggle switch in the treble position. But if I want some
weird effect, I'll put it in the middle. My pickups are in reverse
phase so that if you go up the guitar from the bottom string you
get a wa-wa effect without a pedal. It alternates between phasing

out the lows and highs. It makes a nice rhythm sound some-times."

For bottleneck, Krieger switched to a Gibson Les Paul with Gibson medium-gauge strings.

Drummer John Densmore also varied his musical equipment over the years. "In the beginning I had one tom-tom on the bass drum and one floor tom and a snare," he told Robyn Flans for *Modern Drummer.* "Gretsch . . . then I went to Ludwig not too long after, like the third album. I had a Ludwig snare all the way. I have a couple of them, but I still have the original Doors one. I still love the sound. I like to take the bottom heads off my toms to make them bark and growl. I hated new skins—I love the sound of them after they'd been beaten to death for months. Snarling as hell—that was my sound. I used a basic four-piece setup: snare, bass, and two tom-toms. I used Zildjian cymbals on first three LPs, a twenty-inch medium ride, sixteen-inch-thin crash, and fourteen-inch high hats. Later I got couple Paiste 605s. I never went for the two-bass-drum routine; there are lots of peo-ple who can do more with one than most guys can do with two. I always felt I should practice more rather than add more drums."

The Doors in New York

The album took two weeks to record and five weeks to mix. Although it was not mandatory that they be present, The Doors wanted to be a part of the mixing process and continued coming to Sunset Sound throughout October. As Rothchild and Botnick blended the sounds they had recorded the album gradually began to take shape.

That same month, Bobby Seale and Huey Newton launched the Black Panther Party in Oakland. A new breed of black leader appeared: H. Rap Brown ("Violence is as American as apple pie"), Eldridge Cleaver ("You are either part of the problem or part of the solution"), and others took up the more extreme viewpoints of Malcolm X rather than Martin Luther King's pacifism. The Pan-thers with their uniforms of black berets and black leather jackets struck terror in the hearts of white America, and in light of their

extremes, the white middle class began to listen seriously to Reverend King's viewpoints on civil rights.

In November 1966, The Doors headed for New York City to their first out-of-town club date, a week at the Ondine, a small rock 'n' roll sweat cellar in midtown New York. And though they were virtually unknown on the East Coast, some people, including Robby Krieger, think this was when The Doors played their very best. "We were doing like five sets a night in this club, and we were hot. I wished they would have recorded us live then."

They were hired sight unseen on the recommendation of the club owner's friends who said that this was a band "direct from the California underground" and their music was different from anything the New York bands were playing. They weren't danceable to in the usual sense, they didn't dress the way most bands dressed, and they all seemed a little uptight. But by about the third night at the club the girls started latching onto Morrison. A few days after that, they started getting into the music and by the end of the engagement, the crowd at the Ondine was crazy about The Doors.

Steve Harris was vice president of Elektra Records and the Ondine was where he first saw Morrison: "He sauntered over to me from the bar," Harris said in the *Dark Star* photo/biography of Morrison, and I thought to myself, if this guy can recite the phone book he's going to sell a million records . . . He was gorgeous, magnetic . . . whenever he was introduced to journalists or record company people . . . and they had their wives with them, he would always try and conquer the wife first. And he usually did."

The band was developing a keen sense of professionalism to go along with the punch and power that had carried them this far. Their sound was solid, tight, and penetrating. The music conveyed artistic integrity, yet the sound was raw and menacing at a time when most bands were writing and singing about peace, love, and flowers. The Doors' tortured psychedelic wrenchings made a huge impact on the few New Yorkers that managed to see them.

While in New York The Doors also signed over their publishing to Elektra's Nipper Music and approved the album cover. After much haggling, they also reluctantly agreed to edit "Break

on Through" so that the line "She gets high/she gets high/she gets high" would be changed to "She get/she get/she get/she get." Elektra wanted "Break on Through" to be the first single from the album and Jac Holzman was afraid the reference to getting high might freak out some of the radio stations and keep them from playing the record.

Holzman knew that The Doors had the potential to become Elektra's most important group. Consequently, he made several behind-the-scenes business moves to ensure that the album got the promotion it deserved. First, he decided to hold back the release of the record until January so that the company could give it the maximum attention—no other Elektra records were to be released that month. Steve Harris then hired several young girls to create an air of excitement around the band—scream at the concerts, throw flowers and underwear on the stage, and mob the group wherever they went. Holzman also employed a unique marketing strategy by reserving a billboard on Sunset Boulevard to promote the album. It was the first such billboard in what has now become a tradition on the Strip, but Holzman knew it would make the kind of bold statement he and the group wanted to make. The decision was also made at this time to feature Morrison prominently in all promotion. "It was the group who wanted Jim in front," Holzman remembers. "They felt he was the focus." Morrison, in return, credited all the songs on the album to the group as a whole ("All Songs Written by The Doors"), although he had written most of them. As they would through their entire career, all four Doors shared publishing, recording, and performance income equally.

Back in L.A.

While the band enjoyed visiting New York, they were virtually broke, so most of their days were spent wandering through the streets or hanging around the hotel room getting high. Morrison got off on drinking with the bums on the Bowery and scouring the used bookstores for cheap books. Sometimes, just because he was bored, he would hang out of his hotel room window, swinging by his hands from the ledge.

When The Doors returned from New York in late Novem-

ber, Jim moved in with Pamela. They had been seeing each other on and off for nearly a year and continued to grow closer all the time. Of course, because of the kind of person Morrison was, "moving in" meant merely that he slept there occasionally. Whatever he may have said, both Pam and Jim knew that the only thing he was capable of committing to was that he would show up sooner or later. Despite this, Pam began to grow more possessive of him. It was almost as though she was determined to have a "normal" life with Jim Morrison, something she had to suspect could never be possible.

Two made love in a silent spot
One chased a rabbit into the dark

"They got a place in Laurel Canyon right next to the Country Store," Mirandi Babitz recalls. "My boyfriend and I lived with them for a while when we'd got thrown out of our place. We were all really scraping by. I was the only one with a regular job. If anybody had anything we shared it—drugs or food or whatever. We took a lot of drugs. I was smoking dope in the morning and at night. The relationship between Pam and Jimmy was very similar to the one I had, which was that we were definitely a pair but it just wasn't cool to be in love or be too much of a couple. If there wasn't outside sexual activity there was innuendos of it. Pam and I both wanted things to be more traditional, but we went along with it because the guys were older. Actually we didn't have a whole lot to say about it in those days."

Some of Jim and Pam's happiest days were spent at 1812 Rothdell Trail. "They had some really wild times," Babitz continues. "They both really liked macabre things . . . spiders and black magic, things like that. They used to scare each other. They'd play chicken. If somebody got too freaked out then they would go over to UCLA and get a B_{12} shot or whatever it was they were giving people to bring them down. It was pretty regular that Pam would get too freaked out. She'd scare him and he'd scare her back too much. He'd do things like turn off all the lights and creep around outside or pretend he'd been stabbed. They were always seeking that kind of thrill. But they did very dangerous things too. Like putting the car on the railroad tracks or driving with their eyes closed down Mulholland at night while

on acid. It was a little tense being around them sometimes. We were game for a lot of things, but they were a little bit gamer."

The Doors arrived back from New York in time for the last of the Sunset Strip riots. The Strip had become more and more popular with the young. Droves of them came from the valleys to wander aimlessly along the two-mile section of Sunset Boulevard. What had begun as vague hopes of seeing one of The Beatles or Stones or Byrds or whoever might be hanging out there at the time had now turned into a genuine youth movement. The kids came to "experience" the Strip. Following the fashion of the period they had let their hair grow long over the summer of 1966 and by November they were an identifiable subculture with long hair, bell-bottoms, bare feet . . . the first Los Angeles hippies.

> *The soft parade has now begun*
> *on Sunset*

After a time the local businessmen began to complain to the police. The shop and restaurant owners said the kids were bad for business. They didn't have any money and they were making it difficult for the people who did to spend any of it on the Strip. They jammed the traffic, bumper to bumper, cruising the street or else they roamed up and down the boulevard scaring off any adults who might want to dine or shop. In addition to all this, the real estate barons of the Strip were afraid the kids would botch their plans to make the area a high-rise financial district.

The police responded by imposing a 10:00 P.M. curfew and the kids protested. One night things got out of hand when some people began throwing rocks and eggs. The cops moved in and made forty-seven arrests. The next weekend the kids were more determined than ever and as many as two thousand rioted, smashing store windows and pelting police with rocks and bottles, which resulted in over two hundred arrests. The police, on the other hand, mishandled the situation, charging into crowds of kids, swinging their billy clubs and beating up people indiscriminately. The Strip became a battleground with platoons of cops against long-haired, bell-bottomed teenagers—the "shock troops of Hollywood's psychedelic revolution."

The kids were labeled as "political" which they really weren't and several of the Sunset Strip clubs were ordered

closed. Stephen Stills, of The Buffalo Springfield, wrote a protest song, "For What It's Worth," as a result of having played at a club the police had shut down. The song became an immediate anthem that not only gave the Sunset Strip kids the energy to continue with the demonstrations, but after becoming a hit single also served as a warning of things to come for a nation of discontented youth. In the end, after several rough weekends, the police and the city officials backed off and the Strip did not become full of high rises. And the kids continued to roam the boulevard.

But the Strip wasn't the only place where there was tension among the youth. By the end of the year, five thousand Americans had died in Vietnam. The kids were still singing about peace and love, but underneath it all they were starting to ask some hard questions for which there were no apparent answers. They were ready for The Doors. And The Doors were ready for them.

The Doors: The Album

The album, entitled *The Doors,* released in January 1967, stands as one of the most stunning debut records ever made and, along with The Beatles' *Sgt. Pepper,* was the best album of 1967. It is a portrait of The Doors at their very best—confident, disciplined, selective, and caring. The ultimate expression of The Doors' aesthetic yet also endlessly enigmatic and provocative. It is an album with a scintillating sound that combines rock-blues, theater music, jazz, and lots of improvisation. With its ground-breaking ceremony at the outset and its "West Is Best" axiomatic close, it is more than a simple curio. It represents a milestone in rock.

With its surreal deco green/brown cover and Magritte lettering, the thrust of that first album was essentially a vision of breakthrough—not only lyrically, but musically. The Doors offered a dark and cool surface on the outside and a fierce inferno within. The compelling power of the music was that at any moment the surface could be torn open to allow the fiery core to emerge. Much of the impact of this first album had to do with Morrison's voice and unique style as a rock singer. Most critics agree that his vocals on the first album are awesome, spanning a range of emotions from total vulnerability to sheer defiance—the voice of insolent lust mixed with mystic wisdom, its toughness enhanced by

the sensual precision of the music. Part of the magnetism is the feeling of elusiveness Morrison's voice creates, as if he were singing for himself. Morrison sang rock with a full baritone which was very unique for his time; rock singers usually have high voices or else wind up shouting more than singing. Morrison was a crooner and no one had ever heard a crooner with a hard rock edge before.

The Doors' first album merged Morrison's poetic gifts with the band's improvisational skills, creating an almost overpowering sense of mystery. From the depth of the arranging on several cuts to the overall production of the entire album, the work retains an eerie incandescence that has not diminished over time. The album presents a bizarre collection of lofty promises, alluring imagery, hypnotic gestures, and violent statements. Break on through. The crystal ship. Light my fire. This is the end.

It was a record with a strange new sound, a tense and powerful exertion that balanced a lot of seeming paradoxes. The group's ability to function as a unit made it one of the rare instances of rock theatricality that actually worked. The mood is established, a soliloquy is invoked and more or less carried through to completion. It is this free-form but directed process that made The Doors special. Expert, controlled, and precise in attack, the group ranged from pregnant understatement to exhilarating excitement in a matter of seconds.

The music was new black polished
chrome & came over the summer
like liquid night

The Doors brought many innovations to rock. They were the first group to introduce the theater song and its derivatives into the realm of current popular music. The album was also the first successful synthesis of the spirit of rock and the feeling of jazz. Touches like the cymbal ride intro to "Break on Through" and the Latin feel of the verses to "Take it As It Comes" are more jazz than rock. While "I Looked at You" was basic pop, the inclusion of pure blues such as Willie Dixon and Howling Wolf's "Back Door Man" foretold the white blues revival that was to dominate the rock scene for well over a year.

No one can deny the diversity of the musical styles on the

first album. There're blues ("Back Door Man"), an epic ("The End"), a European feel ("Alabama Song"), hard rock ("Break on Through"), a classical-influenced arrangement ("Light My Fire"), and a couple of pure ballads ("End of the Night" and "The Crystal Ship"). This musical diversity was always part of the band, but the first album stands as the group's finest reconciliation of their schizoid musical impulses. If "Back Door Man" established Morrison's erotic credentials, "Soul Kitchen" enhanced them; if the garish California neon of "Twentieth Century Fox" captured 1967, then "Alabama Song (Whisky Bar)" related it to the 1930s. Just as "The Crystal Ship" described a voyage to unexplored realms; "The End" completed the trip. And while "Light My Fire" may have been the first truly gutsy love song, "Break on Through" was the most deceptive of them all.

There's an equal depth and diversity to the lyrics. The Doors were the first rock band to do a Kurt Weill/Bertolt Brecht composition. "Alabama Song" is from the German opera of the late 1920s *Aufsteig Und Fall Der Stadt Mahagonny* (*The Rise and Fall of the City of Mahagonny*), where every pleasure is for sale and anything is permitted except poverty. It is a sort of sarcastic tribute to the decadent era after World War I when Germany exploded with a depraved insanity that paved the way for the rise of Nazism. Ironically, it was the same type of whiskey and women braggadocio that paved the way for the decline of Jim Morrison.

"Twentieth Century Fox" is a riveting portrait of the surburban wonderchild placing more value on sophistication and control than getting in touch with her real emotions. The message of "Soul Kitchen" is "learn to forget," a phrase on the order of "the answers are blowing in the wind" and one that conjures up similar thoughts and emotions. The song is a harsh commentary on the importance of learning to forget in order to survive emotionally intact in this grubby world.

But "Light My Fire" is really the essence of that first album. One critic called it "a calculated explosion of raw, yet focused power." The music of the song did just what the words talked about: built up heat and light until a fire was started. The "C'mon, c'mon, c'mon" sequence at the end was described by Paul Williams, the founding editor of *Crawdaddy,* as "the most powerfully controlled release of accumulated instrumental kineticism known on record." Williams said the song built "to a truly visual orgasm in sound."

While "Light My Fire" is unquestionably a hypnotic piece of music, there are those who feel it pales lyrically before every other tune on the record. Robby's gifts may have been more melody than words, but there is an implied depth to many of the lyrical phrases that combine with the majestic arrangement and passionate vocal to make a hedonistic, blissful celebration of a Dionysian attitude sound almost intellectual and Apollonian.

The tour de force on the first album is the long, improvised composition, "The End," a staggering drama that broadened the thematic scope of rock. "The End" tells of the impending end of a love affair quite possibly by murder. A cathartic experience, the psychosexual epic ends with patricide and Oedipal love. The song is a theatrical achievement in music; there was nothing in rock to compare to what was done here with one chord in terms of rhythmic and melodic variation backing a complex story line. "The End" builds to a realization of mood rather than being a sequence of events. Morrison's masterpiece was almost pure poetry—an eleven-minute Freudian jam in the key of E which remains perhaps the single most astounding track that The Doors ever recorded. One critic said the lyrics sounded "as if Edgar Allan Poe had blown back as a hippie."

This is Joycean rock, with a stream of consciousness lyric. The song is constructed like a building. There's no story in the beginning, but there is a foundational image of decay.

> *This is the end,*
> *of everything that stands,*
> *the end,*
> *no safety or surprise,*
>
> *Can you picture what will be,*
> *so limitless and free*
> *desperately in need*
> *of some stranger's hand,*
> *in a desperate land*

Morrison, like the best poets, uses words as much for their emotive effect as their meaning. The songs suggest rather than state a psyche swarming with fears of sex, violence, and death. It is the imagery more than the meaning of the words themselves

that conveys the message. After a short trip through a "Roman wilderness of pain" we embark on an even more treacherous journey.

> *Ride the snake,*
> *To the lake, the ancient lake*

Morrison's imagery has a terrifying quality to it—"the snake is long" and he's "old, and his skin is cold." The classic symbol of evil is fitted snugly with images of sex and death.

> *The west is the best,*
> *Get here and we'll do the rest.*
> *The blue bus is calling us,*
> *Driver where you taking us?*

The journey to paradise where all things are possible can be accomplished only by surrendering your final destination to the driver of the blue bus. The journey here is both physical and spiritual. Manzarek discusses this aspect of the song: "I hate to interpret, but I'll draw an analogy to the Blue Bus. The ancient Egyptian civilization, in their rights and religious rituals, had the Solar Boat. When you died, you got in the Solar Boat and went wherever you went. That whole big journey after a kind of death is in the Solar Boat. Well, blue being a heavenly color, blue being associated with mysticism and trips . . . the bus also being associated with trips . . . it's all of the trips you could possibly imagine. The Blue Bus."

> *The killer awoke before dawn,*
> *He put his boots on.*
> *He took a face from the ancient gallery,*
> *And he walked on down the hall.*

It is to the forbidden fantasy of incest and patricide that this bus travels. The long hall is reminiscent of the womb and the ancient gallery of masks is a thinly veiled reference to Greek tragedy.

He went into the room where his sister lived
And then he paid a visit to his brother,
And then he, walked on down the hall.

He came to a door,
And he looked inside,
"Father?"
"Yes, son?"
"I want to kill you.
Mother, I want to . . ."

The primal scream that follows links the almost casually delivered lyrics to the inner rage that prompted them. That these images are followed by the bluesy "Come on, baby, take a chance with us . . . And meet me at the back of the blue bus" indicates that there are even more bizarre journeys awaiting those who dare travel on the blue bus.

This is the end, beautiful friend,
This is the end, my only friend,
It hurts to set you free,
but you'll never follow me.

Apparently, Morrison feels that no one is likely to accompany him back on the blue bus or perhaps the setting free is a reference to the murder of those who would dare to attempt such a foolhardy venture. In any case, when the end comes he is alone.

The end of laughter and soft lies,
The end of nights we tried to die.
This is the end.

Of course, the real value of a poetic piece like "The End" is its freedom of imagery that allows the listener to conjure up a host of meanings. Consequently, any sort of academic interpretation is rendered meaningless in the attempt. Morrison's lyrical thrusts were designed to penetrate our psyches first and the analytical part of our minds later. "The End" is a song that deals with myths. Morrison described it to Jerry Hopkins in *Rolling Stone:*

"Oedipus is a Greek myth. Sophocles wrote about it. I don't know who before that. It's about a man who inadvertently killed his father and married his mother. Yeah, I'd say there was a similarity, definitely. But to tell you the truth, every time I hear that song, it means something else to me. I really don't know what I was trying to say. It just started out as a simple good-bye song. Probably just to a girl, but I could see how it could be good-bye to a kind of childhood. I really don't know. I think it's sufficiently complex and universal in its imagery that it could be almost anything you want it to be."

The implication is that "The End" contains dark and alluring secrets. The promise of wisdom for those willing to journey to the "ancient lake." But the wisdom is the sad, hopeless knowledge of forbidden fruit—the knowledge of evil. Sin without redemption. Dread, violence, guilt, misguided love, and most of all, death.

Paul Rothchild described the meaning of the song this way: "'Kill the father' means kill all of those things in yourself which are instilled in you and not of yourself . . . those things must die. The psychedelic revolution. 'Fuck the mother' means get back to the essence . . . the reality. You can touch it, you can feel it, it's nature, it can't lie to you. The Oedipus section says essentially the same thing that the classic says . . . kill the alien concepts, get back to reality . . . to the beginning of personal concepts. Get to reality, get to your own in-touch-with-yourself situation."

Morrison once summed it up this way: "'The End' is about three things: sex, death, travel." Was this a suggestion that sex is a means of travel to death? "You can take it that way," Jim said in an interview, but then went on to give an explanation that is probably closer to what he intended: "You can also take it the opposite way. The theme is the same as in 'Light My Fire,' liberation from the cycle of birth—orgasm—death."

"The End" contains ample opportunities for the listener to insert meaning and use his imagination. When you consider that it appears alongside the driving "Break on Through," "Back Door Man," and "Twentieth Century Fox" and on the same album as the poetic "The Crystal Ship" and the emotionally charged "Light My Fire," you can understand what got the rock world so excited. That's what raised all the sunken continents in everybody's mind. That depth of thought and power of commitment was a

bright promise on a new horizon to a generation that was eager to believe. Unfortunately, there are two unspoken questions that invariably accompany such promise: "Now that you've made the promise, what are you going to do to keep on fulfilling it?" and "Once you get the world's attention, what wonderful thing are you going to do with all that power?" Jim Morrison would spend the rest of his life struggling to find the answers.

Surrealism

Morrison's art was greatly influenced by surrealism. The concept of using art to help people get in touch with their subconsciouses excited him. To understand his lyrical and poetic imagery on the first album it is necessary to grasp at least the basic principles of surrealist art. Loosely described, surrealism, which rejects traditional values and beliefs, attempts to express the subconscious mind by presenting images in a random rather than ordered path. The idea is that by avoiding traditional concepts of order the surrealist allows his subconscious to flow free through his art. But the surrealists carry it much further than that as C. W. Mills describes in *Surrealism in Art*:

> The objective of surrealism was infinite expansion of reality as a substitute for the previously accepted dichotomy between the real and the imaginary. Acknowledging the human need for metaphysical release, the surrealist believed that through the exploration of the psyche, through the cultivation of the miracles of objective chance, through the mystique of erotism, through the diverting of objects from their familiar functions in surroundings, through a more cosmic perspective of life on this earth and finally through the alchemy of language that would learn to express this more dynamic reality, man might be able to satisfy his thirst for the absolute within the confines of his counted number of heartbeats.

The disorder of surrealism is only on a superficial level. The true surrealists attempt to get in touch with what they consider

the ultimate order contained within their subconsciou
seeking of order through disorder or reality through ill
surrealists believed that creating without a consciou
lowed the subconscious to dominate. Poets call this "poetic im-
pulse" and Socrates said of inspired poets:

> All great poets, epic as well as lyric, compose their
> beautiful poems not by art, but because they are in-
> spired and possessed. Lyric poets are not in their right
> mind when composing their beautiful strains. For the
> Poet is a light and winged and holy thing, and there is
> no invention in him until he has been inspired and is
> out of his senses, and the mind is no longer in him.
> When he has not attained to this state, he is powerless
> and is unable to utter his oracles.

The surrealist assumes that art that flows directly from the
subconscious must be of a higher, more spiritual order. He be-
lieves that the subsconscious is divinely inspired and therefore
any art developed by the thoughts of mere man would have to be
inferior to those of the subconscious. This idea of combining the
poet with an oracle goes way back. There is evidence that the
chants of the cave dwellers were poetic in nature and often
brought on by sensory deprivations and natural hallucinogens. In
the primitive tribes it was the poet-oracle who rose to the posi-
tion of power and authority. He deciphered the spirit world and
directed the tribe through conjuring and the interpretation of
myths.

This concept was embraced by Arthur Rimbaud, a pre-
cocious nineteenth-century French poet whose life as a poet was
over by the time he was nineteen. One of Morrison's biggest in-
fluences, Jim liked Rimbaud as much for his theories about the
art of poetry as for his poems. In 1871, at the age of sixteen,
Rimbaud wrote a letter to a fellow French poet that contained
this passage:

> The Poet makes himself a seer by a long, vast and rea-
> soned derangement of all the senses—every form of
> love, of suffering, of madness.

Rimbaud took the tribal concepts a step further. More than seeking the logical through the illogical, for Rimbaud it was the pursuit of sanity through insanity. This concept became a credo by which Jim Morrison lived his life.

> *Thank you, O Lord*
> *For the white blind light*
> *A city rises from the sea*
> *I had a splitting headache*
> *from which the future's made*

Historically, the rise of the surrealistic movement paralleled the rejection of traditional values and beliefs. As the power of the great religions waned, more new visions of spiritual evolvement were conjured through a mystical mix of poetry, art, the occult, and even satanism and witchcraft. For many surrealists what began as a more objective approach to life often wound up more steeped in meaningless ritual and dogma than the religions they were intended to rebel against. Morrison said that each generation wants new symbols to divorce themselves from the preceding generation and he seems to have been right.

Today, these theories are often embraced by those who feel unfulfilled with the prevailing religion of their era and locale. Quite often, when one becomes dissatisfied with his faith, he or she tends to reject the idea of a personal God for that of a mystical force. Instead of seeking a new approach to God or a better religion, the Bible and any other teaching the devotee has had is thrown out in favor of more stimulating rights of passage. It is safe to say that the young Jim Morrison made this transition. While some may see this idea as a cosmic case of throwing the baby out with the bath water, he saw it as an inspiring new frontier of spiritual awareness.

Socrates taught too that poets had to be out of their minds to be truly divinely inspired. This would seem to indicate a God more of chaos than of order since His inspiration can come only through confusion. The surrealist sees man as being so bound by convention and conditioning that his only hope for true revelation is by altering his state in any way possible, especially the derangement of the senses. To define a man's place in the cosmos through words, poems, and stories, the surrealist believes man

has to totally lose himself in the process. Ironically enough, born-again Christianity also teaches that man must overcome a part of himself to embrace the truth God would have him know. But the Christian views this process as overcoming the sin nature through the sacrifice of Jesus Christ on the cross as opposed to the overcoming of conditioning through chaos and rebellion.

Rimbaud once described the poet as a stealer of fire. He taught that through the forceful, and often painful, overthrow of the senses, these seekers of truth could attain a psychological condition that allowed a deep communion with primal life forces. Even before Rimbaud, Edgar Allan Poe attempted a similar evoking of oracles by achieving exceptional psychic states through the concentrated use of drugs such as opium as well as great quantities of coffee, alcohol, and sleep deprivation.

While some surrealists believe these practices put them in touch with something akin to God, there are others who believe that such intentional altering of the senses evokes demonic spiritual entities and that it is these entities that serve as the poet's muse, i.e., his inspiration. If this were the case then, the surrealistic path to truth does not lead to truth but to more lies. Otherworldly, spiritual lies, but lies all the same.

In 1966 and 1967, Jim Morrison used LSD to take his journey to what the surrealists call the frontiers of divine madness. He forsook reason and sought inspiration at all costs. He ventured into the same realms that influenced Blake, Rimbaud, Poe, and others. The mystical visions and omens Morrison experienced in this condition were the soul and depth of his lyrics and poems, and many of them were clear and compelling, a montage of symbolic mythological images. Sometimes, what he claimed to have seen was horrible and he admitted that the blatant terror and nightmarish feelings he experienced at such encounters simply could not be captured in words. Was he tapping into the mind of God or being duped by a demonic entity using him to influence others? Was this the force he first ecountered at age four on a New Mexico highway or was he merely deluding himself though a drug-based fantasy?

There is little doubt that Jim Morrison was someone on a spiritual quest who had many valid reasons to question and even attack the status quo of his time. But his philosophy allowed his great intellect and wonderful gift for communication to become

of anger, confusion, and self-abuse that prevented ...ieving a fraction of his potential. Whatever one can ...rrealism and Morrison's method toward revelation, ...nly two statements that matter. The first is that, ...m, surrealism influenced millions of others and the secon... that it ultimately destroyed him.

The Release of the Album

The Doors was released in January of 1967 along with the first single, "Break On Through." A ferocious hard-hitting record, the song was the ideal first single for The Doors because its lyrics said much of what they were trying to communicate. It defined their sound and image perfectly and both The Doors and Elektra had believed it would be a smash.

The week the album was released a new billboard appeared on Sunset Strip not too far from the same seedy clubs The Doors had been kicked out of only a few months before. The billboard was a huge blowup of the album's back cover with the words "The Doors—Break on Through with an Electrifying Album." Like the band, the billboard was an original—the first promoting a rock act ever erected on the Strip, which today is covered with them. The Doors saw it and were blown away—Jac Holzman had kept his promise.

The band's press kit was crafted with the same bold approach and contained autobiographical notes such as this by Morrison: "You could say it's an accident that I was ideally suited for the work I am doing. It's the feeling of a bowstring being pulled back for twenty-two years and suddenly being let go." Such quotes were to later set a fire under the music press. Another memorable one from the press bio read: "We are from the West. The sunset. The night. The sea. This is the end. The world we would suggest would be of a new, wild West. A sensuous evil world. Strange and haunting, the path of the sun." Jim also made a point of noting in his personal data that his parents were dead, a complete fabrication, unless you consider that they were dead in his mind.

When the album came out The Doors experienced a tremendous sense of release. The dream they had worked toward for so

long was at last a reality. Creatively, they were freed up as well. Their statement had been made. Now that the first album had been captured on vinyl the band was free to move on to other material and musical ideas. Most of their time now, however, was spent performing in order to promote the record. On January 6, 7, and 8 they appeared at the Fillmore Auditorium in San Francisco with The Young Rascals and Sopwith Camel. The release of the record and the fast-spreading word about the excitement Jim Morrison created onstage had taken them to a new level. Bill Graham's Fillmore did not pay all that well, but it was the best known of the new concert/dance halls where creativity and self-expression were as evident in the clothes and movements of the audience as they were in the performers onstage.

A week later The Doors returned to the Fillmore, on the bill with The Grateful Dead and The Junior Wells Blues Band. This was the weekend of "The Human Be-In—The Gathering of the Tribes" at Golden Gate Park on January 14, 1967. The Be-In was a classic hippie gathering. All the world was young and everything was possible. The message was that with the right effort we could all get along together and just be. The Be-In brought together people who had no common commitment other than they wanted to celebrate how good it was to be alive together in the park at that moment in history. More than twenty thousand people attended the Be-In. It was a perfect San Francisco day, midwinter and yet warm. Quicksilver Messenger Service played as well as several other Bay Area bands and a host of poets and hippie leaders such as Allen Ginsberg, Lawrence Ferlinghetti, Timothy Leary, and Michael McClure were there. The bands played, the poets read aloud, and everyone got along. The Be-In was a milestone in the youth subculture—a great spontaneous celebration and the beginning of a massive expansion of consciousness and an almost childlike utopian dream.

Through the rest of January and up to the middle of March The Doors continued performing in California, picking up new fans and more momentum. They did a week at a dance club in San Francisco with The Peanut Butter Conspiracy in February and appeared at Gazzarri's for a week at the end of the month. It was at Gazzarri's that Tom Baker, a friend of Pam's, first saw Morrison perform. Baker was a struggling actor who greatly resembled Jim in attitude and in his hard-drinking, fast-living ways.

He was voraciously interested in all the arts and would eventually write, direct, produce, and act in several plays and films. More than this, though, Baker had a zest for life and like Morrison repeatedly challenged authority at every turn. He and Pam had a brief affair when the Doors were in New York. Later he met Morrison briefly during which time Jim had managed to display both his serious intellectual and wild drunken sides. Although they would eventually become the best of friends, Baker was leary of Morrison at first, wondering if Pam had told him about their affair. At Gazzarri's, Morrison was drunk and on acid and Baker found him unspectacular except for one moment that he later described for *High Times* magazine: "While stumbling through a song he suddenly let out a deep-throated roar, a bloodcurdling scream, really, and it startled me, as though someone had snapped a wet towel against my bare skin . . . Pam kept telling me I was seeing him at far from his best. I replied that he was a good guy, but he should keep his day job."

On February 22, The Doors played a fund-raiser for CAFF (Community Action for Fact and Freedom), a group formed to close the generation gap on the Sunset Strip after the recent riots. The concert was held at the Valley Music Theatre in Woodland Hills and also featured Hugh Masekela, The Byrds, Buffalo Springfield, and Peter, Paul, and Mary. On March 3 and 4 The Doors crossed another milestone—they headlined the Avalon Ballroom over Country Joe & the Fish and The Sparrow (who later became Steppenwolf). From March 7–11 they again played San Francisco, this time at the Matrix, a small but happening club. By now they were no longer just an L.A. group, having developed a considerable following in the Bay Area.

It was with a mixture of surprise and disappointment that The Doors watched "Break On Through" slip and stall in its efforts to get on the charts. Few radio stations played it and the only place it caught fire was in L.A. Elektra tried hard, even making a film of The Doors performing the single in an attempt to help the record. Directed by Mark Abramson, it showed the band on a small stage in a television studio, and while it reflected the group's power and intensity, the film received little exposure. The cold hard facts were that Elektra was a small label with a limited budget. There was only so much they could do. Danny Fields, a promotion man for the label at that time, recalls their

efforts: "The group was promoted modestly but enthusiastically. The film was to be in places where The Doors couldn't appear to promote themselves. Primarily, it was for television. But it was just getting their name out that was important then."

"Break On Through" never made it into the Top 100, stalling out at 106 in *Billboard,* but it was popular in L.A. Having a local hit was better than nothing, but as they headed to New York in mid-March for three weeks at the Ondine, The Doors began to wonder if the dream was about to fade.

Things were different in New York. This time the press was waiting for them at the Ondine, standing three and four deep around the tiny bandstand to witness the band's return. Richard Goldstein, Paul Williams, Paul Nelson, and many other top New York critics saw The Doors at their raw, powerful, frightening best and heralded them with some exciting coverage. In *The Village Voice* Goldstein wrote: "A typical East Side opening—with this difference. The Doors are a vital new group with a major album and a sound that grips . . . The Doors are a stunning success . . . make it up to Ondine to find out what the literature of pop is all about."

In the early days, no group played rock better or harder than The Doors and the New York crowds turned out to see Morrison at his finest. He may not have been the majestic concert artist he soon became, but he conveyed a real excitement to the audience. In many ways this second stint at the Ondine made the band. When it was over they were *the* underground band to see. Ray Manzarek recalls the debt L.A.'s most famous band owed to New York: "If it hadn't been for Jac Holzman and Elektra Records, a New York outfit, we wouldn't have recorded. If it hadn't been for the media, the publicity we got in New York, the press and everybody, the radio, and the fans all behind us, there wouldn't be any Doors today."

After their New York triumph The Doors returned to L.A. and appeared with The Jefferson Airplane at the Cheetah in Santa Monica on April 9. The gig was important to Jim in that it was the first time the band topped the bill over their San Francisco rivals. It was also the first time Morrison fell off the stage, toppling a good eight feet during a wild rage. Robby remembers the gig: "Everybody was waiting for us. 'Break on Through' was out and

people were turning on to the album. It was our first really large crowd. Over two thousand."

While back in Los Angeles The Doors also performed at Ciro's and Bido Lito's on the Strip. It was at Ciro's where Rich Linnell first saw the band. Linnell later became a major concert promoter and played a key role in The Doors' career, but at this stage his connection to the band came through Robby Krieger's twin brother. "Ronnie Krieger and I were both going to college in San Diego and he kept saying I should see his brother's band. Finally, I said I'd go with him to see them at Ciro's. Ronnie picked me up and said we had to stop off in Laurel Canyon and pick up the lead singer. When we got to the house, Ronnie said, 'Be kind of quiet, he doesn't like a lot of confusion or talk.' I said, 'Okay, fine.' So we picked Jim up and outside of the introductions I don't think anything was said for like twenty minutes. We dropped him off outside and then went in and plopped ourselves down on the floor in front of the stage. About twenty minutes later the band came out to play and what shocked me was that this quiet, mild-mannered, very unassuming guy was a madman onstage. It was a great show and the music and everything just grabbed me. From that point on I became a huge fan."

In the crowd at Bido Lito's was Pamela Des Barres who was seventeen at the time. "The word was out on the street that everyone had to see this lead singer because there had never been anything like him." In her book, *I'm With The Band*, Des Barres described Morrison as moving "with the unnatural grace of someone out of control . . . he looked like a Greek god gone wrong, with masses of dark brown curls and a face that sweaty dreams are made of." Today, Des Barres still recalls that night: "It was really mind-boggling. There was no modern sexy American icon at that time and he instantly became that for me and all the girls I knew and we never missed them. I saw The Doors play a hundred times."

Wary of Morrison's increasing popularity, Pam came to most of the gigs now and almost never missed one of their performances on the Strip where the groupies were most prevalent. Meanwhile, the album grew in popularity. Ever since KMPX in San Francisco became the first underground rock station, FM radio had been gaining favor with kids and the new medium was giving The Doors widespread air play. FM featured rock music in

stereo that transcended the normal Top 40 mode and *The Doors* became one of the first albums popularized by the "progressive" radio media.

> *When radio dark night existed*
> *& assumed control, & we rocked in its web*

On the AM side of the radio dial, "Break On Through" had established the band with a lot of disc jockeys and people in the music business. Elektra had planned all along to follow with "Twentieth Century Fox" as the second single. There were no plans to release "Light My Fire," although everyone hoped it might somehow catch on as an avant-garde hit among the underground. FM radio changed all that. Despite the album's slow start, progressive rock radio was making it an underground favorite and the song the FM deejays played the most was "Light My Fire."

Ray recalled what happened next to Pete Fornatale in *Musician*: "A lot of AM stations were saying, 'Hey, we're getting a lot of requests for "Light My Fire," but we can't play a seven-minute song.' So somebody said, 'Why don't we cut the solos?' And I said, 'Cut the solos? Wait a minute, man, that's the hypnotic part of the song! That's the part you ride on that goes over and over and hypnotizes the audience. We can't cut that out, that's virtually the whole point of the song.' But, sensible heads prevailed and we said, 'Well, let's see how it sounds.' So we cut the solos out and sat down and listened to the tape and said, 'Great, it works. Let's go with it.' Our producer and engineer cut the tape so nice and clean that no one could tell where it was cut. When I hear the song on the radio to this day, I never know if it's going to be the long version or the short version. After Jim sings 'Fire'—there's like five seconds where we have the instrumental like on the long version, and then the cut happens."

In April 1967, "Light My Fire" was released as a single, but again there was no immediate success. The Doors headlined at Chet Helms's Avalon Ballroom again on the 14th and 15th with The Steve Miller Blues Band, but by now their concern was building because the record had still done nothing nationally.

That same April at the Houston Induction Center, heavyweight boxing champion Muhammad Ali refused to be drafted

into the army, claiming to be a conscientious objector. Young and cocky, Ali was by then the best-known sports figure in the world and had succeeded in rolling sports, politics, and religion into a huge ball of brash bravado. In June, he received a five-year sentence for draft evasion and when asked about his motives, said quite simply, "I got nothing against those Viet Cong." For this he was stripped of his title and lost three of his best boxing years. Although later overturned by the Supreme Court, Ali's conviction drew even more attention to the ever widening Vietnam issue.

In May The Doors did numerous gigs including the Avalon again with The Sparrow on the 12th and 13th. It was here that they first hired a road manager. Rich Linnell remembers: "Ronnie Krieger and I had been going to most of the dates around L.A. and helping out with the equipment because the band didn't have anyone doing it. We were going to go up to San Francisco for the weekend and take the equipment in the van. Well, at the last minute my girlfriend canceled, so I called my good friend Bill Siddons. I told him they'd pay for everything but we had to carry their equipment. Once we got there Ronnie and I would each take one end of an amp and carry it upstairs, but Bill was a lot more energetic. He'd grab an amp in each hand and hustle them up the stairs. This impressed the guys, particularly Robby who was in charge of the equipment stuff 'cause he had the more technical mind. So he gave Bill a job."

The band played the Whisky from May 16 to May 21st and on the 20th did a 6 P.M. show at the Birmingham High School football stadium in Van Nuys. The concert turned out to be their largest to date when over ten thousand people showed up to see them and The Jefferson Airplane. Already the rock rivalry between L.A. and San Francisco was building, and though they were the opening act, a third of the stadium walked out after the Doors completed their set.

On June 3 and 4, the band returned to San Francisco again for a concert at the Avalon with The Steve Miller Blues Band. In June 1967 the Summer of Love was just beginning. Long-haired youths flowed to San Francisco, hoping to reshape the world with flowers, LSD, and slogans like Make Love, Not War and Music and Love Will Set Us Free. A beatnik hangout of the 1950s, San Francisco became the alternative capital and Haight-Ashbury the

Xanadu of the individualist, where the hippies shouted, "Do your own thing!" and people actually did it. A group called the Diggers split from the San Francisco mime troupe and began free theater, free clinics, and free stores and coined the phrase "free love." The prevailing attitude was one of total freedom and tolerance. The kids believed that everything should be shared and no one should be judged. They tried to reach out to those in need and believed that nothing, especially the world, was so bad that it couldn't be changed. The cutting edge of the movement was rock music. The boundless possibilities of a generation unfolding before a nation inspired artists to create and the kids viewed music as their primary source of wisdom and power. *Sgt. Pepper* had become the anthem of the era and The Doors' first album was about to join it as the perfect sound tracks for the Summer of Love.

It was at this time, after doing nothing nationally for several weeks, that "Light My Fire" at last broke into the Top 100 and started climbing steadily. Ray Manzarek and Dorothy were driving down Sunset Boulevard when the deejay on the radio announced a new song by a local group: "The Doors and 'Light My Fire!'" At that moment Manzarek knew they had made it.

In June The Doors acquired some managers to help them organize their blossoming career. Asher Dann and Sal Bonafede were an unlikely team. Dann was one of the most successful real estate entrepreneurs in Hollywood and Bonafede used to manage Dion and the Belmonts. Together they had the business savvy and organizational skills The Doors needed. The band also got an agent, Todd Schiffman, who began to drive their price up, getting them better gigs for more money. "Light My Fire" had been generating enough action on the charts that The Doors headlined the Fillmore Auditorium when they returned to San Francisco on June 9 and 10 to appear with The Jim Kweskin Jug Band. After that it was time to return to New York again to promote the now fast-rising single, but before they left, The Doors picked up a last-minute gig at the now dead Hullabaloo at Sunset and Vine in Hollywood. It would be their last gig in L.A. as a hopeful rock band—they would return from New York as stars in the truest sense of the word.

The gig at the Hullabaloo was so last-minute that there

wasn't even time for advertising and Ray Manzarek didn't even find out until it was time to set up. Waiting by the backstage door, hoping to catch a glimpse of Morrison before the show, was Pamela Des Barres: "Jim arrived without his redheaded girlfriend [Pamela Courson] and we climbed this rickety old ladder up to where they stored the old lighting fixtures and stuff. It was very romantic to my eyes. We had this big jug of Trimar which is sort of like liquid PCP. I was a virgin at the time and we never did go all the way, but we were rolling around up there making out like crazy. The lighting was so diffused and beautiful and I was so high. It was like we were there for an eternity and all of a sudden I heard 'Light My Fire' being played. I thought it was probably in my mind or something. But it was being played for real and Jim heard it and he went, 'Oh my God, I'm on.' So he clamored down this ladder behind the stage and threw the curtain back and went on. And I followed him. I was so high, I didn't know where he was going. I just followed him onstage. I can still see the audience looking up at me. I was onstage with The Doors and I realized I shouldn't have been there. One of the roadies came and took me offstage. I don't think I'll ever forget it."

It was one of The Doors' better nights. Morrison slouched over the mike stand and the Hullabaloo's turntable stage slowly began to spin the band toward a wildly shrieking audience. A sea of girls pressed forward against the stage. Morrison grunted, began squirming, and started singing. The music wove and screamed into one climax after another. Before long Jim was rapping the microphone stand between his thighs, advancing toward the hungry girls who were pressing harder now toward the stage. Then, suddenly, he tripped on the microphone cord and fell to his knees. It happened right in time with a musical peak and the girls screamed all the louder thinking this was the way it was supposed to be. Morrison picked himself up off the floor and shouted the lyrics so he could be heard. Then he grabbed the mike stand and threw it down hard on the stage. The crowd couldn't believe it. Some of the girls up front were frightened, but most of them looked as if they were in a trance, caught in an erotic spell, as they watched Morrison jump up and down upon the fallen stand. Again and again he jumped on the stand, screaming out the lyrics, and the girls up front looked like they were having an orgasm.

After the gig, Pamela Des Barres reports, Morrison drove her Oldsmobile all around Hollywood: "He said the Trimar might be hurting our heads and gave me a lecture on drug abuse, telling me the persona he put forward was an elaborate act, and he really wanted to be noticed as a poet . . . and though no one knew that, it would come out in the end. He was getting his poetry out to the world through this music and ultimately he would be perceived as a poet. On our way to Tiny Naylor's on La Brea, he pulled the car over, grabbed the bottle of Trimar, and threw it out the window into a yard full of overgrown ivy. 'Now we won't be tempted.' We had datenut bread and fresh orange juice while the sun came up, then cruised the silent Strip to a little hotel where he was staying during his feud with the redhead. That was the only time I had my hands on Jim Morrison; he turned out to be very much a one-woman man."

When The Doors returned to New York on June 12 they began a three-week stand at The Scene, the hottest of the city's underground night spots. This time *everyone* came to see them. It was becoming impossible to avoid "Light My Fire" on the radio. The single was screaming up the charts and the album had moved from being a big underground item to significant sales all across the country. Robby Krieger remembers: "The first album was like number ninety, and that was about all it was gonna be, and then came 'Light My Fire' and it went wheee up to number one! . . . It happened so fast that we were still playing The Scene when the song hit the Top Ten. We could have been playing giant places and here we were stuck at The Scene making twenty bucks a night."

On June 16, 17, and 18 the Monterey Pop Festival was held just south of San Francisco. It proved to be a great gathering of people, music, love, and flowers. The hippies were demonstrating they could live out their ideology and the fifty thousand people who attended reflected the brotherhood-of-man philosophy. Music was provided by The Jimi Hendrix Experience, The Who, Otis Redding, Jefferson Airplane, Janis Joplin & Big Brother & The Holding Company, The Mamas & The Papas, Buffalo Springfield, and more. Many of these acts were unknown at the time and Monterey made rock history by showcasing the best and the brightest of rock's emerging artists. It broke ground for a whole new area of musical expression in America and became the first

music festival of its kind. Beyond the music, however, the festival
focused on the growing life-style of the counterculture, the
strong sense of community and purpose that made this genera-
tion different from others that had preceded it.

The Doors were upset that they had not been invited to
Monterey, particularly when The Scene closed for the three days
of the festival and they had to pick up gigs in Philadelphia and
Long Island. The festival had been organized before "Light My
Fire" was released and at that time The Doors were considered
just another L.A. band. Nonetheless, Morrison took it personally
and believed it was because The Doors were becoming a symbol
of L.A. and the festival was a San Francisco thing. After this he
considered himself more of an L.A./New York person, resenting
the San Francisco bands even more than he had before.

But in New York The Doors were bona fide stars. As they
played night after night at The Scene you could almost see the
phenomenon growing. Everyone who was anyone came to see
them. The jet set, politicians, movie stars. One night Paul New-
man took Morrison aside to discuss the title song for a movie he
was planning to produce. Another night Jim swung his micro-
phone out over the audience like a madman and scared pop star
Tiny Tim half to death when he just missed his head. Moments
later Asher Dann, The Doors manager, rushed up to try and stop
him and the two of them got into a bloody fistfight right onstage.

Tom Baker was in New York at this time doing a flim with
Andy Warhol, and when he and Warhol stopped in to see The
Doors at The Scene, Baker saw a different Jim Morrison onstage.
"His performance was a classic one," Baker later wrote, "giving
off glimpses of all our beautiful tragic/comic American Heroes
. . . one moment I saw Brando's 'wild one,' the next James Dean's
'rebel,' then Chet Baker, and finally Elvis."

After the show, Baker and Morrison stood talking at the bot-
tom of the stairs that led up to Forty-Sixth Street when Morrison
suddenly started throwing glasses up the stairs into the street. "I
grabbed his arm and yelled, 'What the fuck are you doing?'"
Baker wrote. "He ignored me and threw another glass up the
stairs, simultaneously letting out with his bloodcurdling scream. I
expected hordes of stoned and angry street freaks or a small
army of cops to come charging down. After one final glass and
scream, Jim turned and was gone. I felt frustrated that he had left

for I wanted to tell him that, finally, I had met someone who was truly possessed."

Stardom gave Morrison an arena to make his self-destructive fantasies come true. The attention intensified his outrageous behavior, especially that part of him that enjoyed dangling people from his own self-styled parapet. Danny Fields, an Elektra publicist at the time, recalls one such experience: "One night we went to Max's in New York for dinner and Jim didn't say a word all night. He even pointed out his order to the waitress. He was acting like a six year old, making everyone feel uncomfortable. There was another night at Max's when we were sitting around the table and he was too stoned to go to the bathroom so he took an empty wine bottle and pissed into it. He kept doing it all night. At the end of the evening Jim was smiling and in good spirits. The waitress was cleaning the table and he told her that since he couldn't finish the wine, she could take it home and enjoy it. The waitress was so thankful—Jim Morrison gave her something!"

When The Doors played their last set at The Scene owner Steve Paul locked up and gave a party for the band who had been the biggest draw in the history of his club. Morrison liked Paul and, in fact, used to come down to the club early so he could hang around and "listen to him rap." That last night they polished off a case of champagne and everyone was in a mood of celebration. Robby did his imitation of a shrimp and Jim blew up a rubber and let it go like a balloon, whereupon it landed in a sophisticated starlet's champagne glass. There was no question in anyone's mind that The Doors had made it. The road ahead was filled with bright promise.

Back in California on July 3 The Doors played the Santa Monica Civic Auditorium and on July 15 they did two shows at the Anaheim Convention Center with The Jefferson Airplane. The evening show drew eighty-five hundred people. Morrison's voice was hoarse, sometimes inaudible, and often off-key, and he was looser onstage than he had ever been before. He spoke out whatever came to his mind between songs and even during songs and threw lit cigarettes at the audience. Meanwhile, Elektra was pushing and promoting for all they were worth as "Light My Fire" closed in on number one. In typical fashion, Morrison was not making it easy for them. Danny Fields later elaborated in *Relix*

magazine: "In my continuing publicity campaign for the band I had arranged a telephone interview from L.A. to New York with Gloria Stavers of the trendy *16 Magazine.* The only way of guaranteeing that it would take place according to plan was for me to fly out to L.A., get Jim to a phone, and hook the two together for the interview."

According to Fields the interview went somewhat poorly, but that was only the beginning of a difficult evening. Morrison was supposed to follow Fields in his car to the home of actor John Phillip Law where they were to stay. All the way there Jim kept slowing down and staying back just out of sight, so Fields had to keep pulling over and waiting for him. Once they arrived Fields decided he would attempt to elevate Morrison's tastes in women. "Jim always made himself available to these trolls, druggies, and groupies. I felt that as his publicity agent I should try to do something about it. Two lady friends of mine were at the Castle—Nico and Edie Sedgwick. Nico was one of the Warhol girls and had been a cover girl in her native Germany. She sang with The Velvet Underground and she loved to drink as did Morrison. Nico adored dressing in black leather, something else I found her to have in common with Jim. She had long hair that accentuated her ageless beauty. I thought Nico and Jim would make a great combination."

When Fields introduced the two all they did was stare at each other. "They were like two cats. They watched each other's movements, followed each other around the house, but did not say one word at all! That night, Jim wanted to get a little high, so he smoked about a quarter of an ounce of hash that I'd had, swallowed my entire stash of ups, dropped a few hits of LSD, and downed it all with two quarts of vodka. I saw him do all of this and he was still going strong! He got so stoned that I started to get nervous. I was worried that he was going to decide to go for a ride, so I went down to the car and hid the keys."

Moments later Morrison did decide to leave, but fortunately couldn't find the keys. The rest of the evening was pretty quiet until about 3 A.M., Fields remembers: "I was in my room when I looked out of my window into the Spanish-style courtyard . . . Jim and Nico were standing there under the full moon in the middle of the fountain. Jim was pulling Nico's hair and she was screaming. He never said anything. He just kept pulling her hair.

Suddenly he ran into the house and Nico in her deep voice just stood there in the water sobbing. I had just recovered from that scene, when I glanced up, and there was Jim—stark naked—dancing along the edge of the parapet. I watched him until he bopped out of sight . . . He had to be the center of attention."

During the summer of 1967 while "Light My Fire" was tightening its grip on radio stations across America, riots broke out in the ghettos of 127 U.S. cities. Across the country the poor and oppressed blacks were burning down their own communities in frustration. In July, the Newark, New Jersey, riots claimed the lives of twenty-six people and injured fifteen hundred with an estimated $10 million in property damage. That same month in Detroit it was even worse. Over forty people died, two thousand were injured, and nearly fifteen hundred buildings were burned. As the Detroit fires raged, one local radio station played "Light My Fire" over and over again. In the wake of the burnings the song took on a new meaning in an especially hot summer in America.

On July 28 The Doors opened a three-night stand at the Fillmore Auditorium with The James Cotton Blues Band and Richie Havens. The reviews described them as "first-class instrumentalists" with "great depth." Near the end of the month the band got the call from Elektra they had been waiting for. The label informed them that "Light My Fire" was going to be number one on the next national chart and on July 29 the record officially became the most popular one in America. Robby Krieger remembers: "One of the highlights of the whole Doors thing for me was when I was listening to the Top Five countdown and 'Light My Fire' had pushed out 'Cherish' for number one. It was a thrill for Elektra too. They'd never had a number one song. They were going nuts."

"Light My Fire" was number one for three weeks and on the chart for fourteen weeks. It was Elektra's first Top 10 record after eighteen years of trying and broadened The Doors' base of popularity beyond the underground. With it, the album's sales soared to number one as well and stayed on the charts for two years. "Light My Fire" made an indelible imprint on the Summer of Love and became The Doors' signature tune. That one song es-

tablished for Morrison and The Doors an identity and an image to which the audience could and did respond with an intensity far exceeding anyone's expectations. The power of that single was a heady way for a band that had been together less than two years to break into the big time and it left them with only one way to go—down, slowly at first, but down just the same. "Light My Fire" may have been the sixties' finest song—that infamous keyboard intro riff rising into an intense lightning bolt of wailing passion that crescendos with Morrison's primal scream, a scream that now seems to signify the communal orgasm of that generation and its decade and a band that would flame out and fall silent all too quickly.

You know that it would be untrue
You know that I would be a liar
If I was to say to you
Girl, we couldn't get much higher

THE SHAMAN

The Doors' debut album stood out in a year that was brimming with stellar first efforts—Buffalo Springfield, Jefferson Airplane, Jimi Hendrix, Cream, Moby Grape, Country Joe, and others. It was a magical time and just about everyone under thirty was floating on a psychedelic cloud in the Summer of Love. But underneath it all was a restlessness. The youths of America were starting to get angry. The only response their efforts toward peace and love were generating from the Establishment was laughter at "the crazy hippies singing in the park." Rising slowly among them now was the need for a stronger stance. And The Doors fit right in. The Doors' music was the music of outrage. It didn't soothe as much as it assailed; it didn't inspire as much as it forewarned. And so, without really planning it, The Doors found themselves becoming an important part of the revolutionary hope of America's youth during that renaissance of spirit and emotion in the late sixties.

To the kids of 1967 The Doors were Darkness incarnate—
wild, rebellious, and blatantly sexual, primitives who measured
life only by the compulsive desire to "break on through to the
other side." Their world was the "endless night," a nightmare
jungle where reality was shrouded by both holy and satanic veils,
where joy equated only with power and where fear was abated
by pure daring. They represented concepts as vague as "erotic
politicians" and "unendurable pleasure indefinitely prolonged."
They were what everybody's parents always feared this world
was coming to—"the messengers of the devil, the patricide kids,
and the Los Angeles branch of the Oedipus Association." Yet,
they were also art. They seem to have been the band the music
critics were waiting for and their first album was hailed as a mas-
terpiece. The Doors were attractive and bizarre enough to shoul-
der the weight of any lofty praise or imaginative description the
press could come up with. They were called the "acid evangelists
of rock," "the warlocks of pop culture," and more. Said one re-
view of them: "The agonized grunts and screams that fly from Jim
Morrison's angelic mouth are indeed as enigmatic as the idea of a
butterfly screaming. The Doors are saying there are screams we
don't hear and they're trying to give them shape. Morrison is an
angel; an exterminating angel. He and The Doors are a demonic
and beautiful miracle that has risen like a shrieking Phoenix from
the burning bush of the new music."

Or imagine how Morrison must have felt reading this in
Crawdaddy "*The Doors* is an album of magnitude . . . there are
no flaws; the Doors have been delivered to the public full-grown
and still growing . . . The birth of the group is in this album and
it's as good as anything in rock. The awesome fact about the
Doors is that they will improve." Paul Williams, the editor of the
magazine, also described the debut album as follows: "This is an
album of overwhelming intensity; a veritable tidal wave of
pungent electric sound that heralds a major breakthrough in con-
temporary music . . . 'The End' is rock performing, audience
reaching and communication as it must be and never has been
before." Another critic, Gene Youngblood, said at the time that
"the Beatles and the Stones are for blowing your mind, but The
Doors are for afterwards, when your mind is already gone."

Even the name of their record label, Elektra, was apropos.
According to Greek legend, Electra was the daughter of Agamem-

non. When her father was murdered Electra and her brother avenged the death by slaying her mother, Clytemnestra, and her lover, Aegisthus. In modern psychology an Electra complex describes a daughter falling in love with her father. Maybe it's not a true tale of Oedipal patricide such as Morrison's "The End," but the story of Electra must have certainly impressed Jim Morrison as an interesting name for a record label. Jac Holzman describes the role the label tried to play: "What most of the producers and artists hope for, and what I think Elektra as a company is almost a midwife to, is a stimulation of the imagination. They're creating scenarios without pictures and you supply the pictures in your mind; they supply the mood and the words."

The Doors had it all—they had great commercial success, but were still regarded as artists first and foremost. That was one of the things that had made the Beatles immortal and indeed The Doors' album had usurped *Sgt. Pepper* at the top of the charts. "What we are doing is art, not just popular music, and art is timeless," Morrison said. "You might buy a book of our lyrics the same way you might buy a volume of William Blake's poetry."

With this kind of image and these kinds of expectations to live up to, The Doors returned to Sunset Sound Recording Studios in August to record their second album. While they must have felt considerable pressure at trying to follow up such a great work, they also had a sizable ace in the hole—a wealth of material left over from Morrison's high school notebooks and Venice rooftop days in which to draw on. Many great songs had to be omitted from the first album and most of them had already been polished and perfected. Paul Rothchild was again at the helm and Bruce Botnick engineered. This time around all the tracks were Doors' originals with Robby supplying the lyrics to "Love Me Two Times" and "You're Lost Little Girl" and Jim all the others. The music and arrangements were the usual collaboration of all four band members.

The album took three months to record and The Doors experimented much more with the art of recording. Sunset Sound had expanded their recording gear to eight tracks and The Doors took full advantage of it. For its time, *Strange Days* was an excellently produced record and contained innovations previously considered the exclusive preserve of The Beatles (who were still using four-track equipment at the time). In the studio the four

Doors functioned as a tight team. Morrison's voice was a bit hus-kier now and Krieger's guitar began to muscle Manzarek out of the limelight, but Ray responded by playing more instruments which added a depth of sounds. Densmore again showed off his stuff, often playing without cymbals for an ominous effect. Having eight tracks allowed producer Rothchild to bring out new tex-tures from the band. They now had more freedom to overdub (record on top of an existing track). Manzarek elaborates to Don Paulsen in *Hit Parader:* "In *Strange Days* we laid the basic track and then said, 'Let's put a little extra guitar in this section and let's put a harpsichord here or a little marimba.' There's all kinds of things in there. . . We added a Hohner Clavinet and a harpsi-chord played through a Baldwin amp, which was wonderful. We brought in the late Paul Beaver, a real genius, to put some Moog Synthesizer on a couple of cuts. *Strange Days* and 'Horse Lati-tudes' may have been the first time a synthesizer was used in rock 'n' roll."

Morrison saw the second album as an expansion: "We ex-panded the song form by using plot, the spoken voice as an in-strument, and sound effects. Our first album was a blueprint of where we are going musically. The second album shows that we're part way there."

From having the vocals on the title track being echoed by a synthesizer tone to the use of marimba on "I Can't See Your Face in My Mind" to the one-minute thirty-second poetic freak-out of "Horse Latitudes," the production on the album is a masterful blend of pure music and sonic effect. The most obvious example of pure studio technique occurs in "Horse Latitudes," the resur-rected Morrison high school poem. The basic track of windlike sound was obtained by hand winding a tape of "white noise" to amplify the hiss, over which was dubbed a cacophony of random sounds (including bottles dropped in a trash can) and Morrison's semihistrionic incantation. One of the more interesting sounds comes from playing the inside of the piano. "That's a standard Doors trick," Manzarek explained to Paul Laurence in *Audio:* "Getting your hands on the strings . . . scraping on them, pluck-ing them, hitting on them with drumsticks and putting a delay on it, so if you hit it once, the delay sound keeps happening so it sounds like a lot of people doing it. I imagine everyone got their fingers in for a couple of plucks; it was too much fun."

Other examples of studio experimentation crop up throughout the album. Densmore's cymbal track in "I Can't See Your Face in My Mind" was recorded backwards which was very unusual for the time. Manzarek also did some backwards playing on "Unhappy Girl": "It's a backwards piano. Boy, that was a bitch. I wrote the whole song out backwards. They played the song, the tape came back to me in the earphones, *backwards*. But the beat was there. I started on the lower right-hand side of the chart rather than the upper left-hand side, and read backwards as the song progressed."

The title cut, "Strange Days," features rare-for-the-period electronic voice processing and remains one of The Doors' all-time finest cuts as does the spooky "Moonlight Drive." Manzarek remembers recording "Moonlight Drive": "When it came time to record it, we said . . . we've done that beat [funkier and bluesier]. Let's start this song differently. So we fooled around for a while and I sat at the piano and said, 'Wait a minute, I got it—we're gonna do a tango.' And they said, 'We're gonna do *what?*' 'Don't worry,' I said, 'it's going to be a *rock tango.*' It worked out fine in the end."

The Sunset Sound echo chamber contributed to the liquid guitar sound on "Moonlight Drive" which was done with a slide on an old National electric guitar at low volume. While Krieger's favorite solo occurs in "When The Music's Over," he also likes the one in "People Are Strange" because he did it in one take. Robby describes how the latter song was written: "One day Jim was over at my house . . . where John and I lived together up in Laurel Canyon . . . and he was real down in the dumps, he was on one of his depression trips where he was gonna die and he just didn't think it was all worth it anymore and life was horrible, and so we spent all night talking him out of killing himself and stuff, like we did many times, and finally in the morning he said, 'Well, I'm gonna take a walk up to the top of the hill,' and he came back and he was in the best mood I've ever seen him in . . . 'Man, I've just seen the light, man, it was so beautiful up there and I just wrote a song on the way back down the hill and here's the words'. . . ."

Not all of the experimentation in the studio was of a technical nature. Rothchild wanted something special for the vocals to "You're Lost Little Girl." He suggested that they hire a hooker

to go down on Morrison while he sang the song, but Pam objected, deciding she would rather do the job herself. After twenty minutes of silence from the vocal booth the experiment was abandoned. Something that worked a little better was when Rothchild turned off all the lights in the studio and recorded "I Can't See Your Face in My Mind" with candlelight and burning incense. He told the band to imagine that they were in a Japanese garden with a beautiful girl. It was an amateur attempt at hypnotism to be sure, but it set the tranquil mood he wanted for the song.

Like "The End" on the first album, the recording of "When The Music's Over" was a real highlight of the sessions. Whether The Doors felt obligated or were even trying to recapture the epic magic of "The End" is open to question, but "When The Music's Over" is certainly far more than a sequel. While it is neither as ominous nor bizarre as The Doors' showstopper, it is more fluid musically and understandable lyrically than "The End," which entitles it to a place on the more cohesive "Strange Days."

The song deals with a variety of subjects from the music being our only friend to man's wanton destruction of nature's greatest and most beautiful gifts—the earth itself. Perhaps this was the shaman part of him trying to spread the Indian message of love for Mother Nature and reverence for the planet. As with many Doors songs, Morrison wrote the words and both he and Krieger contributed some melody ideas and then the entire band arranged it. In a similar fashion to "The End," the song developed night after night in the Sunset Strip clubs as a constantly changing free-form piece. "When The Music's Over" embodies much of what The Doors were trying to do, and fittingly, it was the last song recorded for the album. On the afternoon they were to begin laying the track, Morrison was nowhere to be found. After waiting around awhile the band went ahead and did the basic track with Manzarek singing to provide the vocal cues. Amazingly, the track was done in only two takes. When Morrison came in later that evening he put his vocal down in two takes as well—without missing a single cue.

Paul Rothchild was particularly pleased with the album: "There are *no* weak songs on it," he told Blair Jackson in *Bam*, "but it goes beyond that. Jim was singing with the confidence of a man who had just put out The Doors' first album. . . We knew we

wanted to explore additional sounds and rhythms, because we had decided from the experience of making the first album that it would be difficult to sustain a career with a band consisting only of organ, guitar, drums, and a singer. So our challenge was to expand The Doors' sound without overproducing it."

The Theater of Cruelty

Though "Light My Fire" was number one, life was still not a bed of roses for The Doors. One of the first thorns of big-time success came on August 12 at Forest Hills Tennis Stadium in New York when the band opened for Simon and Garfunkel. Jac Holzman had played a tape of the band for Paul Simon maintaining that The Doors were going to be the biggest group in America. Simon agreed and allowed them to open at Forest Hills, but when he stopped by their dressing room to wish them luck Morrison was cool and distant. Onstage Jim had the same attitude and the thirteen thousand folk lovers in attendance were not the least impressed. "I don't think I ever felt worse on a stage then I did at the Forest Hills Tennis Stadium," Ray Manzarek recalls. "I didn't know whether I was playing Forest Hills or Forest Lawn Cemetery. We were in hell. That was one of the all-time lows."

After the band's set, Morrison walked offstage in a slump. He had been rejected before, but that was in cheap bars that were mostly devoid of real music lovers. This was thirteen thousand people in Forest Hills Stadium. Danny Fields, Elektra's Publicity Director, asked Morrison what was wrong and he said, "They hated it. They laughed at me." Fields said later that Morrison was so angry he wanted to kill the entire crowd.

The band bounced back in their hometown, headlining the Cheetah on August 27 with The Nazz and the Watts 103rd Street Rhythm Band as the opening acts. With the success of the record the live performances took on a whole new importance. As with any true rock group, the records were best appreciated after seeing the band in concert. Despite disasters like Forest Hills, being new was usually an advantage to The Doors in those days. In most cases they were performing for people who had never seen them before and since the media had not yet locked on to

an image, the audience didn't have any preconceived notions. They came with open minds.

Although there were still a few rough edges in these early concerts—Morrison's approach was more geared to small clubs than concert halls and the band's sets were often too short—the impact they were making upon audiences was far more important. It was a different experience from the usual rock concert. Something new and fresh was happening even if it conveyed a slight unearthiness, an eeriness. Robby describes it: "In the beginning, we were able to weave this psychic web and people became caught up in it. They had to learn to get into our music. They had to let the music sink into their unconsciousness so they could actually feel it. It had to reach their soul."

In September, while the recording sessions were still underway, Elektra released "People Are Strange" as a preview of the new LP and The Doors went back out on the road. On the 9th, they played the Village Theatre on the Lower East Side in New York with The Chambers Brothers. With the strength of a number one record behind him, Morrison became even more outrageous onstage and the shows more theatrical. When the band was introduced at the Village Theatre he grabbed hold of the curtain and rode it halfway to the ceiling, dropping down to a huge ovation. Throughout the show he paced the audience, moving them from rising anxiety to unleashed excitement and over-the-edge fright and joy. During "The End" he spoke the Sophocles section in soft, ominous tones and then fell forward on the stage, worshipping a girl in the crowd who had knelt in homage to him. Then suddenly he flew into the air in a leap and began swinging the microphone around his head, moving closer to the audience with increasingly violent strokes as if prepared to release . . . something . . . everything. And the crowd felt it. A feeling of impending doom pervaded the entire audience—as if surely one of them was about to die. "This is the end," Morrison sang softly, "my only friend," and with those words the crowd was suddenly released. The tension broke into a sea of relief. After the show, *Crawdaddy*'s Paul Williams wrote: "The Doors, in person, have become the best the West has to offer . . . the best performers in the country, and if the albums are poetry as well as music, then the stage show is most of all drama, brilliant theater in any sense of the word."

Poetry and high drama had been essential to The Doors' peculiar passion play from the outset. From his woodshedding days in the L.A. clubs, Morrison had developed a keen sense of theatrics which he integrated with his song and poetry ideas. "I didn't start out to be a member of a band," he later said. "I wanted to make films, write plays, books. When I found myself in a band, I wanted to bring some of these ideas into it."

Onstage now he would shout incoherently one moment and stand silently clutching the microphone stand the next. Often he would close his eyes and pause for long periods of time, milking the moment. Morrison had learned that stopping gets an audience's attention even faster than shouting and tended to pause whenever he felt he was losing his grip on them. Sometimes he would drop lifelessly to the ground as if suddenly struck down by all the gathered voltage in the mountains of amplifiers behind him. This onstage unpredictability merged with the improvising of Manzarek, Krieger, and Densmore to create an air of mystery around the band.

The type of theater that so influenced Jim Morrison's stage performances was called the Theater of Cruelty and was originally developed by a Frenchman, Antonin Artaud (1896–1948), in a number of essays and manifestos published between 1932 and 1938. Artaud's approach was primitive, carnal, and so violent that the audience was simultaneously assaulted and exalted, stunned and benumbed. Beginning with long hair and wild patterns of dress, rock music became very visual and very close to Artaud's theater, a theater meant "to break through language in order to touch life." The colorful descriptions contained in his famous "First Manifesto" read like newspaper articles of the late 1960s describing the Avalon Ballroom or the Fillmore East.

Artaud was a recognized genius, an eccentric, a poet, an actor, and a director who also spent nine of his last eleven years in tragic confinement in asylums for the insane. Of the phrase "theater of cruelty," he had this to say: "This Cruelty has nothing to do with Sadism or Blood . . . I do not cultivate horror for its own sake . . . Without an element of cruelty at the root of every spectacle, the theater is not possible. In our present state of degeneration it is through the skin that metaphysics must be made to reenter our minds. The action of theater . . . impelling men to see themselves as they are, causes the masks to fall, reveals the lie,

the slackness, baseness, and hypocrisy of our world . . . revealing their dark power, their hidden force, it invites them to take a superior and heroic attitude they would never have assumed without it . . . we need a theater that wakes us up: nerves and heart."

I

The chief difference between Artaud's vision and others is that the spectator was to be directly involved. Above all, the Theater of Cruelty is designed to promote a catharsis of the most basic instinctual appetites and fantasies. "The theater," he wrote, "will never find itself again except by furnishing the spectator with the truthful precipitates of his dreams, his taste for crime, his erotic obsessions, his savagery, his chimeras, his utopian sense of life and matter, even his cannibalism."

A number of repertory groups and theater companies have experimented with and advanced the concepts originated by Artaud in the Theater of Cruelty, but Jim Morrison was the first to successfully apply it to popular music. In the Depression and war years of the thirties and forties the theater made life tolerable for many. In the Establishment/counterculture clash of the sixties the rock concert provided a similar escape. Morrison believed that bringing suppressed problems to the surface rendered them less potent. If you can watch someone fighting it out with his hang-ups onstage, you might be able to gain a little ground on your own. Rock music is ideally structured for this in that the audience is used to seeing themselves in their idols. When the legions of Doors fans watched Morrison express his frustrations and battle his inner conflicts, they were better able to contain their own.

Morrison was well-suited to this approach. Under the slowly shifting shapes of the light show he offered an astonishing range of personal images. One moment the masculine lover, the next an innocent maiden, then a vulgar hustler or a cuddly child, a crazed demoniac or an angel by Michelangelo. He was a multiple personality, an image that could only be internalized in much the same way that real stars, celestial ones, are photographed—through extended exposure to distinct, but ever distant images. Like the theater itself, the power of the whole was

greater than the sum of its parts. Jim Morrison was a human the-
atricon.

Morrison wanted to blend rock and drama to create a new
theatrical form. He and Manzarek talked of using primitive masks
and a dummy of a woman in concert (part of the initial stage
vision of "The Celebration of the Lizard") and the theatrics he
employed during "The End" rivaled many a full-scale dramatic
performance. The Doors were in search of total sensual contact
with their audience. "We want our music to short-circuit the
conscious mind and allow the subconscious to flow free," Man-
zarek said at the time.

Of course, all of this was a little strange to Middle America.
The Doors became one of the first long-haired groups that played
the Bible Belt and these concerts met with sporadic success at
best. The band's first appearance in the Midwest was on Thursday
September 14 at Musicarnival, a tent theater-in-the-round located
ten miles outside of Cleveland in Warrensville Heights. The the-
ater's public relations director had a feeling the audience was in
for a "different kind of an evening" when before the show Mor-
rison walked toward the dressing room and then suddenly
dropped down on his hands and knees and crawled in. By show
time, The Doors had attracted only seven hundred people.
Dressed in black leather, Morrison said, "Where is everybody,
man?" Jokingly one reporter answered, "Maybe Cleveland isn't
ready for you." Morrison sneered and said, "They will be. Wait
until next time."

To the adults of some of these Midwestern cities The Doors
probably looked like outlaws pulling into town. To them long hair
represented drugs and liberal ideas and that was downright scary. In
more ways than one. John Densmore remembers: "L.A., New York,
San Francisco were hip, into what we were into. Diners in Ohio
called us fags for wearing long hair. Morrison was devastating in
those days. He wore his leather pants twenty-four hours a day and
looked like some kind of swamp lizard out on the border."

Guerrilla band inside the town

The Doors didn't exactly endear themselves to the folks of
the Bible Belt either. Imagine what Midwesterners thought when
they read this statement by Ray Manzarek: "We're saying that

you're not only spirit, you're also this very sensuous being. That's
not evil, that's a really beautiful thing. Hell appears so much more
fascinating and bizarre than heaven." Although they were playing
to jam-packed arenas in hipper areas like New York City one
night and half-filled halls in the sticks the next, the size of the
crowds never bothered Morrison, but their reaction did. The re-
sponse from those unfamiliar with the group's music was not
nearly as good as it was from those who had heard their records.
The Doors were simply not that digestible the first time around.
They were very strange compared to the likes of, say, The
Monkees or Paul Revere and the Raiders. The Doors were bizarre
and in the Midwest that bordered on insanity.

Morrison was capable of doing just about anything at any
time and even seasoned pros were sometimes made nervous by
his unpredictability. Bill Graham, the legendary concert pro-
moter who brought rock to the Fillmore, Winterland, and other
venues, maintained that The Doors were usually easy to work
with except for one night in late 1967, which he described in the
July 3, 1981, issue of *Bam.* "I was in the back of the Fillmore
watching The Doors when Jim started swinging the microphone
like a lasso, making the swirl larger and larger each time he
swung it around. It started with three or four yards of cord, but it
kept getting bigger until eventually the swirl went beyond the
edge of the stage and over the front of the crowd. I was afraid he
was going to hit somebody with the damn thing, so I started to
work my way through the crowd, pushing my way to the front. I
thought that if Jim saw me he'd stop. Well, when I got about
fifteen or twenty feet from the stage, the microphone *did* finally
hit someone. There were a couple of thousand people there that
night, and I always thought one of the miracles in rock 'n' roll
that I went through was that it was *my* head that it hit. It really
conked me pretty hard. So after the set I went upstairs and said
to Jim, 'Thank God it was me that got hit. We could've had quite
a lawsuit over that one.' Jim apologized profusely. He seemed
genuinely sorry. A couple of months later when The Doors came
back to San Francisco, the group presented me with this big gift
box. I opened it up and inside was a construction helmet on
which they'd painted 'The Morrison Special.'"

Morrison was becoming looser both onstage and off. While he
had pretty much confined himself to minor shenanigans such as

hanging out of windows or being rude in restaurants on the pre-
vious out-of-town dates, he now felt free enough to indulge him-
self on the road. One of the most publicized escapades occurred at
a performance The Doors gave that fall for the Yale University
crowd. After the concert, Jim apparently decided to climb the
campus' sixteen-story bell tower with a local coed. When he was
two hundred feet above the heads of a crowd of terrified onlook-
ers, he swung out on the bell tower shutter—stark naked! Natu-
rally, the police arrested him and the papers loved it.

Another stop on this tour was Washington, D.C., near where
Morrison's parents were now living. Steve Morrison at age forty-
seven had become the youngest admiral in the navy and was
assigned to the Pentagon, moving the family to Arlington. It wasn't
until well after the release of the first album that Steve and Clara
became aware of their son's new career. To them Jim had long since
disappeared into L.A.'s "beatnik" underground. They had heard he
had some vague notion of starting a rock band, but didn't take it
seriously. Then a friend showed Andy Morrison the first album
and Andy recognized his brother. He rushed home and played
the record for his parents. When the album was first played in the
Morrison home, Clara actually seemed to like most of it, but the
commander sat hidden by his newspaper, pretending not to listen.
When the Oedipal section of "The End" came on, the newspaper
began to shake as if with trembling or rage and kept shaking until
the completion of the song. But the elder Mr. Morrison didn't say a
word and has never once publicly commented on his son's career.

Clara, however, made a determined effort to reconnect with
her son, whom she hadn't spoken to for well over a year.
Through Elektra Records she was able to reach Morrison on the
phone and ask him, please, to come home for Thanksgiving.
Whether he would have acquiesced at that point is debatable, but
the next words Clara said assured that he would not. "One thing,
Jim," she added. "Will you do your mother a big favor? You know
how your father is. Will you get a haircut before you come
home?" After he had said good-bye, Morrison turned to one of
the roadies and said, "I don't want to talk to her ever again."
Thus, a mandate was so issued and when Clara tried to come
backstage at the Doors' show in Washington, D.C., she was con-
tinually diverted and discouraged. Morrison never saw or spoke
to her again. Money and power now ensured that his world

didn't include anything in it he didn't want. And, among other things, that meant his parents.

Why was Morrison so adamant about not reconciling with them? No one knows for sure because most of the time he refused to discuss his parents and any answers he would have given at the time would have probably been intentionally misleading anyway. Perhaps the answer lies in a dream that Morrison once described. "I'm a baby on this beach," he told a friend, "this beautiful beach and there are all these grown-ups around. Only I've never seen any of them before. And two of them pick me up and play with me and I want them to be my mother and father, they're so beautiful! And when I wake up, I'm always looking at a motel ceiling . . ."

A longing for family & the
safety magic of childhood

Image Makers

The Doors were now a viable commodity selling millions of records and earning close to ten thousand dollars per night—a sizable income that filtered through many hands from the consumer to the record store and the distributor to the label, the manager, the producer, the agent, the concert promoter, the road manager, the roadies, and more. They were becoming an industry. There are two words in the term "music business" and the biggest one is "business." Rock is hip but it's also driven by money and if you are the critic's favorite but you fail to make the Top 20, the music industry couldn't care less. They want stars who are "dynamic," but their dynamism is spelled in dollars and cents.

Like any product, The Doors had to be packaged and promoted. Normally, the record label would have created what they felt was a marketable image for the band, but Morrison had already taken care of that. His image had been created amid the drab yellow walls of George Washington High School, refined at UCLA, and perfected on Sunset Strip. The next step for The Doors then was a media blitz to solidify their image with the public. With success came the image makers—the media moguls who descended on Jim Morrison like celluloid vultures determined to milk his full potential as a sex symbol and sell their

wares or exhaust and overexpose him in the process. But Morrison was ready—indeed he had no intentions of shunning the press like Dylan or cursing them like Lennon—he wanted to use them. In the naïveté of youth he was convinced he could give them everything they wanted and still not exhaust his mystery. The twenty-three-year-old Morrison believed that "only shallowness could be overexposed and that only those who are not photogenic have anything to fear from photographs."

Morrison oozed sex, and in the bizarre world of pop commerce, eros is a very salable commodity and sex symbols get rich. It was a simple matter of arithmetic. In 1967, 75 percent of all singles and 45 percent of all LPs were bought by girls between the ages of twelve and seventeen. *16 Magazine* had an official circulation of one million teenyboppers but another four million friends read it for free. In fact it was the late Gloria Stavers, then editor of *16*, who introduced Morrison to the camera as a living entity with "a spirit of its own." As editor of the most powerful teenage magazine, Stavers was a star maker who some said had made it with many of the teen idols she handpicked for her covers, but her late-night meeting with Morrison in her Manhattan apartment was the beginning of an intimate friendship. She took out her camera and said: "It's not just a lens you look into. It's an opening. A doorway that you pass through and when you do you may be whatever or whoever you choose to be—a lover, a killer, son, animal, or a Knight Templar. You may seduce, terrify, amaze, mystify, or cast a spell. All you have to do is dance for it and the camera will reflect your persona to the world."

Camera, as all-seeing god, satisfies our longing
for omniscience

"Jim was a natural—like James Dean and Marilyn Monroe," Stavers later remembered in *Relix* magazine. "He took to the camera like a lover to the beloved. It was utterly fascinating to photograph him. During the sessions we circled each other like curious lions. He loved it. That first night he said to me, 'Oh, I see—I am the snake and you are the flute,' and I said, 'Exactly.'"

Morrison could relate to this imagery and for the rest of the night the long session vibrated with his own special kind of madness. No doubt, in the end, the snake won. "Some very sensitive

and intuitive performers—particularly luminescent stars—instinctively perceive the hidden magic of the camera," Stavers later said. "They are, so to speak, able to 'enter' the camera and to surrender up to it some of the mysteriousness of their inner being. Replications of such stars in these moments are piercing and unforgettable. They stay with us forever. One night when we were in the midst of such an exotic saraband Jim suddenly asked me, 'Is is true that each time I look in there [the lens] and you shoot me, you take a piece of my soul?' 'Yes,' I replied. 'It is an act of love.' He considered this for a moment and then, in a very soft voice, said, 'Love is an invitation to larceny.' 'Yes. It is,' I said. 'And I am accepting the invitation when I look in?' he asked. 'Yes,' I said. A strange sadness seemed to sweep over him. After a few beats he said, 'Then sometimes I won't look at you. Some things I will keep secret.' And he turned away for a while, back into his private and inviolate inner world. The quality that Morrison has got is that anybody can read what they want into him. The teenagers see their thing. The secretaries in my office have become entranced with him. The New York hippies at the Fillmore dig him. There's something for everybody. But it's still whole. He walks through the fire and he comes out whole. He's left impressions on me that are lasting."

Morrison felt that most reporters and critics used him and therefore he was totally justified in using them. From the start he was exceptionally good at it. He deftly manipulated his interviews and resorted to ardent distortions when answering direct questions. He considered interviews almost as a separate art form unto themselves, opportunities to spontaneously create prose poems that fit the moment and still expanded upon the mystique that he was crafting. Like the best of the advertising pros, Morrison spun out vivid slogans one day and pages of multilevel commentaries wrought with symbolism and hip proverbs the next. He knew he had the press in his hip pocket.

W/ the divine mockery
of words

Later he admitted to Bob Chorush in the *L.A. Free Press:* "I think that more than writing music and singing, my greatest talent is that I had an instinctive knack of self-image propagation. I

was very good at manipulating publicity with a few little phrases like 'erotic politics.' Having grown up on television and mass magazines, I knew instinctively what people would catch on to. So I dropped those little jewels here and there—seemingly very innocently—of course just calling signals."

The media people loved Morrison. He was not only good-looking, but articulate, intelligent, and usually spouting a steady stream of enticing and vaguely menacing quotes. The teen magazines saw him as a gift from the gods with the most photogenic face since Elvis Presley. The underground press locked on to his artistic and revolutionary side. Both seized upon Jim Morrison as the perfect fuel for their copy mill and the image they created emerged full-blown as some sort of messiah come to enlighten and lead America's youth. No wonder the Establishment got worried. They were facing someone bigger than life.

Joel Brodsky took many of The Doors' best-known photos including the back cover of the first album, the award-winning cover of *Strange Days,* and its famous inner sleeve. In the fall of 1967 he shot what has come to be known as the "young lion" photos, by far the most publicized of the thousands of photographs taken of Jim Morrison. Jim had his shirt off for most of the shots and the group photos were taken with the other three Doors in black ponchos positioned against a black background so only Morrison's figure and the three heads would appear in the photograph. "I always thought it was sort of funny that in the pictures of Morrison from that session, which were the most used, Jim was totally plastered," Brodsky commented in *Bam* Magazine. "The Doors were among the brighter groups I'd shot at that point. They had a visual orientation and seemed to understand the potential of a good photo session. Initially, there seemed to be a little jealousy that Morrison was being put so up front in the photos, but basically the others understood that Jim was the sex symbol and an important visual focus for the band."

After Brodsky finished the group photos he went to work on individual shots and decided to save Morrison for last. "I knew I was going to be spending the most time with him, so I didn't want them to have to sit around and wait too long. Well, while this was going on, Jim was drinking quite a bit. So by the time I got to shooting the individual shots of him, Morrison was pretty loose. Near the end, he was so drunk he was stumbling into the

lights and we had to stop the session. He wasn't a wild drunk—
actually he was kind of quiet—but his equilibrium wasn't too
terrific. Still, he was great to photograph because he had a very
interesting look. It seemed like a good session to me, and then a
week or so later we ran one of the photos in *The Village Voice*. I
heard they got something like ten thousand requests for the pic-
ture. You know, Morrison never really looked that way again. His
hair never looked that good again. I think I got him at his peak."

The photo that appeared in the *Voice* was a sensual bust shot
showing Morrison bare-chested and wearing a single strand of
beads (the ones Gloria Stavers had given him), with his lips
parted provocatively, his hair a perfect Alexander the Great lion
mane, and an expression of intense sensitivity on his face. Elektra
called it the "Young Lion" photo and it crystallized Morrison's
image as a sex symbol. He looked like a warrior from ancient
Rome come miraculously back to life, but, with his high cheek-
bones and long hair, the shots also conveyed the look of a high-
fashion model. In fact, that September Morrison was asked to
pose for *Vogue* magazine. For Jim, *Vogue* was special because it
meant recognition far beyond the music world. *Vogue* meant
stardom. As always, Morrison was eager for the session and he
knew what he wanted. "I want it to be me," he told a friend.
"They're not going to put me in the background just like a
model."

Baron Alexis Waldeck was almost a caricature of the interna-
tional hip—he drove a Rolls-Royce, skied in St. Moritz, vaca-
tioned in Sardinia, and took celebrity photos for *Vogue*. The
Waldeck studio was a large but raunchy Chelsea loft in New
York. As soon as he entered it, Morrison was attracted to the vast
quantity of exotic clothes the baron placed at his disposal. He
poured through the racks, improvising, turning belts into neck-
laces, scarves into shirts. And then the baron took command. "I
let him do completely what he wanted in the beginning," Wal-
deck said later, "but the pictures were directed by me." Hoisting
his Nikon 105 lens and mumbling about his own special filmic
formula, Waldeck circled Morrison snapping ferociously. Al-
though it was fast and furious, the baron claimed he knew exactly
what he wanted. "In Jim Morrison I saw a peasant," he later
stated. "He could be a Russian peasant. I would love to photo-
graph him in a wheat field in a wagon, with an open shirt. There's

a similarity between Nureyev and Morrison. There's that pride—
you know, very much Self. They both like to see themselves.
Morrison loves himself."

The public reaction to the media campaign was swift. From
The Village Voice to *Vogue* to *16 Magazine* to *TeenSet,* Jim Mor-
rison was studied, not as a rock singer, but as a sexual symbol. "If
my antennae are right he could be the biggest thing to grab the
mass libido in a very long time," wrote *Voice* columnist Howard
Smith. "I have never seen such an animalistic response from so
many different kinds of women."

The campaign also included television, and on Sunday, Sep-
tember 17, The Doors appeared on the top variety show of the
time—*The Ed Sullivan Show.* The band was an enigma for televi-
sion producers. They wanted them because "Light My Fire" had
been a huge hit, but they were also wary of them because of
Morrison's skintight leather pants image and writhing stage ac-
tions. Consequently, on shows like *Ed Sullivan,* The Doors usu-
ally felt they were treated like the Geek Act. They arrived at CBS
studios in New York to discover that the set consisted of several
different "doors" hanging suspended from the ceiling. There
were doors everywhere. There were even doors *above* the band,
hanging flat over their heads almost like a flat, gaped, floating ceil-
ing. And, as if that wasn't enough, their name was spelled out in
big block stand-up letters behind the stage.

This wouldn't have been so bad in itself. It was geeky all
right, but at least it was an attempt at art. Next The Doors dis-
covered that the CBS censors had a problem with the words to
"Light My Fire." "We have the tiniest little problem," Bob Precht,
the show's director and Ed Sullivan's son-in-law, explained to
them in their dressing room. "It's about your song 'Light My Fire'
which I think is just wonderful. CBS does not want you to use the
word 'higher' . . . I know it's silly but we'll have to change the
song."

The Doors were not surprised. Above all, their own record
company had edited the word "high" from "Break on Through"
and a week earlier Pete Seeger had been censored on *The
Smothers Brothers Show,* another CBS program. Bob Precht had
even personally censored Dylan's appearance on the *Sullivan*
show. Meanwhile, Precht waited while the band members looked
at each other. Morrison broke the silence. "Sure," he said, "I

think we can come up with another line." A moment later Ed Sullivan himself came in and talked briefly with them. But as soon as he and Precht were gone The Doors looked at each other again. They all agreed. They would sing a new line in rehearsal, but when it came time for the show they'd sing the original. Since it was live TV, once it was out, there'd be nothing CBS could do to stop them.

Appearing on the *Sullivan* show that night were Yul Brynner, Steve Lawrence, Eydie Gorme, and the Kessler Twins, but it was The Doors who drew the screams from the girls in the audience. It was somewhat of a television first. Before a viewing audience of ten million, Jim Morrison stood onstage, appearing to be in less than full control of his faculties, as he writhed and contorted while his black leather pants revealed an unmistakable bulge. First they performed "People Are Strange," the new single, and then they launched into "Light My Fire." When it came time to sing the edited line Morrison boldly sang out the original lyric, "Girl, we couldn't get much higher."

In the control room, Bob Precht screamed in anger: "You can't do that! You guys are dead on this show! You'll never do this show again!" But The Doors couldn't hear him. When the show was over he walked up to the band and just looked at them and sort of whined, "You promised me . . ." Morrison shrugged. "Gee," he said, "I guess we forgot in all the excitement."

Needless to say, The Doors never did play the *Sullivan* show again. Later, when Elektra publicist Danny Fields was asked how things went, he replied, "Not *that* bad really, aside from tearing down the whole set and after promising not to use the line about getting much higher, singing it anyway. The sponsors went wild."

For Jim Morrison, however, everything seemed to be going according to plan. This was the persona he wanted to create. This was what he knew the kids would love. Morrison once described television in this way: "TV is both beautiful and malignant, restricting reality to a small gray tube—we are spectators—metamorphosed from a mad body dancing on the hillside to a pair of eyes staring in the dark." Morrison knew about the power of television to communicate an image. What he didn't yet understand was the power of that image coming back at its creator.

While all of this attention bolstered Morrison's ego, it did not free him of his restlessness, his doubts, and his demons. Rock

stars are like the shooting stars that Morrison once compared himself to—when their moment of brilliance comes, they are almost by definition doomed. Nothing that burns so brightly can last very long. Perhaps a sparkler is even a better comparison in that stardom may have validated Jim Morrison, but it also lit the fuse that proved to be his undoing. Money meant more freedom and while that meant he could afford the time and the best tools to create his art, it also meant more booze, more drugs, and the squalid one-night stands that he imagined were not only his due as a rock 'n' roll star, but his duty as a great romantic.

Morrison seemed compelled to sabotage his greatest victories, to blemish his finest triumphs. After a New York party to celebrate The Doors' success, Gloria Stavers rode home in the limo with Jim. She later described what happened at *Trouser Press:* "As the limo turned the corner Jim Morrison leaned out the back window and tossed the antique ivory and gold telephone Andy Warhol had given him into a New York City Department of Sanitation trash can. It was 3 A.M. on a Saturday morning in 1967 and Jim was about to make a brief antisocial call on the president of his record label, one Jac Holzman, who had made the dire mistake of no-showing at The Doors' introduction to stardom press party earlier that evening. Andy Warhol had been there, so had the late Lillian Roxon, Steve Paul, Scott Muni, Danny Fields, three stunning half-clad model groupies, the across-the-board music press, and a token celeb or two. The party was in honor of the chart-topping first Doors LP and its hit single, the shortened version of 'Light My Fire.' In fact things had been going along so swimmingly for the burgeoning L.A. rock guerrilla group that the aforementioned Mr. Holzman saw no need for his presence at the party. A serious misjudgment as he was soon to learn. In a loud whiskey slurred voice Jim ordered the limo driver to the Holzman's elegant Chelsea address.

"From my place in the front seat I distinctly felt each and every hair on the back of my neck coming to rigid attention. The formerly rollicking backseat had turned into the executioner's booth. Was old Jimbo really drunk or just pretending? It was a query no one was foolish enough to make. Well, too late now—all to hell in a barrel. Tough twinkies, kiddies. That's what you get for playing with fire. At Jac's house, naught would do but that we all pile out and accompany rock's fastest heartthrob to

the very door of Holzman's ten-room luxury apartment. For you
see, after the man's leaning upon the buzzer offered no response,
our young hero rang *all* the other apartments until one, no doubt
insane insomniac, buzzed us through. Clever boy. We all schlep-
ped off the elevator and up to Jac's front door, where we mutely
watched Jim's performance graduate from persistent ringing to
axing and stomping the door (steel it was) with the flailing ex-
tremities of his precious body. After beating himself to the floor
and still receiving no response (let me tell you it was as quiet as
death in there), Jim ripped up half the carpet from the hall and
then noisily led his obsequious band down the eight flights to the
lobby where he carefully and methodically threw up over the
entire entrance area. It was an unforgettable moment in rock his-
tory. We later learned that Jac and wife indeed were at home,
wisely huddled in stark terror underneath their king-size bed."

Holzman shrewdly forgave and forgot the incident, knowing
that it really had little to do with him personally—he was just the
closest thing to an authority figure in Morrison's life at the time.
Morrison had a need to rebel and he would rebel whether there
was a reason to or not. There was a deep insecurity in him that
could not be satisfied by fame or fortune. Nothing so superficial
could heal those needs because they had more to do with the
needs of a four-year-old boy than they did with a twenty-three-
year-old man.

> *Between childhood, boyhood,*
> *adolescence*
> *& manhood (maturity) there*
> *should be sharp lines drawn w/*
> *Tests, deaths, feats, rites*
> *stories, songs, & judgements*

Aware of these needs and the trouble they caused, Pam often
tried to help Jim or get him to seek help. One time when she
suggested he see a psychiatrist he spent a couple of hours dis-
cussing the advantages and disadvantages of choosing one who
followed Freud, Jung, or Adler until she suggested he just see
someone who had been recommended highly. "Evidently, some-
thing had happened and he wanted to please her," Pam's father,
Corky Courson, recalls. So he went down there and came back a

couple of hours later. Pamela said, 'Well, how did it go, Jim?' 'Aw, pretty good,' he said. "The doctor asked some questions . . . and he said I'm supposed to go back in a couple of weeks' . . . So a couple of weeks later, he went again, came back, same thing: 'How'd it go?' 'Pretty good.' 'You goin' back?' "Naw, I don't think I'll go back.' Well that psychiatrist started calling and he called every day for about a week. Jim had so turned him on to all the problems in the world that Jim had that he couldn't wait to get him back in. Jim never went back. Of course, knowing Jim, you never know whether he's putting you on or not. I can just see him there, sitting there with this psychiatrist really giving this guy the biggest trip in the world."

By now Jim and Pam had been together over a year and a half and they had their ups and downs. According to Mirandi Babitz they argued with the same intensity as that with which they loved: "She was just as volatile as he was," Babitz remembers. "He'd scream out, 'Where's my shirt?' or something, and she'd yell back, 'I never touched your fucking shirt.' And off we'd go. Before long somebody would get hit or thrown around the room. Or stuff would start flying. She'd haul off and hit him and sometimes he'd hit her back. They'd have these megaclashes and it would always escalate and they'd both try and outdo each other. They'd play tricks on each other. One time when we were living in the apartment with them, she was pissed off at him because she thought he was running around with someone else. So she took his favorite vest that he liked to wear onstage and wrote "FAGGOT" across the back of it with a bunch of colored markers. She cut up a bunch of his clothes and planted everything where he would find it. Then she left for a day."

This story raises the bisexual question, but Babitz doubts there is any substance to it. "Pam would never tell me exactly what she meant by that, but I'm pretty sure Jim never had anything like a gay affair because she would've found out and that would've really upset her. If that had been going on, I'm sure she would've told me. I think he probably had a gay experience at one time because of his experimental nature, but nothing like regular experiences. I know their sex life was weird. He tied her up all the time and sometimes he was really really brutal with her. It was okay with her to a point, but then he would always go over the line. I think part of the fag stuff came from the fact that

he really preferred women from the backside. Pam was always
very pissed off about that but that was apparently what he was
into so she stuck with it. That was part of the reason she was
always snarling at him."

Strange Days

In October 1967, Elektra Records brought out the second
album, appropriately entitled *Strange Days.* Released only nine
months after the first album, it captured The Doors at the height
of their powers. Although the "People Are Strange" single was
not a huge hit, the album sold well, reaching number four on the
Billboard chart in two weeks. For the next month, *both* Doors
LPs were in the Top 10.

One glance at the mysterious dark brown and gray cover
and you knew *Strange Days* was going to be an unusual album.
The unsettling photo of cavorting circus sideshow performers in-
cludes a dwarf in a rumpled hat prancing with a pearl-handled
walking stick, a bald, grunting strongman lifting a heavy weight, a
white-faced juggler, two acrobats, and a street musician. They
look like a Fellini troupe of street entertainers playing for nickels
and dimes, and the broken stone street and ivy-covered old
buildings add a European feel. The back of the wraparound cover
shows a woman watching from a doorway as the identical twin of
the first midget holds out his tambourine asking for a handout.
One of the reasons the *Strange Days* cover is so unusual is in
how the band is pictured. The Doors appear very subtly—on a
wall in the background of the curious sideshow scene, they stare
two-dimensionally from a black-and-white poster partly covered
by a strip that says "Strange Days." It's one of the most original
album covers in rock and it drew much attention and critical
acclaim. In many ways it was as intriguing as the music inside.
Robby Krieger remembers: "It was our idea, we wanted midgets,
freaks, and dwarfs. We just told them to get 'em. We had to fight
quite a bit not to have our pictures on the record."

"I hated that cover on the first album," Morrison said. "So I
said, 'I don't want to be on this cover. Where is that? Put a chick
on it or something. Let's have a dandelion or a design.' The title,
'Strange Days,' came and everybody said, 'Yeah,' 'cause that was

where we were, what was happening. It was right. Originally I wanted us in a room surrounded by about thirty dogs, but that was impossible 'cause we couldn't get the dogs and everybody was saying, 'What do you want dogs for?' And I said that it was symbolic that it spelled God backward. Finally, we ended up leaving it up to the art director and the photographer. We wanted some real freaks, though, and he came out with a typical sideshow thing . . . It looked European. It was better than having our fucking faces on it though."

William Harvey was the art director for the *Strange Days* cover and in "The Doors from the Inside" radio special he recalled the time he had locating the models: "I took a taxicab driver and said, 'For five dollars would you stand there and blow a trumpet?' because he had on a battered old hat. I thought he was perfect. I was looking for these midgets, so I went up to this old hotel. I gathered people from all over. I got the strongman from the circus, found the acrobat guy. We used everybody we could."

The record's inner sleeve has a photo of the band with Morrison gesturing in bare-chested defiance on one side and the lyrics to the songs printed on the other. While some people thought printing the lyrics took away from the mystery, others applauded being able to ponder Morrison's words as poetry. The Doors may have had to battle Elektra not to have their picture on the record, but if the bizarre characters on the sleeve caused reviewers to wonder, the music within reassured. As one Elektra ad for the album read: "The Doors are not on the cover but they sure as hell are inside."

Strange Days functions in many ways as an encore of the first album. Most of the songs were composed during the same period and even the moody Elektra packaging (the dark colors and Magritte-suggestive group logo) is remarkably similar. Like the first album, the band was pursuing their own idiosyncratic vision where everything was not as peaceful and beautiful as the prevailing trend of rock maintained. The themes of *Strange Days* are not only darker than the previous record, they are also somewhat united, making it one of the earliest concept albums in rock.

Given the impact of *Sgt. Pepper,* The Doors took a contrary role by slamming the door on the peace/love dimension. Even

bad boys like The Stones were whining "We Love You," but The Doors gazed deep into the sinful souls of hippies everywhere and offered no quarter. People are lost, strange, confused, alienated, and alone—these are the album's most enduring statements. They were not so much preaching sex as salvation or violence as a way of life as they were saying that sensuality was being overlooked and even peaceniks had violent thoughts in their heads, all of which they believed could be eradicated through the use of music as an aid to understanding. Once out, those inner tensions might not return, or so The Doors hoped.

Yet, no other Doors album is so light on the preaching and so engrossed in the observing. Through a series of images and vignettes, *Strange Days* tells a story of people trying desperately to reach each other through the suffocating haze of alienation, drugs, and artificial masks. Morrison's words are cinematic and each song forms a picture in the mind. The opening cut, "Strange Days" sets a mood of vague menace: *Strange days have found us/Strange days have tracked us down.* More akin to a command than a provocation. At the time this seemed a perfect evocation of 1967. The mood of the times was shifting and the world was becoming strange. It is perfect for 1991 as well, because it's the way the world always feels to an adolescent on the verge of adulthood: *They're going to destroy our casual joys.* The song is also a disturbing insight into Morrison's world, a place where dark unnamed forces hunt down and ruin young lives.

"You're Lost Little Girl" continues in the same restrained vein. The song begins with a tripping base line that blends with percussion to provide a musical image of the running girl described by Morrison's words. But it is Krieger's hauntingly beautiful guitar work that best captures the loneliness of her soul. "Love Me Two Times" follows as if sex were the only solution the singer could come up with to help the girl: *Love me two times girl/One for tomorrow/One just for today.* The sexual strut is well-placed, breaking the solemnity of the album at just the right point.

"Unhappy Girl" and "Horse Latitudes" are both brief, but that's where the similarity ends. The first encourages an escape from a self-imposed prison. The second is a short poem from Morrison's high school notebooks, a dramatic monologue, recited at near-hysterical pitch over appropriate sound effects. The

subject is a ship trapped in still waters forced to jettison a cargo of horses, "legs furiously pumping . . . in mute nostril agony."

There are those who feel that "Unhappy Girl" is a prelude to a part of the album that portrays not only alienation but the effects of drugs on this world of the lonely. The beginning of this part would be the bad trip reflected in the nightmarish feel of "Horse Latitudes." The ranting and raving here is heavy, but the way the gloomily romantic "Moonlight Drive" suddenly slithers out of "Horse Latitudes"'s choked raucousness remains one of the finest heart stops in recorded rock. This abrupt change in tone is matched by the lyrics. From the horrifying "Horse Latitudes" we go to a seemingly straightforward and simple tale of life at Venice beach until the single line "gonna *drown* tonight" twists everything around. The idea of an uncontrollable romantic drowning in a moonlit ocean for the sake of sentimental vision seems somehow alluring. The implied enticement to swim in your emotions even to the point of death is a perfect Morrison credo for the era. "Moonlight Drive" uses traditional images with strong emotional ties to hint at sinister warnings of coming change and revelation: *Let's swim to the moon/Let's climb thru the tide/Surrender to the waiting worlds that lap against our side.*

Side two starts off with another variation on the theme. "People Are Strange" reflects the isolation experienced outside one's familiar world—something The Doors must have felt in their first few months of national stardom, particularly when playing outside L.A. The song is very personal in some ways: *People are strange when you're a stranger/Faces look ugly when you're alone.* When Morrison hits so straight and deep, it becomes apparent that he felt the chill and lived it.

Musically, the song characterizes the deceptively simple yet infectious quality of The Doors' music. Those who relate the concept of the album to drugs interpret this track as a junkie looking for a connection, that is, when you're strung out you've no desire for women and no matter how many people are around, you remain alone, hiding like a wounded animal. When you're "strange," can be translated as being broke and needing money for the drug, a time when fittingly "no one remembers your name." Despite these speculations it seems that while there

is some relationship to the drug culture and the concept of "Strange Days," the dominating theme is more one of alienation and loneliness than of drugs.

The long-range effect of alienation is becoming completely depersonalized. "My Eyes Have Seen You" depicts this as a gradual loss of reality, completed in "I Can't See Your Face in My Mind" from *Let them photograph your soul/Memorize your alleys on an endless roll* to *I can't seem to find the right lie/Insanity's horse adorns the sky.* These two cuts reprise the duality of "Strange Days" and "People Are Strange," moving from a detached overview to a specific personal agony. "I Can't See Your Face in My Mind" with its wisps of an Oriental feel is another languorous dreamy number in the vein of the title cut and sets the stage for the record's masterwork, "When The Music's Over."

"When The Music's Over" closes the album and grants it immortality. Throughout the record Morrison is observing alienation and saying, "Something is really wrong, and let's take a look at it." In the end, he goes back to the only thing he really trusts, the only thing that has never let him down: *When the music's over/Turn out the lights/The music is your special friend/Until the end.* Touching on death, the pollution of the world, love, salvation, and more, "When The Music's Over" is an epic in every sense of the word.

From the opening scream the cut winds through a convoluted set of observations, instructions, and invocations leading up to a highly charged release: *We want the world and we want it now. Now. NOW!* followed by Morrison's powerful screams and the churning musical spell of the other three Doors. A cauldron of energy, excitement, and improvisation, the song is built around a two-chord organ pattern similar to "The End" and much of its power comes from Morrison's vocal maneuvers and Krieger's intense guitar psychedelia.

Part of "When The Music's Over" is a demand for the release of the world from those who have abused it to those who vow to take care of it: *What have they done to the earth?/What have they done to our fair sister?* It's the rape of the world by unfeeling, money-grubbing mankind and Morrison's ultimate disgust at this abuse and lack of faith in man's ability to change is delivered in lines like: *Cancel my subscription to the Resurrection, Feast*

of friends, and *We want the world and we want it now.* In one
sense it is The Doors' first overtly political song, but in another it
is the absolute completion of this story of alienation and the
search for something or someone to hold on to. In it we learn
that music is our only friend in the otherwise bleak world
of *Strange Days.* Music that sounds best on headphones at
extremely high volume—to blast away confusion, drown out
frustration, and burn away loneliness—to dance, shout, and
scream.

 Strange Days is the Doors' best album and it stands up to the
best music the eighties and nineties have offered us so far. If it
were released today it would still be hailed as a masterpiece. It is
a landmark in rock music and at least one of the best dozen or so
albums ever produced in rock.

 Paul Rothchild agrees: *"Strange Days* was the best album. It
said everything we were trying to say musically, and it contains
some of Jim's best poetry. It was musically exploratory. It was
filled with ingenuity, creativity, great songs, great playing, fabu-
lous singing. Even the cover won all sorts of awards. We all
thought it was the best album. Significantly, it was also the one
with the weakest sales. We were *all* at our hottest for that album.
We had a ton of ideas and we went to the moon with it all. We
were confident it was going to be bigger than anything the Beat-
les had done. But, there was no single. The record died on us. It
never really *conquered* like it should have."

 Indeed, while *Strange Days* was lauded by critics and the
album was an instant hit, there was no hit single. No "Light My
Fire," no standout song that everyone would associate with it and
with the times. In retrospect, "Light My Fire" was the kiss of
death. Expecting to come up with another such classic was a
little ridiculous, but The Doors' debut album, like all first albums,
was regarded as a measuring of potential. Imagine how it would
have been for The Beatles if *Sgt. Pepper* had been their first al-
bum and *Abbey Road* their second. It was virtually impossible for
The Doors' second album to completely live up to the glory of
the first.

 The music business functions on economic power and in
1967 that still meant a hit single. The "album group" concept
was just beginning to happen, so while The Doors' artistic stock

was booming, the industry and Elektra began to wonder if they would be able to generate more hit singles.

The truth was that it was the promise of *Strange Days* that the soon-to-be Lizard King and Company were never able to live up to. The feeling of the time was that *Strange Days* was great but not *as* great as the first album. Morrison knew it was his best. "I really am proud of our second record because it tells a story, it is a whole effort," he said in *Downbeat.* "Someday it will get the recognition that it deserves. I don't think many people were aware of what we were doing."

In October, the month that *Strange Days* was released, a hundred thousand marched on the Pentagon to protest the war in Vietnam. Abbie Hoffman declared that five-sided figures were symbols of evil and applied for a legal permit to levitate the building, even calling in some witches in an attempt to get the job done. The opponents who took this gesture as an idiotic prank never realized that such humor delegitimizes venerable and esteemed institutions very quickly in the eyes of the young.

In that same month the CIA aided local rangers in capturing and assassinating Che Guevara in the Bolivian mountains. As with his life, there was an air of mystery and confusion over Che's death. Although the Bolivians maintained that he died of wounds sustained in the battle, there was evidence that he was executed before he could recover. Guevara had become somewhat of a legend after disappearing from Cuba two and a half years before and his look—the black beret, fatigues, and scraggly beard—was adopted by radical youths everywhere. Che believed that "the duty of revolutionaries is to make revolution" and after taking Fidel Castro from a tiny foothold in the Cuban hills to power in Havana he clashed with Soviet advisers and renounced his Cuban citizenship. Until his death Che's whereabouts were the subject of vast speculation. In the end he failed, some said, because he was more of a romantic than a serious political operator. The same Che who could calmly order a comrade beheaded for a breach of discipline would sit around a campfire for hours afterward leading an avid discussion of Marxist doctrine or reciting his favorite Marxist poets.

Meanwhile, things were changing in hippieland. The dream of Haight-Ashbury was turning into a drug nightmare and what-

ever real values remained were lost in overpopulation, under-funding, and the hype of the media. By October it had gotten so bad that several of the early Haight residents got together and held a mock funeral commemorating the "Death of the Hippie."

On October 15 The Doors did two shows at the Berkeley Community Theater, performing on a rising stage. The crowd screamed loudly as the stage rose, but they soon quieted as Robby's amp shorted out. There was quite a delay and a lot of rushing around while the amp was repaired and the audience's enthusiasm never fully returned. After singing a couple of numbers, Morrison commented that it was the quietest audience he had sung for. "It must be the climate," he muttered, referring to the elitist attitude of the Bay Area crowd who seemed to feel that since rock had come of age there they were justified in being blasé. Tom Donahue, the KMPX dee-jay, introduced the band as "direct descendants of the North Beach beatniks who fled to Ocean Beach and Santa Monica."

On November 9, 1967, *Rolling Stone* published its first issue (twenty-five cents a copy). It was part magazine and part newspaper and the editorial notes described it as "reflecting the changes in rock and roll and the changes related to rock and roll . . . not just about music, but also about the things and attitudes that the music embraces." The name "Rolling Stone" was ascribed to the proverb "a rolling stone gathers no moss," but references to the Muddy Waters song that gave The Rolling Stones their name and Dylan's "Like a Rolling Stone" were also noted.

"Love Me Two Times" was released as a single in November. Robby wrote it about America's boys going to Vietnam and the band going on the road. By now The Doors were becoming the group of choice among the soldiers in Vietnam. The song was banned because of its suggestive lyrics and received very little airplay. Meanwhile The Doors played the Fillmore on November 16 and Winterland on November 17 and 18, where forty-five hundred packed out the abandoned ice skating rink in a run-down section of San Francisco. On the 24 the band played two shows at Hunter College in New York City, where they filled every seat, and one reviewer described Morrison as having "the look of someone who knows he is too beautiful to ever enjoy true love."

Stardom

Because, in his imagination, his career was already well un-
der way from the start, stardom didn't change Morrison much on
the outside. He had *always* been a star. He bought what he
thought was a classy car (a Shelby Mustang GT) and he and Pam
got a better apartment, but mostly he spent his money on party-
ing and taking care of his friends. But stardom did provide some-
thing else Jim Morrison had always been looking for—validation.
Drawing capacity crowds to almost all of their appearances and
earning between ten and twelve thousand dollars per concert
clearly established The Doors as successful in anyone's language.
It sent a message to all those people out there in the world who
thought the way his parents did. They might still hate him and
they could still belittle his talent, but they could no longer deny
his power or influence.

In the fall of 1967, it was difficult indeed to avoid the pres-
ence of Jim Morrison. The stripped-to-the-waist young lion pho-
tos appeared everywhere. The *Vogue* photograph came out in
the November 15 issue and Morrison's brooding sensuality
seemed as at home in those pages as it had in *16 Magazine*. His
head bowed, his hair flowing, his chest bared inside a black
leather jacket, a silver concha belt around his neck, and his eyes
softly closed as he embraced a model, Morrison communicated a
sensual but regal dignity that was rarely seen in a rock star. The
caption read: "Jim Morrison is at twenty-three one of the most
shaken loose, mind shaking, and subtle agents of the new music
of the new, mysticism-oriented young." For Morrison it was a
symbol of how far he had come—from under the boardwalk to
Vogue.

Both *Time* and *Newsweek* ran articles on The Doors that
month as well. In the November 24 issue, *Time* magazine said,
"The Doors ultimately envision music with the structure of po-
etic drama," and went on to describe the band's success. Later in
the month the Record Industry Association of America (RIAA)
awarded The Doors gold records for both "Light My Fire" and
the first album, *The Doors*. "Light My Fire" had outsold every
single but one in 1967 and the first album sold 1,200,000 copies.
It had been number one for 3 weeks, in the Top 10 for 23 weeks,

and would stay on the chart for a total of 104 weeks. The Doors were now mainstream news.

Apollonian and Dionysian

Much of Morrison's philosophy grew out of his fascination with Friedrich Nietzsche's concept of tragedy, and by late 1967 he was regularly quoting Nietzsche in interviews. *The Birth of Tragedy (Out of the Spirit of Music)* was cited by Morrison himself as the volume to read if one hoped to understand his thoughts. In it, Nietzsche isolated two conflicting viewpoints toward life, the Apollonian and the Dionysian. The perspective named for Apollo represented harmony and order as typified by the art of sculpture, while the perspective of Dionysus, the god of wine, represented frenzy and spontaneity as typified by the art of music. According to Nietzsche, it was the clash of these two principles that gave birth to Greek tragedy.

Dionysus is usually pictured as handsome and beardless with long hair, riding a panther or wearing animal skins. Morrison considered himself a personification of Dionysus and said that Dionysus enters through the ears, not the eyes. The Dionysian spirit is championed by the all-out expression of feelings—swimming in emotions—and whatever assists that quest is viewed as positive. True Dionysians not only sanction getting drunk, they deify it. Thus, no matter how alien the idea of whiskey may have seemed to the psychedelicized mind of the 1960s, Morrison saw it as another demonstration of the Dionysian spirit.

The Apollonian is the sculpted perfect, the image of man as embodied in Greek Sculpture—flawless and eternal, but somewhat unemotional. The joy of Apollo is that of uniting with creation—becoming one with the dominant pattern of order in the universe. It is delighting in the essential rightness and completeness of life and, by becoming part of this harmony, learning to stand outside oneself. This feeling can be best realized in the trusting sense of wonder—a childlike trait alluded to by Christ ("Unless ye become as little children . . ."). In modern times the Apollonian viewpoint has been perverted to focus only on the material side, that is, blending in with the goals of a capitalist society rather than those of the universe. The traditional version

of the American Dream is Apollonian. It is a search for youth, money, sex, power, and eternal life through capitalistic means. It has become less of a search for spiritual truth and identity and more of a quest for things.

The Dionysian viewpoint is the antithesis of all this. The ecstasy of Dionysus is more one of being overwhelmed than blending in. In ancient Greece, Dionysian worship services resulted in riotous revelry and debauchery but also produced the earliest Greek theatrical performances. The Dionysian maintains that all people have deep inner feelings that need to be expressed. While the psychologists argue over the specifics of these feelings, they seem to agree on the need for such expression. Frequently the Dionysian drive for expression clashes with the Apollonian tendency toward repression. While "proper" behavior can be taught to a child, a major portion of the unconscious will often remain unsatisfied and wind up being expressed as feelings of hopelessness, or even as a neurosis or psychosis. People who believe in the Dionysian approach think that expressing such feelings can alleviate these problems. That may be true in some cases, but the Dionysian life-style may sometimes generate more problems than it alleviates. The problem is like a hole that needs to be filled. Apollonian repression covers the hole up on the outside and Dionysian expression turns it inside out. In both cases the hole is still there.

The birth of tragedy, Nietzsche said, was in the spirit of music, a primal Dionysian art. Music and rhythm can compel us psychologically and even match our heartbeat and body rhythms to break down barriers and thrust us into another physical and emotional place. Music can change mood and help get rid of neurotic energy resulting in a catharsis of sorts. The music of The Doors was dedicated to this purpose not only for the audience but also for Morrison himself. "There's this theory about the nature of tragedy comedy," Morrison said, "that Aristotle didn't mean catharsis for the audience but a purgation of emotions for the actors themselves. The audience is just a witness to what's taking place on stage."

He took a face from the ancient gallery
And walked on down the hall

Tragedy, Nietzsche said, leaves man with a certain comfort—to know that *life* is at the bottom of things, despite whatever goes on up there on the surface. In the late 1960s, The Doors created the sound of contemporary tragedy. Morrison tried to show the kids that the spirit of tragedy is right beneath the surface of America and he was more than happy to help them find it. This even went for the other members of The Doors as Jim's recounting of the following conversation with Robby in *New York* Magazine pointed out: "Robby and I were sitting on a plane and like it's first-class, so you get a couple of drinks, and I said to Robby, you know, there were these Apollonian people . . . like, very formal, rational dreamers. And there's the Dionysian thing . . . the insanity trip way inside. And I said, 'You're an Apollonian up there with your guitar . . . all neat and thought out you know . . . and you should get into the Dionysian thing.' And he looks up at me and says, 'Oh, yeah, right, Jim.'"

As is the case with most divergent philosophies only a balanced combination of the two is really workable. The idea of going through life drunk and hedonistically is no more enlightening than living out a hypocrisy of false value judgments. The moral responsibilities and discipline of the Apollonian must be blended with the truth seeking and sincerity of the Dionysian in order for one to have a truly fulfilling life. But in the 1960s the Dionysian life-style seemed a viable alternative to the rigid, plastic mold the Establishment was cranking out. Jim Morrison never lived long enough to see the long-term effects of such a life-style unless he was able to observe them on himself. He never saw statistics that correlate alcoholism with depression, failure, and suicide or realized that a lifetime of Dionysian pursuits led to alienation, confusion, and an early death more often than it led to rebirth and enlightenment. If he were alive today Morrison would probably argue that these things were the results of society's oppression of the Dionysian and not the actions themselves. More than anything else, however, Morrison's own life ultimately serves as the best argument for the success or failure of his philosophy and that is something we can all judge for ourselves.

The Concert as Séance

By the end of 1967, The Doors were regarded as the leading exponents of acid rock and Jim Morrison was acid evangelist to a

musical cult that numbered in the hundreds of thousands. As his popularity grew, Morrison came to believe that the more he released his Dionysian side onstage the greater the effect he would have on his audiences. Something happened when the four Doors played together that can only be described as alchemy. The audience felt it and the band thrived on it. They functioned as some sort of living entity held together by sheer nervous tension, expanding and contracting with the music. The passion was always just barely contained within the control. Manzarek played the organ with concentration so intense that his thoughts seemed to translate into wisps of smoke while Krieger was suspended in time droning out slow-motion flamenco notes. Densmore was a flurry of speed and power, punctuating and pushing like a great machine on overdrive. And then there was Morrison. Watching him sing was like witnessing a man dangling in his own anguish. Seeing him scream, writhe, and whisper his way into a head-on clash with some ultimate truth in song could be truly frightening. Even the most unfeeling in the audience sensed that the sudden shrieks and violent screams came from somewhere deep within the subconscious. Morrison was many levels, and not all of them were pretty.

"I find that music liberates my imagination," Morrison said once. "When I sing my songs in public, that's a dramatic act, but not just acting as in theater, but as a social act, real action. Maybe you could call us erotic politicians . . . A Doors concert is a public meeting called by us for a special kind of dramatic discussion and entertainment. When we perform, we're participating in the creation of a world, and we celebrate that creation with the audience. It becomes the sculpture of bodies in action. That's politics, but our power is sexual. We make concerts sexual politics. The sex starts with me, then moves out to include the charmed circle of musicians onstage. The music we make goes out to the audience and interacts with them; they go home and interact with the rest of reality, then I get it all back by interacting with that reality, so the whole sex thing works out to be one big ball of fire."

Onstage Morrison performed with an economy of motion that added a strange significance to his every action. The effect was eerie; Morrison became the embodiment of evil and the world behind his closed eyelids was forbidding, yet enticing. One

moment there was a hypnotic peace throughout the arena and then the mood would grow suddenly ominous and the air would crackle with electricity. The tension would build. Something was about to explode. And then Morrison would strike, seizing the moment the audience least expected.

The Morrison mystique spoke eloquently to these audiences and when he took over, the show turned into a musical séance. His total abandon and blatant sexuality stirred the audience's emotion and the effect was both chilling and numbing. And, like a séance, or more like an exorcism, it usually triggered some sort of magnificent release in both audience and performer. "I think there's a whole region of images and feelings inside us that rarely are given an outlet in daily life," Morrison said in *Eye* magazine. "And when they do come out, they can take perverse forms. It's the dark side. Everyone, when he sees it, recognizes the same thing in himself. It's a recognition of forces that rarely see the light of day. The shock of recognition can return people to their elemental senses. The more civilized we get on the surface, the more the other forces make their plea."

Ray Manzarek discusses the feelings he experienced during a Doors performance. "For Jim, being onstage was just about everything. Onstage he came alive and was the most exciting and dynamic performer I'd ever seen. He would go through trips onstage . . . you wouldn't believe the personalities that would come out of him. The intensity that he would speak to the audience. I've seen him hypnotize an audience . . . fifteen thousand people would just be hushed . . . stopped, not even breathing. Man, when I was onstage with the guy, I don't know *who* was playing the organ. Sure, it was my fingers, but . . . He was an absolutely inspiring person, and he did the same thing to the audiences. They began to get in touch with feelings they didn't necessarily want to express or were afraid of. They got *inside* of themselves. Time would be suspended. It would actually stop. The only thing that would exist would be the energy generated between the audience and the band. The rhythm became a hypnotic drone. It can capture your conscious mind and lull it into a nonstate and allow you to sink down a little lower into your subconscious mind. That's what happened at a Doors concert. Jim. . . Jim was in control of these people, they allowed him to take

them on a psychic journey—to suspend reality and examine the depths of the human psyche."

This immersion of sentiment in sound amplified Morrison's lyrics, causing them to become something more like pageant than poetry. Jim himself was ennobled by the sound. In concert Morrison outdid himself again and again, staggering around the stage, pressing himself against the mike stand, and working himself into a rabid frenzy. He gave no thought to danger or moderation, climaxing each show as if it were his last. Onstage, Jim's casual stance became arrogant, his usually soft voice became deep and husky, his face twisted into countless masks of emotion, and his probing eyes became vacant windows gazing out at the crowd with the blank stare of a clairvoyant looking into another dimension. "The only time I really open up is onstage," Morrison said. "I feel spiritual up there . . . I'm shy except when I'm onstage."

The Doors' concerts of this period were especially memorable. After the band came on there would be a sudden silence, the crowd waiting as if about to hear an orderly performance of chamber music. A great blast of sound and a primal scream would signal Morrison's arrival. Attired from head to toe in leather, he captured the crowd's every gaze as if each visual and vocal gyration was part of some primitive ritual. As the sonic waves exploded behind him, he was electric—exuding sensuality and magic. He was on fire—twisting in pain and crying in anxiety as the music penetrated and ground its way into the audience.

Ray Manzarek describes the metamorphosis Morrison underwent onstage. "It was a psychological horror, freak show in the sense of the shaman—the sense of possession, the sense of participating with the powers of the universe that Jim Morrison was capable of doing. The people who came to the early Doors' shows came to see that. So Morrison was like the shaman who took people on a mystical journey to a darker, psychic realm that people today would just be scared shitless to enter."

And the other members of the band were not idle in this process. "We played a lead-and-subjugation thing with each other," Manzarek said in *New York* magazine. "We may have looked cool, but we were really evil, insidious cats behind Jim. We instigated the violence in him. A lot of times he didn't feel particularly angry, but the music just drove him to it. . . . I could

send an electric shock through him with the organ. John could do it with his drumbeats. I could hit a chord and make him twitch."

The Doors used their electricity to invoke a cold-steel, almost satanic sensual sound. The music, while emphasizing mood rather than meaning, switched from gentleness and love to death, pain, and even violence at a moment's notice. It was an eerie amalgamation of primitive pulsations and lyricism that reeked of hypnotic decadence. "Music is very erotic," Morrison said. "One of the functions is a purgation of emotion. To call our music orgasmic means that we are able to move people to a kind of emotional orgasm through the medium of words and music. A concert clicks when the musicians and the audience reach a kind of united experience. It is stirring and satisfying to know that the various boundaries which separate people from other people are lowered for the space of one hour."

Invoke, palliate, drive away the Dead. Nightly.

And so it was. During the next hour or so The Doors would get right out on the edge and stay there. Manzarek, Krieger, and Densmore excelled in musicianship and Morrison stole the show. When he slunk across the stage, eyes shut, dazed, and crooned huskily into the mike, the effect was startling. The audience was reverently silent as if he had captured their spirits and could now do whatever he wanted; ignore them, dance wildly, kneel in front of them, recite poetry, twist and moan, play maracas, or leap off the stage. As the night rocked on, he threatened, cursed, comforted, caressed, consoled, and seduced. His power over the crowd was so great that it would at times seem visible, as if he were a magician or wizard somehow managing to establish direct contact with every member of the audience at the same time. The trip could be terror, madness, violence, chaos, death, or it could be a catharsis, a gentle rebirth culminating in joy. Morrison seemed guided by an inner light that only he saw, blinded to reality and reeling out of control. Like a madman, he teetered precariously on the edge of the stage moment to moment, swaying and staggering, losing his balance and regaining it. It was insane, it was frightening, but above all it was thrilling—like the twisted nightmarish reality of a vivid dream or the compelling

horror of a terrible accident. You simply never knew what was going to happen next. Every night was Halloween when The Doors were in town.

Drummer John Densmore elaborates: "A Doors' concert was an event as much for the band as it was for the audience. It was total theater—it wasn't planned or conceived in the studio, it was fairly subconscious. Jim was magical—he never quite knew what he was going to do each night and that's what was so exciting—the suspense, because obviously we didn't really know either."

It was this total attention that the audiences sought and The Doors exploited. Robby Krieger remembers: "We tried to connect everybody in the audience to everybody else. We wanted them to become one mind, one entity. We were revivalists as well as musicians and wanted our audiences to undergo a religious experience."

The Doors were clearly speaking to their peers and their language was not communicable to any others. Their music was harsh and aggressive. Poetry in those days came with guitar, organ, and drum accompaniment. The audience plugged into Morrison and thousands of watts of amplified sound blasted through their minds, a sound so loud it drove out thought and pinned the value judgments of the adult world to the far wall. It was an overwhelming shock wave combined with an anguished plea from deep within the soul of a very lost and lonely young man. A Doors concert was like taking a trip inside a nightmare landscape by Hieronymus Bosch. A walk on the edge of the abyss of chaos, violence, and pain as well as a vision of love and death. In the end, the audience was often left too stunned to be able to muster immediate applause for the finale. There was that moment of awed silence and then the whole place would break loose in a thunderous ovation.

After a Doors concert the crowd would be wasted. The band had taken them up and down and all around—acting out everything in public that the audience had tried to hide in private. The concerts produced a tremendous rush—all that energy gushing from the stage created a sort of mystical experience. Jim Morrison and The Doors had forced the American Dream to the edge of reality once again—and many of those who saw and heard it would never be the same again.

Shamanism

By now the forces of shamanism were shaping Jim Morrison more than he knew. He joined no cult, attended no services, and followed no spiritual leader, yet his belief in this occult religion provided the prism through which all his other influences were refracted. Shamanism crystallized the bits of Nietzsche, Blake, Artaud, Kafka, and Rimbaud. It focused the passion behind his rebellion and the power behind his persona. It was his magical side—it helped make him special and it no doubt helped destroy him.

Shamanism is the primitive religion of many American Indian tribes and some Ural-Altaic peoples of northern Asia and Europe in which the unseen world of gods, demons, and ancestral spirits can be interacted with through the shamans of high priests of the tribe. It can also occur independently as a psychological technique that employs religious notions. The shaman—medicine man, obtains power from the supernatural through trances brought on by hypnotic music, chanting, and dancing. A mystic, he has the power to leave his body at will through various "techniques of ecstasy" (dreams, visions, trances).

As Morrison said, "The shaman was a man who would intoxicate himself. He was probably already an unusual individual. And, he would put himself into a trance by dancing, whirling around, drinking, taking drugs—however. Then he would go on a mental travel and describe his journey to the rest of the tribe."

The shaman is medicine man, priest and psycho-pomp to the tribe. The key to his power comes from his being possessed by a spirit, and once the trance state is achieved, the supernatural being speaks through his mouth. At that point the "free soul" of the shaman can be guided on long journeys to the sky or the underworld. Through his power to leave his body he is believed to cure sicknesses and escort the souls of the dead to the other world. The tribe considers the shaman the lord of the three realms—the sky, earth, and underworld.

Jim Morrison said many times that he believed he was possessed by the spirit of a shaman and there are many startling similarities between his life and shamanistic rituals. Traditionally, shamans are poets and singers and much of their activity centers on creating works of art, but they are also considered "sacred

politicians" who continually live out a symbolic ritual of mystical death. Morrison once described The Doors as "erotic politicians" and his performances often contained elements of symbolic death. Through his journey the shaman supposedly helps his patients transcend their normal ordinary definition of reality and realize that they are not emotionally and spiritually alone. In order to extract the evil spirits from a patient, the shaman is often obliged to enter the patient's body or take the spirits into his own body and in doing so he may struggle and suffer more than the patient himself. This self-sacrifice results in an emotional commitment from the patients to struggle alongside the shaman to save themselves.

"I see the role of the artist as shaman and scapegoat," Morrison told Lizze James in *Creem* Magazine: "People project their fantasies on to him and their fantasies come alive. People can destroy their fantasies by destroying him. I obey the impulses everyone else has but won't admit to. By attacking me, punishing me, they can feel relieved of those impulses."

Those who believe in shamanism believe that the shamanic vocation is obligatory and one cannot refuse it. The process can be accelerated, however, by a chance encounter with a semidivine being, the soul of an ancestor, or as the result of some extraordinary event. Such an encounter usually begins a familiarity between the future shaman and the spirit that has determined his career, hence the term "familiar spirit." The souls of the shaman ancestors of a family choose a young man among their descendants.

Choose They croon
The ancient ones

There are three ways of becoming a shaman: first, by hereditary transmission of the powers; second, by personal quest; and third, by spontaneous vocation (the call). This "call" can sometimes occur following a traumatic shock or a highly unusual event and one such experience alone can be enough to bring about the metamorphosis. Jim Morrison's belief that he was a modern-day shaman extends back to the incident that happened to him when he was only four years old. Morrison often recounted the accident story and many of his friends believed it.

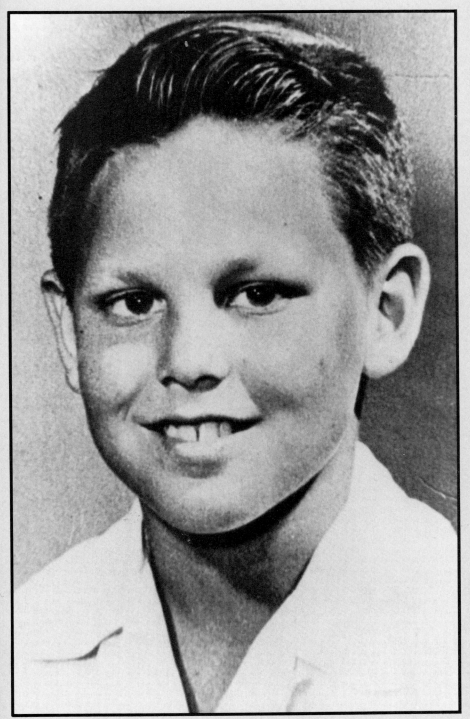

Jim Morrison at age eight ALISON MARTINO COLLECTION

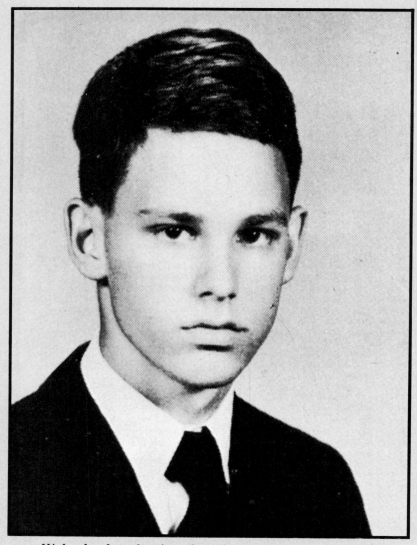

High school graduation photo from the 1961 yearbook of George Washington High School in Alexandria, Virginia

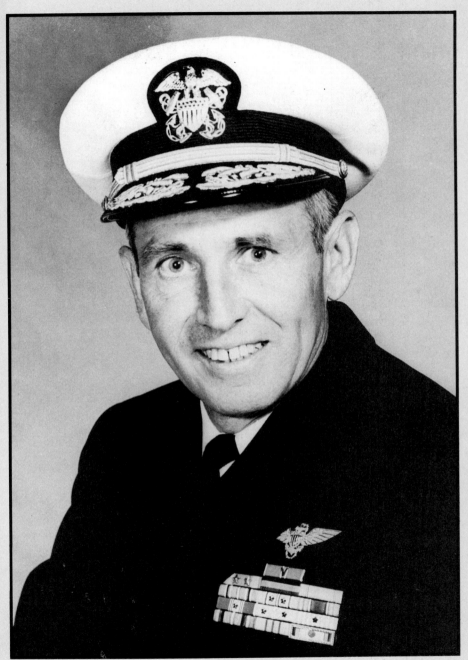

Official Navy photo of Jim's father, Admiral George S. Morrison

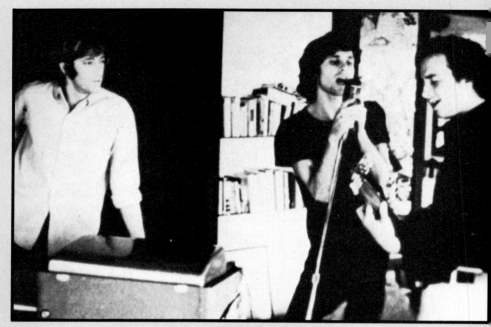

The Doors in an early rehearsal

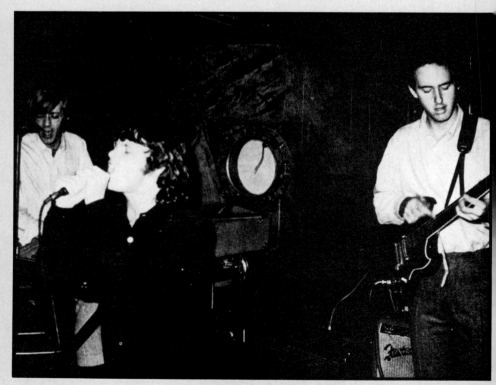

The Doors at an early club date

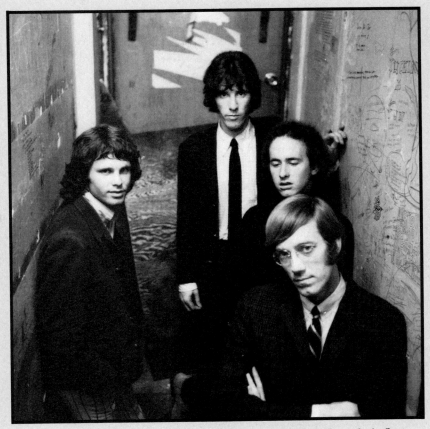

The Doors backstage at The Ondine in New York before their first record was released PHOTO BY TOM MONASTER

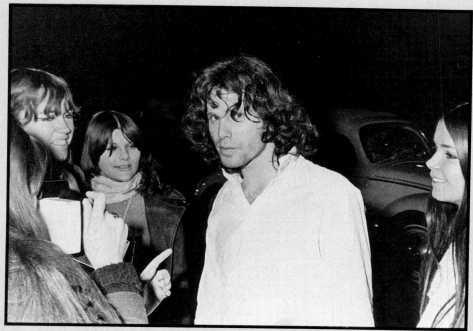

Morrison with early fans outside one of the Sunset Strip clubs

The Doors play Steve Paul's The Scene in New York City as "Light My Fire" moves toward number one. PHOTO BY DON PAULSEN

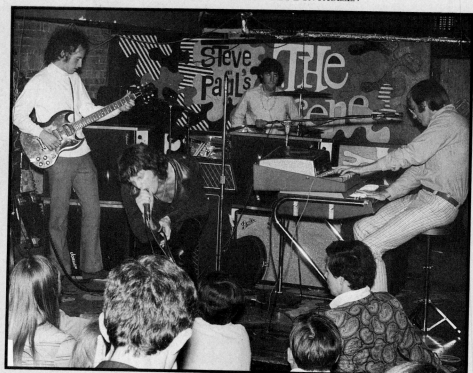

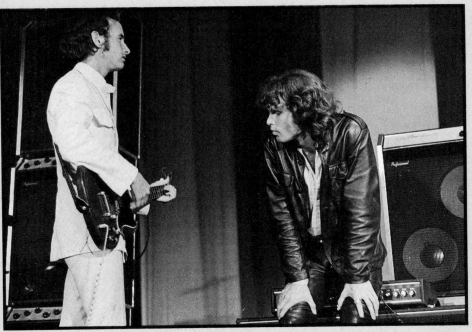

Jim watches Robby's solo at the Village Theater in New York in September 1967. PHOTO BY DON PAULSEN

Backstage at Cleveland's Musicarnival in the fall of 1967 PHOTO BY MARY ELLEN BOWEN

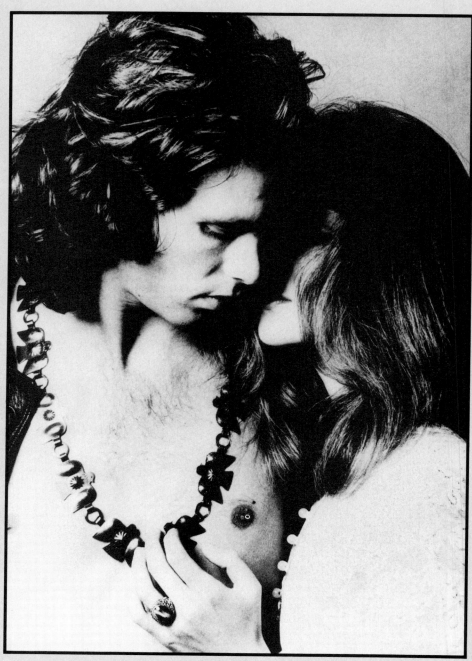

Morrison and an unidentified model from Vogue *magazine* PHOTO
BY BARON VON WALDECK. COURTESY VOGUE. COPYRIGHT © 1967 BY CONDE
NAST PUBLICATIONS INC.

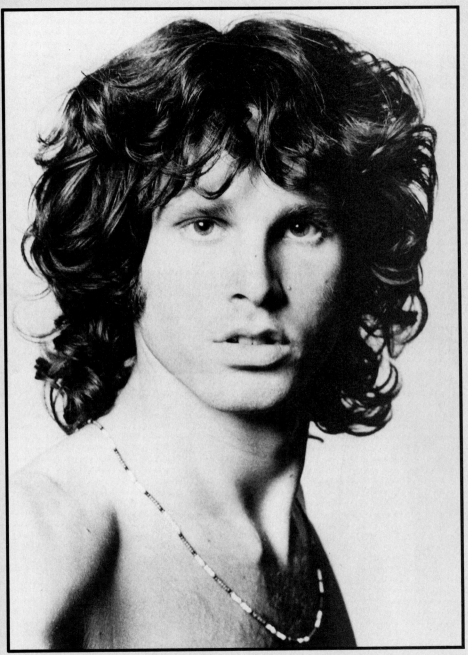

The "young lion" photo helped define Jim's image and became something he felt he could never live up to. ELEKTRA PUBLICITY PHOTO BY JOEL BRODSKY

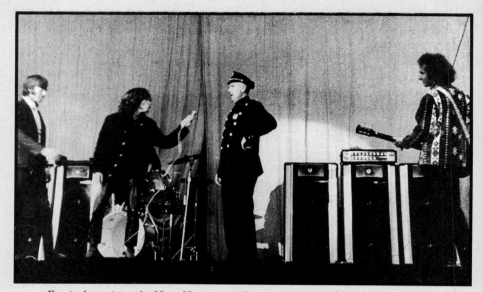

Busted onstage in New Haven on December 9, 1967, Morrison offers a police lieutenant the chance to "say your thing, man." PHOTO BY TIM PAGE

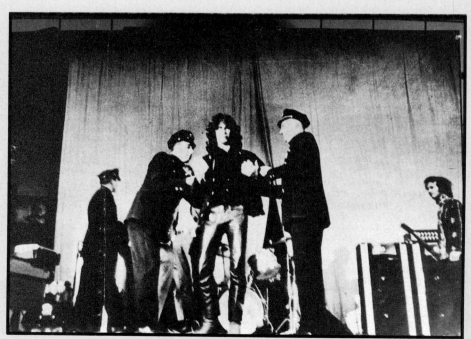

Seconds later he is hauled away and roughed up by the police. PHOTO BY TIM PAGE

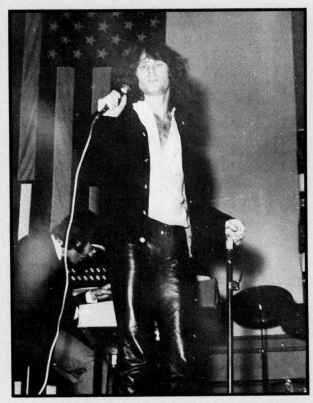

Performing in front of the flag at Cal State Long Beach
PHOTO BY MATT KEEFE

Morrison's mug shot from the New Haven arrest

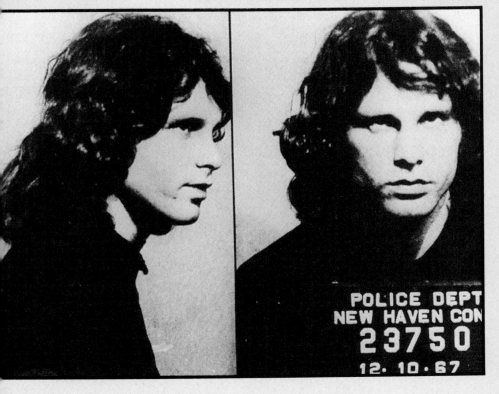

POLICE DEPT
NEW HAVEN CON
23750
12·10·67

The Doors in a typical between-song discussion over what number to play next PHOTO BY MATT KEEFE

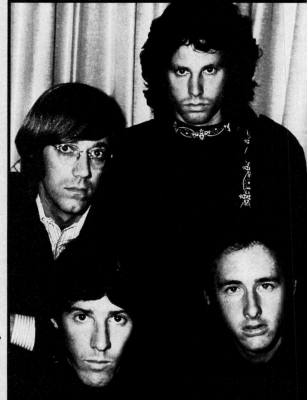

The Doors' Elektra publicity photo taken by Gloria Stavers in 1967

Rare shot of Morrison wearing a hat onstage
PHOTO BY MATT KEEFE

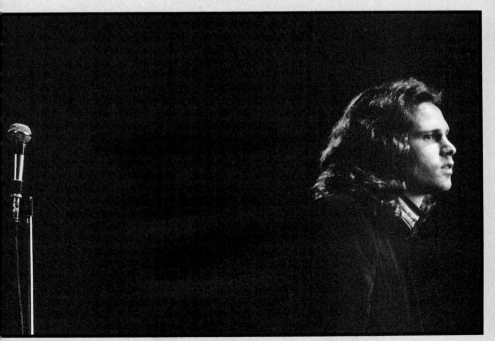

Morrison at the Fillmore East PHOTO BY ELIOT LANDY

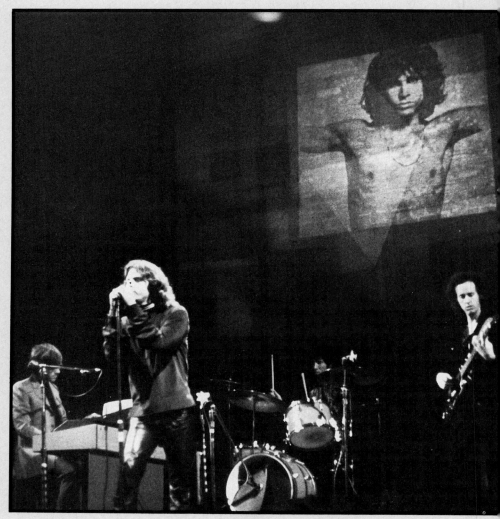

At the Fillmore in March 1968 with the "young lion" image looming above PHOTO BY KEN REGAN

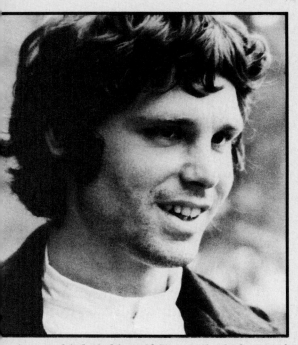

aving cut his hair himself, Jim smiles before performing at the rthern California Folk Rock Festival in Santa Clara, California, May 1968. PHOTO BY JIM MARSHALL

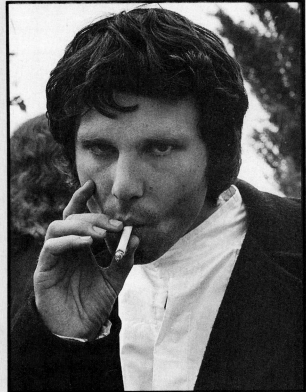

Enjoying a smoke at Santa Clara PHOTO BY JIM MARSHALL

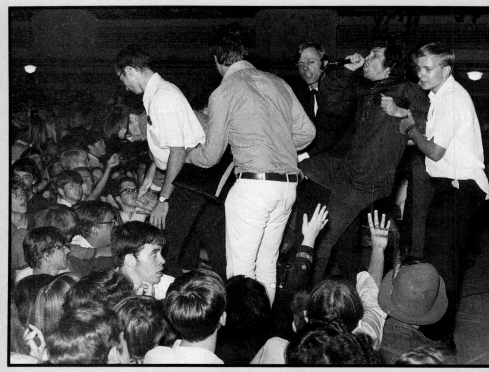

Still singing as the crowd swarms onstage before the Cleveland riot in August 1968 PHOTO BY GEORGE SHUBA

Down, but not out during the Cleveland riot PHOTO BY GEORGE SHUBA

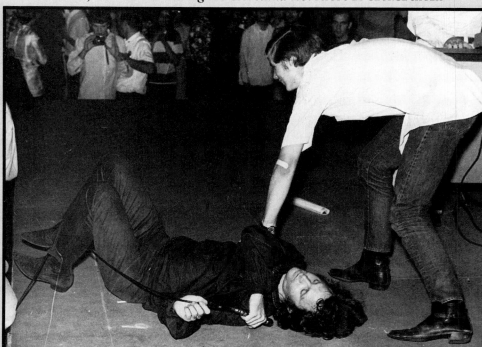

Producer Paul Rothchild was one: "As a child he was driving with his parents, and there was a truck full of Indians that had crashed and overturned. There was a medicine man dying at the side of the road, and Jim, this four- or five-year-old child *vividly remembered* a mystical experience when, as the shaman died, his spirit entered Jim's body. That was the pivotal event of his entire life. He always viewed himself as the shaman, having mystical powers and the ability to see through many façades to the truth. It was this power that drove him. This was the great force that pushed his life and took him out of the rigid, military environment of his youth and turned him into a seer."

Morrison's story not only fits classic shamanistic tales of the "call" happening through a trauma and a chance encounter with a spirit, but it also conforms to several other rites of shamanism. The shamanic vocation is nearly always manifested by a crisis, a temporary derangement of the future shaman's spiritual equilibrium that sets him apart from others. And no matter what method by which a man becomes a shaman, it is a form of initiatory death and resurrection that consecrates him. This initiation must include the ordeal of entering the realm of death, which means the potential shaman must either nearly die through an accident or severe illness or have suffered a psychological or spiritual trauma through exposure to such an experience. This encounter with dying and death and the subsequent experience of rebirth and illumination is the only authentic initiation for a shaman.

As children, future shamans experience rapid transitions from irritability to normality and from melancholia to agitation. The deep-seated desire they possess to contact the spirit world is counteracted by the fear of surrendering their will. These kinds of rapid mood swings are certainly in line with Morrison's turbulent childhood. "Shamans could be any age," Morrison said in a 1969 NET special. "The tribe pushed him into his trip. The shaman was not interested in defining his role in society, but more interested in pursuing his own fantasies. If it becomes too self-conscious of a function, it tends to ruin his own inner trip."

A shaman must be instructed in two areas—the ecstatic (dreams, visions, trances) and the traditional (shamanic techniques, names and functions of spirits, mythology of the clan, and the secret language). The teaching must be done by the old mas-

ter shamans or by the spirits themselves, but it may be accomplished entirely through dreams or ecstatic experiences. During his time at UCLA and in his early days with The Doors, Jim Morrison took vast quantities of LSD on a regular basis and many of his acid trips centered around primal symbols—the earth, moon, and sun. It is very possible that he felt he was receiving shamanistic instruction at this time.

A key element in shamanism is the songs of the shaman and this seems to be the next phase Morrison encountered in his development. The trancelike inspiration he experienced on the Venice rooftop when he "heard" most of the songs to the first two albums is typical of how a shaman receives his songs. The receiving of songs and chants reportedly marks the moment that a shaman's psyche has been transformed from the vulnerable and wounded soul of a man to one heavily influenced by a powerful spirit.

Shamans often use various forms of drugs in their quest for what they call "magical heat." They believe that smoke from certain herbs and the combustion of certain plants increase their power. The trance or ecstasy state is sometimes induced by mushrooms, narcotics, or tobacco, but since shamanism is primarily a state of mind, the drugs are an option and not a requirement. After the Sunset Strip days Morrison pretty much abandoned the use of LSD, believing he had exhausted the augury power of psychedelics. When The Doors were at their zenith he maintained that he could take the trip without the drug.

The art of the shaman is his most vital adaptation and Morrison's use of shamanic lore appears everywhere in his work. He used images from the history of man—broad, universal symbols such as the sun, the sea, the tide, the moon, the earth, running, falling, and climbing. "We appeal to the same human needs as classical tragedy and early Southern blues," he said, describing The Doors. "Think of it as a séance in an environment which has become hostile to life; cold, restrictive. People feel they're dying in a bad landscape. So they gather together in a séance in order to invoke, palliate, and drive away the dead through chanting, singing, dancing, and music. They try to cure an illness, to bring back harmony into the world."

Shamans awaken a particular kind of experience in their audience. The onlookers become participants, experiencing a ca-

tharsis during the trance state that results in a sort of psychological healing. Morrison believed his art could heal "sick" minds and that his mental revolution could lead the way to freedom. Traditionally, shamans use songs, rhythms, and dances in a tribal ritual that must always take place at night in a large enclosed space. Jim tried to translate shamanism into the modern-day rock concert. He attempted to lead the audience on a metaphysical trip in much the same way the shaman leads the tribe on such encounters, by subjecting his body to a trance brought on by rapid movement and chanting. And there are those who believe that he sometimes achieved it.

Ray Manzarek is one of them: "I've never seen a performer like Jim—it was as if it wasn't Jim performing, but a shaman. The shaman was a man of the tribe who would go on a voyage in his mind, who would let his astral body project out into space and, in a sense, heal the tribe and find things that were needed for the safety of the tribe, for the continuance of the species. So, in a modern sense, Jim was exactly the same thing. Like a snake coiling around your body. Morrison would work your mind . . . He would build up a tension to the point where he had total control. He was like a preacher leading the congregation to salvation or slaughter, depending on the mood he was in. In retrospect it may have been a bit premeditated and overly theatrical, but at the time the energy we felt was real."

Shamans often exhibit hysterical and schizoid behavior and bring order to their psyches through entering the trance state. Morrison went through a complete metamorphosis onstage—his voice changing from soft-spoken to a fierce rattle and his personality going from low-key to completely dominant. Offstage Jim was known for teasing and playing games with people's minds, but onstage that side became a sorcerer and all his games were magic spells. In his stage presence he was wild, inner-driven. Like a shaman he would close his eyes, spin, whirl, and dance, creating images set to music by the other Doors. In one form of shamanism the shaman pulls out the sickness of his audience with eerie, earth-shattering screams such as Morrison was known to do. In all forms, the entrance into the trance state is helped by singing. The shaman typically has special "power songs" which increase in tempo as he approaches the trance. There are many

Doors songs that fit this scenario, but the most obvious is "The End."

Shamans communicate in a metaphorical style, a "secret language" that may appear as incomprehensible refrains repeated during the trance. The secret language is sometimes called an "animal language" because it originates in animal cries. In his book *An Hour for Magic*, Frank Lisciandro described one of Jim's stage performances: "He made strange animal sounds, screamed, and cried out as if in pain . . . his movements and gestures became fitful and spasmodic, like a person in seizure. He danced, not with graceful and fluid motions, but with short hopping steps and pistonlike motions, bent forward, head snapping up and down. He moved like an American Indian performing a ritual dance."

> *Snakeskin jacket*
> *Indian eyes*
> *Brilliant hair*

Shamans are held to be masters over fire, believing that fire transforms man into spirit, but their séances take place in complete darkness. It is only in the darkness or with his eyes closed that the shaman can block out the world around him and perceive the nonordinary reality he seeks. But darkness alone is not enough for shamanic "seeing." Often the shaman must be assisted by drumming, rattling, singing, and dancing. The drum and the rattle are important shamanistic tools for establishing contact with the other world and there are significant parallels here with Morrison's maracas and Densmore's drums. The shaman's rattle was considered a sacred instrument, enclosing stones in which spirits hide, summoning the helping spirits and frightening away the evil ones. The beginning of the steady, monotonous sound of the rattle and the drum is a signal to return to the shamanic state and the lightness of the shaman's trance is the reason that a drumbeat must often be maintained to sustain him. If the drumming stops at the wrong time, the shaman might come back too early and thus fail in his work. Laboratory research has demonstrated that drumming produces changes in the central nervous system. Electrical activity in many sensory and motor areas of the brain are affected because a single drumbeat contains many

sound frequencies and transmits impulses along a variety of nerve pathways.

The common shaman dance and one that Morrison frequently did was the circle dance which is a form of ghost dance. Traditionally, the dance circled around a pole that was the phallic symbol of manliness and power. In like manner, Morrison danced around a mike stand. Going around and around in a circle was designed to resurrect the dead, but it meant much more than that. The great Indian chief Black Elk described the circle dance in this way: "You have noticed that everything an Indian does is in a circle and that is because the Power of the World always works in circles, and everything tries to be round. Everything the Power of the World does is done in a circle. The sky is round, and I have heard that the earth is round like a ball, and so are all the stars. The life of a man is a circle from childhood to childhood, and so it is in everything where power moves."

In traditional séances a shaman circles a birch tree several times in ecstasy and then kneels to pray. The dancer's spirit finds its dramatized expression in dance steps, tempo, facial expressions, and gestures. The movements range from a sort of sneaking pace to sudden flying leaps to an almost reptilian writhing. It was very common for the shaman to begin writhing and then leap into the air and try to emit inarticulate sounds which are supposed to be the voice and private language of the "spirits." Anyone who ever saw Morrison in concert remembers his moving in just this way as well as his often inarticulate chanting. (Paul Rothchild remembers a drunken Jim "involuntarily talking in tongues" sometimes in the studio.) The shaman's dance culminates in his exciting himself to the point where he falls to the ground inanimate, in ecstasy. "Sinks," as these sudden drops were called, referred not only to the physical act, but also to the belief that the shaman was able to visit the underground worlds during these periods of ecstasy. Onstage Jim Morrison was known for suddenly dropping to the ground, almost as though he had been struck down, but also he frequently ended emotionally charged numbers such as "The End" by sinking to the ground and remaining motionless for a time.

"In the séance, the shaman led," Morrison said. "A sensuous panic, deliberately evoked through drugs, chants, dancing, hurls the shaman into trance. Changed voice, convulsive movement.

He acts like a madman. These professional hysterics, chosen precisely for their psychotic leaning, were once esteemed. They mediated between man and spirit world. Their mental travels form the crux of the religious life of the tribe."

It is during the trance state that the supernatural being enters the shaman's body and speaks through his mouth. His soul then can be guided on long journeys to the sky or the underworld in a magic flight. One type of shamanic séance required a horse sacrifice to ascend to the sky. Similarly, in "Horse Latitudes" Morrison wrote of a ship that had to sacrifice its cargo of horses to continue its journey. In his book *Shamanism: The Beginnings of Art* (McGraw-Hill, 1967), Dr. Andreas Lommel describes the journey of a shaman: "The soul of the shaman (journeys) into the deepest interior of the earth where the creative power of the world—pictured as a snake—dwells in the depths of the water . . . The aborigines say that various animals, especially snakes, assist the shaman on his journey and give him the strength, the 'medicine' for his office."

Often shamans were assisted by guardian spirits known as power animals. These include more commonly the horse, dog, bear, and eagle, but also the lizard. The power of the guardian spirit made one resistant to illness, providing a "power-full" body that resists the intrusion of external forces. A power animal or guardian spirit not only increases physical energy and the ability to resist contagious disease, but mental alertness and self-confidence as well. The power even makes it more difficult for one to lie. Morrison was known for having great physical energy and could function without sleep for exceptional periods of time. And he was also known among his friends as someone who always told the truth.

A shaman may discover that he already has an unusual connection with a particular animal. This may result from a deep childhood association, a recent peculiar encounter, or a longtime tendency to collect images and drawings of the particular creature. Morrison's central symbol, the Great Snake, with its slippery equation of freedom and violence, appears everywhere in his poetry including both "The End" and "The Celebration of the Lizard." According to Lommel, if a man has a vision of a snake "this means that all snakes assume the status of fathers for him." The idea that Morrison's frequent use of snakes and other shamanic

symbols is coincidental seems unlikely in view of this passage from Lommel: ". . . the people demanded that, to prove he has been called, the new shaman shall dive down into the (lake) and bring back medicine . . . the young shaman dives down into the depths to (The Great Snake) and says to it, 'There are many people standing on the bank, they want to see you.' The old shaman follows him and the two come to the surface with the snake. The two shamans ride on the snake in the water . . . the snake scatters crystals around it. After a while it disappears into the depths again . . . but the two shamans distribute crystals to all those present." That passage from "The End" goes: *Ride the snake/To the lake/The ancient lake, baby.*

Shamans obtain power by surrendering their will to the "spirit of the night" and in that sense they are possessed. The concept of possession has been distorted by popular films and literature to imply a perfectly normal person being violently and completely overtaken by a demonic spirit and undergoing a sudden and usually horrifying transformation. True possession simply means falling under the control of a spiritual entity. The process is usually gradual and not sudden and requires at least the implied consent of the person being possessed. In most cases, possession occurs only after the subject actively seeks to submit his or her will to an entity or demon. This may involve a conscious choice to come under the entity's control or a series of small choices to do the demon's bidding until, finally, the ability to choose otherwise has deteriorated to nothing. Most shamans are probably possessed, but possession is a universal phenomenon that affects more cults than shamanism. Jim Morrison believed he was possessed by the spirit of a shaman, but it's unlikely that this could have occurred when he first encountered the entity at age four. The fixation probably began there, but the actual possession is more likely to have taken place on the Venice rooftop when Morrison, by then well-educated in the ways of shamanism and similar philosophies, made a conscious choice in that direction.

Shamanistic lore maintains that once a man accepts the call to become a shaman, he must continue in the vocation or the spirits force him into madness and sickness until he either perishes under the coercion or frees himself by accepting his role. To those around Jim Morrison his "possession" was regarded

more as imaginative and hip behavior than as an actual state of his mind. His personality changes, the voices he heard, and the lack of control he had over his life were chalked up to his unique creative talents instead of a force that frequently manipulated them. One of the press's favorite quotes describing Morrison in those days came from Elektra publicist Danny Fields, who said, quite simply and ironically, "Morrison's possessed."

While Jim Morrison may have sought guidance from a shamanistic spirit he gave little thought to the source of that spirit's power. Like many during the occult revival of the sixties, he simply assumed that all spirits were good spirits, thus opening himself to be used and abused by any spiritual entity that happened to come along. The result may have been some amazing inspirations, but also a tragically restless and misdirected life.

In the 1960s the youth movement in America was at its strongest and The Doors were among its chief representatives. In some ways they did serve as its shamans, its medicine men. As modern youths grow up and approach adulthood, the musicians they listen to often serve as their conscience. All America is one big tribe, according to some sociologists, and that's why it acts like a giant family that "loves everyone" yet can still hate so much at the same time. The young and the hip of the sixties strongly exhibited a form of tribal consciousness. And if they saw themselves as a sort of community, many of them also saw Jim Morrison as a leader, their super medicine man, their shaman. In Indian societies, the shaman ruled the tribe with awe and mystical power. In modern America, the rock superstar holds similar reign over his audiences.

A new ax to my head:
Possession. I create my own sword

The New Haven Bust

Rock superstar, shaman, or both, Jim Morrison finally crossed the line in New Haven, Connecticut, on December 9, 1967—the day all his challenges to authority were answered. It was the day after his twenty-fourth birthday and The Doors were in the midst of a tour promoting the new album. They had played

Cal State Long Beach on December 1 with Canned Heat in two shows that were the first ever promoted by Rich Linnell. The band played for 50 percent of the gate and made ten thousand dollars, the most money they had earned in one night to date. A week later they crossed the country and played Troy, New York. The real story of the New Haven bust starts with the gig in Troy the night before. Morrison had arrived there late, having missed his plane from New York City. His agent hired a Cadillac limousine to drive him the 30-plus miles to Troy and he showed up not only late but exceptionally moody. Nonetheless, wearing his skin-tight black leather pants, he swaggered on to the stage at the Rensselaer Polytechnic Institute Fieldhouse and did his best. But the crowd was not ready for music that celebrated the black, evil side of life. They treated The Doors as entertainment and to them Morrison wasn't dangerous or prophetic, he was just another singer in another rock band.

After singing for forty-five minutes, Morrison came off the stage and said, "Let's see how they liked us." The response was not good. Rensselaer did not want an encore. The applause died quickly and The Doors hurried to the Cadillac waiting to take them to the airport. Morrison became depressed. There was no escaping that the concert, on this his birthday, had been a bomb. He refused to take the plane and wanted to ride all the 150 miles back to New York City in the limo. The agent agreed, assuring him the audience would be more appreciative the next night in New Haven.

Indeed, the New Haven crowd did seem more like a Doors crowd. There was a vibrancy in the air that night. An intensity. Well before the show, policemen ringed the corridors making sure no one was able to get backstage. Lt. James P. Kelly, head of the New Haven Police Department's Youth Division, was in charge of security. Kelly commanded a small army of loyal blues, each specially equipped for the concert with a can of mace attached to his belt. Maybe things weren't so liberal in the Ivy League after all.

Morrison was in a particularly troublesome mood before the show. He met a local girl, an eighteen-year-old coed from nearby Southern Connecticut State University, and began chatting with her backstage. Looking for a more intimate place to "talk," Jim found a shower stall near one of the dressing rooms. As could be

expected, within a few minutes Morrison and the girl were making out in the shower stall. Rock stars and backstage dressing rooms being what they are, this all might have passed without incident had not Lieutenant Kelly's men decided to be exceptionally thorough and clear the area of any hangers-on before the show. Somehow, no one is sure exactly how, one of the policemen was sent specifically "to get some hippie and a girl out of the showers."

Moments later, Morrison's little party was rudely interrupted when the shower door was suddenly yanked open. The policeman eyed Morrison and the girl suspiciously and ordered them out. The cop, who assumed the star of the show was merely a hippie who had come in out of the cold, told them in no uncertain terms that no one was allowed backstage. Whether through devilment or annoyance at not being recognized, Morrison stubbornly refused to move. The officer insisted, whereupon Jim grabbed his own crotch and told the cop, "Eat it!" At that, the policeman quickly detached his black aerosol can of mace and waved it in front of Morrison's face, warning, "Last chance." Morrison stared at him. "Last chance to eat it," he challenged. Angry now, the cop fired away, spraying Jim in the eyes and face with the mace.

Morrison screamed in pain and ran into the dressing room in a rage, tears streaming down his swollen face. His shouts brought Doors road manager Bill Siddons, who angrily informed the policeman that he had just maced the main attraction. As Siddons helped Jim wash out his eyes the officer acknowledged he hadn't known who Morrison was before macing him, but he still wanted to take him into custody. Realizing the show was in serious jeopardy, Siddons pleaded with Lieutenant Kelly and the other policemen that were there to allow Morrison to go onstage. Siddons argued that there were some two thousand people waiting for the performance and the show was to raise funds for a scholarship fund program. Finally, the police relented and Morrison and the officer who had maced him apologized to each other. Siddons breathed a sigh of relief and everyone settled down for The Doors' performance.

Within a short time, the recovered Morrison and The Doors hit the stage to an enthusiastic reception. The New Haven audience was much hipper than the students at Troy had been and

Jim could feel the difference. Flanked by the six huge amplifiers, he gyrated in his black leather pants and cut loose—singing, jumping, falling, undulating, crouching, fondling, twisting, and projecting electric poetry at more than thirteen hundred watts into the old sports arena. He bummed a cigarette from someone in the audience, threw a microphone stand off the stage, spat past the long line of cops stage front, and sang his songs. The crowd applauded excitedly throughout. In the audience that night were Michael Zwerin, a music critic from *The Village Voice* and several people working on a story for *Life* magazine—Tim Page, a free-lance photographer, Yvonne Chabrier, a researcher, and Fred Powledge, a writer.

In addition to the line of cops out front, more police watched the show from backstage where the audience couldn't see them. They must have been shocked. Morrison *was* dangerous, but danger was part of the show. According to Powledge, Morrison's performance had the same elements of carnality as in Troy the night before, but here the audience was going with it— they, too, were part of the music. As Morrison shouted the last words from "When The Music's Over," dozens of people in the audience shouted it along with him.

> *The music is your special friend.*
> *Until the end*
> *Until the end*

The crowd cheered wildly and The Doors began playing the last song of the evening, "Back Door Man."

> *I am a back door man*
> *I am a back door man*
> *Well, the men don't know*
> *But the little girls*
> *understand . . .*

During the instrumental break, Morrison started rapping to the crowd, improvising in place of the usual Willie Dixon lines. Maintaining poetic meter and in perfect time with the music, he began telling what had happened backstage. He spoke in terms that today hardly seem inflammatory and were certainly within

his First Amendment rights: "I want to tell you about something that happened just two minutes ago right here in New Haven . . . this is New Haven, isn't it? New Haven, Connecticut, United States of America?"

With the beat of "Back Door Man" supplying rhythm, he launched into a tirade against not only the individual officer, but the New Haven police force in general. The crowd grew quieter and one by one the cops at the front of the stage began to turn around and glower. Morrison talked about eating dinner that night, having a few drinks, and somebody asking for his autograph at the restaurant. He mentioned talking with a waitress about religion and then coming over to the New Haven Arena for a concert, where he met a girl in his dressing room. "We started talking," he said, still keeping the rhythm that Densmore was beating behind him. Then, in a humorously distorted Southern accent, he continued:

> *And we wanted some privacy*
> *And so we went into this shower room*
> *We weren't doing anything, you know,*
> *Just standing there and talking.*
> *And then this little man came in there,*
> *This little man in a little blue suit*
> *And a little blue cap,*
> *And he said,*
> *"Whatcha doin' there?"*
> *"Nothin'."*

Still writhing and twisting at the microphone, as if wanting to be identified with the black, evil side, he delivered the heart of his message.

> *But he didn't go 'way,*
> *He stood there*
> *And then he reached 'round behind him*
> *And he brought out this little*
> *black can of somethin'*
> *Looked like shaving cream,*
> *And then he . . .*
> *Sprayed it in my eyes.*
> *I was blinded for about thirty minutes . . .*

Suddenly Morrison shouted, "The whole world hates me! . . . the whole fucking world hates me!" and swung straight back into "Back Door Man" as suddenly as he had departed from it.

> *Oh, I am a back door man*
> *I am a back door man.*
> *Well, the men don't know,*
> *But the little girls*
> *understand . . .*

This lasted for about thirty seconds, which was how long it took for the police to switch on the auditorium lights. When the lights came on Morrison blinked out into the audience and asked why they were on. There was no reply. He then asked if the crowd wanted more music. The audience screamed, "Yes!"

"Well, then turn off the lights. Turn off the lights!"

Ray Manzarek walked over and whispered into Jim's ear, warning him that the constabulary was up in arms, but Morrison nevertheless persisted yelling, "Turn off the lights! Turn off the lights!"

At this point several policemen became incensed and lunged toward the stage and Lieutenant Kelly walked out from the wings. Morrison was nonchalant at first. He even pointed the mike at Kelly and said, "Say your thing, man!" Several more policemen then came onto the stage and one of them snatched the microphone from Morrison's hand as Kelly arrested him. The other Doors looked on in shock. Bill Siddons ran out and tried to protect Morrison's body from the cops with his own, but then more policemen came out and dragged Morrison off the stage. Lieutenant Kelly told the audience the show was over. The crowd was angry. Some started to leave, but others began pushing over the folding wooden chairs in protest. People started climbing onto the stage and a frustrated Siddons tried to protect The Doors' equipment as more policemen ran in. The police were worried now and began getting rough. Several scuffles broke out and more arrests were made.

Appalled by what was happening, the *Life* team tried to protest the arrests. Fred Powledge caught up with Lieutenant Kelly and told him that some of the policemen were being unnecessarily rough. "I thought he could undo what was being

done," Powledge wrote in *Life*: "He seemed surprised. 'It's sickening,' he said. 'It's terrible what went on here.'" When photographer Tim Page pointed out a patrolman who was being particularly rough, the lieutenant said he would speak to the officer as soon as things calmed down. Then Kelly hurried away, and moments later, when Page photographed a policeman "roughing up a kid," the patrolman Page had pointed out to Kelly came back and arrested Page. Michael Zwerin, the jazz critic for *The Village Voice*, describes what happened next: "Yvonne asked the policeman if she could have Tim's car key, cameras, and film. She was arrested. I went over to inquire after the situation. 'Excuse me, Officer, but I'm with these people. Can you tell me . . .' At that point the policeman said, 'He's one of them . . . you're under arrest too.' And I was hauled off."

But it was Jim Morrison who got the worst of it. The cops dragged and pushed him down a flight of stairs through the backstage area and wrestled him out into the parking lot. Vince Treanor, who later became The Doors' road manager, was at the show that night: "We saw two cops, one on either side of Jim, holding his arms. In front there was another cop actually punching and slapping him. After they beat him up, they took him out to the parking lot. He fell as they were trying to stuff him into the police car and they kicked him. Then they picked him up and threw him into the car and arrested the two photographers who got that on film, one from *Life* magazine. They were taken down to the station and the police demanded the film, but the *Life* photographer said, 'You touch this film and I'll see you in the Supreme Court.'"

At the station on Court Street, the policemen taunted Morrison about being "a long-haired pretty boy" and he taunted back that they were "ugly." One particularly angry cop promised to take care of him when he "got off duty at midnight," but fortunately nothing happened. After considerable turmoil, Morrison was charged with "breach of peace, resisting arrest, and indecent or immoral exhibition." His police number was 23750. The police said Tim Page, Michael Zwerin, and Yvonne Chabrier were arrested for "breach of the peace, interfering with an officer, and resisting arrest." The others arrested were all on charges of breaching the peace.

Early Sunday morning, a crowd of about eighty gathered out-

side police headquarters and protested the arrest. Police arrested nine more teenagers during the demonstration. Morrison was finally released from the New Haven jail at 2 A.M. on a bail bond of fifteen hundred dollars which Siddons paid out of The Doors' receipts for the show. The others arrested were released by 5 A.M. on three hundred dollars' bail each and the trial was set for January 2.

The police contended that they had received complaints from audience members who did not like the "foul language" that Morrison allegedly used. According to police, when Jim came onstage he uttered "vile and filthy remarks." Some witnesses disputed this, saying Morrison used "innuendo" but not obscene language. The team from *Life* said there was nothing wrong with any of the lyrics Morrison had improvised and that the entire situation was unnecessary on the part of the police.

The politics of the arrest are interesting: After Morrison was maced, his arrest was prevented only when Siddons pointed out that the performance was for charity. Later, when the arrest actually happened, was it for breaching the peace (the charge) or more for talking about breaching the peace? Would the same thing have happened to a rock group with a different image than The Doors' and did the police have the right to use mace, even if Morrison *had* been a wandering hippie as they suspected? Jim wasn't arrested until he described the incident onstage that evening and changed the story enough to make himself sound innocent, even polite. The police had, after all, lined up at the front of the stage to protect The Doors from a mob and they took exception to Morrison's portrayal, finding his description abusive and inflammatory.

Jim Morrison became the first rock 'n' roll star to be arrested onstage during a live performance. Across the country the headlines read "NEW HAVEN POLICE CLOSE THE DOORS" and "THE DOORS GET SLAMMED!" The press sided with Morrison. Of course, since brother journalists from *Life* and *The Village Voice* had been busted along with him, the battle lines were clearly drawn on Morrison's side. The reporters could find no justification for the arrest; just another example of Jim's enraging the uptight sensibilities of the local guardians of authority and morality. Consequently, they ran articles that asked questions like "How does a truth seeker breach peace?"

No doubt the New Haven bust was considerably precipitated by Morrison's attitude toward authority. The police were anticipating trouble from the moment the concert was announced and overreacted not only in the shower stall, but in the concert hall. New Haven simply wasn't ready for Jim Morrison. Ray Manzarek agreed: "In L.A. you could sing anything without getting busted. But New Haven was a different story. It was a pretty uptight place. It made us aware that we had indeed tapped into reality, that going up against the Establishment means putting your life on the line. It's a life-and-death battle for a life-style, for how far you can think and what you can say."

As far as complaints of an indecent performance, Bill Siddons said: "Of course his performance is indecent. But can you imagine anyone in the audience complaining about it. The police had the nerve to walk onstage during the performance—that would provoke the audience for sure."

These viewpoints were often quoted by the press at the time. The New Haven bust further alienated Morrison from the forces of law and order, as well as deepening the worst suspicions the conservative Establishment had about The Doors. On the other hand, the incident also added to the band's hip quotient. Morrison had proved to the kids of America that he was willing to back up his mouth. In some ways, however, New Haven was the beginning of The Doors' downfall. After the New Haven bust people began coming to the Doors' concerts for the wrong reasons. They began to expect the unexpected. Instead of coming for the music or even for a cathartic experience, they came to see Morrison freak out. "After the New Haven bust," said Manzarek, "the vice squad would come. People would come to see this sex god, and to see what he was up to."

When it was all over Morrison described the New Haven arrest in an interview at the Doors' office later that same month: "There were all these little rooms backstage, see, and I was talking to a girl in one of the rooms. It was actually a shower room, I guess. Then this cop came in and started hassling me and sprayed some gas in my eyes—it blinds you temporarily—and finally someone told him that I was with The Doors and was supposed to be there, or something like that. The cop let me go. Later, when I was onstage, I was singing 'Back Door Man' and in the middle I started telling the crowd what had happened backstage.

The cops pulled me off the stage, and they took a few other people to the police station with me; I guess they were arrested when they protested the cops' pulling me off. Anyway, about a hundred kids followed us to the station to protest, and the cops finally let us go on bail. There was a reporter from *Life* magazine; he had his wife and eight-year-old daughter with him and he told me he wasn't at all worried about what I'd said onstage."

A few weeks after the concert, the New Haven charges were dropped. Morrison's police record shows that "disposition of these arrests reflected the payment of a $25 fine for the breach of peace and a nolle prosequi on the other two charges." *Life* magazine threatened to sue for false arrest and the charges against their people were also dropped. For all the hoopla it got, nothing came of the New Haven bust on a legal level, but it drew so much attention to Jim Morrison that it meant nervous promoters, lost gigs, and angry cops to The Doors. And it raised the ugly possibility that some vindictive right-wing judge would one day decide to make Morrison an example to the other rebellious youth of the nation and send him off to do time. That was a very real possibility in those days. These were the last days of Lyndon Johnson and the first of the second coming of Richard Nixon. People thought that rock 'n' roll could actually change the world. And not all of the people who thought so were rock stars. One of them was J. Edgar Hoover, the head of the FBI, who, after the New Haven Bust, decided that he'd better keep an active file on one James Douglas Morrison.

In December each of The Doors received a royalty check for fifty thousand dollars. For Ray Manzarek it meant something more than money. At last he felt he could support his longtime girlfriend, Dorothy Fujikawa, and they were married at the L.A. City Hall that same month. Morrison was the best man and Pamela Courson was the bridesmaid.

On December 22 and 23, The Doors played a dance/concert at the Shrine Auditorium in downtown Los Angeles. The place was packed with two thousand hippies who listened to Iron Butterfly, Sweetwater, and The Bluesberry Jam before The Doors came on to a thunderous ovation. A few days later the band per-

formed three dates at Winterland with Chuck Berry on December 26, 27, and 28 and then closed out the year in Denver, Colorado, with Allmen Joy (who later became the Allman Brothers) from December 29 to 31. After two months, the *Strange Days* album was still number three on the national charts, due not only to the group's constant touring throughout America, but also to the growing cult of Jim Morrison.

> *There is an audience to our drama*
> *Magic shade mask*
> *Like the hero of a dream*
> *He works for us in our behalf*

THE LIZARD KING

By 1968 the Morrison myth was self-perpetuating. He was the "Acid-Evangelist of Rock," "The Oedipal Nightingale," "A Slithering Sorcerer," "A Demonic Vision out of a Medieval Hellmouth," and before the year was over he would be known forevermore as the "Lizard King." In the beginning, Morrison viewed publicity as a great game that the entire universe had accepted. He loved coining buzzwords and was genuinely surprised whenever he found that people took such things seriously. To him the phrases were obvious jokes, not essential truths. Describing the band as "erotic politicians" and claiming he was especially interested in "activity that seems to have no meaning" was done for the media to pick up on and Morrison thought it ludicrous for anyone to assume that a philosophy worth anything could be summed up in a few choice phrases. Such things were for the press, not for the believers. "I just thought everyone knew it was ironic," Morrison said, "but apparently they thought I was mad."

He was right about that one. The image was starting to out-distance the man. Despite all the media attention, Morrison was misunderstood by most of the press and therefore most of the people. New Jim Morrison stories surfaced weekly and each one was wilder than the last. Jim didn't have to do anything outrageous anymore. The press would do it for him. Of course, that didn't stop his excessive behavior or even slow it down. Morrison was, after all, still Morrison.

Although they paid their dues, The Doors' rise to stardom was meteoric compared to most bands. And few have established such a powerful image so quickly within the mind of the public. It was exciting to the kids and terrifying to their parents. To them The Doors seemed to be not only a band, but a piece of revolutionary theater aimed at the not-so-lily-white hearts of the middle-class American youths. After New Haven, Morrison made the cops edgy just by being around. There had always been bands who conveyed a dark image, but this was something different. The Doors were not just considered tough guys like The Stones. This was a group that sang about the evil and the reptilian and the bloody and they were about to become not just the number one group in America, but the number one *teenybopper* group as well. It was this popularity that scared the Establishment. If the band had been a cult group with only an underground following they would have been no real threat to the American Way, but this group that so boldly sang about wanting the world was now at the top of the charts.

In 1968, Jim Morrison began to discover the power he had. He had become so strongly identified with rebellion that just showing up for a concert was making an anti-Establishment statement. With power, however, always comes responsibility and that meant less freedom—something Morrison abhorred. In the beginning The Doors were a group of four equal parts, but all the attention given to Morrison had relegated the others to the back of the bus. The subtlety of their fine musicianship paled against the more charismatic image of the Lizard King and the greater recognition put more pressure on Morrison. The spotlight was always on now and the media demanded his time nearly as often as the fans.

To add to this pressure, Pamela was becoming more and more demanding. She had settled into the belief that he should quit The Doors and "live a normal life" with her. The way she

saw it, Morrison was a poet first and a rock star second and the life of a poet was much less demanding. When she'd tell this to Jim and ask him to quit The Doors, she never understood why he'd simply say, "But I am The Doors."

More than anything else, though, Morrison was now being pressured to write. This was something totally new to him. Up until now, he wrote poetry and songs when he felt like writing, but now it was time for a new album and The Doors were under the gun. "We were pressured to produce," Ray Manzarek told Pete Fornatale in *Musician*: "We worked on the first album for two years starting from the inception of the band, to writing the songs to finally recording the album. On the second album, half the songs were left over from the initial burst of creation. By the third album, it was time for all new songs, so we had to learn to create at a faster pace. You couldn't just fool around waiting for our Muse to come and visit."

It was in coping with responsibility and stress that Morrison's immaturity became most evident. He was brilliant and he was talented, but he was never very good at having to do something he didn't want to do. As the pressures increased, he began to withdraw and become dissatisfied with the band, the music, and himself. It is very common for people who acquire sudden wealth or fame to begin to question their own worth. There is an inner feeling that they're conning someone—they don't feel they deserve the money or the attention. Since Morrison never considered himself a singer these feelings must have been particularly strong, but it is doubtful that he would be able to acknowledge it. Instead, he continued on an ever-increasing self-destructive path as if to mock his strange glory. As far as his art was concerned, Morrison was often his own worst critic and he was beginning to have doubts about the effectiveness of his music. Sure, he was selling millions of records, but was he reaching anyone? Was anyone changing?

> *The Problem of Money*
> *guilt*
> *do I deserve it?*

It was in this frame of mind that The Doors began recording *Waiting For The Sun.* Like the others, the album was recorded at

Sunset Sound which now sported one of the new sixteen-track mixing boards. *Waiting for the Sun* was different from the previous two albums in many ways, but the big difference was in the material. The demands of success and touring had given the group little time to create new songs and now they were forced to try and write in the studio. They had decided to devote one full side of the album to "The Celebration of the Lizard," a twenty-four-minute poem Morrison had written that had been evolving ever since The Doors recorded a section of it on their demo in 1966. Designed for the stage, the work was a bizarre mixture of Marat/Sade, theatricality, erotic rock, and neobeat poetics. It was to be Jim Morrison's masterpiece. It was to be the coup de gras, the ultimate epic establishing The Doors as *the* artists of the age. Morrison's had even planned on naming the new album after the song and he wanted the cover printed in pseudo-snakeskin, with the title embossed in gold.

Almost from the beginning, the sessions began to go wrong. Morrison responded to the pressure by drinking more heavily than before. He began inviting friends, hangers-on, groupies, and drinking buddies like Tom Baker to the sessions. As a producer, Paul Rothchild, tended toward perfectionism and this often clashed hard with Morrison's improvisational side. Now with Morrison tuning out, Rothchild felt he had to make up the difference. "The production had to be more elaborate," he said. "As the talent fades the producer *has* to become more active. We got into heavy vocal compositing because Jim would come in too drunk to sing decently. Sometimes we put together eight different takes of a song to make one good one. I don't mean a verse at a time either. Sometimes it was a phrase at a time. Very little could happen because Jim Morrison was the creative genius, the *presence.* He was the irreplaceable member."

Though they knew Morrison was getting out of hand the other Doors also felt Rothchild was going overboard. John Densmore called an extreme example in *Modern Drummer*: "The ultimate in indulgence was 'The Unknown Soldier.' Rothchild had us do 130 takes! It was ludicrous. I like the song and the way it sounds, but c'mon. The heart was lost. I think with 'Waiting For The Sun' there are better takes in the can than what came out. Maybe with a mistake here and there, but with heart."

Rothchild says the song took a long time to record because

it was orchestral in design with many different sections, but some say this kind of perfectionism intensified Morrison's drinking during the sessions. Rothchild disagrees: "Jim was really not interested. He wanted to do other things like write. Being lead singer of The Doors was really not his idea of a good time now. It became very difficult to get him involved with the record."

Perfectionist or not, Rothchild's firmness kept Morrison somewhat in check. "He was one of the few guys who wouldn't take shit from Jim," Densmore recalls. "He would say, 'The session is over, Jim,' and that would be that." Morrison's behavior particularly upset Densmore, who finally got so mad he threw his drumsticks across the studio and announced he was quitting the group. "We were in the studio and Jim had a few of his latest friends in there who were just screwed up people and I said to Paul, 'I quit,' and left. I came back the next day. Music is my soul, and as painful as it was, I couldn't give it up. I think Jim's self-destruction was hardest on me. I can't speak for the others, but Robby is quiet and keeps things in and Ray is sort of the father figure. Maybe he really understood Jim way back. I didn't. I thought he was going crazy."

Densmore's brief exit made it clear to Ray and Robby that something had to be done about Morrison's behavior. They decided to hire a different kind of bodyguard—one who could protect Morrison from himself. Paul Rothchild suggested Bobby Neuwirth, a former roadie with Dylan's band, who supposedly could drink, think, and talk on a par with Morrison and still manage to get him to the sessions and gigs on time. The other three Doors agreed and had Asher Dann call Elektra to kick in half of Neuwirth's salary. The hard part was keeping Morrison from knowing he was being baby-sat. Neuwirth came in under the pretense of making a short film documentary on the band with the hope being that he and Morrison would start hanging out together. Morrison, of course, figured out almost immediately what was really happening but he played along anyway. It was as though he recognized his demise enough to not blame the others for the deception and yet still couldn't regain control of himself. Neuwirth soon discovered that no one could stop Morrison from drinking when he wanted to, so he did the next best thing—he drank with him and tried to keep him out of trouble.

It was clear that the group psychology of The Doors was

changing. Though they were friends, The Doors were always more of a collection of individualists than a group. All four of them were essentially loners, preferring to keep to themselves rather than mix in with a bunch of people. They were not gregarious, open, or for that matter, very friendly people. Rich Linnell, who promoted over twenty Doors shows and saw at least fifty, remembers: "The Doors were not the kind of people that you'd slap on the back or be jovial with. They had a sense of humor but they all are very private people. They liked to have their own space and they all kind of went their own way."

Most bands are like schoolboys, teasing each other and joking around, especially in the early days of working together. But The Doors were never like that. They were far too serious as a group. Morrison occasionally played practical jokes, but less and less with the other guys in the band, sensing that he was already stretching their tolerance. Ray and John were too uptight for that kind of thing anyway. Robby was loose enough, but he preferred staying in his own world and tended to not interact unless it was required of him. Morrison could be open and engaging, but he was moody as well and the social dynmaics of the band gradually worked its way to the lowest common denominator—communicating as much as it took to get the job done and sometimes not even that. "The thing that used to always strike me about The Doors," Linnell continues, "was that they didn't talk much among themselves. It was amazing how little communication they had offstage. Onstage they communicated brilliantly but offstage, even at the beginning, it was all nonverbal. I couldn't figure out why nobody talked to each other. There was no camaraderie. They would kind of huddle up a little bit before going onstage just to get the set straight, but more times than not even that was by the seat of the pants. John and Robby would often come to the gigs together, but none of them were ever that warm with each other."

Diane Gardiner, The Doors publicist for many years, puts it more boldly: "They had a pathethic group psychology. I was usually very close to all my clients, but I wasn't wild about The Doors. I didn't even like Jim at first until later when I saw how charming he could be. The thing that bothered me about the others was how guarded they were. They didn't strike me as being genuine. My other clients showed their warts and all, but they were very genuine."

Perhaps Morrison's drinking and increasing unreliability caused the other Doors to become more cautious in an effort to keep things together. "We were worried he would do something inadvertently because he was drunk," Manzarek recalled. "I stayed straighter than I might have. What could you say to him, 'Jim, don't have too many drinks. You're killing yourself?' He'd say, 'It's my life and I'll do what I want.' I think he felt things would turn around because we had so many good memories . . . simply incredible gigs. It started to go wrong around 1968, but up until that time The Doors and everyone else were floating on a psychedelic cloud of just magic. Then, little by little, things started to go bad. And you didn't want to think about the bad things . . . to accept that the times had changed."

On January 19 and 20 The Doors played the Carousel Theatre in West Covina, where Morrison delighted a standing-room-only audience—especially the teenage girls. Jim's wild behavior showed no signs of slowing down, however, despite Bobby Neuwirth's efforts. At the end of the month he and a writer friend named Robert Gover (*One Hundred Dollar Misunderstanding*) had decided to take their girlfriends to Las Vegas to party, but Pam and Jim got in a fight and Morrison wound up going without her. Intent on having a good time anyway, Jim insisted on driving Gover's Olds 98 most of the way there. In Vegas they hooked up with a few of Gover's friends and went to the Pussycat A Go Go to see "Stark Naked and the Car Thieves." That's where the trouble started. In the parking lot Morrison decided to pretend to smoke a joint in front of the theater's security guard. Whether it was because of this or just the shock of seeing a group of hippies approaching him isn't known, but the guard suddenly whacked the first person to reach him with his billy club. Morrison was next, and when the crazed guard came at him, he simply leaned against a wall and continued acting out his joint smoking. The guard bashed him . . . once, twice, three times, and Morrison just kept acting as if he wasn't there. Gover arrived to find blood streaming down Morrison's face and tried to get him away, but by then people were screaming and more security guards rushed in.

The Vegas police then arrived, took one look at the situation, and immediately grabbed Morrison and bent him over the hood of the patrol car. Gover wrote later (in an article entitled "A Hell of a Way to Peddle Poems") that it was a classic example of the

way Jim attracted trouble: "His charisma was such that your ordinary upholder of the established order could be infuriated merely by the sight of Morrison strolling down the street—innocent to all outward appearances but . . . well, there was that invisible something about him that silently suggested revolution, disorder, chaos."

The cops arrested Gover as well and shoved the two of them into the car. Morrison's head was still bleeding and both men rode to the police station in handcuffs. Worse than all this, however, according to Gover was that Morrison's "demons were bubbling up." Angry now, Jim started in at the cops: "You chickenshit pigs, you redneck stupid bastards . . ." Gover attempted to quiet Morrison and believes Jim actually tried to stop: "But it was hopeless, for the demons had him now and were coming through in a hurricane of invectives," Gover later recounted. "It wasn't just our momentary plight that had roused these invisible avenging angel/demons—it was also the temper of the times, the war in Vietnam, the plight of millions all over the planet who are unjustly harmed by such uniformed nitwits as these. Morrison thought and felt in planetary terms, and his mind had an uncanny way of reaching way back in time, as though he were the reincarnation of a pagan priest who'd been burned at the stake during the inquisition and was here to avenge that wrong, along with others. When manhandled by the emperor's troops, it seemed, he would rather be killed than humbled. In the heart and soul of Jim Morrison there was an uncontrollable rage against injustice. While it's true that he put people through psychological changes like you wouldn't believe, I never knew him to harm anyone physically—except himself. And then it was only to make a point, a statement he deemed important enough to suffer for."

At the police station the cops got their revenge for Morrison's disrespect. He and Gover were made to strip naked in front of an office full of people including several women while the cops laughed and made humiliating remarks like "Let's see if they're boys or girls." To make the torture complete the naked men were thoroughly sprayed down with roach powder before being thrown in their cells. Robert Gover later described what happened next: "By the time we'd been booked, fingerprinted, photographed, and thrown into the holding tank, James Douglas

Morrison was no longer present. His eyes were out of focus and he was panting like a fire-breathing dragon. That's when he climbed the bars of our extrahigh cell and drew my attention to the assembled minions of law and order by yelling, 'Hey, Bob, ain't they the ugliest motherfuckers you ever saw?' and such other endearments, delivered in that resonant voice and clear diction that was fast becoming his trademark as a singer. There was no point trying to remind him the police have the extralegal power to kill you, or worse, to beat you into a brain-damaged basket case. Whatever force had gained control of him cared not one bit for the safety of his physical being or mine."

At that point the officers who arrested them returned to announce that they went off duty at midnight and promised they would all then "have a date, somewhere real private." This only made Morrison angrier and he continued to spew forth ravings. As the clock ticked toward midnight, Gover was sure they would be killed but his girlfriend managed to get them out with only minutes to spare. Today, such an incident would trigger huge lawsuits and charges of police brutality, but in 1968 simply getting out alive was enough.

According to the Chinese calendar it was now the Year of the Monkey. Though usually peaceful, monkeys can turn vicious and the dawn of the Chinese New Year proved to be a bloody one in Vietnam. As day broke on January 30, the fireworks celebrating the New Year were mingled with gunshots as the Viet Cong violated the holiday cease-fire and launched a stunning surprise attack against Da Nang and seven other major cities. Within twenty-four hours, attacks had been made on thirty-six of the forty-four provincial capitals and the U.S. Embassy in Saigon. The Tet Offensive, as the attack was called after the Chinese word for the lunar new year, became the most important event of the Vietnam War. Although the invaders were eventually thrown back, the battle shattered America's illusions about a military victory in Vietnam.

The Doors meanwhile decided now was the time to change their management. Morrison had clashed often with Asher Dann when the manager tried to make him behave at performances, even to the point of having a few fistfights. Beyond this, though,

Jim was also suspicious of Sal Bonafede. He persisted in thinking Bonafede was associated with the Mafia, although there was no reason other than Bonafede's Italian looks for him to think such a thing. For their part, the other Doors felt that Dann and Bonafede might be trying to talk Morrison into going solo. Whether or not this was true or just the fears of a group who has suddenly seen one member get all the media attention, The Doors asked for and got an advance from Elektra to buy out their management contract.

The band now decided they could work better without outside business associates, preferring to keep more control by having their management within The Doors family. Their choice for the new manager was Bill Siddons, their road manager who had proven his loyalty to the band time and time again. Siddons was only nineteen at the time, and when The Doors offered him the manager position, his student deferment had already expired, leaving him with a difficult choice. If he took the job he would risk being drafted, but if he passed it up he would be walking out on the opportunity of a lifetime. After much discussion, it was decided that The Doors would pay Bill a weekly salary instead of a percentage and they would also pay all the costs of an attorney to get him out of the draft.

The Doors also considered Vince Treanor for the job. Vince had become the band's equipment manager just after Christmas and he had proven himself invaluable to their live performance. Vince was not your usual sound man. Before joining up with The Doors he was building pipe organs, perhaps the largest and most complex musical instruments of all. Treanor played and listened to virtually nothing but classical pipe organ music until someone played him "Light My Fire." I said, "this is rock music laid out along classical lines," Treanor remembers. "I went to see them at New Hampton and was convinced they were going to be as big as the Beatles. I saw them several other times and maintained contact with Bill Siddons because I was a witness to Jim's beating in New Haven. It was during the week immediately following that Siddons offered me the job. He said he could no longer continue as road manager because he was losing his college deferment and becoming eligible for the draft. Now, here I was, a conservative New Englander, and I was so impressed with this group that I handed over the business to my partner, walked

away from my friends and family, and hopped an American Air-
lines plane for San Francisco with eighty dollars in my pocket."

Treanor's genius with sound equipment soon proved worth
its weight in gold. Once he actually tore down and rebuilt
Robby's amp in the dark during a performance. He was also prov-
ing himself adept in other areas: "It was my job to see to it that
the group got there, that the equipment arrived in working order
and was set up, that the hall, security, lighting, and sound were of
international group quality and reliability. And when the show
was over it was my job to make sure the equipment got taken off
the stage with a minimum of theft and damage and transported to
the next location."

Since Vince was older and more experienced in business
than Bill he felt he should be considered for the management
spot as well and told Ray Manzarek. Ray went to the other band
members and they discussed the situation. Bill was their first
choice because they knew him better and he had handled their
money on the road and somehow managed to get them to the
shows on time in those early days when things were very un-
professional. Also, The Doors were concerned about Vince's tem-
per since he had flared up a few times on the road. Vince
elaborates: "When things screwed up with the halls or the union
guys or anything like that, as a last resort, somebody had to face
my wrath and usually at that point I got my way and it would
have been easier an hour before if they had just done it when I
was trying to be Mr. Nice Guy. That was just part of what it took
to get my job done in those days."

Now The Doors were really faced with a problem—they
wanted Siddons, but they couldn't afford to lose Treanor. They
sought out Paul Rothchild and he advised them to give Vince a
raise and the official title of Road Manager so he would have
more clout with the people he had to deal with. Rothchild knew
Treanor's concern was the band's well-being and he was right.
Vince accepted the deal with no complaints. "I wasn't bitter. I
didn't hold any grudges. I got a raise out of it and a hell of a lot of
authority. I don't think Bill ever forgave me for that. But he was
nineteen years old and suddenly managing the hottest group in
the country. Of course it went to his head. Why not? Whose head
wouldn't it have gone to?"

From this time on The Doors each took salaries of a few

thousand a month and then split the rest at the end of the year after the expenses were paid. Siddons was paid a straight salary and later got a percentage of the gigs, but not of the recordings. He also made sizable money by promoting a few of the band's shows.

The Doors also decided to have their own office at this time and moved into a bright yellow stucco building at 8512 Santa Monica Boulevard in West Hollywood. An ex-antique shop, it was set well back from the street and had a large downstairs room, making it ideal for rehearsals. Siddons set up his office upstairs and the band moved their equipment in downstairs. It was cramped and a bit funky, but well-suited to their needs. Morrison especially liked the office because it was across the street from The Extension, a topless club and near The Palms and Barney's Beanery—if he got too wasted he could always crash on the office sofa.

A thirteen-year-old kid named Danny Sugerman helped the band moved into their offices and after that started hanging around acting as a gofer—going for cigarettes, candy, whatever. But Sugerman was different from other fans. He was pushy and he was smart. Before long he was helping Bill Siddon's assistant, Leon Barnard, around the office, and about the time Siddons was going to throw him out, he had attracted Morrison's attention long enough to get a job answering his fan mail. No one knows what this meant to Jim, but it was an important beginning for Danny Sugerman.

Meanwhile the recording sessions went from bad to worse. Morrison was frequently late and sometimes kept the others waiting for hours. One particular time was described in detail in *The Saturday Evening Post.* Ray Manzarek was hunched over his keyboard that night when he finally asked the question on everyone's minds. "You think Morrison's gonna come back? So we can do some vocals?" Paul Rothchild was listening to the rhythm track the band has just recorded. "I hope so," he said without looking up. Manzarek nodded. "Yeah, so do I." A long while later Morrison arrived. He was wearing his black vinyl pants, and plopping down on a leather couch in front of the speakers, he closed his eyes. A tense silence filled the room. The band continued working and over an hour passed without anyone speaking to Jim. Finally, Morrison made a couple of remarks about hoping to

get a rehearsal in before the next show, but it was clear to the others that he was being ingratiating, making up to them in his own way. They responded to him in cool, emotionless tones. Feeling rebellious again, Morrison leaned back and lit a match. He studied the flame for a while and then very slowly, very deliberately lowered it to the fly of his black vinyl pants. Manzarek watched him with disinterest. The reporter from the *Post* said she had the feeling no one was ever going to leave the room.

One night after a session, Morrison and Jac Holzman went to a nearby restaurant. Holzman describes their conversation: "I chided Jim for having been driving without a license, dead drunk, smashing into an occupied patrol car and getting away with it. Jim said that the only way to live was way out on the edge and then he slyly looked up at me to see what I was thinking. I paused and replied, 'Jim, living on the edge is great. The trick is not to bleed.'"

Morrison continued drinking and partying with the result that "The Celebration of the Lizard," his ultimate masterpiece, had to be scrapped from the album. Apparently, he thought that he could still capture the magic of that epic piece in the studio no matter how much he partied, or else, because of the mounting pressures, he knew in his heart it was doomed from the start and took a "why try?" attitude. The night Morrison's powers finally failed there were a lot of people in the studio and he showed up late and drunk. He deposited his half-empty bottle of wine on top of the control panel and downed the remnants of somebody's beer. When Morrison was drunk, the others worked around him, tolerating him. Rothchild nodded briefly. The others ignored him completely and kept on working. Although Rothchild had the vocal mike off because they were trying to record a rhythm part, Morrison walked into the studio and started singing into it anyway. He writhed and twisted and sang "Not To Touch The Earth," but most of the time no one heard because the instrumental track was being played back.

Finally, Rothchild called Morrison over to listen to a roughly recorded dub of "The Celebration of the Lizard" while Manzarek tried to explain that the song didn't work. Manzarek was gentle, almost apologetic, as he pointed out that the song was simply too disjointed musically. All the various elements had by then been recorded and edited into one twenty-four-minute version, but

only Morrison was happy with it. The other Doors and Rothchild considered the cut too esoteric to experiment with any further except for the most musically accessible section, "Not To Touch The Earth." Rothchild suggested Morrison bring his notebook over the next day so they could work and Jim replied sort of despondently, "Yeah . . . sure."

Defeated, the Lizard King sought refuge within his scales. He disappeared for a while and then returned with a fresh bottle of brandy and went back into the vocal booth to record "Five To One." He turned the lights out, put on the earphones, and began his game: *Five to one, one to five/No one gets out of here alive.*

"Five To One" was recorded when Morrison was stone drunk. Knowing how he felt, the others tried to bury his presence in their conversation, but the power and anger in his voice wouldn't go away. When the vocal was over he came out of the booth and fell back against a wall, almost as though he were being impaled. He was plastered, but still coherent. He looked at the others and muttered just loud enough for everyone to hear: "If I had an ax . . . man, I'd kill everybody . . . 'xept . . . uh . . . my friends."

Later, Morrison had this to say about the failure of "The Celebration of the Lizard": "It was pieced together on different occasions rather than having any generative core from which it grew. It doesn't work because it wasn't created spontaneously. I still think there's hope for it. We should go back to the very free concept and start the whole thing over. We can play it in a half-hour version. It doesn't really interest me that much, though. It was never pushed through and I kind of lost interest in it."

Another Morrison song was rejected at this time as well. Jim had written "Orange County Suite" about Pamela, but after having worked on it several times the other three Doors decided it wasn't right for the album. According to John Densmore's biography, a frustrated Morrison then "turned to a male-groupie-leech named Freddie." Densmore seems to imply a homosexual experience when he adds, "or Freddie got Jim loaded and . . ." leaving the reader to fill in the blank. Whatever Jim's attitude toward the sessions had been before, it was certainly worse now. Robby Krieger describes another incident: "One time when we were mixing 'Waiting For The Sun' at TT&G Studio in L.A., this girl

drove up with Jim in a pink XKE. They just fell out of the car. Jim had drunk at least a quart of Jack Daniel's and this girlfriend had given him eighteen or nineteen reds, or Tuinal, and he was drinking on top of this, right? And he still wasn't dead, he wasn't bad enough to be taken to the hospital. But I don't think he contributed much to the session."

For the band the pressure to come up with new material was now greater than ever. They had been counting on "Celebration of the Lizard" to fill one whole side of the album. Instead, it failed so horribly that all but a small portion had to be scrapped, leaving a huge gap in material that had to be filled in a hurry. In March, The Doors were to play a few dates on the East Coast again, but just before leaving John Densmore quit again. The tension between him and Morrison was just getting to be too great. The interesting thing is that Morrison professed to be totally unaware of any problem between him and The Doors drummer. He was definitely being crude, rude, and inconsiderate to say nothing of irresponsible, but it had nothing to do with his feelings for the others in the band. In fact, it had more to do with Morrison's feelings for himself than for John, Ray, and Robby. The truth was Morrison was becoming so confused by this time that he was virtually incapable at the time of paying any attention to their feelings one way or another.

After Densmore announced he was quitting, Robby Krieger paid him a visit. Friends since high school, they had a strong bond between them. Robby, being the calmest personality in the group, was also a good listener. They sat up all night and talked it out and by the morning John decided to stay with the band.

█

Though the album was nowhere near finished it was time for the group to release a single, and, fittingly, they chose "The Unknown Soldier." By now, tortured images of Vietnam were playing nightly in everyone's living room and as of March, twenty thousand American soldiers had been killed. An antiwar song with martial music, shouted commands, the loading click of a rifle and shots mixed in with instrumental passages, "The Unknown Soldier" gave many a chill to the thousands forced to reg-

ister for the draft that year. The song was about war in general and not specifically about Vietnam, but many radio stations shied away from it as too controversial.

To help promote the record, Elektra produced a film that climaxed with Morrison being shot. With his trouble at New Haven now legendary, it was easy to picture Morrison as a political enemy of the state in real life. In the film, Morrison appears walking along the beach with his arms full of flowers. Next to him, Manzarek, Krieger, and Densmore are carrying a tamboura, sitar, and tabla. The three Doors sit on the sand and play the instruments as Morrison is bound to a stake—an apparent martyr. The camera angle is shot from ground level and catches Morrison's head from below—his eyes closed, a gentle, slightly bearded face, his long clustering locks—and the effect is that of a serene Jesus. At this point the sound track depicts the sounds of a firing squad: Orders are barked, rifle bolts snap, there is a brief drumroll—and wham! Morrison lurches forward suddenly and violently, his head hangs loose like a flower from a broken stalk, and his mouth vomits thick red blood onto the flowers at his feet. Then the music rises and the film displays a vivid kaleidoscope of the flag-waving side of war—orange-gold napalm flashes, burning thatched huts, howitzers blasting away—war is power! Then a quick series of darker images is flashed across the screen—troopers grimly moving out to face death, blindfolded prisoners stumbling, and bodies lying in the sun, crawling with maggots—war is hideous! We cut to two shots of a laughing child and suddenly the whole world starts to celebrate while a "resurrected" Morrison sings on the sound track: "It's all over, baby! The war is over! The war is over!" Images of VJ Day spill across the screen— sailors lifting girls with upswept hairdos; secretaries reeling off tickertape from skyscraper windows, people dancing on top of streetcars, shouting throngs filling the streets, laughing and weeping for joy. The video ends with the three "surviving" Doors departing the beach alone.

Morrison attains a bizarre duality in the video: killed on the screen, but surviving triumphantly in sound as both victim and victor. The music may not live up to the power of the visual images, but the film caused quite a stir. It illustrated Morrison's authoritarian personality and gave the Establishment more to worry about. It also came at a time when the teenyboppers

would accept Morrison doing *anything* and they loved to swoon over the death scene. After all, they had already made him a martyr in their minds.

On March 22 and 23, The Doors became the second act to headline Bill Graham's Fillmore East in New York. Formerly the Village Theatre, the huge Gothic hall presented the best rock on the East Coast for the next three years. It had excellent acoustics, the most visually intense light shows, and featured the top rock acts. The building itself was a veritable cathedral of worn marble staircases, towering columns, and pompous stage boxes which echoed with the ghosts of another era. More than all this, though, it was a place where a culture came together—a second home to the sixties rock generation, where they could be together and be themselves.

Look where we worship

The Doors did four performances over the two days with all twenty-five hundred seats selling out at five dollars each show. Whatever problems Morrison was having in the studio seemed to be overcome at the Fillmore and New York critics called him "mesmerizing," "demonic," and "spellbinding." One account described Manzarek, Krieger, and Densmore as "locking into a wholly cohesive, responsive unit fronted by a man who appeared possessed." At the Fillmore, Morrison was a shadow coming out of the wings—a phantom in a pea coat, a brown leather cowboy hat, extremely tight leather pants, and very long hair. The crowd screamed. He walked up to the microphone, grabbed the top with his right hand, looked up so the light hit his face, and dove head-on into "When The Music's Over." It was the beginning of a two-hour set during which he displayed a remarkable control over the audience. The concert included the full-length version of "The Celebration of the Lizard" and when Morrison performed the masterpiece that he then knew might never be on record, he created an atmosphere that had the audience holding its collective breath.

The Fillmore shows were magic. Rock theater was all that it could be on that practically virginal Fillmore stage. It was before Bowie, before Alice Cooper, and it was performance in a way that Mick Jagger did not know was possible. It was Jim Morrison at his

best. The concert ended with The Doors' screening "The Unknown Soldier" film and playing live behind it. When the song ended the audience leapt to its feet, screaming for an encore. Morrison had sacrificed his cinematic self to the cry of "The war is over!" and survived onstage to herald the good news. At the last triumphant shout, the audience in the theater roared back at the crowd on the screen, "The Doors have ended the war!"

The reviews were stunning—near hysterical raves that made the band sound more like heroes than performers. A female reviewer for one of the fan magazines described Morrison's entrance on to the Fillmore stage: "The world began at that moment. I felt like it was all a dream before that. Nothing was real except his incredible presence. Jim Morrison was there in that room and, baby, you better believe it. There isn't another face like that in the world. It's so beautiful and not even handsome in the ordinary way. I think it's because you can tell by looking at him that he IS God. When he offers to die on the cross for us it's ok because he IS Christ. He's everything that ever was and all that ever can be and he KNOWS it. He just wants to let us know that so are we. That's why we love him."

The Leather Frankenstein

Despite his successes, Morrison continued in his troublemaking mode. His meeting with Janis Joplin was a classic. Around this time Paul Rothchild decided he should get Morrison and Joplin together since he was working with both of them. He described what happened to Blair Jackson in *Bam* Magazine: "I thought here's the King and Queen of rock 'n' roll. They should meet. So I got them together at a party in Hidden Hills. They both showed up sober and are getting along great. Jim is fascinated by this remarkable girl and of course Jim was also a fascinating guy and really good-looking. Janis *loved* to fuck. That was her single greatest pastime. She saw this hunk of meat [Jim] and said, 'I want that.' Jim would get drunk most days and this was no exception and as usual he got rude, obnoxious, and violent. He turned into a cretin, a disgusting drunk. And Janis, who was a charming drunk, was really put off by him. Well, the more Janis rejected him, the more Jim loved it. This was his kind of

match. Janis finally said to me, 'Let's get out of here,' and we went
to the band station wagon that she always drove. Jim came stag-
gering over. He reached into the car and started to say something
and she told him to fuck off. She wasn't interested anymore. Jim
wasn't going to take no for an answer, though, and he reached
into the car and grabbed Janis by the hair. Well, she picked up a
bottle of Southern Comfort she had, reached out of the car, and
wailed him on the head with it. He was *out cold.* The next day, I
saw Jim in rehearsal and he said to me, 'What a *great* woman!
She's terrific! Can I have her telephone number?' He was in *love.*
Physical confrontation was his thing. He loved violence. I had to
say, 'Jim, Janis doesn't think it would be a good idea for you two
to get together again.' And they never did. He was crushed."

> *I drink so I*
> *can talk to assholes.*
> *This includes me.*

Fame and money were providing Morrison with access to
the further regions of reality. With fame came women. Except for
Pamela, the majority of the women he was having affairs (or
more accurately, one-night stands) with were on the bizarre side.
Many were alluring and attractive in their own way, but some
were just outright weirdos who drew Morrison because of their
strangeness: a freaked-out go-go dancer into demonism one night
and someone who had been brutally beaten and thrown onto the
highway the next. Where he found them was a mystery most of
the time, but find them he did. Morrison attracted the strange
and the bizarre like a magnet and he was often surrounded by
mystics, perverts, drunkards, and just plain lunatics. He collected
people like stray dogs. While he knew they were sponging off of
him, he was too kind to drive them away. Sooner or later they'd
disappear. Sometimes he would get drunk and go nuts and that
would scare them off, other times they got bored with him. Mor-
rison saw these people as kindred spirits, people out on the edge,
and he was fascinated by them.

Of course all of this was very frustrating to Pam. Despite
Morrison's flings and refusal to be tied down, she continued to
live out her dream. Often she'd be hours in the kitchen cooking
gourmet dinners only to have him fail to show up. She'd spend

weeks carefully selecting furniture to decorate their apartment and then, invariably, she and Jim would get into one of their knockdown, drag-out fights and smash up the place. Undaunted, Pam would simply go out the next day and start decorating again. One classic story involves the time she wanted Morrison to spend a quiet evening at home and he wanted to go out and party with friends (a frequent source of disagreement). After much bantering, Pam began screaming at him to leave and take his "junk with him" and started hurling books and dishes in a full-on barrage. Morrison scrambled out the door and made it downstairs without getting hit. Once he was in the clear, Pam began heaving his stuff out the window and a huge pile of books, clothes, and records was soon strewn about the front lawn. Meanwhile, Morrison just strolled off to town and did whatever it was he wanted to do in the first place. The next day, when he had sobered up and she had calmed down, they went out on to the lawn, picked everything up, and resumed their life as if nothing had happened.

Around this time Mirandi Babitz returned from England, where she had started a custom-tailoring business. "I was making clothes for a lot of the rock stars. When we got back my parents loaned us money to open a shop on the Strip. I made a lot of Jimmy's black leathers. Some of the more unusual stuff like the sailor-front pants. He used to come into the shop wearing the same clothes that we'd made for him the last time he was in and they'd obviously been worn to death. I don't think he changed much with success though. He cared about success, he liked it, but he was still pretty much the same Jim. Pam changed more than him. She'd gotten full of herself. She was loaded and she was into doing more outrageous things."

Success and fame only amplified Morrison's attitude toward authority. It didn't matter that the very Establishment system he raged against had made him a huge success—he hated it anyway. And now he was free to break more of its rules. A side effect of power is a loss of objectivity. Not only is there the problem of believing your own image (which no matter how absurd it may be, starts to sound true the thousandth time you hear it), but there's also the effect it has on the people around you. Much of our objectivity comes from the reaction we get from others. When you're unknown you can rely to some extent on friends

and others around you to provide you with an objective sense, but when you become famous, most of those around you are in awe of you so much that they are not objective. And if you try to turn to your old friends for that objective viewpoint you discover that their feelings may have been colored by their resentment or jealousy of your success. The bottom line is that you don't know whom to believe anymore.

Around the time of the Fillmore show, Morrison had another clash with Joplin and another rock legend. Danny Fields describes the night Morrison was at the Scene when Jimi Hendrix played: "Jim was *very* drunk. Hendrix was jamming and I noticed some commotion up front and there was Jim crawling on the floor toward the stage. He wrapped his arms around Hendrix's knees and starting screaming, 'I wanna suck your cock.' He was very loud and Hendrix was still attempting to play. But Morrison wouldn't let go. It was a tasteless exhibition of scene stealing—something Morrison was really into. To top it all off, Janis Joplin, who had been sitting in the back of the room, suddenly appeared at the edge of the stage with a bottle in one hand and her drink in the other. She stepped in and hit Jim over the head with the bottle—then she poured her drink over him. That started the three of them grabbing and rolling all over the floor in a writhing heap of hysteria. Naturally, it ended up in all three of them being carried out. Morrison was the most seriously hurt. His body guards were summoned and he was driven away. I'd heard that earlier in the evening Jim had knocked a tableful of drinks into Janis's lap."

The more Morrison drank, the more destructive he became. Anyone could see he was slowly killing himself, so the question arises, why those around him didn't try to stop him. John Densmore had this to say: "In the beginning, we were like brothers. As time went on it became three and one. It was harder to communicate with Jim. Musically, it was always okay because we didn't talk that much about what we were doing, it was intuitive, but it was hard seeing a friend self-destruct and not being able to stop him. It was the sixties when everything was mellow and you didn't really confront. Now I would take him by the shirt. But I was afraid of him, too. He was very powerful. He was a little older and real smart. When he came into a room, it was, 'Jesus, who is that?' That kind of power. He knew I disapproved of what

he was doing by my actions. I wouldn't be around or I'd storm out. I never directly said it, though. You didn't do that. And I believe that if someone is really going to change insight, it has to click, no matter all the verbal drilling you do to them. But if more people had confronted him, we might have had one less great album, but maybe he would still be around."

Paul Rothchild responds differently: "Stop him? Everybody tried to stop him!" he told Vic Garbarini in an interview. "You couldn't . . . strangers would stop him on the street and try to help him. We *all* tried to stop him. We even hired *professionals* to stop him. If you'd known Jim for even ten seconds, you'd know one thing: He was unstoppable. He was his own motive force, an astounding human being. There was no stopping him. Not even the woman he loved most could stop him, even for a moment."

Robby Krieger agrees: "Yeah, there was nothing you could do about it. People would tell Jim he should drink less, and Jim would take them out and get them drunk."

Inside Jim Morrison

In 1968, Jim Morrison was five feet eleven, weighed about 145 pounds; his hair was brown and his eyes a haunting blue-gray. He thought of himself as middle-class America and was proud of it. His car was American and he was a football fan, occasionally going to Rams games and playing touch football with friends. He enjoyed hanging around pool halls and cheap bars, listening to the jukebox and having a few beers. While capable of great intellectual discussions, he could also engage in small talk for hours. He was one of the guys.

Morrison had an almost un-American attitude toward possessions. He never owned a house. While he owned a car for a time, he was often without one and most of the things he did own would have fit into a carryall bag. In his pockets one could find a key to the Doors' office, a credit card, and his folded and torn California driver's license. He was forever giving something away—money, books, clothes—with a natural generosity. No matter how successful he became, Morrison was always taking shelter from the "stumbling neon groves" of Hollywood in cheap

motels because he felt their starkness was more real than the lavish suites his wealth could have commanded. No doubt their low profile was also an attraction. No one could find Jim Morrison when he didn't want to be found.

Frank Lisciandro recalls: "Jim didn't seem to have any sense of ownership about anything. As an example, I said to him one day that I had to go buy some new boots; he said he probably needed some new boots too and he'd come along. So we went to a Western-wear store and both shopped for what we needed. Later I found Jim coming out of a dressing room. He had bought a completely new outfit right down to underwear and then he went over and bought a new pair of boots. It looked like he had changed his skin. And being more reptilian, he left his old clothes behind . . . didn't take them . . . said to the guy at the store, 'Burn 'em or throw 'em away or give 'em to somebody.' We walked outside and I looked at him in the sunlight in front of the store and I realized at that instant that he could really live like a snake if he wanted to . . . shed his skin, have a new set of skin underneath, and walk away."

Morrison's personal life was a sometimes fascinating, sometimes sad blend of innocence and excess ranging from the sacrificial lamb on the one side to the demonic prince on the other. He lived very intensely with frequent mood swings from euphoria to depression. But despite this he was magnetic and usually very upbeat and fun to be around. Sometimes he would be a clown, acting silly and even making himself the butt of a joke. He had an ability to laugh at even the things he most treasured about himself—his rock star image and the way in which he let stardom confuse him into a betrayal of his poetic gifts for a time.

Morrison looked at everything in life as an ongoing experiment. He loved to play the provocateur, always testing people, one-on-one, in groups, and ultimately in large auditoriums. He delighted in catching people with their defenses down. Most of the time this was just good-natured teasing, but when he was drunk or depressed this side of his character became loud and argumentative, often resulting in senseless acts of violence. "Jim's greatest talent was to make you drop your guard," Bill Siddons adds. "He would provoke you intentionally sometimes, just to get a reaction and then he'd laugh. He wanted to knock you off guard so you would be honest and real and not just delivering some

sort of prepared dialogue that you'd said thousands of times. He wanted people to be real and if that meant jarring them a little to force that reality, then that was fine with him."

Morrison was a complex and talented man who made a determined effort to live by William Blake's proverb, "The road of excess leads to the palace of wisdom." While these excesses may have brought him liberating wisdom, they also led him to foolish self-parody and waste. He was well known for his antics, but he never did them for publicity. He did them for excitement. He got in barroom brawls. He swung nude from the bell tower at Yale. He played matador with the cars on the freeway. He challenged cops repeatedly and was maced, clubbed, and beaten more than once. He intentionally provoked crowds to rush the stage because he "wanted to see what would happen." What happened several times was a full-scale riot which excited him all the more.

Steve Harris, an Elektra executive, is quoted as remembering Morrison telling him over a beer, "You know the difference between me and you? The difference is that I could throw this bottle against that mirror, smash it, and in the morning I wouldn't have any guilt. None."

Morrison loved the threat of danger. He sometimes jumped out of a moving car "for the experience" and he would often hang by his hands out of windows several stories up just to tease someone or simply because he was bored. He seemed to have unlimited energy and didn't have any sense of when to stop or taper off. Bill Siddons describes Morrison's excessive nature: "He was one of those people who would find a new experience and do it beyond any rationale to find out where it would ultimately get you . . . He did a number of things that were beyond comprehension. In Seattle one time he jumped out of the *15th-floor* window, but he grabbed the window ledge on the way out. And of course everybody in the room lost their minds for that long. People were screaming and gasping. Then he came back going, 'Ha, ha . . . gotcha.'"

But while Morrison pulled his share of wild stunts, that's not what his friends remember most. "Most of my memories of Jim are much calmer," Rich Linnell maintains. "I remember intelligent conversation. Jim was usually able to steer a conversation and add insight. But he was often very introverted, quiet and off to himself. And I recall him much more like that than I do the

wildness. He had a powerful effect on people. I remember one incident in Santa Barbara, backstage in the dressing room in 1967. It was a large room and there were a number of people there, fifteen or twenty at least. Some of them were friends and some were just hangers-on. Jim came into the room and nodded at a few people and then walked over and sat in a chair to the side and didn't say anything. And within about three minutes that room became silent. And, of course, once it became silent, nobody wanted to talk, so it remained silent for a long time. It might have been ten or even twenty minutes until someone else came in or they had to go onstage or something. Jim didn't ask for anyone to be quiet or anything. It was just the aura that he put off and people's respect for him."

Along with a great awareness of life, Morrison had a great awareness of death. He wrote and sang about it and often talked about it. It wasn't a death wish as much as it was the thrill he got from trying to experience the sensation of death. He saw it as the other side of life and he was fascinated with its mystery and danger. It was this part of him that reasoned as follows: "I wouldn't mind dying in a plane crash. It would be a good way to go. I just don't want to die of old age or OD or drift off in my sleep . . . I want to feel what it's like. I want to taste it, hear it, smell it. Death is only going to happen once. I don't want to miss it."

> *Death of you will give you life*
> *& free you from vile fate*

There are also conflicting accounts as to Morrison's responsibility and reliability. While he almost never knew the time and was usually late to events and appointments, this was more a matter of his tendency to be entranced by the present moment rather than simple shiftlessness. Actually, Morrison took his business matters very seriously. He even insisted on having his own desk at the Doors' office and often answered his own mail.

Alcohol and psychedelics were really the only drugs Morrison did to any extent. He was not a junkie (in fact he abhorred needles) and he wasn't much into coke or pills. From 1965 to 1967 Morrison used LSD for the mind-expansion experiences he believed it provided, but later when he felt he had exhausted its possibilities he turned more to alcohol. He had been a social

drinker for years, but by 1968 he was becoming an alcoholic. Morrison saw alcohol more as an adventure than a weakness. He drank all varieties to excess, but his favorite was Bushmills Irish Whiskey. He knew he drank too much and accepted it as though he had no other choice in the matter. He seemed to believe he was destined to drink, as if it was part of his nationality or his art. "I'm not a musician, I'm a poet. And I'm Irish. The drug of Irish poetry is alcohol," he said more than once. Morrison viewed alcohol as romantic. He saw himself as a drinking man in the image of Hemingway or F. Scott Fitzgerald. He disliked the whole netherworld of dope and all its contacts and connections. It made him feel dirty. But he said of alcohol: "It's so sociable, and accessible . . . conventional. Besides, booze beats dope for me any day. Soul beats money and booze beats dope. Hands down."

The truth was, Morrison didn't create because of alcohol. He created in spite of it. In the early years the drinking never seemed to slow him down at all, but as time went on his love of excess became more apparent. He reveled, sometimes wallowed, in his mire, and as his alcoholism increased, his creativity decreased, but he was never not driven by the passion to create and everything good he ever wrote was written when he was sober. He often wrote in the early morning, in the fresh light of dawn, when it was quiet and clear. He wrote an amazing amount of poetry in those sunrise hours and that supply later sustained the band's need for lyrics when his drinking began to keep him from creating new work.

Morrison's personality and even inner motivations have to be put within the context of his era. Much of what society knows now about handling problems and nearly everything that has been discovered about the artist/star mentality simply wasn't known then. There were no role models. Rich Linnell elaborates: "The late sixties were a renaissance in music that had very little to do with what had gone on before. Today you can draw a straight line from The Doors, Led Zeppelin, and The Beatles to every group we have right now. Alice Cooper could look back on the role model of Jim Morrison and learn from Jim's mistakes and Alice wasn't that far behind Jim. Jim had no one to look at like that nor did any of the rest of us when it came to learning how to deal with things. In retrospect, that was the biggest mistake. Having worked with a lot of artists since then, I learned the biggest

lesson—to make sure your artist always has an out. Never paint them into a corner or make them feel trapped. Jim felt trapped. He felt there was no way out."

On April 4, Martin Luther King was killed by a sniper in Memphis, Tennessee. The man whose dream of racial equality had charted the course of civil rights in America for nearly a decade was killed shortly after marching for Memphis sanitation workers. The evening before his assassination King said in a speech: "I've looked over and seen the Promised Land. I may not get there with you, but I want you to know tonight that we as a people will get to the Promised Land." Although his widow pleaded for calm, blacks throughout urban America rioted when King was killed. Fires were set in Washington, Chicago, Baltimore, Kansas City, and over a hundred other cities as police and federal troops battled to restore order.

The *Life* magazine article on The Doors appeared in April, complete with photos of the police busting Morrison onstage in New Haven. The article was far more than the usual page or two the magazine devoted to popular music artists. Instead, The Doors received an eight-page spread and Morrison would have been featured on the cover had not Martin Luther King been killed the previous week.

On April 11 the band did a benefit at the Kaleidoscope (formerly the Hullaballo) in L.A. for radio station KPPC along with Love, Bo Diddley, and Pacific Gas and Electric. Eight days later they played two shows at the Westbury Music Fair in Westbury, Long Island, New York. The next week they were back in L.A. and Morrison ran into Pamela Des Barres. Des Barres had been one of Morrison's earliest groupies and was surprised to see him stagger into the Whisky a Go Go the night The Ohio Express played. "He took a full bottle of beer and threw it into Miss Lucy's face," Des Barres later recalled. "And when she screamed, 'That wasn't very nice!' he looked up painfully and said, 'I know.' Why did he do it? What's the reason he spits on people, beats on them, throws up on them? What can be going on in his head? I'm fascinated while others are repulsed . . . They had to turn the sound and lights off at the Whisky . . . because he climbed onstage with the very upset Ohio Express and shoved the microphone down his pants!

People aren't ready for him, but they watch *because* it's him . . . He's such a one-of-a-kind freak, so beautiful . . . I've never seen a more exquisite face. I wish I could hear him say something other than, 'Get it on' or 'Suck my mama.' Jim Morrison wrecked two cars in one week . . . and just left them in the streets and wandered into the abyss . . . Captain Beefheart asked John Densmore why he didn't get Jim to meditate, and he said first he would have to get him to communicate! The group seems to have given up worrying about him. What can they do? When we were sitting at his table tonight I had my eyes closed and was listening to the music when I heard him mumble, 'I'm going to take over . . . out of sight,' and then he reached over and slapped my face real hard and yelled, 'Get it on!' All I wanted at that moment was for him to beat the hell out of me . . ."

The American Tribal Love-Rock Musical *Hair* opened on Broadway on April 29. Writers James Rado, Gerome Ragni, and Galt MacDermot called for harmony and understanding as they attempted to put the excitement they saw on the Greenwich Village streets into a rock hymn. The rather simple story is about a man being drafted who tries to decide between two life-styles. But *Hair* is a celebration rather than a story. The language, clothing, music, and even the name of the play describe a social epoch in full explosion and helped cause a large audience to turn their heads in another direction—toward the flower child. The score includes "Hair," "Aquarius/Let the Sun Shine," "Good Morning Starshine," and "Easy to Be Hard."

By May, Morrison's drinking began to affect his performances. As the demands of pop stardom wore on his psyche he seemed to be more and more reckless with the tremendous power he wielded over audiences. On May 10, he incited a Chicago audience to riot and escaped through the backstage doors as the crowd battled it out with police, eventually stomping the stage and equipment into twisted debris. During the show one teen got so excited he did a swan dive from the balcony. As the crowd parted he landed with a splat, but miraculously was unhurt.

Despite the increasing violence at Doors concerts, Morrison maintained in a *Rolling Stone* interview that he never intention-

ally provoked the kids to riot. "I just try to give them a good time. They rush the stage because the cops are there and that's a challenge. It's like a game. The kids try to get past the cops and the cops try to stop them . . . If there were no cops there, would anybody try to get onstage? Think of the free concerts in the parks. No action, no reaction. No stimulus, no response. You see cops with their guns and uniforms and the cop is setting himself up like the toughest man on the block and everyone's curious what would happen if you challenged him. I think it's a good thing, because it gives the kids a chance to test authority. It's never gotten out of control, actually. It's pretty playful really. We have fun, the kids have fun, the cops have fun. It's kind of a weird triangle. Sometimes I'll work people up a little bit, but usually we're out there trying to make good music and that's it. Each time it's different. There are varying degrees of fever in the auditorium waiting for you . . . this rush of energy potential. There are no rules at a rock concert. Anything is possible. Let's just say I was testing the bounds of reality . . . I was curious to see what would happen. Just push a situation as far as it'll go."

As his power and reputation grew, Morrison began to feel trapped. On the one hand, crowds were turning out in droves encouraging him to do something more outrageous with each new show. And everytime he did something crazy it made The Doors more controversial and ultimately more successful. On the other hand, he was under the gun from the Establishment, taking the brunt of the heat from the cops and the press. In short, he was damned if he did and damned if he didn't.

What am I doing
in the Bull Ring
Arena

On May 18 and 19 The Doors appeared at the Northern California Folk-Rock Festival held at the Santa Clara County Fairgrounds. The outdoor festival also featured Jefferson Airplane, Big Brother, The Animals, Country Joe and the Fish, The Electric Flag, The Youngbloods, and Taj Mahal. The Doors performed on Sunday the nineteenth and encountered several problems. The ground was cold and wet and there was nothing for the crowd to sit on. As the day wore on the sun grew hotter, making the au-

dience more tired and disagreeable, and a few Hell's Angels lost their tempers and beat some people up backstage. On top of this the musical preferences of the Santa Clara crowd ran more to the San Francisco groups than to performers from Smog City. To his credit, Morrison put his all into the show but the band was not that well received. Having tired of hearing about the length of his hair, Morrison cut it himself the week before (causing a frantic series of transcontinental phone calls by New York groupies to find out just how short it was) and he looked more like a mid-sixties English pop star than a West Coast acid rocker. His performance was sort of a colossal superstar freak-out and when he tripped and fell at one point—a genuine accident—the audience actually groaned with disgust. Their faces were saying, "Another put-on, huh, Morrison? We know what *your* thing is, man!"

Morrison never liked performing outside or in the daylight and Santa Clara convinced him he was right. "We've never done too well in those outdoor daytime concerts. I think that we need the night and a sort of theater-type atmosphere and mood in which to work. There's something about the daylight and the open spaces that just sort of dissipates the whole magic."

As the album sessions dragged to completion in May, Morrison turned his attention to film. Bobby Neuwirth, his film director/bodyguard/pal had recently departed, but not before actually making a short film of *Not To Touch The Earth* and The Doors decided to shoot a full-length documentary. Jim had received many acting offers, including one from Desilu Productions to remake the old swashbuckler films with him playing the roles originated by Douglas Fairbanks, but The Doors decided a documentary would not only be fun, but a good investment. Dylan's *Don't Look Back* had done well as a feature release, but even a television sale would put the project in the black. Film was the direction that many hip rock bands were considering in 1968 and The Doors figured they could enhance their creative status and make a lot of money at the same time. They even planned to shoot some fictional sequences (Morrison decided they should describe it as a "fictional documentary" just to keep everyone puzzled). The band agreed to share the cost and spent twenty thousand dollars on cameras, lights, and tape recording and edit-

ing equipment. Paul Ferrara, a friend of Jim and Ray's from their UCLA film school days, was hired to shoot the movie and he brought in Babe Hill to do sound. Later, Frank Lisciandro, another UCLA film school friend, was added to help edit. Babe Hill would prove to be one of Morrison's closest friends—a drinking buddy, but more than that, someone who really cared about Jim's welfare. He was stocky and beer-bellied, with long hair and a beard and a stamina that outlasted Morrison's own and enabled him to spend many nights carrying his unconscious friend from bars to motel rooms all over the country.

On June 5, Senator Robert Kennedy was shot to death in Los Angeles, shortly after giving his victory speech for the California presidential primary. The assassination disillusioned many youths who had banded together to make themselves heard in the political arena. Kennedy had advocated getting out of Vietnam and throughout the campaign issued a challenge to the conservative Establishment: "Some men see things as they are and say, 'Why?' I dream things that never were and say, 'Why not?'" Although it was Senator Eugene McCarthy who first rallied the youth of America together to fight an uphill political battle against incumbent Lyndon Baines Johnson, it was Bobby Kennedy who captured their hearts.

Waiting for the Sun

Meanwhile The Doors were finding themselves under a great deal of pressure to come up with a hit single. Nothing had really cracked it for them since "Light My Fire" and they'd missed three times in a row. "Love Me Two Times" had been banned on quite a few stations for its suggestive lyrics, "People Are Strange" simply hadn't sold well, and "The Unknown Soldier," despite its promotional film, was just too controversial to get much airplay. Trapped by the respective demands of their conflicting audiences, the one demanding hit singles, the other "art," The Doors were never able to come up with a compromise to their own satisfaction. They had sold millions of records to the teeny-boppers on the strength of "Light My Fire" and the Morrison mystique and had managed to hold on to their underground au-

dience via the epics "The End" and "When The Music's Over." Though "Light My Fire" had been edited somewhat, it was still a classic song and not the least bit of a commercial compromise. None of the other songs Elektra released as singles could have been called a compromise either, but unfortunately none of them had done nearly as well as the label and the band expected. The second album had no hit single and The Doors and Elektra felt that they simply must come up with one for the third album. The song that did it for them was "Hello, I Love You."

Released in June, "Hello, I Love You" became number one after five weeks, stayed at the top of the charts for three weeks, and lasted over three months in the Top 40. The teenyboppers loved it, but to the underground it seemed like a betrayal. The lyrics were simple and the melody trite. The fuzz tone guitar that dominated the track was an overdone cliché and the shallow lyrics could only be compared to bubble gum. As a huge hit single, it was plastered all over the radio, causing The Doors' intellectual image to take a nosedive among the "heads" of the time. Some critics called it "the most blatant sellout single of the year."

These were the days when FM was dedicated to underground music and considered itself the artistic alternative to bland AM radio. For a band with almost impeccable underground credentials, this was such a crass Top 40 single that some fans immediately tossed in the towel and went off in search of more committed anti-Establishment groups. To make matters worse many people accused The Doors of ripping off the song's melody from The Kinks' 1965 hit "All Day and All of the Night." Ray Manzarek remembers: "Yeah, we were conscious of it. When we first started doing it we thought, hey, this song's a *lot* like a Kinks song! . . . Well, it doesn't sound *that* much like a Kinks song. It's all rock 'n' roll and we're all family. We're not stealing anything from them."

The Kinks were a band The Doors had always admired, but any similarity was purely coincidental. Ray Davies, leader of the group, said he could never hear the resemblance and Morrison's anthem to the girl on the street was one of his earliest compositions based around something he'd said to a girl at Venice beach.

The diehard Doors fans of the time claimed such "psychedelic

bubblegum" had to be a put-on. John Densmore's explanation is more likely: "The thing that was really a drag was singles. That's where the pressure was. We didn't try to write singles, but when it came time to choose them and to guess, 'Well, do you think the kids will buy this one?' No one really knew what was going on . . . We wanted to get something that they'd finally play since our last two singles ["Love Me Two Times" and "The Unknown Soldier"] were banned, so we did 'Hello, I Love You.' A lot of people said, 'Aww, man,' but it was just because we were trying to get back on the radio. They were happy with the album, though, because of all the other stuff."

Twenty-plus years later "Hello, I Love You" no longer sounds trite or meaningless. It has taken on the more lasting persona of the band that recorded it and connotes the hip and artistic. Around the same time, Jose Feliciano's slower, acoustic version of "Light My Fire" also shot to the top of the charts, further validating The Doors within the mainstream pop market. In 1968, with Feliciano's hit and a second number one summer single in "Hello, I Love You," The Doors were at the peak of their success, but they had begun to alienate the hip underground that first discovered them.

In July 1968, *Waiting For The Sun* was released and was a huge success with the kids and Top 40 radio. Entitled after a song that wound up being deleted from the album, it sold enough copies on its first day of release to qualify for a gold record. In some ways, because of all the flak over the simpler songs, the album has been somewhat underrated. It focuses very much on love. Love in wintertime, in summer, wild love, our love, the street of love, hello there, love—as if The Doors had embraced the heart of hippiedom at last. The record is a mixture of avant-garde efforts and Top 40 pop songs. "Hello, I Love You," "Wintertime Love," and "Love Street" are the obvious pop numbers while "The Unknown Soldier" and "Not To Touch The Earth" are more artistic efforts. The latter was the only thing salvaged from the failed epic, "The Celebration of the Lizard."

The result is a rather eclectic and strangely disjointed collection of eleven songs. There is undeniably great power in some of the performances on this record, but it is uneven and the shallow tunes ("Wintertime Love" and "Summer's Almost Gone") counteract any power mustered by the others. Part of it is a sum-

mertime mellow album which, while it might have been fine for The Beach Boys, did not fulfill the expectations of serious Doors' fans.

Of course the real damage comes when you compare it to The Doors' first two albums. These are works of great power, originality, and imagination, and what's more, they convey a real sense of unity. They flow from one cut to the other as though they simply have to be that way. There is a sense of the classic, a feeling that everything has some sort of great purpose. More than anything else this unity and flow is what *Waiting For The Sun* lacks. Even worse for the band's image, it hints for the first time that the group did have its creative limits. There are no long cuts here and no extended solos to speak of. While *Waiting For The Sun* is spasmodically brilliant and Morrison's voice sounds better and more under control than before, it simply does not overwhelm like the previous records. It is gentler and more romantic and it was not what the critics and longtime fans expected.

When the stiffening counterculture withheld the hip endorsement for *Waiting For The Sun* one would have thought the record was pure trash rather than just not as good as the albums before it. The critics wrote that the group sounded "as if they were running out of steam" and were "trying to imitate themselves" because they had "lost much of their spirit and creativity." And worst of all, *Waiting For The Sun* strengthened the dreadful suspicion that The Doors were in it just for the money. The fickleness of the hip press can be seen by the reviews The Doors received in the underground papers of the time: how quickly, they said, Morrison went from inspired artist to "only in it for the money" and The Doors from "breaking new ground" to seriously dabbling into "bubblegum."

All the rave reviews of the previous albums now came back to haunt them. As good as the Doors were, the early praise was out of proportion to the reality of their talent. The very praise that vaulted them to such lofty heights had now become the yardstick by which to measure their fall. Rock critics love to discover a new talent and champion him to death until the masses finally embrace him, at which point the critics may condemn and disown the artist for being too "commercial." The vast praise The Doors initially received forced them to have to live up to an

overblown success image before they had much of a chance to move on in their own direction. And there were many in the 1960s who were convinced that anything that was so instantly popular could not have any real value.

The sixties rock press, like the rock press of today, could be a schizophrenic monster. Sometimes they killed their own. Many were frustrated—writing so well they deserved to be paid far better and recognized as artists in their own right but instead treated one notch above groupies, they continually saw the bands they took under their wing turn on them. The more a critic succeeds at drawing attention to a band, the more likely the band will refuse to talk to him. The result is critics are like wounded lions waiting for an artist to make a wrong move. In the late sixties, half of them were looking for a new Beatlemania and the other half were condemning anyone who was dared compared to the Fab Four. In the seventies they would long for a new Dylan and almost destroy Bruce Springsteen's career before it had begun because his label had dared to hype him that way. The press, like politicians, believe their own hype and tend to blame the artist when he proves them wrong. They can undercut the substance of the music by analyzing the audience that rushed to embrace it, rather than the artist who labored to create it.

To be sure, there were many critics who defended The Doors at this time, but it was more on the basis of their previous excellence than on the current album. A few of the more extreme claimed the album was part parody. Perhaps Morrison's strategy all along had been to eventually show the world that rock machismo equaled Bozo in drag and that all rock stars were huge Oafus cartoons. Perhaps the guises of both "poet" and "shaman" were also just modern repackages of good old American snake oil. After all, this was the sixties and every piece of music seemed to have at least three deeper meanings then anyone had thought of yet.

Most of Morrison's defenders simply maintained that it was "a little early to be disillusioned" and insisted that The Doors were only "stalling . . . slipping into the teenybopper circuit." Some predicted that the band would only get more mechanically repetitive and that ultimately Morrison would break away to go his own, more creative direction. Those on the inside knew that

if anyone was slipping, it was Morrison, and while he might one day break away, it wouldn't be to pursue a new musical direction. The Doors *were* his musical direction.

There are some notable distinctions about *Waiting For The Sun,* however. It contains Morrison's first blatantly political song, "The Unknown Soldier." This was 1968 and political unrest had swept the United States with the assassinations of Martin Luther King and Robert Kennedy, draft card burnings, and student riots from Columbia to Berkeley. Morrison's commentary on war fit right into the landscape. "The Unknown Soldier" was timely all right, but the execution drama that made up its center, while very effective onstage, lost a little in the translation to vinyl.

An even more revolutionary number can be found in "Five To One" with its call-to-arms battle cry and mysterious ratio. The title has been the source of endless speculation and while most often interpreted as the ratio of young to old in America at that time, it also neatly fits the number of whites to blacks and non-marijuana smokers to marijuana smokers as well. Morrison never fully acknowledged his intended meaning. On previous records The Doors seem to comment without taking a stance, but on "Five To One" and "The Unknown Soldier" they assume a total authority within the mysterious world of their own projection. Even today the brazen antiwar and anti-Establishment rants on the end of each side of the album remain rather terrifying butterfly screams, though the societal convulsions that forced them out are long forgotten. Those were supremely desperate times, those dry-mouthed days and nights in the long hot summer of 1968 and The Doors were there.

Another interesting distinction of *Waiting For The Sun* appears on its inside cover. There, as if in defiant apology, is Morrison's 133-line theater composition, "The Celebration of the Lizard." "It was a brilliant poem," Manzarek recalls, "actually a series of poems and songs about people abandoning cities in search of something better. This tribe of people wanders through the wilderness and the desert for years, and each night they sit around the fire and retell the story of why they left the city. It's like an Indian tribe retelling the myths of where they came from."

Morrison once described the poem as "kind of an invitation

to dark forces." The lines about lizards and snakes reflect his fascination with the creatures. "I used to see the universe as a mammoth peristaltic snake and I used to see all the people and objects and landscapes as little pictures on the facets of its skin, its scales. I think the peristaltic motion is the basic life movement. It's swallowing, digestion, the rhythms of sexual intercourse, and even your basic unicellular structures have this same motion."

The inclusion of the poem characterized Morrison's increasing desire to be regarded as a poet rather than a rock star. Almost in blatant contradiction to that desire, though, is the album cover itself. *Waiting For The Sun* continued the snazzy Elektra product packaging, but this time the dominant color was bright pink (the color of bubblegum) rather than the surreal deco greens and browns and grays of the first two albums. While the feel of the design of the first two albums was avant-garde but slightly understated hip, the cover of the third was typical rock, even pop.

As to the other cuts on the album, "Spanish Caravan" with its flamenco-inspired acoustic guitar shows real arrangement/production expertise (as when Krieger switches his nylon strings for fuzz tone). Although the melody is simple, it conjures up some images of gypsies and bygone days. "Yes, The River Knows" finds Morrison at his mystical and enigmatic best with a particularly jazzy guitar solo being the highlight. While the cut has some of the feel of lounge song, the occasionally ominous lyrics delivered in Morrison's sultriest baritone make up for it.

"Love Street" is a very appealing ersatz Kurt Weill number. The flip side of the "Hello, I Love You" single, it's a jaunty tune with a bit of a technical sheen. The song, which describes a "house and garden" and the "store where the creatures meet," was written about Rothdell Trail where Jim and Pam lived together in a green house behind a country store in Laurel Canyon. Often they would sit on their balcony and watch the hippies come down the canyon to the store on what Morrison referred to as "love street."

"Summer's Almost Gone" is a rather mournful love song, but its "Strange Days" feel results in some interesting musical passages. It leads into "Wintertime Love," a harpsichord waltz,

which, while lyrically parallel, doesn't make for all that great a contrast. Since it comes in at less than two minutes (1:52), one gets the feeling it was a last-minute add-on. "We Could Be So Good Together" is built around another fuzz tone riff, but the lyrics have evocative moments.

"Not To Touch The Earth" is one of the more interesting cuts. It's the far side that Morrison so often felt. The lovers-on-the-run segment of "The Celebration of the Lizard" is particularly disturbing in the squealing discord between Krieger's guitar and Manzarek's organ. It moves along nervously to an insistent chorus that features a classic descending guitar figure and great drumming. The organized chaos of the ending is primo Doors and the final couplet (*I am the Lizard King/I can do anything*) ensures this sinister rocker with an immortality all its own.

"My Wild Love" is done a capella; handclaps and chanting provide an eerie backdrop for Morrison's soulful singing. Its chain gang cadence makes it as much a poem with harmonic moans as a song.

"Five To One" finishes the album in a big way and breaks the doomed-love glossiness of the preceding songs. It is both a masterpiece of prophetic warning and an inspiring call to arms. When Morrison drawls out *They got the guns, but we got the numbers,* you can forgive him the lightweight songs that came before. The imagery of a sordid love affair gone to ruin is a perfect analogy for Morrison's feelings toward America. When he reminds the girl that her ballroom days are over and refers to her walking across the floor with a flower and her saying no one understands, it is clear that he foresees not only revolution in America, but the failings of the flower children to stop it. Its macabre sense of sarcasm and danger build into a hissing monologue and accompanying chant which can imply all sorts of vile activities and impending doom. Musically, the song's mammoth bass lines, basic Indian rhythm, and charming guitar figures punctuated by Densmore's explosive bursts make it quite unlike the sound of most Doors' material. Though he never revealed the exact meaning, there is little doubt that in "Five To One" Morrison is speaking for an entire generation as well as speaking for himself. The anarchistic credo bears such stark contrast to the album's shallow ballads that it serves to remind listeners of the potential The

Doors were missing on most of the cuts. "Five To One" is the strongest track on the album and one of the more dramatic in The Doors catalogue.

Number One Group in America

By mid-1968 The Doors were firmly entrenched as the number one group in America. They commanded vast sums to appear before huge crowds in auditoriums, concert halls, and sports arenas from California to the shores of the Atlantic. Morrison's face had national recognition and the press was eager to report each new outrageous escapade. Even traditional Establishment publications ran articles about The Doors. The band rode supreme among American rock groups, with Morrison gaining yet another pseudonym partly from a song and partly from his skintight leather pants and writhing stage actions—the Lizard King had emerged.

Following in the footsteps of The Beatles, they prepared for the Hollywood Bowl and began planning dates for the Forum in Los Angeles and New York's Madison Square Garden. The bigger the arena the bigger the crowds and the bigger the take. The band was pulling in as much as thirty-five thousand dollars a night for crowds never numbering less than ten thousand. Maybe the critics and some of the older fans had abandoned them, but there were hordes of teenyboppers, convinced that Morrison was a sex god, ready and eager to take their place.

Playing the "big time" brought lots of additional hassles, not the least of which was having to compromise the sound quality. John Densmore remembers: "We liked the small, five-thousand-seat halls with the old thick drapes and the dead sound. The large arenas are for sports, not music, and they echo terribly. But we were excited by the mass thing."

Moving into the big halls also caused the performances to suffer considerably. While The Doors had been able to take an audience of five thousand serious underground music fans on a cathartic trip over the course of a two-hour show, it was virtually impossible to have that effect on twice that many teenyboppers within a one-hour set. For Morrison, playing concerts for thousands of screaming teenagers soon became a bore. "It's almost

impossible to bomb in concert," he said, "because just the sheer excitement of the event, the mass of people mingling together, generates a kind of electricity that has nothing to do with music. It's mass hysteria. In a large concert situation, I think histrionics are necessary because it gets to be more than just a musical event. It turns into a bit of a spectacle. I'm too conscious of what's happening. I don't like to be too objective about it. I like to just let it happen—direct it a little consciously, maybe, but just kind of follow the vibrations I get in each particular circumstance. We don't plan theatrics."

A major source of discomfort for Morrison was being expected to play the hits in concert. Before superstar status, The Doors were known for improvising the order of the songs—in fact they often argued onstage over what to play next. This type of spontaneous performing appealed to Morrison, but things changed when the band started playing the big arenas. The tight scheduling demands of a major show and the expectations of the crowd forced them into a more rigid song list. Never one to cope well with routine, Morrison's behavior onstage become more and more erratic. The other band members never knew what he was going to do. One night he'd move all over the stage and the next he wouldn't budge from the mike stand for the entire show. As time wore on and Morrison became increasingly dissatisfied with his role as rock god to a teenybop nation, the bad surprises began to outnumber the good ones.

As the audiences grew larger, Morrison's pension for drama increased as well and The Doors' performances became more show than concert. He began doing calculated moves such as "collapsing" several times during each show and "falling" off the stage every other performance. He moved in an almost choreographed manner instead of just "hanging on the microphone looking like somebody coming down from three days on meth" as he used to. Near the beginning of the year an L.A. newspaper called Morrison's falls "one of the phoniest things" ever done onstage. Jim happened to read it and decided the writer was right, so he stopped doing it. It wasn't that he actually planned out his entire show, but once he discovered a good bit, he tended to use it over and over again. The first time he fell off the stage it had been an accident, but he had noticed that the teenyboppers loved it. So, every few shows he did it again and they

went nuts each time. Part of the reason Morrison resorted to such things was because he felt it was necessary to do more to have an impact on so many people in such a large place. Part of it was because he was bored. But most of it was because he was slowly losing control of his life and now it was affecting his stage performance. The end result was the stereotyping of all those once-spontaneous movements that had originally whacked half the underground out of its collective skull. By the summer of 1968 you couldn't go to a Doors concert without having the feeling that you'd seen it all before.

When drama is unconvincing it appears phony and pretentious. There is a fine line between credibility and phoniness—a line Morrison trod carelessly. The onstage inconsistencies and histrionics did not go unnoticed by the critics. Many of them wrote about Morrison in a manner similar to that of Phillip O'Connor in *Hullabaloo:* "In the early days, no group played rock better or harder than The Doors. Now, instead of meeting the challenge of musical growth, they choose to evade the issue—and responsibility—and assume yet another pose. They say that they are 'delving into theater,' as clever a cop-out for not keeping pace as any I've yet heard. Are we seriously supposed to believe that Morrison jumping, Morrison screaming, Morrison pouting, and Morrison falling down is great experimental art and great theater? Or are we to consider the pathetic reruns of 'The End' in umpteen million different forms as what's happening baby? Is all of that sleepy sloppiness supposed to be avant-garde? If so, the Doors have been sadly misguided. A whole lot of people have been Brechtian-distanced well past the point of no return."

The Doors had become public property and as triumph piled on triumph—hit singles, packed auditoriums, national media exposure—the underground drew back first in dismay, then in disgust. "Incredible," they thought. "The Doors, of all people, had sold out. *Morrison* had allowed himself to be molded into a teen idol for *16 Magazine.*" Something like this was the death knell in the sixties when everyone wanted to believe that communication and art were the *only* real goals for recording artists. Although he'd made very few concessions to commerciality, the public perceived The Doors as Jim Morrison and he was blamed the most for the shift toward Top 40. Although the rock press claim it was liberal, it had its own petty idiosyncracies and conventions

and the critics were starting to question if a "legitimate poet could spout his visions of sex and death out of tiny car radios in between acne and Coca-Cola spots."

Morrison began seeing himself as a misunderstood poet living within the confines of the rock medium. More and more young kids were attending the shows now and most of them couldn't understand or appreciate his lyrics. They saw him only as a sex symbol and just wanted to hear the hits from the radio. The more he realized the words were being overlooked, the more frustrated he became. The truth is, Jim Morrison wanted to be taken seriously as a poet more than anything else. After all, his career as singer for The Doors had been almost a fluke, an impulsive stab that clicked and clicked good. He had always been more interested in film and writing, and he had taken on his duties with The Doors truly believing he couldn't sing a note. Inside, Morrison wanted to be a part of the artistic elite—recognized as a writer, a poet, a true artist. At first, when the sex symbol thing began, he was pleased, believing it could only enhance his power and increase his influence on the people he was trying to reach. But by this time, Jim had grown to hate it.

"I think most rock musicians and singers really do enjoy what they're doing," he said. "It'd be physically unnerving to do it just for the bread. What screws it up is the surrounding bullshit that's laid on them by the press, the gossip columnists and fan magazines. . . All of a sudden everyone is laying all this extraneous bullshit on his trip. So he starts to doubt his motivation. There's always the adulators—they just jangle the sensibilities. So you feel a little sense of shame and frustration about what you are doing. It's too bad. It's really too bad."

Morrison had always believed that one day he'd hang up the leather pants and begin a literary odyssey. Sometime in the summer of 1968 it began to dawn on him, through the haze, that he was a rock star and, worse, that he was likely to remain one. Despite his sense of humor, no one took Morrison as seriously as Morrison took himself. Now, as the tongue-in-cheek Lizard King, he was forced to realize that he would never be so much Baudelaire and Rimbaud as he was Bozo Dionysus. As if grasping at a last way out of the ever-expanding parody he was becoming of himself, Morrison decided to burst his own bubble. He saw the only way out and he took it. He walked into The Doors' office

and suddenly announced he was quitting the group. "It's not what I want to do anymore," he said. "It was once, but it's not anymore."

Amid the openmouthed stares that greeted this remark, only Ray Manzarek was able to rise to the occasion. He talked to Jim, weighing the various possibilities and the ramifications of such a decision. In the end, Ray asked for and got six more months. It was probably the right decision for Manzarek and the rest of the group and it was definitely a plus for the millions of Doors' fans. But though Morrison could reason out the logistics of a decision and make the right choice, he could not always live up to the commitment. No matter what his conscious, reasoning mind determined, there was something about Jim Morrison that always wound up doing exactly what he really wanted to do whether it was the right choice or not. He had given his word to his oldest friend that he wouldn't quit The Doors for six months. But inside, past the conscious mind, Morrison decided he would quit being a sex symbol. He began a rebellion against his own image, something he'd created but that was now out of control. He began searching for a way to break through the trap that was slowly choking the life out of him—some monumental act that would free him of the sex symbol image forever.

It may have been that Morrison only wanted to express his dissatisfaction with the way things were going. It was becoming harder for him to communicate to the others and blurting out that he was quitting may have been the only way he could broach the subject. Vince Treanor, for one, did not believe Morrison would actually leave the group: "He had no intention of quitting that band. That was all a myth, you know, just talk. He was scaring the group. What he was saying was 'Does somebody love me?' That's all it was. He wasn't stupid. Because the minute you take away a forum from a guy like Jim, he becomes a nonentity. What the hell was Morrison gonna do without The Doors? When a guy *needs* a stage to speak from is he going to quit the stage? And what would he do for money? How would he pay for his drinking, his parties, all those plane tickets, and those bashes in Palm Springs? The boy wasn't stupid."

Around the time *Waiting For The Sun* was released, Morrison became so discouraged that he didn't write at all. He just drank and sobered up and then drank some more. Sometimes

he'd have a fight with Pamela and say, "Well, you don't love me anymore, so I'm gonna . . . I'm gonna jump." Then he'd crawl out the window and hang from the ledge. He'd just hang there and after a while he'd say something like, "You better be nice to me or I'm gonna let go."

Booze was becoming a daily escape. He and Tom Baker were regularly getting drunk at Barney's Beanery in Hollywood. Morrison liked Baker even though Baker needled him constantly. Known for his starring role in Andy Warhol's *I, A Man* in which he did a nude scene, Baker used to chide Jim for being afraid to "let it all hang out." When Morrison argued that blatant nudity wasn't art, Baker called him a "prick tease." Morrison laughed it off, but never took a dare lightly.

Another time, Jim, totally drunk, walked into a jeans store and took his pants off and then waited half-naked while the clerk tried to find a pair of leathers he liked. Finally, he tried on a pair that laced up the front but then paid the clerk five hundred dollars to put a zipper in them, even though he knew there was an identical pair with a zipper already sewn in available on the rack.

Pam, too, had her escapes and not all of them were drug-related. Around this time she decided to open a boutique in West Hollywood. Mirandi Babitz remembers: "About six months after I opened my boutique, Pam opened one. By that time I was designing a lot and getting recognition in *Vogue* and Pam gravitated to that. I think she was trying to find another identity. She was struggling to be somebody on her own . . . especially with Jimmy taking off all the time. Boutiques were not that common yet, so we were mostly each other's competition, but the thing that caused a problem between us was that she did it very deceptively. She came into my place a few times and asked me a whole lot of questions and then I didn't see her for like two months and the next thing I heard she was opening this shop."

At one point Pam and Jim were thinking of calling the new boutique "Fucking Great," but she ended up naming it Themis, after the Greek goddess of justice. Pam went on an extended buying trip all over the world to find items to sell in the store. Of course Morrison paid for it, but even though the boutique eventually cost him over three hundred thousand dollars, he didn't consider it a loss because it made Pam happy. "Jimmy was being pretty generous," Mirandi Babitz recalls. "He gave her something

like twenty thousand dollars just to open the shop. She mirrored the ceilings and then bought thousands of pheasant skins and layered them onto the ceiling with the mirrors. It was all padded and velvet. Actually, there really weren't a lot of clothes. It was more of a place to hang out than the normal kind of shop. There were always a lot of hip people hanging around and it reeked of dope."

> *She was such a trip*
> *She was hardly there*
> *But I loved her*
> *Just the same*

The Hollywood Bowl

The Doors concert at the Hollywood Bowl was touted as *the* rock event of the season in L.A. In fact, in the weeks before the show the band had a meeting to discuss some new ideas especially for the Bowl. Vince Treanor remembers: "Everybody was called into a big meeting . . . all The Doors, myself, Bill Siddons, and Kathy Lisciandro [Frank's wife who was now The Doors' secretary]. Ray had worked out an elaborate production idea for the show—having the band wear Kabuki masks and Oriental theatrical costumes with special lighting and dances . . . a whole theatrical production. It was very interesting with all this incredible shit going on before, during, and after the performance. But the other guys felt that it just wasn't The Doors. Jim didn't say much of anything. He didn't give a damn what they did. He didn't care if they had fire hoses onstage at that point. 'Just give me my microphone and do whatever you want to do.' Jim was pretty straightforward about what he wanted to do. 'Let's just get up there and do it.' None of the bullshit."

The mass acceptance of The Doors was evident in the show being cosponsored by local Top 40 radio KHJ, one of the stations that had refused to play the band's records in their underground days. Steppenwolf and The Chambers Brothers were chosen as the opening acts and everyone who was anyone was at the Bowl on July 5. Mick Jagger and Jimmy Miller, The Stones' producer, had gone out with The Doors to dinner and now they were sit-

ting up front which no doubt added some pressure on Morrison, as Jagger watched his every move. The Doors had fifty-four amplifiers spread ninety-six feet across the stage producing sixty thousand watts of power. All eighteen thousand seats were sold out. This was their homecoming concert and they wanted it to be special.

Steppenwolf opened. John Kay and company had a big hit with "Born To Be Wild" and they were well received. The Chambers Brothers ("The Time Has Come"), however, stole the show. Known as a hard-working stage act, they put their all into it and came off great. Perhaps too great. When their set was over there was definitely a feeling of anticlimax in the air. The Doors came on and opened with "When The Music's Over." For some reason they decided to extend the keyboard intro a great deal longer than usual. The idea was to build the suspense, but the passage went on so long that it became monotonous and the audience began to get impatient. By the time Densmore did his drumroll and Morrison his scream, the crowd was already primed for a less than spectacular evening. Audiences never knew what to expect from The Doors, however, and for a while they waited expectedly—waiting for Jim Morrison to do *something.* But he didn't. He just stood there and sang his heart out.

A lot of people claim Morrison was great that night. Few had actually heard what a powerful range he had, but for some reason Jim got down and *sang* at the Bowl. The energy he usually put into his physical movements onstage went into his voice. Maybe it was because he'd dropped acid just before the show or because Jagger was in the audience or perhaps it was because he was tired of playing the freak. Whatever the reason, the crowd was caught totally by surprise. After the first three or four songs the audience began to get edgy. Why isn't he *doing* anything? Even "Hello, I Love You," The Doors' current big hit didn't seem to pacify them. Later, the audience cried for "The Crystal Ship" and Morrison shouted back at them and then sang what he wanted to sing. The crowd seized such moments for all they were worth. They were desperate for him to be larger than life. They wanted the myth and not the man.

After another couple of songs including a section of "The Celebration of the Lizard," a few teenyboppers began to scream for "Light My Fire." Onstage The Doors talked among themselves.

Though they were tired of performing their first hit, they would have to do it sooner or later in the show anyway. Why not give the crowd what they wanted? Seconds later, as the famous intro began, loud cheers broke out all over the Bowl. People began lighting sparklers and throwing them at the stage. It was a moment.

But soon the song was over and still the audiences waited, waited for something from Morrison that he just wasn't prepared to give. It was the day after the Fourth of July and the evening was punctuated with leftover firecrackers from self-appointed entertainers in the audience. At one point some agile outsiders scaled the walls of the Bowl, attracting attention as squads of ushers converged on them. One diehard fan even managed to dodge his way right on to the stage. Morrison paid him no mind and just kept singing. It didn't bother him. In fact, almost nothing bothered him that night. Morrison was never more open or more generous with his audience. He was playful—singing, dancing, joking, and reciting poems. Everything went smoothly, too smoothly for many in the crowd and they became restless. The impact of "The Unknown Soldier" seemed dissipated. Instead of being entranced by chaos and surrounded by passion, love, violence, and death, the audience had been reduced to mere spectators watching a well-executed performance which contained nothing of crucial significance. It was a good show and nothing more. The mystique had turned mundane.

The sense of unpredictability and spontaneity, so important to the success of a Doors concert, was missing. Apparently Morrison had decided to show what a professional he could be and that was exactly what the audience did not want. What they wanted was temperament, tension, the feeling that something was about to snap unleashing something horrible and utterly uncontainable. At the climax of the show when the lights didn't go down during "The End," they didn't want Morrison to keep his cool and go on singing. They wanted him to scream, make a fuss, or maybe even walk off the stage. If he had they would have screamed for refunds, but they would have understood and they would have been satisfied. Instead Morrison was not only cool about it, but actually playful . . . joking around. Joking around during "The End"? It was unthinkable. Never mind that he had probably performed the song a thousand times by then. He was

not only supposed to feel it, but be overcome by emotion and outrage at his own words written long ago when he was a different man in a different world.

Perhaps the Bowl itself was to blame. It was a forbidding place, forcing the crowd to keep its distance and reeking of austerity. When it was over Morrison left the stage, slumped and exhausted. He seemed smaller at that moment, almost slight as he walked toward his dressing room, eyes blank, face covered with sweat. The Doors' concert at the Hollywood Bowl should have been the return of the conquering heroes. It should have been a high point in the career of a local group who had become the number one American rock 'n' roll band. Instead it was a bore. And to Jim Morrison it clearly showed that another possible escape route from his bizarre and glamorous prison had already been sealed off.

The spectator is a dying animal

Meanwhile, Jim and Pam's clashes continued. Although the boutique kept her busy, it didn't do much for her insecurity, and the effects of his drinking and her drug use were now taking their toll. Mirandi Babitz elaborates: "Pam and I used to do a lot of coke together in the early days, but now she was getting into heroin. She was snorting it. I don't think Jim cared if she did it, but if he found she was getting too fucked up or too fucked up to be of any use to him he would probably get upset. I'm sure they were like any addicted couple would behave. Each one blamed everything on the other's problem."

Others claim Morrison got very angry with Pam over her use of heroin. A neighbor in Laurel Canyon recalls Pam describing a violent argument over the issue where she locked herself in the closet to get away from Jim's rage. Supposedly, Morrison then doused the closet with lighter fluid, tossed a lit candle at it, and left the house. After a few tense moments, Pam was able to break through the door and put out the fire. Close friends of Morrison's doubt the validity of this story, however, saying that while Jim might do such a thing for effect, it would only be if someone was there or if he knew there was some other way for Pam to get out of the closet.

The Doors were earning more than ever and the money en-

abled Morrison to buy just about anything he or Pam wanted, but as most successful people discover, material things aren't enough to fill the void that insecure people feel inside. Like drugs, money just provides a temporary escape from the problem. Not that Jim and Pam didn't give it a try. "I remember he bought her this XKE," Babitz continues. "She was such a little thing you could barely see her. Pam was this little orange head peering through the top of the steering wheel. Pam changed with his success. She cared a lot about having money. She didn't want a car, she wanted that XKE. But the more success he had the more outrageous things she did."

After the Hollywood Bowl The Doors went on the road playing Houston on July thirteenth, Dallas on the fourteenth, and Honolulu on the twentieth. In Honolulu a thoroughly plastered Morrison tried to rent a motorcycle to ride all over the island, but was thwarted when Bill Siddon's wife, Cheri, sent the cycle back. Pam, feeling ignored while Jim was on the road, had a fling with actor John Phillip Law of *Barbarella* fame. She made sure Morrison heard about it and they had many a long-distance argument over it. Her idea was to force him to come home and finally he did the next best thing. Mirandi Babitz remembers: "He finally said she better get her ass out to New York where he was. She drove to the airport, parked the car in the regular parking lot, and took a flight to New York. She came back two weeks later and the police had towed it and discovered the kilo of marijuana she'd left in the trunk. They busted her, but Diane Gardiner [The Doors' publicist] had someone get her out on a first defense. I don't know how . . . a kilo was a lot in those days, but I think they realized she wasn't selling, she was just spaced out."

The Singer Bowl

On August 2, The Doors played the Singer Bowl in Flushing Meadows Park, in Queens, New York. The arena was left over from the old New York World's Fair and the double bill with The Who was a total sellout that was to be filmed for possible inclusion in The Doors documentary. It was a humid, tense, end-of-summer Friday night, and Morrison, Doors film crew members Babe Hill and Paul Ferrara, and Ellen Sander, a writer

for *Hit Parader,* climbed into a limo at the motel and rode out to the Bowl. Right off things started going wrong. The driver got lost and Morrison began accusing him of "anarchy." Then they got caught in the traffic of the crowd arriving at the show. Eventually they found a road that led to the stage entrance, but as the limo rounded a corner a host of fans rushed toward it. They had been waiting for just this car.

The kids surrounded the limo forcing it to stop halfway to the entrance. Then they moved in pressing their hands and faces against every available window. Some even jumped on the back of the car, laughing and squealing. Several reached for the door handles. Sanders reached across Morrison to snap down the lock on his door, but he got there before her and opened it. The kids went nuts, reaching in, grabbing at Morrison, pulling at his clothing. Jim made no resistance and even climbed out of the car and stood in the midst of them. They converged on him, pressing beads and photos and drawings into his hands. Morrison smiled. "Will some of you girls escort me backstage?" Sander reported him saying. He laughed huskily, almost embarrassedly. "I might get mobbed or something."

Backstage was crawling with photographers and fans who had managed to get past the guards into the steamy cement locker room. There had never been any trouble at the Bowl, so security was lax. To make matters worse, Morrison decided to take a walk inside the arena. He got about twenty feet before hundreds of people swarmed around him and he had to return backstage. Babe Hill came running up. "There's already been some trouble." He grinned. "The Who don't want The Doors' equipment onstage when they play. I think they're sore because they didn't get top billing. They threatened to wreck it if it's there when they close the set."

By the time this was all sorted out, the program started late. A surprise third act, The Kangaroo, was announced, angering the crowd, but their set was over soon and The Who came out. Then, just when everyone thought things would settle down, it got worse. The Who were not performing up to par and the revolving stage stalled during their set, resulting in several hefty repairmen hustling onstage to bang away in an attempt to fix it. Nothing doing. It was stuck and stuck good. When operative, the revolving stage made it possible for the act to be seen from all

angles. When it stuck, a fourth of the crowd was left with a view of nothing but amplifiers and these people were starting to get mad. In an effort to calm things down, Pete Townshend did a bump and grind on stage and joked that he "had to get one in before Jim Morrison comes on." At the close of The Who's set, Ray, Robby, and John came outside to watch the band's famous equipment destruction finale. Townshend had to slam his guitar to the floor several times before it shattered. Then he threw the pieces out into the audience and the crowd fought among themselves for the fragments. Keith Moon kicked in his drums and rolled them off the platform. One of The Who's road crew lit up a smoke bomb, but it was all sort of anticlimactical. The Who had played a bad set. The equipment smashing came off too easy, too planned, as though it was the only way off the stage.

Nonetheless, the crowd roared. They were ten thousand strong, whipped into a frenzy from sheer frustration if nothing else. When The Who came offstage Townshend told Elektra publicist Danny Fields that the audience was "real tense and ready to explode." Fields hurried to tell The Doors. Morrison just looked at him as though he was an idiot and said, "How can *you* tell?" The crowd was anxious but The Doors decided to take their time about coming on. A full half hour passed and still no Doors. By this time the audience was stomping and shouting, demanding The Doors. Finally, Manzarek, Krieger, and Densmore were introduced and they began a musical vamp while waiting for Morrison. Jim deliberately took his time, already getting off on manipulating the crowd to relieve his boredom.

When he did come, he came with an entourage of security cops forming a wedge in front and behind him, completely hemming him in. People leaped at him and tried to touch him, but the cops got him safely to the stage. Morrison grabbed the mike and began to sing, but a good portion of the audience still couldn't see. They began storming the stage hoping for a better view, but the cops turned them back. As if to further infuriate the angry crowd The Doors stalled onstage, messing around between songs. Every now and then a few people would try and climb on the stage and the rest of the crowd would cheer them on. Morrison played it to the hilt, growling songs at them rather than singing, ad-libbing, improvising, doing some kind of ominous dance. And everywhere he went The Doors film crew followed,

all over the stage, trying to capture his every move. In the crowd there was a mounting sense of hysteria.

Adding to the volatile atmosphere the houselights had been left on for The Who's set as planned, but they were turned off for The Doors. This was a New York crowd and the concert was punctuated with hostile shouts as people screamed at each other to sit down or more often "get the hell out of the way." Morrison made an offhanded effort to control it. "Cool down," he urged almost seductively. "We're going to be here a long time." The audience responded by shouting for "Light My Fire." Jim threw himself into the show, playing off the mood. He shrieked, moaned, and slithered right to the edge of the stage, hovering over the ringside crowd who desperately tried to reach out and grab him as the cops pried them away.

In the middle of "When The Music's Over," Morrison launched into poetic raps touching on several pieces including "Indians scattered on dawn's highway bleeding, ghosts crowd the young child's fragile eggshell mind." After a while he became lewd, stirring up the crowd with a rap about a "Mexican whore sucking my prick" and some bit about "the keeper of the royal sperm." With each obscene remark there was a noticeable wave of response from the crowd. Next, The Doors performed "Wild Child," a full four months before its release. Then they did the "Wake Up" section to "The Celebration of the Lizard" and "Light My Fire." With each song the tension seemed to build. Morrison continued to milk it, lying on the stage, writhing snakelike, and singing as police formed a bulky barrier against the fans repeatedly charging the stage. That night, with his hair shorter and the beginnings of paunch, Jim seemed not possessed, but plastered. He continually threw himself down on the stage and crawled around on his belly, making it even more difficult for the obstructed audience to see.

The feeling of impending violence was there the whole set and then Morrison decided to finish with "The End," the most radical, emotion-stirring song in The Doors repertoire. Now he was letting it all go. At one point in the song he made eye contact with a girl in front of the stage, flirting with her. Her boyfriend glared at him and he glared back. Then he looked at the girl again, grabbed his crotch with both hands, and thrust toward her, shouting the most vulgar remark he could come up with. Some

say that her boyfriend then went for a chair and that started the riot. Others say he was just one of many who later went crazy. All we know is that it was just past midnight when the number ended. At the last notes, Morrison fell back on the stage and screamed. As if on cue, over two hundred youths suddenly rushed the stage. The outburst was thundering and spontaneous, like an earthquake or a sudden violent storm.

Fifteen private policemen held back part of the audience, but others outflanked them and stormed the stage. The people in the blocked seats began tearing up their wooden chairs and flinging them around the stadium. Some of the audience threw chair legs at the stage. And then people started throwing whole chairs. Paul Ferrara and Babe Hill, still trying to film, ducked as a piece of wood came flying toward them. Without hesitation Morrison leaped up and grabbed the piece of wood, heaving it back into the crowd. A moment later it came sailing through the air again. There were so many cops around them now that The Doors were hardly visible. People started fighting everywhere and several more made it on to the stage. As the crowd took over, The Doors were forced to flee. They had to be dragged through the mob of screaming kids.

Backstage, the area was cleared of everyone but The Doors and their crew. Like wounded animals, the kids kept slamming against the backstage doors, banging and shouting, shaking the walls. Onstage, armed with pieces of the broken chairs, they began smashing The Doors' equipment, systematically destroying it as police tried to intervene. For an hour the riot raged on. Inside the backstage area, Morrison and the other Doors passed beer around while Jim talked to a girl who was bleeding from a head wound. When it was finally over, twenty people were hospitalized, three with serious injuries, and two were arrested. The concert grossed seventy-five-thousand dollars.

The next day, The Doors played Cleveland at the Public Hall. At Musicarnival, a year earlier, only seven hundred people showed up to see them, but this time Cleveland was ready for The Doors and ninety-two hundred strong turned out. Hordes of young adults stayed up all night to be first in line for the show and the tickets were sold out in less than four hours. Morrison showed up loaded and in a mood to provoke trouble. He strolled out in front of the curtain for an instant before the show, causing

the kids to yell and scream. A brief interview conducted by a local newspaper as Morrison squeezed through the groupies on his way to the stage revealed his frame of mind.

Q: How would you define your act?
A: Easy, man. It's not an act. It's politics. We're erotic politicians.
Q: What are your interests?
A: Anything that has to do with revolt, disorder, chaos, activity that's got no meaning.
Q: What has meaning?
A: Things that seem to have no meaning.

The performance that night was described as "a sustained forty-five-minute scream." Morrison was wild. During "Break On Through" he suddenly punched the mike and shouted, "I'm getting real repressed up here. We're going to stay here until we have some fun!" He went through his best gyrations and during "Light My Fire," when the crowd was at a peak frenzy, he did the craziest thing he could possibly do—he jumped off the stage into the audience! Immediately he was mobbed. The crowd went insane. Shirts were torn, punches exchanged, and chairs thrown as the people converged on him. A good deal of Public Hall property was damaged and one of the security guards called the concert, "the worst ever."

Order was eventually restored, however, and Morrison ended the show by flinging himself to the stage in a mock death, lying totally motionless on his back with his eyes closed. The fans screamed out their lament. Somehow a kid from the crowd managed to get onto the stage and leaned over him with a camera. The bulb popped with a flash and Morrison leaped to his feet. Once again, total pandemonium threatened. But then the beat picked up behind him and Morrison grinned devilishly at the young faces who now stood and applauded his resurrection as the show ended.

As if all this wasn't enough, when the crowd was exiting, Jim ran back out onstage causing everyone to struggle again as they stormed the hall for a last glimpse. Panting as he left, Morrison told a reporter, "This was the biggest reaction I've ever had."

The Cleveland newspapers described the concert as consist-

ing of "off-key singing, staggering and shouting obscenities before 9,200 fans, many fifteen years old and younger." For Jim Morrison the concert riots at Cleveland and the Singer Bowl were exercises in crowd control. The problem, he was starting to realize, was not in controlling the crowd, but in controlling himself.

In August, thousands of protestors converged upon Chicago to demonstrate at the 1968 Democratic National Convention. The worst riot of a bloody week came near the end when Mayor Richard J. Daley ordered the parks where the protestors had assembled to be cleared. In what was later termed a "police riot," hundreds of protestors were brutally beaten by Chicago police in Grant Park near the Hilton Hotel where most of the convention delegates were staying. It didn't matter if they were long-haired or short-haired, violent or nonviolent, the protestors were struck down. As they fell they chanted, "The whole world is watching," and indeed it was, as presidential candidates, convention delegates, and all America gasped in horror at the bloodbath being broadcast live over national television. Although hundreds of demonstrators were arrested, the needless brutality of the police touched the hearts of much of America. The "street," a crucial symbol of the movement for change, now proved to have great potential as an arena for antiwar consciousness.

The European Tour

On September 2, The Doors left for a seventeen-day tour of Europe. The first stop was at the London Roundhouse, a former train station converted into a twenty-five-hundred-seat concert hall. The concert with The Jefferson Airplane had been billed as "the biggest freak-out since Babylon." With The Airplane opening, The Doors did two shows per night for two nights selling out all ten thousand tickets. This was somewhat surprising since only "Hello, I Love You" had successfully made it on the British charts. Morrison stood still with eyes closed through much of the show and the band played so loud that soot occasionally fell from the roof. They started out with "When The Music's Over" and went off on an extensive jam followed by "Five To One," "Spanish Caravan," "Back Door Man" (with "Crawling King Snake" in

the middle), "The Celebration of the Lizard," "Light My Fire," and "The Unknown Soldier." The latter was The Doors' only staged number and when Manzarek raised and lowered his fist, Krieger pointed and shot his guitar at Morrison in time to Densmore's rim shot. The English audience was overwhelmed. The Morrison superstar trip was unknown to most of them. It was just The Doors and when the show was over, the band's status in Britain had attained legendary heights.

The first concert was filmed for a British television program, "The Doors Are Open." While it was good, Morrison described the final show as "one of the best we've ever done. They were one of the best audiences . . . It was different because in the States they are there as much to enjoy themselves as to hear you. At the Roundhouse everyone was there to listen. It was like going back to the roots again and it stimulated us to do a good performance . . . we enjoyed playing at the Roundhouse more than any other date for years."

The sixty-minute film was a black-and-white video tape of live footage from the Roundhouse spliced together with shots of 1968 political events like the Democratic Convention in Chicago and the "Battle of Grosvenor Square" which had taken place outside the U.S. Embassy earlier that year in London. The film also contained an interview with The Doors and showed Ray Manzarek singing "Hello, I Love You" during the sound check—sounding, interestingly enough, a great deal like Morrison. Always a student of filmmaking, Morrison said: "I thought the film was very exciting . . . The thing is, the guys that made the film had a thesis of what it was going to be before we even came over. We were going to be the political rock group, and it gave them the chance to whip out some of their anti-American sentiments, which they thought we were going to portray . . . but I still think they made an exciting film."

In the interview, it was Morrison, in open-necked shirt and tight black leather pants, who clearly dominated. Instead of the flippant tone of the Cleveland interview a month earlier, he was now pondering every question to the extreme—sometimes taking so long to answer that the interviewer lost track of the question. On being a sex symbol, Morrison commented: "Sex is just one part of my act. There are a lot of other factors. It is important I guess, but I don't think it is the main thing, although our music is a very nature-based thing. So they can't be separated."

Often, when such questions were asked, Morrison would give sort of an inward smile as if reluctant to take himself so seriously. When asked about politics he replied, "I don't think politics have been a major theme in my songs. It's there, but it is a very minor theme. Politics is people and their interaction, so you cannot really separate it from anything . . . The United States is undergoing a lot of very interesting changes right now. A lot of people are waking up to the fact that they live in a whole world and not just one country. I've been getting the most incredible letters from young kids—intelligent, sensitive, and very philosophical."

After the Hollywood Bowl someone had asked Mick Jagger what he thought of Morrison's performance. Jagger had replied, "A bore." So when Morrison was asked in London what he thought of Jagger's performance he answered wryly, "A bore." Although he was courteous throughout, a glimpse of Morrison's angrier side came out when one reporter persisted in asking about comparisons to Jagger. "I have always thought comparisons were useless and ugly. It is a shortcut to thinking," Morrison replied. Then he closed his eyes for a moment and asked the reporter, "Well, how do *you* see yourself?"

Another interesting sidelight was how Morrison felt about his recent performances: "I was less theatrical, less artificial when I began," he said, "but now the audiences we play for are much larger and the rooms wider. It's necessary to project more, to exaggerate—almost to the point of grotesqueness. I think when you're a small dot at the end of a large arena, you have to make up for that lack of intimacy with expanded movements." This introspective mood extended into his description of The Doors' music as having a "heavy, gloomy feeling, like someone not quite at home or not quite relaxed; aware of a lot of things, but not quite sure of anything."

The remainder of the European tour was also with The Jefferson Airplane. The plan had been for The Doors and The Airplane to take turns headlining, but The Doors received such overwhelming responses that they wound up being regarded as the headliners nearly every night. One of the reasons for the band's great success in Europe may have been that the kids there were more politically oriented at the time than the kids in America. The hippies and teenyboppers of America were coming for the "rush" or the "religious experience," depending on whom

you talked to, but the Europeans loved the political side of The Doors. Morrison loved the fans: "They really take music seriously over there," he said. "It's not just a province of children. A new album is like a new book. They discuss it."

The Doors played to standing-room-only crowds in London, Frankfurt, Copenhagen, Amsterdam, and Stockholm. It was only in Amsterdam that Morrison had problems. Grace Slick, the lead singer of The Jefferson Airplane, remembers: "In Amsterdam drugs were legal. That was sort of Jim's problem there. There was one sort of main street with a lot of psychedelic shops . . . and both bands were scattered about walking down this street . . . and the kids would come up to us and offer us everything . . . drugs of all kinds. And we'd say thank you very much and put them in our pocket . . . I'll have a little bit later . . . or I'll have a little drag off of this . . . but you don't take everything you're given otherwise you'd be dead. Jim, on the other hand, took *everything* that was given to him on the spot."

Paul Kantner, the rhythm guitarist, recalls the show that night: "We were playing in Amsterdam and Jim came out in the middle of our set . . . somewhat drug-abused . . . and started doing almost Sufi dancing to 'Plastic Fantastic Lover' . . . he started spinning and we in our perverse manner started playing faster just because he'd sort of invaded our turf without asking. We didn't plan it, it just occurred and it was amusing . . . he just kept going faster and faster."

Marty Balin, The Airplane's other lead singer, described what happened next in *Bam* Magazine: "Jim had his arms over his head and was spinning in circles like a flamenco dancer. I'm singing and he's dancing, and we were circling each other, wrapping the microphone cord around us. We were tying ourselves up going around and around, and we unraveled at a perfect place in the song. Jim looked at me real funny and then, CRASH!—he dropped to the floor. I finished the song leaning over him. He was totally out. He wasn't moving. He didn't even make the show that night, he was so out of it. The amazing thing, though, is that The Doors went on anyway. Manzarek sang all the songs and sounded *exactly* like Morrison. I couldn't believe it. If you were blind you wouldn't have known Morrison wasn't up there."

"Manzarek is amazing," Grace Slick adds, "because I watched him and heard other stories about him having to do things that

are just incredible. I don't know another band where the key-
board player can just all of a sudden take over and do the rest of
the show and sing and play the piano and get all the phrasing
right . . . and probably never having done it before. I don't know
of another band where the lead singer was that erratic."

> *A feast of friends—*
> *"Alive!" she cried,*
> *Waiting for me*
> *Outside!*

After Morrison pulled his stunt, the three other Doors were
so angry that they decided to go on alone and give the perform-
ance of their lives. The result was an exceptional show and a
huge ovation. Deep Purple organist, Jon Lord, was in the au-
dience that night and he said that "it was the best show The
Doors did here. They were tighter than ever before."

Morrison, meanwhile, was taken to the hospital where he
woke up feeling fine the next morning. Then he read the reviews
and learned that the band had not only done the show without
him, but done it extraordinarily well. On the outside he joked a
bit and shrugged it off, but on the inside something else was hap-
pening. Vince Treanor reveals for the first time that Amsterdam
was a major turning point for The Doors: "Nobody talks about
Amsterdam, but the full perspective of the group and Jim's part in
it changed tremendously after Amsterdam. Here was Morrison in
the hospital the next day, reading incredibly rave reviews about
how the rest of the band put on an outstanding performance
without him. Their performance was one of the finest that any-
one there had ever seen or heard and Jim wasn't there. Now
imagine what that would do to his ego. Jim suddenly realized that
at any time the group could walk away from him and kiss him
good-bye. I think from that point on Jim decided to show the
group that he was boss. After we came back from Amsterdam
there was a radical difference in how he behaved onstage. His
music even changed and got further away from The Doors' basic
sound."

One would have thought that superstardom would have
given Morrison enough confidence to weather any such fears, but
Treanor claims this is not the case: "Jim was never a secure per-

son. That's why he behaved the way he did. He had no security in what he could do. If he had, he wouldn't have been a drunkard. I think he may have looked at it all like, 'My God, what's happening.' But the other guys didn't want to deal with what had happened either. In a way they were sort of afraid of what they had seen. They saw an out and they were terrified of where they were and what could happen. When things got worse with Jim they didn't want to remember what had happened in Amsterdam. They said it was just because they were all hyped up and The Airplane played before them and so forth."

Morrison was back to full strength when the band played Stockholm a few days later. The Doors did two shows and even included a version of "Money" and a couple of verses from "Mack the Knife" (from Brecht's *Three Penny Opera*) as a lead-in to "Alabama Song." That night when Morrison came to the line in "Five To One" that goes "got to go out in this car with these people and get . . ." he shouted "FUCKED UP!" instead of slurring it like he usually did. When the Stockholm shows were over the other Doors returned to America, but Jim and Pam headed back to London without bothering to tell anyone where they were going. There Morrison hooked up with the American poet Michael McClure who would prove to be one of his closest friends and a frequent source of inspiration. McClure read some of Morrison's poetry and was so impressed that he wrote down the number of his agent, suggesting Jim try to get it published.

While Jim and Pam were gone, another incident happened that drove a wedge between Morrison and the rest of the group. An ad agency offered the band considerable money to use "Light My Fire" in a Buick commercial. Bill Siddons elaborates: "Jim had decided to disappear. Which, for me, was the first time he disappeared. For four days no one had any idea where he was and suddenly Buick was offering close to a hundred thousand dollars to use 'Light My Fire' in a commercial. It was going to be 'Come on, Buick, Light My Fire.' Since Robby was the actual writer of the song, I felt he should make the decision. For some reason it was a high pressure, 'You gotta give an answer now' situation, so together we all decided, 'Well, what the hell . . . why not?' You know, we were all practically teenagers. I mean, Ray was the old guy at twenty-five. And Jim came back in a couple of days and just freaked out. He thought it was the tackiest thing in the world

to do with The Doors' music. Subsequently, I figured out that he was absolutely right. Jim knew that for what The Doors were doing and for what they meant to people, it was the wrong thing to do. Obviously it didn't destroy their career, but it created a real anger in him that anyone would do that. It left a stronger division between Jim and the other three Doors. He felt betrayed by them because of it. And no one did it to betray him. We didn't know what to do and it was free money being dangled in front of us."

Pam's father, Columbus Courson, also remembers the incident: "Jim was mad as hell. He called Ray and said, 'Hell, this song will be a classic. We sell it in a damned ad, that'll be the end of it, nobody'll ever give it anything.' He was just furious and he hung up on him. And Pam said, 'Jim, he's your best friend,' and Jim was sort of violent . . . and she said, 'Well, what do you think they're gonna do?' He said, 'Don't worry, they're not gonna let their little goldfish swim away.' "

There is little question that Morrison was particularly sensitive about "Light My Fire." Once, when he was riding down Sunset Boulevard with Paul Rothchild, he asked the producer what he thought of the words to the song. Rothchild, not knowing who had written what, assumed that Jim was the sole lyricist. "They're great," he said, "except for that bit about 'no time to wallow in the mire.'" As it turned out, that line was the only verse Morrison contributed to the song. While "Light My Fire" opened The Doors to worldwide success and eventual status as a legendary rock band, it also took them from being the darlings of the underground to the princes of pop. In time, Jim Morrison would come to hate the song.

Perhaps it was because Amsterdam was still fresh in his mind that Morrison got so mad at the others over letting "Light My Fire" be used in a commercial. Or maybe it was because, while Jim was unaware of so many things that the others in the band considered important, he was acutely aware of other things that they did not.

Back in the U.S.A.

When The Doors returned from Europe they had another surprise waiting for them. The Association of Concert Halls had

decided that a special rider should be attached to all performance contracts involving the group. Bill Siddons remembers breaking the news to the band: "This group of men sent out a letter saying that The Doors were troublemakers and that, if in the judgment of the hall manager, the content of the performances was immoral, indecent, or illegal, the show would be ended immediately. So the promoters had to do a lot of pushing and fighting to get us into the halls. They had to give a personal guarantee that if anything happens, *they*, the promoters, would be solely responsible for it."

At this time the band's accountants advised them that they were also in a crisis situation over "Feast of Friends," the title they had decided to call their documentary (after a line in "When The Music's Over"). Some thirty thousand dollars had already been spent on the project, but there was still a great deal of editing to do and none of the planned fictional sequences had been filmed. While Morrison was satisfied with the progress, the other Doors were worried that the film was turning into another white elephant along the lines of "The Celebration of the Lizard." Frank Lisciandro recounts what happened: "Robby, John, and Ray pulled the plug because the accountant had a bottom-line mentality about it. We were in the middle of the editing process. Paul [Ferrara] and I went to see Jim, who was staying at one of his infamous small motels somewhere. We said, 'What's going on? We're in the middle of this project, we've got most of it filmed, what are we gonna do?' He said, 'Don't worry about it. Just keep working. I'll take care of it.'"

A compromise was reached. Plans for additional filming were dropped and Ferrara and Lisciandro agreed to work without salary. The Doors put up the four thousand still needed to complete the editing and lab work. Morrison later described the situation to *Rolling Stone*: "In conception, it was a very small crew following us around for three or four months in a lot of concerts, culminating in the Hollywood Bowl. Then the group went to Europe on a short tour and while we were there, Frank and Paul, the editor and photographer, started hacking it together. We returned, we looked at the rough cut and showed it to people. No one liked it very much and a lot of people were ready to abandon the project. I was almost of that opinion, too. But Frank and Paul wanted a chance, so we let them."

Through the rest of October, while the band began rehearsing for a new album, Morrison often managed to get away to help Lisciandro edit the film. "My editing space was a small room at the back of The Doors' office," Lisciandro recalls. "Although the room was hot, cramped, and cluttered, it could not have been in a better location. If the film was about Jim and The Doors and how their music reflected and commented on America in the sixties, then I was fitting the pieces together right in the eye of The Doors' hurricane."

When Morrison saw footage of the Singer Bowl carnage it was as if a shaman had been allowed to see himself in his possessed trance state. He claimed to realize something about his stage performances that he had never known before. "I was rather taken aback," he said, "because being onstage, being one of the central figures, I could only see it from my own viewpoint. But then to see things as they really were . . . I suddenly realized that I was, to a degree, just a puppet, controlled by a lot of forces I only vaguely understood."

Around this time, the 1968 Summer Olympics ended in Mexico City. The famous image of the games was sprinters Tommie Smith and John Carlos, gold- and bronze-medal winners in the two hundred-meter dash, raising black-gloved fists on the victory stand as the national anthem was played. For what the runners termed a "display of black unity and protest of black poverty," the two were suspended by the Olympic Committee.

In October, *Eye* published a unique article. Asked to do an interview, Morrison said interviews were too frustrating for him and offered to write what he called a "rap" instead. The magazine agreed and the article, as the following excerpts indicate, proved to be more revealing as to what was happening inside the mind of Jim Morrison than most interviews would have been.

He sought exposure and lived the horror of trying to assemble a myth before a billion dull dry ruthless eyes.

Ask anyone what sense he would preserve above all others. Most would say sight, forfeiting a million eyes in a body for two in the skull. Blind, we could live and possi-

bly discover wisdom. Without touch, we would turn into hunks of wood.

Mates are first chosen by visual. Not odor, rhythm, skin. It is an error to believe that the eye can caress a woman. Is a woman constructed out of light or of skin? Her image is never real in the eye, it is engraved on the ends of the fingers.

Throughout the early part of November The Doors toured the United States, performing in Milwaukee, Columbus, Chicago, Phoenix, Madison, St. Louis, and Minneapolis. The constant criss-crossing the country wore on everyone's nerves, but the only real incident was at Veterans Coliseum in Phoenix where there was a near riot. The Phoenix show was promoted by Rich Linnel who by now had become a major concert promoter working with several major acts all along the West Coast and in Phoenix. People now came to see The Doors as much for their unpredictability as for their music, and on November 7, Morrison was at his most unpredictable. Robby Krieger recalls that Jim kept saying, "I want to see Phoenix flip out." There were ten thousand teenagers and young adults at the Coliseum as part of the Arizona State Fair. The Doors had an equipment problem and Morrison was abusive onstage. When the crowd failed to respond with enthusiasm he shouted, "This might be our last time in Phoenix. Why are you just sitting?" Witnesses said he made vulgar gestures with a scarf and then threw it into the audience. Later, he referred to Nixon's winning the recent election, "We are not going to stand for four more years of shit." At one point Morrison tantalized the crowd to leave their seats. About five hundred teenagers charged the stage, but were repulsed by police. The kids then milled through the aisles, occasionally throwing things toward the band, and pushing against the line of security police blocking the stage.

There were over fifty security men on duty in the Coliseum that night, including highway patrolmen, Phoenix police, and private security forces. In an effort to restore order, they dispersed a crowd of fairgoers that had gathered outside the building to listen, pushing and shoving many of the kids. At least seven people were detained after the show including one girl charged with

using vulgar language, another with assault, and two accused of disturbing the peace. Arizona Highway Patrol captain Bill Foster said at the time that he "feared the incident was going to develop into a full-scale riot." Concerning Morrison, Foster said, "He certainly encouraged and invited the problem. If he had not called for the youngsters to leave their seats, there would have been no problem."

Asked why Morrison was not arrested for using vulgar and obscene language, Foster admitted he "was right on the brink" several times. The Phoenix papers reported as follows: The concert erupted into a war between kids and cops. Lead singer Jim Morrison appeared in shabby clothes and behaved belligerently. The crowd ate up Morrison's antics which included hurling objects from the stage to the audience, cussing, and making rude gestures." The management of Veterans Coliseum was outraged, calling Morrison's actions "unbelievably provocative and obscene." Wes Statton, executive director of the hall, fumed, "Morrison will never play here again. His conduct before the kids was unprofessional, common, and embarrassing." Criminal charges were even filed against Morrison, but later they were dropped. In short, The Doors were now taboo in Phoenix.

When they played St. Louis, The Doors arrived during a heavy snowstorm and while Bill Siddons, Ray, Robby, and John all came off the plane wearing heavy winter coats, Morrison, insolent even about the weather, refused a coat, opting instead to wear only tight leather slacks and a T-shirt. It was also cold and wintery the following day, November 10, when the band played Minneapolis. Tony Glover of Koerner, Ray & Glover, a folk blues group that had recorded five albums for Elektra, interviewed The Doors the day of the show for *Circus* magazine. After the interview, Manzarek asked Glover to bring his harmonica to the show. Glover agreed, figuring they would jam backstage.

That night at the concert Glover was delayed by a mix-up at the gate and didn't get backstage until ten minutes before show time. He asked when the group wanted to jam and Morrison said, "We'll do about three numbers, then you come on." "Onstage?" Glover asked, not believing they were serious. But they were. So, after the first couple of songs Glover came out and began playing on "Back Door Man" in front of a packed house of eighty-five hundred. After his solo Glover chorded along with the band. He

remembers: "Suddenly Jim was singing 'Fuck me, baby, fuck me, girl, suck my cock, honey, around the world.' There were whistles and applause, and I glanced into the wings, figuring that the fuzz were about to swoop down and carry everybody, even little innocent me, off forever, but they just stood there. Either they didn't hear it or they didn't believe they heard it . . . But what counted was the music. It was a gas to do it, especially with musicians who were madmen like me."

The sessions for the new album began that same month and "Touch Me" was soon released as a single. With its sensual references to touch, the first step to physical contact and sex, it was an instant hit with the younger crowd. If you listen close to the ending of the song, however, you can hear someone in the band saying, "Stronger than dirt" under his breath (mocking a commercial for Ajax that was popular at the time). Although a seeming contrast to the message of the song, it also somehow fit.

In December, The Doors did *The Smothers Brothers Show*. Since the New Haven bust, television producers had been leery of them, but the Smothers were known for their radical stance on many issues—especially censorship. The Doors did "Wild Child" and then "Touch Me" was performed with the Smothers Brothers Orchestra. It was interesting to see an orchestra in full-dress tuxedos playing violins and horns behind The Doors. Also onstage with the band was Curtis Amy, the sax player who did the solo on "Touch Me." The appearance was also notable because Robby Krieger was sporting a conspicuous black eye and Jim came in late at the beginning of the second verse of "Touch Me," obviously missing his cue. When it was broadcast Sunday, December 15, 27.1 million people watched the show.

The L.A. Forum

The L.A. Forum show on December 14 provided a fitting end to 1968 for The Doors. It had been a year of tremendous success and equally tremendous failure. On the outside, the group was hailed as the biggest band in the country. The media called them "America's Rolling Stones" and they sold records by the millions and filled huge arenas with screaming fans. But on the inside they were decaying fast. Morrison was losing it, and while no one ad-

mitted it, they all knew it. In an interview conducted the afternoon of the Forum show, Jim indicated that he knew the band was running out of steam. "I don't know what will happen. I guess we'll continue like this for a while. Then to get our vitality back, maybe we'll have to get out of the whole business. Maybe we'll all go to an island by ourselves and start creating again."

The Forum gig presented the same sort of success/failure duality. It was sold out, all eighteen thousand seats, but it was a typical Morrison crowd from the start. Ray Manzarek, ever the artistic soul, had gotten the others to agree to have the evening opened by a traditional Japanese koto player. Vince Treanor remembers: "The guy was into traditional Japanese art music, poetic music. The stuff he played was young if it was two thousand years old and this was in front of eighteen thousand teenage kids. Well, they damn near had a riot, they booed the guy so bad. I felt horrible for him. It was just so irreverent and terribly rude and the guy could not help but realize what was going on, but he was a traditionalist and therefore he had to finish his performance. And he went through to the bitter end."

Jerry Lee Lewis didn't fare much better, playing mostly country songs to an audience who repeatedly let him know what they thought of country by booing their hearts out. Sweetwater, a local rock group, followed and did the wisest thing possible— shortened their set in front of the wild crowd and got offstage as quickly as they could. There was little doubt that the atmosphere at the Forum was ripe that night for Morrison to do something truly excessive and that was what the majority of the crowd had come to see. They came to see Morrison get outrageous. Why should they expect less?

Instead, Jim returned to his dignified stance. He stood almost motionless, remaining calm throughout the entire concert, castigating the audience for demanding that the poet be a clown. The Forum was jammed with the cream of L.A.'s teenybopper set. "Play 'Light My Fire,'" they called out as soon as The Doors had finished their opening number. "Yeah, 'Light My Fire,'" another one shouted from the vast darkness. Their voices were almost insolent. As far as the kids were concerned it was *their* song. It belonged to them and The Doors should have little, if any, say in the matter.

One look at the stage, however, and it was apparent that The

Doors had something else in mind. Besides thirty-two amplifiers, they had brought along a string sextet and a brass section. They were ready to perform the new music they were currently recording in the studio. The album, which would be entitled "The Soft Parade," was to be their most elaborately arranged and produced work. They hoped it would be on a par with the immortal *Sgt. Pepper,* the crowning achievement in their career that would silence forever any doubts about their artistry. Even Morrison was excited, hoping the new material would release him from the hold his image had on him.

But the kids wanted no part of it. "Strings and horns? . . . The Doors?" What was going on? The crowd had come to hear the hits and that was all there was to it. During "Touch Me" and "Wild Child," Morrison was only a glimpse away from being understood, but during other songs the yelling for "Light My Fire" increased. Finally, The Doors acquiesced. As they had at the Bowl, they figured what the hell, they were going to have to play it sooner or later anyway. As soon as the opening strain of "Light My Fire" began the auditorium exploded in cheers. Instantly, the entire arena was aglow with sparklers lit in tribute to a song the kids practically worshipped. But even the long version of "Light My Fire" doesn't last that long, and as soon as the song was over, the kids began shouting, "One more time." The Doors looked at each other. This couldn't be happening. The crowd actually had the nerve to expect them to play the very same song again. "Play it again . . . Play 'Light My Fire' . . . one more time!" they were shouting.

Morrison had all he could take. Wearing a loose black shirt and skintight black leather pants he walked defiantly out to the very edge of the stage. "Hey, man," he shouted, his voice booming out from the speakers on the ceiling. "Cut out that shit." The crowd giggled. He sat down cross-legged on the edge of the stage and asked the audience what they really wanted. "What are you all doing here?" he challenged them. No one said anything. He glared at them. "You want music?" he yelled. The crowd immediately boomed back, "Yeah!" But Morrison wasn't through with them yet. He was angry. "Well, man, we can play music all night, but that's not what you *really* want, you want something more, something greater than you've ever seen, right?"

"We want Mick Jagger" someone shouted. "Light My Fire"

someone else said to laughter. The crowd began to giggle with nervous embarrassment. Most of them had no idea what Morrison was alluding to. They hardly knew *who* they really were much less *what* they really wanted. Only a year before The Doors were playing three-thousand-seat auditoriums and Morrison had total control over the audience, but now in the big arenas the audience was in control and they were taking Jim on their trip. But not tonight. Not at the Forum and not in L.A. Tonight, Jim Morrison was determined not to become the freak they wanted to see. In defiance of their demands he stood on the edge of the stage and recited "The Celebration of the Lizard." All 133 lines of it. When it was over he glared out at them one more time and then silently left the stage to almost no ovation.

The thing about teaching people rebellion is that the moment you relax your grip, they will rebel on you. Morrison could no longer control the kids. The young kids, the teenyboppers, had belonged to The Doors. Morrison's mystique had won them. His combination of sensuality, mysticism, and magic had captured these wondrous children of the love generation, heart and soul. In return they had made The Doors the biggest American group in rock. But now their love had turned into a worship that demanded something more than their man-made gods were prepared to give. They wanted more than Morrison's body—that he would have given them—they wanted him to conform to their demands—that he would give to no one. So now in the band's hometown at one of their biggest concerts ever, the kids dared laugh even at Morrison. Not much, but they had begun.

Few people saw it from Morrison's point of view. If he attempted to create a reflective mood in concert, it would be shattered by rude and obnoxious shouts from the audience. If he decided, on the other hand, to give in to the temptation to push a situation as far as it would go, madness would soon result. He knew the crowd would be satisfied with nothing less than a spectacle. They felt it had been promised to them with the price of their ticket. Just as the shaman took on the troubles of his followers, Morrison had become the release for the inhibitions of his audience. They not only came to expect the bizarre of him, they needed it. And when they didn't get it, they were disappointed.

To the kids at the Forum that night the band would never,

could never, top "Light My Fire." The new music The Doors had wanted the crowd to like that night sounded to them like Lawrence Welk. And "The Celebration of the Lizard" was simply crashing abstract noise behind a rambling poem they didn't understand. They related to the hits, but when Morrison coiled up like a black leather whip and lashed out at them in astounding bursts of energy and hysterical poetry readings, he was much too heavy for the young crowd. No doubt most of them went home that night feeling burned and cheated, denied their big moment—the moment when Jim Morrison would do something totally crazy and they would have been there to see it. These new fans seemed to love him for all the wrong reasons. They liked his looks. They liked it when he showed up smashed to the gills and fell off the stage. They loved it when he baited the cops. They couldn't get enough of him. They wanted to take home a piece of him. They wanted more than a show, they wanted a spectacle. They wanted to watch him die.

"I am the Lizard King, I can do anything," he had the strange young nerve to say and believe. It was pretentious and the stuff legends are made of, but it also reeked of paranoia. Trapped by his image, Morrison rebelled the way he had always done—by engaging in more and more outrageous behavior. But he was caught in a no-win situation, an enigma that had no solution. The more outrageous he became, the more his reputation grew and the more the kids were attracted to the freak show. The image had become a monster and the wilder Morrison became, the greater the monster grew, digesting each new exploit without even a blink and hungering all the time for more. The harder Morrison struggled against it, the more the monster snarled and the tighter its grip grew on him. Jim Morrison's obsessions were sex and death, and while he touted them to his minions, he secretly saw them as unconquerable enemies lying deep within. When he had the special and twisted gall to sing about love and the funeral pyre in the same breath, it seemed a pretty conceit during the Summer of Love. It was less pretty now during the Summer of Anger when it became obvious that Morrison, growing ever darker and more estranged with each concert, wasn't just writing poetry and singing rock songs, but trying desperately and futilely to vanquish his demons and curses the only way he knew how—by invoking new demons and curses.

When the Forum show was over, Morrison said it had been "great fun," but the party backstage felt like a funeral. Afterward, Jim went out to the Forum parking lot and played kick the can with his brother, Andy, and Pamela. If only the teenyboppers had known.

A monster arrived
In the mirror
To mock the room
& its fool alone

WEIRD SCENES INSIDE THE GOLD MINE

As 1969 rolled in The Doors were at the zenith of their popularity. They may have been rapidly deteriorating internally and have alienated many old fans, but they had gained legions of new ones. Near the end of January they headed to New York for their ultimate triumph—performing at the prestigious Madison Square Garden. Of the West Coast groups that emerged in the late sixties The Doors were the first to graduate from the ballroom circuit to the giant arenas, and now they were about to play the largest one yet. Bill Graham had wanted them to return to the Fillmore East for four dates, but the group reasoned they could do one show at the Garden and reach more people. Bill Siddons was still upset with Graham over an argument the two men had about the finances the last time The Doors played the Fillmore East, but Siddons never did anything the band didn't want and it was the group who decided they had outgrown the Fillmore. Graham warned that such huge halls

would mean losing the intimacy with their audience that had been their trademark. To some extent, he had already been proven right, but playing the Garden was an honor they couldn't pass up. Morrison even left for New York a few days early to do some interviews and talked his old friend Alan Ronay into coming along. They stayed at the Plaza, went to movies, and incognito hung around Greenwich Village.

Madison Square Garden's twenty thousand seats were sold out a month in advance. The gate was nearly $125,000 and The Doors' take-home pay of $50,000 made them one of the highest paid acts in show business. To Morrison the money was small compensation for the futility of trying to hold a séance with such a vast number of people, many of whom were now a football field away from the stage. The sound system at the Garden was abominable, so The Doors had Vince Treanor, their "equipment maniac," custom-build a PA system, but since the acoustics were designed for boxing matches and basketball games—the highs were still screeching off the walls. But when The Doors took the stage on Friday, January 24, and heard the shouts of twenty thousand teenyboppers banded together in a roar that sounded like the crack of doom, it was all worth it.

Morrison began the concert similarly to the way he had begun the Forum show—mellow, subdued, no howls or writhing. He was self-assured, even smiling, and some say he never sounded more melodic. He didn't engage in any strenuous theatrics, but still displayed why he was rock's most exciting performer. All he had to do was strike a pose bathed in the crimson lights and the kids went nuts. As the band played their axes, Morrison played the audience and at the Garden he made it look easy for a change. Early on, he carefully wrapped his black leather jacket into a shape suitable for air travel, let fly with an eloquent belch, and then heaved it far into the $6.50 seats. The kids swarmed over the jacket shredding it in seconds like piranhas swarming over a cow in a river (later, in an uptown Chinese restaurant, Morrison would shiver pathetically with no coat to keep him from the New York winter chill).

Both The Doors' strengths and weaknesses were apparent at the Garden. There were moments of brilliance when Morrison appeared to be in full command and others where it was apparent that he was weary of the rock life-style. At one moment he

pointed to one side of the arena and said, "You are life," and then pointed to the other side and said, "You are death." Then as if to parody his own performance he added, "I straddle the fence . . . and my balls hurt."

But the kids lit up the night with their own madness which ranged from a constant blast of camera flashbulbs to lighting sparklers and running up and down the aisles. The concert was in the round and the teenyboppers covered the Garden like insects, squirming close to adore Morrison. "Light My Fire" as usual drove them right up the wall. Midway through the set they started rushing the stage. The front line was made up of about twenty girls. While the security guards had their hands full with the charging females, Morrison didn't help matters much by extending his hand and helping the girls up onto the stage for a kiss and a hug. Before long, the audience got the message that security was lax and the chairs and bottles began flying as the arena erupted into a brief riot.

> *The 1st electric wildness came*
> *over the people*
> *on sweet Friday*

But order was soon restored and the overall feeling was one of controlled madness—a scripted craziness that was Morrison's alternative to utter chaos. As Ellen Sander wrote in *Hit Parader*: "A crowd schooled in the game rules of a Doors concert turned out. A Doors concert is a McLuhanist football game. A roar of noise when the group is brought to the stage, a constant demand for 'Light My Fire,' the crowd rushes the stage and gets turned back, kids light sparklers and cops extinguish them, the crowd boos. We'd seen the show before."

The reign at the top of the rock world is always a brief one. The Doors were riding out their momentum and they knew it. Even at the Garden the kids could somehow sense that the kingdom was crumbling. The missile that powered The Doors was burning out and the kids were wailing at the wake. As Sander commented: "But it's been over for the Doors for a long time now. Once they were fiery, arrogant renegade emperors of the rock scene and once they deserved it. They've made an unforgettable mark in the business, they remained unique in their

prime . . . But they know and you know and I know that it's a charade at this point. The Doors should rest in peace, not do an overlong encore. It hasn't lit anyone's fire in a good long time."

It was around the time of the Garden concert that Morrison met Patricia Kennealy. Pretty, with long dark red hair, the twenty-two-year-old Kennealy was editor of *Jazz & Pop* magazine: "I went up to the Plaza Hotel to interview him," Patricia recalls. "To begin with, I was stupefied that he'd actually stood up upon my entrance into the room. I loved the Doors' music and was knocked out by Jim as an artist, but even though I sort of had a feeling about what was going to happen between us, I was still expecting either the Prince of Darkness or the Pig Man of L.A. What I got was Ashley Wilkes: this tall, soft-spoken, intellectual Southern gentleman. We shook hands then and there were sparks. Static friction of course, from my boots on the carpet, but you could actually see a shower of blue sparks like something out of a fairy tale when the prince and princess touched for the first time. I thought I was going to die right there. When I looked up at Jim, he was laughing. 'A portent,' was all he said." Morrison's instincts were right because Kennealy would soon become an important figure in his life.

The Countdown

The inner turmoil driving Jim Morrison began to peak in early 1969. The tremendous frustration he was feeling toward his art became more and more dominating until it dictated many of his actions. The release he had always felt before being onstage was becoming one of increasing anger toward the audience. In concert now he would often shout obscenities at girls in the audience. Backstage, he sometimes demanded oral sex from groupies no matter who else was present. The fans had given him the platform from which he thought he would be able to do so much and now he believed they were making a mockery of it. As the cumulative effects of years of drinking began to take hold, Morrison couldn't see that it was he who had made himself a clown. It was his drinking and his refusal to take responsibility for what The Doors had become that prevented things from turn-

ing around. It was he who had embraced the sex symbol role and now it was he who was rebelling against it.

But this private war with his image was destroying not only any remaining joys he had left in performing with The Doors, it was destroying the group itself as well. Tensions within the band were increasing. Morrison's unreliability was making it more difficult for all of them. The rest of the band was also facing disillusionment. The world they thought they were going to change was refusing to change. The Doors said, "Break out of the old conditioning and be free," and while they had made a difference in the minds of millions of kids, nothing on the outside had changed. America elected Richard Nixon president, continued to fight the war in Vietnam, and enforced its drug and obscenity laws just as before. For Ray, Robby, and John it was becoming easier to be jaded. After "Hello, I Love You" and the third album the rock press kept saying they were in it for the money. For all the good they were doing, maybe they should be. They had wanted meaningful change—whether he sought it or not, Morrison had become a figurehead in the new movement of the young. The Doors once believed that records could serve the same purpose printed manifestos had in the past, but amidst the teenybopper screams for "Light My Fire" such thoughts seemed vain and pompous.

The Doors were suffering under the strain of creativity as well. The first two albums had been works of great art and depth as well as commercial successes, but the third album had not been all they had hoped it would be. Now, Morrison's productivity was decreasing rapidly and they viewed recording the rest of the new album with mixed emotions. "Touch Me" had been written by Krieger, and though Morrison professed to dislike it, he had been unable to come up with an alternative in the studio. Originally written as "Hit Me," the single topped a million sales by February and stayed on the charts for thirteen weeks but it continued to strain the group's credibility with the hip underground audience despite its exceptional arrangement and killer horns. The flip side, Morrison's "Wild Child," with its dark, surreal lyrics and hypnotic rock sound was more pleasing to old-time Doors fans. Still, the kids loved "Touch Me" and they were the bulk of the band's market now.

In February, "Wishful Sinful" was released. This second sin-

gle from the unreleased album was also a Robby Krieger song, but somewhat deeper in lyric content than most with a strange duality as its theme. Its images can be interpreted to equate wishes, dreams, and fantasies with the passionate side of life and wildness with the evil side, evoking thoughts of the pleasure/pain principle, good and evil, God and the devil, and perhaps Jim Morrison.

By late February, it was all coming to a head. The Doors began to realize that things were not likely to return to the glory days of 1967. They were tremendously popular, but it wasn't the same. The music was reduced to reflection rather than inspiration and gnawing at their guts was the fear that not only could they never again become what they once were, but maybe it had all been a fluke. Some sort of colossal piece of luck. A cosmic blunder in which their music was suddenly in perfect sync with the times and the minds of a generation. And now the window had closed and they were on the outside looking in and not quite understanding their own greatness. Time would prove that The Doors were far more than a fluke, but in 1969 these were very real fears indeed.

If art was this precarious, how much more so was commerciality. The problem with appealing to teenyboppers is that they are fickle. They change music like their lipstick and will drop you as soon as you become "uncool." And, whether or not they know it, teenyboppers take their opinion of what is cool and uncool directly from the hip crowd, except there is about a one-year-lag time. When the hip crowd grew their hair long, the teenies said it was ugly until it became their new trend a year later. When the hip crowd got into albums instead of singles the teenies thought it was a waste of money until it became the hip thing for them to do. In 1968, the teenies were operating on the premise that The Doors were "the ultimate" the hip crowd had proclaimed them to be the year before. They couldn't see any difference between 1967's "Light My Fire" and "People Are Strange" and 1968's "Hello, I Love You" and "Touch Me." But they were about to find out.

When these sober moments came, Morrison retreated into his poetry. It became the light at the tunnel's end. And the more his hopes for rock declined the more important the poetry became. More than a hope, he saw it as his salvation, his sanctuary.

Unfortunately, it was a sanctuary laced with more frustrations. Though he prided himself on not caring what other people thought, in areas where he was insecure Morrison often judged his worth by the opinions of others. In art, he tended to define it by public acceptance. Thus it was not enough that he felt he was a good poet. It was not even enough that other poets, like Michael McClure, felt he was a good poet. Morrison needed the public to acknowledge his poetic prowess. As most poets will tell you, if you need that kind of feedback, then you shouldn't be a poet.

As a poet, Morrison could hope for nothing akin to the respect and adoration he was used to as a rock star. The best that could be hoped for was small-time sales and a few choice words from some stuffy critics that Morrison's very presence would offend. Sure, there was an underground poetry market and people like McClure had gotten some attention there, but not Morrison's idea of attention. Morrison got more media attention when he cut his hair than modern poets got for their greatest works.

But though it was doomed from the start, Morrison would not let go of his desire to be accepted as a poet. To him it seemed that the roadblock to his poetic dream was his rock star image. If people stopped seeing him as a sex symbol, perhaps they would pay attention to the words again. Of course, the real way out of Morrison's dilemma was to stop conforming to his publicized image. To control his drinking and stop turning concerts into freak shows. It wasn't an immediate solution, but it could have been accomplished a little at a time. If he provided such a performance consistently he would eventually change the audience's expectations and reconvert them. At the same time cutting down on his drinking would probably enable him to create again and free his mind up for inspiration.

But this was an Apollonian, thinking, reasoning kind of solution and it contradicted Morrison's philosophy. He believed the way to inspiration was not found in reasoning, but on the "road of excess." Morrison's Dionysian solution was to go with his feelings and rebel. Lash out against the sex symbol image by doing something so outrageous that the mythical young lion of 1967 would be killed forever. Perhaps, if it he really let go and tossed all reason aside he would be able not only to get rid of the sex symbol image, but reaffirm the validity of the band. The media

loved him after New Haven. The kids listened in rapt attention in those days. And if they listened, they'd hear the words. Since Morrison believed reasoning was the anathema of inspiration and freedom, he would never have consciously thought these things through. But, consciously or subconsciously, he began to look for a way to break through this prison of his own devise. But what would he do? How does one comment on and redirect art through art itself? The answer to these questions came from the avant-garde Living Theatre.

At the end of February, Morrison attended every performance of the Living Theatre at USC's Bovard Auditorium. The group, founded by Julian Beck, was noted for its bizarre approach. On Monday the twenty-fourth, opening night, the show began with a bearded man in a black sweater and Levi's standing at attention in the spotlight for ten solid minutes. This was followed by political commentary conveyed through a mock close-order drill and some witty skits. What made the Living Theater special to Morrison was its efforts to tap into the audience's subconscious mind. On opening night, the best example of this was when all twenty-three men and nine women "died" noisily in the aisles from an atomic holocaust as Beck's hypnotic voice quoted Jackson Mac Low's Street Songs ordering the audience to "Change the world! Make it work! Find a way!"

On Tuesday and Wednesday, the group performed their own version of *Frankenstein* which asked the audience if a society conceived in violence could learn to survive without it. It began with a primitive tribe trying to levitate a girl and when they fail, angrily stuffing her into a coffin, an act that released such violence within them that it eventually results in all their deaths. From their corpses Julian Beck as Dr. Frankenstein creates the "monster" which becomes even more bloodthirsty than his ancestors. The only thing the Living Theatre hated more than brutality was rigidity and at the end of the play everyone in the cast was "arrested," a scene that seemed far too long but that the group justified by their belief that parts of the play are supposed to make you weary and anxious.

On Thursday the program was based on Brecht's version of Sophocles' *Antigone.* Though more conventional than the other performances, the play included bodies crawling in the aisles, sudden shrill screams, and the illustration of a character's psycho-

logical state by facial contortions, elaborate gestures, and other methods. When Antigone refuses Ismene's help, four men suddenly leap around her with arms upraised to symbolize her defensive state of mind.

All of these shows had an impact on Morrison but the performance that most affected him was Friday's *Paradise Now.* That show was almost canceled when Julian Beck refused to go on unless paid in advance. The audience arrived to find the auditorium locked and after a half hour began banging on the doors until Beck agreed to do the show when he discovered his USC contract didn't include advance payment. When the audience was allowed in it was obvious they were angry. The performance began with actors strolling through the aisles berating the repressions of society. "I'm not allowed to smoke marijuana," one performer shouted. "I'm not allowed to take my clothes off," another bellowed. "You can't live without money," a third challenged, "Paradise now." The reason Beck feared not being paid then became evident as the entire cast stripped down to loincloths, formed a human pyramid, and spelled out "A-N-A-R-C-H-I-S-M."

As the evening wore on, the distinction between actors and audience began to fade and much of the performance took place in the aisles. Someone slithered down a rope from the balcony shouting, "I'm alive!" As Beck held a calm political-action seminar in one aisle, a woman in the balcony took off her blouse, claiming it was one of the friendliest things a person could do. By 11 P.M. much of the audience had become part of the show. A fire marshal warned everyone to sit down but left when they refused. Despite the hour, many continued to strip and run through the aisles shouting about freedom and taunting whoever was still sitting down. Morrison sat in the first row and was moved by the performance, identifying totally with the group. They were radical. They provoked the audience, engaging them in dialogue, even baiting to get a response. The actors shouted frequently in anguish and often were close to hysteria. Once when the troupe came into the audience, one of them confronted an old lady. Unsure how to react, the woman began beating the actor with her umbrella and then stormed out of the theater in a huff. As she passed by Morrison, he stood up and grabbed her hat, throwing it into the audience. The crowd gave him a big ovation. Tom Baker was at the show with Morrison that night and later he wrote

about Jim's excitement: "He had a madder than usual look in his eyes, though I knew he was sober. At one point Jim turned to me and said, 'Let's start a fire in the balcony or something. Get a riot going.'"

But the crowd wound down soon after and Morrison left with the rest of the audience. Outside, a dozen police cars were circling the auditorium in anticipation of possible trouble, but after hanging around awhile to see what the police would do, the crowd went home without an incident. USC officials breathed a sigh of relief and canceled the remainder of the Living Theatre's engagement.

The Living Theatre provided the missing piece in Morrison's revolt against the Leather Frankenstein he'd created. It inspired him and he spent that night discussing incorporating what he'd seen into his own show. In fact, he would use several of its confrontive techniques for promoting audience awareness the very next night—on the stage of the Dinner Key Auditorium in Miami.

The Miami Concert

The Miami incident was something that nobody ever thought could happen in America. The concert was set for the following day, Saturday, March 1. In eight days The Doors were to begin their biggest tour ever and Jim and Pam had planned a short vacation in the Caribbean beginning the day after Miami. They already had a house prepared and had even purchased the tickets. On the day of the concert, however, they got into a huge argument and while they calmed down enough to get to the airport, they had another fight while waiting for the plane and Morrison ended up sending her home. In all the confusion he missed his flight, so he reserved a seat on the next one and drank in the bar until it arrived. He drank on the plane as well, downing whatever he could talk the stewardesses into giving him, and at the stopover in New Orleans he got off to have a few quick ones and wound up missing his departure. Once again he arranged to catch another plane and called The Doors to inform them he would be late. And he continued drinking—all the way to Miami.

When you look back at Miami it is as if Morrison's inner turmoil had churned itself to a point of no return and boiled over

)inner Key Auditorium stage—the constant skirmishes
ority, the disgust at being a sex symbol, the fears of not
n seriously as an artist or poet again, the love/hate rela-
‿⌐up with his fans—all of it reached its peak, and on a hot
night in Miami, Jim Morrison finally gave the audience what
they'd come for.

Doors concerts were famous for dealing with reality and the
unexpected. Miami was both. It was more of a sixty-five-minute
incident than a concert. Twenty-two years later it may seem tame
compared to today's liberal exhibitions, but Miami went beyond
pushing at the envelope of the Establishment's standards for
crowd control and public morality, it pushed right through it. It
was the night Jim Morrison went too far, the night they couldn't
forgive him for, the night he crossed the threshold into an other
side from which he never really came back. The concert was an
intense experience, complete with fights onstage, thousands of
gate-crashers, and a police tactical squad waiting for expected big
trouble which never came, but which was always near. Morrison
sang only five or six songs the night he took his sexual politics to
the extreme, but it was the performance that most changed his
life—you could even say it killed him.

> *The killer awoke before dawn*
> *He put his boots on*

It had all started with a poll taken by the university newspa-
per, *The Hurricane,* where the students overwhelmingly chose
The Doors as the group they would most like to see in concert.
The university wanted them at the Convention Hall, but local
promoter Ken Collier and his Thee Image Productions offered
more money for The Doors to play the Dinner Key. Located in
the Coconut Grove area beside Biscayne Bay and just across a
parking lot from City Hall, the Dinner Key Auditorium was a con-
verted seaplane hanger, complete with creaking rafters and a
rickety old stage. It would not only be The Doors' first perform-
ance in Miami, it would be their last.

According to the official count there were twelve thousand
people at the show, but many swear it was closer to thirteen

thousand. The hall was designed to hold only seven thousand and it was virtually bursting at the seams. The promoters had removed the seats in order to cram more people in, but hundreds scaled the walls to enter through second-story windows without paying and still there were another two thousand fans jammed against the doors outside trying to get in. As if this wasn't bad enough, there was no air-conditioning in the building and the night turned out to be one of the hottest Miami had that year. It was sweltering inside the packed arena. The place was stuffed with angry faces glaring at each other, tired of standing around and waiting, broiling in the heat. The Doors were late and people had paid six and seven dollars to suffocate in the blistering arena. The atmosphere in the auditorium was charged with anger. Trouble was in the air. You could feel it.

The Doors were to be paid twenty-five thousand dollars for the show according to their agreement, but Siddons and the band were angry because their fee was based on an auditorium having a forty-two-thousand-dollar maximum. After the contract had been signed Thee Image took out the seats and sold several thousand more tickets raising the gross to something like seventy-five thousand. They had upped the scale without upping The Doors' fee. Ken Collier insisted there was no percentage deal and The Doors had agreed to a flat twenty-five thousand and Siddons had been fighting it out with him for an hour while they waited for Morrison to show. Vince Treanor remembers: "There was trouble right from the beginning. The infighting started right away. Siddons went for an accounting and suddenly found there were no seats in the building."

According to Treanor, when Siddons inquired about the change in seating he was told that the promoters had decided to remove the seats and let the crowd stand. "When Siddons reminded the promoters that this wasn't in the contract the promoters said, 'What are you gonna do about it?' Bill threatened to take the equipment and leave and the promoter said, 'You think you're gonna get this equipment outta here? You're gonna play this show.' Here's the band's brand-new equipment and a hall full of shouting people and the promoter is holding a gun to our heads."

To make matters worse, both Siddons and the promoters were worried that Morrison might not show. It was getting late

and there was no sign of him. And still more people squeezed into the auditorium. "We had one guy stationed at every door," Siddons recalls, "and we had thirteen thousand people in that building and that didn't include the people who got in when my guys were thrown off the door. You ever seen sardines in a can? They have a lot of room compared to what that place was like that night."

There is a lot we still don't know about that controversial night at the Dinner Key Auditorium, but we do know the hall was crammed to well over its capacity with a sweating mass of people driven to a fever-pitch intensity by the heat and lack of air. It was a tinderbox ready at any moment to ignite into a blazing inferno. And then Jim Morrison walked in and lit the match.

Morrison's fame had preceded him to Miami. Ray Manzarek remembers: "There were a lot of psychological factors that entered the picture. This was Tennessee Williams territory. Hot Southern night, too many people, loads of nervous tension. They knew Jim Morrison was from Florida and it was like a native son returning home from Los Angeles, that weird place, who'd taken acid to become the King of Acid Rock. They didn't know what to expect. They thought, something is going to happen tonight. They were ready for something."

Of course, they should have refused to let Morrison go on. Siddons, the promoters, the other Doors—somebody should have stopped him. By the time he finally arrived in Miami, Morrison was completely stewed. Drunk even for Morrison, which was drunk indeed. Bearded and wearing a leather hat adorned with both a cross and a skull and crossbones, everyone knew he was drunk as soon as they looked at him. Morrison, in his stupor, sized up the situation and decided to tease the angry crowd. He took his sweet time coming to the stage while the band played the intro to "Break On Through" over and over again. Morrison watched them wailing away and stood on the side of the stage drinking. Finally he grabbed a microphone and began rambling incoherently—"improvising" his friends said, "babbling" was how others described it.

The crowd was trying to make the best of an impossible situation. The heat was choking and the mass of bodies was causing the temperature to rise even further. In an effort to breathe better and cool off, dozens of young men climbed onto the ceiling

rafters above the stage. People were everywhere, caked onto the walls, painted on the ceiling, smeared across every available space.

All this time the band was playing, hoping to draw Morrison into performing, but apparently Jim had at some point decided not to sing with The Doors that night. Instead, he had joined the Living Theatre, all by himself. After about ten minutes of the intro to "Break On Through," he sang a verse or two but soon broke it off again to aimlessly rap and drink some more. "I'm not talking about no revolution. And I'm not talking about no demonstration. I'm talking about having a good time. I'm talking about having a good time this summer. Now you all come out to L.A. You all get out there. We're going to lie down there in the sand and rub our toes in the ocean and we're going to have a good time. Are you ready? Are you ready? Are . . . you . . . aahhh suck!"

Trying to get Morrison's attention the band began playing "Back Door Man." "Louder," Jim shouted. "Come on, band! Get it louder! Come on! Yeahhhh. I'm a back door man . . ." But after stumbling through most of the song lines he began talking again. "Hey listen, I'm lonely. I need some love, you all. I need some goodtime lovin' sweetheart. Love me. I can't take it without no good love. I want some lovin'. Ain't nobody gonna love my ass? C'mon. I need you. There's so many of you out there . . . hey, there's a bunch of people way back there that I didn't even notice. Hey, how 'bout about fifty or sixty of you people come up here and love my ass. C'mon . . . Nobody gonna come up here and love me, huh? All right for you, baby. That's too bad. I'll get somebody else."

When Morrison paused in his rap the band started playing "Five To One." That was probably a mistake. Morrison sang a few verses, but after that his rap became angry and harshly condemning: "You're all a bunch of fuckin' idiots," he suddenly shouted at the stunned crowd. As waves of outrage swept through the auditorium he went on. "Let people tell you what you're gonna do. Let people push you around. How long do you think it's gonna last? How long are you gonna let it go on? How long are you gonna let them push you around? Maybe you like it. Maybe you like being pushed around. Maybe you love it. Maybe you love getting your face stuck in the shit . . . You're all a bunch of slaves. Bunch of slaves. Letting everybody push you around.

What are you gonna do about it? What are you gonna do about it? . . . What are you gonna do?"

Then he went back into the song. As "Five To One" ended, he began another rap. "Hey, I'm not talkin' about no revolution. I'm not talkin' about no demonstration. I'm not talkin' about gettin' out into the street. I'm talkin' about havin' some fun. I'm talkin' about dancin'. I'm talkin' about love your neighbor . . . till it hurts. I'm talkin' about grab your friend. I'm talkin' about love, love, love, love . . . grab your fuckin' friend and love him."

The band launched into "Touch Me" and Jim sang all of three lines before shouting, "Hey, wait a minute, wait a minute. This is all fucked up. Wait a minute. You blew it. You blew it." Then suddenly, his voice deepened markedly and in a total rage, he screamed, "I'm not gonna take this shit. I'm coming out. I'm coming out!"

On and on the tirade went. When it wasn't incoherent, it was abusive or confusing or both. Throughout most of the concert Morrison staggered around the stage, alternately muttering and shouting obscenities at the audience. Distorted recollections of the Living Theatre's *Paradise Now* perhaps or just a torrential release of outrage at the noose tightening around him. There was no question that he made a fool of himself. Most of the people who were there remember only pieces of his performance. Morrison screaming, "THERE ARE NO RULES!" and urging those sweltering in the back of the auditorium to rush the stage. Or asking the audience, "Anybody here from Tallahassee?" and when many in the crowd responded with whoops of affirmation, smirking and saying, "Well, I lived there once. I lived there until I got smart and went to California."

At one point Morrison leaned close toward Robby Krieger's crotch (some in the crowd claimed he was feigning fellatio) while the guitarist played and did his best to ignore him. Later, Jim grabbed the hat off a policeman who was in front of the stage and hurled it into the darkness. The cop in turn grabbed Morrison's hat and threw it into the crowd as well. The crowd laughed, but that was about it. Since the hat trick had worked so well with the old lady at the Living Theatre performance, perhaps Jim thought he would again earn an ovation. In any case, it was an indication that at least his subconscious mind was more on the improvisational theater group's performance than his own.

At one point in the show Morrison made a more direct reference to the Living Theatre: "Hey, listen," he yelled at the crowd. "I used to think the whole thing was a big joke. I thought it was somethin' to laugh about, and then the last couple of nights I met some people who were doin' somethin'. They're trying to change the world and I wanna get on the trip. I wanna change the world."

Morrison harangued the audience. "Let's see some action out there. I wanna see some action out there." He kept repeating the phrase over and over. "I wanna see some action out there. I wanna see you people come up here and have some fun. Now c'mon, get on up here. No limits. No laws. C'mon. C'mon."

At this point several people in the audience made their way toward the stage. There was a feeling in the air that anything, absolutely anything, could happen that night. Perhaps the crowd would cut loose and trample each other. Or perhaps they would kill Morrison. Perhaps the rest of the band would quit right there, break up and walk off the stage never to perform together again. Bill Siddons remembers the performance almost as a wild and crazy dream: "The gig was a bizarre, circuslike thing, there was this guy carrying a sheep and the wildest people that I'd ever seen."

The lamb belonged to Lewis Marvin of Moonfire who traveled around spreading a philosophy of nonviolence and vegetarianism, carrying the small lamb to help articulate his message. At one point, Morrison held the lamb in his arms onstage. "I just held it awhile," Jim said later, "and there was a lot of noise, a lot of commotion, it was almost deafening but the lamb was breathing normally, almost purring like a kitten, it was completely relaxed. I guess what they say about leading lambs to the slaughter is true."

Meanwhile Jim Morrison was attempting to lead himself, or at least his image, to the slaughter—only it wasn't going quietly. By now a few people had actually made it onto the stage. Vince Treanor was there, trying to restore some order: "Somebody jumped up and poured champagne on Jim so he took his shirt off, he was soaking wet. 'Let's see a little skin, let's get naked,' he said, and the audience started taking off their clothes."

Things got more lewd from then on. Whatever Morrison was up to that night, it wasn't a Doors concert. "I'm not talking about

revolution, I'm not talking about guns and riots, I'm talking about love," he shouted in the microphone. "Love one another. Love your brother, hug him," he said. "Man, I'd like to see a little nakedness around here . . . grab your friend and love him. Take your clothes off and love each other." And the clothes started coming off. People began stripping, shirts and blouses were peeled off and even bras were being thrown up onto the stage.

Again and again Morrison challenged them to rush the stage. He wanted action. The crowd was getting wild, shouting all sorts of profanities and the cops became very nervous. To them Morrison must have seemed a reincarnation of Hitler and a drunk one at that. Then Morrison's random shoutings began to address what was really on his mind. "I'm not going to take this shit. You are all a bunch of fuckin' idiots, your faces are being pressed into the shit of the world . . . take your fuckin' friend and love him . . . Do you want to see my cock?"

As if they knew that a great sideshow was about to unfold, the whole auditorium slipped into a sort of suspended animation, as if time had stopped. There were a few boos here and there, but mostly everyone was quiet. They were waiting for the Lizard King to do something crazy. Morrison leered at them. He knew what they wanted. When you got right down to it, past all the hype, what was this sex symbol thing anyway? "You didn't come here only for *music* did you?" he screamed into the microphone. "You came for something *more,* didn't you?" The crowd began to respond. They didn't know what he was going to do but they could sense the spectacle building. "You didn't come just to rock 'n' roll," Jim screamed, "you came for something else *didn't you?*" More excitement in the crowd. Morrison sauntered to the very edge of the stage and hissed at them. "You came for something else—WHAT IS IT?" Then they all screamed unintelligible answers—chaos, confusion. They didn't know what they wanted. But Morrison did. He strutted across the stage and then yelled into the mike, "You wanta see my cock, don't you? That's what you came for isn't it? YEAHHH!"

There was one long, skyrocketing screech from the crowd. Vince Treanor describes what happened next: "Jim was drunk and the party was going and Ray shouts over to me, 'Vince, don't let him take his pants down.' So I step over John's drum platform and I come right up behind Jim. He's carrying on and doesn't

even know I'm there. I stuck my fingers into his belt loops and I rotated my hands so there was tension on his pants and I lifted him up by his pants. Now I don't know whether he ever pulled his fly down or not, because I was behind him and I couldn't see."

As to what happened next, there is much speculation. It seems Morrison grabbed his shirt and put it in front of his crotch, waving it back and forth like a bullfighter. Now you see it, now you don't. He took it away for an instant and taunted, "See it? Did you see it?" Some say he exposed himself and others say he only pretended to. Robby Krieger says no: "No, and I was right there . . . He may have taken them down, but I don't think he whipped it out. You know for Jim to take his pants down, I wouldn't even have thought of it twice. But actually whip it out? I don't think so."

Densmore agrees: "It was real hot and Jim was real drunk, but as far as I could see, he didn't drop his pants."

Ray Manzarek is unsure. "I don't know *what* he did. I was right there and I didn't see a thing. I had a tendency to close my eyes and put my head down . . . so in Miami I wasn't really looking. I remember Jim taking his shirt off. Holding it in front of him and doing a sort of mock striptease. He had boxer shorts on, and they were folded over the top of his leather pants. And he held his shirt by the collar, covering his crotch. He moved the shirt back and forth, saying, 'I'm going to show it to you, now watch.' And with one hand he'd reach behind and kind of feign opening his fly and pulling it out, and very quickly move his shirt away. 'There it was! Did you see it? Did you see it?' And then he'd bring the shirt back in front of him. I don't think he ever did it. Let's talk technical. When you open it up, you have to unzip your pants and get it through the opening in your shorts. And he was wearing shorts that day, and he was doing a lot of twisting and turning. So he'd have to unzip his leather pants, go in through the shorts, find it [laughter]—it was a huge thing to pull out, you'd think it would have gotten caught around his knees somewhere [laughter], for God's sake. I didn't see him do it, but I did see him intimate to the audience that he was going to do it."

But Manzarek rightfully suggested that the audience saw what they wanted to see, sort of a mass hallucination brought on by the intense heat and the excitement of the performance:

"Miami was the most notorious live performance by The Doors. A steamy night and everybody was in a strange mood. They had a preconceived notion of what would happen. He was the Lizard King, and lizards and snakes play a large part in the subconscious mind of Florida. They wanted to see the primordial snakes that Jim represented and talked about. I think that all went together to make up this incredible concert that Miami was. And Jim Morrison instilled into that crowd a mass hallucination. That's what I think *really* happened—snakes, lizards, craziness—and on top of it, the heat. The people went, 'Yeah, he's doing it. My God, he did it. I saw it!' I still think Jim was right on the mark about some of the things he said to the audience that night."

The Doors had now been playing for almost an hour. During the entire concert the audience had been shouting for "Light My Fire," but Morrison had ignored them. Now the band began the song to the crowd's great pleasure and Jim sang along, slurring his words drunkenly. As the song ended, Morrison began calling for action. "I wanna see some action out there. I wanna see some action out there. I wanna see you people come on up here and have some fun. No limits, no laws. C'mon. This is your show. Anything you want goes. Now c'mon. Anything you want. Let's do it. Let's do it."

More and more people were climbing on the old stage, which began to buckle under the pressure, the huge speaker columns teetering as the crowd pressed in. Finally, the promoters couldn't take any more. They were afraid the spectacle was going to end in some sort of mass violence with them holding the bag. Ken Collier came onstage, grabbed the mike, and flashed a peace sign, saying that he was afraid someone was going to get hurt and insisting that this kind of thing wasn't going to happen in Miami. Meanwhile Morrison walked around the already packed stage, pushing people, bellowing, and acting as if he were masturbating. Then, he grabbed the mike away and shouted "We ain't gonna leave until we get our rocks off." But Collier soon regained control.

Between shoving matches and a tug-of-war over the microphone, Morrison and Collier yelled back and forth at the crowd, but the band was now playing "Light My Fire" so loud that nothing could be heard. Collier then pulled the plug on the music and kicked in Densmore's drums as the houselights came up. People

started throwing things and a lot of fighting broke out. There were nearly a hundred of them onstage now. Morrison began shoving people off, including Collier's brother, a partner in Thee Image, but then another partner who had a black belt in karate came up from behind and literally heaved Jim off the stage into the crowd. Not to be outdone, Morrison immediately stood up and began to lead a snake dance through the audience. Hordes of people followed after him like the rats being charmed into the river by the Pied Piper. The snake wound its way up into the balcony, where Morrison appeared for a brief instant like a mad phantom of the opera surveying the bedlam below. Someone in the crowd spied him and called out. The others looked up from the chaos that had swept through the auditorium and cheered. Morrison just stared trancelike, as if watching something he couldn't fathom—something he had no control over. Then he turned and disappeared into the dressing room. The crowd cheered again. What the concert may have lacked musically, it more than compensated for theatrically. The kids had finally gotten their money's worth, finally gotten what they came for—a real spectacle.

As the crowd filed out, the scene resembled a rock 'n' roll war zone. The stage was now totally broken and leaning precariously to one side. The speaker columns had finally come down. Littered everywhere were hundreds of empty beer and wine bottles. And the floor was carpeted with clothing—dresses, pants, swimsuits, socks, shoes, shorts, shirts, blouses, stockings, bras, and panties. The audience had apparently gone the limit as well.

Of course, most of them had merely watched. Watched with strange mixtures of awe, frustration, admiration, and disgust. For some of them Morrison was doing and saying the kinds of things they had always wished they could do themselves. Manzarek elaborates: "Jim's audiences were always a major part of his performance, his 'theater,' and he instinctively sensed that these exploding young bodies were clamoring for more. So he pushed them and lured them into pushing him. It was an unbelievable dance they did together . . . People were just going *insane,* man. The whole thing was just madness. John, Robby, and I kept playing, keeping it going, keeping the madness going, 'Light My Fire' on and on and on."

Robby agrees: "It looked like a scene from that movie *The Snake Pit,* where people were rushing around in endless waves. I don't know what Ray did, but finally John and I scooted off the stage because someone was yelling that it was about to collapse."

There is no denying that much of what happened that night was related to the powerful effect the Living Theatre had on Morrison. Bill Siddons remembers: "While onstage, Jim adapted the provocational elements of the Living Theatre into his show . . . stopped songs in the middle, taunted his audience, and was telling them, 'I don't want to be this. I'm not here to jump off the stage for you!' "

> *We can play music*
> *But you want more*
> *You want something & someone new*
> *Am I right?*
> *Of course I am*
> *I know what you want*
> *You want ecstasy*
> *Desire & dreams*

Manzarek summed it up this way to Robert Matheu in *Creem* Magazine: "Jim Morrison was a personification of Dionysus and he once said that Dionysus enters through the ears, and not through the eyes. At a Doors concert, you were supposed to close your eyes and feel Jim taking you somewhere you'd never been before. But Miami was different. You've come to see a show, a spectacle like you've never seen before, something to blow your minds, haven't you? Well, I'm going to show you something. How about if I pull out my cock? Will that do it for you? Would you like to see me pull my dick out and shake it around. How about that? And they went crazy. I wish he'd have told somebody what he was planning to do. He said to me the next day. 'Did I do anything wrong?' Whether he was putting us on or not, we'll never know, because he looked us right in the eye and said, 'I don't remember a thing. I had a lot of drinks and don't remember getting to Miami.' Who knows? He may have been absolutely honest in that he didn't remember anything. So here we are."

Everything is vague and dizzy

Whether Jim Morrison actually exposed himself to the Miami audience has never been proven, but exposure is not really the important question. Morrison exposed more of himself by the words he said that night than anything else. Bill Siddons would late be quoted in *Rolling Stone* as remembering Morrison's saying, "Uh-oh, I think I exposed myself out there," to him after the show, but Siddons describes another incident that sheds more light on what really happened in Miami: "The next morning, after the show, we were walking down out of the elevator to go to breakfast, Jim and I and this woman attorney . . . and she said, 'Jim, what are you doing this for? Why do you go out onstage in front of thousands of people like you did last night and go though this whole cathartic experience to try and get them to listen to you? They just wanna boogie.' And Jim said, '. . . I just hope that one day people take me seriously as a poet.'"

There is no question that much of what happened that night in Miami had to do with Jim Morrison's rebelling against his sex symbol image. Besides making a sham out of the "young lion," it was as though he was letting the audience and the rest of his public in on the joke that being a sex symbol really boiled down to. Later he even admitted this to Salli Stevenson in *Circus* Magazine: "I was just fed up with the image that had been created around me, which I sometimes consciously, most of the time unconsciously, cooperated with. It was just too much to really stomach and so I just put an end to it in one glorious evening."

The next day, according to plan Morrison and the others left to vacation in Jamaica even though Pamela stayed behind. Perhaps they should have stayed around for the reviews, for it was after they'd left town that the real trouble started. It began with a sensational newspaper account describing the show as a near riot filled with obscenity and various other forms of mayhem. "The hypnotically erotic Morrison flaunted the laws of obscenity, indecent exposure and incitement to riot," the lengthy article charged, "appearing to masturbate in full view of his audience, screaming obscenities and exposing himself . . . at no time was an effort made by the police to arrest Morrison, even when the mob scene on the bandstand got out of hand."

Larry Mahoney wrote the article for *The Miami Herald* call-

ing Morrison "the king of orgasmic rock" and after the article came out he called several local politicians and asked what they intended to do about the outrage. With the press fanning the flames, the "incident" soon became a political hot potato. The local bureaucrats began bewailing the fact that such an immoral display could take place in a city-owned auditorium and each day the account grew in the newspapers. Before long, local officials and the sponsors of the concert were publicly lauding the audience for its mature show of restraint after being subjected to not only Morrison's vulgar exhibition, but a "hypnotic electric guitar" to boot. In response, letters began pouring in to *The Miami Herald* from angry citizens of all walks of life—"GROSSED OUT BY THE DOORS," "TOO MUCH RESTRAINT SHOWN IN DOORS CASE," "GET RICH QUICK: BE OBSCENE," and other such headlines filled the pages of the paper for days.

As always, when the press starts cooking on something like this, the police were the first ones into the frying pan. Asked why there were no arrests by the thirty-one off-duty policemen hired by the sponsors for the show, acting chief Paul M. Denham said that "an arrest at that time would have created a very serious civil incident." The truth was more likely that the cops simply didn't see anything criminal about the performance. Obscene and profane, perhaps, but criminal? Records show that not a single report on the concert was filed at police headquarters by any of the officers until a few days later when the public outcry began. Denham himself was later quoted as saying Morrison was "the dirtiest, most foul-mouthed person we ever had in Miami's history. We've been besieged by calls. Hundreds of parents and the teenagers are screaming for his hide. I've never seen public indignation at a higher pitch."

The police began making pleas in the media for photographs and recordings of the concert that might be used as evidence against Morrison. Besides incurring the wrath of the police, Morrison's exploits on the Miami stage also attracted the FBI. Shortly after the concert, an FBI informant filed the following report, which appeared, for some strange reason, in a larger report on racial violence in Florida. (It was obtained through the Freedom of Information Act. The blanks represent names deleted by the government under the guidelines provided by the law regarding National Security.)

RE: POSSIBLE RACIAL VIOLENCE MAJOR URBAN AREAS "On March 3, 1969, _____ reported that JIM MORRISON, a rock and roll singer, appeared at the Dinner Key Auditorium, Miami, Florida on March 1, 1969. MORRISON, a white male, age 25, born in Cocoa Beach, B. APPROX. 1944 Florida, and who once attended Florida State University, reportedly pulled all stops in an effort to provoke chaos among a huge crowd of young people. MORRISON's program lasted one hour, during which time he sang one song and for the remainder he grunted, groaned, gyrated and gestured along with inflammatory remarks. He screamed obscenities and exposed himself, which resulted in a number of the people on stage being hit and slugged and thrown to the floor. There were 31 off-duty Miami Police Officers, hired by the sponsors who observed most of the action by MORRISON but failed to make any arrest as to do so might possibly incite a riot. _____ advised that he is conducting an investigation and warrants will be obtained for MORRISON's arrest on misdemeanor charges. In addition, the matter will be discussed with the Florida State Attorney's Office to determine if MORRISON can be charged with a felony."

This report opens the possibility that it was indeed the FBI and not just an angry newspaperman and a couple of issue-hungry local politicians who wanted Morrison put away. After New Haven, the FBI had marked Morrison as a potential threat to America and it may well have been their meeting with Florida's state attorney that shifted the matter from a misdemeanor to a felony.

Meanwhile The Doors' Caribbean trip caused the Miami newspapers to conclude that the band was "already on the run, hiding from the law." No one cared that the vacation had been booked in advance or that no charges had been filed. The public was starting to get angry and the press kept pouring it on with Mahoney leading the way. Finally, on Wednesday, March 5, four days after the concert, the city of Miami issued a warrant for the arrest of James Douglas Morrison. To obtain the warrant, a complaint was signed by an office boy who had attended the show

and worked for the assistant state attorney. It was political to be sure, but it was also deadly serious. Morrison was charged with a felony and three misdemeanors for which he could be sentenced to as much as three years in the state penitentiary. It was becoming very evident that these Florida boys weren't kidding around. They wanted Morrison's ass in jail so they could make an example of him.

In all, six warrants were sworn out by the Dade County State Attorney's Office including a felony charge of "lewd and lascivious behavior" and five misdemeanors: two counts of indecent exposure, two of public profanity, and one of public drunkenness.

By this time Morrison and the other Doors had returned to Los Angeles which meant that Jim would have to be extradited to Florida if the Miami authorities wanted to prosecute. Morrison was shocked by the charges. He never thought it could get this serious. For a while no public move was made but a lot of legal maneuvering took place behind the scenes. Now a wanted man, Morrison brought in his Beverly Hills attorney, Max Fink. The possibilities were beginning to weigh heavily on him. He was keeping out of sight and not giving any interviews and although his friends joked about it, Morrison knew right from the start that there was something different about this brush with the law. He had the feeling he wasn't going to get off so easy this time.

For The Doors, the most immediate result of Miami was a nationwide ban. They were scheduled to begin the tour in Jacksonville on March 9, but as soon as the news broke about Miami, Jacksonville canceled and within days every city on the tour canceled. The Concert Hall Managers Association again warned its members of the Doors' unpredictability and the numerous charges against Morrison. In all, sixteen states banned The Doors from appearing. Ray Manzarek remembered how it was in *Musician*: "I'm getting some sun, relaxing in the Caribbean, and I get this call. 'Ray, you better get back here, there's big trouble.' Trouble, what do you mean? 'You guys are busted.' Busted? I'm sitting on an island in the middle of the Caribbean. How can I be busted? 'Do you know Miami? Well, you're busted.' And the shit hit the fan. It was never the same after that. It was a turning point as far as Jim was concerned. I don't think it really affected his poetic output or his singing, and it didn't affect our actual music.

But it did affect us in relationship to public performances. We had a twenty-city tour scheduled after Miami . . . *Every city canceled out.* Do not bring those guys into town. We are not going to allow The Doors to perform in a public or municipal facility. So we lost the entire tour."

In Cincinnati, the cancellation of The Doors concert scheduled for March 30 resulted in a one-million-dollar lawsuit by the promoters of the show against the city's mayor and three members of the Music Hall Association who stopped the show. A spokesman for The Doors announced that the band would not appear publicly or even record until summer. So for the moment, the biggest band in America was virtually unemployable. The Doors were show business poison. Bill Siddons describes the pressures the ban exerted on the group: "It cost us at least a half million dollars and almost caused the group to break up. It really destroyed our morale. What we considered a minor incident turned into a tremendous problem."

The press was having a field day at Morrison's expense. Because he was a public figure who advocated freedom and frequently clashed with the law, he was presumed guilty without being heard. Of course, under the circumstances it is doubtful anything Morrison could have said in his own behalf would've made much difference. The press had already locked him into an image and they were not about to let him out.

The Doors expected such an attitude from the traditional media, but they were hurt to see it in the rock press. Since Morrison's actions had been so outrageous of late and the recent recordings had triggered doubts about his artistic integrity, the underground figured exposing himself was just the kind of stupid scandalous thing he would do. Hardly one of them voiced concern that he might be unfairly treated at the hands of the Establishment or that the right wing might try to use the incident to silence him for good. Like the fans, the music press was more interested in picturing Morrison as a clown, a foolish drunken freak whom they could not forgive for impressing them so much and then failing to live up to the godhead potential they had assigned him. *Rolling Stone* ran a Western-style wanted poster of Morrison and later entitled an article "Morrison's Penis Is Indecent" and everyone laughed. Other papers blasted him for providing the Establishment with the kind of fuel it needed to

ban concerts and pop festivals. That crazy Morrison had gone and done it and now everyone would have to suffer because of him was the prevailing thought. Densmore remembers that the band "didn't get any support from the rock 'n' roll community. They seemed glad."

But most of the press were vultures
descending on the scene for curious America aplomb

And the public was even worse. They were getting bored with what one critic called "the mechanical Mickey Mouse Theater of The Doors, its madman star and its constant travails." Morrison was becoming yesterday's news. Instead of igniting the fires of praise as the New Haven bust had done, the Miami incident only sealed his fate in the minds of the public. He was a jerk, they reasoned, who thought he was so cool that he could get away with anything. They were no longer interested in breaking on through. And Morrison was caught on the other side alone.

When Morrison indicated that he had no intentions of returning to Miami to face charges, the FBI again stepped in and issued a fugitive warrant, charging him with flight to avoid prosecution. This was especially ludicrous since there were no charges to avoid when Morrison left Miami. If these facts had been known, the underground press might have rallied behind Morrison after all, for clearly the FBI was taking the lead in getting him to trial.

The topper came when a group of high school students with support from Archbishop Coleman F. Caroll and a local radio station decided to hold a widely publicized Rally for Decency at the Orange Bowl. The original announcements for the rally stressed that "longhairs and weird dressers" would not be allowed to attend (since naturally these are the classic telltale signs of indecency). This policy, however, violated government regulations concerning the use of the city-owned stadium, so the decency team relented and everyone was allowed in. The newspapers ate it up. Miami teens, angry at the immoral rock music best typified by Jim Morrison, were answering back with a rally of their own. It was a born headline. On March 23, over thirty thousand, half adults and half teens, gathered at the Orange Bowl to support the crusade for decency in entertainment. Heading up the program

and donating their services were celebrities Jackie Gleason, Anita Bryant, The Lettermen, and the Miami Drum & Bugle Corps.

Led by seventeen-year-old high school senior Mike Levesque, the decency team stressed that the event was not a protest rally. "We're not against something," one member said. "We're for something." According to the program, what the crowd was for was five virtues covering God, patriotism, family, sex, and the equality of man. Cards were handed out that described the teens' five-point stand and quoted Levesque's "Manifesto": "It isn't all the evil in the world which troubles me. It's the fact that so many good men sit back and do nothing." The teens led the crowd in pledging allegiance to the flag and then listened to several ministers preach. Jackie Gleason, who lived in Miami, said: "I believe this kind of movement will snowball across the United States and perhaps around the world." Since Gleason had a reputation of being a big drinker, playing a champion of virtue was an interesting role for him. Numerous religious organizations contributed to the four-hour decency rally and American Legion volunteers handed out ten thousand small American flags during the event. All in all it was quite an outpouring of energy and emotion over something as insignificant as Jim Morrison's exposing himself.

Three days later President Richard Nixon sent a letter of appreciation to Mike Levesque, who announced that he was going to appear on the *Today* show and had offers from four major cities to stage similar rallies. Of The Doors concert Levesque said: "I was more disappointed than disgusted, disappointed that adult promoters could charge kids six or seven dollars to see something that cheap." Although the "Clean Teens," as they were known, came to a sudden halt three rallies later when they began fighting among themselves, they had done their share of damage to Jim Morrison. If public sentiment hadn't been convincing before, it was now overwhelmingly evident. Miami wanted to hang Morrison and the rest of America didn't think that was too bad an idea either. With that in mind the Miami prosecutor developed his case.

Meanwhile, the city of Miami continued its newfound assault on rock by denying permission for the Dinner Key Auditorium to be used for a three-day Easter happening featuring The Grateful Dead. George McLean who ran the auditorium in cooperation with the city had this to say about it: "They're the same type

people and play the same type music as The Doors. It's this underground pop music. I don't think our community could stand another affair such as that." Also scheduled to appear at the Easter concert, which was moved to another auditorium, were Country Joe and the Fish, Creedence Clearwater Revival, and The Steve Miller Band. Country Joe had played Miami in the past and had included his famous F-U-C-K cheer without incident—but that was in the days before the Morrison-inspired resurgence of decency in Miami. The Miami police took no chances and canceled all leaves over the Easter holiday (later the concert was rescheduled for April 24 and 25 only to be banned once more by the city fathers).

A side effect of The Doors scandal in the Miami area was the rise of vigilantism. One source who refused to be identified was quoted as saying, "It's worth your life to have long hair in Miami these days." The angry crowds in Miami struck fear in the hearts of hippies across the country. It appeared that a massive wave of antirock repression might soon sweep the nation. In California, two right-wing politicians, sniffing communism, warned that rock along with sex education was "designed to eat away the minds of the nation's youth and cause them to revolt" (true, of course). Representatives of two large rock-music-booking agencies were quoted in the press as saying that business was fine except in Miami, but they did admit that, after Morrison pulled his fast one, the industry had been fearful of nationwide cancellations.

Meanwhile the ban of The Doors extended to the airwaves. Although "Touch Me" had gone gold, after the decency crusade radio stations began to drop their records. This contributed to the already-strife-ridden condition of the band. The other three Doors were angry over not being able to perform, something they dearly loved, and they began to resent Morrison for once again screwing up their lives. The group dynamics were now permanently changed. The press had long ago singled Morrison out, but now this distinction was becoming apparent within the group. Instead of it being four people committed to the same vision, it was now Morrison on one side and Manzarek, Krieger, and Densmore on the other. While Manzarek attempted to remain Morrison's friend throughout the madness, there was no denying the simple fact that Jim was drastically altering all their lives for the worse. From this point on, no matter how hard they tried to work together, it would never be the same.

Miami had become a dark shadow hanging over The Doors, one that would stalk Jim Morrison like a raging beast to the day he died. It is easy to dismiss the incident as simply a crazed act by a drunk who finally had one too many, but there are those who believe Morrison's behavior was neither accidental nor a mistake. If freeing himself from his sex symbol image in "one glorious evening" was not a conscious effort, it was certainly at least a subconscious one, but Miami goes beyond that. In many ways the incident stands as the ultimate test of his philosophy. There is no question that it was badly timed and poorly calculated, but in a sense it was the logical culmination of everything Morrison had ever tried to say to the world. He had whispered, spoken, and sung his words many times before and few had listened. Now he shouted them one last time in desperation. Whether intentional or not, Miami was Morrison's attempt to fuse sex and violence, the elements he believed were the key to shattering the cocoon mankind had woven around itself. Miami may not have been sensual in the same way that "The Crystal Ship" was, for example, but those who were there say there was something erotic about it and part of the eroticism was that (like "The End") it was so violently shocking. That is what had the authorities up in arms in the first place. How dare Morrison do such a thing. In this sense it was the logical conclusion of New Haven, the natural end of the Whisky a Go Go, and the final expression of the Venice rooftop and the New Mexico highway. It was the shaman overloading on a twelve-thousand-man trance.

And, in this sense, the failure of Miami was also the ultimate failure of Jim Morrison and the "break on through" philosophy. Miami failed to make the audience look at themselves, it failed to make them learn about who they were, and it failed to make them cognizant of their own dark side in a way they could possibly accept. Sure, it made them *afraid,* but being afraid is not understanding fear. It made them *angry,* but being angry is not mastering the emotion, only releasing it. Thus, the Dionysian fell short in Miami just as it had missed at the Singer Bowl and become a joke at the Forum. Nietzsche works only on paper and in small doses. Carrying it out to the extreme backfires every time. There are those who will argue that Jim Morrison had lost too much to alcohol to carry forth his vision, but they are missing the point. The alcohol was part of the vision and it too betrayed him. As the effects of Miami settled in, Morrison not only had the fist

of the law hanging over him, he also had the uncertainty of a man who was slowly beginning to realize that the truth, the real truth, was not where he thought it was at all.

We must try to find a new
answer instead of
a way

Morrison later said something that seems to confirm Miami as an attempt to both kill the sex symbol image and take the philosophy to its ultimate conclusion. "I think that was the culmination, in a way, of our mass performing career. Subconsciously, I think I was trying to get across in that concert—I was trying to reduce it to absurdity, and it worked too well. I think there's a certain moment when you're right in time with your audience and then you both grow out of it and you both have to realize it; it's not that you've outgrown your audience, it has to go on to something else."

And indeed, after Miami, Jim Morrison pretty much made up his mind to go on to something else. Miami was the turning point in his life. After Miami, music became something for him to enjoy, not change the world by. All of the former ambitions he had held for music were now once and for all switched to poetry and film. He became convinced that this was where his destiny lay, but now somewhat shocked by the knowledge that he could not be all and do all, he approached these avenues with considerably more caution than he had shown in recent years. He had become mortal and when the mortality of age overtakes the blind conceit of youth, both fear and wisdom are born. So, for the first time since leaving the rooftop in Venice, Jim Morrison was wise enough to be afraid. With this mental change Morrison's physical appearance began to change as well. He gave up his leather pants, gained weight, and allowed his beard to grow out. He no longer cared about his looks, rarely bathing and sometimes wearing the same clothes for weeks at a time. The break from touring had given him a chance to work on his other projects. He put in a good deal of time on film projects and self-published two books of his poems *The Lords: Notes on Vision* and *The New Creatures.* Both were privately circulated editions of one hundred (later published in one volume by Simon & Schuster). But he didn't

quit drinking. The voices that he drank to quiet were, if anything, stronger than they had ever been. "Jim was escaping from an inner anguish," Mirandi Babitz maintains. "The guy was in a lot of pain over something. It was dark around him. It didn't feel cheerful. He was often just too loaded to have much of a personality. Offstage he was like a puddle, but when he got onstage he came alive."

Poetry Sessions

In March, Morrison entered the studio to record some of his poems in the hope that Elektra would release an album of him reciting his poetry. He figured that, while many of his younger fans would have a hard time getting into a book, they might be able to appreciate poetry if they could listen to it on record. Morrison asked John Haeny, an engineer who helped build Elektra's studio, to record the sessions because he wanted to keep it simple with very little production. They recorded several poems at Elektra Studios one night including "Bird of Prey."

> *Bird of prey, Bird of prey*
> *flying high, flying high*
> *In the summer sky*
>
> *Bird of prey, Bird of prey*
> *flying high, flying high*
> *Gently pass on by*
>
> *Bird of prey, Bird of prey*
> *flying high, flying high*
> *Am I going to die*
>
> *Bird of prey, Bird of prey*
> *flying high, flying high*
> *Take me on your flight*

The plan was for Morrison to read his poetry dry and then add a few sound effects later. Some of the poems were sung a cappella while others were spoken very slowly and deliberately.

Winter Photography
our love's in jeopardy
Winter Photography
our love's in jeopardy
Sit up all night, talking smoking
Count the dead & wait for morning.

Frank Lisciandro describes Morrison's attitude toward poetry: "Jim published three books of his own poetry with his own money. He did it on his own without the help of anyone except perhaps Pamela. He didn't come to me or anyone else and ask what we thought. Not Jim. Jim was self-confident as a poet. He didn't even bother to go to publishers and try to get his poetry published. He would send them to newspapers and magazines and never ask for any compensation. His models were the poets who used to have their poems printed on broad sheets of paper—broadsheets, they were called. And they'd just give them away or sell them for like a penny a piece. There's a tradition of this kind of poetry—penny poems—and the poets couldn't live off of them, but their joy was the expression and to know that people were touched by them. That was Jim's joy too."

Whiskey, Mystics And Men

Well, I'll tell you a
story of whiskey and
mystics and men,

And about the
believers and how the
whole thing began

First there were
women and children
obeying the moon,

Then daylight brought
wisdom and fever and
sickness too soon.

Morrison Surrenders

The FBI was continuing to try to have Morrison extradited to Florida. While The Doors organization felt the extradition war-

rant was a technically illegal phony, they also knew that it was important that Jim not appear to run from it. On April 3, Morrison turned himself over to the FBI. Max Fink accompanied him to the FBI's downtown Los Angeles branch, where he was arrested on the federal warrant charging him with interstate flight to avoid prosecution for six charges of lewd behavior and public exposure. Morrison appeared before a United States commissioner and was released on a five-thousand-dollar corporate surety bond. Morrison's comment on being tried in Florida was simple and to the point: "They're gonna crucify me."

On April 29 the U.S. commissioner in Miami advised that the federal process against Morrison be dismissed and on May 1 Assistant U.S. Attorney Michael J. Osman declined prosecution and requested that the Federal complaint for interstate flight be dismissed. The flight to avoid prosecution had been a trumped-up charge in the first place, and now that Morrison was going to Florida for trial, it was no longer needed. In Miami the heat had by no means died down, however. Circuit court Judge Arthur E. Huttow, the head of the Greater Miami Crime Commission, asked the grand jury to undertake a full-scale investigation. He called the show "a conspiracy to corrupt the morals of our youth." Acting Miami police chief Paul Denham said, "It is our intent to serve these warrants on him . . . We'll extradite him to Miami from any place on earth. We'll bring him back here for his day in court."

Meanwhile, Jim and Pam were living in a rented house in the Beachwood Hills section of Hollywood. All these pressures naturally affected their relationship and Morrison's drinking was now so pronounced that their sex life was seriously impeded. One morning after Jim was again unable to make love, Pam took her lipstick and wrote "Some sex symbol—can't even get it up!" on the bathroom mirror. But the bottom line is that Pam and Jim were used to difficulties. There was already so much chaos in their lives that the aftermath of Miami was not about to split them apart. About a month after the incident, though, Pam's curiosity finally got the best of her and she asked Morrison if he had exposed himself or not. Reportedly, he gave her one of his best little boy looks and nodded yes. When she asked why, he broke into a wide grin and replied, "Honey, I just wanted to see how it looked in the spotlight."

HWY

The time off created by Miami allowed Morrison to work on another film project. *HWY,* named after the road symbol for a highway, not only starred Morrison but was written, directed, and produced by him as well. Frank Lisciandro describes it: "The original scenario was where this hitchhiker called the Kid came out of a wilderness area and roamed around the country with a band of hobos. On his way to the city he kills a cop and possibly several others. Then he's hunted down and put away. At that point the film was to go into a sort of dreamlike sequence in which the Kid is executed for murder and then reunited around a campfire with the same people he was with at the beginning. Then you realize that the beginning of the film was also a rebirth, so you have this archetypal character, maybe Jesse James, maybe Billy the Kid, maybe Jack the Ripper, who comes back every lifetime and, because he's headed that way by fate, goes through the same ritual every time. The other characters were named Doc and Clown Boy and they were probably all three aspects of Jim. He saw himself sometimes as a clown, sometimes as kind of a wise, older guy that was Doc, and sometimes as the Kid."

> *The hitchhiker stood by the side of the road*
> *& levelled his thumb in the*
> *calm calculus of reason*

Just after Easter the same crew that had filmed *Feast of Friends* got together to do *HWY.* Duties were shared on a need basis but for the most part Paul Ferrara did the camera work, Babe Hill did the sound, and Frank Lisciandro edited. As was typical with most Morrison projects, the film was shot with the emphasis on spontaneous creation. Lisciandro elaborates: "We went to the desert to film, but we didn't know exactly what yet. We shot for three or four days there and two days in town, but we didn't get to film everything to complete Jim's scenario. Jim decided to use what we had as sort of a calling card to go and raise money for the rest of it. So we put it together in sort of a linear fashion—the guy comes out of the mountains and goes to the city and we were satisfied with that."

The piece is more of a film-poem than a film. Shot in 35-mm, the fifty-minute movie contains many evocative images of man in relation to nature and himself, but the only element left of the original scenario is the hitchhiker. The bearded Morrison is first shown swimming in the wilderness amid an assortment of nature symbols—a waterfall, the moon, the sky. Later, he begins hitch-hiking into the city. As he waits on the road, Morrison pulls at an imaginary gun at his side or like a bullfighter waves his leather jacket at the passing cars. In one scene he climbs out of a dirt-encrusted abandoned car off the side of the highway and then suddenly leaps upon the hood and smashes in the front wind-shield with the heel of his boot.

Finally, someone in a Shelby Mustang (no doubt Morrison's own) stops and gives the hitchhiker a ride. We never see the person or what happens, but mayhem is presumed because in the next scene the hitchhiker is driving the car alone. On the road he comes upon a group of children singing and dancing and joins them. Later, he hot-rods the Shelby around and around in a cir-cle, kicking up waves of sand and dust. Of the desert scenes, the most interesting is when the hitchhiker stops to watch an injured coyote on the highway because it parallels the highway incident in Morrison's childhood. While the coyote, a symbol of the wild and primitive, lies struggling and presumably dying on the road, a domestic dog watches from the safety of a nearby parked car. The dog suddenly becomes desperately still for an instant and then bolts and tries to hide under the seat. The scene conjures up the dying Indians on the roadside being watched by the young Jim Morrison from his parents' car as he first feels the shaman's presence in his life.

After getting some gas and becoming fascinated by a ca-rousel rack of pornographic paperbacks, the hitchhiker moves on, traveling past impoverished barrios littered with trash and graffiti. As night falls, he spreads a map upon the ground and passes over it with a divining rod. He eventually arrives in the city, where he enters a cheap hotel room and urinates. After stopping in a bar for a brief moment the hitchhiker makes a strange telephone call, nonchalantly describing how he was hitchhiking out on the desert and killed one of the drivers who picked him up. Later he walks on the roof of a building and surveys the city (for this shot Frank Lisciandro watched a tipsy

Morrison tightrope walk a fifteen-inch-wide ledge atop the roof of the towering 9000 Building on Sunset—"We used to call him the Human Fly," Kathy Lisciandro said. The film stops rather than ends shortly thereafter and leaves one with the feeling that things have never really started, much less gotten anywhere.

While *HWY* does have some powerful images there is virtually no dialogue, and like most art films of the period, the scenes are laboriously slow, focusing on minute detail rather than plot. One city sequence that lasts several minutes shows a busy intersection as it churns on from dawn to day to dusk to night via time-action photography. It is easy to imagine Morrison and the others, caught up in the joys of filmmaking, abandoning traditional storytelling values in favor of a less structured form. The film's sound track is interesting, especially the passages that sound like chants and cries of tribal Indians and a couple of haunting folk songs sung by Georgia Ferrara.

HWY was to be a stepping-stone to a full-length feature film. "This was a demo," Lisciandro continues. "Jim felt that if there was an audience for it a distributor with money should commit to finishing it. As it was he ended up spending close to forty thousand dollars. Even then film was not a cheap medium to work in."

Morrison had this to say about the film: "It's more poetic, more of an exercise for me, kind of a warm-up. Essentially there's no plot, no story in the traditional sense . . . A person played by me comes down out of the mountains and hitchhikes his way through the desert. We don't see it, but we later assume that he stole a car and he drives into the city and it just ends there. He checks into a motel and he goes out to a nightclub or something. It just kind of ends like that . . . and when the music's over, turn off the lights . . . It's a very beautiful film."

The finished project may seem dated and arty, but while countless other rock stars talked about making fiction-based feature films in the 1960s, Morrison is one of the only ones who actually did anything about it. Since he has virtually no lines, we can tell little about Morrison's acting ability from *HWY*, but he does have a strong screen presence, and even in its somewhat unfinished state, *HWY* was enthusiastically received at both the Vancouver Film Festival and the "Jim Morrison Film Festival" in Toronto.

Recording *The Soft Parade*

Morrison never relished the studio. The first two albums were fun, but they required The Doors to be in the studio for only a few weeks. By *Waiting For The Sun* The Doors were in and out of the studio for six long months. *The Soft Parade* was even worse. They had begun the recording in November 1968 and they were still at it in May 1969. It would be July before they were finished. The sessions at Elektra Sound Recorders were riddled with personal problems and disagreements and it was made more difficult by the outside circumstances. The cooped-up feeling that being in the studio gave Morrison had been relieved on *Waiting For The Sun* by gigging between sessions, but after Miami there were no gigs. The ban was also creating great financial pressure making completing the album even more important. As usual, pressure only made Morrison's problem worse. "It was like pulling teeth to get Jim into it," Paul Rothchild recalls. "It was bizarre . . . it was the hardest I ever worked as a producer. It was nearly impossible to get Jim to sing well and have the band play well on a whole take. It was *hell.* By this time, they'd run out of all their material and what they came in with was raw, very green stuff. As the talent fades the producer *has* to become more active."

Like a makeup artist for an aging beauty queen, Rothchild tried to cover the flaws with production—horns, strings, trimmings, and trappings. Morrison's lack of involvement was a critical flaw for The Doors. With the legal turmoil continuing and the blow that Miami had dealt his public and self images, Morrison's mind was clearly on other things during the making of the record. His creative energy was pulling away from the rock medium which had stung him so badly and redirecting itself into poetry and films. "I think he was trying to show the band that they weren't shit without him," Rothchild told Blair Jackson in *Bam*: "Ninety percent of the time when he was drunk, he was impossible to deal with. The other ten percent he transcended himself and was totally brilliant. The ten percent is on his records. The other ninety percent is total garbage. Off-key singing. Mushmouth. Bratty stuff. Fooling around. It's not great stuff. It stinks. You can't put out an album of Doors' outtakes because they're embarrassing."

Manzarek, Krieger, and Densmore were irrevocably bonded

to a guiding force who could no longer even be counted on for any creative inspiration, much less any real direction. Only a few scant months before, they had been the number one group in America and now they found themselves at both a creative and popular low. In desperation they turned more to the confident voice of Paul Rothchild: "I was always encouraging them to expand musically, and Ray and Robby were always interested in expanding the band's instrumental concept."

The result was that *The Soft Parade* was a striking departure from its three predecessors. If longtime fans thought part of *Waiting For The Sun* didn't sound like The Doors, they would be dumbstruck by *The Soft Parade*. Ray Manzarek recalls how the idea began: "We'd always talked about using some jazz musicians—let's put some horns and strings on, man, let's see what it would be like to record with a string section and a big horn section."

For the first time Morrison and Krieger shared the writing equally, each writing four songs on the album and collaborating on one. But unlike Krieger's efforts on previous albums these new songs were clearly separate from those of Jim Morrison. None of Morrison's songs had strings, horns, or orchestral arrangements, while all of Robby's did. But if Morrison protested the arrangements, he was too caught up in his own problems to fight against them. His comments about *The Soft Parade* sound more defensive than anything else. "One thing about the fourth album that I am very proud of," Morrison said later, "is that 'Touch Me,' which was also a single, was the first rock hit to have a jazz solo in it, by Curtis Amy on tenor saxophone. I guess 'Tell All The People' was a dumb song, but everyone wanted me to do it, so I did."

In May, "Tell All The People" was the third single released from the forthcoming album. While Morrison was unmoved by "Touch Me," he hated "Tell All The People." It was the exact kind of overtly idealistic political-rock-god-mush that he always feared the press would saddle him with. At first during the sessions Morrison refused to sing the line *can't you see me growing, get your guns.* "I'm not singing those lines," he told the others. "That's not where I'm at." Although he relented and sang the song, he felt so strongly about it that he insisted on separate writing credits for the album and *The Soft Parade* was the first Doors album to list the individual writers of each song.

The Atlanta Film Festival

In May, the Atlanta International Film Festival awarded *Feast of Friends* first prize in the documentary division and invited Jim and Frank Lisciandro to the ceremonies. Morrison couldn't wait to go. It was an opportunity to escape L.A. for a few days and the drudgery of waiting on the court procedure. Frank Lisciandro remembers: "*Feast of Friends* was accepted in five major film festivals including Atlanta and San Francisco. In fact it was accepted at virtually every festival we submitted it to. It vindicated Jim's decision to continue making the film."

The finished documentary was a forty-minute montage of a rock 'n' roll band's travels across the country. Shot in color with some black-and-white footage, the film doesn't have an overall theme or direction. There is footage of The Doors on a monorail with a voice-over bemoaning executions in Vietnam, a senseless conversation with someone claiming to be a "minister-at-large," a strangely humorous backstage dialogue between Morrison and a girl who was hit in the head with a chair, a somewhat self-conscious but enjoyable sequence with Morrison banging on the piano and singing about Nietzsche's horse, and shots of The Doors on a peaceful sailboat. Not surprisingly, it is the concert footage that stands out. The riot scenes at Cleveland and at the Singer Bowl in New York are exciting to watch. Many rock music documentaries have shown the grabbing hands and fanatical faces that stalk the superstar, but few have captured what actually takes place during a concert riot. There are several prerecorded songs in the film including "Strange Days," "Wild Child," "Moonlight Drive," "Five To One," "Not To Touch The Earth," and a live fourteen-minute rendition of "The End" from the Hollywood Bowl. The credits list photography and design by Paul Ferrara, sound by Babe Hill, editing by Frank Lisciandro, and The Doors as the producers.

The riot footage is particularly interesting. At the Singer Bowl the screen shows Morrison lying on the stage, undulating snakelike and singing while several policemen protect him from charging fans. The cops stand on the stage in a loose semicircle acting as a bulky barrier against the crowd. As if in a trance, Morrison keeps writhing and singing as the fans rush the stage with incredible persistence. The shocking immediacy of the hand camera combines with the eerie neon green lighting to create a de-

ranged feeling and a bizarre scene. At another concert, the film
again captures Morrison's movements and incendiary lyrics mov-
ing an audience to frenzy. There, police and security guards ring
the edge of the stage as Morrison tries desperately to squeeze
through to the crowd. The people in the audience hurl them-
selves at the phalanx of police—grabbing at the microphone
cord, scrambling under cops' legs, trying to catapult over them.
Each time the guards pick the kids up and bodily heave them
back into the crowd. Eventually, the show is stopped and Mor-
rison is led away. During it all, cameraman Ferrara stays near
Morrison, giving the footage something of his point of view.

Films have an illusion of timelessness fostered
by their regular, indomitable appearance

The film's strong point is the vibrant urgency that occasion-
ally arises from the juxtaposition of a typical sixties pop group-
film sequence (the monorail for example) with the reality of
hard-edged documentary (the Singer Bowl riot). Technically,
Feast lacks much. It was edited from over ten hours of footage
and one expects more. Shot mostly with one camera, the action
in the riot scene is very difficult to follow since it is only seen
from one angle and perspective. The sound is inconsistent and
much of the music is taken from Doors album tracks which un-
dermines the live feel of the riot footage. Morrison said the film
was an attempt to capture some of what the band encountered in
their travels, and in an impressionistic fashion, this was accom-
plished.

The technical deficiencies made *Feast of Friends* unsuitable
for television or wide-scale distribution. The group was planning
on releasing the film on the art house circuit (it premiered at the
Cinematheque 16 on Sunset Strip), but after their business ad-
visers cautioned that the riot footage could hurt the band's
chances for getting off the concert hall blacklist, they decided to
restrict the showing to film festivals.

The important thing to Morrison, though, was that the film
was accepted and the recognition by the Atlanta Film Festival
proved that it was. Jim and Frank arrived in Atlanta the day be-
fore the awards ceremonies and wandered through the hippie
section to see what was happening. Someone invited them to a

"rent" party in a nearby old Victorian home (rent parties, for the uninitiated, were designed to raise emergency funds to keep the landlord at bay and have a good time in the process). According to Lisciandro, Morrison was "open, approachable, funny, and friendly" at the party. "He threw a twenty-dollar bill in the collection for a beer run and even offered to help carry the booze back to the house. He helped out in the kitchen preparing snacks, picked out albums, changed records, passed out beers, and listened to complaints about cops, school, and parents. He did not offer advice, but he shared his own similar experiences. His presence at the party, and especially his no-bullshit lack of pretensions, conveyed a total equality. It was like he was one of them and his fame was theirs to share, because he spoke for them."

At the next night's banquet, the two California filmmakers relished being obvious exceptions at the black-tie affair and proceeded almost immediately to get drunk. As the evening progressed Morrison tried to get Lisciandro to agree to walk up and accept the award because he was too drunk. Lisciandro agreed, figuring that he was less likely to cause a scene than Morrison, but when the time came to accept the award, Frank discovered he was simply too drunk to stand. Realizing he had no choice, Morrison rose and walked up to the dais where an excitingly beautiful-looking girl handed him a gaudy black-and-silver plaque. Jim smiled and gave her his room key. He came back to the table carrying the plaque with a wide grin on his face.

Before returning to Los Angeles, Frank and Jim, determined to have a road adventure, rented a car and drove to New Orleans. Morrison managed to remain unrecognized until he sat in with a local rock band. Although no one knew who the bearded Morrison was when he took the stage, as soon as the first notes rang out, the crowd began murmuring, "Morrison, Morrison." It was time to return to L.A.

The NET-TV Special

Also in May, The Doors taped a program for the National Educational Television network in New York. By now Morrison, with his full beard, looked more like Che Guevera than a rock star and to complete the effect he sported a cigar and sunglasses

for his appearance on "Critique." The taping consisted of thirty-five minutes of music and a ten-minute interview conducted by Richard Goldstein, a longtime Doors fan and one of the most articulate critics in rock at the time. Later, a panel of critics was added to the program with Goldstein, Al Aronowitz, Rosko (Bill Mercer), and Patricia Kennealy engaging in a fifteen-minute discussion of The Doors' music. For the interview, Morrison's mood was relaxed and assured. He was asked how it felt to be the Father of the Decency Movement and replied, "Feels good to be the father of anything, I guess." It was his first interview since Miami and on the advice of his attorney he refused to discuss his legal adventures. "I just can't talk about it at all. Three or four years of my life are at stake."

The Doors had wanted to perform on educational television for a long time because it was much less concerned with censorship and commerciality than network television. "Here the group has complete freedom to play whatever they want," Morrison stressed. "There are no guest stars, no patter, and no dancing girls—just serious talk and serious music presented in an appropriate, professional, and respectful manner."

The highlight of the special was The Doors' performing songs from *The Soft Parade* with just their instruments and no horns or strings. They did "Tell All The People," a medley combination of "Alabama Song" and "Back Door Man," "Wishful Sinful," and "Build Me A Woman" before breaking for the interview. In the beginning of "Build Me A Woman" Jim sang "Sunday trucker, Christian motherfucker" and though he slurred over it, the word was clear enough to be understood. After the interview, The Doors performed *The Soft Parade.* When Morrison came to the "best part of the trip" section the lights were dimmed and the silhouette of Jim and the band working their hardest and yet casting only a shadow of their former selves was a perfect image for The Doors's difficult summer of 1969.

"Rock Is Dead"

Back in L.A. Morrison broke his silence about Miami, hinting at how he felt about it to Hollywood columnist Joyce Haber, "Six guys and girls are naked every night in *Hair* and nobody calls the cops. My audience expects me to do something freaky. If I'd been in L.A. or New York, nothing would have happened."

With the album sessions nearing completion The Doors's spirits began to rise. One evening, after dinner and a few drinks, they began a long improvisational jam. The track soon evolved into the beginnings of an epic song that is now referred to as "Rock Is Dead." But it was never finished and outside of a bootleg recording of the jam, it was never released. Morrison recalled the jam in one of his interviews: "We needed another song for this album. We were racking our brains . . . We were in the studio and so we started throwing out all these old songs. Blues trips. Rock classics. Finally we just started playing and we played for about an hour, and we went through the whole history of rock music—starting with blues, going through rock 'n' roll, surf music, Latin, the whole thing. I call it 'Rock Is Dead.'"

Although twenty-one minutes of the jam was captured on tape, the best part was never recorded. Ray Manzarek elaborated to Paul Laurence in *Audio*: "'Rock Is Dead' doesn't really exist in a form worth putting out. When we recorded it, it was just a bunch of drunks fooling around and jamming in the studio and then we started to get into something. Unfortunately, the tape ran out halfway through and by the time they got it back on five minutes had elapsed and we were right in the middle of doing surf music. We went into the control room and said, 'Gee, that was really great, hope you guys got that down on tape.' And they said, 'Well, we got all of it down, except we missed some of the last "Rock Is Dead."'" And I said, 'That was the only thing that was any good.' And we missed it. It was parodies on various styles of music and I don't even remember what was left out."

Most of the jam consisted of stock blues phrases with Morrison ad-libbing a steady stream of lines, some of which worked and some of which didn't.

When I was a just little boy about the age of five
I went to sleep, I heard my mama and papa talking
She said we gotta stop that boy
Getting too far out
He's going wild, we got to stop that child

Let me tell you baby about the death of rock
I used to be a boy in my home a lot
Used to be alone and I heard some news
Bunch of cats got the rockin' news
You know I love my rock and roll people

As long as I got breath
The death of rock is the death of me
And rock . . . is . . . dead

Morrison once described the content of the song as follows: "I was saying . . . the initial flash is over. What used to be called rock 'n' roll . . . got decadent. And then there was a rock revival sparked by the English. That went very far. It was articulate. Then it became self-conscious, which I think is the death of any movement. It became . . . involuted and kind of incestuous. The energy is gone. There is no longer a belief."

The lines and Morrison's interpretation of them reflect the growing disinterest he was experiencing with the music scene. At the end of May, he joined a group of friends for a night of poetry reading at the Cinematheque Theatre to raise funds for Norman Mailer's campaign for mayor of New York. "He said Mailer wanted to turn New York into another country," Michael Ford remembers. "Jim loved that kind of buffoonery. He asked me to read and I agreed. I remember we all sat on barstools. It was Jim, Tom Baker, Seymour Cassel, Mary Waronov, Ultra Violet, Jamie Sanchez, Jack Hirschmann (who subbed for Michael McClure), and myself. And Robby Krieger was there noodling notes while we read."

Ford says this was only one of many examples of Morrison's giving of time and money to help people: "Jim did a lot of things like that which no one knows about. He contributed money to American Indian funds. He helped out his friends. I think he really wanted to help people, but he was so beleaguered by pressures it was difficult for him to do much on a large scale. A lot of it was just real sad. He couldn't really do what he wanted, whether it was something humanitarian or creative. He couldn't move without bumping into a wall of subterfuge and misinterpretation. Jim couldn't deal with obstacles with patience. He either dealt with them heroically or he gave up and it was around the time of the poetry reading that I sensed he was giving up a lot more."

Though it was now summer the ban on The Doors was still going on. The St. Louis city council refused to allow them to perform there in a show that had been planned for June 13 and substituted a decency rally instead, but only fifteen hundred peo-

ple showed up. The hard truth was that most concert promoters wouldn't touch The Doors—they were simply too risky. Fortunately, Rich Linnell's firm, West Coast Promotions, became involved. "We began lobbying the various hall manager associations," Linnell recalls. "We started keeping what we called the clean file, which was a record of very clean shows and good reviews. We had good relations with a number of halls, so we began talking to these hall managers and trying to figure how we could get around this. A lot of places didn't care. They didn't want The Doors no matter what. Others were more negotiable given some assurances."

It was not an easy task. The company had to post a ten-thousand-dollar bond to enable the group to play in a union hall and another five-thousand-dollar bond redeemable only if the show passed the moral scrutiny of the promoters, the city fathers, and other recognized pillars of public decency. This later requirement came to be known as the "fuck clause" since that was one of the prime words it was designed to guard against. Linnell describes Morrison's reaction: "Jim was very annoyed by it. On some dates we had clauses where we would be fined so much for each 'fuck.' I remember my partner at the time saying, 'Jim, just remember it's a thousand dollars a letter.' Then he reminded Jim again just before The Doors went onstage and Jim got very upset that the guy thought he had to remind him again. It was like 'Give me a break, I heard you the first time.' Jim was not stupid and he did care about those kind of things. He was probably so aware of it that my partner didn't even need to mention it once."

The bottom line was that Morrison's stage performance was now under close examination by the very people he most resented. The results of his strange rebellion against his image had led to the thing he always feared the most: His art was now in a sense being controlled by the Establishment—people not unlike his parents were evaluating his performances and in a very real sense deciding how his life was lived.

Magic in Chicago

It wasn't long before The Doors got word that they would be playing Chicago on June 14 with dates in Minneapolis and

Mexico City to follow. The long drought was finally over. The band performed two sold-out shows at the Auditorium Theatre in Chicago. It had been three and a half months since their last performance and they were excited to be back onstage. The hall held only three thousand people and the show brought out people from all walks of life. There were many longtime fans present, out to show their support when the group needed it most, and there was also the society set—minks in June. This was a happening of the highest order.

The radio ads said, "The Doors will begin where they left off in Miami," but Chicago was nothing like Miami. The Doors were out to prove to the audience and to themselves that they were back. This was more than a concert and more than an event like Miami, this one was magic.

> *resident mockery*
> *give us an hour for magic*

Before the first show, the feeling in the concert hall was one of tension and anticipation. Waiting for The Doors was not like waiting for any other rock group. What would happen? What would Morrison do? The Staple Singers were the opening act and they put on a good show, but the anxiety carried right through their set. Then it was time for The Doors. Behind the curtain, roadies began arranging the familiar set. Manzarek's organ, Densmore's drums, and Krieger's amplifiers gradually took shape on the stage. Last, a lone mike was positioned, that thin steel instrument of torture standing alone in the midst of it all. Then the sounds of the roadies stopped and all was quiet. There was electricity in the air. When would the curtain rise? The suspense had become almost unbearable. Finally, the curtain rose, the auditorium was immersed in the sound of The Doors, and at center stage was the personification of all they stood for—Jim Morrison.

The reaction was half gasp and half applause as the crowd recognized the intro to "When The Music's Over." There was Manzarek hunched over his organ/bass, eyes closed, head swaying from side to side, wearing a black suit and looking like some sort of hip undertaker. Krieger was lurking insidiously in the wings in a blue shirt and bell-bottoms. Densmore was on a small platform wearing all white. And there was Morrison dressed all in

brown and sporting a full beard to go with his long thick hair. His head was leaning to one side and there was a cigarette in his hand. As the music pounded he turned slowly and walked back to Densmore's platform, set down the cigarette, and just stood there. The Doors were prolonging the introduction and the tension built to a new high. Then, suddenly, Morrison ran full speed to the front of the stage and attacked the mike letting out a great s-c-r-e-a-m! It was an agonizing scream of terror that roared through the sound system. Morrison screamed that night in Chicago as only he could—without restrictions, without fear of damaged vocal chords, without any thought whatsoever except the release of the tension from three and a half of the hardest months in his life.

The crowd was spellbound. They had been on the edges of their seats and that scream shot right through them. Some people near the front shrieked in surprise. Morrison came down from the scream and collapsed on the mike hanging on for dear life, but the thrust continued as Robby Krieger sent a huge wail of electronic terror soaring through the hall. The vast swell of sound receded like a wave that had crashed against the rocks and was now rolling back out to sea. Morrison raised his head, cupping the mike between his hands to sing: *When the music's over . . . turn out the lights . . .*

In the middle of the song he leaned into the mike: "We want the world and we want it . . ." The audience waited, knowing it was coming. Morrison waited, letting it build. Then he spoke, "Now . . . Now! . . . N-O-W! As he screamed, the amplifiers behind Manzarek and Krieger came alive again with a huge, ominous drone of raw power. Morrison folded under the blast and the crowd reeled back in their seats as the great surge wrapped around and penetrated through everything. Then, slowly, the wave subsided again and the auditorium became quiet. Morrison was a picture of brooding tranquility as he eased up to the microphone and gently sang the final passage: *Music is your only friend . . . until the end.*

Over eleven minutes had passed in an instant. How do you follow something like that? But they did, with "My Eyes Have Seen You" and "Back Door Man." Morrison was enveloped in the sound, trapped between the power of the amplifiers behind him and the applause of the crowd in front of him. Then the band

launched into songs from the new album: "Tell All The People," "Touch Me," and even "The Soft Parade." How much better they sounded without the strings and horns. This was The Doors' sound. Another moment and it was over and The Doors were gone. But then the MC came out and said something about a Doors concert not being complete without "Light My Fire." The crowd cheered. The Doors came back onstage and performed "Light My Fire." During the instrumental break, Morrison disappeared behind a bank of amplifiers, leaving the spotlight to Manzarek, Krieger, and Densmore. He returned and finished the song to heavy applause. As they left the stage, Morrison flashed the peace sign to the crowd and said, "Be good."

The audience went wild, giving them a standing ovation and shouting for more. To everyone's surprise the band walked back on stage and Morrison said into the microphone, "We're going to show you how the blues are played." With mike in hand he walked over to Manzarek and said, "Play some blues for me, Ray." Manzarek cut loose and the crowd cheered. Then Morrison went to Krieger. "Say a few things to the audience, Robby." Krieger replied, "I'll let my guitar do the talking," and an incredible passage came searing off his guitar. Then Morrison sang, "I'm only twenty-five, but I'm an old blues man . . ." And so it went. The Doors departed to another huge ovation. When it was over you felt a sense of suspension as though you were floating, not walking out of the auditorium—and an eerie feeling that you had just experienced something very special that might never happen again. That night when you tried to sleep, the echoes of the amplifiers were still ringing in your head. The music is never over.

Despite the success of Chicago, the Establishment was still extremely wary of The Doors. In Hawaii, the Director of Auditoriums of Honolulu led a group that canceled two concerts there. The events had been planned for July 4 and 5 and were never rescheduled. The Doors' image also caused them problems with a proposed date in Mexico. They were originally going to appear in Mexico City's largest bullring, The Plaza Monumental, on June 28, but that show was canceled by city officials when they discovered the date was the first anniversary of the 1968 student revolt in that city. The mayor and others feared that the kind of crowd who would turn out to see The Doors might provide an easy catalyst for dissenters to touch off a demonstration

commemorating the anniversary of the student uprising. The Doors were disappointed. They had been excited about the concert because it would have been the first rock concert ever staged in the forty-eight-thousand-seat amphitheater. Because they felt that the prestige and aesthetic value of the show were more important than the money, the band had even scaled down the ticket prices to between forty cents and a dollar in order not to exclude the poor.

After the cancellation, the event was rescheduled for the end of July and the promoters made attempts to obtain permits for the group to perform at the Mexican arena, the National Auditorium, and even, in a high-security performance, for the students at Mexico's National University, but permission was denied for all these venues. Finally, in desperation, the promoters kept to the first date, but switched the location and nature of the show at the last minute. The Doors and especially Jim Morrison had been looking forward to the gig as a welcome escape from the oppressive atmosphere surrounding them in America, but when they arrived in Mexico City they discovered they had been confined to performing a four-night engagement at the Forum Club (June 28, 29, 30, and July 1), a one-thousand-seat supper club. This was bad enough, but the price had been raised to two hundred pesos (sixteen dollars) which only a select crowd of Mexico's young rich could afford. The Doors were informed of these changes at the last minute and they were furious. But, gigs being somewhat of a rarity, they chose to play even though they were only getting five thousand dollars per night.

The show at the Forum Club turned out very well and the audience response was very enthusiastic. *"Buenas noches, señores y señoritas,"* Morrison greeted the crowd, and then introduced the band as Ramón Manzarek, Juan Densmore, and Roberto Krieger. The audience roared. But while the Mexican youth relished the band, the local press and city officials were somewhat critical and guarded. The newspaper called the group "hippies" and referred to them as "undesirables" and they were denied accommodations in several of the large hotels, ending up staying in a smaller, private hotel in one of the residential sections. The promoters originally hoped the concert would open Mexico for future shows by top American rock groups, but choosing The Doors was probably not in their best interests.

It was around this time that *Easy Rider* was released. Starring Peter Fonda and Dennis Hopper, the story of two longhairs on a cross-country search for personal freedom was the kind of statement that Morrison wanted to make. Heading down that great symbol of adventure, The Road, they meet a boozing civil liberties lawyer played by Jack Nicholson in the role that made him a star. As wistful George Hanson, Nicholson laments: "This used to be a hell of a country. I wonder what happened." *Easy Rider* portrayed an America that was at odds with itself and planted the seeds of tolerance and acceptance for the youth of the era by painting an extreme picture of prejudice and rejection.

Jim Morrison's Tribute to Brian Jones

On July 3, Rolling Stones guitarist Brian Jones was found drowned in his swimming pool. The news so saddened Morrison that he wrote a poem entitled, "Ode to L.A. While Thinking of Brian Jones, Deceased." Morrison published the poem at his own expense, and when The Doors played the Aquarius Theater in L.A. at the end of July, he distributed copies to the audience. Many of those lucky enough to receive a copy of the seventy-three-line poem were astounded by the elegant words Jim used to commemorate Jones's passing. The irony of the poem is undeniable especially when you consider that Jim Morrison would also be found dead in water two years to the day later.

> *The angel man*
> *w/Serpents competing*
> *for his palms*
> *& fingers*
> *Finally claimed*
> *This benevolent*
> *Soul*

On July 20 the lunar module *Eagle* landed on the moon's surface and astronauts Neil Armstrong and Buzz Aldrin began a two-and-a-quarter-hour moonwalk. As he stepped down from the ladder onto the moon's surface, Armstrong said, "That's one small step for man, one giant leap for mankind."

The Aquarius Theater Shows

The two shows at the Aquarius were significant because they were the first hometown concerts in months and were being recorded for inclusion on a live album Elektra wanted to release by the end of the year. The label was pushing hard for the live LP to help offset the huge budget of *The Soft Parade*. Originally the recording was to have been done at the Whisky a Go Go from May 19 to 22, completing a cycle for The Doors that began on the Strip only three years before. At the Aquarius, the musical *Hair* was playing, but Elektra had reserved the theater for four weeks on the dark night (Mondays) in order to showcase some of their acts. Tickets for both Doors shows had been sold out for weeks and on July 21, the hip L.A. fans turned up to see just what it was that had made those Miami kids lose their cool.

It was during the sound check for these shows that The Doors did "Gloria" which fortunately was not only recorded, but preserved for later release on *Alive She Cried*. It was yet another Jim Morrison who climbed on the stage that night at the Aquarius. With his full beard, slight paunch, tinted glasses, and no leathers, he looked more like a rabbinical student than the Sex God of Rock. Those who arrived early were surprised to find Morrison calmly sitting on a stool at center stage as he finished the sound check and this laid-back attitude prevailed through most of the show. That night Morrison sang better than many people thought he could. He sang with a sensual intensity and deliberate phrasing that made for an extremely powerful delivery. The truth was that Morrison projected more real sexual allure this way than he ever had with preplanned writhing and groaning.

This is not to say that the two ninety-minute sets did not contain some theatrical excitement—one time Morrison left the stage for a few minutes and then suddenly appeared bathed in blue light, high above the audience, teetering atop a scaffold from the *Hair* set. As the crowd strained their necks to see him, he snarled out "The Celebration of the Lizard." When finished, he grabbed a nearby rope and swung out over the crowd and the amplifiers like Zorro, completing the maneuver with a perfect double kick that placed him square in the center of the stage. The audience reaction was overwhelming at the shows. The crowd seemed to sense that Morrison was trying something dif-

ferent and they were with him. Rothchild taped the entire con-
cert and later selected "The Celebration of the Lizard" and "Soul
Kitchen," which was the encore, to be included on *Absolutely
Live.*

Morrison had made a reverse fashion statement with the
heavy beard, white sport shirt, and loose, carpenterlike pants. By
getting rid of all the old symbols, he hoped to prove he was more
than a rock star sex symbol, more than a black leather madman,
and much more than a Miami incident. Morrison had resolved to
show the world that he was an artist first and foremost even if he
did slip into madness now and then from the booze. At the
Aquarius he took a major step toward accomplishing that goal.

After playing the Cow Palace in San Francisco on the twenty-
fifth, The Doors played the Seattle Pop Festival on July 27 and
Morrison proved that, if he had learned a lesson from Miami, he
was still having a hard time putting it into practice. Besides The
Doors, the three-day festival featured Led Zeppelin, Santana, Va-
nilla Fudge, Ike and Tina Turner, Chuck Berry, and several others.
The Black Panthers provided the security for forty thousand peo-
ple and only a chicken-wire fence separated Morrison from a host
of screaming teenyboppers. Jim had been drinking and the kids
were at their worst, banging on garbage cans and empty wine
bottles and chanting, "We want Morrison, We want The Doors!"
The band opened with "When The Music's Over" and when it
ended someone in the crowd tossed a crumpled paper cup at
Morrison. Angered, Jim flashed the finger at the audience and that
made things worse. The kids loved it when Morrison lost his cool
and for the rest of the set he abused, insulted, and ridiculed
them. At one point a young man smarted off Morrison, called him
a big-mouthed bastard, and he dared him to repeat it. "Get it all
out. All the little hatreds, everything that's boiled up inside you.
Let me have it."

"Fuck you," the crowd screamed back. "That's the word I
wanted to hear," Morrison said. "That's the very little word." The
Doors played mediocre versions of "Light My Fire" and "Five To
One," and during the latter number, Morrison grabbed a maraca
and pretended to beat off, triggering nightmare visions of Miami
to the other members of the band. Then he hugged Krieger and
made faces at the teenage girls. Finally, after more disconnected
rambling, Jim sputtered his way through "The End" and finished

the show with a crucifixion pose. But the crowd didn't think he was funny anymore. This full-bearded, slightly overweight man was not the Jim Morrison the young chicks had come to see. Even the security people could tell the times had changed for The Doors. The tension on the fence was relaxed. There was no worry that the teenyboppers would try to rush the stage. They didn't care that much.

Being drunk is a good disguise

The *Rolling Stone* Interview

That same month, Morrison was interviewed by *Rolling Stone.* Today this interview still stands as one of the most articulate ever given by a rock star. Morrison couldn't talk about Miami because of legal reasons, but he discussed many other topics including the history of The Doors', his theories on film, politics, morality, and drinking, and admitted his parents weren't dead. Published in the July 26 issue, the eight-thousand-word interview closed with a long and untitled poem of Morrison's which later came to be known as "An American Prayer." Undoubtedly, what gave Jim the most pleasure from the article was the credit that used the name he preferred for his poetry, James Douglas Morrison.

Originally, Morrison had been reluctant to be interviewed by *Rolling Stone* since he was most wounded by their coverage of the Miami concert and its aftermath, feeling they had made him seem a clown. Eventually, though, he changed his mind and met with writer Jerry Hopkins several times in just over a week.

Bill Siddons had been quoted at the time as saying, "Jim used to have a lot of little demons inside him . . . but I don't think he has so many anymore," and the interview seemed to agree with this. Morrison had mellowed somewhat, even matured. Perhaps Miami knocked the wind out of him. He wanted to be taken seriously, but like most poets, his life-style had often made that very difficult. This too was evident in the interview. The first session began in The Doors' office but wound up at one of Morrison's local drinking spots called the Palms. After another session, Morrison talked Hopkins into having a few drinks at a topless joint where Jim was

also a regular. They talked as Morrison drank boilermakers and watched young girls bump and grind to "Hello, I Love You" and "Love Me Two Times." For Hopkins it was a bizarre scene that should have been captioned, "What's wrong with this picture?" but for Jim Morrison it was a rather mellow day.

The Soft Parade

Although many of the magazines were speaking favorably of The Doors again, among the hipper critics it had become fashionable to knock the band by the time *The Soft Parade* was released in July. To them, Morrison's flights of mystery, mysticism, and imagination had deteriorated into childish pranks. While Richard Goldstein still described Morrison's lyrics as "literate, concise and terrifying," Jon Landau now saw them as "cast in the mold of poetry, but really only posturizing and attitudinizing."

Morrison's credibility as a poet/singer/songwriter was on the line with *The Soft Parade*. The depth of the band, once a foregone conclusion, was now suspect. The Doors became "the band you love to hate." There was no question that some of this abuse bothered Morrison. Once when Ellen Sander had referred to him as "Mickey Mouse de Sade" in *The Saturday Review,* Morrison cornered her at a press party and made her sing for him. In the early days, *Los Angeles Times* critic John Mendelsohn described "The End" as "singularly simple, overelaborated psychedelic non sequiturs and fallacies." When Morrison happened to meet the critic nearly a year later he looked at him and said, "Singularly simple, overelaborated psychedelic non sequiturs and fallacies, huh?" After Miami, however, he learned to roll with the punches somewhat, partly because the criticism had gotten so bad that it had become ridiculous, even funny. The real irony of *The Soft Parade* was that it gave the impresson of a band that was a little too confident of its popularity when actually the reverse was closer to the truth. Considered by The Doors and their fans to be their worst album, it took nearly a year to make and was even more frustrating to record then *Waiting For The Sun.* Morrison's lack of involvement was painfully apparent and Krieger's juvenile-by-comparison lyrics dominated the work. Although "Touch Me" was a big hit, seven months had passed since the release of

the masterfully crooned, but rather conventional love song, and its success hardly affected the reviews. Morrison came off foolish, trying to sing Krieger's lyrics surrounded by middle-of-the-road trappings. In all fairness it should be noted that Krieger came through when the band needed him most. With Morrison's high school and Venice notebooks exhausted the burden of new material fell on Robby and he responded with a wealth of it, establishing his own distinct style. Unfortunately, it was not the style that true Doors fans were craving. After the Top 40ish *Waiting For The Sun* album, they wanted a return to the musical mastery and lyrical imagery of the first two albums. What they got was a poor imitation of Blood, Sweat & Tears. To a public whose artistic stock in The Doors was already plunging, *The Soft Parade* provided a new all-time low. It rendered their distinctive sound almost unrecognizable and sent their fans back in time to a dynamic album recorded by an unknown Los Angeles rock band and quietly released on a relatively small folk label. The Doors had not only failed to live up to that original promise—they had turned it into a joke.

Incredibly short for a Doors album at only thirty-four minutes, *The Soft Parade* is undefined and, like the title says, soft. Even the sleek cover shot of The Doors positioned around a 35-mm camera on a tripod is too posed, too clean, too soft. It's not that it's a bad album, it's only bad for The Doors. It doesn't touch upon the inner aches that require strong rock to be effectively understood, and while Morrison talks about wild children and pleads for them to listen to him, he doesn't reveal them from the inside out, the way other Doors albums do. But there are a few great moments such as the "Do you remember when we were in Africa?" coda to "Wild Child," the howling sermon, "You cannot petition the Lord with prayer."

The title song was an attempt to return to the one-long-track policy abandoned on *Waiting For The Sun.* It is built on tidal shifts of music and kinetics that allow Morrison to get back at his Southern roots by first portraying a fire-and-brimstone preacher and then pleading for sanctuary and finally proclaiming a few of his favorite "sinful" things in the Babylon of L.A. The music changes radically throughout—from a somber, almost Oriental section to an upbeat California sound to a jazzy passage. Following that is a heavy rock section during which Morrison says,

"This is the best part of the trip," and then a long section that might sound like something from *Strange Days* were it not for a multitracked, almost chanted vocal.

Like all of Morrison's lyrics the song was both biographical and symbolic. While he asked for sanctuary, a place to hide, and soft asylum, it was the imagery more than the actual words that reflected his situation. Stating that there were only four ways to get unraveled, he lists them as: sleep, travel, being a bandit up in the hills, and loving your neighbor up until his wife comes home. This can be translated as the four options Morrison saw open to him. He could remove himself from consciousness, escape temporarily through travel (mental or physical), run away and revolt against the pressure, or continue his attempt to communicate what he felt was truth. His understanding that this last option had failed of late is reflected by the same kind of "love your neighbor/illicit sex" duality that dominated the Miami performance in the tag "till his wife gets home."

Clearly Morrison was no longer the invincible Lizard King. He had discovered his own weaknesses and was now alarmed to see that "the man is at the door." By the end of the song he seems to have decided on escape and revolt judging by his reference to meeting at the outskirts of the city and bringing a gun.

What keeps the song from being a true Morrison masterpiece is its fragmented nature. Part of it sounds like The Four Freshmen, part like The Doors of old, and part like it could have come from "L.A. Woman." Paul Rothchild reveals a little-known fact that explains this choppiness: "Whenever we got stuck in the studio with a bridge section, I'd ask Jim to get out his notebooks and we'd find a piece that fit rhythmically and conceptually. A lot of the fragments were just bits of the poetry we put together."

"Shaman's Blues" is obviously another somewhat autobiographical song, especially in the title, but also in lines like: *He's sweatin', look at him (You'll be dead and in hell before I'm born)* and *The only solution—Isn't it amazing!* In this barrage of images there are many possible explanations, but all of them refer to Morrison's doubt and desire for a way out that included even death as an escape. The song has some good imagery ("Nursing penitentiary") and rhythmic changes.

The insights into Morrison provided by the title cut and "Shaman's Blues" contrast greatly with Krieger's vision in "Tell

All The People" of a much more goal-oriented Jim Morrison. Critics lambasted the song as "an innocuous hippie call to arms" and it may not be how Robby saw Morrison, but it is surely how most of Jim's fans would have liked him to be. "Wild Child" may be Morrison's answer to "Tell All The People." It is probably the best cut on the album and shows much of the old Doors' fire so lacking on the rest of the songs. It is hypnotic, with a touch of evil, and indicative of Morrison's musical direction turning toward the blues.

"Wishful/Sinful" with its love/hate, good/evil theme may also be about Morrison, but it comes off more as a pop standard. The arrangement is excellent, but not for The Doors, as the strings and woodwinds undercut the vocal. "Runnin' Blue" doesn't know what it wants to be. A mixture of soul and bluegrass, it has an R&B horn section, but also a country fiddle and mandolin. The lyrics are Robby's tribute to Otis Redding but one verse is an unmistakable takeoff on Bob Dylan. Though confusing, the song has its moments and it was released in August as the fourth single from the album in just over eight months. Krieger sang the lead and Morrison joined in on the chorus. Another song, "Do It," is the only collaboration between Morrison and Krieger on the album, but it's mostly a repetitive line ("please, please listen to me children") and some simple music. And finally "Easy Ride," Morrison's country and western song with a rock ending, does little but contribute greatly to the schizophrenia of the album.

The biggest shocker for Doors fans was of course the horns and strings. The album is loaded with outside musicians, often resulting in Manzarek's keyboards being snowed under. Both Manzarek and Densmore, however, had long envisioned a jazzier kind of album and since Blood, Sweat and Tears and Chicago were so popular and The Doors were so desperate for direction, it seemed like a good move at the time. Densmore remembers: "Even before the first album, Ray and I, old jazzers, had talked about using horns someday. We got Curtis Amy, this West Coast sax player for 'Touch Me' and told him to play like Shepp or Coltrane and just lose it, go outside the courts. We had a real good time."

Rothchild agrees that it was the band's decision as much as his own: "It was a compromise that they were very, very de-

lighted to participate in," he told Vic Garbarini. "'Touch Me' sold a couple million records—their second most successful single. It lost them part of their original audience while at the same time gaining them an enormous number of new fans . . . On *Soft Parade* we were really trying to hit the mass market . . . At that point Jim was pretty bereft of ideas and he was losing interest in the music in general."

Neither Morrison nor Krieger was pleased with the album. "An album should be like a book of stories strung together, with some kind of unified feeling and style about it, and that's what *The Soft Parade* lacks," Morrison said. Krieger in particular did not like the arrangements: "The strings and the horns on *Soft Parade* were Paul's idea," Krieger maintains. "I'd like to rerelease that album without any of the horns or strings." Nonetheless, all of Krieger's songs employed the backing orchestra while none of Morrison's did. Most likely this is because Robby was willing to go with the direction the others championed. In a way you have to admire Rothchild, Manzarek, Densmore, and Krieger for attempting a Doors version of *Sgt. Pepper's,* but to acid rock fans a preponderance of orchestration was unthinkable. How could The Doors have thought it would be otherwise? Perhaps they were betrayed by their own literacy. They had read too many record reviews where BS&T and Chicago were lauded for venturing into the big band sound. But more than that, the real folly was trying to make such an ambitious record without the total cooperation and insight of the most creative member of the band.

Woodstock

On August 15, 16, and 17 over four hundred thousand people attended the Woodstock Music & Art Fair in the Catskill Mountains in Bethel, New York. The "Woodstock Nation" gathered for three days on the six-hundred-acre farm of Max Yasgur and expressed the ideas of the new generation—communal living, getting high, arts and crafts, wearing unique and colorful clothes, and listening to the music that not only best typified the movement, but helped create it. Billed as "An Aquarian Exposition of Music and Peace," Woodstock was that and much more. It was the moment when the special culture of American youth dis-

played its strength, appeal, and power. The festival became the most famous testimony to the values of the sixties and ranks as one of the significant sociological events of the age.

Woodstock accomplished two important steps for the emerging underground culture—it showed the world they were a force to be reckoned with and it proved that the movement's concepts could work. Despite the shortages of food, water, and medical supplies and in defiance of torrential rains and improper sanitation facilities, the people communed together in peace and harmony. The audience was the real star of Woodstock. Hundreds of thousands of youths who had previously thought of themselves as an isolated minority discovered that *they* were what's happening. They sent a signal to adults everywhere that the children of the welfare state and the atom bomb not only marched to the beat of a different drummer, but did so in great numbers.

Over thirty acts played at Woodstock including Jimi Hendrix, Jefferson Airplane, Sly and the Family Stone, Janis Joplin, The Who, Santana, Crosby, Stills, Nash and Young, The Grateful Dead, Ten Years After, Creedence Clearwater Revival, Richie Havens, Country Joe, The Band, and Joe Cocker. The Doors had been invited, but refused to go because Morrison didn't want to perform outside anymore. How ironic that the height of the sixties and everything Morrison had stood for came at The Doors' low point. In all the publicity about the Woodstock Generation that followed in the weeks to come Jim Morrison could not help but feel he had been passed by.

In September, the Chicago Seven trial started and Bobby Seale was gagged and chained in the courtroom. The image of a bound defendant was riveting and even middle-class America began to have second thoughts.

On September 13 The Doors headlined the Toronto Rock & Roll Revival Show in Varsity Stadium. When The Doors had agreed to perform, the concert was basically a tribute to rock 'n' rollers from the fifties. Many of the band's adolescent heroes such as Chuck Berry, Little Richard, Jerry Lee Lewis, Fats Domino, and Gene Vincent were on the bill. But by the Monday before the show, only eight hundred tickets had been sold. In desperation, one of the promoters contacted John Lennon and asked him if he would MC the show. Amazingly, Lennon offered to put a band

together and play instead. As soon as the promoters announced that John Lennon would be there ticket sales went through the roof. By Saturday, the day of the show, all twenty-two thousand seats in the stadium had sold out! Also on the bill was Chicago and an unsigned band called Alice Cooper, who was fronted by one of Morrison's drinking buddies, Vincent Furnier.

The Doors remained top-billed because that was how the contract had been signed, but there was no question that it was the Plastic Ono Band with John Lennon, Yoko Ono, Eric Clapton (guitar), Klaus Voorman (bass), and Alan White (drums) that everyone turned out to see. Lennon had expected the concert to be small and was a little nervous. He hadn't played live in some time and this was his first gig without The Beatles. The hastily assembled band performed six songs including "Blue Suede Shoes," "Money," "Cold Turkey," and "Give Peace a Chance" and their show was filmed for posterity.

The Doors closed the concert as agreed, but refused to allow any filming because of Morrison's rather bloated appearance. It must have been a shock for the fans in Toronto. The year before, at the Coliseum, ten thousand people had squeezed into a seven-thousand-seat hall to see a thin, leather Adonis reaffirm his reign as the Sex God of Rock. Now Morrison, his hair shorter, was wearing faded blue jeans and looked down and out. Despite his appearance, however, Jim put on a good show in Toronto. When The Doors performed "Back Door Man," Morrison had the band slow it down and sang, "Keep your eyes on the road, your hands upon the wheel, you know we're going to the roadhouse, have a real good time." Then it was back into the song, but for an instant the crowd had gotten a glimpse of the new material he was writing and rehearsing.

After a few more numbers Morrison started talking to the crowd over the intro to "The End": "You know I can remember . . . about the seventh or eighth grade . . . when rock 'n' roll first came on the scene and for me it was a very liberating experience . . . it burst open whole new strange catacombs of wisdom that I couldn't remember and I didn't know about and I couldn't see any equivalent for in my surroundings . . . and that's why for me this evening it's been . . . a really great honor to perform on the same stage with so many illustrious musical geniuses . . ." The Doors finished the show with "The End."

Despite the tame quality of recent shows, the ban-The-Doors movement had not died out. The two shows in Philadelphia on the 19th were allowed only after promoters went to court and the judge lifted the ban on the morning of the concerts. The Philadelphia crowd was a strange mixture of longhairs high on dope and crew cuts carrying cameras in the hope they might get a shot of a rock star's organ, but despite the freak show audience the band cooked and Morrison conjured up memories of The Doors of old. In Pittsburgh, the next day, Morrison remained cool but the crowd got carried away and the show was halted when hundreds of teenagers rushed the stage. The University of Toledo then canceled a concert scheduled for September 21. The Doors had become that worst of all things, a political football, and the Establishment was having a wonderful time kicking them about. In many cases, the powers that be would allow a concert to be scheduled and the band hired in order to drum up publicity for themselves, when they canceled it a few days before the show. Of course this kind of thing wreaked total havoc for The Doors and their organization. And all of it could be traced to one hot drunken night in Miami.

In October, America was shocked by the horrors that were revealed when the police captured Charles Manson. The bizarre ritualistic murders of actress Sharon Tate and four friends had been discovered in the Hollywood Hills that August, but it wasn't until Manson's capture that the public realized the extent of the crimes. One of the victims killed with Sharon Tate, was Jay Sebring, the hairstylist, who had cut Morrison's hair into the (Alexander the Great) young lion look. Tate was married to film director Roman Polanski (*Rosemary's Baby*) and was eight months pregnant at the time of her death.

Through ready administration of LSD and a messianic message Manson attracted a virtual harem of adoring women and used offers of sex with them to draw men into the group. Eventually, he had assembled a raggedy gang of twenty-five members and nearly sixty associates, many of whom blindly followed his revelations. The story of a bedraggled band of dropouts turned into murderers by a bearded, wild-eyed Svengali seemed like some sort of twisted cross between Nathanael West and *Easy Rider* and was similar in many ways to Morrison's original theme for the film *HWY.* The event had a great effect on the youth

movement. By the fall of 1969, most people had accepted that the "flower children" were relatively harmless. What made the murders by the Manson family so frightening was that the killers looked so innocent. Many of the young women involved were from peaceable middle-class backgrounds. Leslie Van Houten had been a homecoming princess. "Better lock your doors and watch your own kids," Susan Atkins later warned the jury that convicted her.

It was in October that Morrison had some poetry published in in an alternative newspaper called *The Los Angeles Image*. Michael Ford describes what happened: "Rick Merlin was the helmsmen of that paper and he published some of my work. I showed it to Jim and he liked it. He gave me the collection he called 'Dry Water' and I selected a couple of pages' worth and put a spread together for the paper. I credited it to James Douglas Morrison. And when he saw it he was real pleased and said, 'That's who I wanna be now, James Douglas Morrison. That's whom I'm going to become.'"

Entering the Plea in Miami

On November 9, Jim Morrison at last returned to Miami. He flew in from L.A. and was officially arrested at 9:50 P.M. by the Dade County Public Safety Department. Morrison gave his address as 8512 Santa Monica Boulevard (The Doors' office) and entered a plea of not guilty. The bond was set at five thousand dollars by Judge Murray Goodman of the Dade County Criminal Court. Morrison paid the bail and was released in twenty minutes. The case was adjourned and the trial set for the following year on April 27. The judge also allowed Morrison's attorney, Max Fink, thirty days in which to file any motions to request additional time before the trial. In addition to Fink, Morrison retained a Miami attorney named Robert Josefsberg, who told Judge Goodman that he wasn't yet ready to decide on waiving a jury trial.

After the brief hearing, Morrison left Miami immediately and flew back to Los Angeles. The initial wait over and the reality of a trial sinking in, Morrison braced himself for the long dread. There

are those who say Jim Morrison lived to cause trouble while others maintain that he was simply a magnet for it. Whatever the case, it seemed no matter how much he tried to avoid it, trouble and the law was always just a half step behind.

The Phoenix Airline High Jinks

Two days after the hearing Jim and Tom Baker along with Frank Lisciandro and Doors publicist Leon Barnard, decided on impulse to "lend moral support to the Rolling Stones" who were in concert at the Veterans Coliseum in Phoenix (where Jim had been permanently banned from appearing). It was a fateful mistake. Tom Baker described how it began: "He handed me a bottle of whiskey and waved a fistful of choice front-row tickets around. He planned to stand outside the auditorium and randomly hand them out to young fans who couldn't afford a ticket, saying, 'This is courtesy of your old pal Jim Morrison. Enjoy the show.' He felt this would be a good-natured and harmless way to upstage Jagger and Company."

Both Morrison and Baker were drunk when they boarded Continental Flight 172 and became noisy and boisterous almost as soon as they sat down. When they discovered takeoff would be delayed, they started walking around the plane and Morrison began smoking a small cigar in spite of the fact that the No Smoking sign was on.

After a half hour delay, the flight left at 5:10 P.M. with seventy passengers on board. Morrison sat across the aisle and one row ahead of Baker in the first-class section. Shortly after takeoff Morrison and Baker started making obscene jokes and became so loud that they interfered with the stewardess's instructions on how to use the oxygen masks. Baker pointed to the mask and said loudly, "My girl has one of those, but she calls it a diaphragm." The two continued to irritate the stewardess by making off-color hand signs and acting as if they were going to grab her as she served drinks. Finally, after passengers complained about foul language, the stewardess threatened to call the captain.

When the trouble continued, she reported the incidents to Capt. Craig A. B. Chapman, who told her to tell them to behave or else he would have to come back and talk to them. Despite

the warning, Baker continued to goof around, getting bars of soap from the lavatory and trying to sell them to the passengers and then dumping a handful in Morrison's lap. Baker then threw soap around the cabin and landed one in Morrison's drink. At this point the stewardess headed up to the cockpit and told the captain what was going on. Captain Chapman then came out and asked the two men to observe the rules and show proper conduct. He directed most of his remarks to Baker who seemed to be causing most of the trouble. According to the captain, Baker and Morrison attempted to "back talk," but he was very firm until they quieted down. He told them if they didn't straighten out he would either turn around and return to Los Angeles or land at the nearest suitable airport and they would be arrested. The captain then asked if he had made himself quite clear and Morrison said, "Hey, look what he did, he put soap in my drink." Baker then promised that there wouldn't be any more problems.

The clash with the captain had a temporary calming effect, but after a short time they started up again. Covering a pint-sized bottle of Cognac with a comic book, Morrison and Baker began passing it back and forth. Baker got up to go to the lavatory and, seeing the stewardess by the door, forcibly threw it open, striking her with it. Moments later, Morrison then tried to trip the upset stewardess and Baker threw an empty glass at her for no reason. Baker was now really getting wild and proceeded to kick a drink out of Morrison's hand. In the cockpit the captain and his first officer could hear the noise and decided to radio Phoenix. Captain Chapman told flight operations that he had some passengers on board, "of the long-haired type," who were causing problems and asked for police to take them into custody. At 7:10 P.M. the aircraft landed at Phoenix and began to taxi. The noise from Baker and Morrison had become so loud that the captain considered stopping the plane on the runway and having the police meet the aircraft there, but instead proceeded to the gate.

I have a vision of America
seen from the air
28,000 ft. & going fast

Morrison and Baker now hurriedly got their belongings together and stood by the front door with complete disregard for

safety regulations. The stewardess asked them to be seated until the plane reached the terminal, but they ignored her. Then they noticed the police waiting at the ramp and Baker began jumping up and down and shouting, "I didn't do a goddamned thing." Moments later, the door was opened and members of both the Phoenix police department and the FBI came aboard the aircraft. Local police, feeling they lacked jurisdiction over an aircraft in flight, had called in the FBI. At this time Morrison and Baker became very quiet and didn't make a move. They smelled strongly of alcohol and their eyes were bloodshot and watery. It was obvious that they were drunk. The police asked the captain whom he wanted taken off the plane and Captain Chapman said he would leave it to the discretion of the stewardess who had been caused all the trouble. She pointed out Morrison and Baker and the two were searched and a large knife was found on Baker. Both men were then handcuffed and taken into custody.

The captain told police that action should be taken to file federal charges against Morrison and Baker for interfering with the operations of the flight crew. A complaint was signed and a "drunk hold" was tacked on the two men until further charges could be filed. It was the federal charge that made the incident more than simply another drunk-and-disorderly adventure. Due to recent airplane hijackings, a new law had been passed that made interfering with the flight of an aircraft a federal offense that could result in a ten-year prison sentence plus a ten-thousand-dollar fine. The assumption was that anything that distracts an airline crew from performing their duties is endangering the lives of the passengers. It might be arguable when applied only to a stewardess, but there was no denying that Morrison and Baker's antics severely divided the pilot's attention. Being drunk and disorderly on the ground is one thing, but at eight miles high it is quite another.

Morrison and Baker were booked at the Phoenix city jail and charged with interfering with the flight of an intercontinental aircraft and public drunkenness. While The Stones were doing their thing before a packed house (including Frank and Leon who had decided they might as well go to the show), Morrison and Baker were languishing in jail, unglamorously booked as common drunks. Rich Linnell remembers: "Here I was promoting The Rolling Stones and we had the distinction of *not* selling out

which came as a real surprise to all of us. Bill Siddons was very instrumental in landing The Stones for us so he was sort of a silent partner and he gave Jim some tickets. I remember I was having some trouble with gate-crashers and all kinds of things and sometime after the show had started Frank Lisciandro comes waltzing up saying, 'Jim's in jail, we've got to get him out,' and I said, 'Frank, I'm sorry, I'm just too busy. Bill's over there. Go get him.' It turned out nothing could be done until the next morning, anyway."

At a magistrate hearing in city court the next day, both men pleaded not guilty to the city's drunk charge. Trial on the misdemeanor was set for December 2 and each man posted sixty-six-dollars' bail. They were not released, however, but were instead turned over to the custody of a U.S. marshal, rearrested, and re-jailed to answer the federal charges. A federal grand jury was hastily convened and promptly handed down an indictment charging them with three counts of assaulting, intimidating, or threatening a flight attendant and the newly enacted antihijacking measure. All of the charges were felonies. Bail was set at twenty-five hundred dollars each and Bill Siddons posted it out of a brief-case full of cash from the show's receipts. Federal judge William D. Copple stipulated that Morrison and Baker could return to California, but could not leave the confines of that state. They were instructed to appear before Judge Copple again on November 24 for arraignment and bail review. Motions by Morrison's attorney for reduction in bond were denied.

In all, Morrison and Baker were in jail for over eighteen hours. On the twenty-fourth they failed to appear and Judge Copple issued an order for their appearance for December 1, 1969. At this time they appeared and entered pleas of not guilty to all three counts of the indictment. The trial date was scheduled for February 17, 1970, in the U.S. District Court at Phoenix. As if things weren't going badly enough, Jim Morrison now had a lot more than Miami to worry about.

In November, the story of the My Lai massacre broke in the press after having been kept secret for twenty months. The account of American GIs murdering five hundred old men, women, and children in a small Vietnamese hamlet gripped the American consciousness like a grisly vise. For a brief instant the entire na-

tion was taken to the edge of the abyss and forced to look at the horrors of Vietnam. That same month 250,000 marched on Washington, D.C., to protest the war.

By late 1969, The Doors had determined that the Aquarius shows were not enough for a live release and Elektra began pressuring for a studio album until other concerts could be recorded. Sales of *The Soft Parade* were far off the level of *Waiting For The Sun,* and because of the elaborate production, it had cost a great deal more. The band realized it was time to go back into the studio. As free as Morrison and the other Doors liked to pretend they were, they were still bound to contracts and had significant responsibilities. In short, they had to go to work even when they didn't feel like it. So in November they went into the studio to try to get some of the new songs they'd been developing down on tape.

Even though he was pleased with many of the new songs, Morrison drank heavily during the recording sessions. As usual, this put additional pressure on everyone involved. Pam came to a few of the sessions, but her presence did little to change things. One time, however, she got hold of Jim's bottle and drank it to keep him from it. Bruce Botnick describes what happened next: "So here were the two of them, completely out of their minds and crying. He started shaking her violently. I think he was putting me on. She was crying out of control, telling him he shouldn't drink any more and that's why she drank it. And I'm cleaning up, and I said, 'Hey, man, it's pretty late.' He looked up, stopped shaking her, said, 'Yeah, right,' and hugged her, and they walked out arm in arm. I felt he had done all that for me. I'd seen him do that sort of thing before, because he'd always give you a funny look afterward, to see your reaction."

Altamont

The idea was for The Rolling Stones to throw a free concert commemorating the end of their tour, sort of a "Woodstock West." The Stones wanted it to be as "free" as possible and for hundreds of thousands of kids that translated into not only free admission, but one gigantic party—all kinds of dope and no rules.

Besides The Stones, the hastily organized concert included Jefferson Airplane, Santana, Crosby, Stills, Nash and Young, and The Flying Burrito Brothers. By December 6, the day of the show at Altamont Raceway near San Francisco, there had already been three deaths—two Berkeley men were run down the night before in a hit-and-run accident as they sat around a campfire by the side of the road and another drowned when he slid down an irrigation canal and was caught in the current. There were other problems as well. The site had been changed at the last minute and the stage was at ground level, making it impossible for most people to see, but the real nightmare sprang from hiring a hundred Hell's Angels to act as security instead of police and giving them a bonus of five hundred cans of beer.

The Grateful Dead had often used the Angels as security without incident, and when their manager suggested the idea to The Stones, they readily agreed, but from the outset there was trouble. During The Jefferson Airplane's set a couple of Hell's Angels began punching a man in front of the stage and when lead singer, Marty Balin, tried to intervene, he was knocked unconscious. Later in the day, reports surfaced that the Angels were bouncing full cans of beer off people's heads and fighting with anyone that came within striking range. Augustus "Owsley" Stanley III, the San Francisco psychedelic manufacturer, was giving away LSD and the Angels were eating it by the handfuls and smearing the excess on their faces.

The Stones had planned on going on at sunset but for some reason they kept the crowd of three hundred thousand waiting until it was dark and cold. Finally, amid mounting tension, Jagger took the stage and opened with "Sympathy For The Devil" (nice choice, Mick) but stopped soon after to quiet the edgy crowd when a motorcycle blew up nearby. Throughout The Stones' set, Jagger made repeated efforts to calm things, but he had little control over the crowd and none over the Angels. Apparently, the Angels' definition of security was pulverizing anyone who came near the stage. During the show they spun like madmen, swinging out at random as if the stage was now Hell's Angel turf and no one had better approach it. One Angel laid into fans with the butt end of a lead-weighted pool cue, knocking one unconscious with a blow to the side of the head whereupon other Angels jumped in and started kicking the boy. From the stage Jagger kept asking,

"Who's fighting and what for? Why are we fighting? We don't want to fight." But no one was listening.

After a few more numbers, The Stones did "Under My Thumb." In front of the stage a black man in a flashy blue-green suit got tired of being pushed around and pulled out a nickel-plated revolver, but before he could threaten them with it, the Angels pounced on him and one of them buried a long knife in his back. They then kicked and clobbered the unconscious man repeatedly. Afterward, the Angels guarding the stage refused to allow those carrying the injured man to pass by them to get to the Red Cross truck located behind the stage. The man, eighteen-year-old Meredith Hunter, died.

When it was over, the dream of Woodstock was forever silenced and the curtain had fallen on sixties innocence. Whatever victories had been gained through the peace and love philosophy were now forever tainted by blood and needless violence. The Stones had played their comeback tour and had gotten more publicity than ever before. They were still the "world's greatest rock 'n' roll band," but all the bad boy stuff somehow didn't seem so much fun anymore. If Altamont was an example of "Sympathy For The Devil," what could they do for an encore to human sacrifice?

Meanwhile, the press over the Phoenix arrest had convinced Morrison's fans that he was far from giving up his outlaw ways. But with two trials and several paternity suits pending, Jim Morrison could not afford any more trouble and the ever-present threat of legal harassment had become a tether that held him at bay. He hated the feeling that the moment he stepped out of line he was going to be jerked back into place. For Morrison, trying to walk the straight and narrow was not only grueling pressure, but a virtual impossibility. He could not be something other than who he was and all the grinding and twisting of the Establishment would not make him fit its mold.

Besides these pressures, Elektra was waiting for the new album with baited breath and fear. They wanted a big hit single and The Doors didn't know if they had one. Morrison was also being torn between the friends with whom he had created outside projects and the other Doors. Some of the film projects he had begun were unfinished and others had never been started, but the rest of The Doors felt these projects were draining Jim of

energy he should be devoting to the group. Since he was drink-
ing more than ever, they had a valid point. He had only so much
clearheaded energy to give and *The Soft Parade* album had suf-
fered considerably because of his lack of involvement. The other
Doors also wanted Morrison to shave his beard and lose weight
so he would look good on the tour to promote the forthcoming
album, but Jim was not looking forward to it. The impression that
he made a fool out of himself in Miami remained. The teenybop-
pers only pretended to be horrified, but the old Doors fans, the
intellectuals and the critics, were seriously offended. How could
Morrison do that to his art? To himself? To *them*? A few probably
even envied his being allowed to throw a full-blown temper tan-
trum in front of twelve thousand people, but they also resented
him for "getting away with it."

Jim's relationship with Pam was also becoming strained. She
was constantly demanding that he quit the band, now claiming
that it was rock 'n' roll that was getting him into trouble, but
Morrison knew that, Doors or no Doors, he could never lead the
kind of life she wanted. Perhaps worst of all for Morrison was that
his attorney had forbidden him to speak out about Miami. He
longed to proclaim his disgust at the hypocrisy of the whole af-
fair. "People believe old press clippings," Morrison said later. "A
couple of years ago, I filled a need that some people had for a
figure who represented a whole lot of things, so they created the
thing."

Morrison had once described the role of the artist as similar
to that of a shaman and believed that by projecting fantasies on
to him and then attacking him for those fantasies people could be
free of their destructive impulses. There was no question that
Morrison was often attacked, but he had brought most of it on
himself. Whether his actions in Miami had been a subconscious
rebellion or not, they had only worsened his situation and
heightened all the pressures upon him. Morrison was learning
that all freedom, even the wild spontaneous behavior of the true
Dionysian, had its price to pay. And Jim had run up quite a bill.

In December, Jim Morrison turned twenty-six. The day after
his birthday he sat on the sofa in The Doors' office drinking a
beer and trying to figure it all out when Bill Siddons and the
others came in. Jim looked up at them and said slowly, "I think,
I'm having a nervous breakdown."

From someone like Morrison it was an unusual and even frightening plea. As far as most people knew, Jim never let anything really get to him. Whenever fear or doubt started to creep in, he always got thoroughly screwed up or did something outrageous to take his mind off it. Even the people closest to him had never seen him so vulnerable. No one knew what to say.

You must confront your life
Which is sneaking up on you
Like a rapt, coiled serpent

THE DOORS' COMEBACK

As the new decade dawned, The Doors began a see a few rays of light trickling through the dark Miami cloud. The bad press was starting to die down—after Altamont, My Lai, and Charles Manson, Jim Morrison didn't seem like such a bad guy after all. In fact, now that he'd been taken down a notch or two and was still kicking, he was proving to be an admirable survivor. As the sessions for the new album wound down, Morrison's attitude seem to change as well. This time the studio had served as a retreat from the pressures outside. Forgetting the pretensions of *The Soft Parade* and the artistic disappointment of *Waiting For The Sun*, Rothchild and the band just had a good time on *Morrison Hotel*.

The album was raw Doors from the beginning. Ray Manzarek remembers: "At that point we said, 'Oh the hell with horns and strings and any of that stuff, man, let's just play Doors—let's get back to Doors basics.'"

Morrison described it as follows: "The Doors are basically a blues-oriented group with heavy dosages of rock 'n' roll, a moderate sprinkling of jazz, a minute quantity of classical influences, and some popular elements. But basically, a white blues band. Our music has returned to the earlier form."

A big factor in the recording was the strength and vitality of the new songs. Lyrically, the album was Morrison's best in years and the others rose to the challenge by providing strong support. The nationwide ban after Miami gave Morrison the time and freedom to create a wealth of new material. Instead of being forced to try to write on the road or throw something together in the studio, he had the opportunity to labor over the songs and keep making them better. *Morrison Hotel* was all Morrison. He wrote or cowrote every song on the album and was a vital force throughout the recording.

The Doors returned to Sunset Sound for the album, recording many of the basic tracks at the rate of a song a day. Playing together was fun again and getting back to rock made it a real joy. "The music sprang from doing old stuff like 'Money,' or any old standard," John Densmore recalls. "We got that hard rock feeling by running over all those old tunes, and then did the original tunes with the same feeling." The Doors brought in rock 'n' roll innovator Lonnie Mack ("Rebel") to play bass on "Roadhouse Blues" and "Maggie M'Gill" and former Lovin' Spoonful leader, John Sebastian, to play harmonica on "Roadhouse."

As soon as the album was completed the group went out on the road. Although yet another date in Honolulu was canceled, it seemed the ban was now a thing of the past. Perhaps it was because of the reasonably good behavior Morrison had shown on the concert stage since Miami. Sure, he'd gotten in trouble on the flight to Phoenix, but onstage he had mellowed quite a bit or so the promoters and city fathers of America hoped. Just to be on the safe side, though, The Doors decided to hire another "bodyguard" for Morrison. Tony Funches was a six-feet-four-inch football player who had been Mick Jagger's personal bodyguard during the recent Rolling Stones tour. Funches's main task was to keep Morrison away from bars and out of trouble. Fat chance.

Before hitting the road, Morrison did an interview with Howard Smith of *The Village Voice* at The Doors' office in Hollywood. Morrison was playful—talking in a mock Southern accent

and putting the writer on. Asked how long he felt The Doors would continue, Morrison replied without hesitation, "I reasonably project at least another seven to eight more years." When Smith inquired about his legal troubles, Morrison accused him of "getting too heavy and trying to put a bummer on me" and decided that they should change the subject. "Let's talk about something light, let's talk about you, Howard." Later, Smith said Morrison looked like he was putting on some weight and Jim challenged him to arm-wrestle. Then he joked about being fat in college and said that the young lion image had been a "difficult burden to bear . . . but there were times when it got me some places with some women . . . it came in handy there." The interview proved that whatever changes were going on inside of Jim Morrison, his sense of humor remained.

About this time Elektra held a party to show off their new office space. Morrison, Babe Hill, Tom Baker, and Danny Sugerman were standing on the roof of Themis, Pam's boutique, watching people go in. According to Danny Sugerman in *Wonderland Avenue,* Morrison didn't want to go to the party, but finally he relented, saying, "I might as well go. Hell, I paid for the fucking place. Might as well see where the money went."

Naturally, the group was surrounded as soon as they entered the party. Before long Tom Baker led Morrison down the hall to see the new executive suites. As usual, Baker was antagonizing. "You're a fucking corporation, Morrison. You paid for all this corporate shit."

"All this doesn't mean anything to me," Morrison argued, but Baker wouldn't give up. "You hypocrite, Morrison. You're financing the very authority you claim interest in overthrowing." No matter what Morrison said, Baker had a comeback telling Jim to "take some responsibility" and "prove that none of this expensive shit means anything to you."

Baker always knew how to get to Morrison. Finally, when he called him a "chickenshit," Morrison knocked Baker over one of the new desks and then proceeded to wreck the place. He flung everything off the desk and dumped it on its side. Then he pushed over a few file cabinets, threw a couple of typewriters, and pulled some telephones out of their sockets until a bunch of people came charging down the hall and grabbed him. It took about ten of them to get him out of the office and into a lim-

ousine while an Elektra vice president shouted at the driver, "Get him away from here!"

The tour opened on January 17 and 18 with a four-concert run at the Felt Forum in New York's Madison Square Garden. The band had wisely chosen not to perform in the Garden's vast main arena, remembering the acoustic failure of their last show there and deciding they were better suited to a more intimate setting. The four-thousand-seat Felt Forum was crescent-shaped with excellent acoustics which was important since the entire series was being recorded for the still-unfinished (and long overdue) live album. The Doors were out to prove they were still capable of outstanding musical performance regardless of the decline in their popularity, and rather than come on all flash and fury, they toughened back into their former steely selves, managing to be staunch and fiery at the same time. "Roadhouse Blues" started the set and the other *Morrison Hotel* songs, "Maggie M'Gill," "Ship of Fools," and "Peace Frog" were a return to the rhythmic feel of the first albums. But the non-Doors songs like "Money," "Little Red Rooster," and "Who Do You Love" also went over big and it was clear the band enjoyed playing them. The performance was straightforward with no nonsense and the histrionics were gone. No falling off the stage, no screams, no leaps. "YEAHHH, we're really going to git it on t'night," Morrison leered from the stage at the concert's outset, and get it on they did. Jim's voice was in top form, ranging from strained whispers to bellowing, mike-swallowing roars. The Doors took over the crowd.

With his beard gone and weight down a bit, Morrison looked almost like he did in the "ride the snake" nights at the Whisky. The Felt Forum shows proved he could control himself and still ignite an audience as repeated assaults by younger members of the crowd had to be fought off throughout the night. At least two dozen girls and quite a few boys had to be dragged away by stagehands and prevented from wrapping themselves around Morrison. But this time the charges at the stage were different, coming closer to joyous adoration than the frenzied, riotous rushes of the more notorious Doors concerts. Morrison even joked about it—"Well, that's New York for you . . . the only people that rush the stage are guys."

Throughout the evening he was relaxed and playful with the crowd. When someone threw a joint on the stage Morrison

picked it up and cracked, "Well, that's a New York joint for you
. . . thin enough to pick your teeth with." And when it came time
for "Light My Fire" Jim announced it by saying, "Now we're
going to give you a famous radio song," without a trace of bitter-
ness. There may not have been much of the mystical momentum
that used to rivet the Doors' audience to their chairs, but there
was plenty of good music, and by the time the show was over,
the stage was littered with bras, panties, rings, and other gifts.

The message was clear. The Doors were back. Confident and
spirited, they charged through the first month of the tour. Mor-
rison kept relatively cool onstage and was occasionally joined by
guest artists such as John Sebastian. In San Francisco on February
5 and 6, Morrison went full steam both nights and as a result his
voice was noticeably hoarse the next night at the Long Beach
Arena, but he pushed hard all the same. After the last song at the
Arena, the lights came on and people began leaving until Mor-
rison came back out and said, "Hey listen, turn these lights off.
Does anyone here have to go home early tonight? (NO!) Let's
have some fun then." The Doors went on to blast through several
more numbers. During "The Crystal Ship," however, Morrison's
voice cracked badly and he stopped in midsong to note "an out
of tune 'Crystal Ship' is worse than no 'Crystal Ship' at all." The
audience appreciated his newfound willingness to admit flaws
and the concert finished with power and energy.

> *Cold electric music*
> *Damage me*
> *Rend my mind*
> *w/your dark slumber*

Morrison also saw Patricia Kennealy, the editor of *Jazz &
Pop*, during this time. Kennealy fascinated Jim. She was intellec-
tual and attractive, but while she appeared rather conservative,
she had a bizarre side that excited Morrison. For one thing Ken-
nealy was a practicing witch who belonged to a coven in New
York City. "One of the first things I told Jim when we started
seeing each other was that I was a witch into Celtic mysticism,"
Kennealy recalls. "Witch is such a loaded term that I really hate
to use it. Jim was looking for the truth as far as God goes and I
think this was one of the things that attracted him to me. He

could identify with it and maybe it spoke to his Irish Celtic roots."

> *A young Witch from*
> *N.Y. is laying novice hexes*
> *on my brain-pan*

It was after the Felt Forum show that Kennealy met Pam. Born in the same year on an opposite coast, also red-haired and with a similar name, Patricia Kennealy recalls meeting Pamela Courson: "It was one of the stranger moments of my life," Patricia remembers. "We all went to dinner. Pam and Jim and myself and David Walley, a former boyfriend. Leon Barnard, The Doors' press agent, and Raeanne Rubenstein the photographer were also there. The six of us went out to dinner and what made it so bizarre was that David, Jim, and I all knew that Jim and I were having this affair, but Pam didn't. So the three of us were radiating stuff across the table at one another and Pamela had no idea what was happening."

While in New York, Morrison divided his time between Pamela and Patricia. He shopped with Pam on Fifth Avenue and took her to some fancy New York restaurants, but at night he often went to see Patricia in her small apartment.

On February 13th in Cleveland, the Allen Theatre was sold out for both shows. Public Hall, the city's largest arena, was in use, so The Doors opted to do the shows at the three-thousand-seat smaller hall in the heart of downtown. Like most of the concerts on this tour, both the crowd and the band seemed to have a good time. After a strong first show about twenty Hell's Angels came in and sat in the front to wait for the second show. In the aftermath of Altamont and perhaps because it was Friday the thirteenth, murmurs of apprehension swept through the auditorium. The Angels wanted no trouble, however, and moments later the curtain opened and The Doors performed "Roadhouse Blues." To Cleveland the music was new and the look was different. Manzarek's hair was longer. Krieger now sported a short beard, and Densmore had taken the heads off his toms and his bass drum now housed a microphone wrapped inside a blanket. It was definitely time for rock 'n' roll.

But it was Morrison who best typified the new Doors. The

leathers were still gone and apparently not about to return. A long-sleeve black shirt hung out over his black jeans and maracas were stuck in the front of his pants. His voice sounded great and he gave no sign of slowing down. When the opening songs were over, Manzarek took off his suit coat, rolled up his sleeves, and played the intro to "When The Music's Over." Morrison adjusted the microphone and walked back to Densmore's platform and stood motionless while the music was building. Krieger stuck some cotton swabs into his ears and turned his guitar all the way up. Suddenly, Morrison ran forward, attacked the mike stand, and screamed. At that instant, as the audience was hit with that monstrous blast of sound, they knew The Doors hadn't lost it. Before the song was over they would reexperience the unbearable tensions and sudden releases of "When the Music's Over" in a way they hadn't heard for a long while.

At one point, Morrison grabbed the mike and then bugged out his eyes, collapsing to the floor as if electrocuted. The crowd stood, convinced something had gone wrong, but Morrison jumped up and smiled faintly as if to say, "scared you, didn't I?" Later, when the mike stand came off its base he twirled it like a baton and teased that he might hurl it like a javelin into the audience. "Open up your left eyeball," he joked, but instead tossed it harmlessly off the side of the stage. On this tour Morrison seemed to love his audience. Perhaps he realized it wasn't their fault that they had missed his original intentions and later worshipped an image he couldn't live up to. A rock star's fans are like his children. Like a disappointed father he may be angry with them, but no matter how dissatisfied he is, he knows in his heart that he taught them everything they know, especially the very things he dislikes.

It was a laughing and fun-loving Jim Morrison who sang "Maggie M'Gill" for ten minutes in Cleveland, ad-libbing, "I'm not leaving here until I see someone boogie and I've got lots of time to wait." Soon people were dancing in the aisles. Never before had Morrison interacted so easily with the audience. This was the Jim Morrison that would have overcome the freak show image if he'd only been able to avoid Miami. No longer the shaman or the sex idol, Morrison had become someone the audience could relate to as a friend, announcing an obviously political number as follows: "It's called 'Peace Frog' . . . funny name for a song, huh?" Indeed, it was a name he would never have chosen before Miami.

The band did a lot of material from *Morrison Hotel* and even had an upright piano wheeled out for "The Spy." They finished the Cleveland concert with "Light My Fire" and the curtain closed to loud cheers. The audience then began filing out as the houselights came on. People were talking about what a great time they'd had when suddenly, from behind the curtain, out stalked an angry Jim Morrison. He stared out at the surprised crowd and shouted, "Which son of a bitch took my jacket? Thank you Cleveland!" And then stomped off the stage. The confused audience began muttering that whoever had the jacket should give it back. After all, this was the dead of winter. Then Morrison reappeared and, in the true tone of the show and the tour, said, "Ah that's okay, forget it. Come on back, we're going to play some more music." This time when the curtain opened, he latched onto it and rode across the stage.

During the encore, as they would throughout the tour, the other Doors got into the act. Manzarek played keyboards with the heel of his boot à la Jerry Lee Lewis, Krieger did a Chuck Berry duck walk, and Densmore bounced his sticks off his drums into the crowd. These were good times for The Doors. They could enjoy themselves onstage now. There was no dark and somber mysterious image to live up to. Most of that died with Miami and the press that followed it. What was left was the freedom to play the kind of music the group had evolved into playing—good old-fashioned rock. The Cleveland crowd recognized it as good music and remained on their feet throughout the encore. Somewhere during the course of "Who Do You Love," "Money," and "Little Red Rooster," Morrison's jacket made its way back riding the upraised arms of the crowd from the rear of the hall all the way to the stage, where one of the roadies took it.

But The Doors weren't through with Cleveland yet. When the blues medley was over they performed "Break On Through." A girl in the front row held out a beaded necklace and Morrison swooped her onto the stage and gave her a passionate kiss, spinning her around and around and then gently setting her back offstage. Then he grabbed a beer from a washtub and said, "I'm going to break the world Olympic record for downing a can of beer. I want you to count out there." By the time the crowd got to six, the can was empty and Morrison went to say something into the mike, but a huge belch came out instead. He laughed and so did the audience. Like many of the concerts on the *Morrison*

Hotel tour, the Cleveland show went way over, lasting until 1:30 A.M. The truth was that the band had such a good time they just didn't want to get off the stage.

The Chicago Seven Trial

Another show came to an end that same month in Chicago when a jury acquitted the Chicago Seven of conspiring to incite a riot during the 1968 Democratic National Convention, but convicted five of the seven of seeking to incite a riot through individual acts. Abbie Hoffman, Jerry Rubin, Rennie Davis, Dave Dellinger, and Tom Hayden were found guilty (which was later overturned) of crossing state lines with intent to riot. The other two defendants, John Froines and Lee Weiner, were found not guilty and an eighth original defendant, Black Panther leader Bobby Seale, had been tried separately. The trial of the group of activists ranked as the most significant legal confrontation of the decade between authority and dissent.

Abbie Hoffman said before the trial that the only chance they had was to repeatedly challenge the court's authority until "the judge's bigotry comes out." While Hayden, Davis, and Dellinger favored long diatribes on the American political system, Hoffman and Rubin transformed the courtroom into a blend of the Living Theatre and The Marx Brothers. Hoffman held center stage as the antiwar movement's mad genius of media events and accomplished as much with mockery as his fellow radicals did with ponderous argument. He somersaulted into court one day, wore judicial robes another, and at one point accused Judge Julius Hoffman of being his illegitimate father. Asked on the stand where he resided, Hoffman said, "Woodstock Nation . . . a nation of alienated young people which we carry in our minds, just as the Sioux Indians carried around the Sioux nation in their minds . . . It is dedicated to . . . the idea that people should have better means of exchange than property or money."

During the trial the judge found all seven defendants *and* both defense attorneys guilty of contempt of court. Tom Hayden said, "We are on trial for our identity. The constant theme of government testimony is against the symbols of our generation's

political and cultural identity. Long hair, burning draft cards, obscenity."

Morrison Hotel

Morrison Hotel, The Doors's fifth studio album, was released the first week in February. It reached number four and stayed on the charts for a full six months. This was especially significant since the album was the band's first without a concurrent single. In fact it wasn't until March that "Roadhouse Blues" came out. With a barrelhouse piano and a fierce guitar, the single featured one of Morrison's most raunchy and convincing vocals. It stands as one of the all-time great beer-drinking songs of the decade and was a fitting number for a hard-drinking Irish American like Morrison. The same week it was released the music trades announced that *Morrison Hotel* had been certified gold and The Doors had become the first American hard rock band to achieve five gold albums in a row.

The critics and public alike loved the album because it saw the return to prime of one of their favorite bands. Different from any of the previous works, the album contains no extended cut and no poetry/revolution saga. Instead it offers a raw bluesy sound that leaves the strings and horns of *Soft Parade* faded in the dust. Morrison wrote all the lyrics for the album and it is a voyage into both the promises and nightmares of America. An audio *On the Road,* it is driven by a restless fever, constantly moving, forever changing as it crosses the winding snake highways from rural town to fast-paced city.

The music provides the engines that power this drive; riffs rise and repeat, creating a great churning motion: *Keep your eyes on the road/Your hands upon the wheel.* All the songs in *Morrison Hotel* work together, complimenting each other and playing off their strong points. They combine to create a vision of America from its fierce underbelly to its awesome splendor. "Roadhouse Blues" begins the journey with an optimistic tone. But while we know we're going to have a "real good time," we are cautioned to keep our eyes on the road and our hands on the wheel because like any great adventure, there is danger as well as delights out there on America's road. Krieger's guitar rips and

burns throughout the song and Morrison proclaims that despite his past visions of fire and fury, he has now settled into an easier frame of mind. While The Beatles were telling us to let it be and The Stones were saying let it bleed, Morrison advised us to let it roll.

After a long drive into the black night the sun breaks through the dark sky: *Standing there on freedom's shore/Waiting for the sun*—lines that communicate Morrison's particular passion, hope, and disappointment in America. Raised under the stars and stripes, he expected so much more. Like much of his best work, the lyric can be applied both to a love relationship and an entire nation. Morrison had spent years describing change in harsher terms to America, but the masses had never fully understood the song and now the singer was no longer able to sing it.

"Waiting For The Sun," originally written for the third album, hints at the group's early mystical feeling, but more than that it provides the vision of utopia that America is built upon. The American Dream that never comes. New cars get old and young girls do too. There is more to life than the promise of paradise. Musically the song offers that balance The Doors so often achieved between intricate tapestries of sound and raw power. Next, the theme of movement is echoed in "You Make Me Real." While the verses sound dated, almost like the early Beatles, the chorus reminds us to "roll, baby roll." We roll with it into a startling portrait of America at the dawn of the seventies— riots and abortions and streets filled with blood. "Peace Frog," taken from a poem of Morrison's called "Abortion Stories," drives this horror home: *Blood in the streets, & it's up to my ankles . . . Blood on the rise, & it's following me*—lines that indicate a new concern and reflective viewpoint. To seal the biographical slant to the song Morrison breaks into a poetic rendition of *Indians scattered on dawn's highway bleeding/Ghosts crowd the young child's fragile eggshell mind,* giving "Peace Frog" a dynamic blend of personal history and political commentary. With such an odd title, there is little doubt that Morrison was trying to intentionally offset the direct approach of the lyric, one of his most openly stated and introspective protest songs.

"Blue Sunday" then adds another element of time to the rambling journey across America. The trip begins in the spring,

passes through the horrible summer of "Peace Frog" and now seems to hang in idyllic bliss on "Blue Sunday," a strangely moving ballad. "Ship of Fools" and "Land Ho" signify new adventures. "Ship Of Fools" is musically rather bland, but the lyrics describe the ultimate fate of the decadent human race, choking from smog but still mounting flights to the moon. "Land Ho" opens side two. Though it lacks much of a melody, it provides the retrospective side of the commentary made in "Ship of Fools," describing the lofty hopes and dreams of the pioneers who first settled America. The three ships described in the song are akin to the *Nina, Pinta,* and *Santa Maria.*

"The Spy" is a brief pause to reflect on secret fears and dreams. Its moody atmosphere conjuring up a smoky nightclub on the South Side of Chicago where "the dream that you're dreamin', the word that you long to hear, and your deepest, secret fear" are bound to be found out. The "Queen of the Highway" returns us to the road as a classical couple of the 1960s tries desperately to make their relationship work. The song is Morrison's celebration of Pamela. He is the American boy, a monster, black-dressed in leather and Pam is the American girl, a princess, a queen of the highway. It is followed by "Indian Summer," a simple but tasteful ballad that reminds us our time in the sun is limited and the days are growing short.

The journey ends with "Maggie M'Gill," a slow blues that completes the round trip by heading back to the roadhouse. After passing through America past and present, we pick up Maggie and head into "Tangie Town" where the people "really like to get it on." The last thing we hear is "Roll on, roll on, Maggie M'Gill." So the theme of the album is repeated once more. No matter how bizarre or mundane our life is, our task is to live it out and make the best of it, trying to have a good time.

Artistically, *Morrison Hotel* is a comeback for The Doors. Their sound is revitalized, resurrecting both poetry and parable within the work. It is fitting that The Doors would do an album focusing on America. They had held the position of the number one band in the land and the rest of the world still saw them as one of the great American bands. But beyond their level of success The Doors had all the qualities a truly American band should have. Morrison grew up all over the country (Florida, New Mexico, California, Virginia), Manzarek was born and raised in the

Midwest, and Densmore and Krieger were from the West. Like
the country, the band was a melting pot, a myriad of back-
grounds, ideas, and influences that came together through hard
work. They exhibited a brashness and a gaudiness in keeping
with the style of Americans and they were characterized not only
for their commanding victories, but also for their huge public
failures. Everything they did, the good and the bad, the wise and
the foolish, was always paraded wide open for all the world to
see and they went from hero to goat, sage to clown, innovator to
laughingstock several times in their career. Like America, when
they were good, they were the best and when they were bad,
they were the worst. And like all great American heroes, Jim Mor-
rison was both horrifying and absurd—a visionary prophet one
moment and a drunken fool the next. But there was no denying
that he was obsessed with America and America was obsessed
with him.

> *America, I am hook'd to your*
> *Cold white neon bosom, & suck*
> *snake-like thru the dawn, I*
> *am drawn back home*
> *your son in exile*
> *in the land of Awakening*

The album was named for a real hotel at 1246 S. Hope Street
in the skid row area of L.A., where the rooms went for $2.50 a
night. The place was discovered by Ray Manzarek and his wife,
Dorothy, during one of their weekend drives through the city.
Manzarek looked up and there it was, in big red and white let-
ters—Morrison Hotel—and said, "That's the album cover!" The
album became noted for its rock-vérité cover of the real Mor-
rison Hotel and the back cover shot of the original Hard Rock
Cafe located at 5th and Wall (also lowdown in "phantastic L.A.").
The funky building was a perfect symbol for the band's new blue-
sier direction and the fact that it's a hotel is also significant.
Hotels are, after all, places where many different types of people
with different beliefs and ways of life come together. The real
locale of the Morrison Hotel described by the album is no doubt
the hotel of Jim Morrison's mind.

Inside the gatefold cover The Doors are depicted in pale

yellow bar light. Looking like friends who have been through so much together that differences no longer matter, they appear forever bonded by time and experience. Which by 1970 is exactly how it was.

Although the Phoenix and Miami trials were still pending, the future was looking better for The Doors. In a later interview, Morrison described the band's musical history: "Three years ago, there was a great renaissance of spirit and emotion tied up with revolutionary sentiment. When things didn't change overnight, I think people resented the fact that we were just still around doing good music . . . that great creative burst of energy that happened was hard to sustain for the sensitive artists . . . they might be dissatisfied with anything except the *heights*. When reality stops fulfilling their inner visions, they get depressed. It becomes a question of longevity. The music was rougher, revolutionary in the beginning but it got better and better, more subtle, more sophisticated musically and lyrically. If you keep saying the same thing over and over it gets boring."

On The Doors' image Morrison said, "I think we're the band you love to hate—it's been that way from the beginning . . . We're universally despised and I kinda relish the whole situation. Why? I don't know. I think that we're on a monstrous ego trip, and people resent it . . . they hate us because we're so good!"

The Phoenix Trial

Morrison may have been having a good time with his music and slowly reconciling his image, but past sins were still demanding atonement and the Phoenix trial was the first to convene. On March 3 the grand jury in Phoenix reviewed the facts concerning Morrison's case and issued the following indictment:

Count I

On or about the 11th day of November, 1969, while aboard an aircraft in flight in air commerce between Los Angeles, California, and Phoenix, Arizona, in the District of Arizona, Thomas Frederick Baker and James D. Morrison did assault, intimidate, and threaten Stewardess Reva Mills, who was then and there a flight

crew member of Continental Airlines, Flight Number 172, from Los Angeles, California, to Houston, Texas, so as to interfere with the performance of her duties.

Count II was essentially the same charge as applied to Morrison and Baker's treatment of another stewardess, Sherry Ann Mason. The third count of the charge was dropped by the Phoenix state attorney's office and the trial date was set for March 12, but it was later delayed. On March 23 Morrison and Tom Baker waved jury trial and faced U.S. District Judge William Copple. The courtroom was mostly vacant with only the witnesses and a handful of Doors' fans in attendance. Stewardess Sherry Mason testified that she was harassed and threatened during the two-hour flight on November 11, 1969. At his attorney's suggestion, Morrison wore a suit and tie to court and both he and Baker sat quietly during the trial and only spoke to acknowledge the seriousness of the charges in response to the judge's question, and to enter their not guilty pleas. In all, three stewardesses and several other passengers took the stand to testify during the one-day trial. One of the stewardesses testified she heard Baker remark to Morrison, "Let's kill them," but she acknowledged that this was more a "popping off" type of remark rather than an actual threat.

After deliberating for a few days, Copple found Baker not guilty as charged in the indictment and Baker was acquitted. The judge found Morrison innocent of Count I as well, but guilty of Count II. Morrison was shocked. After all, Baker had been the one causing most of the trouble and Morrison had half expected to get off, but it seemed as though his reputation had again preceded him. Sentencing was ordered for April 6 and Morrison's attorney advised him that he could get as much as three months in the slammer and a three-hundred-dollar fine. Things had suddenly turned for the worse.

The next day Morrison and Baker got drunk at the Palms bar and Tom wound up tipping over the pool table. The police were called and Morrison and Babe Hill had to drag Baker down the street to The Doors' office. Once there Baker became argumentative again and Morrison told him he was fed up with paying for everything and always taking the rap. The two men began to fight when a friend of Baker's showed up and jumped on Morrison. Tony Funches then arrived and grabbed Baker's friend. A brawl

ensued and Morrison became worried they would wreck the place, so he slipped into Siddon's office and called the sheriff. The cops busted in moments later, having been just down the street at the Palms. After they broke up the fight they were surprised to learn it was Morrison who had called them.

Tom Baker was stunned. "You called the cops?" He stared at Morrison for a long time and then left with his friend. By the time he returned a few minutes later to throw a brick through the window, Morrison was already drinking at Barney's Beanery. It was the last time the two men would see each other for eight months.

Meanwhile the Phoenix proceedings took another turn. During the trial one stewardess had consistently testified that Morrison had done things that were actually done by Baker. Pursuing this angle, Morrison's attorneys Max Fink and Craig Mehrens turned up some interesting new evidence. On April 1, a motion was filed for an extension of time before sentencing in order to file a motion for a new trial. It was granted and on April 10 a motion for new trial was heard based upon evidence that one of the prosecution witnesses would be changing her testimony. Mehrens told Judge Copple that one of the stewardesses had informed him she had misidentified Morrison as the person who had assaulted Miss Mason. Mehrens did not reveal the name of the stewardess but told the court she was willing to supply an affidavit changing her testimony. Since she lived in Houston, however, additional time would be needed. The sentencing was then changed again from April 17 to April 27. By April 20 Fink and Mehrens had what they needed and a motion for Morrison's acquittal was heard based on the testimony of stewardess Sherry Mason who now admitted she too had confused Morrison and Baker's identities. Assistant U.S. attorney N. Warner Lee told the judge that the stewardess testified she had confused Morrison and Baker's identity. The motion was granted by Judge Copple and a Judgment of Acquittal was issued. The sentencing date was vacated and Morrison's bond exonerated.

Morrison had nearly been convicted on a case of mistaken identity. It was Tom Baker who had been the instigator of most of the trouble on the flight. In fact, Morrison's biggest mistake was in going along with Baker by laughing and joking around with him. Though things had been straightened out and Morrison

was now free the Phoenix trial had given Jim a good scare. He had now seen firsthand that the system didn't always work—at least not the first time around. While waiting for the big one in Miami, Jim had been subjected to a roller coaster of a situation in Phoenix that had drained him and forced a break in the tour, costing the band more money. The experience had served to forge yet another chink in the fading armor of Jim Morrison. To add another nick of their own, the Federal Aviation Association (FAA) announced on the day of Morrison's acquittal that they were considering suing Morrison and Baker for two thousand dollars each to recover damages (a threat they later abandoned).

When the Phoenix adventure was finally over Morrison had this to say: "I was acquitted because the stewardesses mistook me for someone I was with. They were going by the seat number, saying that the person in such and such a seat was causing all the trouble. They all identified me as being in this seat. They were just trying to hang me because I was the only one that had a well-known face. The trouble with these busts is that people that don't like me like to believe it because I'm the reincarnation of everything they consider evil. I get hung both ways."

By April Morrison was changing again. Gone was the frivolity of his earlier days and the good-natured approach he'd adopted at the beginning of the year. He was less playful, more solemn. He smiled less readily and moved slower. He no longer gave the impression of a coil about to spring. Instead he was calm, thoughtful, even resigned. When asked about this change, Morrison shrugged and said with a mocking laugh, "The love-street times are dead."

The Miami trial had been scheduled to start in April, but it was now pushed back to August. While the delay gave Max Fink more time to prepare his defense, it also gave Morrison more time to contemplate his potential doom at the hands of the Establishment. More and more now he began talking of getting away from it all once the trial was over. Some place very different and far away.

The Lords and The New Creatures

Morrison's spirits were greatly lifted when *The Lords and The New Creatures* came out that same month. The hardcover

edition of his writings published by Simon & Schuster was the
first real acceptance of his skills as a poet apart from The Doors.
The book combined two small collections Morrison had pub-
lished himself in 1969 as private editions of a hundred copies
each, *The Lords: Notes on Vision* and *The New Creatures.*

Although Morrison was obsessed with being a poet he had
never thought of selling his poetry until his friend Michael
McClure encouraged him to get it published. Morrison received
the new edition on April 7. McClure remembers: "When the
book had been published and the first copies arrived by mail in
L.A., I found Jim in his room, crying. He was sitting there, holding
the book, crying, and he said, 'This is the first time I haven't been
fucked.' He said that a couple of times, and I guess he felt that
was the first time he'd come through as himself."

The appeal of cinema lies in the fear of death

While *The Lords* contains many interesting insights on vi-
sion in general and cinematography in particular, it is *The New
Creatures* that really shows Morrison's poetic side. Dedicated
"To Pamela Susan," the work resounds with imaginative verse
centering mostly on sexual conflict and is interwoven with im-
ages of pain and death. Some of the poems began as ideas for
songs while others took the themes of songs and explored them
in a new direction. Though the meanings are usually obscure
and shadowy, the language and depth of thought is often fas-
cinating.

> *Cancer city*
> *Urban fall*
> *Summer sadness*
> *The highways of the old town*
> *Ghosts in cars*
> *Electric shadows*

There is little doubt that Morrison had a poet's soul rather
than that of a rock star. His greatest gift was words and his poetry
resounds with a driving rhythm, wild contrasts, and a fierce and
brutal honesty. His insight into the people and places of his era

reverberates across time and stands even today. Morrison's vision took him to the dark underbelly of society and his images are as grotesque as Hugo's beggars and gargoyles, Genet's thieves and murderers, and the tortured souls of Rimbaud.

Diseased specimens in dollar hotels

Morrison had originally thought of the "Lords" as the people who control society, but later the concept evolved into something else: "Now to me, the 'Lords' mean something entirely different. It's like the opposite. Somehow the Lords are a romantic race of people who have found a way to control their environment and their own lives. They're somehow different from other people."

The Lords appease us with images. They give us books, concerts, galleries, shows, cinemas. Especially the cinemas. Through art they confuse us and blind us to our enslavement. Art adorns our prison walls, keeps us silent and diverted and indifferent.

The Lords and The New Creatures sold well in hardcover and a year later was released in paperback. To Jim Morrison, who more than anything else in life wanted to be taken seriously as a poet, this was a special blessing indeed.

The Establishment vs. Jim Morrison

While the ban was off The Doors' concert appearances the pressure was not. After Miami, it had become almost a game for local law enforcement agencies to try to nail Morrison in their city. To the Establishment he was still a threat and every concert was closely scrutinized for a potential incident. Morrison was marked as a troublemaker. It had started with the New Haven bust in December 1967 and snowballed—charges of inciting riots in Chicago, New York, Cleveland, and Phoenix. And it culminated in Miami, where the list of charges took up half a page. James Douglas Morrison, FBI number 511–448–F, was clearly a man for the bureau to be wary of. His record included

arrests for drunkenness, petty larceny of a police helmet and an umbrella, battery, lewd and obscene performance, breach of peace, resisting arrest for vagrancy, drunk driving, no valid operator's license in possession, lewd and lascivious behavior, and interfering with the flight of an aircraft to name a few. And these were only the times he'd been caught and charged.

Morrison was the perfect symbol for everything the Establishment detested. His very presence made the cops uptight. Right from the beginning he made statements like "I've always been attracted to ideas that were about revolt against authority. When you make your peace with authority, you become an authority. I like ideas about the breaking away or overthrowing of established order. It seems to be the road toward freedom."

Part of the trouble had to do with stardom. Touring exposed Morrison to a variety of police officials and there were things he regularly got away with in L.A. that got him busted elsewhere. After all, it was one thing to be lewdly suggestive in the relaxed morals of Hollywood, for example, and quite another in Bible-bred Peoria. Morrison's public had an insatiable appetite for the outrageous, the wild, the unpredictable—and his beliefs made him feel responsible to give it to them. And despite the resulting risks and legal hassles, everybody knew the escapades usually meant more record sales and more attention focused on The Doors. But when the fists of society's outrage came down, it was on Morrison alone.

"Jim became a figurehead," Manzarek recalled. "They were going to stop all of rock 'n' roll by stopping The Doors. As far as Americans were concerned, he was the most dangerous . . . Janis Joplin was just a white woman singing about getting drunk and laid a lot and Jimi Hendrix was a black guy singing let's get high. Morrison was singing, 'We want the world and we want it now.' They called us the Kings of Acid Rock, so there was plenty of hounding. It's always hardest for the groundbreakers. You come up against the morality of a country for the first time and the shit's gonna hit the fan, man."

Morrison said it this way to Jerry Hopkins in *Rolling Stone*: "You can do anything as long as it's in tune with the forces of the universe, nature, society, whatever. If it's working, you can do anything. If for some reason you're on a different track from other people, it's going to jangle everybody's sensibilities. And

they're either going to walk away or put you down for it. So it's just a case of getting too far out for them . . . As long as everything's connecting and coming together, you can get away with murder."

The busts took their toll on Morrison though. The canceled tour and radio ban had hurt his finances considerably and his public image and self-esteem had never fully recovered from Miami. By April 1970 he was still reeling from the effects of one federal trial and about to face another. And the FBI had marked him. It was they who had made the charges in Miami stick and they had played a significant role in the airplane bust. As far as they were concerned, Morrison was guilty before he was arrested. But the particular crimes were not the problem. The real issue was because he was guilty of being Jim Morrison, a larger-than-life symbol of rebellion to the youth of America and thereby a threat.

The busts cost Morrison a great deal of money, but more than that they wore him down and sapped his enthusiasm for life. "The vice squad would be at the side of the stage with our names filled in on the warrants, just waiting to write in the offense," Manzarek recollected. "Narks to the left, vice squad to the right, into the valley of death rode the four. . . They wanted to bust Morrison—Morrison and The Doors. They did it in Miami; well, by God, we'll bust them in Cincinnati, we'll bust them in St. Louis, Chicago, Minneapolis; I mean name your major city, they were all out to bust The Doors. They couldn't bust The Beatles because they were nice—'All You Need Is Love'—and The Stones were from England, and yeah they were bad, but those fuckin' Doors—those were the ones. They all wanted to stop Morrison. They wanted to show him that he couldn't get away with it—he was going to far. But he always said to the Establishment, 'Fuck you. You're not going to stop me.'"

The Doors felt the cops were there almost to goad Morrison into doing something unlawful. Most of the band's performance contracts now included a clause that freed the promoter from any responsibility to pay the group if Morrison lost his cool onstage. "There were two forces working," Robby Krieger recalled. "One force of change and the other force that wanted things to stay the same . . . It didn't bother me that much, but it sure did Jim. He was the one getting busted all the time."

The following FBI record, NUMBER 511 448 F **FOR OFFICIAL USE ONLY**

CONTRIBUTOR OF FINGERPRINTS	NAME AND NUMBER	ARRESTED OR RECEIVED	CHARGE	DISPOSITION
Tallahassee, Fla.	James Douglas Morrison #19324	9–23–63	drk PL of police helmet & umbrella	
Inglewood, CA.	James Douglas Morrison #A–30794	1–23–66	batt	dism
Los Angeles, CA.	James Douglas Morrison #LA 813 311–M	2–11–67	647f PC (drk.)	
New Haven, Conn.	James Morrison #23750	12–10–67	lewd & obscene perf. B of P resisting	bond forfeit
Las Vegas, Nev.	Jim Douglas Morrison #132938	1–28–68	Vag Drunk	
Los Angeles, CA.	James Douglas Morrison #C–663112	2–7–68	Drunk Driving Misd. And No Valid Operator's License in Possession	
Los Angeles, CA.	James Douglas Morrison #9053–28055	4–3–69	U.F.A.P. lewd & lascivious behavior	TOT LA Co.CA.SO 4–14–69 for extradition to Fla.
Safety Dept. Miami, Fla.	James Douglas Morrison #129247	11–9–69	lewd & lasc behavior/ind exp/open profanity	
PD Phoenix, Ariz.	James Douglas Morrison #635205	11–11–69	interference w/a flight of an aircraft	
USM Phoenix, Ariz.	James Douglas Morrison #2137 b 69	11–12–69	crime aboard aircraft	

Despite the police harassment (or maybe because of it), the concerts in January and February passed without trouble, but the specter of Miami lingered in the shadows. Sooner or later, something was bound to give. As it turned out it happened in Boston. Morrison had gotten drunk for the April 10 show, but still performed well. The Doors, like on so many other dates, were really into playing and didn't want to stop. Though they had been performing for two solid hours, they ignored the promoter's request to stop playing. At around 2 A.M. the hall management decided to take matters into their own hands and unplugged The Doors. The power was cut in the middle of a song and all the equipment suddenly went dead. As fate would have it, for some reason the center microphone was still working long enough for Morrison to angrily respond to the shutdown with a loud, "Those cocksuckers."

The ever-vigilant Ray Manzarek reacted quickly, running over and clamping Morrison's mouth shut with one hand and half carrying him across the stage. Breaking away from Manzarek, Morrison charged back toward the audience yelling, "We should all get together and have some fun, because the assholes are gonna win if you let them."

Fortunately for The Doors, the crowd was probably too tired to riot. After a bit more raving, Morrison grabbed the mike stand and slammed it repeatedly into the stage floor and then left. Unfortunately, the manager of the Salt Lake City arena was also at the Boston show and he immediately canceled The Doors' performance scheduled there for the next night. Rich Linnell, who was promoting the Salt Lake City show, remembers: "I was sitting in a hotel room in Salt Lake when Bill Siddons called and told me the news. The hall manager there was a pretty good guy, but his board had asked him to see the band first, so he told me to pick a date where I didn't think there'd be any trouble—I picked Boston. We lost our hall deposit and all the money we'd spent on advertising and the thing about it was that Boston was a really good show."

Morrison's stormy relationship with Pamela continued on a somewhat more even keel. What with his court and concert schedule and her activities with Themis they were better able to give each other the distance that Jim required and Pam abhorred.

When *Jazz & Pop* gave *The Lords and The New Creatures* a

favorable review, Morrison sent Patricia Kennealy a telegram thanking her. On the first of May, when The Doors played the Spectrum in Philadelphia, Patricia showed up to see him. She explained she was in Philadelphia to visit other witches and they made arrangements to get together in New York after The Doors played the Civic Arena in Pittsburgh the following day.

In New York, Morrison stayed with Kennealy. One evening, they went to the Fillmore East to see The Jefferson Airplane and Jim chatted with Allen Ginsberg in the lighting booth during the show. The Airplane concert set off Morrison's old rivalry with the San Francisco group when Grace Slick, aware that Morrison was in the audience, put down a heckler by saying, "Oh, I see Jim Morrison is here tonight." Jim shrugged it off, but later criticized The Airplane's music to Patricia.

At the end of April, President Nixon announced that U.S. combat troops were moving into Cambodia in an offensive against Communist border sanctuaries. The move, referred to as an "incursion" by the government, was not sanctioned by Congress. By this time forty thousand Americans had been killed in the war and few issues stirred emotions in the way that Vietnam did. Though Nixon reasoned that entering Cambodia was necessary to halt the Viet Cong raids, the youth of America saw it as another expansion of the war and cries of protest rang out all over the country, including one particularly tragic incident on May 4 at Kent State University.

It had taken half a century to transform Kent State from an obscure teachers college into the second largest university in Ohio with twenty-one thousand students, but it took only ten terrifying seconds to convert it into a bloodstained symbol of the rising student rebellion. After Nixon's announcement, the protests at Kent State had been especially hostile. Ohio national guardsmen, already weary from several days' keeping the peace at wildcat Teamsters strikes, were called in on Saturday, May 2, after students burned down the campus ROTC building in protest. The students began rioting in downtown Kent but dispersed when the guardsmen appeared. On Monday the trouble started when a thousand students gathered to protest while at least twice that many watched from nearby walks and buildings. The nine hundred guardsmen ordered them to evacuate the area, but the demonstrators refused. The guard began firing tear gas can-

isters, scattering the crowd. As they pursued the fleeing students, a group of about a hundred guardsmen found themselves suddenly cut off by a fence and flanked by rock-throwing demonstrators. The protestors were too far away to hit anyone, but many began to taunt the guard while the spectators cheered. At this point the guardsmen ran out of tear gas and became frightened, retreating back up a nearby hill. While their squad contained a few officers, they had been separated from their designated leaders and were unsure what to do next. When they reached the top of the hill many knelt and pointed their rifles at the students, a handful of which were still coming at them throwing rocks. Then it happened. A volley of shots rang out from about fifteen guardsmen and four innocent people were killed.

The victims—Allison Krause, Jeffrey Miller, Sandra Scheuer, and William Schroeder were not involved in the protest in any way. In fact, two of them were on their way to class and were quite far away from the confrontation when they were hit by stray bullets. Ten more students were wounded, three of them seriously. Students reported that the guardsmen made no move to help the victims, being frightened themselves. Later, several students reported they'd seen an officer raise his baton and claimed that the moment he dropped it was when the shots rang out. Many witnesses said the guard was organized, pointing and firing at the same time like a firing squad.

The nation was shocked by the tragedy. A national student strike followed which affected 441 universities across the country, shutting many of them down entirely. The incident woke up a lot of people and antiwar fever surged upward. The horrors of the Vietnam war had come home at last.

When The Doors heard about Kent State they tried to arrange a concert there, but they were refused. But on May 8, good times were in order in Detroit when The Doors put on one of the best shows the city had seen in a long time. Once again, Morrison had problems ending the show however: Although the band had been contracted to play until midnight, Morrison decided they should go an extra hour. "Don't let them push us out," he shouted to the crowd pressing at the stage. And this time they backed him up. The music reigned supreme and the concert went on until Morrison decided it was over.

The Seattle concert on June 5th was a disaster. There, Morrison received what one reporter described as the "coldest reception this town has ever accorded a superstar." It may have been because the last show in Seattle was poor and it surely was because much of the country's attitude seemed to be asking, "Who the hell does this Jim Morrison think he is anyway?" But mostly it was because Morrison had decided to get drunk before the show. He dawdled for periods of up to ten minutes between songs. It was reminiscent of Miami in that the band would launch into a song and Morrison would just ignore them. Clad in a simple blue T-shirt and black pants, with his beard back again, he paid no attention to the clamor of the crowd. After a while the young kids started shouting for "Light My Fire" but when Morrison ignored them someone called out, "Sugar, Sugar . . . anything!" The more they shouted the more remote he became. At one point he described Seattle as "a 1930 version of twenty years in the future." No one got the joke. Ray, Robby, and John seemed powerless to do anything and just kept looking at each other, shaking their heads. "Give the singer a chance," Morrison pleaded at one point. "I haven't been to Seattle in two years." The audience rebutted: "You were here last summer!"

Later in the show Morrison began playing with the microphone, making it squeal and feed back. In his drunken stupor this fascinated him and he kept it up for several minutes. He was like a kid who wouldn't stop playing with a toy. Ray Manzarek remembers: "He'd had too much to drink and he held the microphone into the monitors and worked feedback for fifteen minutes! We played two concerts in Seattle and both of them were just . . . Jim was drunk out of his mind and just fed the feedback god. They never got a good concert out of The Doors in Seattle."

Vince Treanor also remembers Morrison's "feedback concert." "He got onto the mike and started doing this feedback thing. He kept doing it and doing it. I was sitting to John's left, behind the amp and finally John couldn't take it anymore. He turned around and hit me with his drumstick. 'Make him stop it,' he snapped at me. I said, 'I can't make him stop unless I shut the mike off and then who knows what the hell he'll do.' Finally, Jim stopped and went on to something else. After the show I talked to him and said, 'Jim, this is totally out of line. These people don't

want this.' And he said, 'Okay, I shouldn't have done that. I'll try better next time.' The audience didn't want to see a drunken lout stand up onstage, make a fool of himself, disgrace his fellow group members, and put on a show that was worse than many I had seen by high school kids."

And Jim Morrison didn't want it either. But he couldn't stop himself. Though the band had been revitalized with both a highly successful concert tour and a smash album, the inner turmoil in Jim Morrison had not lessened. His drinking was becoming intolerable. He would often vomit or urinate in public now without any warning and seemingly without much desire to control it. And he was still taking risks. One of his favorite tricks now was to jump out of a moving car. Often he would drop by to watch his friend Vincent Furnier rehearse (Alice Cooper) and more than once he talked one of the band members into driving him up into the Hollywood hills at high speed so he could throw himself out of the car.

Despite the renewed success of the band Jim was not convinced The Doors were back. For one thing, *Morrison Hotel* had no hit single. Neither "Roadhouse Blues" nor "You Make Me Real" fared all that well in the Top 40. Weighed down by the threat of prison and the police dogging him at every public appearance, Morrison was burning out. He enjoyed performing sometimes, but the hassles of touring dragged on him. He had been taking stock of himself and his situation ever since the Miami bust. Poetry and films were becoming increasingly important to him and Morrison continued to channel more of his energy into areas other than music.

He began working with Michael McClure on several different projects including a screenplay which Morrison described this way: "It's called *The Adept* and it is based on one of Michael's unpublished novels . . . It reminds me of *The Treasure of Sierra Madre.* It's about three cats in search of a psychic treasure . . . a young guy named Nicolas who lives in New York . . . a friend of his named Rourke who's a revolutionary-turned-neocapitalist, and they both have long hair . . . they fly to Mexico and meet up with a black cat named Derner. They venture out on the desert to meet a half-breed border guard to make a score."

It was about this time that Michael Ford approached Jim concerning another project. "For several years I had been trying to

put together an anthology of poetry to raise funds to cover medical expenses for the poet Kenneth Patchen," Ford recalls. "After I lined up all the contributors I went to Jim and he gave me the money to put it out. It was called the *Mt. Alverno Review.* Each poet had his own page, like a tiny broadside, and we had Charles Bukowski, Jack Hampton, Jim, and nine others. Jim contributed a poem that began 'We reap bloody crops on war fields.'"

I

In the months after the tour, Morrison let his beard grow out again and gained more weight. The decline in his physical appearance was rapid now. Many of those who knew Morrison consider his sizable and rapid changes in appearance indicative of the two sides of his personality. Recording engineer John Haeny elaborates: "There were really two people there and they were visible physically. When he had to do a performance the beard was gone, the rock star clothes went on, and he was a rock 'n' roll star. But as soon as he didn't have to be on the road, the beard grew, and he put on a little weight. He took on this rather Allen Ginbergish kind of appearance. If people would have been wise during that period of time, he could have been seen walking up and down Santa Monica Boulevard, reading, sitting, and thinking, hours and days on end. Same person. Two personalities guided by one mind. My belief is that his mind was the mind of the man with the beard not the rock star."

There is no question that Morrison had mood swings, but then so do most alcoholics. In Jim's case, however, it seemed like more than that. He would often change from being kind and receptive to brutal and insulting with no apparent provocation. Some say the internal battle was between the poet and the rock star, but you could also argue that Morrison was part sage and part maniac, a kind and gentle spirit and an utter madman. Psychologists call it schizophrenia, spiritualists call it possession. Most people that knew Morrison just called it weird.

Frank Lisciandro described Morrison's appearance changes: "He ceased being other people's image of him. He changed, he developed new skills, put on weight, grew a beard, shaved it off, and grew it back again. He became himself. Jim changed on the outside because his mind was evolving into new levels of awareness."

∎

Not everyone agrees about Morrison's changing appearance being indicative of his inner conflict. Robby Krieger is one of them: "Bunch of hogwash. I don't think he purposely wanted to change his image from a rock star to a drunken bum, you know. I think it just happened that way because . . . he'd start drinking too much and so he got sloppy and fat. I don't think he wanted to be that way at all, 'cause I remember he tried out for a couple of movie parts . . . a Steve McQueen movie and stuff, and I could see that he was real embarrassed at the way he looked . . . For the one, he cut his beard and cut his hair, and he looked pretty bad. I think he thought he would look just like he used to if he cut all his beard and stuff off, but he looked terrible. He looked like Engineer Bill or somebody. He always wore these Engineer Bill pants. He came back from the interview and he was pretty embarrassed. So I don't think he purposely tried to look that way like some people would say."

Shortly after the tour was over Morrison concluded a verbal deal with MGM to finish *The Adept* and coproduce and star in the film as well. He also agreed to lose some weight for the project. As soon as the deal was arranged, he took off for Europe, hoping to escape the madness of L.A. for a while. Morrison had long desired to visit Paris, which held a great fascination for him as a historic center of the arts. Before heading overseas, however, he had an important stop to make in New York. The recording for the live album had concluded with the end of the *Morrison Hotel* tour and he was entrusted with delivering the tapes to Elektra for mastering.

In New York, Morrison went straight to Patricia Kennealy's office and she recalls that from the day he arrived they "wore each other to ruins." Once Jim pulled out her diaphragm just before they made love—something that was to result in unhappy consequences. The romance climaxed with their getting married in an ancient witch's ceremony known as handfasting. Since it was a pagan Celtic rite, it was not recognized as a legal wedding, but the ceremony was binding to practitioners of the religion, according to Patricia Kennealy. "It was a sworn oath before powers that Jim respected and understood—you only have to listen to his words to know that. He may not have entirely ac-

cepted it all on his own, but he did because I did. This wasn't something he had to do—he did it because he wanted to and because he knew it would give me great joy."

Jim and Patricia wore black robes for the ceremony as did the officiating high priest and high priestess. The two women also wore silver crescent moon crowns and jewelry. Like shamanism, the heart of the primitive Celtic religion is celebrating and invoking power from nature. The wedding was held on June 24 which in medieval times was known as Midsummer Day. Patricia describes the ceremony: "A magical circle was cast with a consecrated sword and invocations were made to the guardians of the Four Quarters and everyone was then purified by earth, air, fire, and water. Jim had to take a ritual bath of purification beforehand. After a charge was read by the priestess (similar to the "speak now or forever hold your peace" part of the usual wedding ceremony), we took our vows. Small cuts were then made on Jim's right hand and my left with a Scottish dagger and a few drops of blood from each of us were mixed into a grail of concecrated wine. Our wrists were then pressed together and bound with a red cord and we drank from the grail and exchanged wedding rings."

The rings were Irish *claddaghs,* two hands holding a crowned heart. Patricia's ring was silver and Morrison's was gold. "Today I wear both rings on my left hand," Patricia says. "Pamela returned Jim's ring to me after his death. The rings are traditional Irish wedding rings, but most people don't know that they symbolize the Sacred Marriage of the Goddess and the King."

The ceremony concluded with the couple stepping over fire and a sword and then Patricia drank the remainder of the blessed wine and blew out the altar candle that represented the presence of the Goddess. It was at this point that Morrison fainted. "Jim did pass out," Kennealy recalls, "but it wasn't because of the blood. Jim fainted because when a magical circle is constructed for a ritual, a tremendous amount of energy builds up inside. Because the circle contains the energy, it becomes magnified. It was unbelievably intense even for me and the two other witches and for Jim it was overpowering. He told me afterward that it felt like somebody enormous pressing down on him from all directions on the outside—as if he was imploding."

Later, after Morrison was revived, the high priest presented a

wedding document written in witch runes and the couple signed it in ink and added a few drops of blood to seal it. Then, when they were alone, they made love inside the magic circle.

Wild sounds in the night
Angel siren voices

The next day Morrison became very sick and it turned out he had developed pneumonia. How much the condition may have been related to the ceremony is not known, but with Patricia's help he was soon healthy again. As soon as he recovered, Morrison went ahead with his vacation, going off to Paris with Doors publicist Leon Barnard. Many people have taken this to mean that he didn't take the wedding seriously, but Kennealy disagrees: "We had talked about getting married when he came to New York after I'd seen him in Philadelphia. He proposed to me right in the middle of Central Park on a lovely spring afternoon. On one knee or both? That's my secret. Anyway it was not a traditional relationship and it was not a traditional wedding, not even legal. But whether people like it or not, it *was* a real spiritual commitment and I am the only woman with whom he ever went through any form of wedding ceremony. We seemed to like and need the long-distance thing. I don't think we necessarily wanted to be around each other all the time which, frankly, suited me very well. I didn't exactly see Jim and me in cozy domesticity, having to wash his socks or whatever. I'm not the sock-washing type."

While in Paris, Morrison connected with Alan Ronay. Ronay worked at the company that processed the film for *Feast of Friends* and *HWY* and had often talked about Paris to Morrison. While there Jim saw the sights for a week like any other American tourist and then went to Spain and North Africa for two more weeks. He relaxed and tried to get the pressures of the group, the Miami trial, and life in L.A. off his mind. When he returned to L.A., Morrison had a recurrence of the pneumonia he had contracted in New York. But, true to form, he bounced back quickly and by the time Elektra released the long-awaited live album he was at full strength.

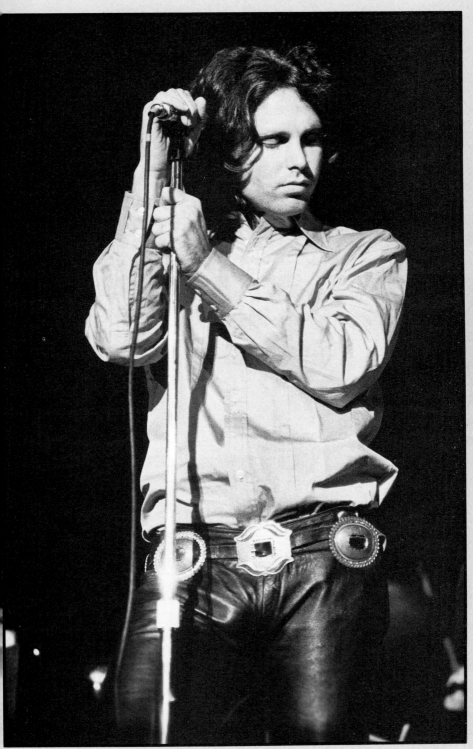

Performing in Minneapolis in November 1968 PHOTO BY MIKE BARICH

With Pam at a party in 1968

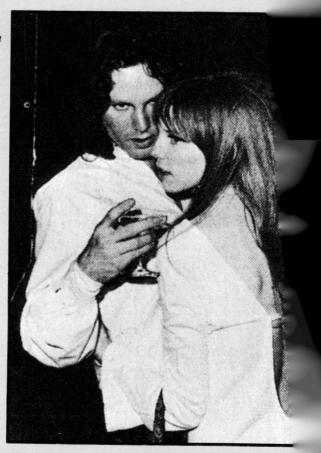

The Doors onstage in Minneapolis PHOTO BY *MIKE BARICH*

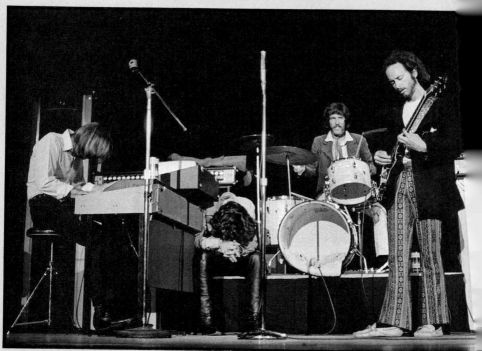

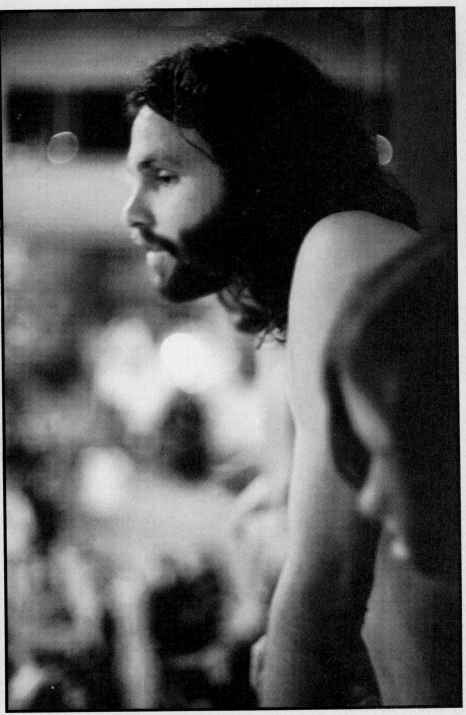

Seconds after the Miami concert ends, Jim Morrison emerges from his dressing room to stare down at the chaos below like the Phantom of the Opera. Photographer Jeff Simon said Morrison looked as if he were awakening from a trance. PHOTO BY JEFF SIMON

Patricia Kennealy
PHOTO BY DAVID WALLEY

Morrison and Patricia Kennealy PHOTO BY JANICE COUGHLAN

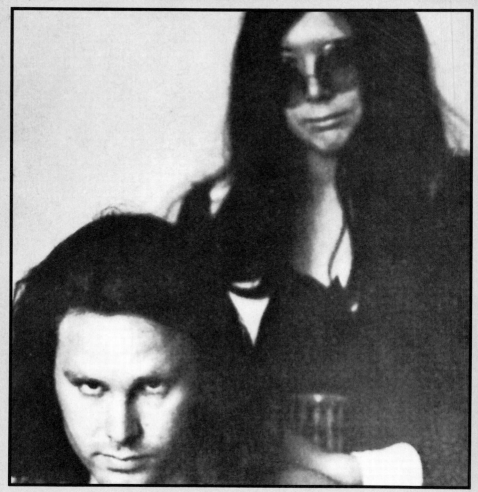

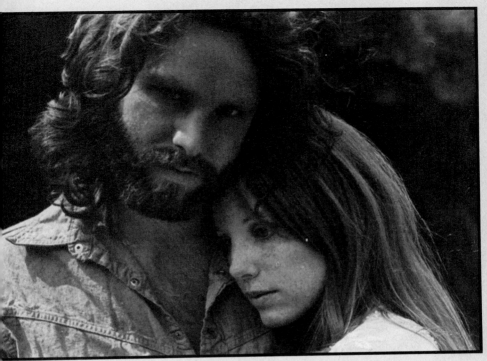

Jim and Pam in the Hollywood hills PHOTO BY EDMUND TESKE

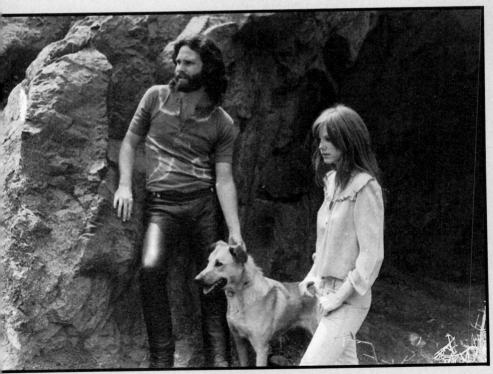

Jim and Pam with their dog, Sage PHOTO BY EDMUND TESKE

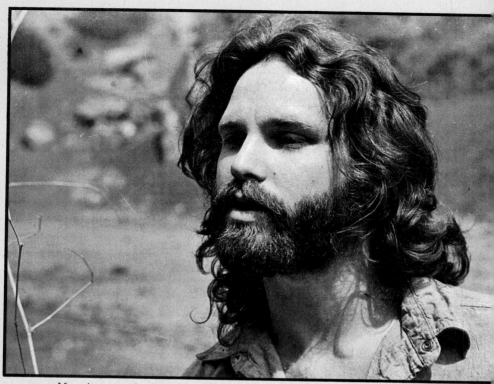

Morrison at the Bronson Caves in Hollywood PHOTO BY EDMUND TESKE

*Patricia Kennealy and Tandy Martin with a self-portrait that
Morrison painted for Tandy* PHOTO BY DAVID WALLEY

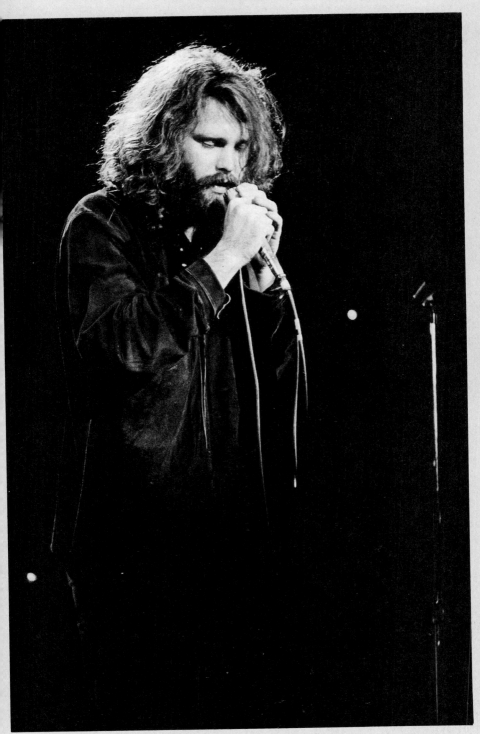

Morrison back onstage after the Miami ban PHOTO BY MIKE BARICH

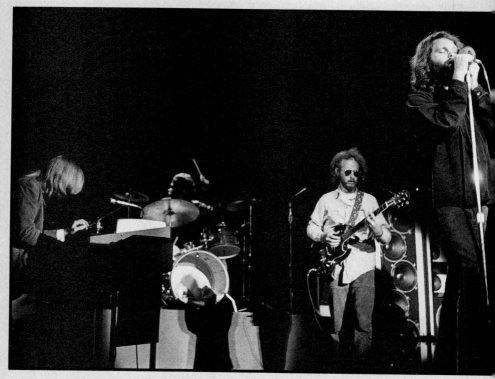

The Doors performing in Minneapolis in Jun 1969 PHOTO BY MIKE BARICH

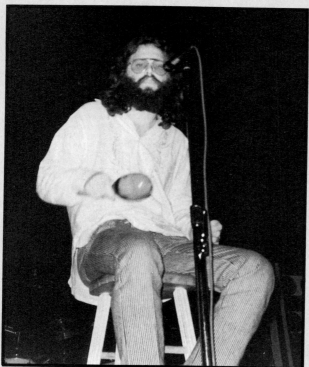

During the sound check at the Aquarius Theater in July 1969 PHOTO BY BILL MUMY

*im and Pam in late
1969 PHOTO BY RAEANNE
RUBENSTEIN

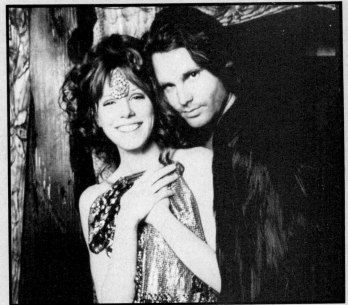

*At Themis, Pam's
boutique, with friends*
PHOTO BY RAEANNE
RUBENSTEIN

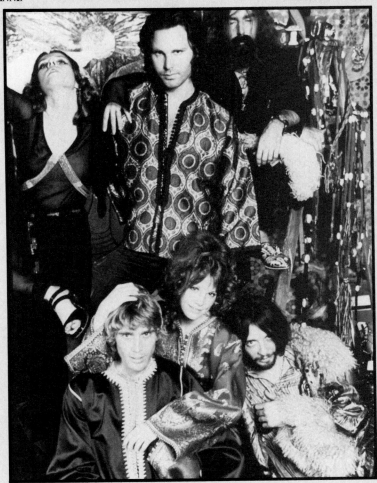

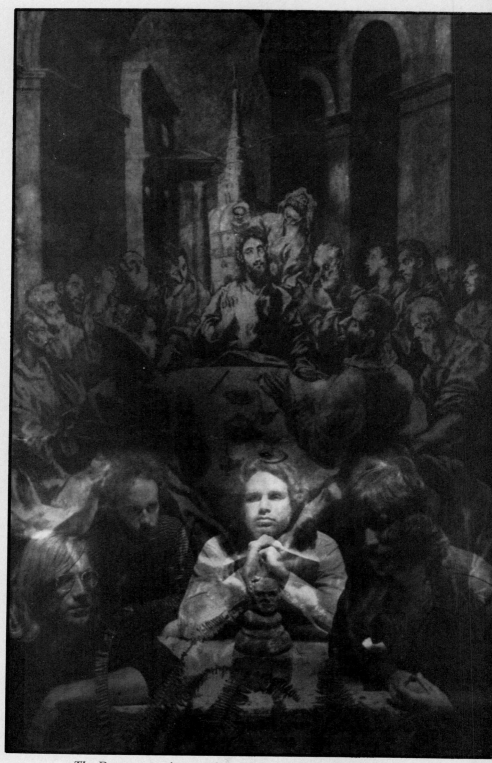

The Doors superimposed on El Greco's "Last Supper." PHOTO BY
EDMUND TESKE

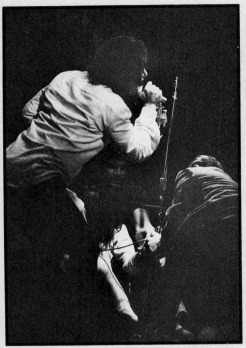

Jim and Pam's mantelpiece from late 1969 with an upside-down doll's head and earlier photo PHOTO BY EDMUND TESKE

Swamped by fans at the Felt Forum in January 1970 PHOTO BY JANICE COUGHLAN

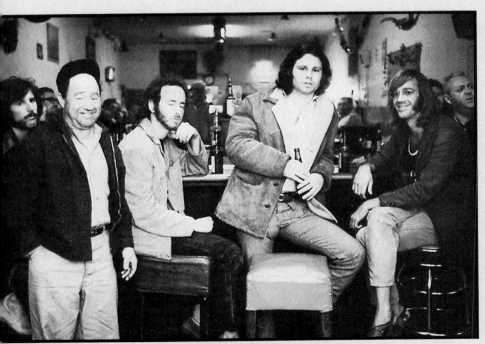

The Doors at the Hard Rock Cafe—an outtake from the inside cover of Morrison Hotel *photo session PHOTO BY HENRY DILTZ*

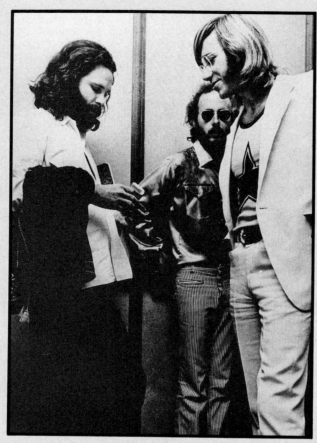

Outside the Miami courtroom with Ray and Robby PHOTO BY THE MIAMI HERALD

On trial as attorney Max Fink speaks to t*he jury* PHOTO BY THE MIA*MI* HERALD

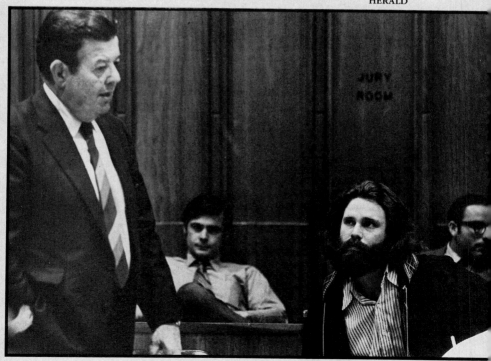

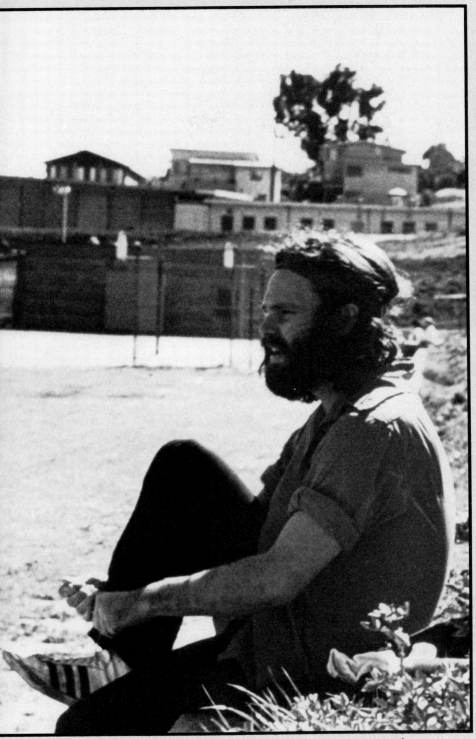

Jim preparing to play touch football shortly before leaving for Paris PHOTO BY KATHERINE LISCIANDRO

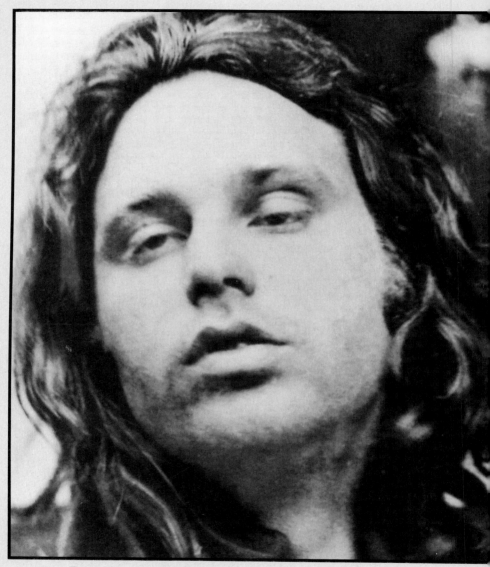

Escaping through alcohol during the last days of his life in Paris
PHOTO BY HERVE MULLER

Pamela Courson as she looked around the time of Jim's death PHOTO BY HERVE MULLER

The surviving Doors as they appeared in 1987 PHOTO BY PETER BORSARI

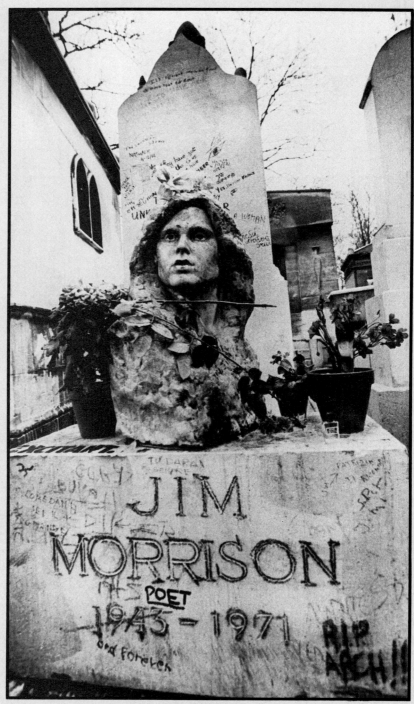

Jim Morrison's grave PHOTO BY AP/WIDE WORLD PHOTOS

Absolutely Live

The *Absolutely Live* album was made up of concert record-
ings from July 1969 to May 1970. It was an "organic
documentary" covering a year of performances and spliced to-
gether to sound like one ideal eighty-minute set. The concerts
represented included the Aquarius Theater in L.A., the Felt
Forum in New York, the Boston Arena, Cobo Hall in Detroit, the
Spectrum in Philadelphia, and the Civic Center in Pittsburgh. Pro-
ducer Paul Rothchild elaborates: "I made that album at one of the
hottest points in their career. We couldn't have done it earlier
and had it sound good from a recording standpoint. You wouldn't
believe what we had to do to make it, how many *centuries* of
tape we had to glean to make that fairly skinny double-record set.
I couldn't get complete takes of a lot of songs, so sometimes I'd
cut from Detroit to Philadelphia in midsong. There must be two
thousand edits on that album. On some of the cuts, Jim was
drunk, but that went with the territory. Some of it was terrific,
though, and that's on there too."

Bruce Botnick remembers engineering the album. "I used
some stereo microphones and special techniques, generally ex-
perimented. Robby, Ray, and John each had ten columns of amps
and Jim had twenty. They set the levels and balanced themselves
onstage, there was no mixer out in the audience. To record them
I miked it. I took a lot of it direct. It was eight tracks. I used one
stereo microphone for the audience. There was no rerecording
in the studio. None. It's truly a live record. As it says on the
record, recorded live except for editing and sequencing, there
were no overdubs."

It is due to the abundance of material recorded for
Absolutely Live that many "new" Doors tracks have been re-
leased in recent years. Robby Krieger explains: "'Roadhouse'
came out right before we started working on the live album, so
we figured we couldn't put it out live so soon afterward. In fact,
there was another thing we were going to use, but we had some
trouble among ourselves as to whether we should use it. That
was 'Gloria.' Jim always liked to do 'Gloria' onstage and we al-
ways figured we'd like to get a version of it out on some kind of
record some day."

Absolutely Live became a classic party album and is still

popular to this day. The recording captures Morrison's high spirits during the *Morrison Hotel* tour. Musically, Manzarek's wizardry can truly be appreciated for the live record makes it clear how hard he had to work onstage. The band fluctuates quite a bit, but this faithfulness to the live sound is part of the album's appeal. This is the real stuff, raw and uncut. While it's obvious Morrison was drunk on "Back Door Man" what would a Doors live album be without Jim being drunk on at least one of the cuts?

Absolutely Live includes six songs not available on any other Doors recordings—"Who Do You Love," "Love Hides," "Build Me a Woman," "Close to You," "Universal Mind," and "The Celebration of the Lizard." "Who Do You Love" opens the album. It was written by Bo Diddley and features Krieger's squealing slide guitar. The medley that follows includes "Alabama Song," "Back Door Man," "Love Hides," and "Five to One." "Build Me A Woman" opens side two and "When The Music's Over" finishes the first record. The second disc begins with Morrison's great rap from the Pittsburgh show leading up to "Close To You" on which Ray Manzarek sings lead. "Universal Mind" is next and then "Break On Thru #2" which begins with a startling reverb chamber explosion followed by the "Petition the Lord" intro from *The Soft Parade*. "The Celebration of the Lizard" follows, and after much cheering, "Soul Kitchen" provides an exciting encore and a fitting finale to the album and "concert."

One of the real highlights of the record is Morrison's humorous raps on life and liberty in concert hall America. "Now is that any way to behave at a rock 'n' roll concert?" he asks at one point. Later, he stops "When The Music's Over" and screams at the audience to "shut up." Then, while Ray Manzarek dutifully plays a two-note organ riff over and over, Morrison says, "You don't wanna hear that for the next half hour, do you?" The lead-in to "Break On Thru #2" is classic Morrison street poetry: *Dead cat in a top hat ... Thinks he's an aristocrat/That's crap ...*

"Build Me A Woman" begins with "I got the poontang blues," but the best rap of all is the intro to "Close to You," where Morrison makes light of himself and the infamous Miami incident while attempting to announce Ray Manzarek will sing lead: "Ladies and gentlemen ... I don't know if you realize it but tonight you're in for a special treat [the crowd then cheers

wildly]. No, no, not that, not that . . . last time it happened grown men were weeping, policemen were turning in their badges . . ." It's the best example of Jim Morrison poking fun at himself and reveals a sense of humor that was much greater than most people of the time thought possible. The Doors weren't afraid of being foolish, especially Morrison. Anyone who had the courage to go back onstage after Miami marked him as a clown of epic proportions was not afraid to laugh at himself.

Perhaps the most significant contribution *Absolutely Live* makes to The Doors legacy is that it captured Morrison's epic poem "The Celebration of the Lizard" on record. What The Doors couldn't do on *Waiting For The Sun* was accomplished via live performance. The sprawling theater piece is too disjointed to easily digest, but parts are dazzling. After an intro of random drumbeats and percussion, Morrison shouts, "WAKE UP!" as a violent organ passage builds the tension. Manzarek introduces the singsong segment: *I think you know the game I mean/I mean the game called 'go insane.'* Morrison's voice turns to an instructive sage for the next section and then the "Not To Touch The Earth" segment picks up the pace, allowing the band to erupt in a surge of solos. The next part releases some of the tension before the epic's final verse, delivered almost impassionately and accompanied only by the same sort of eerie percussion heard at the beginning of the piece. As the instruments drop out, Morrison finishes the work completely alone, to a huge ovation.

The poem stands as one of Morrison's most impressive works and connects many of his dominant themes and ideas. Although it's clear why Rothchild and the others felt the music was simply too diverse for the *Waiting For The Sun* album, the disruptive atmosphere of a live recording compensates somehow, resulting in a piece that makes up for its strangeness with moments of great imagination.

Jim Morrison had this to say about *Absolutely Live:* "I think it's a fairly true document of what the band sounds like on a fairly good night . . . There are a few cuts that were done for the first time onstage . . . that have flaws in them, but I don't think it's significant. People don't realize how different playing live is from recording. You work for days to get an instrumental track and hours to get a vocal . . . in a live thing, it's just that one shot."

As August and the Miami trial approached, Morrison began

to get nervous. After returning from Europe, he spent the majority of his time trying not to think about the upcoming trial, but it played heavily on his mind. He made fun of it in an interview with Howard Smith of *The Village Voice*: "I might even buy a suit to make a good impression on the judge and jury . . . Suit and tie . . . Kind of a conservative dark blue suit. Not one of those paisley ties, but more of a . . . instead of those narrow, those real thin ties, I'd like a big fat tie with a great big knot. I think I'll get a suit and take a lot of tranquilizers and just try to have a good time. Maybe I'll keep a diary of the whole thing and publish it in *Esquire* or something. My impressions of my hanging."

In the beginning of August, he got so drunk one night that he couldn't find his way back to the house he shared with Pam and wound up being left by a friend on a stranger's doorstep. Unfortunately, the house belonged to an old woman who, upon seeing him the next morning, immediately assumed he was another Charles Manson and called the police. Jim was booked on a charge of public drunkenness. By midmorning he was out, however, and the next day he was on a plane for Miami.

> *Those who Race toward Death*
> *Those who wait*
> *Those who worry*

ON TRIAL

In the beginning, the trial was big news. Max Fink, Morrison's attorney, described the media uproar as "the biggest thing to hit Miami since Columbus landed!" Morrison, a native son, was coming back to be tried in his home state. How ironic it was that *The Miami Herald* reporter who had stirred up the controversy, Larry Mahoney, had also attended Florida State University in 1963, the same time Morrison was there. There were more ironies: prosecutor Terrance McWilliams was an ex-guitar player and Morrison had been one of his idols. Judge Murray Goodman was originally appointed to fill a vacancy on the court and was up for reelection in November. Surely he knew that the publicity from the Morrison trial could brighten his prospects. To top it off, the judge may have had some resentment for Morrison's Miami attorney, Robert Josefsberg, who had been offered the vacant seat on the court before Goodman but had turned it down. It was shaping up to be quite a battle. For

the next forty days, the state of Florida would try to prove beyond reasonable doubt that Jim Morrison was obscene.

Before the trial Morrison made light of it, but deep inside he was fearful. Having been raised in Florida, Morrison was well aware of the reputation of Raiford State Penitentiary, one of the toughest pens in the South. He knew even a short sentence there might turn out to be fatal for him. Vince Treanor elaborates: "Jim was afraid of jail. And he found out they meant business when they said 'Morrison, just get up there and keep your mouth shut,' and that scared him. When the authority he had so little respect for clenched its fist and held it two inches from his face, it scared the shit out of him because he was terrified of jail."

Miami became a larger issue to Jim Morrison than his personal well-being. It was Morrison against the Establishment. Morrison represented the politics of feeling, of freedom and emotion. This clashed hard with the bastion of unfeeling, rigid insentience that ruled in the courtroom. They were the "arms that chain" and the "eyes that lie" and they wanted to make an example of him by slamming him in jail and throwing away the key. Not only were the cards stacked against him, but the game was being played in the state of Florida.

Of course, these kind of odds were not new to Morrison. He had always beaten society at its own game and now he went to Miami ready to beat the law at the law. He was ready for the biggest challenge, the one with the greatest risk and the largest pot. Both rock 'n' roll and Jim Morrison were going on trial and if Morrison could win, he would be proving more than his innocence. He would be proving that he had been set up as a symbol, a warning to the youth movement in general and the rock stars that led it in particular. If he could win, he would be shoving that warning back down the throat of the very powers that most wanted him and those like him out of the way. If he could win and win convincingly, it would be a victory of the youth against the Establishment, of the powers to be against the powers that were, of the future against the past. Yes, they had the guns, but we still had the numbers.

A year and a half had passed since the night of the infamous concert at Dinner Key Auditorium in Miami. Eighteen months for Morrison to think about it, to dwell on what might happen to him. And now he was back in Dade County to stand trial.

Dread the milk'y
Coming of the day

The Prosecution

The prosecutor who originally filed the charge against Morrison was Alfonso Sepe, the assistant state attorney. Sepe was about to run for a judgeship and it was no secret that he felt putting Morrison up on charges would get his name in the limelight. Prosecuting attorney Terrance McWilliams remembers the climate in Miami at the time: "In the beginning it was very politically charged and that had something to do with the filing of charges. There was a public outrage because of the number of young children there. It made itself felt in talk shows and newspaper articles, and that put a lot of pressure on the authorities to do something about it."

Before Sepe could start extradition procedures, however, he needed a witness to sign a complaint against Morrison. He didn't have to look far—it turned out that a clerk in his very own office, Bob Jennings, had been at the show. Jennings signed the complaint and Sepe began to build his case. One of the people he contacted was photographer Jeff Simon who had taken over 150 shots at the concert. "Sepe asked me if he could see the photographs of the concert," Simon remembers, "and when I brought them in he said, 'Oh yeah, these are great. This is just what I need. We'll be able to get him with these.'" None of Simon's photographs showed Morrison exposing himself, however, since Simon was under the stage when the incident allegedly occurred. "It was getting pretty crazy," Simon recalled, "and when the speaker columns started wobbling because so many people were pressing up against the stage and some girl behind me started biting me on the neck, I figured I'd better get out of there because I had like three or four expensive cameras around my neck. There was nowhere to go, but under the stage. So I was down there trying to make my way past all the supports and stuff to crawl out the other side when all the uproar stared. I never did know if it happened or not."

Once the charges were filed, Sepe and another prominent prosecutor who was also running for judicial office were assigned

to the case. Terrance McWilliams, at that time a much younger
and less experienced prosecutor, was assigned to assist them.
McWilliams remembers what happened next: "The two pros-
ecutors were going to leave the state attorney's office and on a
wave of publicity seek their judicial campaign. I was selected only
to help out with taking the depositions and so on. But as the trial
got closer and closer it looked like there were a lot of problems
with the case and it became a real political hot potato. Max Fink
had come up with this community standards defense and the case
didn't look like a winner anymore. So, right before the trial, one of
the prosecutors told me he wasn't going to participate but I
needn't worry because the other one would handle it. Then the
other one told me the same thing. So I wound up doing it alone. I
was in the second day of jury selection when my boss found out
that I was down there trying the case. He was upset because a case
of such magnitude was now being tried by a very junior member
of the team, but there was no one else prepared to do it."

One of the first things McWilliams did was offer to reduce
the felony charge if Morrison would plead guilty. "Prior to trial I
offered to reduce everything to misdemeanors in return for a
sixty-day jail sentence at the stockade which was minimum se-
curity, a camp more or less. That meant Morrison would have
done approximately thirty to forty-five days and had to pay a
small fine. I had great difficulty convincing my bosses to go along
with this, but finally they did. But Max Fink told Morrison, 'We're
going to win this case—there's no way we're going to take any
kind of plea.' On the advice of his attorney Morrison turned the
offer down."

Jury Selection

Case No. 69–2355, the *State of Florida* v. *James Morrison,*
began on August 10, 1970. Morrison was charged with four
counts:

1. Lewd and lascivious behavior—Florida Statute 798.02
2. Indecent exposure—Florida Statute 800.03
3. Open profanity—Florida Statute 847.04
4. Drunkenness—Florida Statute 856.01

The first count was a felony and the other three were misdemeanors. If the state of Florida convicted him, prison doors would swing open for Jim Morrison. Conviction on all four counts could have brought him a sentence of three years and 150 days in prison.

Send my credentials to the
house of detention

The trial was held at the Metropolitan Dade County Justice Building and The Doors stayed nearby at the Carillon. On the morning of August 10, Max Fink waited in the lobby. Morrison was not late. And he was not the image that he had been for so many years. He appeared with a full beard and had discarded the idea of a suit and tie, wearing instead black jeans, a white peasant shirt, and brown cowboy boots. Under his arm was an embroidered navy blue caftan jacket and he carried a black Scholastic notebook. He was ready. With him was Babe Hill and soon afterward came the other Doors. The ride to the courthouse took fifteen minutes.

The courthouse was crowded. And crowded not just with teenyboppers. All ages were present and the press was everywhere. Robert Josefsberg, Morrison's Miami co-counsel, greeted Jim's entourage with a packet containing the 150 glossy eight-by-ten photographs of the concert that the prosecution wanted to submit as evidence. Morrison looked through the Jeff Simon photos in the hallway. As he leafed through them, Jim began to get a kick out of the whole thing. In the photos he looked the picture of evil one moment, and a total clown the next. He laughed. "That's where I'm supposedly giving head to Robby's guitar." He continued scanning the photos. In some he was wearing a leather hat with a skull and crossbones on it and in others he was holding a lamb. Morrison smiled again. "That hat belongs to Moonfire, and that lamb was purring amid all that chaos. I look sort of satanic there, taking the lamb to the slaughter . . . and the band played on." As he finished looking through the photos and turned toward the courtroom, Morrison mused, "You know, I'm beginning to believe I'm innocent!" The others laughed.

Inside, Judge Goodman announced that he had another trial that day. Apparently Morrison was given second billing as the judge put his case back an additional two days. Another delay.

Learning to live with the delays was a big part of achieving success in the legal arena. Morrison was never good at waiting and each new delay took its toll. Postponed from April, the trial had been rescheduled for the third of August, then the tenth, and now to the twelfth. Goodman had already announced that the trial would be held every other day. This was unprecedented and had infuriated Morrison's defense attorneys because it meant that the trial would last twice as long, forcing The Doors to cancel more gigs. As it was, they could still have done a few performances, but the judge kept changing the schedule on them and they never knew from one day to the next when court was going to be in session. Still, it wasn't the money that bothered Morrison. It was the Sword of Justice hanging over his head. Outside the courtroom he told a group of reporters that "The significant issue here is artistic freedom of expression."

So it was on August 12, a Wednesday, that the trial actually began. More than a hundred fans were jammed into the corridor of the Metro Justice Building hoping to get a glimpse of Morrison entering court. Doors publicist Mike Gershman was in the hall giving newsmen copies of a new book of poetry that Jim had self-published entitled *An American Prayer*. It was a small red-bound collection of verse that focused on the decaying of America and Morrison had printed up five hundred copies for fans and friends. Moments later, the teenyboppers pressed forward as Morrison arrived, but only a few fans were able to make it inside the small courtroom to watch the tedious process of jury selection.

In the state of Florida, court is six people. Max Fink had wanted a twelve-person jury, but his request had been denied. The prosecution and the defense each had six peremptory challenges which meant they could arbitrarily excuse six jurors apiece and the judge could also excuse jurors. Max Fink began the day's excitement with a somewhat expected move by rising and moving for dismissal of the charges on the grounds that they were unconstitutional under the First Amendment and a violation of Morrison's free speech. It sounded great, but no one really expected it to work. Judge Goodman was not impressed. Preferring to get on with the task of selecting the jury, he dismissed the motion and cleared the room of all spectators. A moment later, the prospective jurors came in. There were thirty-nine of them. The questioning began with a former dancer whom the prosecu-

tion immediately dismissed because of her connections to a show business fraternity. As she stepped down from the stand Jim Morrison smiled and scribbled in his notebook.

Later, Max Fink read Mrs. Trussell, another prospective juror, a list of some of the best-selling books from the last two years in an effort to show that community standards had changed. He told her, "I will request the judge to allow the jury to see some of the current plays and films. If Jim Morrison used some slang expressions, some words you as an individual may consider crude, four-letter words, you would find the same words physically and verbally are a part of the dissenting scene in this country. By evidence of the plays, books, and thinking people of this country, would you be shocked?" Mrs. Trussell thought for a moment. "I'd be shocked," she said. Fink nodded and dismissed her.

When a young, mod hairstylist wearing an Edwardian suit was called, spirits on The Doors side seem to rise. Here was someone who might understand. At least he had sideburns. Johnny Weiner said he often went to a nightclub called The Climax, and that he even owned a few Doors albums. Max asked him, "Would you believe that because, in a rock band, a singer crawls on his hands and knees to fondle another man that he is feigning oral copulation?"

"I'd have to see it," Weiner said. After a while the prosecution dismissed him as well.

It was during the jury selection that prosecutor McWilliams wrote Jim Morrison a note. "Max Fink was up there asking everyone if they would acquit Morrison if they believed that the concert was in the mores and contemporary standards of the community. That's when I wrote the limerick . . . and I just threw it on Morrison's desk when I got up to ask my questions. It read, 'There once was a group named The Doors/Who sang their dissent of the mores/To the youth they protested as the witnesses attested/While their leader was dropping his drawers.' Morrison read it and he started giggling."

McWilliams was clearly not your usual kind of prosecutor and certainly not what Fink and Josefsberg had expected. The real problem though was the way the jury was shaping up. Those even remotely sympathetic to anything to do with youth were being flatly dismissed. The prosecution knew what it was doing.

An elderly lady was dismissed for expressing that she was "very fond of young people and would not want to injure the young man [Morrison] in any way—there's a two-generation gap."

Later, a Mr. Karl Beidl, a mechanic, was asked if his background in the Coast Guard could prejudice him since Morrison's father was a high-ranking admiral in the navy. Mr. Beidl didn't think so and he was retained. By the day's end the state had excused six potential jurors, the judge another six, and the defense two while only five people had survived challenges from both sides.

On Friday, jury selection was completed. The six-person jury chosen was made up of four men and two women with two women alternates. Besides Mr. Beidl, they were John Cone, a machinery worker; Herbert Franks, a tile setter; William Bowen, an elementary school art teacher; Elaine Humphrey, a middle-aged Miami housewife; and Audrey Tompkins, a housewife and former insurance underwriter. When it was all said and done and the jury sworn in on August 14, you couldn't help but notice a few inconsistencies. It certainly was stretching it to say that youth was properly represented on the Miami jury. The age of the youngest juror was forty-two. One had the feeling that the prosecution and Judge Goodman believed anyone under the age of thirty would be necessarily prejudiced. Morrison's attorneys objected on the grounds that these people could hardly be considered as the defendant's peers. The judge merely noted their objection and then adjourned the trial for the weekend.

That night Morrison and a group of friends went to see Creedence Clearwater Revival at the Miami Beach Convention Center. After all the publicity, Morrison had a strange notoriety in Miami. Fans gathered around him wherever he went. Some wished him good luck or smiled and waved. Others just stared. Fascinated. The kind of people who might buy a ticket to a slaughterhouse just to catch a glimpse of terror in the animal's eyes. They'd never see that in Morrison—even if he felt it. After Creedence's show, Morrison headed over to the Marco Polo Hotel to see Canned Heat play in some place called the Hump Room. He was trying to have a good time and get the trial off his mind. Bob Hite, the lead singer, immediately greeted Jim at his table, giving him one of his famous Bear hugs, and then climbed up onstage to introduce him to the audience. Soon Morrison was up there with

them, singing a version of "Back Door Man" and rock standards like "Rock Me Baby," "Fever," and "I'm a Man." The Bear blew away on his mouth harp, calling it his "Mississippi saxophone." And Morrison sang like there was no tomorrow. Maybe that was just how he felt.

The Witnesses

At 10 A.M. on Monday the 17th, the action began with Robert Josefsberg asking to subpoena certain motion pictures (*Woodstock, Tropic of Cancer,* etc.) playing the Miami area. Josefsberg explained that he wanted the jury to see these films as part of his defense that Morrison had not exceeded acceptable community standards during the concert. There were legal complications involved in holding the films until the judge could approve their relevance.

Judge Goodman pondered only a brief moment before denying the subpoenas. The judge explained that the court wasn't concerned with the contents of *Woodstock* and motioned to the bailiff to usher in the jury. Morrison's defense was visibly shaken. Later the judge would have to rule on whether or not the jury should review contemporary entertainment to determine community standards. If he didn't allow it, Fink and Josefsberg might as well start over as their entire defense plan would be ruined.

The prosecution was well aware of this and a special prosecutor had been assigned to specifically nullify this line of defense. Terrance McWilliams remembers: "Leonard Rivkind was a special prosecutor who only handled obscenity and pornography cases. He was assigned to help neutralize and eliminate the contemporary community standards defense. That was his only job on the case. The idea was that if we could show it was not a valid defense than no witnesses would be allowed to testify along those lines."

As the trial continued, one couldn't help but get the feeling that no one really cared what happened to Jim Morrison in Miami. It was as if the trial were happening in a dream state, and nothing could penetrate the outcome of that dream—not the Constitution, not Max Fink, not the jury, and certainly not the truth. It seemed that the entire courtroom was on a dream train

taking Jim Morrison for a ride. And nothing could break that dream. Somebody needed to stand up and shout, but the one person there who had that kind of courage was Morrison and his only defense was to play it cool. Real cool, calm, and collected.

Prosecutor Terrance McWilliams now read the charges against Morrison. As he did so, he walked from his side of the court over to where Morrison sat, then deliberately stopped. Morrison turned his face up to look at McWilliams, blinking his eyes while listening intently. After a short pause, McWilliams continued reading from the complaint, "The defendant did lewdly and lasciviously expose his penis in a vulgar or indecent manner with intent to be observed, place his hand on his penis and shake it, and further the said defendant did simulate the acts of masturbation upon himself and oral copulation upon another . . . used profane language . . . performed under the influence of intoxicating drugs or liquor." When McWilliams finished, he remained standing in front of Morrison as if it would be disrespectful to leave so quickly. Then he looked at Morrison with what seemed to those present to be the utmost admiration. The dream continued.

Then, from the record, McWilliams quoted some of the profane language Morrison was said to have used during the performance: ". . . YOU ARE ALL A BUNCH OF FUCKING IDIOTS. YOUR FACES ARE BEING PRESSED INTO THE SHIT OF THE WORLD. TAKE YOUR FUCKING FRIEND AND LOVE HIM. DO YOU WANT TO SEE MY COCK?" The jury sat quietly, expressing no reaction whatsoever to the words.

Around noon Max Fink got his turn. His opening speech to the jury had to not only outline Morrison's defense, but also bridge a formidable generation gap. He gave it a pretty good shot and seemed to be getting through. "Your imagination may run rampant," Fink told the jury, "but there's a small difference between the prosecutor's evidence and their witnesses. There is no question about the use of the words. I'm sixty-two and I haven't been to one of these concerts, but it is what they say these days. Young people use these words with no prurient intention whatsoever."

According to Gloria Van Jac in *Rolling Stone*, Fink then quoted the "Gimmie a F-U-C-K" cheer used by Country Joe & The Fish at rock festivals. "This is what they say and do," he went

on. "A rock concert is an expression of dissent. Let's have love, let's take care of our minorities, let's have oneness. You will see photographs of the audience making peace signs, you will hear what Mr. Morrison said to his audience of twelve thousand people. You will hear the audience yelling, 'Fuck you,' and 'You're a fairy,' at him . . ."

Then Max zeroed in ever so lightly on the conspiracy element behind the trial. He said it without saying it because that was the only way he could get away with saying it at all. "There were twenty-six officers present in uniform and nobody arrested Mr. Morrison. Nobody claimed there was a crime then, because there was no crime. The words we admit, that's free speech. The evil is in the mind."

Fink had been good, but then the trial continued back on the dream train as though he had never spoken. There was a mythical feeling to it like the archetypal Norse trial by fire which, stated simply, presumed that if you were innocent, you wouldn't burn, but if you were guilty you would go up like straw and die. Needless to say, the Viking prosecution had an incredibly high percentage of victories.

The Constitution of the United States rules out a Trial By Fire, so McWilliams and Judge Goodman tried their own version: Trial By Boredom. The more they delayed, the more they could drag things on, the less the public eye would be on the trial. And the less attention the national media paid to the trial, the more likely the prosecution could railroad Morrison on the dream train to jail.

McWilliams describes some of the tactics he employed during the trial: "I knew their main defense was that this was a political prosecution and I neutralized that because I was a very young prosecutor with no political connections or anything that would indicate that I had anything to gain. I knew what the defense would be and I pursued it in that vein. I dressed accordingly in rather modern clothes with kind of wild shirts and crazy cuff links—everything that was contrary to a political figure. I didn't make any speeches, give any press conferences, nothing. I even had a high school girl sitting with me in court helping me out. It just didn't look like what they had pictured it was going to be."

Everything McWilliams was doing was perfectly legal and any good prosecutor would probably have done the same. The

concept of downplaying the political nature of the case even extended into what witnesses were called: "There was originally going to be a whole lot of politicians and bigwigs called to say that this was *against* the community standards, but when I took over as the prosecutor I elected not to use any of those people at all. I had a good case on the facts themselves and I didn't want to pursue the political avenue because it led right into the defense."

That eerie feeling of pervading unreality continued with the prosecution's first witness, Colleen Clary, a frail, seventeen-year-old drugstore cashier, inspired to testify by her brother-in-law, a Miami policeman. Her blonde hair was parted in the middle and swept up into a ponytail. Colleen looked tired, her blues eyes dark, sunken, and icy. She testified that she'd attended the Dinner Key concert and had sat in the bleachers where the lights were dim. She said she'd been shocked by the things she'd seen Morrison do. "He pulled down his pants . . . and stroked . . . stroked it . . . It was disgusting." Everyone in the court began to feel for Colleen's sensitivity. She testified that she saw Morrison expose himself. "I guess it was for about ten seconds," she told McWilliams.

"How did it affect you?" the prosecutor asked.

"I was shocked, it was disgusting," answered Colleen, wringing a handkerchief.

Then Max Fink began his cross-examination. When he read from a deposition that Colleen had given earlier, he caught her in one inconsistency after another. In her sworn statement, taken in April of that year, Colleen had stated that she saw Morrison rubbing against a girl onstage. But she couldn't remember whether his pants were up or down. Max stopped reading and pointed out that the sworn statement had been made five months ago, much closer to the event. He continued reading from the April testimony: "Were you able to actually observe his genital area when he dropped his clothes?" Suddenly, Colleen looked peeved as Max quoted her answer from April, "Most of the time he was moving around."

Finally Max asked, "Have you had trouble with your memory of late? Has your memory been affected in the last few months?"

Colleen answered, "I don't know," turned her face away from the jury, and began to cry. Judge Goodman gallantly called a short recess and everyone felt sorry for the girl. From the defen-

dant's table Morrison rose, taking notes as he looked at Colleen, now facing the wall. A poor innocent girl confronted with the evil Lizard King doing his damnedest. Of course she couldn't handle it, right? Wrong. According to Mike Gershman, during the lunch break, a teenybopper bopped up to this flower of Miami youth and said, "You're really being mean to Jim." Without batting a tearful eye, Colleen replied, "Fuck off, you little bitch."

Back on the train after the break, Max asked Colleen how far down Morrison's trousers were. She nervously answered that they were "above his knees." Max again read from her previous testimony concerning Morrison's trousers, "I could see it was below his knees." Max appeared sincerely understanding, "Then did the court reporter improperly quote you?"

Colleen winced. Max continued. "Did you see Mr. Morrison put his hand inside his trousers?"

Now very unsure, Colleen replied, "I think so."

Again Max Fink nailed her by reading from the sworn testimony made in April that asked if Morrison placed his hands inside his clothing at any time other than when he dropped his pants. Colleen's answer at that time was "I couldn't see."

So much for Colleen's testimony. Next up to bat was her boyfriend, Carl Huffstutlear. Carl took the stand. He was twenty and wore mod clothes. He stated that he and Colleen were seated eighty to ninety feet from the stage and that the exposure lasted "five to eight seconds," but admitted that his vision was partially blocked. Robert Josefsberg then asked Carl if he was shocked. Carl shook his head. "Not to myself, but to my girlfriend." He then went into great pains to tell how tenderhearted Colleen was.

That evening Morrison faced a different kind of trial when Patricia Kennealy showed up at his hotel. She had called him on Friday the fourteenth to tell him she was pregnant with his child. Kennealy describes how she felt on the flight to Miami: "In my heart I thought, 'This kid is going to be a god. How could it not be?' But then I thought, gods have to eat and go to school. You always have to be there for a child and I'm not very good with kids and I didn't think Jim was any better."

His mind consumed with his other troubles, Morrison was in no mood to be understanding. "It was a hellish situation for us both," Kennealy recalls. "Jim was cold at first, didn't want to talk

about it for the longest time, but I could see he was scared to death. They were really out to put him away. Jim was devastated that he wasn't getting any public support. All the people who were always there to egg him on were nowhere to be found when he needed them in Miami. Even the press. He really thought there was going to be this sort of children's crusade . . . that everybody would be standing up for him the way he'd seen himself standing up for them, but there was only a kind of embarrassed silence. It was such a disappointment for him. He just kept saying, 'They think I'm a bozo. That's all they see. They just see the Bozo prince of rock 'n' roll and they don't see what this is really about.'"

When Morrison finally broached the subject he told Patricia that he couldn't handle the idea of her having the child. "He said that if I had the baby," Kennealy recalls, "it would ruin our relationship as far as he was concerned; my life would be changed forever and his wouldn't change at all. Or perhaps it had something to do with the twenty paternity suits against him . . . Whatever, I do think if the pregnancy had occurred at any other time, things might've gone differently."

In the end, they agreed that Patricia should have an abortion and Morrison promised that he would be by her side during the operation. But when it came time for the operation, Jim never showed and he didn't call. Later, however, Patricia discovered Morrison had called a couple of her friends and asked how she was doing. "When I went to get it done I found that I was too advanced for the physically easy kind so I had to do it the hard way which was utter and complete hell," Kennealy says. "I will never be completely over it—no woman who has an abortion ever is. But you can ruin your life with second-guessing—I'm not sorry I had the abortion, but I'm not glad either. Jim could have handled it a lot better than he did. I don't think he was ultimately a strong person and he wasn't good at dealing with adversity. As soon as a relationship got trying, made demands on him, he would back away, run away even. He didn't seem willing to work on his relationships. Still he had this other side—I wouldn't have put up with him if he hadn't. When he'd finally reduced me to tears after I'd started out strong and defensive, he was weeping with me."

When the trial continued on Wednesday, state witness

number four, an attractive policewoman named Betty Racine, testified she'd observed the concert from outside the ladies' room and from the balcony. She claimed Morrison did indeed pull his pants down and that she heard him shout an obscenity, "It sounded like, 'Do you want to see my cock?' He then pulled his pants up again." Again Max Fink went to the previous depositions. In her statement of June 2, 1970, Officer Racine stated she'd heard or seen nothing of the sort. She is quoted as saying she didn't remember hearing any profanity.

"Has your memory improved since then?" Fink asked. McWilliams objected as Mrs. Racine sat there, quietly fuming. Fink continued reading her deposition. In it she was quoted as being "too busy" to have heard profanity or see any of the acts charged. Under pressure, Racine then admitted she'd heard a tape of the Dinner Key performance in the last two months. "I heard something . . . I wasn't supposed to say . . ." Her testimony was stricken from the record and the jury told to disregard it. Caught in a definite no-no, prosecutor McWilliams blushed as Officer Racine left the stand.

Jeffrey C. Simon, the photographer, was the state's fifth witness. A former University of Miami student, he was handsome and seemed to be on Morrison's side. Simon stated that he was three to five feet from the front of the stage and that he had been called to the state attorney's office a couple days after the concert last year. Later, under Fink's cross-examination, Simon turned and spoke directly to the jury, telling them that he didn't see any genital exposure. Fink asked him to explain the so-called oral copulation shot where Jim was kneeling in front of Robby. Holding up the photograph Fink asked, "The projection down here is the guitar?" Simon said, "Yes." His 150 photographs revealed no exposure at any time!

The real excitement came later that day. The prosecution tried to enter a misleading negative as evidence when a perfectly good quality eight-by-ten print was available. Josefsberg was furious over the incident, but Judge Goodman more or less laughed it off. "Don't get upset. They made a nice try and it didn't work." Josefsberg was even more infuriated over the judge's attitude and for the rest of the day mumbled about judicial ethics. The judge's bias was already becoming apparent. How dare he

compliment the prosecution on a "nice try" at introducing mis-
leading evidence.

The brakes were screeching, but the train was still chugging
closer to its destination. No matter what inconsistencies Fink or
Josefsberg uncovered in the prosecution's charges, everything
proceeded the same way, as if these inconsistencies had never
been revealed. Morrison had always been noted for overcoming
impossible odds, for taking everything to the very edge and then
springing back just before he plummeted over the side. Now it
was as if the gods themselves were testing him against the worst
possible odds, as if hoping he would overcome all the handicaps
and be acquitted, to come out of the trial even stronger than he
went in.

One of the oddest things about the trial was the relationship
between Morrison and prosecutor Terrance McWilliams. Despite
being on opposite sides it was often evident that the two men
respected each other. The prosecutor was not the Establishment
type that Morrison expected. "He and I got along fine,"
McWilliams remembers. "I used to talk to him from time to time
when we'd bump into each other . . . He didn't have anything
personal against me at all . . . He even liked some of the things I
pulled like the limerick. When I needed to play a tape of some-
thing I brought in my big guitar amplifier instead of an official PA
system. I played rock 'n' roll all through college and law school.
He was one of my heroes. I knew the words to all of his songs
and I used them from time to time in cross-examination. It was
kind of like an inside thing . . . I'd say something like 'He's had
his constitutional rights, he's had his right to cross-examine, he
had his fair trial, but now the music's over.' And Morrison would
just look at me like, 'Oh shit.'"

At one point in the trial Morrison even asked McWilliams
how he could purchase the Jeff Simon photos. McWilliams elabo-
rates: "I told him that Jeff was a friend of mine and that I was
going to use him as a witness. Morrison said, 'I don't care. Can I
buy them?' I told Morrison that I would ask Jeff and I came back
and I said, 'Yeah, he wants two hundred and fifty dollars and he
wants credit.' Morrison said, 'Sure, fine, draw me up a contract.'
Here I was prosecuting this guy and it was my witness, my photo-
graphs, and I sat down with my yellow legal pad and wrote out a
simple contract transferring the rights to the photographs to
Morrison under those terms."

The next day, Thursday, August 20, would normally have been a "rest day," but because The Doors were to perform in California on Friday and Saturday, Judge Goodman agreed to have court and then adjourn until the following Tuesday. The sixth witness was Bob Jennings, the person who'd signed the original complaint. Jennings was six feet nine, with medium-long red hair and a beard to match. He was twenty-two, wore a ribbon dog collar, and by all counts was the state's star witness. It seemed a bit hypocritical when Jennings testified that he worked in the prosecutor's office on the sixth floor of the Justice Building as an office clerk and that two of his relatives also worked for the prosecutor. Especially when you consider that in order for Morrison to be formally charged with committing a felony offense a complaint had to be signed against him. In all of the twelve-thousand-plus people in attendance at Dinner Key, only Bob Jennings had the courage or the gall to sign a complaint charging Morrison with a felony and starting the long extradition process.

Jennings testified he'd attended the concert with a friend, and that Morrison had put his hands in his pants and rubbed up and down, put the microphone in his pants and later exposed himself, and had poured wine over somebody's head. Jennings described the hypnotic "drone effect" of The Doors' music and quoted extensively from memory the words of the concert. He testified the exposure lasted "five to eight seconds" just like Carl Huffstutlear had said before him and other state witnesses would say after him. Jennings said his friend didn't see what was going on because he had his "head down and was grooving to the music."

Overall, Jennings was very convincing, and momentarily, a cloak of gloom spread over the defense side of the courtroom. Max Fink then rose and began to cross-examine him. Fink mentioned a conversation Jennings had with another attorney in which he'd said, "I don't see why they want me to testify. What do they want from me?" Moving on, Fink then asked a question concerning masturbation and Jennings said, "I believe the expression is oral copulation. There's a difference, you know." Judge Goodman raised his eyebrows and Fink set Jennings up for the laugh of the morning by asking, "Are you an expert on oral copulation?" Jennings smiled and replied, "I don't have a master's degree in it, no."

Then Jennings's friend James Wood took the stand and testi-

fied that he'd sat next to Jennings for the entire concert and he'd seen no exposure or simulated oral copulation. It looked like a much-needed point for the defense.

This would prove to be only a momentary victory. While the exposure charge had always been flatly denied, the prime argument in Morrison's defense against the other charges was that his use of four-letter words and the accompanying "lewd" conduct were already deemed acceptable by the present standards of the Miami community. This argument was based not only on the considerable number of X-rated theaters in the area, but also on the accepted artistic standards of popular books, theatrical productions, and feature films available. Fink had been waiting for a ruling on his motion that the jury should see such films and plays to prove his point. It came like a shot in the dark.

Out of the blue, the judge dropped the bomb: No evidence relating to community standards would be allowed! With one bold stroke the judge completely undermined Fink's defense. Not only could the jury *not* be taken to see films and plays such as *Woodstock* and *Hair,* or read excerpts from controversial best sellers like *Portnoy's Complaint* or *The Sensuous Woman,* but an order was also now issued that barred any mention of films, plays, and books as "irrelevant to the offenses charged." Max Fink asked that the jury be excused and then gushed forth an angry but brilliant argument against the ruling. It was all in vain. The audience responded quite warmly, but Judge Goodman remained intractable . . . and suddenly the dream train taking Jim Morrison to prison was rolling full steam again as if nothing could stop it.

The trial was getting more and more surreal all the time. Many attorneys not connected with either side have stated that on appeal this decision would unquestionably have been reversed. Terrance McWilliams, understandably, disagrees: "A lot of the adults had brought their children [to the concert] and there were nine and ten year olds there. Because of the children the community standards defense was ruled to be irrelevant. That crippled their defense. Rather than becoming a circus with actors coming in from all over the place saying this was avant-garde,

etc., the defense was struck and it became a straight case on its facts. He either did or didn't do it."

Many observers had the feeling that the transcript of the trial had already been written down before the jury was selected, but it's hard to imagine such a thing could be allowed. After all the publicity the Chicago Seven trial had gotten, no one as well known as Morrison could be railroaded without the media drawing a lot of attention to it. But the truth was no one seemed to care. Perhaps it had to do with the Morrison legend. He had been regarded so long on a mythic level that people could only relate to him that way. The idea of feeling sorry for him seemed ridiculous. He had attained living-legend status, but what he really needed was to be regarded as only a man.

While Morrison confided to friends that he felt he wasn't getting a fair trial, he was not about to lose his cool over it. That wasn't his style. Instead, he developed a strong interest in the mechanics of the law. Outside the courtroom, he'd previously often lapsed into legal jargon just to be funny, but lately there had been an underlying seriousness to his attitude about the trial. He was becoming aware of the changing faces in the gallery of the courtroom. For the first few days, every seat had been packed with a teenybopper, but now numerous elderly people were the daily spectators. In the final analysis, these law-and-order types were more interested in defending their way of life than the teenyboppers and hippies were in changing it. The trial was a party to the kids. Once it got serious, most of them moved on to more pleasant subjects. Miami was reported to be influxed with Jamaican Red during those days and a serious court case just didn't compete as a social activity. In more political cities like Boston, New York, or Chicago things might have been different. Like L.A., the climate of Miami did not lend itself to serious political statements. It is a well-known fact that suntan lotion and social justice don't mix.

The Doors completed their shows in Bakersfield and San Diego and were back in court on Tuesday, August 25. That day the prosecution produced four police officers who swore they'd either seen or heard an obscene word or gesture. One, Richard Flaum, also testified that Morrison grabbed his police cap and threw it into the crowd during the performance. He said he went to Morrison's dressing room about an hour after the show,

where someone paid him for the hat. Asked why he didn't arrest Morrison for his supposedly indecent performance, Flaum said he was afraid of possible retaliation by the crowd. "The temperament of the crowd was not conducive to taking official action against Mr. Morrison without reprisals that the police couldn't handle," he said. On cross-examination, Max Fink asked if the crowd in the dressing room was so large that it prevented twenty-six policemen from arresting Morrison, and Flaum said no.

The next trial day, Morrison may have made a substantial mistake by allowing the prosecution to play an audiotape of the Dinner Key concert for the jury. Considering the age, background, and politics of the jurors, this may well have sealed his fate. It must have been very strange to hear the concert in a courtroom. Morrison closed his eyes and nodded his head in time to the music. His gray-suited attorneys tapped their feet. But the jury, sober faces intact, sat impassively through the entire thing, which included the exhortations between songs. Missing from the recording was the question Morrison asked the audience before state witnesses said he dropped his pants. Even so the tape turned out to be one of the best things the state had going for it, especially considering that most of its witnesses had contradicted each other so strongly.

Yet another victim of the Miami trial was The Doors' second European tour. They had requested that the trial be postponed until October so they could meet the tour schedule, but that request had been denied. Only one engagement was fulfilled and that was at the third Isle of Wight Festival off the coast of England, a three-day event which also featured Jimi Hendrix, The Who, The Moody Blues, Sly and the Family Stone, Free, and others. While The Doors never really liked performing in the open air, it was now a matter of finances. So, on Saturday, August 29, they appeared at the festival before a crowd of half a million. The Doors played between Emerson, Lake and Palmer and The Who, both of whom put on powerful shows. The Doors set consisted of songs from the first two albums, but Morrison's heart wasn't in it. He had been drinking before the concert and spent the entire set hanging on the mike for dear life. The other Doors were embarrassed by his lack of effort in front of the huge festival crowd. Backstage after the show, John Densmore in particular was angry.

Even though Jim was standing only a few feet away, Densmore threw his drumsticks to the ground and shouted, "That's it. That's the last time I'm playing with that asshole." When they returned from the festival, The Doors had their equipment put into storage and indicated that they might never again perform live. Later, Morrison made the rumor official when he declared to the press that, unimpressive as it was, the Isle of Wight would be his last live appearance.

To his defense it should be noted that Morrison was fatigued from the previous night's flight from Miami. At the show his eyes burned hollow and his entire appearance reflected the strain of having to return to trial on Monday. The Doors had asked for a week off to play the festival, but the judge refused, insisting they be back in court on Monday. But after keeping a grueling schedule to meet his demands, when court opened that Monday the judge said, "Let's have a few days off," and postponed the proceedings until Wednesday. Morrison described the trip to Salli Stevenson in *Circus*: "I flew over from Miami, landed in London and drove to a little airport, took a small plane to the Isle of Wight, and then we drove right to the concert. By the time I went on, I don't think I'd had any sleep in thirty-six hours. I wasn't really quite at my best . . . my peak of physical condition."

On Wednesday, September 2, the prosecution rested its case. They concluded without having any hard evidence such as still photographs or moving pictures showing Morrison exposed or the alleged simulated oral copulation with Robby Krieger. The tape of the concert substantiated the various obscenities that Morrison never denied, but there was no crowd reaction to indicate any exposure or other startling behavior. The prosecution's eyewitnesses differed markedly in their statements. Some of them even testified that the concert lasted only twenty minutes, but the tape showed it to be an hour and five minutes long. One of the policemen said Morrison bent over Krieger in a "copulatory manner," while another said it was the other way around. And several of the prosecution witnesses said they were located within ten feet of the stage all night and saw nothing. A local attorney said, "If I were a prosecutor, I would be embarrassed by having to present this case."

Before calling witnesses of its own, Morrison's defense entered a plea for acquittal, maintaining the state's case had been

inherently contradictory and therefore reasonable doubt had been raised. The plea was a gesture, a halfhearted long shot, and no one was surprised when Judge Goodman passed over it. Goodman then released a written order that limited the defense to seventeen witnesses, the same number that had been presented by the state. While the judge justified this order by claiming the defense was considering calling close to sixty witnesses, his rationale of limiting them to the same number as the prosecution was never explained.

Their prepared defense having been ruled irrelevant by the judge, Fink and Josefsberg could do little but call forth a parade of witnesses to counter the prosecution's case. They began with seven kids who had been at the concert who said they had a great time and that they saw nothing like what the prosecution charged. The defense witnesses were convincing, and an air of stalemate began to pervade the proceedings. Prosecutor McWilliams's cross-examination was not up to his usual efforts. It was starting to seem as if the prosecutor would rather be home than trying this case.

Everyone was ready for a break including Judge Goodman. He announced an eleven-day recess. Morrison, accompanied by Babe Hill and Frank Lisciandro, who had also been in Miami for the trial, headed for Nassau in the Bahamas. It was a week of fun and relaxation. Jim learned to scuba dive and even Max Fink joined them for a day of boating and fishing.

The Last Days

It was now that the media needed to be focused on the trial so that Morrison's side could be heard, but they were conspicuously absent. Local TV coverage, daily the first four days of the trial, was now sporadic. The Miami newspapers were also giving the trial less space. Even the rock press was acting as if the trial was going on behind a glass wall. They were just doing a job and if Morrison went to jail for three years, so be it.

Court attendance dropped off to where, for the first time, it was not standing room only. It was painfully obvious now that the groupies were present in court only to be "on the scene." And Morrison himself seemed to have accepted his fate. When

the trial started he took notes like a maniac, filling sixty pages of a school notebook the first four days. For the last two trial days he took only three pages of notes, scribbling his own impressions and giving all the jurors nicknames.

The usual statue of justice portraying a blindfolded figure holding scales should have been replaced for Miami by one wearing earplugs and a sleeping mask. What had been anticipated as a major political struggle was a snooze. The judge looked tired, the prosecution was just going through the motions, and the lawyers who were once excited about defending Morrison found themselves stripped of their defense. They all seemed to be waiting for something. The sun? The moon? Godot? The End? Or just the last destination of the dream train.

Nonetheless, as one witness after another denied the prosecution's charges, the defense's case began to seem much more solid and Morrison's hopes began to rise. Each of The Doors testified that Morrison did not expose himself. They were on the same stage and they saw nothing. Ray Manzarek was asked under cross-examination if he intended to leave The Doors because of the damage the bad publicity had done to their name. Manzarek replied, "We've all had many offers to leave. We're all staying. The Doors are something we all believe in."

Finally, on September 16 and 17, Morrison took the stand and was questioned for four hours. He denied exposing himself and said that while he'd had a few drinks before the concert, he went there "feeling good, but not drunk." By the time he got onstage, though, he was mad at the promoter for overselling the hall. During the concert he felt the band wasn't "getting it on" and then he went to one side of the stage and saw people sitting off in a corner who couldn't even see the show. He became even angrier then and that's when he began swearing. Responding to a question from Max Fink, Morrison said, "I heard a lot of swearing. It was coming from the audience and it ran the full gamut of basic four-letter words. According to the Miami newspapers Morrison was articulate, soft-spoken, and convincing on the stand.

Robert Josefsberg remembers: "Jim knew what the parameters were. He was a very intelligent and cooperative client."

Later Morrison said this about his testimony: "I didn't have to testify, but we decided that it might be a good thing for the jury to see what I was like because all they could do is look at me for six weeks or as long as it went. So, I testified a couple of days. I don't think it meant anything one way or another. They drag it out so long that after a while no one cares. I suppose that's one of the functions of a trial. They muddle it up so much that you don't know what to think anymore. That's society's way of assimilating a horrible event."

Former Miami prosecutor Terrance McWilliams disagrees: "I did a lot of damage during Morrison's cross-examination by getting him to deny certain things and then confronting him with photographs that I had not yet used showing him doing exactly those things."

McWilliams felt that some of the photos he produced clearly showed Morrison exposing himself, but others have said that these photos are blurred and unrevealing, possibly showing the microphone or Jim's hand instead of his penis.

Of all the injustices that occurred during the Miami trial, the one that would have unquestionably seen the verdict reversed happened on the final day, Saturday, September 19. After having produced a dozen witnesses who claimed to have been within a hundred feet of the stage at all times and saw nothing resembling exposure, the defense asked to introduce the sworn statements of another twenty-eight witnesses with similar testimony. Judge Goodman then excused the jury and while they were out of the room said, "Gentlemen, you've proven that Mr. Morrison didn't expose himself. I'm not going to allow this evidence to save time." Then the jury filed back in, but Judge Goodman *neglected* to instruct them of his decision when they returned!

Assuming that the judge would address his remarks to the jury in his final charge to them, the defense went ahead and delivered its closing arguments. Max Fink provided a one-hour-and-forty-five-minute review of the prosecution's case and then Robert Josefsberg followed with an hour-and-fifteen-minute parable based on "The Emperor's New Clothes," by Hans Christian Andersen. Josefsberg showed how the fairy tale matched the prosecution's case and there was much applause in the courtroom at

the end of his speech. By contrast, prosecutor McWilliams was brief and to the point as he delivered a thirteen-minute closing argument. Then came the shocker of the trial. Judge Goodman gave his final charge to the jury and said nothing about the defense completely disproving the exposure charge! As the jury filed out Max Fink, Robert Josefsberg, and Jim Morrison knew they had been had. The judge had pulled one out for the state in the closing seconds. In a sense, it was a left-handed victory because there was no way now that any guilty verdict would stand. All Morrison had to do was appeal.

The Verdict

That night, at around 9 P.M., the jury was sequestered at a Miami hotel. They deliberated for two and a half hours before deciding that Morrison was innocent of charges one and four, lewd behavior and drunkenness, and guilty on the third charge, profanity. The jury was hung and could not agree on count two, exposure, and they recessed until the next morning at 10 A.M. Clearly, the defense's additional twenty-eight witnesses might have swung the verdict on the exposure charge in Morrison's favor.

The next morning, September 20, Morrison was sitting, calmly reading *Sailor on Horseback*, a biography of Jack London by Irving Stone, when the jury returned. After having deliberated only forty-five minutes that morning, they handed down a split-decision: Morrison was not guilty on the felony charge of lewd and lascivious behavior and the misdemeanor charge of public drunkenness, but guilty of the indecent exposure and profanity charges (both misdemeanors). This may seem a little complicated, but that is the nature of legalese. The charge of lewd and lascivious behavior covered three specific actions which were feigning masturbation, feigning oral copulation, and exposing the penis in a vulgar or obscene manner. Since the jury decided Morrison was not guilty on this charge, but guilty on the indecent exposure charge, we must assume that on the night of March 1, 1969, Jim Morrison did indeed expose his penis, but didn't do it in a vulgar or obscene manner. In a way that says it all.

Morrison was released on a fifty-thousand-dollar surety bond.

When the verdict was announced, Judge Goodman asked for the money in cash but relented when Morrison's attorneys objected. The maximum sentence for the charges Morrison had been convicted of were six months and five hundred dollars for indecent exposure and two months and twenty-five dollars for profanity. Not bad if it were served in one of today's white-collar prisons, but even a few months of being thrown in with the kinds of criminals who populated the Florida state pens at this time could turn out to mean a death sentence for someone like Morrison. When he left the court Morrison said, "This trial and its outcome won't change my style because I maintain that I did not do anything wrong." At the end of the trial Manzarek remembers Jim saying, "What can I do? I'm just a poet. We're not politicians. We're not messiahs. We're a rock 'n' roll band just trying to be part of the solution to the problem."

Max Fink said it this way: "The entire situation was unconstitutional. It would have been an absolute cinch appeal. There was no way in the world for the convictions to stand."

If Morrison was obscene onstage at the Dinner Key so were half the comics playing the Miami strip. Only blocks away from where The Doors performed, strippers were taking off their clothes in clubs and X-rated movie theaters flourished. How ironic it was that Miami, called by many the "filth city of America," busted Jim Morrison. How ironic it was that Judge Goodman had ruled that all this was "inadmissible evidence." A year or so after the trial, Judge Goodman was busted along with another judge for taking a bribe in a gambling case, but he was acquitted. He died not long afterward.

The trial cost the state of Florida a lot of money, but considering the attorneys' fees, trip expenses, and the gigs that had to be canceled, it cost The Doors well over a million dollars. When all was said and done, the jury took only a little over three hours to reach their compromised decision. Even though he had been found innocent of lewd and lascivious behavior and drunkenness, the publicity after the trial stressed the guilty verdict. Ironically, the guilty charges were both misdemeanors and the press virtually ignored the fact that Morrison had been acquitted of the more serious felony charge.

The question of exposure overshadowed the real issues. Whether Morrison actually exposed himself or only pretended to expose himself didn't really matter except in a purely legal sense.

Both actions are obscene as far as that goes, but Morrison wasn't merely trying to be obscene. He was crying out against being packaged and boxed in as a sex symbol whose art was then automatically suspect. His mind reeled against the mentality of the typical pop music fan. "Don't my words mean anything?" he wanted to ask them time and time again, but they wouldn't have understood. When over twelve thousand people made it known that they wanted the rock star sex symbol who sang the hit "Light My Fire," and not the poet who wrote the epics "The End" and "When The Music's Over," it intimidated and angered him. His actions on the stage were saying, "I don't work for you. If all you want is a spectacle, I'll give you one you won't forget."

Once convicted, Morrison now awaited sentencing. Everyone knew the judge would give him the maximum. He could anticipate becoming a political martyr, trudging through various halls of justice for years. Morrison had once described The Doors as "erotic politicians." Now, with such a questionable conviction behind him, he could have been transformed into a genuine political star of at least the magnitude of a Jerry Rubin or an Abbie Hoffman if he had agreed to it. "You know," Morrison said, "I was hoping—or I thought there might be a possibility of it becoming a major ground-breaking kind of case. I thought it might become a basic American issue involving freedom of speech and the right of anyone with a personal viewpoint to state their ideas in public and receive a hearing without legal pressure being put on them."

In some ways the trial came at the right time. The popularity of the group had still not returned to its peak level and Morrison had become an unsympathetic figure in the rock world. After the trial he once again became a favorite of the press, taking on an almost martyred character. A rock politician? The stage had been set, the leading actor cast. All that remained was the candidacy.

But, Morrison chose otherwise. He was not up to using Miami as a political stepping-stone in the youth movement. Perhaps it was because he thought it made him look more like a "clown" than a leader or perhaps it was because the media paid no attention to the principles of free expression being contested. Also, Morrison knew that until the appeal, the trial was not yet over and he wisely keep quiet. Those close to him have said that he talked about a book, a screenplay, and poetry inspired by the ordeal of the Miami trial, but nothing ever came from it. Jim Mor-

rison never wanted to be a political leader in the usual sense. He wanted to be what he was, a political leader of the mind. He knew that change came from within. To revolutionize America, he had to first revolutionize America's thought processes. Before any political movement could break out, the minds of its followers had to "break on through." And that is the arena to which Jim Morrison felt he was called.

During the month he waited to be sentenced, he was asked about the trial in an interview for *Circus* Magazine. "It was fascinating . . . very educational. I wouldn't have chosen to have gone through the experience, but while it was happening all I could do was watch . . . I'm admitting the charge of public profanity, but I'm denying the exposure charge. We're going to appeal that for as long as it takes to get it dismissed. It may take another year or two. I think it was more of a political than a sexual scandal. They picked on the erotic aspect, because there would have been no political charge they could have brought against me. It was too amorphous. I really think that it was a lifestyle that was on trial more than any specific incident. Anyway . . . whatever the sentence will be, even if it is suspended and there is a probation of some kind, we will still appeal the conviction . . . so, I wouldn't go to jail immediately, I don't think."

Jimi Hendrix died near the end of Morrison's trial on September 18, 1970, at age twenty-seven. This triggered a depression that was increased just over two weeks later when Janis Joplin, also twenty-seven, was found dead on October 4. In a desperate mood Jim, then two months away from his twenty-seventh birthday, told several friends, "You're drinking with number three."

Back in L.A. waiting for sentencing, Morrison's depressions became violently antagonistic and he fought constantly with Pamela. Finally, she said she couldn't take it anymore and took a flight to Paris. When she didn't return in a few days Morrison moved out of their apartment on Norton Street and got a room at the Chateau Marmont in Hollywood. After a while he heard that Pam had taken up with a wealthy French Count named Jean DeBretti. It made him furious, but he refused to call. He knew she would be back sooner or later. The question was how crazy would he get while she was away.

The Sentencing

After waiting out the month, Morrison returned to Miami on October 30 in a somber frame of mind to face Judge Murray Goodman. To a courtroom packed with Miami newsmen and spectators, Judge Goodman delivered the appropriate lecture before sentencing: "You are a person graced with a talent admired by many of your peers. Man tends to imitate that which he admires and those gifted with the ability to lead and influence others should strive to bring out the best, and not the worst in his admirers."

Then, after setting the proper moral climate, Goodman delivered the final indignity. There would be no suspended sentence for Jim Morrison. Instead, it would be the maximum allowed. For the profanity conviction, sixty days of hard labor in the Dade County jail. For public exposure, six months of the same and a fine of five hundred dollars. The sentences could be served concurrently and Morrison would be released after serving two months with the remaining four months being considered probation. After that he would still be on probation for an additional two years. To Morrison the sentence meant he would walk a legal tightrope for the rest of his life. The dream train had taken him all the way home.

Morrison's lawyers had already filed an appeal. Until it was heard, which could take years, Jim was free on fifty thousand dollars' bail. Just before sentencing, Max Fink made a special plea for mercy. Later, Morrison talked about it: "Max stated that he'd known me for four or five years and that he knew me to be a good man who had contributed some important works to society and most likely would continue to contribute. He stated that the mode of expression used to communicate the thoughts that I had at Miami was common in today's context and that it wasn't of evil intent. As to the other charge, there was no proof. But, it seemed that the judge had already decided what he was going to do. His mind was made up prior to Max's bench appeal."

Max Fink's appeal was denied, but another secret offer may have been made by the Dade County Justice Force. Supposedly, Morrison would receive a suspended sentence if The Doors would agree to perform at a benefit concert for the Miami Police Department. The performance would be sprinkled with a liberal

supply of antidrug and good-clean-fun statements. If indeed such an unlikely offer was ever made, Morrison refused it.

More than anything else it was Jim Morrison's image that was convicted. The sex symbol image he tried to kill on that hot night in Miami may have become maimed and twisted into that of a drunken pervert, but it survived long enough to get him convicted. The bottom line was that both the real and the rock establishments thought Morrison deserved a comeuppance, but for different reasons. The Establishment thought he had gone too far toward threatening its way of life. The powers of rock thought he had deserted his first calling to be a self-serving sex symbol. They were wrong.

When it was all over Morrison had this to say: "I was quite relieved that I wasn't taken into the jail and booked. They could have done it easily . . . The judge's attitude seemed to be that he was trying to prosecute me to the limits of the law. That will be one of our appeals, that I didn't really receive a fair trial because of judicial prejudice. We're going to fight the sentence until it is wiped clean off the records. The appeal motion will first have to go to the circuit court in Florida and if it doesn't pass muster there, it will go to the state court and eventually to the Supreme Court. If they accept it there, it will be a final decision then."

After the sentencing Morrison drove across country to L.A., stopping off in New Orleans and visiting the St. Louis Cathedral, where he scribbled off a postcard to The Doors' office that read: "Don't worry; the end is near, Ha Ha." The picture on the post-card was "The Sacrifice of the Divine Lamb."

When Morrison arrived in Los Angeles The Doors began making plans for a new single. When asked if the new record might be about the trial, their answer was an emphatic no! Pam had still not returned and Morrison continued living at the hotel, prowling the Strip every night looking for someone to temporarily take her place. Those who knew him said the trial affected him deeply. The Miami trial was the ultimate confrontation with the Establishment and Morrison had lost for the first time. He had spent most of his life trying to get beyond the garbage. Then suddenly, at the height of his personal freedom, it finally caught up to him and buried him in an avalanche of bureaucracy and red tape, all beyond his control.

We need someone or something new
Something else to get us thru

The days after the trial were in many ways harder on Morrison than the trial itself. During the proceedings he seemed to be waiting, marking time. Afterward he appeared to lose heart. It broke his will, broke his spirit. His eyes were duller. He was tired and he moved as though he carried an enormous weight, struggling through the motions of a lost cause. He had committed so much of himself to the cause of the free spirit and it crushed him to realize that the victory had gone to the forces of authority and established power. "Before the trial I had a very unrealistic schoolboy attitude about the American judicial system. My eyes have been opened up a bit. . . If I hadn't had unlimited funds to continue fighting my case, I'd be in jail right now for three years. It's just if you have money you generally don't go to jail. The trial in Miami broke up a lot of things."

If he had been honest with himself, Morrison must have known that there was never any doubt as to the outcome of the trial in Miami. The only question open was the degree of his conviction. In the end, though, he was stunned and disillusioned. He had expected more of the judicial system. When he had seen the evidence all laid out and presented correctly, he really thought truth and justice would win out. After all, he was a child of the military and his views of America were still somewhat idealistic. Despite his rebellion against his background, he still believed in the American Dream. And it hurt him when the dream let him down.

Playing warden to your soul
You are locked in a prison
Of your own devise

RIDER ON THE STORM

Ironically, the trial had given Morrison the perfect opportunity to sit down and reevaluate his life. Afterward he seemed to abandon any hope he had left that rock stardom could accomplish his objectives. He had played the game a long time and said just about everything he wanted to say, and it wasn't fun anymore. There were other things he wanted to do with his life. With Pam gone, he spent more time with his friends, growing closer to the people he'd worked with for so long. He joked around, became more accessible, put on weight, and kept his beard. In the past, these periods of sudden exuberance had proven to be outward cover-ups for internal strife which would eventually manifest itself in a massive depression and Morrison was no doubt going through a lot of inner turmoil. An old friend who saw him during this period claimed he'd stopped combing his hair and when asked about it would only say, "A dog doesn't comb his hair," and laugh. It was as

though Jim would shift into a fun-loving persona in order to avoid the doubt that was growing within. The only way you could tell what was happening inside was by watching how much he drank. And he was drinking more these days.

The Doors Workshop

The band was obligated by their contract with Elektra to record one more studio album. All things considered, it was quite natural that The Doors would now do their blues album. Around this time Morrison was asked about the kind of record he wanted to make next. "Probably the things we record now will get back to the blues. That's what we do best. We may even do a couple of old blues songs. It will be electric blues, I hope. You never know when you start an album. It could be entirely different. But that's what I'm going to push for. That's the music I enjoy best. It's the most fun to sing."

Morrison's attitude toward the music had changed to almost a complete opposite, no longer was it an all-consuming obsession to communicate a cathartic experience to his audience. "For me, it was never really an act—those so-called performances," he said. "It was a life-and-death thing, an attempt to communicate, to involve many people in a private world of thought. I no longer feel I can best do this through music and concerts. The belief isn't there."

The trial also had a detrimental effect on The Doors' relationship with Elektra. The company wanted product for the traditionally lucrative Christmas market and it was painfully evident that the new album would still be in the preparation stages. Consequently, Elektra released *13*, The Doors' first compilation album. It contained most of the songs everyone wanted to hear from the first album to *Morrison Hotel*. Side one was made up of "Light My Fire," "People Are Strange," "Back Door Man," "Moonlight Drive," "The Crystal Ship," and "Roadhouse Blues." Side two included "Touch Me," "Love Me Two Times," "You're Lost Little Girl," "Hello, I Love You," "Land Ho," "Wild Child," and "The Unknown Soldier." As complications go, *13*, named after the number of cuts on the album, was better programmed than most

such albums and with three quarters of an hour of almost solid hit songs proved to be an excellent value.

Unfortunately, *13* was released without the band's having much input and this upset The Doors a great deal. The cover has an old rock star type photo of Morrison that had been blown up much larger than the shot used of the other Doors. This was one of the things that irritated the group, especially Jim, who even made a few veiled threats about the band signing with another label after completing their contract. Almost as if in protest, they began rehearsing songs for the new album, their last required by the Elektra deal.

The Doors Workshop was what the band called their combination rehearsal studio/offices in West Hollywood. Upstairs, Doors manager Bill Siddons wheeled and dealed on the phone while downstairs the group roughed out their new songs in a large and littered room. The unpainted walls and dirty carpet never bothered Morrison or the others because to them the room was a laboratory for mixing poetry and voice with music. The *L.A. Woman* album began like most others with Jim reading his new lyrics to the band. He had come up with some excellent new songs—either the time off for the trial or the pressure generated by it had resulted in a new depth of material. After they had put together what they considered enough material for an album, producer Paul Rothchild was called in to listen.

What happened at that point is somewhat debatable, but apparently Morrison's depression kicked in and Rothchild wound up deciding he no longer wanted to produce the band. After guiding them through all their previous albums, he wanted out. Here is his version on what happened at The Doors Workshop that November: "Let's put this in my career perspective. I had close to a hundred LPs under my belt and had just finished making one of the greatest albums of my career, a labor of total love by the most loving and dedicated musicians I'd ever worked with. I'm talking about Janis Joplin's final album, *Pearl.* That music was full of heart, the way it's supposed to be. You got a hundred and ten percent from everybody in the band and a hundred and fifty from Janis. Then I went into rehearsals with The Doors for about a month, but it was a joke. They'd come straggling in. Jim wouldn't even show up half the time. There was no enthusiasm at all. They were drugged on their own boredom. Just totally

bummed out. Ray would try to get things together. John was really angry about Jim's attitude and Robby sort of laughed at it and said, 'That's Jim!'"

But Rothchild maintains Morrison wasn't the only problem. According to him, the entire group had been lazy and had developed only rough versions of four or five songs. "The most complete were 'L.A. Woman' and 'Riders On The Storm,' both of which I thought were great songs, but I couldn't get the group to play either of them decently. There was simply nothing there, no energy. We rehearsed and rehearsed, but it didn't get any better. I figured I'd do it like the last few—patch together the best stuff. We went into the studio and it was dreadful. Jim got into his spoiled brat thing and dragged everything down deliberately. I worked my ass off for a week, but it was still just fucking awful. Hoping to make them angry enough to do something good I'd tell them, 'This isn't rock 'n' roll, it's cocktail lounge music!' But they just didn't have the heart anymore. You know, it got so bad that for the first time in my career I found myself drifting off to sleep, putting my head on the console and nodding off. It was just BAD."

Finally Rothchild told The Doors they should work with Bruce Botnick and produce themselves. They were too reliant on him, he believed, and they needed to generate their own enthusiasm. The producer maintains they parted as friends. Manzarek agrees the band played the songs very poorly, but John Densmore recalls the parting as a bit less amicable. "When we were having the dispute with Rothchild, he called 'Riders On The Storm' cocktail music! I think he was somewhat crazed from working with Jim."

Bruce Botnick saw it differently: "I think he had just said everything he wanted to say and didn't feel that he wanted to go through it one more time."

The Doors were initially demoralized by Paul Rothchild's decision. Completion of the album was especially important to Morrison because it meant he was free of any contracts and could do what he wanted—make films, write poetry, or go off to Europe to be with Pam. Probably with that in mind, he set out to convince the other band members that they could produce the record themselves.

Ray Manzarek remembers: "Everyone looked at everyone

else and said, 'Hey, why don't we record right here?' Why don't we just bring stuff across from Elektra records, fortunately right across La Cienega Boulevard. We just wheeled over a console and a tape machine. Bruce set up everything upstairs and ran cables down out the back door on the second floor, down to the first floor, put the mikes in, baffled the place off a little bit, and we recorded it virtually live. There is very little overdubbing on *L.A. Woman*."

No doubt part of Morrison's problem in the early days of rehearsals was that his mind was on Pam and the jail sentence hanging over him, but by mid-November there were other problems. Though Jim had been an alcoholic for some time now, he had pretty much stayed away from hard drugs since his acid days at the Whisky. But in late 1970 he began to snort cocaine regularly. "Yeah, that's when he started, I think," Vince Treanor agrees. "It was during the *L.A. Woman* sessions because that's one of the main reasons I decided I didn't want to be around during the recording sessions anymore. I mean Jim had enough problems without starting to get into that crap."

Morrison reportedly had major coke sessions with Steve Stills and others at this time, but his drugged fling with a neighbor at the Chateau Marmont was probably the strangest episode. Eva lived in the Chateau with her husband and Morrison had often seen them there. She was from Scandinavia and looked it— tall, fair-skinned, and buxom with long flowing hair. Around the middle of November her husband left for Portugal on business and she and Jim started seeing each other. One night he showed up with a bottle of champagne and a 35mm film can full of cocaine. Morrison dumped out a huge pile and they began snorting it.

Before long they were naked and dancing in the moonlight, their heartbeats racing with the flush of power from the drug. Cocaine is the most insidious of drugs. It deludes you into feeling self-confident and able to handle anything and then leaves you insecure and afraid. So, since the comedown is so disturbing the tendency is to do more of the drug immediately. That is why so many people die from it. Morrison and Eva got very high that night. When they climbed into bed and she said that she and some of her friends used to taste each other's blood, Jim immediately challenged her to do it right then and there. Before long

Eva sliced her thumb and blood spurted out while Morrison tried to catch it in a champagne glass. Later, they smeared each other's bodies with blood and made love. When Morrison woke up the next day, he was lying in the middle of blood-streaked sheets and his body was caked with Eva's blood. For the first time in a long while, he began to worry about just how far he might go one of those wild drugged and drunken nights.

As if in response to this Pam returned from Paris. Though she may have had severe emotional problems of her own, there is little question that Pam was the only real stabilizing force in Morrison's life. When Pam moved back into the Norton Avenue apartment, Jim kept his place at the Chateau Marmont, maintaining that he needed it for business reasons. Doors publicist Diane Gardiner lived downstairs from Jim and Pam on Norton Avenue. She and Pam had become the best of friends and Diane was one of the only people who saw things from both the business and personal sides of Morrison's life. Because she was Jim's publicist she helped him deal with his work, but because she was a friend she helped Jim and Pam try to make sense out of their personal lives as well. This of course was no easy task. Shortly after Pam returned, things were stormy again. In some ways they were even worse because Morrison resented Pam for going off with the Count, but had trouble admitting it since it contradicted his philosophy of total freedom. Instead he was abusive to her when he was drunk which was quite a bit of the time.

For her part, Pam was as fiery as ever. Mirandi Babitz remembers attending a party at Jim and Pam's: "We got invited over for a party on Norton. Diane Gardiner's apartment was downstairs from Jim and Pam's. Diane had this really nice photograph of the two of them where they were kind of gazing at each other. It was really a sweet picture and it was propped up on the mantel without a frame. During this party they were really fighting. Pam came downstairs really irate because Jim was sitting with this girl and she took some scissors, walked over to the mantel, and cut the photograph in half. Diane left it like that, cut in two on the mantel, for a long time."

As fate would have it, Patricia Kennealy decided now was the time to pay Morrison a visit. She'd had the abortion at the beginning of November and when she got out of the hospital she was, in her own words, "a complete wreck." Since she hadn't

heard from Morrison since her visit to Miami, she wrote a letter to him, but on impulse decided to fly to L.A. and hand-deliver it. "I went to The Doors' office to leave him a note," Kennealy recalls. "I nailed it to his desk with a dagger. I thought that would get even his attention and it did. He called me that afternoon."

When Morrison learned that Patricia was staying at Diane Gardiner's apartment he said he would stop by that night, but he never did. A few days later someone called Diane's apartment looking for Pam, and Patricia decided to go upstairs and get her: "She opened the door on an apartment that looked like the inside of Pier One. She was naked to the waist, had a comb stuck in one of her braids, and asked if I were the hairdresser . . . completely luded out on downers or something. Anyway, we went downstairs, she took her call, and we started to talk. A few minutes into the conversation, she asked me where I was from. I said New York and then she asked me did I know Patricia Kennealy, that writer who lived in New York that she and Jim had dinner with one time. I just said, 'Ah, Pam, I'm Patricia. And not only that, but I have a few things to tell you.'"

She ended up telling Pam about everything except the handfasting ceremony. "It seemed dishonorable that I was perfectly sober and she was stoned out of her mind, so I smoked about six joints. But we talked for three or four hours and it was totally nonantagonistic. Among other things she said she thought it was so very sad that I didn't have the baby and how nice it would have been if I'd just had the baby and gone away to live in the country; 'Of course, Jim wouldn't have supported you or gone to see you or anything . . .' And I, who'd been feeling a little sorry for myself, just thought, 'Where is your sense of reality, woman.' But it was always my theory that Jim was never going to get everything he wanted from any one woman; it just wasn't possible. There were things he needed from Pam that he was never going to get from me and vice versa. I think in a Muslim society, for example, we probably could have been wives together and it would've been quite all right with all three of us. When I think of it now, it seems a little weird, but this was the sixties."

The atmosphere changed when Morrison came in however. The situation was simply too tense for Jim to deal with and within minutes he was getting off on the resentment his arrival had produced between the two women. Pam soon fled upstairs,

whereupon Patricia asked Jim if Pam was mad. "As a hatter," he replied unhesitatingly.

That night Morrison slept on the floor with Patricia Kennealy. The next morning Pam came downstairs and found them together, naked and peacefully entwined under an old quilt. Diane Gardiner remembers: "There was a lot of restraint in Jim and Pam's relationship too. Like when Pamela came down and found Jim and Patricia together. It was Pam's birthday and I said, 'Everybody just remain calm and I'll get us some orange juice,' and Pam just said, 'Oh, Jim, you always ruin my birthday,' and that was it."

Despite her love for Morrison, Patricia left that night for New York. She realized nothing could be resolved and was not inclined to play Jim's cat-and-mouse game. Pamela, of course, stayed. For all her faults or maybe because of them, she loved Morrison with a love that was nearly unconditional. She might escape the madness now and then, but she would never give him up and consequently he would always come back to her.

Around this time Morrison was interviewed for *Rolling Stone.* It was one of the last formal interviews he would do and it appeared in the March 4, 1971, issue. In it, Jim appeared relaxed and talked about some of The Doors myths, the trial, his plans to make films, and the future of the band.

Meanwhile The Doors were starting to cook on the album. They had decided to hire Jerry Scheff, Elvis's bass player, to play bass and Marc Benno to play rhythm guitar on a number of cuts in order to really give the record a different sound, more of a blues bottom than a rock rhythm. "The idea occurred to us to use a rhythm guitarist on a couple of cuts to free Robby so he wouldn't have to overdub his solos," Ray stated. "We had been rehearsing in our Doors Workshop for the last three or four years by that point. We knew the sound in there so well—the placement of the organ and the keyboards, where the drums were set up, where the guitar was, where Jim would sing. We had that room down, we could make it sound really good."

Densmore agreed: "When we finally said good-bye to Rothchild, it was so refreshing, doing *L.A. Woman.* Sometimes it would have taken half a day, previously, to go around each drum getting a sound, which is fine when you're making *Sgt. Pepper* or whatever. But, with Bruce Botnick as coproducer, I started playing my drums and he said, 'That's great, that's great,' and in half

an hour it was together. And I thought, 'Shit, this is the sound I've always loved.' I had a lot more jazz influence in *L.A. Woman.* 'Riders On The Storm' is a very jazzy, light thing and I thought, 'Ah, I'm finally getting to really do it!' We went back to eight tracks which sounds crazy, denying the technology, but it forced us to put only really great stuff on that tape. It was one or two takes on every track. We wouldn't have gotten back to *L.A. Woman* without the experimenting we did in production on *The Soft Parade,* however. The last album was much more together because we were more in control, so Jim was more involved in it and it was a lot of fun to make."

It took only a few months to complete the album. It was Morrison's last with The Doors and one on which he enjoyed the recording process for the first time in a long time. After Rothchild left, Jim's mood shifted to a happy one for the rest of the album. Most of his vocals were recorded "live" right in the same room with the group and sometimes he even sang in the bathroom for an echo effect. It was funky, but free. The Doors were making a "garage album" at the end of their career instead of at the beginning. "It's not that we don't like the Elektra Studios," Morrison said, "but we felt we could do a lot better where we're rehearsing. We just leave a tape running. We didn't want all the corporate nonsense getting in our way. We haven't been comfortable over there. Here, it's like being at home, and I think it shows in the music."

Another thing that added to the family atmosphere of the recording sessions was the surprise Ray Manzarek received from the other band members. "Right at the end of the album, John, Jim, and Robby came in and said, 'We're getting you a Hammond organ for Christmas.' And in comes this huge church organ. I finally got my Hammond."

L.A. Woman

The album that resulted from these sessions is a triumph of lyrical power and musical depth. It was a tremendous popular success and contains two classic Morrison songs, "Riders On The Storm" and the title track. It is far from perfect but the album's flaws convey an honesty, making The Doors and especially Jim

Morrison sound more like real people than ever before. Mu rison's voice was degenerating from excessive abuse of alcohol, smoking, and countless high-volume screams, that eerie mystical quality was gone, but the rawness that was left gave it a majestic and commanding quality.

While much of its gritty blues texture is the result of Krieger's guttural playing, the album is also a composite sketch of everything that helped make the band so intriguing. There's a forging of rock and blues, poetry and lyrics, and a good solid dose of inquiries into the unexplainable puzzles of life.

The album's ten songs flow together as a cohesive whole which may account for dropping the individual writing credits. In *L.A. Woman* the group finally attained their peak of musical competence. The musical maturity of the Manzarek/Krieger/Densmore combination sets this album apart from other efforts and the band emerges from behind Morrison's dominant persona to lay down some flashy and imaginative licks. The Doors seemed to have set aside any notions of recording some super album that would win back their once-large public, opting instead to please themselves. Many critics felt that the result was the best album they would ever make. Jerry Scheff was ideal as the band's bassist, providing a low, rhythmic balance for the group's musical highs. For the first time since "The End" and "When The Music's Over" the group was able to pull off some classic long cuts. "L.A. Woman" and "Riders On The Storm" are subtler and more re-signed than the early epics, but they are also timeless and still receive considerable airplay across America.

"The Changeling" kicks off the album with a commanding walking bass and Krieger sounding like the James Brown horn section. The title may be yet another Morrison reference to his childhood trauma. According to legend, when the spirits stole a child, they would leave a "changeling" or fairy child to take its place. It looked like the child, but it belonged to the spirit world. Morrison's voice is so commanding here that it is hard to believe he is at the end and not the peak of his career. Overweight and half-crazy or not, very few performers ever achieve this kind of power on record.

Next comes "Love Her Madly," the hit single, which Robby wrote about his lady always threatening to leave him: *Don't you love her as she's walking out the door/Like she did one thousand times before.* The song features Morrison's melancholy de-

⹂ ⟨464⟩ ⌐1 with the chiming bliss of Densmore's rhythm,
ₛ, and Manzarek's thumping 1890s organ sound—
ₗmark from the very beginning. One of Krieger's all-
ₙgs.

⌐le "Been Down So Long" comes from Richard Farina's
n Down So Long, It Looks Up To Me. It sounds like very
oⅼ⌐ rs, slow blues with Morrison shouting and Krieger slid-
ing. Along with "The Changeling," "Been Down So Long" is Mor-
rison at his most mock tough, the leather-jacketed delinquent.
"Cars Hiss By My Window" is more blues, but more brooding
compared to the rambunctious aggression of "Been Down So
Long." The lyrics date back to Jim's Venice days and are taken
along at an easy pace by Scheff's bass as Krieger weaves blues
lines straight out of the Mississippi Delta.

Then there's "L.A. Woman." An ideal car song, it sounds best
exceeding the speed limit on the freeway. Bright, steady, and
energetic, it captures the paradox that is Los Angeles—a scrapbook
cameo of the city. The golden sunsets and the gritty streets. The
promise of a bright new tomorrow even while unspeakable evil
stalks your door. A modern Garden of Eden on the one hand and an
inescapable web of corruption on the other. The song paints a
portrait of the city as a dark, dangerous, and disturbing place that is
so beautiful at just the right angle and alluring in just the right light
that it is impossible to leave. It is Los Angeles as a femme fatale:

> *If they say I never lov'd you*
> *You are a liar*

Some of Morrison's best lyrics reflect his mixed feeling about
the "city of light." While the song implies Morrison lived in L.A. a
little *too* long, it also communicates his passion for the city. It is
his swan song to Hollywood and you get the impression that this
seamy dichotomy was kind of fun for Jim. The line "If they say I
never lov'd you, you know they are a liar" reflects not only on
"Light My Fire" but stands out over time as if Morrison were de-
fending his views on Apocalypse, Los Angeles style, from the grave.

Musically, Krieger's inventive guitar work and Manzarek's
electric-piano riffing prove the band could still pull off the ex-
tended format. At seven minutes and forty-nine seconds, the song
is interesting throughout. The power of the "Mr. Mojo Risin'"

segment is notable because its return to the opening structure creates a unity that is unusual for a song of this length. Something about "L.A. Woman" captures the kind of excitement The Doors were able to generate in their live appearances and nothing more could be asked of a piece of music than that.

The second side of the album simply doesn't have the power of the first. An ominous guitar solo starts "L'America" which was originally recorded for Michelangelo Antonioni's 1970 film *Zabriskie Point* but was never used. The jovial chorus seems to be ending on a word that starts with *f* and rhymes with "luck," but then turns somehow into "find." This was probably Morrison's way of taunting his legal tormentors. "Hyacinth House" follows and while strangely syncopated with nice coupling between Manzarek and Krieger, it is only adequate at best. The next cut, "Crawling King Snake," is Jim Morrison at his most reptilian. The vocal slithers up to you like a vision right out of Burroughs. This cover of an old John Lee Hooker standard was a staple of the early Doors' stage repertoire and contains more humorous sexual boasting along the lines of "Back Door Man." Krieger plays outstandingly here as he does throughout the album. This is Robby's best album, his guitar glides and slides madly with sleek, liquid phrases that perfectly capture the mood and meaning of each cut.

"The Wasp (Texas Radio & The Big Beat)" combines some of Morrison's most interesting imagery with some very engrossing music. An unusual arrangement of an old Morrison poem, it is a fine example of spoken words as perfectly timed lyrics and weaves a dense, compelling spell. Morrison's double-tracked spoken vocal is hypnotic and so up front that he sounds as if he were in the room with you, especially on the line "Out here we is stoned . . . immaculate." The music is a fine jazz-blues-based feel that showcases Densmore's drumming including one of the earliest uses of synthesized drums.

Ray Manzarek describes the source of the song's title: "When Jim was growing up there was this border radio over in Mexico that would blast out with a huge power signal you could hear after midnight all the way to Florida or to the Midwest, where I was living. Wolfman Jack was on it then and you'd hear this guy with the gravely voice playing the strangest, weirdest rock 'n' roll, stuff you'd never hear on AM radio. To us that's what Texas radio was—border radio, pirate radio, that dangerous, renegade sound."

The final number on the album, "Riders On The Storm" is the last song The Doors recorded as a foursome and the last song Jim Morrison sang in the studio. It captures much of what made them so great. Conjuring up a threatening mood, like the four horsemen of the apocalypse charging the sky amid dark rain clouds, rumbling thunder, and flashing lightning, it is different in sound from anything else The Doors recorded and washes over the listener. The cut is as haunting as earlier Doors songs, but it also exudes promise. It is powerful but subdued, and more palatable musically. A clear indication of a new, maturer musical direction for The Doors—a direction that was never to be fulfilled.

The Poetry Sessions

But *L.A. Woman* was not the only important chapter being written in Jim Morrison's life that December. A significant step in Morrison's recognition as a poet took place when he called engineer John Haeny and said he would like to record some poetry on the night of his birthday. By this time, Jac Holzman had given Morrison a contract with Elektra to do a spoken-word album of his poetry. "He frequently wrote his poetry with a sense of his voice in mind," Holzman said. "He wanted some music and sound effects that would be recorded in the street or on the beach, or wherever appropriate accompaniment could be found. He was still experimenting with the form."

Though Morrison had recorded some of his poetry in March 1969, it was the December session that would form the bulk of the project. Frank Lisciandro elaborates: "Jim was always willing to better what he had done before, which is a mark of a dedicated craftsperson. He was always rewriting his poems. In fact he still reworked parts of *The Lords and The New Creatures* even after it was published. He seemed to want to sharpen his craft or at least his sense of a particular poem until he felt he had it just right. It was the same way with the poems he recorded for the poetry album. Between the two recording sessions he changed the poems and then decided to rerecord a lot of the same poems again because he felt he could read them much better."

Morrison was not only concerned with the art of poetry writing, he also recognized there was an art to the reading of

verse: "I write a poem pretty close to mus
admire poets who can recite their poems
with or without a microphone. Dry readii
of security—it's a lot easier to express my
my poetry dry. I'd like to work on that :

On December 8, 1970, Morrison's 1
birthday, he jubilantly entered the Vill;
L.A. with his poetry tucked under his
work on his dream project. He even inv
including Alan Ronay and Florentine Pabst. Ronay remembers:
"We had made plans to celebrate Jim's birthday, but he changed
the plans around. He said that for his birthday he was going
to give us a surprise gift and he set up a recording session
over at the Village Recorders. He said he wanted to record his
poetry as an experiment and as a gift for us. His heart was set on
it. So we ate over at the Lucky-U and then went over to the stu-
dio. We couldn't have been a happier threesome. He started re-
cording. We just felt really nice, just three friends cutting up and
having fun."

The first poem Morrison read that night began:

> *In that year we had a great visitation of energy.*
> *Back in those days everything*
> *was simpler & more confused.*
> *One summer night, going*
> *To the pier, I ran into*
> *2 young girls. The*
> *blonde was called Freedom,*
> *the dark one, Enterprise.*

Morrison had come to the studio sober, but this soon
changed. "You must understand that Jim did need his drinking
buddies," Ronay continued. "There was something about Jim that
was so simple amid his being complicated. It was as though what
he really needed he couldn't find with many people, so he chose
people with whom he had nothing in common, but it was easy.
They drove him around and they picked him up off the ground or
they laughed at his jokes. They took care of him a lot of times. But
sometimes it was a real problem. During the session Frank and
Kathy Lisciandro walked in. Kathy was the secretary, so she proba-

ne appointment at the studio for Jim. They had come to
e Jim's birthday, but what they brought for him was a case
mething, five bottles of Jack Daniel's or something. I can't
curately tell you what it was, but it was a lot. I mean, c'mon. I
couldn't believe it. I left five minutes later, leaving Florentine be-
hind. I mean, I could see what was going to happen. I'd seen the
same scenario too many times before. Of course Jim was a very
willing participant in all this. He had certain visions of the world
and this kind of thing only backed up something he thought about
people. Sometimes he was willing to be the pawn in order to bring
the truth out, but after a while it would be basically a replay of
what happened the night before with other people. I mean how
many times do you need to go through the same charade."

Frank Lisciandro maintains that he and Kathy were invited to
the session, arrived before it began, and didn't bring any alcohol.

After Ronay left, Morrison continued recording. As Frank re-
calls, Jim kept reading, one poem after another:

> *I walked thru the panther's living room*
> *And our summer together ended*
> *Too soon*
> *Stronger than farther*
> *Strangled by night*
> *Rest in my sun burst*
> *Relax in her secret wilderness*
> *This is the sea of doubt*
> *which threads harps*
> *unwithered*
> *& unstrung*
> *Its the brother, not the past*
> *who turns sunlight into glass*
> *It's the valley*
> *It's me.*

Morrison kept on reading until the recording tape ran out
and John Haeny had to cut in and stop him. But as soon as Haeny
had the tape changed, Morrison was ready to go again and read
on until another roll of tape was completely filled. Finally, after
two hours of constant reading, he announced he was ready to go
get a taco and the little group returned to the Lucky-U. Accord-

ing to Lisciandro, Morrison was in a great mood, feisty, playful, and happy to be recording his poems.

Just as it had been when Morrison was at UCLA, the Lucky-U was favored by film school students for its good food and interesting characters. But tonight, after a taco and a few beers, Morrison was ready to head back to the studio. John Haeny describes how the next part of the session began: "Paul Rothchild told me that the key to Jim's crazies, if you wanna call it that, was not cocaine or marijuana, or scotch, or bourbon, it was Irish whiskey. And as a birthday present I bought him a fifth of Old Bushmills Irish whiskey. He had his material all prepared. He knew what he wanted to read and the order he wanted to read it in. I set one microphone up loosely in the center of the room and encouraged him to move around at will. There was one point during the session when, through an exchange of looks—he had this marvelous impish twinkle in his eyes—he told me that he understood I wanted to record the Irish Poet in him reading his poetry while getting drunk."

Morrison may have intended to read his poetry sober, but he didn't have the power to resist such temptation when it was so conveniently offered. So, for the next hour or so, Jim lived up to his Irish ancestory, drinking the whiskey and reading his poetry.

> *We scaled the wall*
> *We tripped thru the graveyard*
> *Ancient shapes were all around us*
> *No music but the wet grass*
> *felt fresh beside the fog*
>
> *Two made love in a silent spot*
> *one chased a rabbit into the dark*
> *A girl got drunk & made the dead*
> *And I gave empty sermons to my head*
>
> *Cemetery cool & quiet*
> *Hate to leave*
> *your sacred lay*
> *Dread the milky coming of the day*

Later, the bottle was almost empty. Morrison was still excited about his reading, but the booze and the fatigue from

constant reciting were beginning to cause diction errors and he stumbled and slurred over many of the words. Nonetheless, he read an additional twenty pages and then decided to get Lisciandro involved. "I was watching the session," Frank remembers, "when Jim announces, 'All right, tell you what. Me and old Frank are gonna do what you call the old improvosuto.' This was the first I'd heard about it. I hoped Jim wasn't going to ask me to sing. I didn't want to deny him a birthday request, but on the other hand, I didn't fancy making a fool of myself on a tape that was probably going to outlive me."

Morrison was using a tambourine to accent lines and without warning he banged it against the mike, nearly sending Haeny into shock as it amplified through the engineer's headphones. After a few verses he improvised a poem and had Frank chip in with a few choice accents. Then Morrison decided Kathy and Florentine should join him and read the female voice of a long narrative poem in unison while he did the male voice. After a rocky start and quite a bit of good-natured teasing and giggling the girls settled into reading a long passage. In *"An Hour for Magic"* Lisciandro recalled what happened next: "Suddenly a loud crash made us all jump out of our socks. It was Jim who, listening with eyes closed, had started to doze, lullabied by the ladies' melodious voices. He lost his balance and pitched into the mike stands, which ended up on the hardwood floor with him. He laughed as hard as we did and yelled, 'Wait a minute! Wait a minute! Start 'em again. They're great.'"

Haeny wanted to call it a night, but Morrison insisted and the readings went on for another hour. Haeny recalls how the session ended. "I think the second time he knocked over the microphone stand the music stand went with it and sent his papers flying all over the room. I looked at Frank and Kathy and I remember saying, 'I assume you know how to deal with this?' They just looked at me and smiled and said, 'Yes, we do.' They went out, helped him pick up his mess and took him home."

During the four-hour session, Morrison had read his way through a thick sheaf of typed sheets. His poetry spoken by him. The poet's triumph. As a poet, he was gifted with a unique style—his poetry was more a verbal frontal assault than a soothing of the troubled spirit. Not that he couldn't be gentle or poignant, but such moments were invariably followed by the

harsh crashing of gut-wrenching reality as only Jim Morrison could sum it up. Morrison wanted to make you feel his poems—in fact he wanted to flood your senses with imagery so strong that the meaning singed your psyche like an exposed nerve straight to the heart. That was Jim's idea of a good poem.

The Doors' Last Performances

The next day Morrison was so elated over the poetry readings that he felt like performing again. The others were still wary after the Isle of Wight, but agreed to take *L.A. Woman* on the road for a small tour to try the new material out onstage. So a mere two days later on December 11 at the Music Hall in Dallas, the first concert was held. Rich Linnell promoted the show: "We only scheduled one show, but it sold out in advance and another two or three thousand people showed up, so we decided to do a second show on the spot. That one was a half to two thirds full."

"Love Her Madly" opened the show and The Doors did an extended jam in the middle. The version of "Back Door Man" that followed was rousing, if unpolished. The band had been off-stage since the Isle of Wright and they were a bit rusty on some of the older tunes. Through most of the numbers Morrison was a bit off-key, especially on the screams, but in "The Changeling" he took command and his voice sounded powerful instead of broken. But it was "L.A. Woman" that stole the show. Morrison sang the "never saw a woman so alone" section like he really meant it this time and made a strange substitution for "another lost angel," singing, "Are you a lucky little lady in the City of Light or just another dark witness in the City of Night?" What he meant by this no one knows for sure, but it may have been indicative of how he was feeling about L.A. He also improvised the following lines during "When The Music's Over" which closed the first show: *All my life's a bright delusion/All my world's a torn circus/All my mind has come tumbling down.*

The band also previewed "Riders On The Storm" to a delighted audience. Everyone who saw the concert agreed that The Doors' performance in Dallas proved beyond a shadow of a doubt that they still had what it takes. Morrison was in the best of spir-

its and the *L.A. Woman* material was greatly received. The band did two encores and toasted each other backstage after the show.

But whereas Dallas was a triumph, New Orleans was a tragedy. On that night, December 12, 1970, at The Warehouse, The Doors played their last concert as a quartet. Once again they performed songs from *L.A. Woman,* but this time something went wrong. Something happened to Jim Morrison that night. Something so unusual that only those who knew him as a person instead of a star could possibly understand. Some said he was drunk and sick. Others said he had finally burned completely out. And some said the spirit that powered Jim Morrison, the spirit that changed him from a man to a shaman, the spirit that hounded him incessantly every moment of his life except when he stood on that stage—that same spirit left him that night in New Orleans. Ray Manzarek describes it: "Everyone who was there saw it, man. He lost all his energy about midway through the set. He hung on the microphone and it just slipped away. You could actually see it leave him. He was drained. Jim picked up the microphone stand and repeatedly bashed it into the stage, over and over until there was the sound of wood splintering. He threw the stand into the stunned audience, turned, and plopped down on the drum riser, sitting motionless. When I first met him, he was just full of energy, life, power and potency, and intellectual knowledge, and by the time it was over, he was drained and exhausted."

Vince Treanor describes the last song Jim Morrison ever sang onstage: "It was 'Light My Fire.' Jim was very drunk. He was *hanging* on the mike trying to sing. Then when Robby and Ray did their solos, Jim sat down in front of the drum platform and when it came time for him to come back in he just sat there. They went through the cycle two or three times, but Jim would never come back in and they kept having to solo again. Finally, John kicked Jim in the back, poked him with his foot, and Jim got up and went over to the microphone and went, 'Yeah . . . yeah,' into the mike. Then he picked up the mike stand and smashed the whole stand down through the stage and the stage was made of two layers of three-quarter-inch plywood. He destroyed the stage with the mike stand and then walked off the stage . . . and that was it. John stood up, threw his sticks down, and said, 'That's it,' and walked offstage leaving Ray and Robby there."

The rest of the tour was canceled—Manzarek and Krieger finally agreed with Densmore that The Doors should no longer play live. Jim Morrison never again took the stage. The music *was* finally over. And even John knew something different had happened in New Orleans: "Later Ray remarked that during the set he saw all of Jim's psychic energy go out the top of his head," Densmore wrote in his biography (*Riders on the Storm,* Delacorte Press, 1990). "I didn't see that, but it did seem that Jim's lifeforce was gone." Was this the last vestige of something encountered on a New Mexico highway when he was only four years old? Was this the escape of the muse that he sought to possess him on a Venice rooftop? Perhaps. But one thing appears clear. Throughout his career Morrison seemed invincible. He fell out of second-story windows, leaped from moving cars, and totally abused his body with alcohol to the point that most people who knew him wondered what kept him going. But after December 12, it all seemed to catch up to him. By the following July he would be dead.

> *It hurts to set you free*
> *but you'll never follow me*

The inconsistency between Dallas and New Orleans summed up the problems that had plagued The Doors' live shows for the past few years. The irony here is that if Morrison had been able to keep it together in New Orleans, the band probably would've decided to tour *L.A. Woman* after all and Jim might never have gone to Paris.

But despite what happened in New Orleans, there were other changes going on in Jim Morrison that spoke of a new maturity. An interview came out that described him as "placid and peaceful . . . anything but the Jekyllesque character the press had painted him to be." He had aged. There were gray hairs mingling into his beard and long hair. His attitude was different as well. In another article he said, "I think of myself as an intelligent, sensitive human being with the soul of a clown, which always forces me to blow it at the most important moments."

In recent months he had been trying to sort himself out and he had gained a new perspective on his career. In an interview with Salli Stevenson of *Circus* he said: "I'm not denying that I've

had a good time these last three or four years and met a lot of interesting people and seen a lot of things in a short space of time that I probably wouldn't have run into in twenty years of living, so I can't say that I regret it. If I had it to do over again, I think I would have gone more for the quiet, and undemonstrative little artist plodding away in his own garden trip."

Part of this "sorting out" concerned what Morrison was going to spend his creative energies on. He talked in these interviews about setting his sights lower and not worrying about selling lots of records. He discussed making personal appearances. And he talked a lot about doing some writing in Paris.

Paris

It was understood among The Doors that Morrison was leaving for Paris as soon as the *L.A. Woman* album was completed. Pamela had left in February and Jim announced he was going there as soon as possible to take a "sabbatical." The question in the other Doors minds at the time was when would he return? After all, the contract was up and they were free. They could resign with Elektra, sign with another record company, or break up the band. Some people close to Morrison at that time maintain that he clearly indicated he might never sing with The Doors again. Among them is John Haeny: "After *L.A. Woman* was completed, Jim quit the band. Everybody in the band will tell you that before Jim left for Paris, he said he didn't really mean it and that he was planning on coming back and rejoining the band. Personally, I find this a myth created by The Doors. Once Jim quit The Doors he never once mentioned to me that he had any intentions of rejoining the band. His focus was on his poetry. That's what he went to Paris for. After our initial recordings of his poetry he realized he needed to organize his thoughts. It was important to him that the world perceive him as a poet. That's why he signed a contract with Elektra Records to make a poetry album with no participation from The Doors."

The three surviving Doors claim that nothing so permanent was ever said. According to Ray Manzarek, it was understood that Jim was going to take a good long vacation and then return. "Jim left right in the middle of the mixing of *L.A. Woman*. I think we

maybe had two more songs to mix and he said, 'You guys can finish up.' Jim wanted to immerse himself in an artistic environment to get away from L.A., to get away from rock 'n' roll. To get away from all the sensational press that he had, hounded by a lot of yellow journalism. Jim Morrison was a poet. He felt all those titles people put on him were demeaning to what The Doors were trying to do, so in an effort to escape that and to recharge his artistic batteries he went to Paris, the city of art. We had to deliver seven albums over that five-year period of time, so we decided to just take a long hiatus and there was really no reason for Jim to be there for the mix."

The truth that emerges is that Morrison never committed either way. He never promised he would return to The Doors and he never quit either. Bill Siddons remembers: "I was in the meeting in which Jim announced that he was moving to Paris and had no intention of continuing anything or not continuing anything. There was never a question that Jim Morrison was, from the day that *L.A. Woman* was finished, done with The Doors as an obligation. He finished recording all the albums under the contract, there were no plans to tour, and, in fact, while Jim was in Paris, Ray Manzarek, Robby Kreiger, and John Densmore rehearsed with different singers too because they knew that Jim might never come back. He never said, 'I quit. The band is over, forget you, it'll never happen again' . . . he also never said, 'I'll be back in three months.' He just said, 'I don't know who I am, I don't know what I'm doing, I don't know what I wanna do, I'm gone . . . don't count on me, good-bye.' "

The truth is that there was a lot of uncertainty in the group. Morrison was uncertain he wanted to continue singing. Densmore was uncertain he wanted to continue living the kind of pressured existence that Jim's antics had forced upon them all in recent years. Ray and Robby knew that there had to be some changes before the next tour, but they preferred to wait and see what developed before making any rash decisions. And everyone was uncertain how *L.A. Woman* would do on the charts. While they felt very good about the record, they'd learned that the public's reaction to their music was somewhat unpredictable. On the one hand, the album could be a huge success since the songs had flowed so well and they'd all enjoyed recording it so much. On the other hand, it could be a real bomb since it was closer to

more of a basic blues than most of the big-selling albums of the time.

There is also considerable disagreement about Morrison's condition when he left. Some claim he was excited, eagerly anticipating the trip and mentally on top of the world. Rich Linnell recalls the last time he saw Morrison: "It was in February, I think, a few weeks before Jim left for Paris. We had a touch football game at a park near my place in Manhattan Beach. Jim, Frank Lisciandro, Babe Hill, Bill Siddons, Danny Sugerman, my brother, and a few other guys were there. We had four or five on a team and we played for a couple of hours. Jim was on my team and I had him rushing my brother who was the quarterback for the other side. And the thing that I remember most about it was Jim's tenacity. He wasn't particularly athletic, but he kept trying. My brother was real quick, so he was always dodging and Jim would just dive after him. Then he'd get up and run after him and dive at him again. Every now and then he'd get him, but usually he didn't. But he just kept plowing away. I remember Jim saying, 'Boy, that guy's squirmy,' all the time in the huddle. He just seemed to be very enthused."

Others claim Morrison left the States feeling disillusioned and weary. Patricia Kennealy is one of them. After Pam left, she came to L.A. and stayed with Morrison for a week. At first Jim was caring and loving, perhaps seeing another possibility with Pam gone. But the visit did not end well which Patricia blames on the fact that Morrison was drinking very heavily. She describes the last time she saw him: "I took one look at him and knew he wasn't going to be around very much longer. There was no cohesion—the electrons weren't going around the nucleus, just spinning off into space. It seemed not to be *him* anymore; the dark side was taking over. I had always drawn this sharp distinction, almost an opposition, between the public and private persona; there was 'Morrison' the stage lunatic, on the one side, and there was 'Jim,' whom I loved, on the other. And 'Jim' was losing the battle, and I think he knew it too."

True to form, Morrison was different to each person right until the last, but the majority of evidence indicates he left the States feeling discouraged. Beset by legal problems and years of alcohol abuse, he was escaping to France not only to rechart his life, but also to salvage a dream. Shortly before leaving, Morrison

renewed his relationship with Tom Baker. Baker had recently returned from Europe and received a message that Jim wanted to get together. He wrote about Morrison's last days in L.A.: "We went to an outdoor restaurant and reaffirmed our friendship. He told me he'd had the opportunity to patch things up with our old drinking buddy Janis Joplin . . . Apparently he made amends with her just weeks before she passed away, and he was genuinely grateful for it. Jim was drinking, although he was restricting himself to white wine. I looked at him and remembered the first time I had seen him. His once sharply defined face was now bloated by alcohol; his features were soft and pale. His eyes lacked that fierce sparkle and he moved with what appeared to be great effort . . . He confided to me his intention to move to Paris. 'Yeah,' he said, 'my rock 'n' roll days are over, I guess.' Along with Babe Hill we would meet quite regularly for the rest of his time in L.A. and I could tell he had lost much of his fascination for that town. His last day in L.A. he and Babe and I spent wandering around the Santa Monica pier. Late in the afternoon, we returned to his office and he tossed notebooks, manuscripts, and other belongings into cardboard boxes. Various friends stopped by to wish him bon voyage. In the morning he boarded his flight."

The *Los Angeles Times* described Morrison as "attempting to duck the demons for good, but it was almost impossible in L.A." A man on the run all his life, Morrison now fled L.A. before the album's release. He hoped it would be a big success, but he was equally enthusiastic about the poetry tapes. After reviewing them, he called engineer John Haeny and said he was leaving "to work on his reading voice. To clarify his poetic thoughts and to organize his words and ideas."

Morrison felt this could be best accomplished in Paris. After all, Paris was the home of the French Symbolist poets, the birthplace of the Surrealist movement, Céline's misanthropic ellipses, and much more that had undoubtedly inspired him as a youth. He no doubt reasoned that if he couldn't find literary sustenance in that atmosphere, he couldn't find it anywhere. Paris also offered a very real escape from the pressures of L.A. and stardom. Since Paris has been often called the City of Light there is a strong indication that parts of *L.A. Woman* express Morrison's desire to leave the City of Night for the City of Light. In his mind, Paris would serve as a place of refuge where he would reunite

with Pamela and with his art. It would be the sanctuary, the "soft asylum," he needed.

∎

In April 1971, the *L.A. Woman* album was released and there were no doubts about its popularity—it was a monster. "Love Her Madly" was pulled as the single and it immediately zoomed up the charts, becoming The Doors' first Top 10 hit in two years. *L.A. Woman* propelled the group back into status as one of America's most popular bands. *Rolling Stone* called it "the Doors greatest album (including their first) and the best album so far this year."

The cover graphics were quite ambitious. It featured a clear plastic window with the group's picture impressed on the transparency which came to life when the yellow inner sleeve was inserted. Morrison was the last one in the photo, sunken down lower than the others, with a full beard. He was the least focus of attention in the photograph, except perhaps for what seems to be a sly smirk on his face. The back of the inner sleeve was a startling illustration of a woman crucified on a utility pole. All in all, it was a unique and unusual album design.

But, while The Doors' records were selling like the old days back home, Morrison was literally and figuratively miles away. The Morrison apartment was at 17 rue Beautreillis in the Marais on the Right Bank, one of the oldest and most beautiful sections of the city. It was only a few blocks from the Place Bastille and the Metro shops, and the open-air food stores were just paces from their door. It was an idyllic location and the apartment itself was spacious and elegant. Pam and Jim sublet it and Morrison was very proud of it. At first, Jim and Pam had a wonderful time in Paris. Morrison's attitude improved upon arriving and he expressed excitement about the films, books, and poems he wanted to create. For the first time in years, he was free of pressure. He even began to trim down a bit, but after a while realized it was hopeless with the French food. He knew he would never regain the licorice-legged look of the gaunt shadow that once prowled L.A. Shaving the beard did make his face look youthful again, however, and wearing button-down-collar shirts and V-necked sweaters, chino trousers and desert boots, he looked more like a

graduate student than a rock star. Sometimes he was recognized, sometimes not, and he didn't mind either way. For a time it seemed he might actually settle down. Pam told friends she wanted to buy an old church and convert it into a house. It was as though Morrison was at last trying to accept himself and what he had become. He even went so far as to talk about getting together with his parents again.

Alan Ronay, Jim's close friend since UCLA, lived with Jim and Pam in Paris for five weeks and he believes Morrison was attempting to come to terms with himself: "In the beginning he was very hopeful and bright about a new life. Most of the time he was very calm and he wasn't drinking very much. He wrote practically every day. One night we had a conversation that was totally moving. It was full of affection . . . Jim telling funny stories about his dad and so on. The stories were really tender and warm. I wish his parents could've heard it. I really felt that he'd totally reclaimed himself."

Morrison told visitors that he'd written a book that was nearly finished and ready for publication and said he'd begun a book on the Miami trial, but no one actually saw either of these works. He also wanted to get the poem "An American Prayer" translated into French. Though this was an idea that seemed to hold him by the heart, nothing was done about it. In fact, until a discovery in 1987, many people assumed that Morrison didn't write at all in Paris. Much of what he created at this time Pam later stored away in a locked steel box about the size of an attaché case. The strongbox was discovered nearly sixteen years later when friends of Pam in San Francisco tried to sell off the contents. She had written on the lid the words "127 Fascination," but no one knows why. It contained over two hundred pages of unpublished writings and jottings, much of which was written in notebooks. Besides Jim's last writings in Paris, the box included unpublished songs and a small notebook entitled "The Square of Life," the original manuscript of *The Lords and The New Creatures,* and a forty-three-page poem entitled "An American Night."

It is still impossible to tell how productive Morrison actually was in Paris because many of these writings dated from an earlier period, but it is clear that he did do some work there. Frank Lisciandro elaborates: "We have what we call the 'Paris Journal,'

the last book Jim wrote in. In one place Jim seems to be writing
the finished forms of poems with which he was satisfied—there
wasn't any crossing out and rewriting like in his other notebooks.
But in the stuff he actually wrote in Paris he seems to be much
more self-reflective, more aware of the fragileness of existence,
and more self-conscious. In the 'Paris Journal' he seems to be
talking a lot about himself, about what his life had been up to that
point as if he was summing up. I think he was very self-reflective.
Very withdrawn, indrawn. Probably felt a little disconnected, a
stranger, cut off from his source. But he was writing, some beau-
tiful things. Disturbing things and beautiful things."

In Paris, Jim settled into a deep reflective period. His poetry
became questions, analyzing and examining his turbulent life.
Morrison knew philosophy, he knew what the great thinkers had
taught about how to live and for years he had been content to
pick and choose among them, using their theories and weighty
treatises, to explain away his own actions. But now he wanted
to know something more. He wanted to know himself. Naturally,
he pursued this quest through his art. His notebooks reflect
that search in words, and like a man paging through an old
diary, he copied the old poems again—viewing them as finished
at last and perhaps searching through them for lost chapters of
his life.

As I look back
over my life
I am struck by post cards
Ruined snapped shots
faded posters
Of a time I can't recall

Morrison also made some efforts toward film while in Paris,
but most of it seems to have to do with wanting to screen the old
projects rather than writing new material. Perhaps, at least sub-
consciously, he hoped to see something in the films he had never
seen before. He spent a good deal of time checking out places
where he might be able to show them, but when Pamela sug-
gested that he buy a studio to work on the films, Jim insisted that
he wanted to screen them first. "What I am going to do, though,"
he told a friend at the time, "is have a screening here for some

people of my three films—first a documentary of a Doors concert made by some slick professional filmmakers; then another Doors documentary, a much more human, violent look made by the friends I work on films with, sort of how a similar event, a concert, can be seen in different contrasting ways; and last I will show my film *HWY.*"

Here, too, Morrison was taking a retrospective approach rather than the spontaneously creative one that had dominated his life. When he was offered a small acting role in a film with Robert Mitchum about an Alaskan bear hunt based on Norman Mailer's *Why Are We in Vietnam?* Morrison told friends that he didn't think he would do the movie "because it will take up too much time when I could be writing."

Meanwhile, speculation continued about whether or not he would return to America and The Doors. Though he was happy in Paris in the early months, Morrison always maintained that he would return to the United States. But when *L.A. Woman* became a huge success in April, he told friends he wouldn't "be back in L.A. until September at the earliest." He still didn't know whether or not he would give up music. With the great popularity of the new album and the completion of their Elektra contract, the other three Doors meanwhile had no real choice but to prepare for either possibility. They rehearsed new material on a regular basis, figuring that if Jim returned he could sing it, and they also jammed with different vocalists now and then in case Morrison decided to quit the band. In their minds Jim had not made any sort of final decision. Robby Krieger elaborates: "We never really broke up . . . It was understood that it was gonna be a long vacation for everybody. But there was no talk of breaking up The Doors . . . We'd finished our contract with Elektra, as far as albums go . . . we were gonna take a long vacation for sure, but we didn't say, 'Okay, let's break up the group . . . you do a solo album, you do a solo album, and whatever.' Never said that. In fact, Jim had called John Densmore shortly before his death and said, 'Hey, how's the album doin' and stuff. 'Yeah, we might have to come back and do another one pretty soon,' and whatever."

But, while in Paris, Morrison spoke of rock music as if he had definitely finished with it: "I'm twenty-seven years old. That is too old to be a rock singer. It doesn't make sense anymore. I'm so sick of everything. People keep thinking of me as a rock 'n' roll

star and I don't want anything to do with it. I can't stand it anymore."

Bill Siddons agrees: "He went off to Paris to concentrate on his writing. He was working on two different screenplays as far as I know, and he was working on his poetry. But he went off to stop pursuing the rock 'n' roll dream because he'd achieved it and didn't like it. And he said, 'What am I but a writer.'" Meanwhile, Atlantic and Columbia were reported to have made approaches to sign The Doors, but there was no hard evidence the group was planning to leave Elektra. By July everything was still up in the air.

The Last Days

After a few months Morrison realized that the reality of creative exile in Paris was somewhat different from what he had expected. He was writing, but somehow that wasn't enough. He needed something more. Part of this may have been because he now realized that he was a hopeless alcoholic. At Pam's insistence and perhaps because some of his friends had stopped drinking, Morrison made an effort to quit cold turkey and discovered that he could not. It was a classic vicious circle. Jim drank to obtain peace because it was the only way he knew how, but because of his drinking, his life was in a constant state of uproar. Not being able to quit depressed him all the more and he fought the depression with drink, thus continuing the cycle. To break out of this routinized insanity, Jim and Pam spent three weeks in April and May traveling across France, Spain, and Morocco and another ten days at the end of May visiting Corsica. They rented a car and toured the wine country for a month. Pam had her trusty Super 8 movie camera and they both maintained to friends that they had some "fabulous footage." Morrison said he was going to incorporate his North African adventures into something that he was planning to write. "One of the reasons I like Paris so much is that it is so centrally located, not very far from anywhere, not like L.A. We also went to Corsica. We are going to go to London for a few days next week, too."

But the peace Morrison thought would be his in Paris was not coming and he began to realize that the conflicts that so tor-

mented him were not in L.A. or any place that he could run away from—they were inside of Jim Morrison. He took to wild partying again and he and Pam clashed regularly. Often she ran with her friends and he with his just like they had so many times in L.A. Jim met a whole new set of drinking buddies in Paris and he started hanging around sleazy French nightclubs like the Circus. Within a few months he had brought about the very same life he had tried to run away from.

Patricia Kennealy recalls the last time she spoke to Morrison: "He called for my birthday, the first week of March, and apologized for his behavior in L.A. Then I got a couple of letters from Paris promising he'd be with me in New York in the fall. I think we both wanted to believe it. By now I was absolutely convinced he was going to die. It felt as if he wasn't even there anymore. I could feel him leaving, disengaging. Like the moon. Like the tide. Just getting the hell out. I don't think anybody—not Pam, not me, not the other Doors, or his other friends—could have stopped him by then, and I'm not even sure it would have been kind or wise to try. We had all tried in the past, of course, but it was like jumping in front of a runaway car as it heads for the cliffs—it goes over regardless and if you don't go over with it you are left bleeding in the dust. I'd have sold my soul to save him, but I knew that it wouldn't have helped."

Excerpts from Morrison's last letter to Patricia Kennealy in June of 1971 seem to indicate a mood of despondency: "He seemed to be taking a hard look at his life. So many of us go through a deep analytical evaluation of our lives when we reach that age. Jim seemed to have a problem facing it. He wrote that he felt as if he'd 'walked for miles and come home limping.' He felt cornered and wanted to escape and said he sensed he was 'standing on the downslope of some dark, angry void.'"

> *Tell them you came & saw*
> *& look'd into my eyes*
> *& saw the shadow*
> *of the guard receding*

By late June, whatever Morrison had hoped to accomplish in Paris was becoming lost in a sea of booze and he slid into a massive depression. The last thing to go was his art, and while Mor-

rison could still create, he could no longer be satisfied with his
creations. The booze, the aftermath of the trial and what it meant
to him, and the abuse he had inflicted on his body over the years
had left Jim Morrison without either the patience or the disci-
pline to pursue any answers that didn't come easily. Perhaps
these things killed the Muse. Or perhaps it had betrayed him and
left of its own accord on that New Orleans stage—left him used,
broken, and struck by the startling revelation that being an artist
for the long haul means more than harnessing sudden and terri-
ble inspirations. It means being willing to study and grow in
one's character as well as one's art. It means overcoming toil and
trouble and mastering that enemy of all creative forces—doubt.
In the end, the race doesn't belong to the swift, but to the one
who has the tenacity and belief in himself or in something
greater in order to hang in there the longest. When you come
right down to it, it's much easier to be a genius at twenty-two
than it is to sustain it at forty-two—or even twenty-seven. Know-
ing that most of his creative energy and his very lust for life had
already been spent, Morrison came to the conclusion that not
only did he still have a lot to learn, but he no longer had the
energy or the desire to learn it. In the end, Jim Morrison con-
ceded in body what he had granted in spirit, victory to the forces
of decay and duplicity. Having broken through to the other side,
Morrison found himself stranded with no return passage home.

> *Regret for wasted nights*
> *& wasted years*
> *I pissed it all away*
> *American Music*

On Thursday, July 1, Morrison seemed depressed to his
friends, and nothing seemed to cheer him up. The following day
Alan Ronay stopped over and recommended that Jim see a Rob-
ert Mitchum film, *Pursued,* knowing that Morrison admired the
actor. According to Pam, Morrison decided to go and see the
movie and set off for the cinema alone. From this point on there
has been much speculation about what actually happened. Pam's
story was that Morrison came home from the movie and went to
bed. Later, he awoke coughing and complained of chest pains, so
he decided to take a bath. When Pam awoke at 5 A.M. on the

morning of July 3 and didn't see him in bed, she looked in the bathroom and saw him still in the tub. At first she thought he was pretending, but then she realized the horrible truth.

He looked as if he were peacefully resting. Clean-shaven, his head leaning back so that his long wet hair was matted against the rim of the tub, and his arms resting against the porcelain sides. And there was a boyish smile on his face.

> *Into this house we're born*
> *Into this world we're thrown*
> *Like a dog without a bone*
> *An actor out on loan*

STONED IMMACULATE

Like his life, Morrison's death has been shrouded in controversy. For nearly twenty years the truth has been lost in a maze of secrets and bizarre theories which border on the surreal. Although, next to old age, the last thing one would expect Jim Morrison to die of would be a heart attack, that has been the official cause of his death. Until now, all we knew as fact was that Morrison's death certificate said he died of heart failure at approximately 5 A.M. on Saturday, July 3, 1971. The rest has been opened to speculation.

Supposedly, an errant blood clot triggered by a respiratory ailment caused the heart to stop when it made its way into his bloodstream while he was taking a bath in his Paris flat. The respiratory ailment was attributed to an injury Morrison sustained to his lung when he fell from the second story of the Chateau Marmont in Hollywood a few weeks before leaving for Paris. It was a classic Morrison escapade. Jim had been playing around, doing a

Tarzan act, climbing up on the roof and trying to swing into his bedroom window from a rain gutter. He lost his grip and fell two stories. The only reason he wasn't killed was because he bounced off the roof of a shed attached to the back of the cottage before hitting the ground. When he went to the doctor after the fall Morrison was advised to take it easy, but he ignored the warning.

In France, four months later, Morrison was said to be having some sort of respiratory trouble, even coughing up blood now and then. Pam later claimed that Jim saw two doctors during this time and even complained of the condition on the day before his death. The events of that day, Friday, July 2, have long remained a mystery, but according to Pam it all ended early the next morning in a Paris bathtub.

> *I hope you went out*
> *Smiling*
> *Like a child*
> *Into the cool remnant*
> *of a dream*

After discovering Jim's body, Pamela said she called the fire department to attempt resuscitation and the police and a doctor followed. But it was too late. The doctor declared Morrison dead from a heart attack—probably provoked by a blood clot from the respiratory condition and/or a pulmonary infection, but no autopsy was done. The official French death certificate listed him, upon Pamela's request, as "James Morrison, Poet." Since there was no autopsy, no real cause was ever determined and to make matters worse, the casket was sealed without informing the American Embassy.

By Sunday morning there were rumors all over Paris that Jim Morrison had died sometime over the weekend, but when reporters called Pam's flat, they reported being told that Morrison was "not dead but very tired and resting in a hospital." The current of talk soon reached Clive Selwood, general manager of Elektra Records' London office. When Elektra U.K. phoned their Paris branch, they discovered the French office of the label didn't even know Morrison was in the city. Calls to the police and the American Embassy revealed that no one named Morrison had shown up at any city morgue.

Bill Siddons tells what happened next. "It was 4:30 A.M.
Monday, July 5. I got a call from Clive Selwood in London, saying,
'I don't want to upset you, but I've gotten calls from three dif-
ferent writers asking me to confirm that Jim Morrison is dead.'
Now, we'd had scares before. Jim's death had been rumored sev-
eral times over the years, but Clive respected the writers who
had called, so I was anxious. I sat upright in my bed real fast. I
called Jim and Pam's apartment in Paris and got no answer. In the
meantime, my wife had woken up and said, 'Jim's dead.' She *felt*
it. Since I couldn't reach Pam, though, I went back to bed."

When Siddons got up around 8 A.M. he tried the apartment
again and this time Pam answered and claimed the rumor wasn't
true. "She sounded upset, so I pressed her a bit," Siddons contin-
ued. "You see, she perceived the other three Doors as enemies
who were keeping Jim from doing what he really wanted and she
considered me part of that circle . . . I said, 'Look, I'm calling as a
friend, not as a business representative. I don't want to do any-
thing but help you. If there's anything happening, I want to know
so I can help. Tell me, please, the truth—is Jim alive or dead?'
She started to cry, so I told her I was taking the next plane to
Paris."

Siddons took an afternoon flight out of L.A. and arrived in
Paris about 6:30 the next morning. "I went over to the apart-
ment right away. Pam was awake and sitting with Robin, who
was her and Jim's secretarial assistant and a fluent French
speaker. Neither Jim nor Pam knew any French. I talked to
them for a long time and they confirmed that, yes, Jim had died
a couple of days earlier. Pam said that she and Jim had been out
for the evening and had come home. She went to bed and Jim
decided to take a bath. She got up four hours later and found
that Jim had died in the bathtub. By the time I got there the
authorities had already been by, put Jim in a casket which was
still in the apartment, and filed a death certificate that said Jim
had died of a heart attack. It was some sort of heart failure com-
plicated by a lung infection. Blood probably collected from a
clot and worked its way up the chest and blocked a heart valve.
And that caused the heart attack. Jim was very strong, but he
pushed himself to the limits."

Siddons then turned his attention to burying Morrison with-
out it becoming a media event. "We wanted to avoid all the noto-

riety and circuslike atmosphere that surrounded the d
Jimi Hendrix and Janis Joplin . . . so Robin and I got toget.
tried to figure out how we'd get Jim in the ground withou
fying the media. Basically, we didn't tell anyone. The
knew, of course, but some French friends of ours somehow man-
aged to prevent the news from hitting the police blotter for
about three days. Robin and I went down to the funeral home
and arranged for Jim's burial. We wired for money from the
States, paid for it right there, and bought a gravestone which
never appeared for reasons I'll never quite understand. Perhaps it
was the language barrier."

Morrison was buried quietly in a simple service on Thurs-
day, July 8, at the Père-Lachaise cemetery. Père-Lachaise, one of
the oldest and most prestigious cemeteries in Paris, is the final
resting ground for numerous celebrated men and women of arts
and letters including Balzac, Chopin, Molière, Edith Piaf, and Os-
car Wilde. Morrison was buried in the section known as the
"Poet's Corner," near the grave of Molière. The cemetery is 116
acres of nineteenth- and twentieth-century tombs and sepulchers,
some moldering and decrepit, others grandiose and meticulously
cared for. Bordered by the Avenue Gambetta and the Boulevard
De Ménilmontant, Père-Lachaise is a veritable necropolis of cob-
bled avenues, florid tombs, steep slopes, lush vegetation, and
wooded grounds, much of which overlooks the whole of Paris.

All our lives we sweat & save
Building for a shallow grave

Morrison had more or less chosen his own burial sight in
that he had visited the cemetery several times and even told Pam
that he wanted to be buried there some day. Once again, French
friends intervened, somehow convincing the right people to al-
low Morrison to be buried in the cemetery that is virtually a
national shrine. Bill Siddons describes the funeral: "There were
just a few of us at the grave site. A truck carrying Jim's casket
drove up to the grave . . . there was no real service and that
made it all the better. We threw flowers on the grave, said our
good-byes, and that was it. We got him buried without publicity
and sensationalism which I'm sure is the way Jim would have
wanted it. And we buried him where he wanted to be. That after-

noon I flew back to Los Angeles and got together with some newspaper writers and told them the whole story. I went to bed about 11 P.M., totally exhausted from the ordeal. I got up the next day and then spent the next few *weeks* dealing with all the phone calls. But we'd done it. We'd buried Jim with dignity."

It was Siddons who called Morrison's parents to notify them of their estranged son's death. Mrs. Morrison was shocked. "We knew he was in Paris, but we hadn't heard from him." Jim's father, Rear Admiral George S. Morrison, checked with the navy attaché in Paris, who confirmed the death. The family decided not to hold a separate memorial service, but was extremely upset.

Until Siddons's announcement in America, the press had been guessing, still playing off the "tired and resting" rumor. A popular paper in Paris ran a photo of Morrison with the headline reading "JIM MORRISON NOT DEAD," again reporting him "tired from a minor malady." And as late as July 8, after the burial, United Press International's Paris office was reporting Morrison "recovering and being treated in a hospital or sanitarium."

When the news was finally announced to the public it was confusing to say the least. A few early reports said a sudden case of pneumonia was responsible (Morrison had suffered from pneumonia, but that was a year before). A dispatch from Paris quoted police as saying Morrison died in his bath of a heart attack caused by the water being "either too hot or too cold." This report was probably based around the idea that people whose hearts have been weakened by alcohol addiction have to be careful of getting into water that is too hot or too cold due to the shock it can cause to their systems. A police spokesman said there was no indication that drugs were involved. The television news bulletin in America was short: "Rock singer Jim Morrison died last Saturday in Paris, his manager confirmed tonight. He was twenty-seven."

Later, more bits and fragments came in. One story said, "Jim Morrison died peacefully of natural causes in the Paris apartment he and his wife Pamela had shared since March of '71." And finally came the report that blamed the death on a respiratory illness and a heart attack. Then the information stopped and the speculation began.

New Information on Morrison's Death

Until now, all we knew about Jim Morrison's death came from a debatable French death certificate, a grave in Paris that went unmarked for some time, and Pamela's word. Besides the medical examiner, who has remained silent all these years, Pam was the only one who claimed to have seen the body and on April 25, 1974, she died of a heroin overdose (which will be discussed later in this chapter) supposedly taking her secrets with her. While interviews were being conducted for this book new information came to light that answers many questions and opens up new avenues for exploration. First, the official cause of death was always predicated on Morrison's having a respiratory condition that arose from the injuries he sustained in his fall at the Chateau Marmont. These reports have remained unquestioned for two decades, but Dr. Arnold Derwin, Morrison's personal physician of many years, denies them completely: "Jim was in excellent health before he went to Paris," Dr. Derwin maintains. "The fall from the Chateau Marmont did not do any serious damage. His lung was not punctured, only bruised and there was nothing from that injury that would create a blood clot, result in a respiratory condition, or cause him to spit up blood."

The coughing up of blood is somewhat common among longtime alcoholics and it could be speculated that Morrison's alcoholism led to the blood clot, but Dr. Derwin does not agree: "I saw Jim after his fall from the Chateau. I warned him to slow down and stay sober, but it wasn't based on the fact that his liver was shot or anything. It was based on him getting drunk and doing crazy things that could hurt him. He didn't have anything like an embolism, pulmonary thrombosis, or any kind of advanced liver disease at all. I don't believe his drinking could have caused a blood clot."

If a pulminary infection or alcoholism couldn't have caused his death, then what killed Jim Morrison? The answer initially came from a source that must remain unnamed, but the information was then verified as much as possible after the passage of twenty years: "You can't use my name with this, but I think it's about time the truth came out," the source said during our interview. "On the night of July 3, 1971, Pam called a very close friend of mine all in tears and said that Jim had gotten into her

heroin and overdosed. She didn't know what to do but she didn't want it to come out that he died from that, so my friend helped her plan out how to cover it up. Together they worked out all the details and Pam carried out the plan."

When confronted with this information, Diane Gardiner, Pam's closest friend at the time, confirms that it is true: "Pamela told me a lot about Jim's death," Gardiner admitted. "It's true that he got into some of Pam's drugs and overdosed, but I don't think Pam tried to cover it up. She was so . . . for a long time she didn't even think he was dead. You know Jim's weird sense of humor. She just kept thinking he was just playing dead in the bathtub. She talked to his corpse for *so* long before it finally even sunk in. That was her state of mind. She was just starkers. I don't think she was capable of any conscious cover-up."

According to Gardiner, Morrison must have snorted the heroin: "He would never inject himself." But perhaps he no longer cared. Pam told Gardiner she found the last words Morrison wrote in his notebook. Tearfully, Diane Gardiner recalled them: "Pam found the notebook the next day. He had written 'Last words, last words . . . out.'"

> *Leave the informed sense in our wake*
> *you be Christ on this package tour*
> *—Money beats soul—*
> *Last words, last words*
> *out*

Danny Sugerman confirmed in our interview that, once when he ran into Pam a year after Morrison's death, she admitted that Jim took some of her heroin. "She was very distraught and so vulnerable," Sugerman recalls. "If you doubted Jim's being dead, all you had to do was see the condition Pamela was in. Then she started telling me something about Jim's death being her fault and that he had found out she was doing heroin and, 'You know Jim, of course he wanted to try it.' Then she looked at me and said, 'It was my stash—Jim didn't know how to score. He knew how to drink.' She said that later he didn't feel well and decided to take a bath and she nodded out. But when I pressed her for details she suddenly denied the whole thing. Later, she extracted

a promise from me to never say anything to Jerry Hopkins who wanted to interview her for his book."

In his biography John Densmore quotes a disc jockey claiming that Morrison died behind a locked bathroom door and that Pam had to call Jean DeBretti and that he and Marianne Faithfull came over and broke down the door. DeBretti died of an overdose not long after and Faithful denies the story: "I think I'd remember something like that," she says. "I never even met Jim Morrison." Diane Gardiner also maintains the story is false, "It's ridiculous. Pam would've told me if the count and Marianne Faithfull were involved. I don't think that she'd be that detailed in making anything up about finding him and then talking and talking to him. 'Oh, c'mon Jim,' she said she kept saying. 'You know the way he always had that smile,' she told me. When she realized he was dead she didn't know what to do so she packed his body in ice. She got blocks of ice and packed them all around his body."

As to what happened after that the answers come from Alan Ronay. Though he was clearly one of Morrison's closest friends, Ronay has never consented to an interview before now. He maintains that none of the previously published accounts of Morrison's death have revealed the truth: "I can't believe some of the things that have been written about Jim dying in a nightclub or there being bloodstained daggers found under his bed. I mean, I lived with Jim and Pam in Paris for five or six weeks and none of these things are true. Some accounts have us even eating at a sidewalk café on the night of his death and me saying that I thought he was terribly depressed. None of that's true. We didn't dine together that night and I didn't say he looked depressed. I had been living with them but had moved out a few days before that. On July 2nd, I spent the whole day with Jim, but I left him and Pam around six or seven in the evening because I had a date for dinner. I did recommend that he see *Pursued* and he was trying to get me to meet them at the movie. When I saw Pam the next day, amid all the drama, it was like we were in shock. I said, 'Did you go?' And she said they had gone, but that he didn't like the movie very much."

Ronay was one of the first people to learn of Morrison's death: "I received a phone call from Pam early that morning saying that Jim was dead and I was with her almost all the time from

then on. Pam didn't speak French and Robin Wurtele, their secretary, was not in town that weekend, so we were alone in the apartment most of this time. While Pam was in a shocked sort of state for a while, she did recover within a few hours. I found her rather remarkable. She was really a strong person. Though it completely devastated her, in one sense she also showed enormous strength." In her official statement to police Pam said Jim vomited blood three times the night before.

While he won't confirm or deny that Morrison died from an overdose, Ronay does admit that he engineered the cover-up. "I told Pam not to announce Jim's death for a while. I didn't want a circus going on around his death and she agreed with me. Pam originally wanted him cremated and I said, 'No, don't cremate him . . . let's bury him at Père-Lachaise.' It just seemed like the thing to do. I was in a state of shock myself, but it seemed to me that it wouldn've been what he wanted. I got him into Père-Lachaise. There are no spaces left and at the time getting a foreigner buried there was not a particularly easy thing to do. While I can't reveal the details, it didn't prove to be an enormous hurdle, though, and I was even able to choose between two spaces."

Though he won't admit it, Ronay was probably the person who kept the news of Morrison's death out of the police reports (and hence out of the newspapers) and it was he who helped Pam file the death certificate at city hall. Further investigation has disclosed that not one but two doctors came to the apartment to examine Jim Morrison's body. The first doctor was someone brought in by Pam and Alan Ronay to sign the death certificate without asking a lot of questions so that when the police were called and the second doctor arrived with them there would be no need for an examination. Without an official death certificate the police doctor would have requested an autopsy under the circumstances, but once the cause of death had been determined no further examination needed to take place.

Dr. Max Vassille, the medical examiner, described Morrison's body in the police report as follows: "The body does not show, apart from the lividness of death, any suspicious signs of trauma or lesions of any kind. A little blood around the nostrils. . . . I conclude from my examination that death was caused by heart failure." Under French law, since there was no evidence of a crime, the medical examiner has the final say and so the case was closed and permission was granted for Morrison to be buried.

Most likely, releasing the news was delayed to give Ronay time to secure a spot in Père-Lachaise. It was necessary to keep the body in the apartment during this time because involving a hospital or city morgue would have run the risk of an unauthorized examination. Taking the body to America might have resulted in an uproar before the burial and choosing Père-Lachaise also made any later attempts at exhumation far more difficult than with a lesser-known cemetery.

This new information also explains Pam's guilt. Ray Manzarek describes what it was like seeing Pam after Jim died: "I saw Pamela maybe six or eight months later after she'd come back from Europe and a lot of people said, 'Why don't you ask her?' and when I saw her she was just totally broken up. All I could do was hold her because she was crying. I saw her once or twice afterward and the emotional experience of her seeing us, us seeing her, was too much. It was beyond the bounds of good taste to grill her to find out what happened. I just couldn't do it."

According to just about everyone who knew Pamela, she never fully recovered from her lover's death. But there was something more—a guilt that almost seemed to require her to punish herself. Mirandi Babitz remembers: "After Jim died she definitely went for the black side. It was like some kind of punishment thing I thought. She got more and more into drugs and she started hooking to get them. She had a black pimp who was getting her heroin and she was just a street whore. It was awful."

Whatever her reasons there is little doubt that Pam was drawn more and more to drugs as a means of escaping the pain, and in the end they became her only way out. With her death, the complete story of what exactly happened in Paris can never be known.

If Morrison did die from a heroin overdose, it wasn't intentional, but it no doubt did stem from a loss of interest in life. A diary of Jim's thought to be from around this period is riddled with a sense of helplessness—scrawled passages of desperation in lines like "God help me, God help me, God help me" scribbled over and over again, filling entire pages. It is as though he cast away the last visages of caution, finally delving into the one substance that he had held back from before. Patricia Kennealy elaborates: "I think he was just incredibly depressed. I heard stories and I have letters that are just so down. Nothing was happening. He wasn't writing. He wasn't able to get past whatever it was.

Paris was really not what he thought it was going to be. He claimed he was winding up his relationship with Pam and that he'd come back in the fall and we would be together. It made me happy that he wrote that, but I didn't believe it. John Densmore has a similar story about his wanting to get back with The Doors and into music again. I think he was just casting around at that point, looking so desperately for something to believe in."

The Myths Around Morrison's Death

So much as been written and speculated about Morrison's death that it is not enough to merely present the truth as it can best be determined—the myths themselves must be addressed. These "theories" range from logical deductions that deserve serious discussion to wild speculations that are included here because they show the bizarre effect Morrison's death had on his legions of fans.

The fact that theories such as these exist is apt testimony to the confusion generated by someone like Morrison dying of a heart attack. The public had a hard time accepting that someone of such mythic proportions could die such a common death. After all this certainly wasn't the first time there had been death rumors about Morrison. Here was a man who had at least the nine lives of a cat. He had survived so much that those around him began to think he might survive it all. But all that changed on that hot summer day in July when word came back from Paris of Morrison's death. A heart attack—at age twenty-seven? Robby Krieger explains this dichotomy of feeling toward Morrison's death: "In one sense I wasn't surprised by his death. In fact, I was surprised he lasted as long as he did. I guess I prepared myself for it a long time before it actually happened. But, in another sense I didn't believe it . . . part of me figured the guy would never die. I'd seen him on amazing quantities of drugs, and he'd never OD'd. With all the stuff he did, he'd never seemed to get hurt. He'd crash the car, he jumped off roofs, and then to hear that he died of of a heart attack seemed ridiculous."

Ray Manzarek and John Densmore were definitely surprised by Morrison's death. There was the feeling that he would go on forever. Densmore elaborates: "For a while I kept thinking, 'Jesus,

this guy is going to go at this rate,' but then I'd think that maybe he was just an Irish drunk who'd party with a red nose until he was eighty. When he went, though, I was dumbfounded. I feel that Jim was meant to pack it all into twenty-seven years, but I want people to know you can't just drink and wear leather pants and be immortal."

It didn't help that the official cause of death listed on Morrison's death certificate was "heart failure" and not "heart attack." You don't have to be a coroner to know that "heart failure" is death's end result and not a cause of death. Of course the uproar would have been silenced by an autopsy, and the fact that there was none in such a sudden and apparently unexpected demise only heightened it. Much of the controversy was caused by the "missing four days" between the time Jim Morrison died and when Pamela finally notified the American Embassy. Rather than call Morrison's friends and announce his death, Pam chose to keep it a secret, claiming she told *no one* for two full days (we know now that she told both Diane Gardiner and Alan Ronay). It was here that the rumors began.

The first oddity occurred at a local nightclub where somehow, whether through a bizarre coincidence or an unexplainable tip, less than twenty hours after Morrison died a disc jockey reported the news over a loudspeaker. His announcement was greeted with surprise and silence. This was probably the source of the many stories which centered on Morrison's dying at a nightclub.

The story that appeared in some of the French tabloids was that Morrison either instead of or after seeing the movie Ronay suggested visited the Rock 'n' Roll Circus, a sleazy, all-night bar, the design of which consisted of huge blowups of rock stars wearing circus costumes. While there he somehow got hold of some heroin and took it. One story was that a fan saw him at the Circus and turned him on to a really hot shot of nearly pure smack. Since many of Morrison's friends claim he had had little experience with needles or heroin, the idea was that he might have injected an air bubble into his bloodstream or overestimated his tolerance. Also, the amount of heroin necessary to be lethal is lowered considerably by alcohol in the bloodstream because the drugs combine to disable the nervous system and bring

about a quick death. Another report claimed that Morrison thought the drug was cocaine and snorted it.

Hervé Muller, who met Morrison in Paris, claimed in an interview last year with *Globe,* a French magazine, that Morrison went to the Circus the night of his death to pick up a supply of heroin. Muller said a drug dealer named "le Petit Robert" gave Morrison the drug in the men's room of the club and warned him that it was very potent. Supposedly, Jim snorted some right there and went into a coma, after which two men carried him out the fire exit and drove him back to the apartment, where they attempted to revive him in the tub.

The original articles that appeared in a few French newspapers claimed that after Morrison OD'd someone at the club called Pam. Then she and an unidentified friend supposedly carried Morrison from the club to the apartment. Proponents of these theories claim Morrison was found in the bathtub because that was a common procedure of the time to try to revive heroin ODs (though there is no sound medical basis for this).

The most macabre of the theories is that Morrison was murdered intentionally by a low-rent French drug dealer who wanted the thrill of knowing that he'd killed the world-famous lead singer of The Doors. Another persistent theory is that Morrison was stabbed to death by a disillusioned fan. People have also speculated that he was murdered because his refusal to return to the band was going to cost a lot of people a great deal of money. Not just the other Doors and Elektra but hundreds of hangers-on and lower-echelon folks who were further down the line of The Doors institution. Supposedly someone killed him figuring that record sales would then boom as they had after the deaths of Hendrix and Joplin. There have also been accounts that an international conspiracy involving the FBI killed not just Morrison, but Hendrix and Joplin as well.

Perhaps, though, the suicide-related theories are hardest to explain away. Even the new information doesn't explain why Jim Morrison did heroin that night. There are those who say he was at peace in Paris. Pam told everyone during those days that Jim was happy and drinking much less. Others claim Morrison grew very depressed and went wild near the end, drinking more than he had before. There is no getting around the dilemma of the misunderstood artist that was the crux of Jim's difficulty. It's

ironic that his death came when The Doors appeared to be making a comeback, but he seems to have already decided to leave the band either before, or shortly after, arriving in Paris. Some believe that this decision may have triggered a great despair that resulted in Morrison's choosing to get completely away. He was coming face-to-face with the harsh reality that his inability to become the artist he so desperately needed to be was no one's fault but his own. It was not The Doors, the fans, the pressure or the media. In Paris he was free of much of that and yet he was still having the same problems and he knew by then that he could never stop drinking. The peace and joy he and Pam had expected would accompany his newfound freedom to create never came. While he wrote a great amount of poetry in Paris, an examination of that poetry indicates that, more than writing, Morrison was reflecting upon his life. The sad conclusion he may have come to was that he had abused his body, his talents, his mind, and even his spirit too long to realize the potential he once had.

And yet these things are not likely to have prompted Jim to take his own life. He simply was not that kind of a person. No matter how great his inner conflict, Morrison always kept his sense of humor. Depressed or not, he was not a negative person. He loved art and the pursuit of it, he loved keeping everyone guessing, and he loved being difficult. Suicide was not his style. And you can be sure that if he were going to take himself out it would have been in a way more spectacular than a drug overdose. A lightning rod held aloft from the Eiffel Tower during a Paris rainstorm perhaps, but pills or needles in the bathtub? Never.

There is considerable evidence that Morrison was depressed over the things he was discovering about himself in Paris, but it points more to despair than suicide.

In his short time on earth he had screamed, "WAKE UP!" a thousand times in a thousand ways to thousands of people and only a few eyes had even flickered. Maybe what destroyed him was their refusal to let him set them free or, more likely, his realization that he had wasted the best years of his life on a few passages of misguided philosophy.

The mystics also have a few theories which, while pretty illogical, do prove to be interesting. Some agree with one of

Pam's accounts that Jim's spirit often left his body and went off traveling by itself. According to Pam, Morrison would sometimes wake up with strange tales to tell of bizarre happenings and magical cities that his spirit had "visited." These people believe that Jim's spirit simply found a more interesting place than the planet Earth in 1971 and decided not to come back. Although Patricia Kennealy does not agree with this theory she believes she had a "visitation" from Morrison on the second of July: "I had a vision of Jim standing at the foot of my bed in the middle of the night. It was no dream—I knew perfectly well I was asleep, but it was like I was seeing through my third eye. In the vision Jim had no beard and at that time I didn't know that he had shaved it off in Paris. We just looked at each other for a long time, and I knew that he had come to say good-bye. He bent over to kiss me and I could smell the scent of his hair and skin, and even a faint scent of wine. And then he was gone. When I woke up in the morning, my wedding ring was on my other hand. There was no possible way that in my sleep I could have removed a tight-fitting ring from one hand and managed to get it onto the only finger on my other hand that it fit. The Celtic word for this kind of thing is *fetch*. It's a phantasm of the living that usually happens a few days before death when the soul is getting ready to cast off."

Even more incredible are theories that Morrison was murdered through supernatural means. While Jim was fascinated with the occult, it is quite an assumption indeed to believe that a jealous rival or a jilted lover could cause his death in the Paris bathtub by stabbing a voodoo doll (or melting down an old copy of the first album) while chanting a curse.

Another supernatural-based theory is that Morrison's body had been driven to great excesses by the spirit of the shaman that he believed entered him as a child on that New Mexico highway. When the spirit or demon had used his talents to influence the world, it abandoned him onstage in New Orleans and left him a physically wasted and mentally exhausted man who felt used and betrayed with no desire to go on. The answer to all such theories is that they are impossible to totally disprove, but they are equally impossible to prove.

The "Jim Morrison Is Not Dead" Theory

Of all the myths concerning Morrison's death the most popular one has been that he never died at all. Many have believed

that Jim Morrison pulled off the ultimate ruse and faked his own death. There never has been any real evidence for this belief and the idea seems to have grown out of typical Morrison mythology combined with wishful thinking and a few interesting coincidences. Morrison's bizarre life-style inspired such thinking. He often vanished without anyone knowing his whereabouts and he was reported to have died several times before, only to show up unscathed. He often discussed the idea of faking his own death and starting a new life. Early on he had been inspired by the life of Rimbaud who had done all of his writing by the age of nineteen and then disappeared to Africa to become a gunrunner and slave trader. Morrison saw this as a great, dramatic stroke, sort of an exclamation point to life.

Fans were quick to point out that Morrison's sense of irony would have been intrigued by the idea of staging his own death at this time. He was the third major rock star to die within a year and all three (Hendrix, Joplin, and Morrison) were twenty-seven when they died. The date of his death, July 3, was two years to the day after the death of Rolling Stones' guitarist Brian Jones, who also was twenty-seven and in the water (a swimming pool) when he died.

Will be Stink
Carried heavenword
Thru the halls
of music

Danny Sugerman remembers Morrison showing him the lyrics for the *L.A. Woman* album and saying that Mr. Mojo Risin' was "the name I'm going to use when I call you guys from Africa after I split the country and when I don't want anybody to know it's me." The strange repetitive vamp in *L.A. Woman* can be rearranged to spell out the name Jim Morrison in a perfect anagram. Also, everyone knew that Morrison had some good reasons to go underground. After a two-year ordeal Miami was still dragging on. With the appeal pending and a jail sentence hanging over him, it was easy to understand why he might decide to disappear.

The reaction of the press to Morrison's death also contributed to the rumors. It was first reported as if it were a joke and there were a number of denials. *Melody Maker,* the leading British rock journal, reported that rumor of Jim Morrison's death had been "exaggerated," but then a week later confirmed it. On July

10, the *Los Angeles Times* ran an article with the headline "WHY MORRISON DEATH NEWS DELAY?" suggesting that "there had to be more to the story."

The circumstances of Morrison's death didn't help matters. He was buried before the news was even released and the official announcement came from his manager, not from the police, embassy officials, or anyone in authority. There was no hospital involved and Dr. Max Vassille, the doctor who examined the body, refused to talk to anyone. There was no public funeral and since Père-Lachaise was virtually a national monument, it was very unlikely that an American rock singer would ever be approved for burial there. When Morrison's grave went unmarked for a while (because of a mix-up over the headstone), many fans speculated it was to keep anyone from checking on the contents.

Until now it was believed that only Pam and the doctor listed on the death certificate saw Morrison's corpse. When Siddons arrived at the Paris flat the casket was already sealed and the doctor and any ambulance or police people who might have seen the body were gone and never heard from again. Bill Siddons saw the casket but not the body. Often in the years since, he has wondered why he never opened the lid and looked inside. "I spent many, many hours in the apartment and Jim was in the bedroom in a casket. God, I remember so vividly. It was a beautiful white oak casket. I mean, I remember admiring the craftsmanship of it and it literally never occurred to me to open the casket. I, honest to God, never thought of it until Jim was in the ground and I called my business manager and said, 'I buried Jim.' And he said, 'Did you see the body?' and I said, 'No, why would I?' And he was like so astounded that I was that stupid. But, hey, you know, I threw the dirt on his casket. And so it was too late to say, 'Oh, let me go look.' Pamela was his woman for as long as I'd known the guy, and if she said he's dead, he's dead. I never believed in her ability to conspire and none of these myths about Jim's death have ever held any water with me. Certain people are using it to exploit, using it to maintain the mythology. Okay, I never saw his body. But I buried the man. I carried his casket, I put him in the ground. I lived through it with Pamela and I know how real what she was living through was. She wasn't a good enough actress to pull that one off. So, there's never been a question to me. Jim's dead."

Siddons's reference to exploiting and maintaining the

mythology has to do with accusations that he, Columbus Courson, Frank Lisciandro, and others leveled against Danny Sugerman and Ray Manzarek over the 1980 biography *No One Here Gets Out Alive* (Jerry Hopkins & Danny Sugerman, Warner Books, 1980). The book ends with a section on the theory that Morrison might have faked his death. Since Sugerman became The Doors' manager and Manzarek was known to have helped edit parts of the book there were those who accused them of promoting the "Morrison is not dead myth" to increase Doors record sales and reignite the legend of Jim Morrison. "That's preposterous," Sugerman responded in our interview. "As if something like that could be planned. I didn't create this idea. A lot of people were saying Jim might be alive. Jerry Hopkins's first draft described all the versions which I just recopied. I approved of the ending because I think Jim would have appreciated how it was inconclusive about his death, but I didn't create things like the Bank of America and the Phantom. I didn't even say I believed them. I wanted to believed Jim was alive, but I never did."

Over the years the myth has persisted. Several "sightings" have been reported. Most of these rumors came in the first couple of years following Morrison's death when he was "seen" hanging around unpleasant places in Los Angeles, supposedly leading a secret life. The *L.A. Free Press* as well as several other major publications, radio stations, and wire services reported receiving anonymous phone calls maintaining that an employee of the Bank of America in San Francisco had been doing business with someone who claimed to be Jim Morrison. Further investigation resulted in an employee's confirming the rumors, but denying that the customer (who had by then disappeared) had furnished positive proof that he was Morrison.

There were also several rumors that Morrison was living in Louisiana. One of the more ludicrous also tied in the Bank of America, claiming Morrison wrote and published a book called *The Bank of America of Louisiana* (Zeppelin Publishing Co., 1975). The book begins with the words, "This is the story of the reappearance on earth of a dead Hollywood rock star as super hippie, disguised as a mild minded Louisiana banker." It is 188 pages of fiction "based on fact" with the disclaimer that "certain things had to be changed such as names, because if I did not, I would find myself back in the Courts." It is signed "Jim Morrison"

and the last words of the book are "The B of A & Company, USA . . . where monkey business is big business."

There were other "sightings" of Morrison in Louisiana. The reason for the flux of "Jim Morrison is alive in L.A." rumors is obvious, but no one knows why there are so many Louisiana stories unless it's because Morrison's last concert was in New Orleans. Another flurry of rumors happened in 1974 when an album was recorded for Capitol Records called *Phantom's Divine Comedy*, featuring drummer X, bassist Y, and keyboardist Z, with a phantom lead singer who sounded like and was rumored to be Morrison. If the record was a publicity stunt, it failed because it never charted, but the label stuck to its guns and never released any pictures of the group or revealed their identities.

At an obscure Midwest radio station Jim supposedly showed up in the dead of night and did a lengthy interview that explained it all. After the interview he vanished into the darkness again. As you might guess, no tapes were made of the interview and no reliable sources remember hearing the show.

The speculation became so great that one group of concerned fans tried to obtain permission to open the grave in Père-Lachaise with a copy of Morrison's dental charts, but were blocked by Morrison's family and estate. Finally, even the surviving Doors began to wonder. Ray Manzarek comments: "If there's one guy who would have been capable of staging his own death—getting a phony death certificate or paying off some French doctor . . . and putting a hundred and fifty pounds of sand into a coffin and splitting to some point on this planet—Africa, who knows where—Jim Morrison would have been the guy to pull it off."

In retrospect it is easy to see how ludicrous these theories are. To fake his own death Morrison would have had to include Pam in on the plan, but it is very unlikely that Pam could have kept the secret. She was emotionally unstable and she would not have been able to put herself through such misery. And Morrison would never have allowed Pam to suffer as much as she did. If he had gone into hiding he would've come out when he heard what was happening to her. Jim was so worried that Pam might not hold up without him, he even had a clause put in his will that said she would not be able to inherit anything unless she survived his death by six months. He loved her too much to have been able to watch her collapse and virtually OD because she was in such pain without him. Paul

Rothchild elaborates: "Pam and I were very dear friends. She sat on this sofa night after night and she cried, with the *deepest* grief over the loss of Jim. Night after night. It became a mania for her. She eventually gave up her life because of her love for Jim. The Doors may not have seen Jim dead, but Pam sure as hell did."

In a way, though, the mystery was the perfect exit for such an enigmatic individual as Morrison. The outrageous showman and the mysterious shaman to the very end—and beyond. He would have loved all the uproar.

Don't miss your chance
To swim in mystery

It is infinitely more romantic to picture Morrison as the eternal provocateur, still out there living somewhere on the edge. But the truth is that everyone who lives so close to the edge eventually falls off. By the time of his death Morrison already knew that the real things tormenting him would not change with a new identity. He had a taste of that in Paris and discovered that it didn't matter where he lived, how famous he was, or what kind of work he did. The problem had to do with the way he was inside. And running away doesn't change that. He may have been tired of bearing the public image of Jim Morrison, but that wasn't what chained him and weighed him down. It was his inability to cope with the forces inside him that was destroying him. The tormenting echoes that drove him to the brink of madness on an almost daily basis. The only escape Morrison knew from them was alcohol. And, in the long run, the alcohol just made things worse. He was caught, trapped by his own decision to release himself to the dark urges of his subconscious without holding back. Short of some deep spiritual turnaround, which his blindness would not have allowed him to see even if an opportunity for it had surfaced, Jim Morrison was lost. If there was a greater power that could overcome the forces that had dominated his life since he was four years old, his condition prevented him from seeing it. And so his only true escape was death. Whether it came from his own hand or tempting fate one more time did not really matter.

Finally, we don't need these stories about Morrison's faking his death to exploit or maintain the mythology or to keep his

memory alive. The myth of Jim Morrison will live on without intentionally fueling the fire. And he left behind a considerable legacy of work. It's not that he died, it's that he lived.

Door of passage to the other side
the soul frees itself in stride

Pamela Without Jim

From the day they met when Morrison was struggling to find himself as a lead singer, right up unto his death in Paris five years later, Pamela Courson was the catalyst that enabled Morrison to become all that he became. She was not the force behind the man, but her love gave him the freedom to extend himself further and further away from the shaping of his childhood and deeper into the vision. He knew she would always be there for him.

Their relationship was far from traditional. It fluctuated dramatically on an almost moment-to-moment basis. Sometimes they lived together, sometimes they lived apart, and sometimes they even took up with other partners for brief flings. But they always came back together. They may or may not have been good for each other, but they were obviously dependent on each other. He dedicated his books to her and left everything to her when he died. She virtually dedicated her life to him and his death destroyed her.

In Pamela Courson, Morrison finally met his match. In many ways, she was as bizarre as he was, always looking for something exciting, something different, something special. She preferred chaos to boredom, trouble and anxiety to peace and contentment. Whatever was in Jim that drove him to live out on the edge was also in Pam. She too was out there where the strange and dangerous were infinitely preferable to the mundane and safe. Ray Manzarek remembers. "Pamela was Jim's other half. The two of them were a perfect combination; I never knew another person who could so complement his bizarreness."

"She really was beautiful," remembers her longtime friend Mirandi Babitz. "She had a prevailing innocence in spite of the fact that she lived hard and didn't stop at anything. She still man-

aged to stay young and pretty. Men just fell in love with her, I guess, because she always seemed to need protection."

While Pam entertained a fantasy of one day settling down with Morrison and living a normal life, she must have known the reason they thrived together was because they both loved action and always generated it. They secretly liked things to get out of hand and chaotic because they wanted life to happen with a ferocious intensity. The abnormal was a cause for rejoicing and an outright crisis was all right too as long as the experience could be savored and relished.

"Jim had a continuing love relationship with Pamela," Paul Rothchild remembers. "She was the nice sweet girl next door, a vision. They were the classic fighting couple. They couldn't live without each other. He tried her mentally. Took her to the wall mentally over and over. Drove her to a very strange place. Pam would challenge him . . . she would drive him crazy because he loved her and she him. She was able to stand up to him."

Pamela pulled Morrison to a different direction. It was no secret that she was extremely possessive and wanted Jim to herself, but she also firmly believed in Morrison's poetry. She warned him that rock 'n' roll would kill him and she was always encouraging him to be a writer and a poet.

> *Girl, you gotta love your man,*
> *Take him by the hand, make him understand*

Few of their friends believed that Jim and Pam were ever actually married, but if they were, it was in Paris. Apparently they took out a marriage license there ("I know because I saw it," says Bill Siddons), but it is doubtful that they ever used it. Sometimes Pamela claimed they were married in Mexico, but other times she admitted they hadn't been married at all and that she had just changed her name. In the long run it doesn't really matter. She called herself Mrs. Morrison and that was fine with Jim.

There was a strange duality to their relationship. She was the only woman he lived with on any kind of regular basis and the only woman he ever trusted. But she was also the one he abused the most. And while Pam encouraged and inspired Jim, she also harassed him. Frustrated, she left him several times, but really could not live without him. Paris was for both of them a

last-ditch attempt at living out the dream that, away from the pressures of superstardom, they would be contented together. And, when they discovered the pressures came from within themselves, that dream turned into a harsh reality. Finally and fittingly, it was Pamela who discovered Morrison's body, and it was she, more than anyone else, who would struggle with his death.

From the moment Morrison died Pam sunk into a deep depression and never really got out of it. She returned to the United States in a state of shock after the funeral and went into seclusion. Her life after this seemed to be a series of self-destructive actions. One day she walked into Themis and poured perfume all over the clothing. Friends said she was delirious with frustration and grief, and she dramatically closed the boutique soon thereafter, driving a truck headlong into the storefront, breaking a window, and damaging the front of the building.

Diane Gardiner recalls her close friend. "Pam was one of the funniest people I ever met. She was beautiful, she looked like the Snow Queen and yet she did things like collect Lugers. She had a vicious sense of humor. She loved travel because she said you never had to think about it. When you were traveling and you were a tourist, you got up and life happened to you. I liked her. She was the most dangerous girl I ever met. After Jim died and we were both just out of our heads we would do things like go to Tijuana and get crazy. We'd check into sleazy hotels and go down to Rosarita Beach and drink everything in sight. One time this guy that was with us yelled some really bad things to La Policía and they came after us. One guy was trying to take the keys to Pam's new VW away, so I hit him over the head with my shoe. And we had to pay them off on our MasterCard. We ran it through at a hotel and they actually let us charge our bribe. I don't behave like that normally. Pam had that kind of effect on me."

Morrison tried to protect Pam in his will, but it still presented her with a lot of problems. He had left everything to her and named her coexecutor along with his attorney Max Fink, who drew up the document. Nonetheless, Pamela received no money from the estate for almost two years because she objected to the approximately seventy-five thousand dollars in attorneys' fees submitted by Fink and others for work on Morrison's Phoe-

nix and Miami trials among other duties. Rather than accept the
fees as valid, Pam sought legal retribution. She wound up chang-
ing lawyers four times before she finally gave in and agreed to
pay. When it was all settled she ended up with about a hundred
and fifty thousand in cash and Morrison's sizable investments in
land and oil. Friends said the first thing she did when she got the
money was buy a VW and a mink coat.

As time wore on, Pamela's state of mind worsened. She lived
for a time in San Francisco, where she supposedly tried to com-
mit suicide several times. She began talking about "us" as though
Morrison were alive. "Jim's spirit often left his body and he re-
turned from magical cities with strange tales to tell," she told
one friend, and then added, "This time he didn't come back . . .
that's all."

Pam began saying she couldn't remember seeing Morrison's
body taken away or buried. She started living in a fantasy and
flirted with death all the time. The more depressed she became
the more she wanted people to pay attention to her and the
more she lived a precarious existence. Former Doors publicist
Danny Fields remembers. "When she returned home to California
I flew out there to be with her. She was living in a little house in
Sausalito with Sage, her golden retriever. Pamela was obviously
quite despairing and she was all of the proof there was that Jim
had actually died. So there was Pamela with her dog. Every time
the dog would make a sound, she would kneel beside him and in
a soft voice would ask, 'Yes, Jim? What are you trying to tell me?'
She *truly* believed that Jim's spirit had certainly returned in the
dog."

And our summer together
Ended too soon

The Doors Minus Morrison

Until Jim Morrison died all three surviving Doors had felt
that he would one day return and they would make music to-
gether again. John Densmore believes Morrison would have
come back because music was in his blood and the group would
have continued in the blues vein. Robby Krieger agrees to a

point: "We'd have probably done the blues thing for at least one album or two, and after that, who knows? But I couldn't really see The Doors existing in the Seventies. It was too boring. I think we'd have probably given up music and gone into movies or something."

Ray Manzarek feels if Morrison were alive today he would probably be involved in films and The Doors would probably make a record every year or two. But as far as 1971 goes, he's not only sure the band would have continued in a blues direction, he also believes they would have returned to live performing: "One of the saddest aspects of my life—other than Jim leaving the planet—is that we never got to play *L.A. Woman* live. We were going to take Jerry Scheff with us and we were even thinking of taking the rhythm guitarist, Marc Benno, so The Doors would go from four pieces to a six-piece band. I was really looking forward to that because . . . that would have freed me. Leave the rhythm to the bass and drums . . . Let me play organ, synthesizer, string synthesizers, clavinet, Fender Rhodes, piano . . . all the stuff. We were really looking forward to it. Even Jim was excited about it. He definitely wanted to take it on the road. After all, *L.A. Woman* was recorded live in the studio."

The other Doors were disorientated by the death of Morrison. The closeness and the support of the group was not usually emphasized by the press, but four people so obviously well suited to each other don't go through six years of proximity without emotional intimacy. Densmore remembers. "When we received the news from Paris about Jim, we were shocked beyond belief . . . We just thought, 'What now?' We sat around and then we jammed a bit, and finally we decided to keep on making music. The vibes between the three of us had been so good that we felt we just had to continue. Jim was a friend, somebody we'd lived with and made music with for so long, but eventually we realized that we had the rest of our lives to live, so after we'd gotten over it, we started to think about what we'd do. None of us really wanted to go play with anyone else."

The other Doors were faced with picking up the pieces of their lives. Men whose very lives were music, they had essentially three choices: disband and join other bands, replace Jim Morrison with another singer, or continue as a threesome. When viewed in this light it is easy to understand why they decided to

continue as The Doors. Each of them was far too much of an individual to be able to plug into another band and while they had considered Terry Reid, Iggy Pop, and others as possibilities to replace Morrison, they knew in the end that it was ludicrous. The inevitable problem of comparisons discouraged them. Manzarek agrees. "We thought that even if we got someone really great, could he fit in with the psychic vibrations that the three of us have and that the four of us had built up over four or five years of playing together? We decided that it would be impossible to try and work with somebody else because it just wouldn't be right somehow."

So it was that after months of rumors and speculations, The Doors called a press conference to announce that they had decided to continue as a trio with assistance from friends in the studio. There was some precedence for this; they had performed without Morrison once in Amsterdam during their 1968 European tour with The Jefferson Airplane and it went extremely well with Ray doing the singing. And, after all, before The Doors were formed, Ray sang with his brothers in Rick & the Ravens (as "Screamin' Ray Daniels").

Many fans have wondered why Manzarek, Krieger, and Densmore chose to keep The Doors name instead of changing it. At first the group was going to change the name, but they couldn't come up with anything that they felt didn't sound pretentious. In an interview with John Tobler, Manzarek recalled: "We even thought of calling ourselves 'And The Doors' because it had started out The Doors and then, after a few years, it was Jim Morrison and The Doors . . . but we kept The Doors because that's who we were; there were four of us—now there were three of us."

While it all made sense at the time, there was no getting around the powerful impact Jim Morrison had made on the consciousness of music fans everywhere. If the guys in the band wanted to call the trio that went on after Morrison's death 'The Doors,' they could, but nobody else did. In retrospect, keeping the band together did give the members a renewed purpose to their lives. They resigned another long-term deal with Elektra Records and began work on their first album without Morrison. The saga of of The Doors seemed closed, but Manzarek, Krieger, and Densmore wouldn't give up.

The new band would provide them with more chance to express themselves and some of the material they would be recording, such as "Down on the Farm," were in fact songs that Morrison had rejected. "There were a lot of songs that I had written," says Krieger, "that Jim didn't feel. That's why he didn't want to sing them and I can understand that. In a way, that was a limitation on us."

The new album was recorded over a period of three months in the familiar surroundings of the rehearsal hall at the Doors Workshop. As they had done in *L.A. Woman,* the group produced with help from longtime engineer Bruce Botnick. The Doors decided who would sing what song by a process of trial and error. Each song was recorded with both Krieger and Manzarek singing it alone and in various combinations with each other and Densmore. Whoever sounded best would cut the final take. Manzarek wound up with the most leads, but Krieger also did a lot of harmony. Although the trio were seasoned performers, making the step to singing proved to be a difficult one which finally came down, like most things in rock 'n' roll, to gutting it out. Manzarek remembers: "It was a matter of just standing up in front of the mike and doing it, taking a deep breath and saying, 'Okay, it's got to be done.' It came out pretty well. And it got easier and easier. The first song was very hard."

Obviously, *Other Voices,* as the new album was called, was a different sound and, in effect, a different group. It was indeed other voices. Vocally and lyrically, it required the audience to adjust to a new sound. No longer were they hearing Morrison's voice although they were still hearing The Doors' music. It was a contradiction in sound that could be eliminated only by time and open minds. The Doors themselves knew that it wasn't the same, but then it wasn't supposed to be. The natural role of leader fell to Ray Manzarek and he talked about the new direction the band was taking in an interview at the time. "We spent a lot of time exploring the dark side of the soul . . . in the subconscious mind, finding all the strange weird things down there. Now we're going to come up for a breath of air. Come up for some light, for some sunshine, and get some light into those dark corners. Making music and the fun of making music."

Other Voices was finished in September 1971 and released toward the end of October. The album was handled with ex-

treme caution by fans and reviewers alike. It hit number thirty-one on the U.S. album charts, but never really caught on. The consensus was that it was Doors music mainly due to its trappings. The sound was there and that strange and special instrumental mood, but listeners found themselves waiting for the voice, waiting for the violence and the genius of the singer that never came. It was obvious that Jim Morrison was more than just a singer and that the band seemed to have lost its purpose. *Other Voices* had only eight tracks and it tried to explore a few too many avenues, resulting in a generally inconclusive album. Many reviewers claimed that Manzarek, Krieger, and Densmore were struggling for a direction and an identity. In many ways this was true, but part of the problem was that Morrison was viewed as such a heavy that without him everything appeared lightweight. The strange, haunting organ riffs and ominous chordal patterns suddenly sounded more cute and clever than mysterious. Above all, Morrison's talents as a lyricist were sorely missed. His lyrics that had provided the drive for the others powerful instrumentation. And now, that focus was gone.

The critics were right, but it would take another year for the band to admit it. Instead they decided to return to performing, playing smaller houses and trying to bring the music closer to the people. The November cross-country tour included eleven dates in such cities as Minneapolis, Buffalo, Hollywood, Philadelphia, and Berkeley. All in all, it was a success. They were, after all, still The Doors and these were small venues, so every concert was standing room only. The reviews were virtually unanimous in their praise of the performances. As with the old Doors, the band evolved into somewhat a different entity onstage than on record. Part of the show became a sort of unintentional tribute to Jim Morrison and this may have been the key to the tour's success. The old Doors numbers the group performed at the concerts received huge ovations, especially "Light My Fire."

Despite the success of the tour there was little doubt that the remaining Doors were living under Morrison's shadow. In January 1972, as they began rehearsing titles for a new album, Elektra released a compilation album, *Weird Scenes Inside the Gold Mine.* The two-record set included two songs that were previously only available as B-sides of singles. "Who Scared You" was the flip side of "Wishful Sinful" and reflected the same style

of horn arrangements. "(You Need Meat) Don't Go No Further" was Chicago blues sung by Ray Manzarek and appeared on the back of "Love Her Madly." The collection was not the resounding success one would have expected and only reached number fifty-five on the American charts. Nonetheless, it was the first of many steps to come in keeping the memory of Jim Morrison alive.

In L.A. the recording of the second post-Morrison LP and the last one under the name "The Doors" commenced with some changes. The process was transferred from the Doors Workshop to the A&M studios in Hollywood and coproducer/engineer Bruce Botnick was gently dropped in the move. This time The Doors arranged and recorded the instrumental backing track by track and decided among themselves when it was right. From March 2 to March 12 they did a short tour which consisted mostly of Southern dates including FSU, Morrison's old alma mater, and even a show in Miami.

After a brief return to recording they broke in April and May for a European tour which included Germany, France, and the U.K. The tour was successful, but not hugely so. If the band had gone overseas hoping to find the onstage magic they created as a threesome in Amsterdam in 1968, they must have been disappointed. They returned to finish the new album in time for release in July 1972.

Full Circle, as the new venture was called, was a curious album right from its foldout cut-along-dotted-lines mobile wheel album jacket. Just looking at the album's psuedo-surrealistic cover, which would have been unthinkable when Morrison was alive, gave reviewers the feeling that the worst was yet to come. Inside the music was not as bad as the cover suggested but it too was curious. The style was sort of a confused avant-garde jazz. It was as though Morrison was the glue that held the band's sound together. In *Other Voices* it was just beginning to slip, but by the new album, it had broken into scattered musical pieces and does indeed go full circle, running the gamut of musical styles and sounds. Like the previous work, the vocals were a problem, ranging from merely acceptable to what one reviewer called "decidedly dubious." The musicianship was up to the usual impeccable standard with Krieger seeming to dominate now, but the material and production were not. In the end, taking on the production chores may have been a bad move. The new album seemed to

suffer from a lack of studio skills and the poor production wound up highlighting several problems that the band had previously covered or worked around.

The consensus among critics was that *Full Circle* left the listener with an impression of emptiness and inconsistency. By this time it must have been obvious to Ray, Robby, and John that The Doors were just not The Doors without Jim Morrison. One of Morrison's functions with the band had been that of a catalyst that brought out the very best in the others and without him they were never the same. John Densmore commented to John Tobler on the *Full Circle* album. "In retrospect, *Full Circle* was a bit of a disaster, but at the time we had our hearts in it. About halfway through, the songwriting thing started to get on everyone's nerves . . . which songs are we going to do, Ray turning this way, Robby that way, so it all got a little touchy, which is why I don't think the album turned out that well."

On the charts *Full Circle* reached number sixty-eight, which was a pretty fair showing considering the weakness of the material and the critical and the public disfavor the band was now inevitably attracting. It was as though everyone approved of their doing one album to get it out of their system and to remember Morrison by, but to go on from that point was blasphemy in the eyes of critics and fans alike. On tour the band realized that the public was growing disinterested in them, so strong was the feeling that Morrison was The Doors all by himself. In their last appearance together as a threesome, The Doors played the Hollywood Bowl on September 10, 1972. The show was a triple bill with Frank Zappa and the Mothers of Invention headlining and Tim Buckley opening the show. The concert was sold out but the group was not well received. After a somewhat bland set The Doors closed with "Light My Fire" and dedicated it to Jim Morrison. When it was over, a frustrated Ray Manzarek stood up and said, "Next time we will be sure and bring Jim Morrison." And he walked out. Right to the end, The Doors were somehow still The Doors.

The public of the Seventies "me decade" was too caught up in itself to focus on the dark inner visions that had always been the core of The Doors' music. The three remaining members of the band had persevered through *Other Voices* and *Full Circle* and while they would have been fairly good albums for most

other groups, they were not good for The Doors. It was time the band accepted the fact that while Jim Morrison was able to go beyond The Doors, it was inconceivable for The Doors to go beyond Jim Morrison.

Closing the Doors

As a last-ditch effort, The Doors decided to look for a new singer and that quest resulted in their traveling to London in the fall of 1972. While the band considered L.A. the unquestionable music capital of the world, they went to London in the hopes of recharging their creative batteries, just as Morrison had wanted to do when he went to Paris. But it didn't work out. It was time to close The Doors and in 1973 the group disbanded. John Densmore remembers those last days. "Everyone was writing songs and all of Ray's were real personal and it was obvious that he was the only one who could sing them. We realized how very differently our musical directions were heading and Ray split back home. Then Robby and I decided that as we'd come over to start something new we might as well do it anyway and so for the next four months or so we jammed with different people and eventually sorted something out."

That something was The Butts Band, a group Densmore and Krieger put together in 1974 with Jess Roden that became one of the first white American bands to play reggae music. And Manzarek in the meantime wasn't idle. He did two solo albums in 1974, *The Golden Scarab* and *The Whole Thing Started with Rock & Roll, Now It's Out of Control.*

Manzarek, Krieger, and Densmore had struggled valiantly for two albums, but it was clear they lacked direction without their leader. You can not replace a Jim Morrison. Manzarek remembers: "I think there was some good stuff on those albums. But there was just a lack of direction after Jim died. Because before, when he was alive, the four of us had a balance. Then when he died it was totally gone. The Doors were Jim Morrison, Ray Manzarek, Robby Krieger, and John Densmore—four equal parts. Take away any part and it's not The Doors. We lost our number one part—the singer, the word man. We shouldn't have called

ourselves The Doors anymore. It should have been Manzarek, Krieger, and Densmore."

When The Doors broke up they walked out on a deal with Elektra that included three more albums at a guarantee of $250,000 each. It was clear that it wasn't money they were after. They just recognized they couldn't compete with the ghost of Jim Morrison.

Pamela's Death

Despite her somewhat unstable condition, Pamela wanted to be involved in any business decisions that concerned Morrison's contributions to The Doors. After the band broke up, those close to her said she felt she wasn't being consulted enough by the attorneys and the other ex-Doors. In one incident she became very upset over a plan to sell rights to "Light My Fire" for a Tiparillo commercial. Although Robby Krieger wrote the song, Pam knew Jim had felt strongly about such things, particularly since he'd argued with the others over Buick's attempt to buy the song in 1968. Since publishing rights to the Doors' songs were now owned jointly by Pam and the other three Doors, she asked Ray Manzarek to meet with her to discuss it. And although it cost him and the others a great deal of money, Manzarek felt sorry for her and agreed not to sell the song. For Pam it was an important issue since she saw herself as the guardian of Morrison's interests. She carried his poems around with her and even had whole notebooks xeroxed so that she could store them in a safe place during her travels.

In late April 1974, there was another clash between The Doors organization and Pamela. A lawsuit was filed in the L.A. superior court on behalf of the three ex-Doors claiming that Pam owed them $250,000 which had been advanced to Jim Morrison as loans from Elektra before his death. The suit alleged that Pam had refused to let the surviving Doors deduct those advances from her share of the record royalties. When news of the lawsuit broke in the press, Bob Greene, the Doors business manager said, "There's no significance to the lawsuit; it's a protective move, a legal maneuver, because Pamela's attorneys didn't prepare certain papers in time. It's not a real lawsuit; it doesn't mean the

estate will actually have to pay any money. There won't be any trial."

Supposedly, the lawsuit was the result of a lack of communication between the attorneys involved and not a personal problem between Pam and the other Doors. If this is true, it is unfortunate and the publicity came at the worst time possible for everyone involved. Pamela Susan Courson Morrison died only a few weeks later, on April 25, 1974, in her Hollywood apartment of a suspected heroin in overdose. Ironically, she was twenty-seven—the same age as Morrison when he died. According to the police report, Pam's body was found by John Mandell who claimed to have been a friend of Morrison's staying with Pam. The police were called and when they arrived, they found fresh needle marks in her arm and a hypodermic syringe. Jim Martin, a detective with the Wilshire division, reported at the time that the police "were calling it accidental heroin overdose." Martin said the police did have some evidence that Pamela had threatened suicide in the past, but they did not think her death was suicide. "We believe she's been using heroin for about a year," Martin said at the time, but he refused to expand on this.

Reportedly, Pamela's state of mind at the time was better than it had been in months. Her friend Diane Gardiner was shocked by the news. "She didn't seem depressed. I had lunch with her the day before she died and she talked about going to Mexico."

While the amount of heroin injected was clearly an overdose, Pam's friends continue to question why she would kill herself just when she seemed to be doing a little better. Some even suspect foul play, saying that although Pam had been using heroin she could not shoot herself up. She always had to have someone else do it. Whoever did it, they claim, knew he or she was injecting her with a lethal amount. Perhaps it was an accident. Heroin is a crapshoot—a slow suicide with commercial breaks. Even if Pam had not intended to die on that particular night, she must have realized death was getting closer with every fresh needle.

On April 29, at Forest Lawn's Old North Church, an unusual memorial service was held. The service was not only for Pamela but also for Jim. Her body was not displayed and guests were asked not to wear black. Ray Manzarek played several Doors

songs on the organ ("When The Music's Over," "Love Street," "The Crystal Ship"). Pamela was cremated and her ashes buried in Morrison's plot at Père-Lachaise in Paris.

Death makes angels of us all
& gives us wings

With Pam's death, Morrison's estate went to her father and mother, Mr. and Mrs. Columbus Courson. Later when Morrison's parents contacted him, Courson agreed to split the inheritance with them. But Pamela had also entrusted her father with something even more important. She had told him that if anything ever happened to her she wanted "Jim's words brought to America's attention." Courson would become an invaluable contributor and a key factor in the release of Morrison's poetry album, *An American Prayer.* He would keep his promise.

The Doors were now something to be remembered. At that time no one realized for how long that memory would burn in the hearts of fans. On July 3, 1974, the third anniversary of Morrison's death, Ray Manzarek led a memorial bash at the Whisky à Go Go which he called the "Jim Morrison Memorial Disappearance Party." Iggy Pop came on wearing a Jim Morrison T-shirt and sang "L.A. Woman," "Maggie McGill," and "Back Door Man," and it was obvious that Manzarek enjoyed performing the songs again. The party reflected the attitude of good-natured mystery that has prevailed in anything and everything to do with Morrison since his death. And so, without knowing it, Ray had set the stage for the future again. The Doors were over, but the music was not. Their solo albums did not fare well and the group members remained relatively absent from the public eye. But The Doors' music continued to beat as an undercurrent in the public consciousness . . . waiting.

We live, we die
& death not ends it

"RENEW MY SUBSCRIPTION TO THE DOORS' RESURRECTION"

It is a full-moon night in 1976 and Robby Krieger can't sleep. Every time he drops off for an instant he hears Jim Morrison reciting poetry. It's the poetry Morrison recorded on his twenty-seventh birthday only seven months before he died. Now, five years later, Jim seems to have escaped his Poet's Corner grave in Paris to dance around Krieger's bedroom in L.A. Finally, Robby gives up on getting any rest and starts looking for the phone number of John Haeny, the engineer who recorded the poetry sessions. Haeny is surprised to hear from Krieger and when Robby asks if he happens to have a copy of the Morrison poetry tapes, Haeny says he has better than that. He has the originals.

Ironically, The Doors' resurrection did not begin with the raw power and sensual fire of the rock music that made them famous. It began, as Jim Morrison would have wanted, with his poetry. Since the group disbanded, Manzarek, Krieger, and Dens-

more had been pursuing a variety of solo projects, but it didn't take them long to decide that this was something very special. At Haeny's suggestion, they reunited to listen to Morrison recite his poetry. John Densmore describes what happened: "We decided to do an album. Jim wanted a poetry album . . . so we thought, 'Let's do this.' It was planned for an orchestra, but who better to do it than his old music friends who used to support his poetry with music? We viewed his lyrics as poems from the very beginning."

I got some friends inside

Soon Frank Lisciandro and Corky Courson were called in to make the team complete. The idea was ingenious—taking Morrison's previously recorded poems and backing them with new music composed and performed by the group. It was a simple concept, but it abounded with technical trappings. Putting new music to long ago previously recorded vocals had been tried by other groups before, but it almost always failed. One of the things The Doors had going for them was that Morrison had recorded the initial poetry session on a multitrack recorder, which meant that other tracks (music and sound effects) could be added much easier and with better quality.

It's no secret that in the music business the successful dead are rarely laid to rest. As long as money can be made, product will be repackaged and pieced together like some sort of musical jigsaw puzzle. Many great artists have suffered because some of their obscure works, never originally intended for release, have been put out and hyped to the max. This was not the case with *An American Prayer*. It obvious by the nature of this work that the group was seeking goals far loftier than more income. The truth is that Manzarek, Krieger, and Densmore do quite well on the continued sales of the Doors' albums alone and the last thing they would do is compromise that legendary reputation by "selling out." Instead, they threw themselves into a project that became a truly remarkable recording. As a result of their painstaking dedication, the album came out sounding more like unadulterated Doors than any musically pieced and patched commercial album ever could.

An American Prayer was put together from nearly twenty-

five hours of poetry readings, old interviews, and live concert performances. The poems were selected from Morrison's birthday session in 1970 and a session recorded at Elektra studios nearly two years earlier. All the poems were previously unpublished with the exception of the title selection which had been made into a pamphlet for friends and special fans. The three Doors began the project by distilling the material down to an album's worth. They put the poems on cards and made a storyboard, conceptualizing the whole thing. Then they began composing new music to fit the moods of the poetry, selected a few old Doors cuts they felt were appropriate, and prepared to record. But because of complexities in the Morrison estate it was two years before they could actually begin. When finally cleared, The Doors rehearsed for two weeks and then reunited in the studio for the first time in five years. They spent the better part of twelve months putting the album together—recording, splicing, choosing poems and sound effects. "We didn't know if it was going to work or not," Krieger recalled. It could have come out totally ridiculous. We didn't really know until we laid the first vocal into the music—'Yeah, it works! Amazing.'"

"We're bringing people Jim Morrison, the poet," Manzarek said. "That was always a sore point for him that people never appreciated him as a poet. Now that he's been gone so long and you can forget what a good performer he was, you can begin to realize that he was probably one of the major poets of his time . . . This is the Jim Morrison we always knew. He was a very warm person. The guy onstage was another person. He could be terrible. The guy we worked with and traveled with though could be a whole lot of fun."

When you listened to what Manzarek, Krieger, and Densmore accomplished playing to a prerecorded track, there is no denying they retained their chemistry in the studio. After a band this good has played together for so long the passage of a few years makes little difference. And, in a sense, the process of recording the new musical pieces behind Morrison's poetry was very similar to the way The Doors had always made records. The main difference this time was there was no way Morrison could be persuaded to change the phrasing or pacing of any of his words in order to fit the music.

Fortunately, Morrison read poetry with a natural rhythm—

similar to Indian chanting. On *An American Prayer* The Doors made that implied rhythm more explicit. Manzarek elaborates: "We spaced it out a little bit, made a few cuts here and there, kind of, 'Wait, Jim, wait four bars and let us play this little line, then you can come back in again.' It was very eerie, because Jim was really there at rehearsals. It was the three of us and Jim was on tape."

"If you listen to the record," Densmore adds, "it's like a movie for your ears. That's how we made it. It's real complex . . . that was the tribute we did. I think Jim would be blown away."

Though the work was often detailed and exhausting, the team established a strong camaraderie in the studio. Like any group working together in a creative process they sometimes argued over each other's views, but they also laughed together and encouraged each other, sharing in the triumph as the project came together. Frank Lisciandro describes the sessions: "We used to joke, as we toiled and argued in the recording studio trying to fit Jim's words on vinyl, that the lead singer never showed up for any of the sessions. But almost everyday, in some way, he made his presence felt."

"One day," Manzarek recalled, "a little bird flew in through the window, fluttered above so long, then flew out. Like it was saying, 'You guys are doing a good job' . . . We did this for Jim, our tribute to him. He's dancing over this one, man. When we were making this record, we thought, 'God, would he love to be here.' . . . He would have had the time of his life."

We're perched headlong
on the edge of boredom
We're reaching for death
on the end of a candle
We're trying for something
That's already found us

An American Prayer: The Album

In November 1978, nearly eight years after the last poetry recordings, *An American Prayer,* credited to "Jim Morrison with Music by The Doors," slipped relatively quietly into release. Morrison's lyrics and poetry always worked best by a surprise attack and the lack of hype seemed fitting. Its artistic combination of

poetry, music, and sound effects was unlike anything ever re-
corded in the rock sphere. When this album is listened to it is
difficult to believe Morrison has left us at all.

The poetry here is something Morrison perfected until its
strength and gut-wrenching power were considerable—words
that devoured and liberated at the same time. Morrison is heard
in all his roles: the singer, the performer, the poet, and the per-
son behind the myth. The album is often in pointed conflict with
the myths while at other times indistinguishable from them, but
An American Prayer affirms that there was more to Morrison
than legend and that the legend had its foundation in fact.

The record is a mythic rock star talking in a poet's tongue.
There are back glances, interpretations, and insights sprinkled
throughout and supported by The Doors' sympathetic and strong
music. Morrison is magnetic and compelling as ever, but the
poems provide a new sense of intimacy that reveals more of
the man. His incantations, both sacred and profane, trace his life
from wonder-filled childhood to exhilarated adolescence to tu-
multuous adulthood—and beyond. The instrumentation dances
in broken circles around incessant rhythms, and as usual, the
powerful voice carries the music along in its wake. *An American
Prayer* is well crafted and magnificently put together. Through-
out the album, Morrison draws ambiguous lines between good
and evil, life and death, the holy and the sacrilegious. Often the
poetry is directly autobiographical but sometimes experience is
used as a catapult to release imagination.

The album is divided into five sections which clearly repre-
sent five definitive stages of Morrison's life. Side one contains the
more private side of Jim Morrison while side two focuses on his
public life. It is fitting that the work should begin with "Awake," a
poem dealing with a child "choosing" or perhaps being chosen
by the "Ancient Ones."

> *Awake*
> *Shake dreams from your hair*
> *My pretty child, my sweet one*
> *Choose the day & the sign of your day*

This leads into "Ghost Song" and Morrison's description of
the roadside accident that he later perceived as "the most impor-

tant moment in my life." It is eerie to hear Morrison's own voice describing spirits entering his soul.

> *Indians scattered on dawn's highway bleeding*
> *Ghosts crowd the young child's fragile eggshell mind*

This is followed by "Newborn Awakening" which centers on a similar theme—the dead being called forth "to anoint the earth" and "glory in self like a new monster." After the "Awake" section the album weaves through scenes of Morrison's adolescence in the late Fifties in a segment title "To Come of Age."

> *The bus gives you a hard-on w/books in your lap*

The work explores the young Morrison's seamy teenage sexual adventures and hints at an inner philosophical awakening. In "Stoned Immaculate" he describes the tormented confusion of an adolescent exploding into puberty. The first side concludes with "The Poet's Dreams" which entails Morrison's interest in both film and poetry. Often his thoughts centered on the impact film has on our society and his very life was like a movie—a fantasy in which he was both hero and villain.

> *The program for this evening is not new.*
> *You have seen this entertainment thru & thru.*
> *You've seen your birth, your life & death;*
> *You might recall all of the rest*
> *(Did you have a good world when you died?)*
> *Enough to base a movie on?*

Side two opens with "World On Fire" which includes a previously unreleased live version of "Roadhouse Blues" and it is definitely one of the highlights. The cut might be considered an unusual choice for a poetry album since lyrically it shows Morrison at his least inventive. But it also reveals that primitive animalistic power The Doors were capable of unleashing, and Morrison's slurred, midsong chanting conjures up the shaman side of his nature. The live cut does an excellent job of capturing the Sixties and its rock-stars-as-god hysteria:

Ladies and gentlemen!
From Los Angeles, California
. . . The Doors!

It is the power side of Morrison—the rock star in command of a legion of fans—and it gives the listener a taste of his world. Just after the cut ends and the fans scream their approval Morrison shouts, "I'll tell you this, man—I'll tell you this—I don't know what's gonna happen—but I wanna have my kicks before the whole shithouse goes up in flames . . ."

When "Roadhouse Blues" screams to an end the album cuts into a montage depicting a slice of Morrison's rock star world. There is a confusion of dozens of screeching voices crying, "Save us . . . save us . . . Jim . . . Jim . . . Eeeee—I touched him." A revealing burst of the fabled madness at the top, the section shows how fan worship can turn into a crushing horror. It then evolves into Morrison's disdainful reaction to his sex symbol idolatry with all its trappings.

The most vulgar and shocking piece on the album, "Lament" provides insight into Morrison's paradox. Simultaneously basking in the role of a sex idol and feeling a burning hatred for what the image did to his credibility, he intones a "lament for my cock." It is a graphic and occasionally amusing passage which makes for great contrast to the preceding noisy idol worship. "Death, old friend," he says over a mock funeral organ line, "death and my cock are the world." A bit of bawdiness from the late, late show.

It was just this kind of extremist reaction to being a sex symbol that got Morrison into trouble in Miami. The rebellious attitude that says, "All right, if that's all you care about, then here it is." The essence of "Lament" is one of ritual mortification. In the final passages Morrison refers to what created the sex god image and what he hoped, through his poetry, would destroy it:

Words got me the wound & will get me well

This is Morrison at his most transparent and alone. As they were in all his works, sex and death are prevalent themes here. Morrison viewed sex as the ultimate expression of both mortality

and immortality. He saw the sex drive as our most basic corporal instinct and its fulfillment, the orgasm, as a sort of momentary ego death—an enlightenment occurring the instant after self has been satisfied. Known for approaching life at the extremes, what he called "the highest and lowest points," Morrison once said everything that was "in-between was only that, in-between." Sex starts life and death ends it. This tendency to the extremes also explains his great concern with the themes of birth and re-birth.

As death was on Morrison's mind, so was murder. His imag-ination led to wild fantasies that often showed up in his writing and one of these moments has been preserved on *An American Prayer*. Taken from a scene in *HWY* where Morrison calls Mi-chael McClure from a phone booth, the track provides one of the record's most chilling moments. "I don't know what to tell you," Morrison drawls in the flat emotionless monotone of someone who cannot begin to comprehend the ramifications of his actions, "but, ah, I killed somebody. It's no big deal, ya know, I don't think anybody will find out about it . . . but this guy gave me a ride, and started giving me a lot of trouble, and I just couldn't take it, ya know? And I wasted him."

> *There's a killer on the road*
> *His brain is squirming like a toad*

The ominous overtones of "Riders On The Storm" become even more threatening as they echo softly behind this conversa-tion. *An American Prayer* uses vintage Doors music to bridge the gap between the uncharted realms of Morrison's poetry and the more familiar rock star persona.

The poem, "An American Prayer," makes up the fifth and final section and it is a summation of the entire album. It too relates to death describing it as "pale & wanton thrillful . . . like a scaring over-friendly guest you've/brought to bed," but also covers many other topics including a somber thought about where the actual power in America lies.

> *Do you know we are ruled by T.V.*

Such a realization is juxtaposed with the desire to escape and the acknowledgment that freedom can only be attained through spiritual means.

Let's reinvent the gods, all the myths
of the ages
Celebrate symbols from deep elder forests.

Though many of the verses overflow with a dark pessimism, there's also a sense of mythical euphoria as if those who know the world is falling apart and look for the answers in spirit and truth will survive. As Morrison recites the final lines to his epic poem the classical instrumental piece, "Adagio" by Albinoni, plays in the background, providing a suitable mood for the end of the work.

Morrison had a few weaknesses as a poet. He sometimes used worn poetic devices ("cool jeweled moon") or profane imagery ("Lament for my cock") and many of his insights were pedestrian, but he also possessed an uncanny freshness and a defiance in his poetry. He would not let himself be restricted by the meanings of words. He bent them, shaped them, forced them into different combinations to get the desired effect. He played words like an instrument and often succeeded in turning some of his shortcomings into poetic gems.

The essence of Jim Morrison has been captured on this record, and *An American Prayer* is a fitting tribute. For the album shows more what Morrison was and less what The Doors were. An audio documentary, it is unique and does not exploit or abuse. In fact, though some of the best moments come when the poetry is enriched with Doors material, this is clearly not common practice on the record. The poetry and the poet are always given precedence. The album is a gift from special friends to a man who was never fully appreciated for his greatest talent.

Inside the fold-out jacket of the original release of the album was an eight-page booklet that included photos, poetry and lyrics, and some of Morrison's own drawings and pen doodles. *An American Prayer* is definitely not the sort of album that will appeal to everyone or even all Doors fans. Those dedicated enough to really listen and absorb will find a fundamental simplicity at its core. It is Jim Morrison searching amongst the crudeness for a

metaphysical purity—that he never found the answer to his spiritual question, or that he may have embraced an answer that was all too wrong, does not change the magnitude of the quest. In the poet's fascination with death there exists the breath of life. The work is mysterious, philosophical, and yet charmingly naïve. *An American Prayer* is about America and about Jim Morrison as a symbol of America.

Obviously the album did not receive a great deal of radio airplay and many of the cuts were never aired at all because of their profane or sexually explicit nature. Eventually, Elektra released a special radio version of the album that contained only those cuts that broadcasters could air without censorship. "We're up against the morality once again," Manzarek said at the time. "The White Anglo-Saxon Protestant puritan morality. Here we are again putting out a record with a lot of dirty words on it. We could have cut out all the dirty words and we'd have a better chance of selling more records. Elektra said, 'Hey, the rack jobbers are not going to handle this.' Whoever has the balls to handle this record, let them do it. They ought to have the guts to say this is poetry. It's not dirty for the sake of being dirty."

Hear me talk of sin

There are those who disagree with the way *An American Prayer* was compiled and recorded. Among them is The Doors' former producer, Paul Rothchild, who gave a blistering attack on the album in an interview for *Bam* in 1981: "I think anything that was done during Jim's lifetime that might have offended him would disappear into total insignificance compared to what I'm positive would have been his reaction to *An American Prayer.* That album is a rape of Jim Morrison . . . I have a tape of Jim reading that poetry in the style and meter he intended . . . When I listen to that original tape, I hear something compelling. The poetry is chilling. To me, what was done on *An American Prayer* is the same as taking a Picasso and cutting it into postage-stamp-size pieces to spread across a supermarket wall . . . Jim never intended this . . . He definitely wouldn't have used Doors music. He was talking to people as diverse as Lalo Schifrin, whom he

wanted to write some very avant-garde classical music. He wanted it to be sparsely orchestrated."

While Rothchild's observation may be somewhat prejudiced since he wasn't part of the project, it's true that no one could possibly know how Morrison would have used the material. In fact, *An American Prayer* utilized less than one sixth of the poetry known to have been recorded. The Doors have acknowledged that Morrison originally wanted bits of orchestral music on the project, but since there was no way Morrison's specific vision for his work could be fulfilled without Morrison, they have felt justified in providing their own interpretation. No matter how great their dedication to the man and his poetry, the confusion created by the efforts of the tape cutters makes it impossible for us to ever to determine what Jim Morrison actually created and what has been spliced into reality. But the power of Morrison's work armors his poetry against excessive doctoring. And the devotion of its creators overrides any flaws in their creation. As Morrison devotee, singer/poet Patti Smith, said in her review of *An American Prayer* for *Creem* magazine: "Its flaws lie in the forgivable limitations of these friends and sometimes in the poet himself . . . His fatal flaw was that his most precious skin was the thin membrane that housed the blood of the poet. He pledged his allegiance, in the end, to language, to the word. And it did him in . . . *An American Prayer* resounds in the silence that surrounds the cocoon of the lord, he is sleeping, hibernating, awaiting the changeling and the elegance of his change."

An American Prayer reached number fifty-four on the American charts and sold over a quarter of a million records, the largest-selling record of verse in history. The art and music world cheered Morrison's poetry presented as he spoke it, and fittingly, it became the only Morrison/Doors album ever nominated for a Grammy. It is interesting to note that it was an album of Morrison's poetry, not rock music, that touched off the band's return to mass popularity. Poetry was Jim's first love. It was his passion. *An American Prayer* may be filled with the flawed aspirations of youth, but whenever it breaks through to brilliance, it clearly illuminates the meaning of what might have been had the poet had time to reflect on his inner turbulence with the wisdom of age.

James Douglas Morrison: Poet

The cord that connected the many sides of Jim Morrison's life together was his writing. He was writing poetry as early as the fifth grade and he continued until the very end. The Doors were birthed out of his poetry and vision was his primary concern—rock 'n' roll just happened to be the medium. Morrison filled hundreds of notebooks with brilliant images ranging from nightmarish specters and wild rantings to classically structured works of great depth. It was writing that got Jim Morrison through each day and he wrote incessantly, no matter what else was going on in his life.

> *A series of notes, prose-poems*
> *stories, bits of play & dialog*
> *Aphorisms, epigrams, essays*
> *Poems? Sure*

Morrison described his love for poetry in this way: "Poetry appeals to me so much because it's so eternal. As long as there are people, they can remember words and combinations of words. Nothing else can survive a holocaust but poetry and songs. No one can remember an entire novel. No one can describe a film, a piece of sculpture, a painting. But so long as there are human beings, songs and poetry can continue."

Words for Morrison were to imply and suggest and elicit a reaction from the listener's whole body rather than just his mind. His poetry constructed murals of feeling. As he once said, "If my poetry aims to achieve anything, it's to deliver people from the limited ways in which they see and feel."

Michael Ford, who won a 1986 Grammy Award for a spoken-word album of his poetry, describes Morrison's writing: "Jim turned language into mystery, into a priesthood. He was the conjurer, wearing the cloak of the shaman, weaving a magic carpet of words that soar and sail and swing and fly. He was constantly a practicer of charms and talismans to help all of us travel to our metaphoric destinations and maybe that's another way of doing what the witch doctor does when he does the ghost dance. I think Jim's involvement with shamanism—the idea of going into a trance and playing off people's fantasies—was to get people to

respond to the idea of magic. It was in the William Butler Yeats sense that poets need the aspects of charlatan imagery in order to conjure images imaginative enough to affect people. That's the same thing the witch doctor tries to do."

Another unique aspect of Morrison's poetry is that he was not limited to one style. Frank Lisciandro elaborates: "The poetry Jim wrote is so varied. He seemed to write spontaneously, that is, he could set pen to paper and produce a finished poem. The right meter, right number of syllables per line, and so on. If Jim would've read, say, a dozen sonnets by three or four different writers he could probably have sat down and produced a sonnet on the spot. He was that facile with the language. And he did produce iambic pentameter and the classical things. There are other poems that, like everything else he did, had a tendency to move out beyond that . . . explore new forms that were unique to him."

In addition to being involved with *An American Prayer,* Frank and Kathy Lisciandro, along with Corky Courson, were key figures in getting recent books of Morrison's poems published including *Wilderness: The Lost Writings of Jim Morrison* (Villard, 1988). Frank says: "In *Wilderness* we attempted to present Jim the poet on the broadest possible basis. Not all of the poems are Jim at his most profound and powerful. As a matter of fact, it was some of the poetry that was earliest in his career after *Lords and The New Creatures.* But it was poetry that was accessible to the vast majority of readers. We knew the book would be popular and wanted those readers who would pick it up because they were interested in Jim to find poems they could grasp at first reading."

The poetry in *Wilderness* was gleaned from a massive collection of notebooks of poetry that Morrison left behind. Lisciandro served as editor of the book which proved to be extremely difficult: "If Jim was alive and I were his editor, I could say, 'Do you really want that word, is this spelled right?' But we didn't have that choice . . . we have to take it as it is. I only agreed to work on the project if I could be faithful to the material. We did not change any words or meanings. A lot of the stuff is on loose sheets or in notebooks where it's impossible to tell when they were written. At first we had no way of knowing what versions were the most finished ones. That was very agonizing for me be-

cause I wanted to be true to Jim's work. It took months of study-
ing the material to establish a chronology."

Lisciandro and Courson recently finished a second book of
Morrison poems, *The American Night* (Villard, 1990), which in-
cludes previously unpublished parts of *An American Prayer.* "An
American Prayer actually has two other parts," Lisciandro ex-
plains. "Part two begins, 'Great screaming Christ, upsy-daisy Lazy
Mary, will you get up on a Sunday morning' and then there's a
third, fourth and fifth part. In this book we present it as a whole
piece the way Jim really intended it to be. We also have enough
recorded poetry for another album. And now, having really stud-
ied Jim's poetry (*Wilderness* is now taught at Stanford, Duke, and
Yale), I believe the material we didn't use on the first album is as
good as the material we did use."

The primary motivation behind Courson and Lisciandro's
work is to bring Morrison's poetry to the attention of the public
and establish recognition for Jim as a major American poet. "I
think if I were to produce a small volume of this many good
poems I could call myself a poet," Lisciandro says. "But this is not
even a hundredth of the amount of poems Jim wrote. So can we
say he was a poet? I would say he was a poet. And I would say he
was a poet first because that's what we have more of his than
anything else."

While the works have helped to draw attention to Mor-
rison's poetry, (*Wilderness* is now taught at Stanford, Duke, and
Yale), the books have been criticized because some of the poetry
seems unfinished. "My first feeling was that Jim wouldn't have
wanted some of this in print," Michael Ford reasoned. "I mean I
wouldn't want a lot of my first drafts in print to be judged as
literature. Mostly, though, I don't think he would've allowed the
form that it's taken. He would've preferred having several little
chapbooks just like he did in life. On the other hand, any of Jim's
writing that comes out helps offset the rock star grunt-brain atti-
tude. If you read his work and then read the lyrics of somebody
like Axl Rose or Prince, you realize that Morrison was really in-
side. It lends credibility to Jim's worthiness as a writer."

If a choice between his two sides has to be made, Morrison
was, when all is said and done, a poet first and a rock star second.
To be a poet and be heard in his time, however, he may have
had to be both. It was the images of the poet that inspired the

music of The Doors and it was the madness of the poet that so ignited the fire of the fans. And though the image of the ultimate rock star he created constantly shadowed his life, in the end Jim Morrison's words are winning out. It may have required his death and twenty years of settling before they could be heard over the screams of the superstar, but the words of the poet are enduring.

If Jim Morrison were alive today, he would be forty-seven years old, and there's not much chance he would still be singing about chaos and revolution. There are many who were close to Morrison who think that everything he'd been through had finally produced a kind of battle-scarred wisdom in him. His friends believe that if his body had not given up the fight, he might have been able to harness that wild side of his nature at least long enough to have mellowed into a true poet. He may have become less of a cultural icon, but hopefully this would have been balanced by the realization that he had become more contented and an even greater poet.

Morrison once said it was only through the words and the music that one could really know him. Perhaps he was right. And when he died, Pamela insisted that the death certificate officially describe him as she had always seen him and as he saw himself: "James Morrison, Poet."

Words dissemble
Words be quick
Words resemble walking sticks
Plant them
They will grow
Watch them waver so

I'll always be
a word-man
Better than a birdman

The Doors' Resurrection

Interest in The Doors began again with the release of *An American Prayer* in 1978 and has not stopped since. Morrison

has been dead for twenty years and the Doors still sell over a million albums in the United States and abroad nearly every year (over two million in 1981, 1982, 1989, and 1990). That's the equivalent of another gold and platinum record *every* year. In fact, the truth is that The Doors are selling as well now as they did in 1967. Even more unusual is that their music has transcended two generations—both parents and their children listen to the same band.

In 1979 Morrison's ominous monologue "The End" provided a fitting atmosphere on the sound track of Francis Ford Coppola's *Apocalypse Now.* An uncanny passage into psychotic love, guilt without hope of salvation, violence, and undeniable death, it is the perfect song for the horrors of Vietnam. Originally Coppola approached Ray Manzarek about composing the score, but Manzarek's first commitment was to *An American Prayer.* The Doors were considered by many to be the favorite band among the armed forces stationed in Vietnam and the original script included a savage firefight accompanied by "Light My Fire." Though this was never filmed, Coppola did shoot Marlon Brando (as renegade Special Forces officer Kurtz) teaching his army of native tribesmen the song in their own dialect, but the scene was later edited out. Eventually, Coppola settled for opening and closing the film with "The End." He had David Robinson remix it to bring up the guitar and Morrison chanting, 'Kill, kill, kill,' and later 'Fuck, fuck, fuck'—vocal parts that were mixed way down in the original recording. The song underscores Martin Sheen's (as Captain Willard) napalm nightmares in the beginning and later it is used with Morrison's chant to accompany Willard's ceremonial killing of Kurtz in the climax of the film. Like *An American Prayer,* the *Apocalypse Now* sound track was nominated for a Grammy Award in the Best Spoken Word Category.

In 1980 a compilation album, *The Doors Greatest Hits,* was released, followed in 1983 with a live album, *Alive She Cried,* and both of these records sold into the millions. In 1985 another compilation album *Classics* also proved to be very popular. The summer of 1987 was a virtual nirvana for Doors fans. The digitally remastered compilation set, *The Best of the Doors,* and all six Doors studio albums were released on compact discs by the fall. In 1991 Elektra released the original sound track to the film

The Doors and planned on releasing a Doors CD boxed set consisting of the studio albums, a compilation of music from their live albums, *An American Prayer,* and some previously unreleased material. The set is to be boxed in a black leather-looking case with The Doors logo in red.

The music & voices are all around us

And their music continues to be featured on film sound tracks with surprising regularity—each new year sees the inclusion of a Doors song in a major Hollywood film. By the time this book is published, Carolco Pictures will have released *The Doors* directed by three-time Academy Award winner Oliver Stone *(Platoon, Wall Street, Born on the 4th of July)* and starring Val Kilmer as Jim Morrison, Kyle MacLachlan as Ray Manzarek, Kevin Dillon as John Densmore, Frank Whaley as Robby Krieger, and Meg Ryan as Pamela Courson and Kathleen Quinlan as Patricia Kennealy. Like the band it describes, the thirty-five-million-dollar film will most assuredly be a controversial one. In our interview, Oliver Stone said he wanted to make a film about Jim Morrison because of "Morrison's beauty, grace, and daring—his laughter and sense that the world was mad." Val Kilmer said Morrison "went for what he was most afraid of . . . if the dragon wasn't staring at him in the morning, he'd rush out and try to find it . . . as fast and as hard as he could."

Although Ray Manzarek has never liked the script and says the film "isn't the story of The Doors," he and the others who control Morrison's songs or poetry agreed to let the film be made. For many years the squabblings between The Doors and the Coursons hindered any project that would include both lyrics and poetry, but this was resolved when Stone came into the picture. From having read the script and watched some of the filming, there is little doubt that Stone's film will draw heat because of its explicit sexual scenes, but it may also attract great praise because of the fine performances of its cast and its intricately detailed set design which makes it one of the few films to successfully capture not only the look, but the feel of the 1960s.

The Doors have also fared well with their videos. *A Tribute to Jim Morrison* and *Dance on Fire* have been regularly aired

on MTV to over thirty million viewers. *Dance on Fire,* a collection of rare film and television clips released in 1985, was MCA's best-selling music video. In addition, a sixty-five minute home video, *The Doors Live at the Hollywood Bowl,* was released to much acclaim in 1987. It is a full-color chronicle of the sold-out July 5, 1968, performance at the Bowl with a matching six-song sound track. In 1989 *The Doors in Europe* was released consisting primarily of the band's performance at the London Roundhouse and the "Doors Are Open" interviews shot by Granada Productions. In 1991 a new video entitled *The Soft Parade* will be released from the group's 1969 NET special. A number of syndicated radio specials chronicling the career of The Doors have also been aired including *Three Hours For Magic, The 20th Anniversary Salute To Light My Fire,* and *The Doors From The Inside.*

There have also been successful books, including *No One Here Gets Out Alive* (Jerry Hopkins and Danny Sugerman, Warner Books, 1980), which has sold over a million copies; *An Hour For Magic* (Frank Lisciandro, Delilah, 1982); and *The Doors: An Illustrated History* (Quill, 1983). Current Doors manager Danny Sugerman's biography, *Wonderland Avenue* (Morrow, 1989) focuses on the powerful effect Morrison had on his life, while *Riders on the Storm* (Delacorte, 1990) tells the Doors' story from John Densmore's point of view. *Dark Star* (Dylan Jones, Bloomsbury/Viking, 1990) and *MojoRisin',* (St. Martin's, 1991) contain little new information, but provide some interesting photos. *Morrison: A Feast of Friends* by Frank Lisciandro (Warner Books, 1991) also has many great photos and includes remembrances from many of Jim's friends and associates. Like everything else about Morrison, the books have inspired much heated debate. The past and present Doors organizations seem divided over *No One Here Gets Out Alive,* with Courson, Rothchild, Lisciandro, Bill Siddons, and Vince Treanor claiming the work was grossly inaccurate and sensationalized, while Sugerman and the surviving Doors acknowledged the sensationalism, but maintained its truth. Some say the Coursons' objections to the book are debatable because they "live in a fantasy world and never really knew Morrison," whereas others claim that Ray Manzarek edited many passages of the book to enhance the legend ("crossing out the bad stuff," according to Densmore) and argue

that the segments describing Morrison's relationship with teen-ager "Denny Sullivan" refer to Danny Sugerman and are largely fictional. Morrison no doubt would have loved the controversy.

As for the poetry books, *The Lords and The New Creatures* has continued to grow in popularity. In November 1988, *Wilder-ness: The Lost Writings of Jim Morrison* was released. The book is 209 pages of some of Morrison's best poetry and also includes photos and reprints of poems in his handwriting. A companion volume *The American Night: The Writings of Jim Morrison* was released in September 1990.

The Doors' popularity and Morrison's identity as a cult figure are by no means limited to America. The mystique transcends language barriers and The Doors' recordings and videos sell very well internationally. And in recent years a Morrison postage stamp has even been issued in West Germany.

Perhaps the strongest testimony to the continuing popularity of The Doors is the marketability of Jim Morrison. His image is emblazoned on countless T-shirts, posters, calendars, and the like. There are conventions where everything from candid photos and magazine clippings to programs and official Elektra press photo-graphs are available. And for serious collectors there is an entire underground network of bootleg memorabilia where un-authorized tapes of many performances are offered. Prices vary with the rarity of the article from a few dollars to upward of two thousand dollars for something like a limited-edition poetry col-lection published by Morrison himself or an album autographed by all four Doors.

The Reasons Behind The Doors Phenomenon

The Doors' impact was heightened greatly by the era in which they existed. From Kennedy's Camelot to the Age of Aquarius it was a time of terrifying importance for anyone who lived through it and the fact that The Doors' music has persisted is a testimonial to how closely they paralleled those times for most of the world's youth. Rock music was at the forefront of every social movement in the 1960s and the kids grew up with it being one of the most important things in their lives. They be-lieved Bob Dylan when he told them the answer was blowing in

the wind. They believed John Lennon when he pleaded for peace and love. And they believed Jim Morrison when he urged them to break on through. The Doors sang about unknown soldiers, having the numbers if not the guns, and wanting the world, but more than that they typified their generation by daring to describe the dark passions as well as the high ideals that were driving it.

Back in those days everything was simpler
& more confused

Today the sociologists, politicians, and philosophers are still debating whether the sixties succeeded or failed. Even the brilliance and promise of the music pales somehow with the visions of Jim Morrison dead in a Paris bathtub, David Crosby hiding out with a stash of coke and a gun, and John Lennon murdered on the streets of New York. But amidst these cries of failure looms something less tangible but every bit as real. There was a Summer of Love, there was a generation of kids who joined together and risked their lives because they believed America was selling out, and there were leaders who dared to voice a dream that could not be silenced by the gun. And maybe in a few years the sons and daughters of our materialistic society will have a thing or two to add to life in the nineties. And if they do, you can bet whose songs they'll be singing and whose lyrics they'll be quoting.

In some ways people in the nineties understand The Doors better than those from the '60s. Much of what the group attempted to do in the sixties was obscured by the popularity of their hits on the radio. The people who are into The Doors today are usually into everything they recorded, not just "Light My Fire." They are into the music and not just the myth. Teenagers in the 1980s didn't really have a generation they could call their own. They didn't have a movement, and they wanted one. All teenagers need a cause. It's part of growing up. So guess where they went? Back to the sixties and a wild kid named Jim Morrison. Because, for all his tragic flaws, Morrison was not faking it—his "show" was theatrical, but his rebellious image and philosophy of life were not.

Most popular music is trendy and vanishes without a trace

within a few years, but The Doors' music survives because it's almost classical in its approach. Thanks to Paul Rothchild and the timelessness of the songs, The Doors' albums don't have the clichés and gimmicks that clearly date other groups of their time. They were a very literary band and good literature tends to survive the test of time. Morrison was a poet with a universal message.

Another key to the Doors phenomenon is their identification with eccentric, artistic L.A. In 1988 a *Los Angeles Times* poll named the band L.A.'s all-time greatest band. "The West is the best," Morrison exclaimed in 1967 and everyone in America between the ages of twelve and thirty knew he was right. The Doors *had* to be from L.A. because that is where their audience wanted to be. Morrison said in an early interview: "The city is looking for a ritual to join its fragments. The Doors are looking for such a ritual too. A sort of electric wedding." In the Doors' hometown, the group's impact must be measured on the Richter scale. Moves that Morrison tried out at the Whisky a Go Go over twenty years ago can be seen on any given night in L.A.'s leading rock clubs today. The Doors retain the sensuality and mystery associated with the City of Angels. It even could be said that you can not fully appreciate their music until you hear it while driving down Sunset Boulevard on a warm summer night. And that kind of thing doesn't go away. It doesn't fade with time. It may even be said to get stronger.

The grip the Doors still have on impressionable young minds in the nineties goes well beyond record sales. Their influence is almost totally pervasive throughout the rock music world. In fact, it is hard to think of a rock band that does not owe something of its sound, show, or attitude to The Doors. That sinuous guitar-keyboard sound, the expressionistic drumming, and Morrison's theatrical approach to such themes as sex, fear, alienation, and the inevitability of death have been incorporated into the work of countless contemporary rock groups. Like that of the Beatles, Dylan, and The Stones, it is a force that goes beyond influence and stands more as a monument in rock.

The Doors were one of the first rock groups to record extended pieces, and in dramatizing Morrison's poetry in concert, they became the first to consciously inject theatrics into their act. Consequently, they also were one of the first rock bands to

have their performance described as art. Morrison made conscious efforts to turn concerts into a theater of confrontation, urging audiences to the extremes even as he pushed himself beyond all conventional standards of behavior.

Many of today's bands openly admit they have based their style on The Doors and at one time there were at least six Doors tribute bands around the country. Crystal Ship, Soft Parade and L.A. Woman in the East, Moonlight Drive in the Midwest, and Wild Child and Strange Daze on the West Coast. More significant, though, is the impression their music has made on young musicians who adapt the sound to their own purposes. In the 1980s, acts like INXS, U2, The Cure, Echo and the Bunnymen, X, The Police, The Cult, and Billy Idol regularly employed old Doors' licks. In the Seventies you could easily hear or see their influence in artists like Patti Smith, Iggy Pop, and Alice Cooper. All of heavy metal owe a debt to The Doors and the Punks especially owe Morrison for the pseudo-blackness of their themes. And there isn't a lead singer in rock who hasn't borrowed something from Morrison's persona whether it is his psychedelic witch doctor rap, his black leather pants, or his dynamic stage presence.

Probably most important, the reason The Doors are so popular is because teenagers are always looking for a sense of personal freedom and Jim Morrison represents it better than just about anybody. Morrison tapped into the spirit of rebellion that all young people must contend with. The Doors were demanding to know what life was all about and that is still the burning question seething in the minds of most adolescents. Morrison wrote about the forbidden subjects like sex, death, and power, and these are as important now as they were then, especially in the atmosphere of censorship in the 1990s. From the moment puberty strikes, these things take on a new and deeper meaning. And though it may seem dated and sixties-ish to talk about "trips" and "freedom," the new audience, the adolescents of the nineties, relate to the Doors' lyrics on a level that is immediate and powerful.

The distance between Morrison's life and their own youth likely fuels this idol worship. If kids saw Morrison today, they wouldn't be so certain all his activities were godlike, but in death, he remains an uncompromised hero. He will always be twenty-seven—forever young. He's not going to change. He's not going to repent and start preaching against liquor and drugs. He

will always keep saying the things teenagers like to hear. He will never be an overweight, gray-haired grown-up with a burned-out voice. For Morrison there's nothing quite like being dead to stay popular.

But the attraction goes beneath surface appearances. The Doors were the first to explore in rock language the turbulent underpinning of violence, sex, alienation, and mysticism which fills the minds of American adolescence. The sheer shock of realizing, not only that there are people who want to have sex with their moms after killing their dads, but that something all too close to that evil gnaws in all of us. And lastly, the exciting appeal of a handsome and charismatic man calling himself names like the Shaman and the Lizard King, and singing about "screaming butterflies" and making "the blue cars" go away.

In addition to all these reasons for the Doors' continuing popularity, a very practical one, promotion, must not be discounted. Throughout the years The Doors management has displayed a keen sensitivity not only to its sixties fans but to those up through the present generation. In the late seventies Ray Manzarek and his manager, Danny Sugerman, heard a radio broadcast that referred to Jimi Hendrix and Janis Joplin as the late-great rock stars of the sixties. The program omitted Jim Morrison and that was when the two realized that, in their efforts to not over-hype and commercialize the band's recordings, they were allowing Morrison's memory to be eclipsed by those whose repackages and rereleases had saturated the market. It was decided to launch a three-pronged attack to celebrate the memory of Jim Morrison. Danny Sugerman remembers: "We decided that with the poetry album out and the book *(No One Here Gets Out Alive)* coming out we would develop a radio special and a greatest-hits package to cover the recording, print, and radio mediums. We resolved never to glut the market or release anything Jim wouldn't have wanted out."

While Krieger and Densmore have participated and no doubt benefit in The Doors resurrection, Ray Manzarek has really become the keeper of the flame. Manzarek was, is, and always will be a member of the Doors. In his biography, John Densmore makes reference to "Father Manzarek" and says Ray's continual spouts about the Doors in the press make him sound like the Maharishi trying to raise Doors consciousness. "Jim's message

was endarkenment," Densmore says, "only Ray is so illumination-bound that he doesn't see his own darkness . . . Ray loved Jim as a son, and it's tough for a father to accept his son's demise."

Sugerman too has been criticized for profiteering from the dead and for pushing his way into The Doors inner circle. "Sure I pushed my way in," he admits, "but nobody else wanted to promote The Doors in the late seventies. Maybe a lot of people could've had the job, but they didn't want it because at that time there wasn't any money in it. I didn't care about the money. If I wanted money, I would've gone to work for my father. Ray came to me and said he felt The Doors should live on for future generations and I agreed. Everything I've done was out of affection for Jim and The Doors. The money came later when Doors records started selling again and proved that Ray and I were right."

Unlike the product that has been released on Jimi Hendrix, Elvis Presley, and others, Doors records are still up to their original high standards. Great care is taken with each one and all three ex-Doors as well as Sugerman should be commended not only for such a highly successful marketing campaign, but also for a phenomenal sense of timing.

Jim Morrison: The Man and the Myth

More than anything, the key to the lasting popularity of The Doors is Jim Morrison, the man and the myth. Larger than life, his legend fuels a mystique that has not abated after all these years. In some ways he was the perfect artist for the sixties generation. In a very real sense, his life was a representative microcosm—a mirror and a touchstone for the decade that started out believing music and love would set them free only to wind up ensnared by that freedom into decay and despair.

One way of looking at Jim Morrison's life and death is as a testimony to that offensive myth that claims artists are somehow a race apart and thereby entitled to the most outrageous actions imaginable in the name of art. The sad truth is that such insane tolerance contributes to their drying up as artists. Most of the rock 'n' roll heroes from the sixties who managed to survive the decade have proven this out by ending up having nothing to say. If everyone around an artist is catering to his whims or sheltering

him from the consequences of his actions, he will lose touch, first with his art, then with his audience, and finally with himself. It was the change from showman into man that was the hardest for Morrison. He seemed to feel alternately trapped and emboldened by the respective demands of The Doors' dual audiences of teenyboppers and intellectuals. Obsessed by the idea of music as ritual, Morrison both accepted and thrust maddeningly at its limitations.

Youthful success, even in the strongest of personalities, often results in one's becoming symbolic before one is real, becoming someone created by others before one can create oneself. All true media stars are faced with a hard choice. They can choose to totally become their image and let go of who they might actually be inside, or they can fight to hold on to their true personality and feel phony when they have to play the image. True to form, Morrison chose neither option. Instead he tried to change an image that was one of the strongest ever created.

Perhaps Morrison's real legacy is how he took the fear that accompanied the explosions into freedom in the sixties and, after first making it even more bizarre, dangerous, and apocalyptic than anyone thought possible, diffused it all by turning everything we were taking so seriously into a big joke midstream. He helped us handle the times by showing us that it wasn't all that heavy after all.

Much has been written about the magic of the Morrison mystique. Twenty years after his death the legacy continues to grow. The quintessential group of the 1960s has proven to be one of the most influential bands of the 1970s, 1980s, and 1990s. And the legend of Morrison remains as exaggerated as it always was. Yet this legend does not distort the music. Rather, the myth serves as a platform and an only slightly veiled invitation to the music. The Doors were perfectly built around Morrison's style. Without them, he would have been a singer without a microphone. And without him they would have been only accomplished musicians, perhaps a little avant-garde in approach but lacking the intensity and power of true innovation. True innovation requires taking risks. Morrison gave the others that foundation on which experimentation could be welcomed instead of discouraged. He was the fire that enabled their talents to burn bright and they were the fuse that ignited him.

And though it cannot be said for sure if it was the white-hot flame of the shaman spirit that drove Morrison to the pinnacle of rock, or if that force abused and corrupted the very special gifts of a child meant for an even greater destiny, there is no denying that Jim Morrison left his mark on our world.

Today if you go to Père-Lachaise cemetery you would find the other graves are quiet and "dead," but Morrison's resting place is "alive" with visitors twenty-four hours a day. The fourth most popular tourist attraction in Paris, it is a living monument complete with ever-changing graffiti and a party atmosphere. Every July 3 there is a huge pilgrimage of his fans and a full-scale celebration. The Doors may not make music together anymore, but they are still a part of the American way of life and as such will always be a part of growing up for every generation. In the last analysis Jim Morrison failed to break on through, but his persona lives on and his music has reached the loftiest of plateaus— it has become the sound track for a generation.

> *The music is your special friend*
> *Dance on fire as it intends*
> *Music is your only friend*
> *Until the end*

In Flint, Michigan, a carload of teenage boys break into cheers as "Hello, I Love You" comes on the radio.

On Sunset Boulevard in Los Angeles a man gets out of a BMW and walks toward a business meeting. He stops dead in his tracks as he passes the Whisky a Go Go and hears a band playing "Soul Kitchen," feeling suddenly propelled back in time to the same spot twenty-five years ago. Finally he realizes it is a new band playing an old song. He shakes his head and walks on . . . remembering.

In Milan, Italy, a thirteen-year-old girl listens to the radio and asks her older brother, "Who is this new American band?" The boy hands her a cassette and says, "Don't you know anything, Maria? They have the number one record this week. It's The Doors. I'm going to call my friend in Rome and see if he can get me tickets when they come to perform."

A University of Illinois college professor and his wife make an attempt to put the magic back in their marriage. The kids are away and he has called in sick to the faculty meeting. She pours the wine and he plays "Light My Fire" on the stereo.

In Paris, seven teenagers and two couples in their forties huddle around a grave listening to "Riders On The Storm" on a cassette player. One of the older men lights a pencil-thin joint and passes it to a boy about the age of sixteen. The boy smiles, pulls out a huge elephant joint of his own, and hands it to the man.

Nine people join hands and focus on a lighted candle in the center of the room in Venice, California. It is the room where Jim Morrison lived a quarter of a century ago and every Thursday night a séance is held in an attempt to contact his spirit.

In Washington D.C., a United States senator takes a break from the speech he is writing urging new cuts in the military budget. He leans back in his black leather desk chair and pushes the play button on his stereo. The song that plays is "The Unknown Soldier."

A teenage boy in Cleveland, Ohio, tries to explain to the hairstylist the kind of look he wants. He hands her a CD of *The Doors Greatest Hits* and points to the "young lion" on the cover.

In Miami, Florida, a member of a popular black rap group peaks through the stage curtain and checks out the audience. He focuses on an older policeman standing near the stage and wonders if the band will be busted for obscenity. The policeman already knows they will, but he laughs to himself remembering another obscene performance shortly after he first joined the force so long ago.

In London, a British film director decides he will make a film about the student riots in China. He already knows what he wants for the title theme—"Break On Through."

At a Denver, Colorado, swap meet a thirty-three-year-old woman pays three hundred dollars for a publicity photo signed by Jim Morrison. She already has seven other Morrison autographs, as well as two hundred photos, seventeen albums, twenty-five bootleg concert performances, fourteen posters, fifty-nine buttons, and twelve T-shirts. She calls herself a collector but sees a psychologist twice a week about her obsession.

In Moscow, the lead singer of one of the city's most popular rock bands carefully unwraps the package he has had shipped from his cousin in the States. His eyes beam as he looks at the contents, a pair of black leather pants.

In a run-down section of the Bronx, New York, a shy, college kid hauls his sleeping bag up the steps of an abandoned office building. He lights a candle, opens the book he has been reading on shamanism, and listens to "The Changeling."

A young man in Osaka ignores a blind street beggar playing the flute until he recognizes the melody to "People Are Strange." He turns around and drops enough for a simple meal into the man's cup.

In Witchita, Kansas, the spinsterish head of a west side branch of

the library locks up for the night. As she drives home "Love Me Two Times" comes on the radio and she begins to cry, remembering her one experience as a groupie and the man she never got over.

An irate father slaps his rebellious teenage son in Berlin, sending the boy to his room. The boy closes the door, fights back the tears, puts on his headphones, and listens to "The End."

In Los Angeles, California, a keyboardist leaves a movie theater and hopes that he is not recognized. He gets into his car and turns on the radio just as "When The Music's Over" begins to play. He sighs. For the past twenty years he has not been able to listen to the song all the way through.

At Elektra Records in New York City, the new Doors' boxed set of CDs is shipped out to record stores across the country. A high school boy sealing the cardboard mailers pauses long enough to slip two sets into his backpack. One is for his girlfriend and the other is for his dad.

Somewhere a bright little boy stares out the window of his father's station wagon, stroking a pet lizard he keeps hidden from his parents in a shoe box. The boy is tremendously talented, but a little introverted and born into a family that has great difficulty understanding his particular gifts. And the battle begins all over again . . .

The Doors, Elektra Records, January 1967
Strange Days, Elektra Records, October 1967
Waiting for the Sun, Elektra Records, July 1968
The Soft Parade, Elektra Records, July 1969
Morrison Hotel, Elektra Records, February 1970
Absolutely Live, Elektra Records, July 1970
13, Elektra Records, November 1970
L.A. Woman, Elektra Records, April 1971

Other Voices, Elektra Records, November 1971
Weird Scenes Inside the Gold Mine, Elektra Records, January 1972
Full Circle, Elektra Records, July 1972
An American Prayer, Elektra Records, November 1978
The Doors Greatest Hits, Elektra Records, October 1980
Alive She Cried, Elektra Records, October 1983
Classics, Elektra Records, May 1985
The Best of the Doors, Elektra Records, June 1987

The Doors Live at the Hollywood Bowl, Elektra Records, June 1987
Original Sound Track to "The Doors," Elektra Records, March 1991

Memorial

As an ongoing memorial to Jim Morrison, The Doors and Jac Holzman have set up a scholarship fund to enable UCLA film students to finish their projects. Often students run out of money and are unable to complete a film project that may be necessary for them to get their degree. This fund is designed to help them. To contribute, send a check or money order to:

Jim Morrison Film Fund
Department of Theater Arts
The UCLA Foundation
405 Hilgard Avenue
Los Angeles, CA 90024

Books, Newspapers, and Magazines

"Age of Aquarius," *Newsweek,* August 25, 1969.

"Are You Ready for the Doors?" *16 Magazine,* December, 1967.

Aronowitz, Alfred G. "The Doors Seek Nirvana Vote Here." *The New York Times,* November 25, 1967.

Artaud, Antonin. *The Theater and Its Double.* New York: Grove Press Inc., 1958.

Atlas, Jacoba. "An Interview with Jim Morrison and the Doors." *Hullabáloo,* October, 1968.

———. "An Interview with Jim Morrison and the Doors—Part Two." *Hullabaloo,* November, 1968.

———. "A Doors Rap." *Hullabaloo,* December, 1968.

———. "The Doors: Amputated but Alive." *Circus,* January, 1972.

Babitz, Eve. "Jim Morrison Is Dead and Living in Hollywood." *Esquire,* March, 1991.

Baker, Robb. "The Sound." *Chicago Tribune,* May 13, 1968.

Baker, Tom. "Jim Morrison: When the Music's Over." *High Times,* June, 1981.

Balfour, Victoria. *Rock Wives.* New York: William Morrow & Co./Beech Tree Books, 1986.

Bangs, Lester. "Morrison Hotel." *Rolling Stone,* April 30, 1970.

———. "Thirteen." *Rolling Stone,* January 7, 1971.

———. "Jim Morrison—Bozo Dionysus a Decade Later." *Musician,* August, 1981.

Blackburn, Richard. "Jim Morrison's School Days." *Crawdaddy,* May, 1976.

Blake, William. *The Portable Blake.* New York: Viking Press, 1946.

Booth, Stanley. "Altamont Remembered." *Rolling Stone,* September 13, 1984.

Bornino, Bruno. "This Is the End, Friend." *The Cleveland Press,* July 16, 1971.

Bradley, Jeff. "Breaking the Spell." *Los Angeles Times,* June 19, 1988.

Bradley, Tim. "Robby Krieger." *Guitar World,* January, 1983.

Breen, Walter. "Apollo and Dionysus." *Crawdaddy,* September, 1968.

Breslin, Rosemary. "Jim Morrison, 1981: Renew My Subscription to the Resurrection." *Rolling Stone,* September 17, 1981.

Broeske, Pat H. "Jim Morrison: Back to the Sixties, Darkly." *Los Angeles Times/Calendar.* January 7, 1990.

Bronson, Fred. *The Billboard Book of Number One Hits.* New York: Billboard Publications, 1985.

Brown, Toni A., and Leslie D. Kippel. "Morrison's Celebration of the Lizard, A *Relix* Interview with Danny Fields." *Relix,* June, 1981.

Burks, John. "Uh-Oh, I Think I Exposed Myself Out There." *Rolling Stone,* April 5, 1969.

Campbell, Elizabeth. "Easy Rider." *Rolling Stone,* September 6, 1969.

Carney, Leigh. "Hair Rock." *Rolling Stone,* December 7, 1968.

Carpenter, John. "Morrison." *L.A. Free Press,* July 19, 1968.

"Che Guevara: The End of a Revolutionary." *Newsweek,* October 23, 1967.

Chick, Donna. "Doors in Concert at Forum." *Los Angeles Times,* December 17, 1968.

Chorush, Bob. "Jim Morrison on Trial." *L.A. Free Press,* September 4, 1970.

———. "The Lizard King Reforms: Taking the Snake and Wearing It." *L.A. Free Press,* January 15, 1971.

———. "James Douglas Morrison." *L.A. Free Press,* July 16, 1971.

"Cincy Promoter Files $1-Mil Suit Re'Closed' Doors," *Variety,* March 26, 1969.

Cott, Jonathan. "Doors, Airplane in Middle Earth." *Rolling Stone,* October 26, 1968.

"Crawdaddy!" *Newsweek,* December 11, 1967.

Cromelin, Richard. "Spectre of Morrison." *Los Angeles Times,* September 12, 1972.

————. "A Door Opens on Morrison As a Poet." *Los Angeles Times/Calendar,* November 19, 1978.

Cuscuna, Michael. "Behind the Doors." *Downbeat,* May 28, 1970.

Dangaard, Colin. "Singer Jim Morrison Guilty of Indecency." *The Miami Herald,* September 21, 1970.

"Decency Rally Fans the Flames, A." *Rolling Stone,* May 31, 1969.

"Decency Rally Sparks National Drive." *The Miami Herald,* March 29, 1969.

Densmore, John. *Riders on the Storm.* New York: Delacorte Press, 1990.

DeSavia, Tom. "Profiles." *Cash Box,* May 16, 1987.

Des Barres, Pamela. *I'm with the Band.* New York: William Morrow & Co., 1987.

Didion, Joan. "Waiting for Morrison." *The Saturday Evening Post,* March 9, 1968.

Diehl, Digby. "Teens Turn Out for CAFF Concert." *Los Angeles Times,* February 24, 1967.

————. "Love & the Demonic Psyche." *Eye,* April, 1968.

DiMartino, Dave. "Morrison in Miami: Flesh and Memories." *Creem* (special summer edition), 1981.

DiPerna, Alan. "Strange Days . . . Again." *Modern Keyboard,* March, 1989.

"Disgrace at Dinner Key." *The Miami Herald,* March 6, 1969.

Doe, Andrew, and John Tobler. *The Doors in Their Own Words.* London: Omnibus Press, 1988.

Doerschuk, Robert L., "Ray Manzarek of the Doors." *Keyboard,* February, 1991.

"Doors: A Critical Discography, The." *Bam,* July 3, 1981.

"Doors by The Doors, The." *The Beat,* January 27, 1968.

"Doors Campus Show Canceled." *The Toledo Blade,* September 17, 1969.

"Doors Concert Starts Riot in Long Island." *Rolling Stone,* September 14, 1968.

"Doors Continue As a Threesome." *Rolling Stone,* November 25, 1971.

"Door New Riot-Concert Tour a Smash in Phoenix, Arizona." *Rolling Stone,* December 21, 1968.

"Door Slammed for Obscene Reasons." *Rolling Stone,* January 20, 1968.

"Doors Will Do It in a Bull Ring." *Rolling Stone,* June 14, 1969.

Dubro, Alec. "The Soft Parade." *Rolling Stone,* August 23, 1969.

Edwards, Henry. "The Doors: Following in the Wake of the Lizard King." *Crawdaddy,* January 30, 1972.

Eliade, Mircea. *Shamanism.* Princeton: Princeton University Press, 1964.

"End of a Legend." *Time,* October 20, 1967.

Esslin, Martin. "The Theater of Cruelty." *The New York Times Magazine,* March 6, 1966.

Eszterhas, Joseph. "The Massacre at Mylai." *Life,* December 5, 1969.

———. "Morrison's Dying Another Sour Note for World of Rock." Cleveland *Plain Dealer,* July 16, 1971.

Everett, Todd. "Not to Touch the Earth." *Trouser Press,* September, 1981.

FBI Record of James Morrison, Federal Bureau of Investigation, United States Department of Justice, Washington, D.C.

Fink, Mitchell. "The Jim Morrison Legend Resurrected with New Doors Poetry Album." *Los Angeles Herald Examiner/Sound,* November 19, 1978.

Fisher, Annie. "Riffs: Jiiimmieeeee!" *The Village Voice,* January 30, 1969.

Flans, Robyn. "Reflections." *Modern Drummer,* December, 1982.

Fong-Torres, Ben. "Jim Morrison's Got the Blues." *Rolling Stone,* March 4, 1971.

———. "James Douglas Morrison, Poet: Dead at 27." *Rolling Stone,* August 5, 1971.

Fornatale, Pete. "Doors Organist Ray Manzarek." *Musician,* August, 1981.

Fricke, David. "Alive and Selling." *Star Hits,* Spring, 1983.

Garbarini, Vic. "Blues for A Shaman." *Musician,* August, 1981.

Garvin, Paula. "3 Is Still The Doors." *Rock,* December 20, 1971.

Gershman, Mike. "Morrison's Miami Trial: If All Else Fails You Can Petition the Lord with Prayer." *Rock,* Fall, 1970.

———. "Apathy for the Devil." *Rock,* Fall, 1970.

———. "Morrison: No News is Bad News." *Rock,* October 11, 1970.

———. "Morrison Convicted: So Much for Law, Back to Politics." *Rock,* November 2, 1970.

Gleason Ralph J. "A Roll of Drums and, Lo, The Doors!" *San Francisco Chronicle,* October 18, 1967.

———. "Just Doing It at Santa Clara." *San Francisco Chronicle,* May 20, 1968.

"Giant Leap For Mankind, A." *Time,* July 25, 1969.

Glover, Tony. "Interview with The Doors." *Circus,* March, 1969.

———. "I Went to Hear The Doors the Other Night." *Circus,* March, 1969.

———. "Doors: Their Music and Their Hassles." *Circus,* April/May 1969.

———. "Onstage with The Doors." *Circus,* April/May 1969.

————. "A Coexistent Conversation with The Doors." *Circus,* June, 1969.

————. "This is the end . . . beautiful friend, the end . . ." *Circus,* July, 1969.

Goldman, Albert. "Rock Theatre's Breech Birth." *Vogue,* August 1, 1968.

————. "The End." *Penthouse,* April, 1991.

Goldstein, Richard. "The Doors Open Wide." *New York Magazine,* March, 1967.

————. "Pop Eye." *The Village Voice,* March 23, 1967.

————. "Pop Eye: The New Jazz." *The Village Voice,* June 22, 1967.

————. "Pop Eye: Leather Tiger." *The Village Voice,* December 14, 1967.

————. "The Shaman as Superstar." *New York* Magazine," August 5, 1968.

Gormley, Mike. "The Doors—An Exciting Concert." *Detroit Free Press,* May, 1970.

Gotz, David M. "Bruce Botnick." *Record Review,* February, 1981.

Grace, Francine. "Vibrant Jazz-Rock Group at Gazzarri's." *Los Angeles Times,* February 28, 1967.

Grant, Mike. "The Explosive Jim Morrison." *Rave,* Fall, 1968.

"Grossed Out by The Doors." *The Miami Herald,* March 6, 1969.

Guthmann, Ed. "The Doors Break On Through at Carousel." *The San Gabriel Valley Daily Tribune,* January 27, 1968.

Gwenn, Carol. "Perpetuating the Morrison Myth . . . Sort Of." *TeenSet,* September, 1968.

Hadlock, Clyde. "Mr. Mojo Risin'." *Kicks,* July, 1980.

Halifax, Joan. *Shamanic Voices.* New York: E.P. Dutton, 1979.

Harner, Michael. *The Way of the Shaman.* New York: Harper & Row, 1980.

Harrington, Stephanie. "It's Hard to Light a Fire in Miami." *The Village Voice,* March 13, 1969.

Hersh, Seymour M. "My Lai—Breaking the Story." *Memories,* October/November, 1989.

Hickey, William. "Theater in the Round Rolls Along Nicely." Cleveland *Plain Dealer,* June 23, 1967.

Hilburn, Robert. "Audience Hears a New Jim Morrison." *Los Angeles Times,* July 28, 1969.

————. "The Doors Bring Rock to Long Beach Arena." *Los Angeles Times,* February 9, 1970.

————. "Why Morrison Death News Delay?" *Los Angeles Times,* July 10, 1971.

————. "L.A.'s Greatest Rock 'n' Roll Band—Who Is It?" *Los Angeles Times/Calendar,* August 21, 1988.

————. "Is Rock Running on Empty?" *Los Angeles Times,* July 15, 1990.

Hirschman, Jack. "Jim Morrison: Notes Toward a Tomb." *L.A. Free Press,* July 23, 1971.

Hodenfield, Chris. "The Doors: From Demons to Darlings." *Circus,* February, 1970.

Hodenfield, Jan, with Andrew Bailey and Eithne O'Sullivan. "Wheeling and Dealing on the Isle of Wright." *Rolling Stone,* October 1, 1970.

Hogan, Richard. "The Doors Tapes." *Circus,* January 31, 1981.

"Hollywood Murders, The." *Newsweek,* August 18, 1969.

Hopkins, Jerry. "The Doors on Stage: Assaulting the Libido." *Rolling Stone,* February 10, 1968.

———. "Doors' Movie Is a Feast for Friends." *Rolling Stone,* July 12, 1969.

———. "The *Rolling Stone* Interview: Jim Morrison." *Rolling Stone,* July 26, 1969.

———. "The Doors in Mexico." *Rolling Stone,* August 23, 1969.

———. "Mr. Mojo Rises." *American Film,* October, 1990.

———, and Danny Sugerman. *No One Here Gets Out Alive.* New York: Warner Books, 1980.

Horowitz, Michael. "The Morrison Mirage." *Crawdaddy,* April, 1969.

Houghton, Rob. "L.A. Woman." *Creem,* September, 1971.

"100 Best Singles of the Last 25 Years, The." *Rolling Stone,* September 8, 1988.

Huxley, Aldous. *The Doors of Perception.* New York: Harper & Row/Perennial Library, 1954.

"Interview: The Doors," *Mojo Navigator,* August, 1967.

Jackson, Blair. "Paul Rothchild." *Bam,* July 3, 1981.

———. "The Second Coming of Jim Morrison." *Bam,* December 1, 1978.

Jahn, Mike. "The Doors: The West Is the Best." *Ingenue,* May, 1968.

———. "20,000 Hear Doors Give Rock Concert in a Packed Garden." *The New York Times,* January 25, 1969.

———. *Jim Morrison And The Doors.* New York: Grosset & Dunlap, 1969.

———. "The Doors Draw Active Audience." *The New York Times,* January 19, 1970.

James, Lizze. "Jim Morrison: Ten Years Gone." *Creem* (special summer edition), 1981.

"Jim Morrison, 25, Lead Singer with Doors Rock Group Dies." *The New York Times,* July 9, 1971.

"Jim Morrison Convicted: Assault." *Rolling Stone,* April 30, 1970.

"Jim Morrison Raps." *Eye,* October, 1968.

"Jim Morrison Takes a Trip." *Rolling Stone,* December 13, 1969.

"Jim Morrison Tells All." *Rolling Stone,* June 14, 1969.

Johnson, Pete. "Lost in Space." *Los Angeles Times,* July 18, 1966.

———. "Doors Open Up." *Los Angeles Times/Calendar,* February 26, 1967.

———. "Doors Rattle Hinges at Whisky a Go Go." *The Los Angeles Times,* May 18, 1967.

———. "The Doors' Hypnotic Music." *Los Angeles Times/Calendar,* October 29, 1967.

———. "Doors Play at Hollywood Bowl." *Los Angeles Times,* July 8, 1968.

Jones, Dylan. *Dark Star.* London: Bloomsbury Publishing, 1990 (Amer. ed., New York: Viking, 1991).

"Jury Set for Trial of Singer." *The Miami Herald,* August 15, 1970.

Kafka, Franz. *The Basic Kafka.* New York: Washington Square Press/Pocket Books, 1979.

Kasindorf, Martin. "Keeping Manson Behind Bars." *Los Angeles Times Magazine,* May 14, 1989.

Kaufman, Eileen. "Doors Set Night on Fire." *L.A. Free Press,* May 26, 1967.

Kennealy, Patricia. "The Lords and The New Creatures." *Jazz & Pop,* May, 1970.

———. "Morrison Hotel." *Jazz & Pop,* May, 1970.

Kerouac, Jack. *On the Road.* New York: Viking Press, 1955.

Knapp, Dan. "Morrison's Last Days in L.A.: Hope for the Future." *Los Angeles Times/Calendar,* July 25, 1971.

Kordosh, J. "Strange Days." *Creem* (special summer edition), 1981.

———. "The Soft Parade." *Creem* (special summer edition), 1981.

Laurence, Paul. "Ray Manzarek." *Audio,* December, 1983.

Leimbacher, Ed. "Seattle Gives Peace a Chance." *Rolling Stone,* September 6, 1969.

Levine, Paul. "Doors' Singers' Case Given Second Billing." *The Miami Herald,* August 11, 1970.

———. "Morrison's Peers Try for Glimpse at Trial." *The Miami Herald,* August 13, 1970.

———. "Singer Exposed Self, 2 Spectators Testify." *The Miami Herald,* August 18, 1970.

———. "Morrison Blurred in Photos." *The Miami Herald,* August 20, 1970.

———. "Movies, Play Barred as Morrison Defense." *The Miami Herald,* August 21, 1970.

———. "Officer: Morrison Fans Feared." *The Miami Herald,* August 26, 1970.

———. "Jurors Hear Morrison Tape, but No Call to Join in Nudity." *The Miami Herald,* August 28, 1970.

———. "Judge Rejects Morrison Plea for Acquittal." *The Miami Herald,* September 3, 1970.

Lisciandro, Frank. *An Hour for Magic.* New York: Delilah Books, 1982.

Lombardi, John. "A Lot of People Were Crying, and the Guard Walked Away." *Rolling Stone,* June 11, 1970.

———. "The Lords and The New Creatures." *Rolling Stone,* September 3, 1970.

Lommel, Andreas. *Shamanism: The Beginnings of Art.* New York: McGraw-Hill, 1967.

Lustbader, Eric Van. "Jim Morrison: Riding Out the Final Storm." *Circus,* September, 1971.

Lydon, Michael, "The Doors: Can They Still Light My Fire?" *The New York Times,* January 19, 1969.

McClure, Michael. "Michael McClure Recalls an Old Friend." *Rolling Stone,* August 5, 1971.

McCracken, Melinda. "Rock and Roll Revival Surprise: John & Yoko." *Rolling Stone,* October 18, 1969.

Mahoney, Larry. "Rock Group Fails to Stir a Riot." *The Miami Heald,* March 3, 1969.

———. "Public Reacts to Rock Show." *The Miami Herald,* March 4, 1969.

———. "Rock Singer Charged." *The Miami Herald,* March 6, 1969.

———. "Concert of Religion and Rock Is Banned." *The Miami Herald,* March 18, 1969.

———. "Morrison and Miami: Beginning of the End." *The Miami Herald,* July 10, 1971.

———. and Joe Averill. "Will Doors Open in Jacksonville on Sunday Night?" *The Miami Herald,* March 5, 1969.

———, and Ray Villwock. "Disorder Follows Pop Concert." *The Miami Herald,* March 2, 1969.

Malcolm, Andrew H. "Guam Refugees Host: George Stephen Morrison." *The New York Times,* April 30, 1975.

Marsh, Dave. "Morrison Hotel." *Creem,* February, 1970.

———. "Absolutely Live." *Creem.* October, 1970.

———. "13." *Creem,* March, 1971.

Masterson, Mike. "Doors an Individualist Group Unified Despite Diversity." *The Beat,* October 7, 1967.

Matheu, Robert. "Through The Doors Again." *Creem* (special summer edition), 1981.

Mathews, Linda. "Rockers Perform at Shrine Auditorium." *Los Angeles Times,* December 26, 1967.

Mayer, Ira. "Riffs: Jim Morrison." *The Village Voice,* July 15, 1971.

Meltzer, Richard. "The Doors Are Still Real Good." *Circus,* September, 1970.

————. "L.A. Woman." *Rolling Stone,* May 27, 1971.

————. "Leaving the Door Ajar." *The Los Angeles Herald Examiner/Sound,* June 13, 1980.

"Message of History's Biggest Happening, The." *Time,* August 29, 1969.

Miller, Jim. "Waiting for the Sun." *Rolling Stone,* September 28, 1968.

Milliken, Page. "Robbie Krieger." *Guitar Player,* March, 1973.

Morgenstern, Joseph. "On the Road." *Newsweek,* July 21, 1969.

Morris, Chris. "The Doors: A Reopening." *The L.A. Reader,* March 28, 1980.

Morrison, Jim. *The Lords and The New Creatures.* New York: Simon & Schuster, 1970.

————. *Wilderness.* New York: Villard Books, 1988.

————. *The American Night.* New York: Villard Books, 1990.

"Morrison: Audience Cussed." *The Miami Herald,* September 17, 1970.

"Morrison Hands Himself Over." *Rolling Stone,* May 3, 1969.

"Morrison of Doors Dead in Paris at 27." *The Cleveland Press.* July 9, 1971.

"Morrison's Penis Is Indecent." *Rolling Stone,* April 19, 1969.

Mueller, Carl R. "Antonin Artaud and the Theater of Cruelty." *Mankind,* March, 1980.

Muller, Hervé. *Jim Morrison au-delà des doors.* Paris: Editions Albin Michel, 1973.

————. "Jim Morrison's Last Days." *Globe,* March, 1990.

"My God! They're Killing Us." *Newsweek,* May 18, 1970.

Nelson, Paul. "Strange Days with The Doors." *Hullabaloo,* 1968.

"New Haven Police Close The Doors." *The New York Times,* December 11, 1967.

Nietzsche, Friedrich. *The Birth of Tragedy and The Case of Wagner.* New York: Vintage Books, 1967.

————. *Basic Writings of Nietzsche.* Translated and edited by Walter Kaufmann. New York: The Modern Library, 1968.

Nirkind, Bob. "The Doors Aftermath." *Phonograph Record Magazine,* April, 1972.

Nisley, Richard. "The Doors in Retrospect." *Record Review Magazine,* June, 1978.

Obrecht, Jas. "Beyond The Doors." *Guitar Player,* February, 1983.

O'Connor, Phillip. "Slamming The Doors." *Hullabaloo,* January, 1969.

"Olympics Extra Heat, The." *Newsweek,* October 28, 1968.

"On The Scene: The Doors." *Ingenue,* January, 1968.

O'Toole, Shamrock (Patricia Kennealy). "Doors in New York." *Jazz & Pop,* April, 1970.

————. "Absolutely Live." *Jazz & Pop,* October, 1970.

Paegel, Tom. "Doors, Airplane at Convention Center." *Los Angeles Times,* July 18, 1967.

———. "Death of Rock Star Jim Morrison Disclosed." *Los Angeles Times,* July 9, 1971.

Paulsen, Don. "A Year of the Doors." *Hit Parader,* February, 1968.

Paulsen, Don. "The Doors." *Hit Parader,* April, 1967.

———. "Doors Are Different—Part 1." *Hit Parader,* September, 1967.

———. "Doors Are Different—Part 2." *Hit Parader,* October, 1967.

———. "Doors Talk Music." *Hit Parader,* May, 1968.

Pearce, Mike. "New Doors Album Incredible." *L.A. Free Press.* November 10, 1967.

Pearlman, Sandy. "Doors & Kinks." *Crawdaddy,* January, 1968.

Perr, Harvey. "At the Bowl." *L.A. Free Press,* July 19, 1968.

———. "Living Theatre." *L.A. Free Press,* February 28, 1969.

———. "Stage Doors." *L.A. Free Press,* August 8, 1969.

Phillips, Tom. "Rock Musicals: The Hippies Are from *Time* Magazine." *Rolling Stone,* July 20, 1968.

Pierce, Brad. "How The Doors Opened." *Flip,* Winter, 1968.

Podelco, Grant. "The Doors That Never Close." Cleveland *Plain Dealer,* October 16, 1987.

Pollock, Bruce. "After the Fire." *Guitar,* September, 1988.

Pond, Steve. "Jim Morrison's Spirit Keeps The Doors Alive." *Rolling Stone,* November 27, 1980.

Powledge, Fred. "Wicked Go The Doors." *Life,* April 12, 1968.

Reabur, Chris (Bruce Harris). "Morrison Hotel Revisited." *Jazz & Pop,* September, 1970.

Richman, Robin. "The New Rock." *Life,* June 28, 1968.

Riegel, Richard. "The Doors on Record." *Creem* (special summer edition), 1981.

Riordan, James. "Producers: The New Studio Stars." *The Chicago Daily News,* January 26, 1978.

———. "American Prayer." *Star Newspaper Group,* December 8, 1978.

———. "Doors Greatest Hits." *Rock-Pop,* November 7, 1980.

———. *The New Music Business.* Cincinnati: Writers Digest Books, 1988.

———, and Bob Monaco. *The Platinum Rainbow.* Chicago: Contemporary Books, 1980.

Robins, Wayne. "Lucky Demeter, Rhythm Sleuth Meets Ray Manzarek." *Creem,* December, 1974.

"Rock 'n' Roll Concert Breaks Up in a Scuffle, A." *The New York Times,* August 3, 1968.

"Rock Singer Released on $5,000 Bond." *Los Angeles Times,* April 5, 1969.

"Rock Star Sought After Show." *Fort Lauderdale Sun-Sentinel.* March 6, 1969.

Rompers, Terry. "Looking Through the Doors." *Trouser Press,* September/October, 1980.

Rosen, Steve. "Ray Manzarek, From The Doors to Nite City." *Keyboard,* September, 1977.

Sager, Mike. "Val Kilmer." *Interview,* November, 1990.

Sander, Ellen. "The Doors: The Kingdom Has Crumbled." *Hit Parader,* November, 1969.

Sanders, Buck. "Full Circle." *Creem,* November, 1972.

Scott, Jane. "The Doors, Morrison Light Their Fires." Cleveland *Plain Dealer,* August 4, 1968.

———. "The Happening." Cleveland *Plain Dealer,* September 22, 1967.

———. "Doors Swing Out Thursday." Cleveland *Plain Dealer,* September, 1967.

Sims, Judith. "An Introduction to The Doors." *TeenSet,* June, 1967.

———. "Jim Morrison: Superstar." *TeenSet,* April, 1968.

———. "An Afternoon with Jim Morrison." *TeenSet,* June, 1968.

———. "Long Beach Opens Doors Concert." *L.A. Free Press,* February 27, 1970.

———. "Pam Morrison: A Final Curtain on Her Affair with Life." *Rolling Stone,* June 6, 1974.

———. "1967, The Summer of Love." *Los Angeles Times/Calendar,* August 2, 1987.

Sink, Steve. "Morrison Gets 6-Month Sentence, $500 Fine." *The Miami Herald,* October 31, 1970.

Smith, Howard. "Scenes." *The Village Voice,* December 14, 1967.

Smith, Patti. "An American Prayer." *Creem,* January, 1979.

Somma, Robert. "Banging Away at the Doors of Convention." *Crawdaddy,* October, 1968.

"Space Odyssey 1969." *Time,* July 25, 1969.

"Split Decision in Morrison Trial." *Rolling Stone,* October 15, 1970.

Stavers, Gloria. "Meet Jim Morrison of The Doors." *16 Magazine,* November, 1967.

———. "The Strange Mystical Magical World of Jim Morrison." *16 Spectacular,* Fall 1967.

———. "The Doors: Memento Morrison." *Trouser Press,* April, 1979.

———. "Jim Morrison & the Midnight Photographer." *Relix,* February, 1983.

Stein, Mark A. "Summer of Love Infiltrated the Modern World." *Los Angeles Times,* June 21, 1987.

Stevenson, Salli. "An Interview with Jim Morrison." *Circus,* January, 1971.

————. "The Jim Morrison Interview—Part II." *Circus,* February, 1971.

Stickney, John. "Four Doors to the Future: Gothic Rock Is Their Thing." *Williams College News,* Fall, 1967.

"Strange Days." *Rolling Stone,* November 23, 1967.

"Strange Days: A Multi-media Collage History of The Doors." *Bam,* July 3, 1981.

Sugerman, Danny. "A Shaman's Sojourn Through The Doors." *Rock,* January, 1977.

————. *The Doors: The Illustrated History.* New York: William Morrow & Co./Quill, 1983.

————. *Wonderland Avenue.* New York: William Morrow & Co., 1989.

Sullivan, Dan. "A Living Audience for Living Theater." *Los Angeles Times,* February 26, 1969.

————. "Frankenstein at USC Theater." *Los Angeles Times,* February 27, 1969.

————. "The Living Theater Presents Antigone." *Los Angeles Times,* March 1, 1969.

————. "The Living Theater Presents Paradise." *Los Angeles Times,* March 3, 1969.

"Sunset Along the Strip." *Time,* December 2, 1966.

"Swimming to the Moon." *Time,* November 24, 1967.

Tamarkin, Jeff. "Renew My Subscription to The Doors' Resurrection." *Goldmine,* June 21, 1985.

————. "Renew My Subscription to The Doors Resurrection, Part II." *Goldmine,* July 5, 1985.

Taylor, Derek. *It Was Twenty Years Ago Today.* New York: Fireside Books, 1987.

Tereba, Tere. "Goodbyes." *Crawdaddy,* August, 1971.

"This Way to the Egress." *Newsweek,* November 6, 1967.

Tobler, John. "Stoned Immaculate." *Zig Zag Magazine,* March, 1979.

————, and Andrew Doe. *The Doors.* London: Proteus Publishing, 1984.

"Too Much Restraint Shown in Doors Case." *The Miami Herald,* March 9, 1969.

"Top 100: The Best Albums of the Last Twenty Years, The." *Rolling Stone,* August 27, 1987.

Tosches, Nick. "The Doors." *Fusion,* June 25, 1971.

————. "Jim Morrison: The Late, Late Show." *Rolling Stone,* January 25, 1979.

"Tribute to the Fillmore, A." *Planet Magazine,* December, 1971.

Vanjak, Gloria. "Absolutely Live." *Rolling Stone,* October 1, 1970.

————. "State of Florida vs. Jim Morrison." *Rolling Stone,* October 1, 1970.

Van Ness, Chris. "The Doors after Morrison." *L.A. Free Press,* November 26, 1971.

Walley, David. "Waiting for the End." *East Village Other,* January, 1970.

Walls, Richard C. "The Doors." *Creem* (special summer edition), 1981.

———. "Waiting for the Sun." *Creem* (special summer edition), 1981.

Wardlow, Jean. "Clean Teens Rally for Scour Power." *The Miami Herald,* March 9, 1969.

———. "Teens Stage Rally for Decency Today." *The Miami Herald,* March 23, 1969.

———. "Decency Rally Rattles Orange Bowl to Rafters." *The Miami Herald,* March 24, 1969.

"Warrant Issued for Top Rock Singer." *The Fort Lauderdale News,* March 6, 1969.

Wasserman, John L. "Exciting Instrumentalists." *San Francisco Chronicle,* July 31, 1967.

Weintraub, Kris. "Oh Caroline." *Crawdaddy,* June, 1968.

Whited, Charles. "Get Rich Quick: Be Obscene." *The Miami Herald,* March 6, 1969.

"White House Letter Comes for Clean Teen." *The Miami Herald,* March 27, 1969.

"Widow of Rock Star Morrison Is Found Dead." *Los Angeles Times,* April 26, 1974.

Williams, Liza. "Liza Meets Infante Terrible." *L.A. Free Press,* December 20, 1968.

Williams, Paul. "What Goes On." *Crawdaddy,* January, 1967.

———. "Rock Is Rock—A Discussion of a Doors Song." *Crawdaddy,* May, 1967.

———. "Rothchild Speaks." *Crawdaddy,* July/August, 1967.

———. "What Goes On." *Crawdaddy,* October, 1967.

———. "Music Without the Myth." *Rolling Stone,* September 17, 1981.

Williamson, Herb. "In Their Zealous Search for Youth Delegates Were Beaten and Ignored." *Rolling Stone,* September 28, 1968.

Windeler, Robert. "Doors, a Way in and a Way out, Rock on Coast." *The New York Times,* November 20, 1967.

Wolfe, Bernard. "The Real-Life Death of Jim Morrison." *Esquire,* June, 1972.

Youngblood, Gene. "Doors Reaching for Outer Limits of Inner Space." *Los Angeles Free Press,* December 1, 1967.

Zevallos, Hank. "The Doors." *Happening,* Summer, 1967.

Zimmer, Dave. "Robby Krieger: Opening New Doors." *Bam,* November 5, 1982.

Zwerin, Michael. "Jazz Journal." *The Village Voice,* March 7, 1968.

Radio, Television, and Video Sources

Feast of Friends, A, produced by The Doors, Los Angeles, CA, 1969.

"Artist in Hell," KPFK–FM Radio, Los Angeles, CA, 1979.

Dance on Fire, Doors Productions, MCA Home Video, Universal City, CA, 1985.

Doors Are Open, Granada Productions, London, England, 1968.

"Doors from the Inside," Valley Isle Productions (Sandy Gibson with Jac Holzman), Media America Radio, Los Angeles, CA.

Doors in Europe, Doors Productions/HBO Productions, 1989.

"Doors: 20th Anniversary Salute, The," Mark Coppola, Jon Sargent Productions, Radio International Network, Los Angeles, CA, 1987.

HWY, produced by Jim Morrison, Los Angeles, CA, 1969.

In the Studio/L.A. Woman, Bullet Productions, Burbank, C.A.

In the Studio/Strange Days, Bullet Productions, Burbank, C.A.

In the Studio/The Doors, Bullet Productions, Burbank, C.A.

Live at The Hollywood Bowl, Doors Productions, MCA, Universal City, CA, 1987.

"Morrison Interview," with Howard Smith of *The Village Voice,* New York, NY, 1970.

"Soft Parade, The," NET, New York, NY, 1969.

Three Hours for Magic, Frank Lisciandro, Jon Sargent Productions, distributed by London Wavelength, Los Angeles, CA,

20th Anniversary Salute—Light My Fire, The, Denny Somach Productions, ABC Rock Radio, New York, NY, 1987.

Audio
"Ray Manzarek" by Paul Laurence, *Audio,* December, 1983, for the following quotes, pp. 115, 154, 325.

Bam magazine
"Paul Rothchild" by Blair Jackson, *Bam,* July 3, 1981, for the following quotes, pp. 103, 109, 114, 156, 157, 179, 214, 215, 228, 229, 319, 320, 338, 385, 422, 423, 495.
"Strange Days: A Multimedia Collage History of The Doors" by Blair Jackson, *Bam,* July 3, 1981, for the following quotes, pp. 84, 104, 162, 167, 168, 268, 269, 454, 455, 456.

Circus
"An Interview with Jim Morrison" (Parts 1 and 2) by Salli Stevenson, *Circus,* January/February 1971, for the following quotes, pp. 303, 409, 416, 418, 439, 440. Copyright © 1971 by Circus Enterprises Corp. Used with permission.

Crawdaddy
"Jim Morrison's School Days" by Richard Blackburn, *Crawdaddy,* May 1976, for the following quotes, pp. 54, 64, 65, 66, 91, 92, 97, 99, 104.
The Morrison Mirage" by Michael Horowitz, *Crawdaddy,* April 1969, for the following quotes, pp. 51, 52, 165, 166, 168, 169.
"Rothchild Speaks" by Paul Williams, *Crawdaddy,* July/August 1967, for the following quotes, pp. 109, 110, 113, 114, 131.

Creem
"Through The Doors Again" by Robert Matheu, *Creem,* Special Summer Edition 1981, for the following quotes, pp. 100, 187, 188, 217, 294, 299, 300, 302, 374, 438, 461, 475.

Vic Garbarini
for the following quotes, pp. 21, 109, 112, 179, 193, 232, 320, 340.

Goldmine
"Renew my subscription to the Doors' Resurrection" (Parts 1 and 2) by Jeff Tamarkin, *Goldmine,* June 21, 1985, for the following quotes, pp. 22, 90, 110, 208.

Hit Parader
"The Doors: The Kingdom Has Crumbled" by Ellen Sander, *Hit Parader,* November 1969, for the following quotes, pp. 260, 284, 285.

Keyboard Magazine
"Ray Manzarek, from The Doors to Nite City" by Steven Rosen, *Keyboard,* September 1977, for the following quotes, pp. 77, 78, 112, 117, 119.

Modern Drummer
"Reflections" by Robyn Flans, *Modern Drummer,* December 1982, for the following quotes, pp. 80, 81, 89, 90, 94, 96, 102, 105, 107, 118, 120, 214, 215, 232, 249, 250, 340, 427, 428, 462.

Musician
"Doors Organist Ray Manzarek" by Peter Fornatale, *Musician,* August 1981, for the following quotes, pp. 83, 141, 155, 213, 299, 300, 306, 320, 354, 380, 424, 427.

New York magazine
"The Shaman as Superstar" by Richard Goldstein, *New York,* September 5, 1968, for the following quotes, pp. 34, 161, 185, 188, 191.

Relix
"Morrison's Celebration of the Lizard, A *Relix* Interview with Danny Fields" by Toni A. Brown and Leslie D. Kippel, *Relix,* June 1981, for the following quotes, pp. 147, 148, 231, 475.

"Jim Morrison and the Midnight Photographer" by Gloria Stavers, *Relix,* February 1983, for the following quotes, pp. 165, 166.

Rolling Stone

"The Rolling Stone Interview: Jim Morrison" by Jerry Hopkins, *Rolling Stone,* July 26, 1969, for the following quotes, pp. 22, 31, 41, 44, 46, 47, 48, 53, 101, 102, 130, 131, 224, 239, 250, 252, 272, 325, 326, 373, 374, 380, 497.

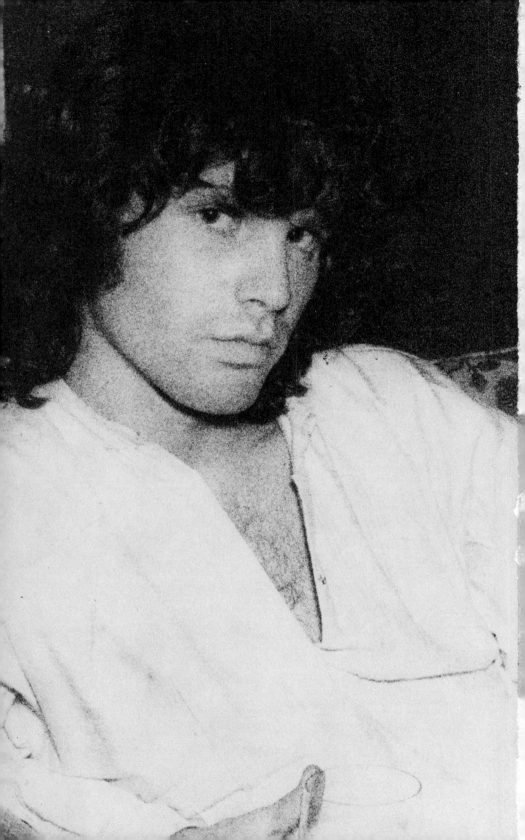